# WHAT BECOMES
# A LEGEND MOST

A BIOGRAPHY OF

# RICHARD

# WHAT BECOMES
# A LEGEND MOST

# AVEDON

## PHILIP GEFTER

HARPER

*An Imprint of* HarperCollins*Publishers*

HarperCollins books may be purchased for educational, business, or sales promotional use. For information, please email the Special Markets Department at SPsales@harpercollins.com.

FIRST EDITION

*Designed by Bonni Leon-Berman*

Library of Congress Cataloging-in-Publication Data has been applied for.

ISBN 978-0-06-244271-0

20 21 22 23 24   LSC   10 9 8 7 6 5 4 3 2 1

For Richard Press

Fame is a bee.
It has a song—
It has a sting—
Ah, too, it has a wing.

—EMILY DICKINSON

# CONTENTS

# INTRODUCTION

On the occasion of her starring role as King Lear on Broadway, the great British actor Glenda Jackson, by then eighty-two years old, asserted that Shakespeare remains the most contemporary dramatist in the world "because he really only ever asks three questions: Who are we? What are we? Why are we?" These same existential questions underscore the body of portraiture produced by Richard Avedon in the second half of the twentieth century. We are all of the same species, he was saying, and with each portrait he made, regardless of whether it was of the Duke and Duchess of Windsor, Marilyn Monroe, Truman Capote, or a drifter in the American West, he rendered a specimen of our species to be contemplated in the context of his ongoing catalog of humanity, prompting us to consider ourselves over and over again, as if in mirror image: *Who are we? What are we? Why are we?* And, yet, in Avedon's lifetime, he was dismissed as a "celebrity photographer"—an intellectual slur that stuck to him as gum on his shoe, and to which he was often quick to reply: "Don't think about who they are; just look at their faces."

Avedon's 1957 portrait of Monroe is one of his most recognizable images. If all his portraits are self-portraits—"My portraits are much more about me than they are about the people I photograph," he said on more than one occasion—then the question of how to refer to this photograph presents an additional anomaly about the nature of portraiture: Do Andy Warhol's silk screen multiples of "Marilyn," for example, or "Jackie," or "Liz," constitute portraits of legendary icons, or are they Warhols first? A comparable example

might be John Singer Sargent's bravura portraits of society figures of the late nineteenth century that depict a class and an era with accomplished brushwork and daunting spontaneity. Yet we recognize the exquisite Sargent before identifying the woman in his risqué portrait, "Madame X," say, as Virginie Gautreau. No anecdote better epitomizes this paradox than the one recounted about Picasso's portrait of Gertrude Stein. When confronted by someone who claimed that the portrait didn't look anything like Stein, Picasso said with imposing confidence: "It will." The same could be said of Avedon's portrait in which Marilyn Monroe appears "unmasked." It may not represent the public image of the radiant movie star, but it has fallen in place historically as Avedon's "Marilyn." That is true of all his portraits. They are recognizably Avedons first, even before the viewer identifies his subject.

Today, in the pantheon of portrait photographers, Avedon stands alongside Nadar (Gaspard-Félix Tournachon), who photographed in his Paris studio the significant artists, writers, musicians, and thinkers of nineteenth-century Second Empire France; Julia Margaret Cameron, who photographed the artists, poets, philosophers, and aristocrats of nineteenth-century Victorian England; August Sander, who made a chronicle of societal archetypes in early twentieth-century Germany; and, of course, his own contemporary, Irving Penn. All of them photographed the significant figures of their time, each one asserting a distinct visual signature that defines the artist as well as the period in which they each lived and worked. Avedon's signature was the formality of a straight-on figure against the white nuclear backdrop, with a proscenium frame composed of the edges of the film printed as part of the image— the ID picture taken to its apotheosis.

In his fashion work, he brought a native poetic impulse and youthful exuberance to his discovery of Paris after the Second World War and transformed the representation of women's fashion

in photography into the defining look of an era. "He knew that 'women are a foreign country,'" Judith Thurman writes about the young Avedon in her essay in *Made in France*. "He also knew, like every other precocious young aesthete raised among philistines . . . that Paris is the capital of that foreign country."

In his lifetime, Avedon endured personal, as well as professional, prejudice. He was brought up in New York between the world wars, when anti-Semitism and homophobia forced him to make decisions that shaped the course of his life. His father, Jacob Israel Avedon, anglicized his name to Allan Jack Avedon, and his son grew up believing that, as a Jew, assimilation and aspiration were the same thing. Avedon had his nose surgically altered in 1941, at the age of seventeen, to appear less Jewish. Several years later, he began psychoanalysis to try to cure himself of unwanted homosexual feelings. He married (twice), a necessity in mid-twentieth-century America for anyone who wanted to have professional options and societal standing. By sheer force of will, and not a little talent, he rose to become the most successful fashion photographer in the world, and, then, among the greatest portrait photographers—along with Irving Penn, to whom he would become tethered in history as Picasso is to Matisse; Pollock to de Kooning; and Roth to Updike.

As an artist, Avedon found that the world of fashion did not satisfy the breadth of his curiosity and creativity. "Avedon was like Fragonard," one colleague said about him. "Like many decorative artists, he despised his gift." His "gift" became a noose around his neck (albeit one that was perpetually lucrative and made him very rich). He wanted to be taken seriously as an artist but was foiled by the bastard medium he embraced—photography—which made the struggle to be seen as an artist that much more encumbered. In his final years, Avedon witnessed a respect for his chosen medium that had been long overdue in the art world and that he had had a hand

in bringing about: his own tireless efforts to have his work shown in galleries and museums throughout his career tracked simultaneously with the rise in stature of the medium of photography itself.

In Avedon's lifetime, two other luminaries had instrumental roles in garnering respect for photography in the art world: the curator John Szarkowski had the institutional platform of the Museum of Modern Art on which to make his persistently eloquent case for photography as an art form of equal consequence among its fine art peers; and Sam Wagstaff, an institution of one and one of the very first photography collectors, who almost single-handedly established the art market for the medium. Avedon was third in this triumvirate, despite the fact that the curator and the collector refused to take his work seriously. Yet, in 1978, when Avedon's fashion work was exhibited at the Metropolitan Museum of Art, it broke photography out of its circumscribed ghetto, unfurling his name on a huge banner in front of the most august museum in America and landing him on the cover of *Newsweek*, still then a pillar of journalism and an oracle of cultural significance. No other living photographer had situated himself so prominently in the public eye. For better or worse, Avedon became a household name. "He is one of the major photographic artists of the twentieth century, and one of the most influential," said Mia Fineman, cocurator of his exhibition of portraits at the Metropolitan Museum of Art in 2002. "Practically every day you'll come across an Avedon imitation. The portrait style he established has become part of the vocabulary of photography. That work is seminal, and his fashion work, too. He was groundbreaking in both."

I wrote this biography because of my belief in Avedon as one of the most consequential artists of the twentieth century, closer in his sweeping art-historical gesture toward flattening out the image on a two-dimensional surface to Andy Warhol than to Diane Arbus. While his fashion work was revolutionary in its time—essentially in the 1950s and 1960s—not to mention stylish, debonair, and visually

arresting, his portraiture was radical in its formal simplicity; monu-
mental in its existential purity. Avedon advanced the genre, falling
in place after August Sander. I set out to explore the combination
of qualities and circumstances that formulated Avedon's unique
sensibility, which carried the allure of international glamour and,
along with it, something profoundly sexy that was hard to define.
In the riddle of that examination was my own quest to understand
how the culture of the second half of the twentieth century evolved
from a particular nexus in New York and Hollywood, in the years
of my own youth, the 1950s and 1960s: Avedon was at the center
of a profoundly influential group of individuals—Leonard Bernstein,
Truman Capote, James Baldwin, Allen Ginsberg, Harold Brodkey,
Sidney Lumet, and Mike Nichols—who shaped the cultural life of
the American century and whose music, books, and films clarified my
own understanding of my time. Avedon's world was a nourishing one
to get lost in while I researched, contemplated, and laid out the story
of his life. It was an exercise that confirmed a guiding belief of mine,
one exemplified by Avedon himself: Know thy culture; know thyself.

Finally, my goal was to make a case for Avedon's place of achieve-
ment alongside his peers in the pantheon of twentieth-century arts
and letters. He lived a most remarkable life—he knew everyone;
he went everywhere; he lived well; he worked hard. He straddled
glamour and pathos in equal measure. Behind the glossy name,
though, or in spite of it, he was an individual with crackling intelli-
gence, unbounded curiosity, originality, and vision. Of course, it is
a fine line between ambition and delusion on which the artist is so
precariously, if steadfastly, balanced, and Avedon walked that line
in a high-wire act that would leave almost anyone in a perpetual
state of vertigo. What makes a legend most, indeed!

—*Philip Gefter*
NEW YORK, 2019

# WHAT BECOMES
# A LEGEND MOST

# 1

# PICTURES
## AT AN EXHIBITION

(1975)

His best portraits are what the Seagram Building is to
architecture: the ultimate manifestation of modernism.

—NEIL SELKIRK

Overheard by a reporter: "This is *the* place to be in New
York tonight!" It was September 9, 1975, and the recep-
tion had drawn an unexpected crowd of three thousand
people, more than the lavish Midtown gallery could comfortably
hold. One attendee attempted in vain to look at the pictures on the
wall while being jostled by the celebrities in the room, muttering in
exasperation that the entire event "is a parody of itself."

They all had come for Richard Avedon's first commercial gallery

show, at the Marlborough on West Fifty-Seventh Street. Among the guests being pushed about were Andy Warhol, Warren Beatty, Norman Mailer, and Nora Ephron. The legendary magazine editor Clay Felker was there as well as the museum director Thomas Hoving. The diversity of attendees made it difficult to identify any single strata of society, other than to say *Le Tout New York* showed up: The civil rights lawyer William Kunstler was talking to the model Lauren Hutton, stylishly donning a cowboy hat; the A&P grocery heir Huntington Hartford stood next to the film director Francis Ford Coppola; the socialite Gloria Vanderbilt was whispering to the philanthropist Lily Auchincloss; the outré actress Sylvia Miles (who, it was often mumbled, would attend "the opening of an *envelope*") huddled in a corner together with the legendary restaurateur Elaine Kaufman.

Of course, there were those at the opening who came to see their own portraits on the wall, rendered with Avedon's austere white minimalism and bold graphic punch. Viewers could examine any one of the daunting wall-size portraits—a stunned-by-life facial expression, the width of a nostril, the weight of a flaccid chin—with a freedom that would never be possible standing before the real-life subject. "Avedon took great care to photograph the folds of skin, wrinkles, and moles, all with a very sharp lens," Paul Roth observed when he was director of photography at the Corcoran Gallery of Art, almost a half century after the 1975 exhibit. "Traditionally, portraiture idealizes its subject—and gives some sense of their clothes and surroundings. Avedon dispensed with all of that. It's hard to overemphasize how radical that kind of portraiture was at the time."

Reactions to the portraits on the walls varied widely. "Brilliant" was a standard refrain heard throughout the gallery, but, equally, murmurs of disdain wafted above the din in reaction to the bald depiction of age etched into the faces of some subjects, expressions

of despair or surprise or chagrin captured in others. Truman Capote was vocal about his "very unflattering portrait," as he called it, asserting that his half-crossed, half-closed eyes were the result of an illness on the day the picture was taken. John Gruen, in a rather piquant review of the show in the *SoHo Weekly News*, would describe Avedon's Capote as "paralyzed and somnambulant by what must be the crushing workings of his inner life." The writer Harold Brodkey arrived at a more essential conclusion about his own portrait: "It's not the way I look, but the way I am," he said. Amelia "Lee" Marks, a Marlborough gallery assistant at the time, remembered Polly Mellen, the illustrious *Vogue* fashion editor, basking in the media attention: "The flashes kept going off as she posed in front of her portrait."

People swarmed around "Dick"—as everyone called Avedon—worshipful in their genuflections and hyperbolic with praise. Dressed in a three-piece suit, the man of the hour—fifty-two years old and not very tall—was easily identifiable by his flowing salt-and-pepper hair. He was accustomed to the limelight and handled the attention with seasoned insouciance, smiling gratefully, demurring appropriately, laughing at witty asides, the gradations of his acknowledgment calibrated to the individual's designated place in his intricate and ever-fluctuating hierarchy of regard, affection, or usefulness. And, yet, within the imperceptible gulf between *Avedon*, the main character on this stage, and *Dick*, the vulnerable artist, a clench of anxiety held him hostage in a struggle against his all-too-familiar dread and suffocating self-doubt. Paradoxically, the undulating crush of people in the gallery proved to be a buffer that allowed him to execute the ritualistic nods, fleeting kisses, and perfunctory felicitations required of a virtuoso.

Avedon had long been recognized as the world's most famous fashion photographer; in fact, his urbane and elegant images of women in Balenciaga or Dior or Givenchy had become a brand

all their own. And, yet, despite his towering commercial success, he had been reaching for years toward something purer and more universal with a simultaneous body of work—these portraits. With this exhibition, he wanted recognition not as someone who influenced the present, but, more urgently, achingly, as an artist inventing a visual language that would become ever more coherent in time. For Avedon, the stunning originality of his work and the prodigious intelligence behind it were not in question, per se. The issue had more to do with whether his work would be acknowledged as Art—with a capital *A*—or would it remain in the purgatory of high commerce?

IN 1975, THE ELEVATION of photography's stature in the art world had not yet occurred. Photography was regarded, still, as something of a utilitarian medium, whether photojournalism, advertising, passport ID photos, family snapshots, or forensic evidence. Photography served any variety of applications that were commercial or practical or personal. While several landmark photography exhibitions had been mounted at the Museum of Modern Art—such as *New Documents*, a 1967 show that introduced the work of Diane Arbus, Lee Friedlander, and Garry Winogrand—these exhibits were known primarily within the confines of a small and circumscribed photography community. A history of the medium had not yet been introduced into the history of art. In the mid-1970s, still, museum curators and art critics looked askance at photography, considering it, at best, an art world afterthought. They were slow to recognize that, during the 1960s, the photographic image was marching through the studios of the artists of the day and hiding in plain sight in canvases on the walls of museums and galleries, in works by Warhol and Rauschenberg, John Baldessari and Ed Ruscha—all of whom were using photographs

in the service of their larger conceptual ideas. And, yet, while these artists were conditioning an art-going public to the language of the photograph, the photograph itself was dismissed as nothing more than a graphic art.

The timing of the Avedon show at Marlborough gallery could not have been better for Dick—and, it turns out, for photography itself. Destiny is always a marriage of fate and will. *Fate* might land you in the right place at the right time, yet *will* is what determines how you deal with such karmic good fortune. By the fall of 1975, when the Avedon show opened, word had already made its way through some quarters of the art world that photography was being monetized. A year before, an album of photographic portraits by the nineteenth-century British photographer Julia Margaret Cameron sold at Sotheby's in London for $130,000, a jaw-dropping figure at the time. It sent shock waves across the Atlantic. Photographs never had been thought to have any value as collectible items, primarily because they were ubiquitous and so easily reproducible in newspapers and magazines. However, the Cameron album was unique. It contained dozens of one-of-a-kind vintage prints from the nineteenth century and photographic subjects composing a pantheon of arts and letters in nineteenth-century Britain—Thomas Carlyle, Lewis Carroll, Charles Darwin, and Alfred, Lord Tennyson, among the ninety-five portraits. With his bid of $130,000 for the "Herschel album"—so called because Cameron had assembled it as a gift for her friend John Herschel—a former American museum curator named Sam Wagstaff had given birth to the photography market.

The Avedon show at Marlborough gallery caused a stir. The dialogue it precipitated in the art world aimed precisely at the utilitarian character of the medium in general, and the susceptibility of critics to categorize Avedon's work, specifically, as quintessentially commercial. It's true, for example, that many of the portraits in the

show had been made on assignment for the magazines he worked for; and, yet, overlooked was that Avedon had made over one hundred prints, ranging in size from sixteen by twenty to wall-size murals, at his own expense in an attempt to create a historic record of an era—not unlike Julia Margaret Cameron.

Avedon was known for his methodical, meticulous—even maniacal—approach to his work. He obsessed over every detail of every photo shoot. When it came time to organize the Marlborough show, he applied the same level of rigor and focus. Between May and September 1975, working day and night, he and Marvin Israel, the former art director at *Harper's Bazaar*, his old friend and invaluable colleague, transformed the studio in Avedon's town house on East Seventy-Fifth Street into an exhibition laboratory. A scale model of the Marlborough gallery was built; prints of the more than one hundred portraits under consideration for the show were made in miniature and sequenced on the walls of the scale model. Avedon then would study the images late into the evening, moving them around like pieces in a jigsaw puzzle.

Once Avedon identified omissions in his pantheon of accomplished individuals, he set out to make eighteen new portraits for the show, some in his pristine white studio, including sittings with William Burroughs and Harold Brodkey on the same day. Others required a pilgrimage. Early that July, Avedon flew to Buenos Aires to photograph the writer Jorge Luis Borges, bringing with him several of Borges's books to read during the all-night flight. Upon arrival, he was told that Borges's mother had died only hours before; but Borges, nonetheless, agreed to proceed with the shoot. As Harry Mattison, Avedon's assistant, set up the lights, the white paper backdrop, and the eight-by-ten Deardorff view camera, he simultaneously translated the conversation with Borges, who, despite being multilingual, chose to speak to Dick in his own native Spanish. "Borges and I talked about death," Avedon said. "His

mother's death, the deaths of other people in his family, ways of dying, the death of my own father." Avedon would note later that, despite the intimacy they had established during this discussion, his portrait of Borges turned out to be stillborn, a death mask, "icy cold and empty of what I'd hoped would be there." That did not prevent him from including it in the show.

Less than a week later, he was on a sprint to the seaside community of Mabou, in Nova Scotia, to make a portrait of his contemporary Robert Frank, whose photographic masterpiece *The Americans* had not yet been established beyond a small group of photographers and curators as one of the most influential photography books of the twentieth century. Avedon had known Frank for years, although they were not friends and their social or professional orbits rarely, if ever, overlapped. Frank lived downtown and Avedon lived uptown, a divide that was then characterized as bohemian versus bourgeois—in Avedon's case, high bourgeois. (Marvin Israel once asked Dick how he could "be an artist and live on Park Avenue." Dick shrugged and said, "Easily.") Late in Frank's life, asked about this photo shoot, he was disparaging of Avedon. "Avedon was a *Sammy*. That's what we always called him," Frank said. *Sammy* referred to Sammy Glick, the protagonist in the 1941 Budd Schulberg novel *What Makes Sammy Run?*, a seminal rags-to-riches story about a scrappy kid from the ghetto on the Lower East Side who elbows his way to the top of the Hollywood studio system. On Frank's tongue, a *Sammy* was a moral slur.

In Avedon's portrait, Robert Frank appears wholly at ease in his body, standing unshaven, uncombed, unfettered, his sweatshirt clearly weathered, staring at the viewer with an unflinching animal confidence. Frank's dog, Sport, has jumped into the frame from below— a Jungian surprise—and he scratches the dog's snout affectionately, absentmindedly. He appears as a man without pretense, one who could care less about the social rituals and cues of his contemporaries.

It is most curious that after photographing Frank in Mabou, Avedon made a self-portrait in which he, too, appears vaguely unkempt, his hair uncombed, his polo shirt opened wide enough to see the hair on his chest, an uncharacteristic counterpoint to his usual stylish grooming. Avedon made many self-portraits in his lifetime, but this is the only one in which he is uncoiffed and stripped of his urbanity. This raises a question about whether Avedon intended to compare himself with the wild man Frank, who, with what little inner-sanctum art world approval was given to a photographer at the time, was thought to be the real thing, a photographer's photographer—an *artist*.

In fact, Avedon may have considered his excursion to Mabou as a spiritual reckoning with a man he truly respected but was perhaps also intimidated by. Frank's obdurate refusal to conform to the value structure in which Avedon had so successfully risen might have felt as if a repudiation.

Avedon lingered in Mabou, and one afternoon he, Frank, and Frank's wife, the artist June Leaf, took a long walk by the sea, where the three spent hours collecting stones. By Avedon's account, when Leaf later invited him into her studio to see her work, "all of a sudden, from a rather silent woman, this knockout of a person came out." He had not planned on photographing her, but he was struck by Leaf's "lack of self-consciousness" and asked if she would mind posing for him.

In this now well-known portrait—which may be one of Avedon's finest—Leaf's arms are crossed over her chest, each hand clutching the opposite shoulder. "It was cold that day," she later said, explaining the gesture. Her breasts are visibly outlined under the summerweight fabric of her shirt and her elbows are pressed against them, an unwitting symbol of universal fecundity. She does not project any vanity about how she looks, rather staring at the viewer with an ease of expression both welcoming and inquisitive. "June is one of

the most beautiful women I've ever photographed—maybe, in part, because she's not a professional beauty," Avedon told the *Times* in a feature story written on the occasion of the Marlborough gallery show. "She makes me feel I'm just learning to photograph women."

At the end of July, Avedon visited Washington, DC, to photograph Rose Mary Woods, secretary to former president Nixon. Avedon was known primarily for his portraits of celebrated figures, but he was fascinated with the idea of Woods's unlikely prominence during the Watergate scandal, when she was accused of erasing eighteen minutes of an Oval Office audiotape. She appears in her portrait prim, her coiffure tidy, her pearl earrings matching her necklace, the tailored fit of her long-sleeve, block-patterned silk blouse accentuating her sizable bosom. The expression on her face is inscrutable, her mouth frozen into what must have been years of dutiful good cheer. One might view the constraints in Rose Mary Woods's constructed persona in direct opposition to the natural ease of June Leaf.

If, in 1975, the inviolate and, now, almost quaint chasm between the commercial and the artistic possessed any contradiction, it was that photography was being transformed into a collectible fine art by a market phenomenon. On September 30, 1975, during the run of the Avedon show at Marlborough gallery, *Art in America* presented an all-day symposium called "Collecting the Photograph," at Lincoln Center. John Szarkowski, the legendary curator of photography at the Museum of Modern Art, spoke about the function of a photography collection in an art museum; Peter Bunnell, the director of the Princeton Art Museum, spoke about the value of a photography collection in teaching art history at the university; Weston Naef, a photography curator at the Metropolitan Museum of Art, spoke about photography in the context of an Old Masters collection; and Sam Wagstaff talked about his evolving personal photography collection.

Meanwhile, magazine articles were beginning to debate photography's importance as a fine art. In November 1975, maybe because Warhol had attended the Avedon opening, Andy Warhol's *Interview* published an entire issue on photography. "Is Photography Art?" was the title of an article that gathered answers from a variety of art world denizens. Yes, thought Robert Hughes, the art critic of *Time*, who said that the question was resolved by the photographs themselves: "A great thing about this whole photography being art [debate] is its sudden emergence into the sale rooms. But the fact that photography has become collectible has got nothing to do with whether they are works of art or not." Lee Witkin, of the Witkin gallery, one of the few galleries in New York exclusively dedicated to photography at the time, wryly observed that, whether the medium is paint, watercolor, or the camera, "art is what a human being produces in any form. The right human being." Louis Malle, the film director, said that photography is the art of stopping time, which, as a filmmaker, fascinated him. "It's trying to grab moments and fixing them which is what we're all after." Henry Geldzahler, curator of twentieth-century art at the Metropolitan Museum, offered an impish anecdote about a course on aesthetics he took as an art history major at Yale. "One week the question was, Is photography a science or an art? And the session went on for an hour and later in the week for another hour and I finally couldn't stand it anymore and I raised my arm and . . . said, 'I always thought it was a hobby.' And that cracked the class up and ended the discussion." John Richardson, the Picasso biographer, was equally dismissive about photography, saying, "Artists make excellent photographers—Degas, Eakins, Samaras, Hockney—but photographers seldom make good artists."

Avedon was fully cognizant of this art world prejudice about the medium in which he worked and felt the taint of being a commercial photographer. The barrier between art and commerce was

then as impermeable as that between church and state. To add an additional layer of discrimination, he was a "fashion" photographer, an arena of commercialism without an iota of cultural gravitas. In the art world, fashion photography was a joke.

ONCE THE FINAL SELECTION of more than one hundred portraits had been made for the Marlborough show, they had to be printed. Avedon was exacting about his prints, and he relied on his studio assistants to get the results. "I never once saw Dick step into the darkroom," Gideon Lewin, his chief studio assistant throughout the 1960s and 1970s, said. "He knew what a great print was, and he knew when it wasn't good enough." Avedon would draw multiple circles on the face of a portrait—every portrait—and assign each circle a tonal grade. Sometimes he drew a dozen circles on a single work print, each with a different grade, creating a minefield for Lewin and his other assistants. Since the prints in the show were, for the most part, wall-size—an unprecedented decision in 1975—and since technology at that time was not digital, but chemical, it was at great cost in labor, materials, and time to match the level of precise optical fidelity Avedon required.

The "conversation piece" on opening night was a larger-than-life group portrait called *Andy Warhol and Members of the Factory, New York, October 30, 1969*, an eight-foot-tall, thirty-one-foot-long triptych composed of thirteen life-size figures standing casually in a lineup across three frames, almost half of them fully nude. "I had to dodge and burn with my entire body," Lewin said about printing this wall-size paper mural. It had to be made in a commercial photo lab, and because the largest photographic paper came in rolls that were only fifty-three inches wide, the image had to be printed in sections and spliced together. In a large room outfitted with darkroom fixtures, Lewin would fasten an eight-foot-tall

piece of photographic paper to one wall, and, as the negative was projected through a horizontal enlarger across the darkened room, he would stand in front of the paper, five seconds here and five seconds there. He would single out specific areas of the picture that required more, or less, exposure, which he was able to dodge or burn by blocking sections with his body. Then, as if a symphony conductor, he burned and dodged areas above his body height with cutout shapes at the end of a baton. Splicing together the eight-foot-by-fifty-three-inch strips of exposed paper was a laborious and intricate enterprise, another minefield in which the tiniest ripple in the paper as it was being affixed to the next strip could destroy a section of the mural and would require it to be done again. No artist had printed mural-size photographic portraits before.

Janet Malcolm, writing about the show in the *New Yorker*, cited the unprecedented size of the pictures, and acknowledged Avedon's instinctive, almost palpable feel for the broader stylistic currents of the time: "The show bristles with its connectedness to the morphologies of Warhol's 'Chairman Mao,' Christo's 'Valley Curtain,' Smithson's earthworks, Chuck Close's Photo-Realism, the realism of William Bailey. More consciously and deliberately (and, again, characteristically), the prints reflect Avedon's grasp of the crucial importance of scale in the exhibition of photographs."

Malcolm went on to applaud Avedon's keen awareness of the visceral impact of scale on a gallery wall versus the photograph on a printed page—clearly an element of the show that warranted attention, even going out on a limb to proclaim an "exquisiteness" about the prints that "sets a standard for exhibition printing." But, then, quite suddenly, as if she felt alone and insecure in the intellectual ether for deigning to praise such accomplishment, she delivered a gratuitous judgment about the literal cost of thinking big: "Nothing could be more alien to the fetish of inexpensive equipment and simple darkroom techniques so beloved of the great and near-great

of photography (Weston was proud of his $5 camera, and Stieg-litz's darkroom was like a schoolboy's) than Avedon's D Day-like preparations for this show, in which every modern technological resource was utilized, thousands of dollars' worth ungrudgingly and carelessly spent, and spates of technicians, assistants, and sec-retaries were employed."

It was a provocative decision for Avedon to exhibit the group portrait of "The Factory" (Andy Warhol's New York studio) as a mural, and even more so because of the nudity. The portrait includes the transsexual Candy Darling unclothed in full makeup and long, flowing hair, her male genitalia an incongruous note opposite Joe Dallesandro, a specimen of perfect male anatomy, also nude. Until 1965, under the Comstock laws, it was illegal to send pictures of naked men through the US Postal Service, so it was daring in 1975 to exhibit full-frontal male nudity on a gallery wall. Exhibiting the group portrait that size was in keeping with the gestalt of its subjects. The Warhol Factory retinue, in turn, projected its own extravagant bohemian counterpoint to mainstream convention, an irreverent challenge to the status quo with its sexual candor and gender fluidity—equal parts revelry, mockery, and blasé urban cool.

Of course, this wall-size triptych mural—among several more politically grounded mural-size group portraits in the show—the Chicago Seven and the Vietnam War Mission Council—created just the kind of controversy Avedon had intended, and relished. At the time, the nude figures in Avedon's group portrait stood in direct sexual confrontation with the viewers, but the simplicity and lucidity of this image would come to assert Avedon's signature portrait style of straightforward authority.

Years later, Avedon provided some insight about what he had been trying to achieve: "At the Marlborough exhibition, wherever you stood was the center of the maze, and wherever you looked you were out of scale—Gulliver in the doorway with Godzilla down

the hall," he told Jane Livingston, whether Godzilla was Candy Darling, Abbie Hoffman, Renata Adler, Edward Albee, or Willem de Kooning. It was Marvin Israel's breakthrough to show the pictures at such scale, but he claimed that he would not have pursued such extreme size with any other photographer. "Avedon's pictures are incredibly sparse," he said. "The danger is that they can become caricatures. And sometimes, on a page, they do. But in such large scale, every feature means something—a hand becomes a landscape." At their first meeting with the Marlborough's director, "Avedon walked to within a few inches of the blank wall, mimed a gallery goer's lean-and-squint, and said: 'How long are people going to have to do this?'"

Today the Warhol Factory portrait is emblematic of the era, both in a representation of the sexual revolution with its nonchalant lineup of nude and clothed figures, and in its clear-eyed regard of the Warhol "superstars" whose constructed identities manifest an avant-garde urban hauteur born of mind-expanding drugs and a contempt for the squareness of Middle America. Their life-as-art gestures turned out to be of revolutionary significance, paving the way—at least in the media—for a social movement that eventually became known as the gay, lesbian, bisexual, and, much later, transgender community. Lou Reed wrote "Walk on the Wild Side" about this group. Avedon broke up the figures into small clusters and scattered them across the empty white space in each section of the triptych. Some figures overlap, their bodies appearing spliced into two sections. The multiframe composition evokes the sequential panels of a classical frieze, "as if the figures progressing around the belly of a Greek vase had paused for the photographer's camera," wrote Maria Morris Hambourg, the curator of photography at the Metropolitan Museum, in 2002. "This reference to classical antiquity is further suggested by the 'satiric charade of the three male (as opposed to female) graces' enacted by the three male nudes

in the central panel, and a subtle 'play of hands owing much to Renaissance painting.'"

Viva (Janet Susan Mary Hoffmann), one of Warhol's "superstars" in the portrait, had over the years posed for Avedon on several occasions. "I kind of got sick of doing them, but Avedon kept calling," she said, describing a routine in which she would feign exhaustion whenever he called her to ask her to pose for him. He would then entice her with an offer to send a limousine. "Well, grab me some caviar and champagne, too," she would tell him. "So every time I went over there—which was at least four or five times—he would know to have a limo, champagne, and caviar in a white porcelain jar. He was very warm and sweet to me."

DAYS AFTER THE OPENING of the Marlborough show, the verdict started to trickle out. Owen Edwards, writing in the *Village Voice* as a social critic more than as an art critic, was mindful of the changes occurring in the photography world at that moment. He made a potent argument in favor of Avedon as an artist and started his case with a simple and wise observation about his portraits: "After a certain forgiving age our faces bear witness for or against us whether we like it or not." And, with that premise, he addressed the existential minimalism in Avedon's work that was so often mistaken for mere stylization: "A great photographer can talk to us so intimately that we feel his breath. In his personal life Avedon is an energetic and inspired storyteller, and that characteristic strongly invests his work. What emerges in the show is an elaborate dialogue with the viewer about the photographer's own peculiar, quirky, and ongoing family of man. It is a conversation that only appears to ramble: Avedon's eye is clear and consistent, and we would do well to search for the shadow of his meaning."

Regardless, Avedon's celebrity preceded him, and the taint of

commerce sullied his expectation of a smooth transition into the precincts of art. Hilton Kramer, the chief art critic of the *New York Times*, who wielded the most authoritative voice, wrote a thoughtful, if in the end dismissive, review of the Avedon show. Acknowledging the technical and psychological finesse of the pictures, he concluded, ultimately "with Mr. Avedon's work, far more than with most photographs of comparable ambition, the observer feels himself to be the target of a carefully calculated effect. Even when we surrender to the effect, as we usually do, our skepticism is not assuaged. A sense of something illusory lingers on." In other words, Kramer, known for his fidelity to the art-historical canon established over time by a Caucasian male academy, wasn't having any of it. Neither were several other critics, who arrived at similar conclusions: Avedon's portraits were assuredly "high style," the implication being that that prevented his entrée into the sacred realm of art.

Avedon would have to contend with this attitude throughout his career. He believed himself to be an artist, yet his bravado too often obscured the substance of the work. The Marlborough show was considered audacious, flamboyant, and cheeky in the art world of 1975; it was difficult to circumvent the glitz factor of a fashion photographer in a blue-chip gallery, never mind a blue-chip gallery even showing photographs. Had Avedon started smaller, perhaps in one of the few photography galleries that existed in New York at the time, and with a more modest approach, art critics might have been willing to acknowledge the significance of his portraiture within the "upstart" medium. But his vaulting ambition was somewhat obstreperous and could not be so contained.

Obviously, Avedon believed that his work justified the splashy gallery debut and the blue-chip representation, and he didn't understand how it could be so easily dismissed as hubris. Were the gatekeepers so offended that they turned a cold eye on the

driving ambition of a genuine artist? "I often feel that people come to me to be photographed as they would go to a doctor or a fortune teller—to find out how they are," Avedon said several years later. Anatole Broyard, reviewing Janet Malcolm's book *Diana and Nikon* in 1980, underscored Avedon's point with an astute observation about the human condition as he perceived it in mid-twentieth-century New York, asserting that "the camera confirms their worst fears and therefore makes them happy, for American intellectuals in the last few decades are never so happy as when they are expressing their pathos."

Avedon's stone-cold, corpse-like representation of individuals in the second half of the twentieth century would remain the existential register of his portraiture, and, as Owen Edwards perspicaciously understood in 1975, we would do well to search the "shadow of his meaning." It was a complex combination of qualities and experiences that shaped Richard Avedon's unique sensibility, propelled his ambition, and determined the character of his work. The only way to search the "shadow of his meaning" is to start at the beginning.

# 2

# KEEPING UP
# APPEARANCES

(1923–1936)

In a neighborhood temple on the Upper West Side of Manhattan, the service had been going well until the rabbi whispered something in the bar mitzvah boy's ear. Suddenly, the wisp of a lad whipped off his thick black glasses with Coke-bottle lenses, stood back, and peered at the ponderous Goliath in heavy black robes. Little Dicky Avedon's body was trembling with indignation.

Almost a half century later, Richard Avedon would recount that indelible moment, when he was thirteen years old, to Lauren Hutton, one of the most glamorous fashion models in the world. For *weeks*, he told her, *months*, he had been bursting with excitement in anticipation of his bar mitzvah. It was *his* day, and it was *this* moment in the ceremony when the rabbi was supposed to whisper the secret of life—the actual meaning of existence—into his ear. That's what he had been led to expect and it was the only reason he agreed to go through with the torturous ordeal. In his young and ever-so-

fecund imagination, the rabbi's secret was supposed to propel him into an incontrovertible metamorphosis beyond the tyrannies of his gloomy little childhood. He expected a miraculous and immediate steely confidence to replace the quaking terror and deep shame that consumed him every day of his life, and to imbue him with the same kind of certitude with which his father barked orders, or the steady authority with which his teachers took command of their lessons, or the sure-footedness of his classmates when they reveled in pushing him around. He thought being told "the meaning of existence" would hurl him into a new realm of consciousness that only adults seemed to have access to, their heads floating higher in the ether and, therefore, closer to the ear of God.

For this reward alone, young Dicky Avedon, son of Jacob, had endured an entire year of tedious Hebrew lessons, boring Torah study, and noose-tightening panics while reading his speech aloud at home in front of his parents, his silent younger sister, Louise, and his opinionated cousin Margie in their claustrophobic apartment on East Eighty-Sixth Street: "Speak with more purpose," demanded his father. "Don't pause in the middle of that sentence," counseled Margie. He was paralyzed by the weight of his dread as he imagined himself in front of the congregation, choking from terror about the unreliability of his changing voice. What an unbearable hazing for one life-altering moment. And, yet, instead of the apotheosis he anticipated, the rabbi made him feel like the victim of a tragic cosmic joke. Avedon told Hutton what the rabbi had whispered into his ear: "The truth is a fountain." The great photographer and the glamorous model burst into uproarious laughter.

At the time Dick shared his bar mitzvah anecdote with Lauren Hutton, a dinner party joke was making the rounds in the city, a variation of the inveterate *New Yorker* cartoon in which a guru sits atop a mountain as a truth seeker clings to the ridge by his fingernails, announcing: "I've come to learn the meaning of life." The

guru responds: "Life is a fountain." The truth seeker looks at him and counters, "No it's not." Perplexed, the guru says, "Oh, it's not?"

It's possible that Dick's memory of the rabbi's bromide was based on the punch line of the joke du jour. It was not uncommon for Dick to recount such moments in his life with a loose tether on the actual facts, the events adjusted, the details embellished for a good story or to create just the right image. Regardless, Dick's bar mitzvah anecdote was intended to convey the pivotal moment in his life when he became a secular—as opposed to religious—Jew.

IN 1936, ON THE pulpit in the sanctuary of the neighborhood temple, in the flash cut of the rabbi's betrayal, Dicky searched his parents' faces in the first row. His father, stalwart and proud, meticulous in a three-piece suit and fine silk tie, sat with his prayer book in hand and allowed a smile to crack through the usual scowl of disapproval on his face. Jack Avedon was a stern disciplinarian who never stopped drawing on the dark lessons of his hardscrabble childhood in the tenements and orphanages on the Lower East Side: he set an oppressive tone in the modest Avedon apartment, quoting William Shakespeare and Teddy Roosevelt with a pomposity that underscored his perpetual drumbeat about self-reliance, earning him the disparaging household sobriquet "the Judge." On this day, though, Dicky could see his father's unassailable approval of the sacred tableau on the pulpit before him. Today, Jack was glowing with pride as he watched the rabbi talking some sense into his irrepressible son. It only made Dick loathe his father more.

Dick's mother, Anna, by contrast, was a more effervescent presence. She looked up at Dicky knowingly, the tilt of her head a calming salve to cushion the sting of the rabbi's betrayal. Anna Avedon knew how to present herself for an occasion—whether she could afford it or not—and Dicky found solace in the dark velvet

collar of her smart tailored suit. Anna had come from better circumstances than her husband and held on to a set of expectations about living gracefully that ultimately eclipsed Jack's ability to satisfy them. From Dick's perspective, his mother was entirely more imaginative, more optimistic, and more fun than "the Judge." It was into her arms that he couldn't wait to flee from the pulpit to expose the fraudulence of the rabbi—in fact, to blast the entire schmear of Judaism. Never again, he vowed, would he set foot in a temple as long as he lived.

For Dick, the meaning of existence would remain unsolvable, an endless riddle about which the wise old rebbes merely stroke their beards in a collective shrug: "The meaning of life? *Who knows?*" In 1994, at the age of seventy-one, Dick would tell Helen Whitney, the documentary filmmaker: "I'm such a Jew, but at the same time completely agnostic." For Richard Avedon, the eternal questions would be answered not by religion but in poetry, theater, dance, photography, the magic of art, our reflection in literature. Perhaps it was the meaninglessness of life that drove him to try to invent meaning in the originality of his work.

DICK'S FATHER, JACOB (JACK) Israel Avedon, was a Jewish immigrant, born to Israel and Mathilde (née Sater) Avedon on October 7, 1886, five years before they would emigrate to the United States from Lomzha, in the province of Grodno, on the borders of Lithuania and Poland in what today is called Belarus. Jack's father, Israel, had been a tailor in Grodno, a civilized, centuries-old town in which the principal sources of income were from agriculture, timber, and crafts. More than half the factories, workshops, and real estate properties were owned by Jews. In 1881, when Alexander III of Russia ascended the throne, the systematic ethnic cleansing he imposed throughout the Russian Empire created the

pogroms that drove the diaspora of eastern European Jews to the United States, South America, and South Africa.

Dick's grandfather Israel arrived at Ellis Island alone in 1890, followed a year later by his wife, Mathilde, and their five children, including Jack. (To explain a devil logo he used on his stationery, Dick would tell of the family name being changed at Ellis Island from Abaddon, meaning "the angel of death" in Hebrew.) They would make their way to the heart of the Jewish ghetto on the Lower East Side of Manhattan, where life in the New World commenced for them in an overcrowded tenement at 413 Grand Street. Israel soon abandoned the family, leaving them destitute in a foreign country. The logs of the Brooklyn Hebrew Orphan Asylum document the admittances of Dick's father, Jacob, along with his brothers, William and Samuel, on several occasions for periods varying from six months to three years in the last decade of the nineteenth century.

In *What Makes Sammy Run?*, Budd Schulberg offers an apt description of the Lower East Side in the era of Jack's childhood: a "cradle of hate, malnutrition, prejudice, suspicions, amorality, the anarchy of the poor." He describes Sammy Glick, his protagonist, who came out of the ghetto neighborhood of Jack's childhood, as "a mangy little puppy in a dog-eat-dog world." Schulberg's conclusion about life in the Jewish ghetto in Lower Manhattan might well apply to the circumstances in which Jack Avedon had grown up, too: it wasn't that he had been born into the world any more "selfish, ruthless, and cruel" than anybody else, but to survive in that scrappy social environment, like Sammy Glick, he had to become "the fittest, fiercest and the fastest." In the intervals between Jack's stays at the orphanage, he would return to his impoverished mother. Yet, despite the dog-eat-dog obstacles of his abject upbringing, the children of that Jewish orphanage received a reasonably good education. Indeed, Jack climbed his way out of the ghetto, finished

high school, graduated from City College, and passed a state pedagogy exam in 1909. For a time, he was a substitute teacher, until he and his brother Samuel opened Avedon's Blouse Shop on Broadway and 110th Street in 1913.

Jack and Sam did so well with their small shop on upper Broadway that they soon moved to Madison Avenue and Thirty-Fourth Street. That shop, too, was successful enough to propel the ambitious and clever Avedon brothers to obtain a twenty-year lease on a parcel of land at Fifth Avenue and Thirty-Ninth Street. In 1920, they commissioned a highly reputable Manhattan architect, and construction would begin on a six-story limestone building in the Italian Renaissance style. In early 1921, they opened Avedon on Fifth, a formidable retail women's clothing emporium—evening gowns, tailored dress suits, coats, lingerie, millinery, blouses, shoes—along the posh Library section of Fifth Avenue. The walls of the main floor were finished with Carrara marble and trimmed with polished mahogany.

Out of the ghetto on the Lower East Side, Jacob Israel Avedon had become a prosperous man, as well as a suitable match for the well-brought-up Anna Polonsky, of 270 Riverside Drive. In the announcement of their engagement, published in the *American Hebrew and Jewish Messenger* on November 18, 1921, he was identified as "Allan Jack Avedon of this city." This was the name he assumed for the rest of his life, whether to counteract the pernicious anti-Semitism that foisted untold obstacles in the way of professional advancement for Jews in America, or to erase from his own name that of his father, "Israel," who had perpetrated the ultimate betrayal of family abandonment.

Anna was a first-generation American Jew. Her mother, the former Rebecca Schuchman, emigrated from Odessa before the turn of the twentieth century. Rebecca had come from a well-to-do family with high social standing; she held the equivalent of a high

school diploma, an accomplishment in an era when the education of female children was not encouraged. Family lore has it that Rebecca's brother, Julius, was a poet in the Russian court and composed verse that was often fifty pages long. Among other family tidbits handed down through the generations was the scandalous reputation of Rebecca's sister Sonya, a *bonne vivante*, who had five husbands and many children. She loved the opera and was known to wear excessive amounts of jewelry.

Anna's father, Jacob Polonsky, was successful enough as a manufacturer of suits and coats to afford an apartment on Riverside Drive, where a doorman stood at the entrance and the apartments had majestic views of the Hudson River. This is where Anna and her older sister, Sally, grew up. Jacob Polonsky was known to indulge in baronial luxuries, such as owning his own Lincoln and employing a full-time chauffeur to drive him around town in the 1920s and 1930s. According to a family tree drawn by his granddaughter, Marjorie Lederer Lee—Dick's first cousin—Jacob also owned a horse. During Prohibition, he even made his own whiskey.

JACK AND ANNA AVEDON were living at 150 West Eighty-Seventh Street, a tidy block of solid limestone row houses and small apartment buildings between Columbus and Amsterdam Avenues on the Upper West Side of Manhattan, when, on May 15, 1923, Richard Charles Avedon was born.

Things were going well for Jack Avedon when Anna gave birth to their son. He had become a respectable man with a thriving business and likely benefitted from his father-in-law's penchant for grand style. Anna, too, would benefit from her husband's success in business. In a formal photographic portrait taken a year or so after Dick was born, she sits holding her infant son upright on her lap, her dark hair in a swank modern bob, her handsome features

composed in an expression of willing amusement. She is draped in a fashionable silk lamé hostess gown, of the kind that would have been sold at Avedon on Fifth, one with a florentine neckline and a soft iridescent sheen on its luxurious fabric; over the dress is a sheer, floor-length wrap with loose kimono sleeves and a border of patterned silk that cascades like a liquid column across her lap and down to the floor. Dicky is standing on her knees in a white baby frock, steadied in her firm grip, his eyes open wide with an alert, penetrating stare, the dimple in his right cheek almost visible.

Richard Avedon was born the same year that Edward Steichen had been recruited by Condé Nast to work for *Vogue* and the newly inaugurated *Vanity Fair* at the highest salary yet paid to any photographer in the world. The photograph of Anna holding Dick as an infant was made around the same time that Steichen posed Marion Morehouse (Mrs. E. E. Cummings), his favorite model, in a lamé dress by Lucien Lelong that epitomizes the slender "flapper" column of the Jazz Age 1920s. Steichen captured the impeccable proportion of the dress—and the fashion of the era—in Morehouse's stance, poise, and attitude. Arguably this is one of the finest fashion photographs in the history of photography. Anna Avedon was acutely aware of the fashions of her time and, in her portrait, she strikes a stylish equivalent to the Steichen photograph. While this might seem like nothing more than coincidence, it is only the first of many historic overlaps that might be thought of as foreshadowing hallmarks in the unfolding of Richard Avedon's remarkable life.

On April 2, 1925, a year after the portrait of Anna with her young son was made, she gave birth to Dick's sister, Louise. The family was growing as the store was expanding. In 1926, an article appeared in *Printer's Ink Monthly*, an advertising industry newspaper, highlighting the Avedon brothers' advertising strategy. It not only cited the architecture and location of Avedon on Fifth as

a successful asset for drawing customers, but also acknowledged the elevated tone of the store itself: "In their every contact with the public they put their best foot foremost—they express distinction and refinement in their advertising, their packages, their delivery wagons, and their store." Included in this article is a picture of several elegant Avedon hatboxes with the store's trademark imprint of a Beardsley-like drawing of a woman in profile under fine deco graphics, epitomizing the high style of the store in the Roaring Twenties.

In fact, the store had gained a reputation among the younger debutante set, the kind of imprimatur that secured its stature in the hierarchy of women's fashion in New York. An article in the *Hartford Courant* from the late 1920s reported "Avedon has built up a tremendous following at Smith, Wellesley, Mount Holyoke and other important schools. When these girls are in town, they come to Avedon on Fifth Avenue, for they like to buy their coats and more important frocks here. . . . The college contacts which have proved such an important item in the growth of this store began in the days when Avedon was at 34th and Madison Avenue and blouses were the specialty. Hardly a wardrobe trunk went back to college without a dozen or more crisp tailored blouses for school wear."

ASPIRATION AND ASSIMILATION WERE interchangeable for the Avedons, whose families had arrived in America during the largest wave of Jewish immigration from eastern Europe, between 1881 and 1924. By 1918, the United States would have the largest Jewish population in the world. At Ellis Island, arriving immigrants were required to undergo health inspections that determined their eligibility to become US citizens, and the photographs made during these inspections revealed to American citizens the striking

"otherness" of these refugees seeking asylum on their soil. The new immigrants were described as "different," thus fueling, among a range of discriminatory attitudes and practices, the eugenics movement in the United States.

Not only was there a pervasive fear of contagious diseases brought to their shores, but Americans believed that the moral character of the immigrants could be discerned by their anatomical features: "According to 19th-century science, small hands indicated a pension for crime, and an attached earlobe or a widely separated big toe betrayed a tendency toward degenerative behavior, and a low forehead revealed feeblemindedness. Physiognomic findings of this kind served as grounds for deporting immigrants."

At the turn of the twentieth century, Henry James, the great American author, represented an ethos of WASP breeding and refinement that felt itself to be in a state of siege against the influx of the Jews; he considered the immigrants to be "a class of people who exerted an un-attractive pressure upon the fondly remembered genteel New York of yore." As American ruling-class anti-Semitism rose, the social, professional, and financial mobility for the Jewish arrivals was hampered at every turn. In this climate, then, it is a tribute to Jack Avedon and his brother Samuel to have understood the anatomy of the American class system enough to navigate the anti-Semitic tide and to have established their well-regarded retail shop on Fifth Avenue, one that appealed to Seven Sisters students and debutantes of New England, exemplars of WASP breeding and refinement—Isabel Archers, one and all.

In 1926, Allan Jack Avedon, his name permanently anglicized, moved his family to a cozy, two-story house with a front lawn and a backyard at 253 Villa Place, a leafy cul-de-sac in Cedarhurst, on the South Shore of Long Island. A mere ten-minute drive to the Atlantic Ocean, this tony suburban enclave was developed in the late nineteenth century as a resort community for the wealthy

members of the Rockaway Hunt Club and their friends. The Hunt Club and the Beach Club and the Golf Club were all "restricted"; membership was not available to Jews or to Catholics. Yet once the Long Island Rail Road established its South Shore line, the daily commute to Manhattan became a comfortable reality and the area's population grew considerably. There was a sizable Jewish community by the time the Avedons moved to Cedarhurst. The Inwood Country Club and the Woodmere Golf Club were not "restricted," and Jack and Anna became members to take advantage of the amenities, playing tennis and golf, and dining with a circle of new acquaintances. In the 1930 Cedarhurst census log, the four Avedon family members were listed at the address of 253 Villa Place along with an additional resident, Viola Givens, who was identified as "servant"; she was twenty-seven years old and had been born in South Carolina.

Several specific memories of Dick's early years in Cedarhurst surface repeatedly in the interviews he gave throughout the course of his life. One strikes a decidedly Proustian note, a sensory association that was meant to convey the love he felt for his mother. He would speak of her as adventuresome, saying, "She had a great sense of fun." He described a moment not long after they moved into their "nice stucco house in Cedarhurst," as he categorized it, when he remembered her "climbing over the wall of the big Singer estate nearby, stealing lilacs and singing all the way home." The moment itself was seared into his memory, one he repeated on occasion, his very own *petit madeleine*. And then he would follow his description of that halcyon image by offering this syllogistic conclusion: "She always wanted me to become an artist."

While his mother was intent on establishing a foundation of creative inspiration, Dick's father had a different set of building blocks in mind. Jack's own rags-to-riches odyssey gave him a clear-eyed sense of what it took to become a successful, upstanding

citizen. In family portraits throughout Dick's childhood, Jack projected himself as a proud man, prosperous and stylish, whose well-dressed family, proper home, and smart automobile would reflect appropriately on the integrity of his achievement. He had learned how to be respectable the hard way, and he was compelled to teach his son those lessons.

"The only way he knew how to show his love was to try to make me as strong as possible in this terrible world," Avedon told a reporter at *Newsweek* magazine. Having endured the pitfalls and hardships of growing up in and out of an orphanage, Jack was unrelenting in his attempts to toughen up his often too sensitive son. In particular, he wanted to impress on Dick the value of money. Jack gave Dick a weekly allowance of five cents, payable on presentation of a budget to allocate every cent.

On Dick's fourth birthday, Jack tried to teach him arithmetic. He picked his young son up and said: "Dicky, how old are you?" Dicky said, "Three." Jack corrected him. "You're four." Dicky insisted he was three, and Jack raised his voice. "*Four.*" Dicky got so upset that he hit his father on the face. Jack hit him back, harder. Dicky hit him again, now crying, and his father hit him again, harder still. But Dicky would not give in. He held on to his position through his tears and anger until his father dropped the subject. This pattern of resistance to Jack was set early in Dick's life. Often he refused to tell his father what he wanted to hear or to do what his father wanted him to do as a matter of course, with little regard for the repercussions. "He wanted me to be prepared for what he called 'The Battle' in the ways he felt one had to be prepared: through education, physical strength and money."

Most important for Jack, however, was to be able to provide for his family, in contrast to his own father, who had abdicated that responsibility. This was Jack's singular requirement for being a mensch, an ethic Dick embraced throughout his life, wholeheartedly,

even though the bounty of luxury he showered on his own wife and son could be, at times, an insubstantial substitute for genuine emotional contact.

IN 1920, ANNA AVEDON'S older sister, Sally, wearing a gown embroidered in crystal beads over silver cloth, had married Sydney M. Lederer in the grand ballroom of the Astor Hotel. Over two hundred people were in attendance. Sally gave birth to a daughter, Marjorie, the following year. Soon after Margie's birth, Sally's husband, Sydney, abandoned her, and, when Margie was five, they were officially divorced. Sally would suffer a range of psychological and emotional disorders that required periodic institutional treatment for the rest of her life. Little Margie, while living with her mother in her grandparents' apartment, now on West End Avenue, felt like something of an orphan, and shuttled back and forth between her grandparents' apartment and the Avedons'. Margie—Dick's cousin—would stay with his family for extended periods during the summer months, providing Dick a bonus sibling and a childhood best friend.

Margie, two years older, lorded the power of age—and a fiery will—over Dick with an influence that would be truly formative. "We were so close," Dick told the writer Adam Gopnik. Whenever Margie returned to their grandparents' apartment on West End Avenue after a stay at the Avedons' in Cedarhurst, "we just *had* to phone each other." In particular, during the Depression, telephone use was so expensive that they were not allowed to talk for more than three minutes. "I remember being dragged away from the phone, in hysterical laughter," Dick recalled.

Margie (Marjorie Lederer Lee) would grow up to marry, raise five children, and publish three novels and umpteen pseudonymous self-help books. Her 1961 novel, *The Eye of Summer*, is a fictional

evocation of her childhood relationship with Dick. Reviewed in the *New York Times*, it was described respectfully as "a curiously exotic relationship between two little lost Katzenjammers who attempt to prolong adolescent kinship into maturity. Connie, age 10, is the neglected child of a divorcee; Spence, age 8, is a favored but alienated only child—and the two have a desperate fondness for each other that smolders from summer to summer in their private Netherland, a Fire Islandish resort where they spend their holidays." *The Katzenjammer Kids* had been a long-running popular syndicated comic strip about two defiant pranksters always getting into trouble, and the reference is not at all inaccurate.

It is impossible to read *The Eye of Summer* without regarding it as a literary proxy to the intimate entries of a personal journal. While the names and specific activities in the book might vary from a chronicle of actual events, the story is derived with the emotional tenor and psychological interplay that so firmly characterized the nature of Dick and Margie's childhood relationship. "They were really like siblings," Marjorie's daughter, Alison Teal, said. "And, in the book, *The Eye of Summer*, you will feel the bond between them."

Early in the novel, Marjorie Lederer Lee, the author, describes the arrival of her alter ego, Connie, to the beachside summer community:

> *From the very first day of Connie's arrival they were filled with a wildness that lay dormant throughout their distant winters, and which seemed in each of them to be aroused only by the other. On that initial day of meeting, a strange light came over their faces: a recognition of some deep and secret tie between them which held them in wondering shyness for one second and then sent them shrieking into each other's arms. And it was from that instant until the end of summer that they would be carried along, above and beyond the reach of their elders, two crazed creatures, free of the*

*world, yet completely dependent upon each other, and, because of it, half hating, half in love.*

*"Spence! Oh, Spence!" Connie would scream as she met him on the warped wooden platform of the station. "I'm here, Spence! I'm here!"*

*"Connie!" he would squeal from the highest register of his little boy's voice.*

Connie is precocious, mischievous, and irascible, and she embroils Spence in antics spawned not only from her peripatetic imagination, but, equally, out of a bottomless well of need. As the ringleader, she often gets them both in trouble. In one chapter that epitomizes her demonic provocations and his naive acquiescence, they are on the beach not far from the house likely based on the Avedons' house in Cedarhurst; they have just eaten the sandwiches packed by the maid for an afternoon picnic. Connie gathers the paper bag, the wax paper wrappings, uneaten bread crusts, and napkins into a little heap, and idly lights it with a match from a matchbook she has taken from the kitchen. In order to keep the fire going, she orders Spence to collect a few pieces of driftwood, followed by seaweed strewn along the beach, and, finally, clumps of seagrass from the dunes. He complies, happily lost in the adventure, placing the last batch of seagrass on the fire, when, suddenly, the wind changes and the flames flare up, singeing him and causing him to scream. Several adults come running and whisk him off to his mother at home, who calms him down, administers ointments, and leaves him to recover in his room for the rest of the afternoon. Connie is left to endure the silent judgment of her aunt (Anna) and uncle (Jack), and retreats to her room, disappointed and alone.

In the early evening, Spence is at her door holding a big glass jar filled with hard colored candies, a present he was given to make him feel better. He offers one to Connie while informing her that

his parents are downstairs having cocktails with their friends. They tiptoe down the hallway and park themselves at the top of the stairs. While listening to the adults talk about things they don't understand, they whisper and giggle and suck on their candies. Every so often, Connie playfully elbows the candy jar closer to the edge of the stairs, which Spence finds deliriously funny. He then echoes her gesture, further inching the jar with his finger to the point that it "jiggled once, fought for its balance, and pitched forward," Lee writes. "And, huddled there in the darkness, entangled inseparably as ivy in each other's limbs, Connie and Spence heard, among the shrieks from below, the gorgeous staccato clacking of a hundred candy *ack-acks*, aimed by two small snipers against an enemy world."

"I was deeply in love with Margie from the age of 4 until I was 18," Avedon, in his sixties, told Nicole Wisniak. "It was only with her that I could breathe freely. We were precocious from the start. When the Cocteau movie *Les Enfants Terribles* came out, we knew we were those children. We saw it over and over. Our feelings for each other were so intense, so forbidden, so conspiratorial."

In 1928, Eva Le Gallienne, who founded the Civic Repertory Theatre in New York, put on an ambitious and now legendary production of *Peter Pan*, in which she starred as the young boy who won't grow up. With elaborate sets and vibrant costumes, the show contained music, dancing, fencing—and *flying*. Le Gallienne thrilled audiences as the first Peter Pan onstage not only to fly through the window, but, as her grand finale, to fly over the entire audience, a feat of theatrical hijinks, canny jury-rigging, and, in 1928, as close to virtual reality as was possible. Avedon described this period of his childhood when busloads of children would fill the Saturday matinee audiences of Broadway productions. He and Margie, on their own, would sneak into second acts. "Margie and I went to the Eva Le Gallienne *Peter Pan*, and when Peter turned to

the audience and asked if we wanted Tinkerbell to live, we shouted from the balcony, 'No!'"

"The connection they had was extraordinary," said Steven Lee, Marjorie's second-born son. "Dick had this kind of amazingly energetic quality, a childlike quality, and the sense of holding on to that creative energy, and the two of them I guess played off of each other as kids. . . . Hence her novella, which was the story of their relationship."

"I STARTED TAKING PHOTOGRAPHS at the age of nine with the Box Brownie," Dick told Michel Guerrin during an interview for *Le Monde* in 1993, characterizing the Brownie camera in the early 1930s as a technological advancement that turned photography into a national hobby. "It was *affordable*. It cost a dollar and took six pictures, two and a quarter inches square. The same size as the Rolleiflex, which was my favorite camera and still is."

Dick's father had explained the principles of photography to him—the way in which light traveled through the lens and exposed the sensitive surface of the film—and Dick let his imagination roam. "I was nine years old when I realized that my skin was a sensitive surface," he remembered. "I took a negative of my sister, and surgical tape, taped the negative on my shoulder. And then I went out in the sun. It was in the summer. After two days I peeled the negative off." Her image had burned like a tattoo onto his arm. This investigation into the properties of photographic exposure, albeit primitive, was ingenious—ahead of its time. If the Montessori concept of education had been in wider practice when Dick was in school, he would have been congratulated on his curiosity and creativity. Yet his experiment might have been motivated less by his interest in the physics of photography than out of affection for his sister. Louise was something of a family enigma because of

her inability to express herself. His mother used to tell her that she didn't have to speak if she didn't want to; it was enough that she had such beautiful eyes and gorgeous skin.

"Her beauty was the event in our house," Dick often said. "Her shyness was never examined." Dick often felt the instinctive need to protect her. As a teenager, Louise would be diagnosed with schizophrenia, something she had in common with her aunt Sally, Margie's mother. Regardless, the sunburned image of Louise's face on Dick's skin constituted what he liked to call his "first photographic print."

While the Avedons' residence in Cedarhurst had brought with it a suburban version of modern prestige and an accumulation of new comforts, Anna was resolute about familiarizing her children with the fertile cultural life of the city. As often as she could, she brought Dick, Louise, and Margie into Manhattan and introduced them to "painting" in the museums, "the theater" on Broadway, and "music" in all variety of concerts. "My mother used to bring the three of us here on a route: the Met, the Frick, and Carnegie Hall, all in a row. We'd sit and talk about what we'd seen."

Dick was particularly fond of Rembrandt's *Polish Rider*, a 1655 painting that hung at the Frick Collection. He looked forward to seeing it whenever they visited the museum. In it, Rembrandt depicts a handsome, well-dressed young man on horseback with a bow over one shoulder and a set of arrows fanning out of a crafted leather case at his waist. He sits upright, proud and confident, looking out beyond the viewer into the mythical distance. An amber glow suffuses the entire canvas, and a bright golden outline on the rider's shoulder illuminates a part of his face. The horseman is wearing red velvet pants, painted with vivid intensity under his fine, well-tailored coat. The vibrancy of his pants lends sizzle to his already commanding appearance.

Revisiting the museum in the 1990s, Dick recalled the strong

impression the painting had made on him. "I was that young man, and I was in love with him—with myself, my idealized vision of myself, what I might be. I saw him as me, that possibility in life— everything lying ahead, and not yet knowing, not looking at the road, but out. It sounds grandiose, I know, when you say it, but the sense I had was so *strong* that someone else, Rembrandt, had felt everything I was feeling. I was so *reassured* by that picture."

For the ten-year-old Dick, the Rembrandt—just as with theater or movies or music—was an early glimpse into the transformative nature of art. Each form provided a transcendent experience that offered the young Richard Avedon recognition of what might be possible, as well as an acquaintanceship with his own longing. Each genre offered a different portal out of the mundane and morose present into a utopian promise of life as he thought it should be experienced. It may have been *The Polish Rider* that, early on, allowed Dick to exercise his keen observational ability, even though it would take him half a century to explain what the painting had meant to him. Dick's dark, intense eyes were wide open from the moment of his birth, and observation is what he thrived on. His eyes were a window through which he could nurture his intelligence and ignite his imagination, whether from the sheer lilac membrane petals in his mother's hands or the Polish rider's poised glamour at the Frick. Both had been seared into his sensory memory as archetypes of his childhood.

IN 1930, A YEAR after the stock market crash brought untold numbers of American businesses to an abrupt halt, Avedon on Fifth became another victim of the depressed economy. Jack and his brother were forced to file for bankruptcy and shutter permanently the store that they had worked so hard to build. Jack had taken great pride in the store; it gave him credibility as an upright

citizen in his community and as a worthy role model for his children. How was he going to justify to himself—never mind to his son—its demise? How was he supposed to explain to his young son the most important life lesson of this historic cataclysm—that the vagaries of fate are at constant odds with the determination of one's will?

The bankruptcy, while not due to a failure of stewardship by Jack or his brother, commenced a painful period for the Avedon family. Humiliated and nearly destitute, Jack took a job selling insurance for Connecticut Mutual. When Dick was barely nine, they had to sacrifice their comfortable home in Cedarhurst and move back to the city. In reduced circumstances, they took a small apartment at 16 East Ninety-Eighth Street. Tensions mounted between Jack, who shouldered the burden of supporting his family with the solemnity of his disgrace, and Anna, who felt the elegant wings of her spirit to be unceremoniously clipped. Soon enough Jack would take a new job as a buyer at the Tailored Woman, a retail store on West Fifty-Seventh Street, and Anna would continue to make the best of a tiny allowance. Ever resourceful, she continued her children's cultural education by attending concerts at Carnegie Hall and plays on Broadway, dressing down intentionally to look as if they didn't have money—which they didn't—and tipping the ticket taker twenty-five cents to let them sneak into the theater without tickets.

The dining alcove served as Dick's bedroom. "I was eleven years old. The walls beside my bed and the ceiling above were my domain, and I covered them with my chosen view: a gleaning of five years of Christmas Tuberculosis seals, three hundred Dixie Cup tops, and the photographs of Martin Munkacsi," he would write in 1963 for an introduction to a book about Munkacsi's work. "I cared nothing about photography and less about fashion, but the potentialities beyond 98th Street filled my waking dreams, and because

my family subscribed to *Harper's Bazaar*, it became my window and Munkacsi's photographs my view."

Now that he lived in Manhattan, Dick was able to spend more time with Margie. He would ride his bike across Central Park to his grandparents' apartment on West End Avenue and West Eighty-Fourth Street. Sergey Rachmaninoff, the great Russian composer, lived in the apartment above the Polonskys—or, by then, the Posts, as they, too, anglicized their name—and Dick and Margie liked to listen to him tinkling out a set of high notes or banging out the deep chords of his Fourth Piano Concerto as he labored over the stormy melodies on the grand piano. "The minute he started practicing, my cousin Margie and I would go up the back stairs and sit on the garbage cans by the service elevator to listen to him play." When the music stopped, the two Katzenjammers would run back downstairs and listen for his footsteps in the kitchen, where they could hear him open the refrigerator door and get something to eat. Then, again, when he headed back toward the piano, they ran back up the stairs and listened some more.

One day, Dick asked the doorman to let him know when the maestro called for his car. At the call, Dicky scurried down the stairs and waited for Rachmaninoff to emerge from the entrance. He remembered the countenance of a White Russian aristocrat: "very severe," he said. "Rachmaninoff stopped and stood in front of a fire hydrant. I had my Box Brownie and *click*, and that was it." Avedon would claim this to be "my first portrait" ever. Two weeks later, Anna took Dick to a Rachmaninoff concert at Carnegie Hall, which may have included works that Dick and Margie had listened to him rehearse. "I had my picture. I wanted to get him to autograph it, but for some reason we couldn't get backstage; something went wrong, and it broke my heart."

This might be an opportune moment to consider the veracity of Dick's childhood anecdotes, the stories he would recount in inter-

views in his later life to offer a glimpse of his precocious, if alien-
ated, youth. In 1989, Avedon published an essay entitled "Borrowed
Dogs" in the fine literary journal *Grand Street*. The first paragraph is
a beautifully crafted memory that serves as a fitting metaphor about
his family's deliberated construction of *la façade*, as the French call
it, and their benign machinations to present themselves as a hap-
pier and more well-to-do family than reality bore out:

> *When I was a boy, my family took great care with our snapshots.*
> *We really planned them. We made compositions. We dressed up.*
> *We posed in front of expensive cars, homes that weren't ours. We*
> *borrowed dogs. . . . Looking through our snapshots recently, I found*
> *eleven different dogs in one year of our family album. There we*
> *were in front of canopies and Packards with borrowed dogs, and*
> *always, forever, smiling. All of the photographs in our family*
> *album were built on some kind of lie about who we were . . . and*
> *revealed a truth about who we wanted to be.*

Indeed, their maintenance of a certain image might have been
tinged with residual bitterness at the more constrained conditions
of their unintended lifestyle. Until the stock market crash and
the bankruptcy of the store, Jack and Anna Avedon had become
the very people of their own aspiration—stylish, dignified, and,
to some extent, cultivated. They lived in a comfortable house in a
smart, verdant suburb; they socialized over cocktails and dinner
with friends at the club. The impulse to be recognized as a prosper-
ous and affable American family gave them further immunity from
the prejudice and judgment of anti-Semitism. They may have had
their pretenses, but it was with instinctive self-protection that they
aimed for a facade that was decidedly American.

While the family snapshots exist as proof that the Avedons
posed with other people's dogs, there is no evidence to corroborate

Dick's recollections of his "first photographic print"—which faded with the tan on his arm—or verifiable proof that his "first photographic portrait" was of Rachmaninoff, who did live above Dick's grandparents on West End Avenue. Both stories are plausible, and yet they were recounted long after Dick had become "Richard Avedon," each anecdote fashioned with a certain je ne sais quoi to suggest in retrospect the clever precocity and quiet derring-do of the nascent artist. Yet how many borrowed dogs did it take to come up with such fitting, if unassailable, tales about the great photographer's "first portrait" and "first print"?

IN 1935, DICK SAW the movie *Top Hat*, which threw the lapidary Polish rider off his saddle, so to speak. In Fred Astaire, Dick was given an entirely new standard of adulation. Astaire plays Jerry Travers, a smooth and hopelessly urbane song-and-dance man, in the kind of cinematic spectacle that Hollywood produced to lift the spirits of moviegoing audiences during the Depression. While it may have been perverse to flaunt the excessive luxuries and frivolities of the very rich in front of penniless audiences, moviegoers flocked to the theaters. Dick saw *Top Hat* at Radio City Music Hall, itself a daunting spectacle of art deco high style, with celestial golden crescents emanating from the proscenium stage, and no fewer than six thousand seats, all of them filled for this charming celluloid bonbon—the biggest box office draw in 1935.

*Top Hat* is a sublime entertainment—sumptuous, sophisticated, and smooth, a comedy of mistaken identity and snappy patter that breezes through an array of beautiful rooms with sleek white furnishings, fluttering gossamer curtains, and gleaming marble floors on which Fred Astaire in his white tux and top hat and Ginger Rogers in her swirling silk gown with bouncing white feathers dance together so effortlessly and with such fluidity that we find

ourselves in the dreamiest precincts of our collective imagination. The movie took the breath away from the twelve-year-old Richard Avedon, and his heart pounded from the unfathomable glamour and the magic of their dancing. "The first time I saw Fred Astaire making love to Ginger Rogers with his feet, I thought, 'I get it. That's a man a person could be proud to be,'" Avedon said, many years later. "I ran up the aisle of Radio City Music Hall kicking the seats, imitating him."

Dicky's exuberance would again be manifest when, the following summer, he took to the stage in a solo performance at summer camp. It was not a happy experience. In his father's ongoing campaign to teach Dick to be resourceful and practical—and stay alert to the unspoken dictates of assimilation—he was sent to a YMCA survival camp. These intensive camps teach useful and potentially lifesaving outdoor skills in preparation for camping or hiking in natural surroundings or, perhaps, surviving alone in the wilderness: foraging for food; trapping and snaring animals; fishing; building fires from scratch; creating shelter in nature; rappelling down a waterfall. Jack was forever admonishing Dick to be more self-reliant and to learn to protect himself: "If you don't watch out," he would caution his son with one of his persistent and disparaging refrains, "you're going to join the army of illiterates and end up as a taxi-driver."

Norma Stevens, who served as Richard Avedon's studio manager and all-around coconspirator for thirty years, recounts in her memoir a poignant conversation with Dick—at the time in his late fifties—following dinner in a world-renowned restaurant. He summoned the painful memory of that YMCA camp, bemoaning his "miserable father" for forcing him to run that gantlet. Dick had already suffered the humiliation of his inadequacies by the time he arrived at the camp, and his bunkmates made it worse: He was "too short, too skinny, too myopic," and, on top of that, a terrible

athlete. They taunted him for "throwing a ball like a girl." Norma had heard the YMCA camp stories before, but, on this particular evening, he divulged to her something completely new, and important: he had had "stirrings" for a boy in his cabin named Patrick, whom he described as having "freckles and butterscotch hair." In the context of his bunkmates' bullying and ridicule, Patrick had showed him an unusual kindness one morning by telling Dick that he was going to pray for him. "My heart turned over," Dick told Norma. His desperate need for acceptance was now compounded with the entirely new sensation—*desire*—and it compelled Dick to prove himself worthy of Patrick's friendship. He convinced his drama counselor to let him do his Fred Astaire *Top Hat* routine during intermission at the upcoming camp play. "On the big night, after I finished, I took a deep bow, then blew a big fat kiss to the audience—only, without even thinking, I aimed it directly at my butterscotch boy," Dick told Norma. "He stood up, looked straight at me on the stage, and—it still hurts to remember—mimicked throwing up." Then he stormed out.

One can imagine Dick tap-dancing on the stage, lost in an abandon of pure joy. He may have been trying to prove something to his fellow campers but, naively and unwittingly, he had performed a pubescent mating dance. This unabashed display of affection turned his bunkmates' all-too-familiar aversion toward him into bald revulsion. They would have burned the "pansy" at the stake had they been given the chance. Worse, Dick had marked the very object of his affection—whose kindness now hardened into contempt. Alone on the stage after his bow, Dick felt like a leper, naked and desperate for the safety of his own quarantine. Embarrassment didn't begin to describe how he felt—stabbed in the heart and humiliated at the same time.

When Dick was seventy, he was asked in a public conversation at the Whitney Museum to describe despair: "I can only speak for

myself," he said. "It starts as being an isolated child, an isolated person, who wants to perform, wants to give to the family, the world, and can't do it the way they want, or can't enter the world in the way the world appears to be set up. So, you make your own world."

Dick knew it would be too dangerous to return to his bunk that night; in a state of hysteria, he called his parents and complained that he had been the target of discrimination, referring to what he told them were anti-Semitic taunts—even though it was really nascent homophobia—and begged them, for his own safety, to come pick him up. His father drove two hours that night to get him.

Dick could not have known at the time that he was a victim of his own attributes. He suffered as a victim of his fragility, the prejudice endured as a Jew, his enthusiasms for things other than sports, and his bubbly excitability. The characteristics that made him unique, for which he was ostracized as a child, were the very qualities that would propel him toward his destiny. The tragic secret about the hierarchies of teenage life is that those who are the most desirable in high school often reach their social peak at seventeen and those who are fumbling around in adolescence, like Dick, have not yet gotten started but suffer the wounds of rejection nonetheless.

If his social milieu in adolescence had not been confusing and painful enough, the added burden of his parents' expectations further complicated his sense of direction. "Somehow," Avedon said, "I got the message that I had to be one kind of person to please my mother, another kind to please my father."

3

# PREMATURE
# SOPHISTICATES

(1936–1942)

"Grace / to be born and live as variously as possible."

—FRANK O'HARA (GRAVESTONE EPIGRAM,
GREEN RIVER CEMETERY, SPRINGS, NEW YORK)

Imagine two teenage rascals huddled in the corner of the swank art deco lounge of the Croydon Hotel. It was an intimate room and jewellike, with a burnished-steel ceiling that shimmered in the sleek beveled mirrors and ziggurat-patterned wallpaper in alternating shades of silver and cream. In the evening hours, the room was filled with stylish women in feathered homburgs or veiled cloches and respectable men in business suits occupying the cozy leather club chairs nestled around the low, circular cocktail tables, smoking, laughing, clinking their glasses with restless bon-

homie. Before that, though, Dicky and Malca, as he sometimes called Margie, would while away an hour or two after school in the empty lounge, on East Eighty-Sixth Street, hunched over a table at the end of the leather banquette, two dark-haired adolescents cracking each other up with their clever verse and rhymes—until the bartender scooted them out before the cocktail rush.

During their teenage years, Dick and Margie had figured out how to submit their poems to newspapers and magazines and occasionally get them published. Several of Margie's poems and short stories appeared in *Harper's Bazaar*, *Mademoiselle*, and *Ladies' Home Journal* before she reached college. Dick, too, had written a quatrain at the Croydon that was published twice when he was in high school, once in the *Journal-American*, and, again, slightly modified, in the *New York Sun*, at twenty-five cents a line:

Summer heat, like sodden cotton
Is obviously good for notton
And being quite candid
I just can't standid

Sophomoric though it was, Dick's playful ear for colloquial New York eclipsed the thud-a-dud baldness of the rhyme. His poetry would indeed improve along with his ambition to become a poet. In high school, he diligently studied the works of T. S. Eliot, Robinson Jeffers, Archibald MacLeish, Carl Sandburg, and W. B. Yeats. Manifest throughout the many poems Dick would write during his teenage years are the imitative flourishes that any student necessarily attempts—inevitable rites of passage—toward achieving a voice of one's own. Against a claim that Dick often made later in his life about being a "no-goodnik" throughout high school, evidence shows that he was capable of focusing his energy on constructive activities when his interest was piqued; then, his occasional bursts

of expression would emerge like verdant blades of grass that sprout in the cracks of a backstreet sidewalk:

SOME FAWN, EH KID?
This verse is a verse to a lonely fawn.
She lost all her pals through constant quarreling,
And now she stands friendless from evening to dawn—
She's everyone's deer, but nobody's darling!

Dicky and Margie were "no-goodniks" in the eyes of his father because of his boredom at school, Malca's disregard for the conventions they were forced to adhere to, and their coconspiratorial impudence. Jack might have used the term *no-goodnik* to instill fear in his son, but more likely, the term contained hidden implications: *no-goodnik* was a euphemism for Jack's disapproval of his son's emotional delicacy, overexuberance, lack of athletic coordination, and interest in, well, the wrong things (such as poetry). Margie complained in her journal about Dick's physical tics—"Dicky's new nervous habit is to make annoying sounds with his mouth." She would remind Dick in later adulthood of another nervous habit he had of rolling his eyes around. These childhood tics might have been symptoms of a brooding frustration and anxiety about the consistency with which his creative impulses were thwarted by his father's harsh judgment.

Anti-Semitism drove Jack's generation toward an assimilation that was not only about fitting in, but about "besting" the natives at their own game (in this case, old-moneyed WASPs). For Jack, any deviation from that strategy would doom the Jews in America to failure. (If a single Jew was arrested, so the saying went, it was bad for all Jews.) From Jack's perspective, Dick was too Jewish in manner and appearance; that he was additionally irascible, excitable, and less than boyish did not help his cause.

For Jack Avedon to even consider that his son might be a bit "fairyish" was too alarming a thought to contemplate: in a diary entry dated February 11, 1937, Margie wrote: "It has been decided that Dick is to go to Boston all by himself during Easter Week to sleep where he can & eat where he can and get a job to pay for it. I think it's a swell idea to give him independence, etc, etc. When Grandma heard it she nearly fainted and said it had to be stopped, but Uncle Jack [Dick's father] won't listen." Jack imposed this particular test of his son's mettle when Dick was only thirteen.

Together, Dick and Malca fueled each other's native talents and egged each other on. Robert Lee, the oldest of Margie's five children, remembers hearing about several of their teenage antics that made mischievous use of Dick's Brownie camera. In one rather mean scenario, the two cousins would spot an elderly woman by herself, either waiting for the bus or seated on a bench in the park. Margie, outfitted in her Sunday best, her hair nicely combed and pulled back, would run up to the unsuspecting stranger, throw out her arms with theatrical emphasis, and exclaim: "Grandma! I can't believe it. What are you doing *here*?" The woman—confused, cautious, *delighted*—would endure Margie's joyful hugs and kisses while Dick snapped away with his Brownie. And then off they would run.

In another of their audacious schemes, the two of them would dress up, as if for Sunday school, and venture a few blocks south of the Avedons' apartment to the newly opened Frank Campbell Funeral Chapel on Madison Avenue, where they attended the funerals of strangers. They would mingle while Dick took pictures of the family mourners, as well as the corpse lying in the open coffin.

Dick's pictures documented their theatrics and provided evidence of what looked to be authentic moments in circumstances that were anything *but* (precursors to his fashion imagery). Yet weren't these pictures an extrapolation of the family snapshots with the

borrowed dogs? Robert Lee never saw any of the Brownie snap-shots, but he believes the stories, passed along as family lore, to be true. "Dick always credited my mother with the lion's share of the creative force they shared as children," Lee said, emphasizing that there was nothing nefarious about their mischief-making; they were exercises of the imagination. "My mother was not mean-spirited or sarcastic."

Margie, two years older, was always introducing Dick to the things she was discovering before he could get there himself. Not only was she his avatar for the more arcane details of the cultural life of New York just beyond his awareness; she led the charge toward pubescence—an entire universe of transformation that bubbled up from the flesh. Margie couldn't wait to share each new revelation with Dicky.

With a kind of brilliant curiosity, Margie was always willing to cross a line, and the closer it bordered on the taboo, the more compelling. She and Dick might not have conformed to Jack's cir-cumscribed vision of the "right way to be," but Anna, despite her genuine trepidation about Margie's influence on Dick, was still more than willing to delight in their wildly creative antics. Anna (Aunt Anne to Margie) was always kind to Margie and believed that her niece could be a positive influence on Dick, too. Surely the fact that their poetry appeared in respectable magazines and newspapers stemmed from Margie's own high-minded ambitions. Anna was ever susceptible to Dick's native charm when he was comfortable enough to allow it to surface. The dimple in his cheek when he smiled and the humor of his cunning little asides about his father were more in evidence when he was around Margie. Anna, too, had a smile that was "not merely a calling card," Robert Lee remembered. "It came from a deep well of repose, generosity and empathy. She laughed heartily, naturally, from her belly." Dick's mother's natural delight was the very sustenance that he relied

on when he ventured into the gantlet of indignities at school that made him feel like such a sad sack—despite the fact that he wasn't.

By now, the Avedons were living at 55 East Eighty-Sixth Street, across the street from the Croydon Hotel, and only a ten-minute walk to the Metropolitan Museum. Their redbrick doorman building stood in the middle-class shadow of the Fifth Avenue gold coast along Central Park, where Gilded Age limestone mansions designed by Carrère and Hastings, Cass Gilbert, and Stanford White for eminent New York families like the Pierreponts, the Astors, and the Vanderbilts gave the avenue its impressive grandeur.

When Dick was barely sixteen, a new development in the family readjusted the composition of domestic life in the apartment: It was a known family scandal that Dick's paternal grandfather had abandoned his wife and children in the late nineteenth century. And it was an endless source of longing for Margie that her father, Sydney M. Lederer, had abandoned her mother soon after she was born. Now, adding an uncanny symmetry to the family legacy of errant husbands, Jacob Polonsky—who had by now anglicized his name to Jack Post—maternal grandfather of both Margie and Dick, left his wife for good.

For years before his final departure, Jack Post would storm around the West End Avenue apartment spewing resentment and disgust at his daughter Sally and his granddaughter Margie for continuing to live under his roof "like leeches." He communicated with his wife by yelling first and then spitting on the floor to emphasize his complaints. Emma, the maid, who had been with them since their more moneyed existence on Riverside Drive, virtually ran the house, openly referring to the Posts, née Polonskys, as "dirty Jews," and to Sally, whose behavior was increasingly bizarre and abusive toward Margie, as "a lazy dog." When Jack Post left for Florida, the Avedons had no choice but to take in Rebecca, Anna's mother. Dick, obliged to give up his bedroom for his grandmother, became

a displaced teenager who was forced to sleep on the living room couch. To be a teenager without his own room was tantamount to feeling punished without having committed a crime.

Margie and Dick attended different schools, as if they had been forcibly segregated by gender—Margie went to the Julia Richman High School, an all-girls school on East Sixty-Seventh Street, and Dick was enrolled at the DeWitt Clinton High School in the Bronx. The Croydon, conveniently, became their home away from home and, after school, they would rendezvous there as a way to avoid the tensions that continued to mount in the Avedon apartment and the insanities Margie had to endure with her mother.

Dicky and Malca worshipped the sophisticated irreverence of the early *New Yorker* magazine writers who composed the Round Table at the Algonquin Hotel, the watering hole across the street from the magazine's Midtown offices. Early on they were in thrall of the discerning—if, at times, almost vicious—writing about the cultural life of the city in reviews and essays by Robert Benchley or Dorothy Parker or Alexander Woollcott. They devoured the secrets about adulthood gleaned from the wordplay and the snappy writing in the *New Yorker*, whether it was a review of a new play or a Talk of the Town piece on a party for a debut novelist. Dorothy Parker could sum up an entire human condition in a single line, as in this twist on a farmyard cliché—"Don't put all your eggs in one bastard." Dick and Margie tried to emulate the ironic remove from which these writers deigned to describe their subjects, practicing the drier-than-a-martini Round Table tone with their own witty asides (to each other). In one Dorothy Parkerism that Margie tried out in her diary, she wrote on January 8, 1937: "One should not marry for love without money, but one should not marry for money without love."

In *The Eye of Summer*, Margie fictionalized the veneration she and Dick shared for these writers. In the novel, Connie and

Spence—now teenagers—are having a conversation with an older guest at a seaside resort, a stylish divorcée who possessed her own saucy brand of urban hauteur. She observes that the beach on which they are sitting is "fairyland, you know—in more ways than one. Haven't you bothered to notice? Or wouldn't you know?" she asks, referring to the "bohemian" nature of the beach community. Spence nods.

> *"We know," he said. "You're talking to the world's two most premature sophisticates. We were weaned on Havelock Ellis [a British progressive intellectual who wrote about human sexuality]. We grew up thinking Pollyanna was Polly Adler [the most celebrated madam in New York], and that babies were brought by the Stork Club. You know who taught us how to speak? Dorothy Parker. We used to read her the way other kids read nursery rhymes. She was really our mother, you know—though she'd probably keel over if she ever knew."*

DICKY AVEDON, THE PREMATURE sophisticate, would become increasingly alienated throughout his adolescence, and not only because of the lack of privacy at home. "See, I was Dick," he told Doon Arbus. "And I was short. And I was dumb. And I was Jewish. I used to walk around as a short, dumb, Jewish dick." Most of the students at the all-boys DeWitt Clinton High School were interested in competitive sports. Dick's enthusiasms were animated in the worlds of music, theater, dance, and poetry. These were not even peripheral interests among his peers, but, rather, perceived as tedious obligations imposed on them by adults. Even worse, Dick's interest in the arts was a conspicuous signal to his classmates that he was an aesthete—a term not yet in cultural circulation, but the idea is loaded with pejorative implication—and it didn't help that

he was uncoordinated on the athletic field. Worse, a word that was very much in circulation was *sissy*—the vilest possible slur to be hurled at any boy navigating the adolescent hierarchies of twentieth-century America. With that target on Dick's back, he was clearly ostracized at school, and the humiliation would take many forms.

DeWitt Clinton High School was a serious institution. The doors of its new building opened on October 29, 1929, the day of the stock market crash, which put a damper on the official speech given by New York mayor Jimmy Walker at the opening ceremony, attended by two thousand people. The building had cost $3.5 million to construct, over $1 million more than the new Yankee Stadium, completed six years earlier.

Nearly twelve thousand boys attended DeWitt Clinton and its annexes, and by 1934, several years before Dick enrolled there, it was known as the largest high school in the world. "Our identity was represented by the front of the building, designed by William Compert, in the grandeur of its façade and the sweep of its land-scape," write Gerard J. Pelisson and James A. Garvey III, alumni and authors of *The Castle on the Parkway*, a comprehensive history of the school. "The lawn was lined with thirteen oak saplings 'in trib-ute to the original 13 states.' There were cherry trees, azaleas, and mountain laurels. Ivy clung to the wall and surrounded the terra cotta friezes that framed the first-floor windows. It had the feel of a college campus." And yet, the majesty of its facade was reduced to a stage set by the back of the building, a shocking contrast in austerity with its absence of any decorative flourishes: the concrete steps were strictly utilitarian, and the paved courtyards composed a more accurate reflection of the school's atmosphere, described by the authors as essentially penal—"a world of inmates more than classmates."

The academic standards at DeWitt Clinton were high; the courses were rigorous; the students were competitive; and, for Dick, who could be painfully shy in the context of his overly aggressive peers, the general climate was foreboding. A surprising roster of accomplished alumni in Avedon's era suggests that the school maintained a strict academic regimen. Those alumni included Richard Rodgers, the composer; Lorenz Hart and Adolph Green, the great lyricists of Broadway; Lionel Trilling, the writer and critic; Richard Condon, author; Burt Lancaster, the Hollywood actor; and Aaron Siskind, the photographer. Among Dick's own classmates were James Baldwin, the literary voice of a generation; "Paddy" Chayefsky, the Academy Award–winning screenwriter for *Network*; A. M. Rosenthal, Pulitzer Prize–winning journalist and longtime executive editor of the *New York Times*; Stan Lee, née Lieber, editor in chief of Marvel Comics and creator of Spider-Man, the Hulk, Black Panther, and Iron Man; Sol Stein, who founded the publishing house Stein and Day; and Emile Capouya, the author, who, as an editor at New Directions published James Joyce, Ezra Pound, and Jean-Paul Sartre, and served as literary critic for the *Nation*. William Kunstler, the radical lawyer and board member of the ACLU, who defended the Chicago Seven, was a few years ahead of Dick. And Neil Simon (*The Odd Couple* and *Barefoot in the Park*), a few years behind. How was a "no-goodnik" like Dick expected to find his way through that labyrinth of percolating ambition?

Of course, in the late 1930s, the formidable alumni with whom Dick had gone to high school were not yet accomplished. They, like him, could not possibly imagine the scope of their achievements or, in their wildest dreams, foresee their places in history. At DeWitt Clinton, they were still a bunch of schlubs soaking up knowledge with no life experience to give meaning to what they were learning.

Throughout high school, Dick could be sullen. The climate at

home was stultifying enough. His father was always breathing down his neck about his poor grades, his bad attitude, and his overall inadequacy. His mother defended him, providing inspiration and encouragement, which only created tension between his parents. At the same time, his mother was focusing more and more attention on Louise, who was unusually quiet and at times sickly. His grandmother, whom Margie once described in her diary, according to her son, Robert Lee, as "grim, authoritarian and unkind," was obsessed with hygiene and made Dick wash his hands and change his clothes whenever he walked in the door. Since he had no room of his own, there was nowhere in the apartment to be alone, to fantasize about the selves he might one day want to try on or the adventures he might conjure for himself.

Magazines helped. As Truman Capote would note in a 1959 essay in *Observations*, Avedon was an admirer of good photography from an early age. "The walls of his room [when he had a room of his own] were ceiling to floor papered with pictures torn from magazines, photographs by Munkaczi [*sic*] and Steichen and Man Ray" that appeared in *Harper's Bazaar*, *Vogue*, and *Vanity Fair*, to which his parents subscribed and where so many important photographers of the period were published. The pictures exposed him to other ways of being, other lives, other worlds. He would read the articles, too, which gave him clues about so many different ways of thinking and behaving. Still, he moped. It was hard to dream in that environment. He could barely even breathe.

Sullen was not a natural state for Dick, who was congenitally wired to be in a perpetual frisson of excitability. But he learned early that the things that excited him were not of equal importance to his classmates. Autographs, for example, had become a wild enthusiasm for him from the moment he had tried to collect the first one, from Rachmaninoff, when he was nine.

"My mother would take me to Carnegie Hall and there was,

literally, Katharine Cornell, who I had just seen play Joan of Arc. I got her autograph," Avedon told David Ross, the director of the Whitney Museum of American Art, in a public conversation in 1994. For his fourteenth birthday, he was taken to see Helen Hayes, the first lady of the American stage, in *Victoria Regina*, and tried to get her autograph. Young Dick tracked Salvador Dalí to his hotel suite and got his autograph on a scrap of paper. Dalí came to the door wearing a snake. Behind him his wife, Gala, posed in the nude.

Dick would collect autographs from the likes of Albert Einstein and Arturo Toscanini. "I have the wildest collection of autographs that any ten-, twelve-year-old ever had. Great judges, great Jews, two starlets named Toby Wing and Lyda Roberti ('I got a cousin from Milwaukee, she's got a voice so squawky'), because I saw them on Madison Avenue," he said in 1994. Dick obtained autographs that came from actors and artists and classical musicians and public intellectuals, but they did not impress his classmates. If only he had sought out Lou Gehrig or Joe DiMaggio, Jean Harlow or Mae West.

"I tuned out completely at school—I could never pass anything," Dick told a reporter at *Newsweek* in 1978. "I forged all my report cards. I flunked hygiene. I felt totally isolated. To myself, I was the known dope. But it's out of that sense of failure that somehow another side of me began to move forward." His aspiration for a more cultivated life was nurtured by the literary and fashion magazines at home and the autographs he was collecting, which made the world of accomplishment vaguely within his reach. "It was about people who had achieved a certain quality in the world of the imagination and of the arts, and law," he recalled. "It was my way of saying I want to get out of this apartment, out of this family, out of this world; *that* is the world I want to join. I wanted to be one of *those* people."

It wasn't as if his parents weren't mindful of the more cultivated layers of existence in Manhattan, in their very midst and well within their grasp. In one of Dick's typical exaggerations, he once claimed, "When the *New Yorker* came out in 1925, I think, my mother and father put it in my playpen." He described with resonance an ideal that his parents held up to him, one that he was very willing to share: "The great Jewish intellectual family of that period was the Strunskys," he explained. "One was the editor of the *Times Book Review*, I think, and to be a Strunsky—one was in a chamber music group—they were cultured, people from Europe bringing their culture to America. . . . Ira Gershwin's wife was a Strunsky. They had a bookstore in the Village—one was named Simeon Strunsky and another English Strunsky. I wanted to be a Strunsky. I didn't want to be an Avedon."

DICK WAS ALIENATED, PERHAPS most profoundly, because of the stirrings of pubescence that he could not make sense of or express to anyone else. There was simply no precedent in the world of men and women, no example in modern literature or cinema, that accommodated the desires surfacing inside him. If he had harbored an attraction for any of the boys in his class, it was such a taboo subject that he had to keep it buried. The feelings themselves were scary enough—unnamable, a desire with a life of its own that was always something to be reckoned with.

If that wasn't complicated enough, his relationship with Margie had its own frightening and consuming dimension as the two of them skated on the edges of an erotic exploration throughout their adolescence that created only more confusion about who he was. In *The Eye of Summer*, at the same seaside resort where Connie and Spence meet the divorcée, they later meet another couple

staying nearby. The man, maybe thirty, is coarse and aggressive and throwing around his machismo as his pretentious young wife expresses embarrassment about her husband's vulgar opinions and his crude behavior. Spence and Connie are coerced into dining with the couple, and, afterward, they return to Spence's room to dissect the evening.

*"I was thinking of them in bed," Connie said. He gave a little laugh and bunched the pillow behind his head. "You're always thinking of everybody in bed," he said.*

This precipitates a long conversation about a night only several months earlier that Connie, in her college dormitory, lost her virginity. After talking through the night, Connie convinces Spence to let her stay with him in his room. "He made a place for her and pulled the sheet down so she could get in," Lee writes.

*Then he switched the lamp off. The room was gray now, growing lighter with the morning. They lay together in silence for a little while and then he turned until he faced her. "Con," he began.*
*"I know," she said again, guiding his hand gently against her breast, moving her mouth toward his. "Trust me, Spence. Trust me—just this once, because I know. I know . . ."*

The youngest of Margie's children, John Lee, recounted a visit from Dick to his apartment on lower Fifth Avenue not long after Margie died, in 1999. "We sat there, and I definitely felt that he had a subtext. Finally, he was confessing something about my mother," John said. "They were involved romantically . . . that's pretty much the conventional wisdom of their relationship that anyone who knows about it would tell you."

STUDENTS COMMUTED DAILY TO DeWitt Clinton High School from all over the city; when the new building opened, the subway platforms had been too narrow to accommodate the influx of students and additional turnstiles had to be installed at the station. Given the multicultural nature of the student body—the term in use at the time was *melting pot*—the development of a social conscience was the presiding tenet of the school ethos. "DeWitt Clinton High School in the 1930s and early 1940s was never about 'me,'" write the authors of *The Castle on the Parkway*. "One's commitment to the greater good was the ultimate value. No wonder the students of that era contributed so significantly to the social conscience of America in the decades that followed."

During the Depression years, when the economy was the prevailing topic of almost any serious discussion, a second issue—racial discrimination—grew in importance. The revelations of vigilante lynching of African Americans that were taking place in the South were chilling. The year Dick arrived at DeWitt Clinton, an English teacher named Abel Meeropol had been so outraged at the sight (in a photograph) of two dead black men swinging from a tree that he wrote a poem-song, "Strange Fruit." The song was recorded by Billie Holiday, and, later, Nina Simone, among many others, eventually becoming an anthem of the civil rights movement. In 1999, *Time* magazine claimed "Strange Fruit" to be the "greatest song of the 20th century." (Meeropol and his wife would adopt the two young sons of Ethel and Julius Rosenberg after their execution for espionage in 1953.)

The development of a social conscience may have been a fine ambition to hold up for the (student) body politic, but there were plenty of students like Dick who felt firsthand the discrepancy between the ideal of liberty, equality, and fraternity, and the anarchic behavior that took place behind the teachers' backs. Where was the

justice in the discriminatory attitudes and bullying tactics of his classmates?

To Dick's great advantage and good luck, he would discover *The Magpie*, the school literary magazine, and join the staff, which provided him an intellectually nourishing and spiritually grounding sanctuary within the less-than-hospitable high school culture. There was the added bonus of a group of sympathetic compatriots among the staff. *The Magpie*'s editorial office was in the (ivory) tower, on the fifth floor, sequestered from the rest of the school. *The Magpie* was Dick's first introduction to the workings of a publication: he learned the entire process of production; he was actively involved in editing and selecting work for the magazine; and he became consumed with writing poetry and essays.

For a high school literary magazine, *The Magpie* maintained the standards of a professional journal. The production values were extremely high. The caliber of thinking, if not always the writing, revealed serious student contributors who were contemplating the social issues of the day and expressing the existential quandaries of adolescence. Dick's poems, too, were getting better and more expressive. Here is one published in *The Magpie* in the spring of 1940, a profound lamentation about the absence of happiness in his life, and a fear that it may be a permanent state of being:

THE REALIST
How can I whip the willow to my side
And sing the lyric; play the melody
Of laughter when the clear and happy voice
Is something that was never meant for me.
How can I stretch a body, stiff with cold,
Into a warm and summer scented sky,
Or turn a timid breath and timid hand
To any likely lass that's passing by.

Oh, I shall never walk a gypsy way
With song and sunshine and a gypsy stride;
With primrose creeping sweet across the path,
And years of road before me, cool and wide.
I shall not play a gay and summer part,
While winter shoots her daggers to my heart.

Eventually Dick would end up as coeditor of *The Magpie* with his classmate James Baldwin. The two boys—one Jewish, the other African American—shared more than an affinity for language and poetry. They became friends and spent time together outside school, sometimes at Jimmy's house in Harlem on West 131st Street and sometimes at Dick's apartment on East Eighty-Sixth Street. In one visit, when Baldwin arrived at the Avedons' doorman building, he was told to take the service elevator. When Anna Avedon learned why Jimmy had arrived at the back entrance, she was so irate that she summoned the doorman upstairs to their apartment, reproached him, and demanded an apology to Jimmy's face.

In 1941, during their senior year, Dick and Jimmy would sneak into the jazz clubs in Harlem, where on any given night at the Apollo or the Lenox Lounge or Clark Monroe's Uptown House, one could catch a performance by Billie Holiday, Ella Fitzgerald, Louis Armstrong, Count Basie, Thelonious Monk, Dizzy Gillespie, or Lester Young. Jazz was the new music of the era, and Harlem the soulful eye of that improvisational storm.

In 1936, Michael Carter, a self-described sociologist with an interest in the effects of poverty and segregation, organized a photographic project called the Harlem Document. He invited eight photographers, including Aaron Siskind (a DeWitt Clinton alumnus), to document Harlem in the years following the profound cultural ripples of the Harlem Renaissance. The photographers set out to cover the neighborhood and all its complexities—the streets, its

commerce, individuals and their residences, the way of life, the nightclubs. Carter, an African American, was in actuality a journalist named Milton Smith who worked for the *Brooklyn Eagle* on the Negro beat and Harlem. One picture in the series, *Savoy Dancers*, taken by Siskind circa 1936, shows a couple dancing the Lindy, the man twice the size of the woman, their hands together in the air, his leg kicked out, her white shoes in perfect two-step, their expression one of utter joy, a simple moment when the music and the mood reached beyond the confines of race.

Dick and Jimmy would soon begin a collaboration that might have been spawned from the Harlem Document, as well as a recently published book called *Let Us Now Praise Famous Men*, by James Agee and Walker Evans, documenting in words and images the plight of sharecroppers and their families during the Great Depression. Avedon and Baldwin's project, "Harlem Doorways," never quite got off the ground. Avedon remembered it as Baldwin's idea. "The name came from him," he said. "The thought came from him. And I thought: *doorways*. That's not where I'm going. Walker Evans I'll never be."

At some point during his senior year in high school, Dick expressed such unhappiness with his appearance—so visibly a Jew—that his father agreed to pay to have Dick's nose surgically altered. Although Jack Avedon was by now the merchandise manager of the Tailored Woman, this was still an unusual extravagance in 1941. According to Norma Stevens, Dick once reminded her "he was the son of an anti-Semitic Jew—a man who had taken elocution lessons to expunge any tell-tale intonation." Dick claimed he wanted a nose job because of an inexplicable desire "to look elegant and sophisticated, by which I mean not Jewish." This was the insidious effect of anti-Semitism not only on Dick but also on the entire population of first-generation Jews in America—and their offspring. Dick claimed that no one at school noticed the difference.

It was Mike Elliot, an older kid in the neighborhood, who convinced Dick to have the surgery. Mike Elliot had recently changed his name from Milton Lipset, along with his brother, Elliot Lipset, who became Steve Elliot. Their mother, Gertrude, owned the candy store at Madison Avenue and Eighty-Seventh Street, where she sold newspapers, magazines, stationery, and other sundries.

The "corner candy store" was something of a neighborhood institution, and Gertrude Lipset's store was no exception. Everyone in the neighborhood relied on her for news of everyone else. Her sons Milton and Elliot delivered newspapers to every apartment building along that particular stretch of Madison Avenue, across East Eighty-Sixth Street, where the Avedons lived, and around to Park Avenue. The two brothers, a year apart in age, would help out in the candy store, too, and, because they were outgoing and enterprising, became known locally.

At the end of the 1930s, when Elliot graduated from college, the two boys, barely twenty years old, succumbed to the assimilationist current that persuaded Jews to anglicize their names for professional reasons—becoming Mike and Steve Elliot—and opened a photo studio above the Russian Tea Room on West Fifty-Seventh Street. Dick, in his senior year at DeWitt Clinton, worked in the studio after school and on weekends. He was the darkroom boy, the all-around assistant who helped out on photo shoots and ran errands delivering photographs to clients. One of their clients was Macy's, for whom the Elliots provided photographs for the store's catalogs. Steve Elliot Jr. remembers his uncle Mike explaining the serendipitous way they got the Macy's account: "He was in the office of some upper-echelon person at Macy's, and the daughter of the owner came out with a big dog," Steve said. "The big dog jumped up on him, and it started a relationship with her that got him in the door."

Mike (Milton) had been known in the neighborhood as some-

one who worked very well with his hands; he dazzled people with the model airplanes that he made from scratch. He could be very exacting. "Mike always expected you to do your part," his son Bob said. "If you fucked up, he would say 'stop being a dumb shit.'" Still, he was a very good teacher and his son is certain that he taught Dick everything about the technical aspects of photography. "I don't see Dick being a technical kind of guy," Bob said. "He was more theatrical. My father would have explained that 'this is what you do with the chemicals, this is the step-by-step process.'"

Carol Marcus, another neighborhood kid, was of a different breed altogether. She would later become the actress Carol Grace, but, also, Mrs. William Saroyan, and, much later, Mrs. Walter Matthau. As a teenager, she lived with her mother and stepfather on Fifth Avenue, around the corner from the Avedons in a higher stratosphere of economic comfort and social privilege. Carol attended the Brearley School, and her best friend, Oona O'Neill, the "young and somewhat sensitive beauty" who was Eugene O'Neill's daughter, attended Dalton, both in the neighborhood of Dick's apartment building. They were good friends with Gloria Vanderbilt, known then as "the poor little rich girl" who endured a very public custody battle between her aunt, with whom she lived, and her mother, an international socialite for whom parenting was an afterthought. (In 1942, Truman Capote would move into the neighborhood and frequent Gertrude Lipset's candy store. Gertrude would later admonish her sons, who could be rambunctious and rude, with the consistent refrain, "Why can't you be nice, like that sweet Truman Capote?")

Carol, Oona, and Gloria—three young swans—were Dick's peers in age. Barely seventeen, they would descend on the Elliot brothers' photo studio on West Fifty-Seventh Street, arriving in the early evening just before the studio closed for the day, and, surreptitiously, perhaps, out of sight of any parental supervision,

change into evening wear for a night out at the Stork Club, where their stealth mission to find suitable husbands allowed tony socializing in a splendorous atmosphere, and also provided a great deal of winsome fun as they masqueraded as adults. Oona had dated Jerry (J. D.) Salinger, the older writer; he had already taken her to the Stork Club for dinner on more than one occasion, and she must have felt right at home there.

Dicky Avedon, the seventeen-year-old darkroom boy—scrawny, awkward, and shy—was a "premature sophisticate" aware of the high-stepping glamour of Fred Astaire and cognizant of the frothy intellectual gamesmanship at the Algonquin Round Table. And yet, imagine his amazement as he watched these three high school girls in plaid skirts, bobby socks, and saddle oxfords undergo a transformation into magnificent creatures in full formal regalia— strapless tulle evening dresses, long white gloves, and shoulder-length hair in the style of Veronica Lake, soft lipstick and pencil-thin eyeliner, sparkling with their mothers' "important" jewelry. To watch them transform into women of the world was nothing less than breathtaking. For young Richard Avedon, who brought a would-be poet's impulse to his observations of the things around him, witnessing the very anatomy of glamour as it materialized before his eyes had to have been a seminal experience.

MARGIE HAD DONE WELL as a student at Julia Richman High—or, as she called it, "Julia Richman Low," despite the circumstances at home on West End Avenue that were nothing less than gothic. In her diary she referred to the apartment as the "house of misery." At school, she had the support of one English teacher: "Jonesie" Jacobs. It was Jonesie who nurtured her writing and encouraged her to believe in her abilities. Margie would take cues about the cultural life of New York from Jonesie, who lived

with her husband on West Fifty-Fifth Street, just off Fifth Avenue, in the heart of Midtown Manhattan. In turn, Margie would introduce these new discoveries about the history and lore of literature, the theater, and the arts to Dick. When Margie's application to Sarah Lawrence College was rejected, Jonesie took on the role of Margie's angel and, in one phone call, made a fervent and convincing appeal to Sarah Lawrence to accept this "prodigy." Margie did attend Sarah Lawrence and made Jonesie proud when she wrote the lyrics to what became the college song.

They remained in touch throughout their lives. When Margie gave birth to her first child, Robert, Jonesie became his godmother. "Jonesie looked like Eloise's aunt in the Kay Thompson books," Robert Lee said, with fond memories of his godmother. "She was spectacularly formal. She was always 'dressed.'" He described Jonesie to be of a certain breed of gentility; she was someone who "conversed," in the sense of proper decorum, and yet managed to "exude warmth and an extraordinarily civilized exuberance. If you were a sucker for that anachronistic belle epoque–type of thing, you felt bathed in her light."

In a letter Margie wrote to her aunt Anna not long before she died, she compared Anna's profound maternal influence in her life with that of Jonesie, her teacher, explaining that she looked up to them both as role models and as mentors. Of course, Anna came first and foremost: "I have said it and will say to anyone who will listen. Dick and I were the kids we were because of YOU. NO ONE BUT YOU. Not all the teachers in the world did that."

While Jonesie was advocating for Margie's acceptance at Sarah Lawrence, Dick was struggling at school, even at *The Magpie*. *The Magpie*'s staff worked under the tutelage of a faculty member named Wilmer Stone. On Friday afternoons, after school was let out for the week, a select group of students stayed behind to meet in the *Magpie* tower high above the school campus. Sol Stein, one of

those students, remembered the group: Richard Avedon, "who was then a poet"; Emile Capouya; Jimmy Baldwin; and several others. "What went on in that tower was excruciatingly painful," he said. "Wilmer Stone read our stories to us in a monotone as if he were reading from the pages of a telephone directory." Stein said that they learned then what all writers must eventually learn, "that the reader has to be moved by the words alone, without help from the histrionic talents of their author."

Wilmer Stone could be withering in his critiques of the students' work, both in class and in individual meetings. "Wilmer Stone," Dick told David Ross in 1994, "was another stony-faced, rigorous, left-wing guy who would be destroyed by McCarthyism, but he was a hero to me." Toward the end of their lives, Dick recounted to Stein the painful memory of one critique in which Stone, discussing with Dick several of his poems, asked him what kind of reading material his parents had at home. When Dick listed the magazines that his parents subscribed to, Stone said, "That's what's wrong with your writing." This was crushing to Dick, whose doubts about himself had already been so deeply ingrained by his father. Stone's observation not only destroyed what little confidence Dick had in his writing to begin with, but, additionally, it added to the doubts in Dick's mind about his parents, who obviously were not even remotely of the caliber of the Strunskys.

Stein writes that "Avedon was then a poet and shy. When we were called upon to sell the [*Magpie*] issue of January 1941, Avedon and I would stand in front of each classroom, Avedon silent, his hands clasped in front of him, while I recited a poem of his from memory."

SIGHT SORE
To find oneself among the cream
Of New York's social brace and beam

One must see sights. One has to bare
The Battery, Bronx and God Knows Where.
One simply has to circulate,
From Ulysses S. Grant to the Empire State—
From the Museum of Art to that triple alliance.
The museums of Industry, Nature and Science.
Socially I've missed the mark. I never got further than
Central Park!

Perhaps this poem—not one of his best—was written after Mr. Stone had gotten to him; in it, he disparages himself as parochial and unworldly. And yet his poems were submitted to poetry contests, both locally and nationally, and, in his senior year, he would win two prestigious awards. In 1941, he won the Scholastic Art and Writing Award, a national award for poetry, with this poem:

WANDERLUST
You must not think because my glance is quick
To shift from this to that, from here to there,
Because I am most usually where
The way is strangest and the wonders thick,
Because when wind is wildest and the bay
Swoops madly upward and the gulls are few
And I am doing as I want to do,
Leaving the town to go my aimless way.
You must not think because I am the kind
Who always shunned security and such
As bother the responsible of mind
That I shall never total up to much;
I know my drifting will not prove a loss,
For mine is a rolling stone that has gathered moss.

This poem is a tender assertion of his will, absent any arrogance, and written with a steady hand and clarity of mind; there are indications of self-knowledge, if not self-prophecy, in this argument of assurance (to his father) that the lessons of life provided within the confines of the status quo are not lost on him; and yet he asserts that the seemingly incomprehensible course of his deeds and his actions have an intelligence of the imagination that will direct him to become the person he should be, one who will realize his potential.

He wrote another poem entitled "Wanderlust," as well, published in *The Magpie* that same year:

## WANDERLUST

If only I could try my wings, and soar
All quivering into a starless night,
And whip my conscience raw against a wind,
And try my body in a whirlwind flight!
If only I could take a ship and cut
Through waters with a free and careless cry,
And feel my wounds stung sharp with ocean salt,
And watch my days lurch madly, madly by!

What would I do to find an open road,
To sing a song to split the world apart,
To set a pace in keeping with my mood,
And ease the ever wanting of my heart!
Oh, I am straining to be off . . . To where?
I really do not know and do not care.

Here is a variation on the Robert Frost idea of the freedom afforded by the road not taken, but what, still, is holding young Richard Avedon back? Is he positing the trepidation of J. Alfred Prufrock: "Do I dare / disturb the universe?" (Or eat a peach?)

Perhaps, as Dick told Sol Stein late in their lives, Wilmer Stone's role may have been significant in discouraging his ambition to be a poet. But there are indications that Dick was discouraged from pursuing the life of a poet by other forces as well.

"It's funny, Margie and I used to go on these long bike trips," he said about their teenage summer odysseys together to places like Rockaway Beach or Fire Island, "hosteling—I wanted to be a hosteler. We would plan our future lives in this wacky way. We used to be dangerous, we were so close." In *The Eye of Summer*, again at the same seaside resort with the vulgarian, whose name is Artie, and his wife, Mitzi, Connie and Spence are lying on the beach, reading. Artie starts in on Spence about why he's reading on the beach and why he shouldn't want to be a poet:

> *"You can't live in your head," Artie Breslo said to Spence.... "You can't futz around being a philosopher all your life and expect to get anywhere."*
>
> *"Poets get somewhere," Spence murmured half-heartedly, more to be courteous than to further Artie's conversation.*
>
> *"Yeah, where?"*
>
> *"To a place within themselves, maybe," Spence offered casually.*

Mitzi tries to change the subject, blathering away about something unimportant before Artie goes into a homophobic tirade:

> *"Poets," Artie interrupted, now piled on the sand like a Buddha, "are* fags. *You take any of these poets you talk about, that they got famous and everybody's quoting them all the time, and I'll show you a fag. When a guy doesn't go out in the world and use his arms and legs and dig a ditch or fight in a war, you've got a guy that's living his life like a woman and it's a hundred-to-one shot he's nothing but a goddamned fag."*

Whether a conversation like this actually took place during one of Dick and Margie's bicycle trips cannot be known, but Margie, in creating the character Artie, gives voice to a pervasive cultural attitude, perhaps then as now, about the effete equivocations of the poet—Walt Whitman, Oscar Wilde, W. H. Auden—that were consistent with the conclusions of Dick's father. It is more than conceivable that this trope of the common man—"Poets are fags"—might have struck a too-tender nerve in Dick and revealed too much about what he was trying to hide, both from his father and in the world.

The dire circumstances of his failing grades and the social alienation he experienced at school were hidden in the glare of the limelight when Dick won first prize in a citywide inter–high school competition for his poem "Spring at Coventry," an accolade that was written up in the *New York Times* on May 24, 1941—Avedon's first mention in the paper of record—with the headline "Student Tops 32 in Poetry Contest": "For his 'Spring at Coventry,' Richard Avedon, 17 years old, of 55 East 86th Street, a senior at Dewitt Clinton High School, the Bronx, yesterday won first prize from thirty-one other high school poets at the eighteenth annual inter high school poetry contest at Washington Irving High School, 40 Irvington Place."

SPRING AT COVENTRY
Spring will come,
And ivy crawl
Over our
Broken wall.

And the rambler
Roses meet
On the torn,
Deserted street.

Spring will have
A world of green
Overlay
The shattered scene.

Wise, she is,
To cover this
With her glowing
Armistice.

World War II had already begun, and while the United States had not yet entered battle, news of the horrors reached across the North American continent. On November 14, 1940, the town of Coventry, in Great Britain, was bombed by the Germans; over 550 people died, 4,300 homes were destroyed, and the Coventry Cathedral, a sacred place, was leveled. Dick's elegiac poem was of historic reach.

And yet there were mitigating circumstances that prevented him from basking in the glow of his achievement. Dick's grades were never very good, and he had taken to forging his parents' signatures on his report cards. While he was the sitting coeditor of *The Magpie* in the spring of 1941, he learned that he had failed too many required courses to be able to graduate from high school. He was told he would have to repeat his senior year, but he deprived his parents the benefit of so shocking a revelation. Some nights he would not even go home. "After school closed, I would hide in the [*Magpie*] tower and spend the night, sleeping under a wooden table, writing poetry and reading proofs. It was my favorite place in the whole world." Perhaps it was under that table that he wrote his essay on Dorothy Parker, which appeared in the spring 1941 issue of *The Magpie*, at once an homage and a critique:

*SPEAKING OF PARKER*

*Speaking of Dorothy Parker is like speaking of March weather, a lion, a lamb, a winter snow storm, a Spring shower, a not-here-not-there combination of the entire year. If she were a little less or a little more a poet there would be no problem. . . . Nevertheless, as a fine writer, I feel that Mrs. Parker is one of the failures of our time.*

*Dorothy Parker has mastered words, has mastered sound and the use of sound. She knows perfectly the technique of writing, but fails in that she has little to say. She is a little woman writing Little woman's verse. Her perfection of form, coupled with the sincerity and the ideas of many of our high school writers, may have produced a great poet. As it is, we have merely an excellent versifier. . . . Don't misunderstand me. Although I regret that her technique was not put to better use, I admit, most heartily, that she is one of the happiest additions to the modern sweet of life. Long, Long may she rave.*

Dorothy Parker was a literary hero of Dick's and he chose to write about her, no doubt, out of adulation. Yet Parker fails Dick as a poet because of the content of her verse, and not the language or the technique. Asked by David Ross why he never became a writer, Dick was circumspect: "Because I wasn't smart, intellectually developed enough, to handle my material, and I was aware of it. I read my poems in my last year in high school and I was embarrassed by them, because I knew what good writing was. I have a learning disability of some kind and I knew I could never get my mind to the degree that my emotions and feelings were."

Meanwhile, Margie, too, had set out to become a writer, and she was a good one. In the final passage of *The Eye of Summer*, when Spence is sixteen and Connie is already in college, after the conversation on the beach with the vulgarian about "poets as fags," and on the morning after their physical intimacy, Spence tells Connie that he is leaving, alone. He gets on his bike and rides away. In 1986,

Dick would tell his friend Nicole Wisniak, a kind of surrogate for Margie in Dick's later life, that "if I was ever to complete myself, grow up and out into the world, [Margie and I] had to shatter our perfect hothouse. . . . In all the years that a young man first experiences life apart from the family, I knew only one person. I think my entire character was formed through that powerful relationship."

Margie's son Steven also heard that when Dick and his mother were young, she had been everything for him. "She was sort of like a Mother Earth, not in a sense of being motherly or matronly, but just being such a large force, a large, creative force," he said. "Dick said to me that, at a certain point, he needed to pull away to find himself and to invent himself. 'I had to get away,' he told me. 'I had to find out who I was and not be in this dyad.'"

In an issue of *The Magpie* after Margie left for college, Dick published an elegy to their relationship filled with remorse:

TO M.L.
If you should die tomorrow, leaving but
This loveliness, this yellow-soaked air,
These flowers all but singing out their joy,
This careless color splashing everywhere,
If you should die tomorrow, leaving just
Wisteria winding cool across the sill,
And poppies playing leap-frog in the field,
And sunlight pirouetting on the hill,

Then I would turn to find another path,
And leave the larkspur and the iris, too,
The lilacs and the baby's breath, and all
The roses and the daffodils we knew.
I would not dare be living near them, lest
They'd find my heart was shattered in my breast.

# 4

# THE MENTORS
## AND THEIR PRODIGY

(1942–1945)

> The main thing he taught me is that life has to be *made* to be
> interesting, that you're only here once and it's up to you to go
> out and get it.

—JOHN AVEDON, ABOUT HIS FATHER

It was the first official photographic assignment Richard Avedon was ever given. As photographer's mate, second class, United States Maritime Service, he was directed to photograph the autopsy of a dead young seaman. Dressed in service khakis, Speed Graphic in hand, Dick stood on a ladder and stared down at the corpse. He watched as the torso was slit from the throat to the navel. "His ribs were open," Avedon said, remembering that the seaman's perfect feet were dangling off the edge of the table like a

child too tall for his bed. He photographed the procedure and ful-
filled the assignment; as he told Vicki Goldberg in 2002, "It wasn't
until I left the room that I passed out."

Dicky Avedon was eighteen years old, a poetry-writing, Dorothy
Parker wisecracking, Fred Astaire tap-dancing, Broadway show–
loving apprentice photographer in the service of his country. He
was, by his own admission, a self-loathing Jew and now, on top of all
that, a recent high school dropout. By joining the merchant marine,
he saved himself the humiliation of repeating his senior year because
of failing grades.

It was 1942, at the beginning of the Second World War, and
Mike Elliot had enlisted in the merchant marine while his brother,
Steve, had joined the navy. They'd had to close the photo studio on
West Fifty-Seventh Street, and it was Mike who suggested that
Dick, now left jobless, should enlist, too. Not only would Dick
avoid the draft, but simultaneously he would solve the urgent
problem that had been consuming his troubled teenage mind: how
to tell his parents that his grades were not good enough for him
to graduate. After all, he had been forging their signatures on his
report cards for a long time. Enduring their wrath would have been
painful enough, but the prospect of repeating his senior year at
DeWitt Clinton High School was a torture too unfathomable to
endure.

Certainly Avedon was not the first photographer to be bored
by school. Almost one hundred years earlier, Gaspard-Félix Tour-
nachon (Nadar), whose life Dick's would parallel in many ways,
had trouble staying in *les écoles de Paris*. "An inconsistent student,
Felix had shown flashes of brilliance but was also prone to unex-
plained lapses," writes Adam Begley, Nadar's biographer. "At age
sixteen, he was already exhibiting signs of a fascination with liter-
ary life and celebrity." This same thing could be written of Dick.
His own attraction to the cultivated world of the Strunskys and the

Gershwins, the irreverent sophistication of the Algonquin Round Table, and the social magic of the three swans in his midst—Carol, Oona, and Gloria, with inside entrée to the most glamorous night spots in New York—all provided more fertile soil for his peripatetic imagination than trigonometry and civics and science.

Avedon's decision to enlist in the merchant marine was given historical perspective in a 2010 essay by Roger Angell, in which the *New Yorker* writer describes the circumstances of every American boy of Avedon's age at the beginning of World War II: "I belong to the generation that was called into service almost *en masse*, sixteen million of us, in 1942 and 1943, and went off to war. We had to go, no two ways about it, and, bitching and groaning, we left school or quit our jobs, said goodbye to our parents and wives or girlfriends, and went and got the great bloody, boring thing done. And came home again, most of us. Mine was an easy war."

Avedon's war turned out to be an easy one, too, insofar as he remained stateside, avoiding a tour of service on the bloody battle-fields of Europe or Asia. Just a year after the bombing of Pearl Harbor, the largest United States Maritime Service training station opened at Sheepshead Bay in Brooklyn. The station was equipped to train thirty thousand merchant seamen a year. At the opening ceremonies on December 12, 1942, Avedon stood with Mike Elliot and more than ten thousand fellow enlistees to hear a message from President Roosevelt read by the commander, offering high praise to the seamen "who are so gallantly working and fighting side by side with our Army and Navy to defend the way of life which is so dear to us all."

Avedon could not have followed a better pied piper into service than Mike Elliot, his elder by four years. Elliot had taken Dick under his wing not only as his boss at the studio but also as something of an older brother. He would become Dick's first important photography mentor. There is no known evidence of how

Mike Elliot became chief photographer's mate, USMS, but as a shrewd, outgoing, and driven young man, he somehow assumed the responsibility of establishing the photography studio on the base. Dick became his first assistant. Mike had already taught Dick everything he knew about how to set up and operate a photography studio, as well as the technical stages of the entire photographic process: loading film into the camera, lighting the subject, adjusting for exposure, composing the frame, and, then, after developing the film, how to read a negative, expose it in the enlarger, and take a print through the chemical baths—developer, stop bath, and fixer—before drying it with a squeegee.

In the USMS photo studio at Sheepshead Bay, Dick was responsible for taking identification pictures of every new seaman to arrive on base. A standard ID photograph is a forensic enterprise: the subject stands expressionless against a white backdrop and looks straight at the camera. The picture is used as verifiable evidence of an individual's identity for administrative, governmental, or legal purposes. As a child, Avedon had been fascinated by Wanted posters that hung in US post offices, in which felons are shown from both the front and the side, each one presented as a specimen. Dick photographed the seamen as specimens, too, at once generic and specific, recognizable by face, identifiable by name. "I turned out to be a natural at it," he told Norma Stevens. The process was mechanical, a kind of assembly line in which the subjects were interchangeable while the equipment, the lighting, and the format were stationary and uniform. "I just talked to each guy for a minute or two and clicked. Tens of thousands of times, I might add."

That Richard Avedon, the renowned portrait photographer, started out making tens of thousands of ID pictures of merchant mariners cannot be overstated in the context of his prodigious body of work across the second half of the twentieth century: white

backdrop, forensic lighting, straight-on pose, sober expression— a headshot by any other name. His photographic training in the merchant marine brings to mind the apprentice system in the artist studios of the Italian Renaissance: The dedicated student performed every menial task while watching the master, learning by repetition, and eventually painting figures directly onto the canvas before finally graduating to master draftsman. Eventually the apprentice left to become an artist in his own right.

Asked near the end of his life about his experience making these ID portraits, Avedon was philosophical: "In art, never explain where it comes from. Is it because a man saw apples on a kitchen table through a broken windowpane that he became Cézanne? . . . I don't think that *because* my first pictures were ID cards, I *then* did portraits like this. But, the discipline of the simple portrait means that I was very interested in other people and the body, the body language, the geography of the face—the emotional geography as revealed through what I see on the face."

Certainly his routine in the studio at the merchant marine provided him with a template for the most direct application of photographic portraiture, a genre that goes back to the beginning of photography itself—the daguerreotype, the *carte de visite*, and, later, the passport photo and the photo booth portrait. With so elemental a palette, Avedon would later transform the genre of portraiture, not only stripping the picture frame to nothing but the subject, but also rendering the individual with precision and exacting clarity as both generic of a breed and yet unique as any individual can be. Then he grew the image to be larger than life, literally, adding a proscenium-like border, and thereby constructing a double-edged majesty for his subjects, both document and monument. He established a signature as an artist by utilizing the most basic application of portraiture to assert the existential condition of man in visual terms. That he took the simple ID picture format

as a template speaks most eloquently to the radical nature of what Avedon eventually accomplished with the photographic portrait.

The photo studio on base was also in service of two merchant marine publications, *The Helm* and *The Mast*. Mike joined their editorial staffs and photographed for both of them, bringing Avedon on board as well. The first issue of *The Helm* (volume 1, number 1) lists Mike Elliot as editor and Richard Avedon as assistant editor, over the publication's statement of purpose: "A magazine mostly of pictures, published at the United States Training Station, Sheepshead Bay, New York, for its trainees." It is not known whether Elliot and Avedon conceived the magazine to begin with and generated all the editorial content, but it is likely enough.

The magazines would provide an entirely new arena of editorial training for Dick. Distinct from his responsibility for taking ID pictures of incoming mariners and documenting autopsies, his photographic coverage for both publications was pure reportage— pictures of seamen getting measured for uniforms, climbing mast-sized cargo nets, training to abandon ship, practicing the intricate stages of judo, making soup in the mess for ten thousand trainees, studying a skeleton in an osteology class. Dick was learning to speak a new language—photography—as a reporter as well as a photographer, and he became ever more fluent with each assignment. Under one picture of a seaman being tattooed across his back and arms, the caption offers advice from Denver Ed Smith, the tattoo artist pictured: "Don't come in here, or to any other tattoo studio for that matter, when you're three sheets in the wind and ask me to tattoo your sweetheart's name across your chest. . . . The next day you wake up and find you're wearing some gal's name across your chest, and it isn't your wife's name. If that happens to you, Mister, you better ship out, pronto."

Avedon had not fully abandoned his poetry, even as photography was occupying more and more of his attention. This Avedon poem

appears on the inside cover of one issue of *The Helm* and reflects, for better or worse, the dismissive attitude of the military establishment toward the merchant marine:

Days on the mainland are not dull,
When you hear the scream of every
gull,
And taste the salt of every spray
That swirls a thousand miles away—
Or know the wild and biting roar
Of a wind a thousand miles off shore.
There is no rest for heart or head
On an inland pillow in an inland
bed,
When each sea sound you ever knew
Comes back in the night to laugh
at you.

On the base, Dick lived with a hundred other seamen, but when the daily chores were given out, he seemed to be the one to have to clean the toilets and swab the floors. "I didn't have to ask why," he told Norma Stevens. "I knew—I was the lone Jew. I couldn't even complain; that would have been *too* Jewish," he said. A swastika had been drawn on the wall of his bunk in black crayon, and, from then on, throughout his tour of duty, he proceeded with a persistent undercurrent of dread.

IT WAS DURING THIS period that Dick, still in his late teens, explored a variety of options in his attempt to identify a supportable passion: Before he enlisted, he had taken a class in philosophy in the School of General Studies at Columbia University—as if

to try on the identity of a college student. He nurtured his love of dance by attending modern dance classes. There he established several enduring friendships, most notably with John Butler, who would become a dancer with the Martha Graham Dance Company and later a choreographer, and Tanaquil Le Clercq, the dancer who eventually married George Balanchine. The movement, the gesture, the poise in his fashion photographs, all harken back to the dance, and his love of dance would prove significant in the way he would later come to pose fashion models, consistently in motion—a spiral, a leap, a plié, a jeté. He even took a sculpture course at the Art Students League. Whether as an artist, a dancer, or a poet-philosopher, Dick found that his predilections were grounded in some form of creative expression, yet the more proficient he grew with the camera, the more natural the idea of being a photographer would become.

He must have been the only mariner on the base to read *Harper's Bazaar*. He was looking at it now with a more urgent curiosity about how photographs served editorial content. Flipping through the magazine, he would run across a full-page picture of "Miss Gloria Vanderbilt," barely eighteen and already married to the Hollywood agent Pat DiCicco. She might be wearing "a perfect pajama outfit for Northern evenings beside the fire . . . sleek black trousers of Celanese slipper satin, with a wonderful bang . . . a white rayon crepe blouse, its plunging neckline skirted by ruffles." George Hoyningen-Huene took the photograph of Gloria sitting on a white sheepskin rug in a demure and seductive pose, beautifully made up in Hedy Lamarr fashion, looking contemplatively off to the side. Less than a year earlier, in the Elliots' studio, Dick had watched Gloria arrive as a giddy schoolgirl and leave as Miss Vanderbilt, the swank young socialite. The transformation from the ordinary into the sublime materialized for him as he watched the construction of her appearance. If Huene could capture little

Gloria as the natural goddess Dick had watched her become, then Dick could make magic with the camera when he got out of the merchant marine.

Meanwhile, Margie was doing very well at Sarah Lawrence. Not only were her poems and short stories being published regularly in magazines such as *Cosmopolitan*, *Mademoiselle*, the *Saturday Evening Post*, and *McCall's*, but she had written a musical called *Prufrock*, based on "The Love Song of J. Alfred Prufrock," by T. S. Eliot, and it was given a performance on campus. Margie invited Dick to come see the play, perhaps even to photograph it for the college yearbook, and asked if he would accompany a friend of hers, Jessica Daves, who was at the time the managing editor of *Vogue*. Dick agreed to make the excursion with her to Bronxville. "I was so noisy," Dick told Calvin Tomkins when he recalled the event many years later. "I remember sitting next to Jessica on the train—she had seven pairs of eyeglasses hanging on a chain—and I told her what was wrong with *Vogue*."

*Harper's Bazaar* had already become the measure of a fashion magazine for the young Richard Avedon. Throughout his teenage years, as he combed the magazines at home, he always found *Harper's Bazaar* to be more literary and visually experimental than *Vogue*. The *Bazaar* had published the first Rayographs by Man Ray; they ran picture features by Brassaï, Henri Cartier-Bresson, André Kertész, and Lisette Model; and they ran fashion pictures by W. Eugene Smith. Editorially, too, Dick was introduced to the stories of John Cheever, Eudora Welty, and Virginia Woolf on its pages. He would have read *Sally Bowles*, by Christopher Isherwood, published in a 1938 issue of the magazine. There were poems by W. H. Auden and William Carlos Williams. Dick did not realize at the time that he could have flaunted the literary gravitas of the magazine in the face of Wilmer Stone, the teacher whose misdiagnosis of the problem with his poetry was due not to the mag-

azines he was reading at home but to Stone's cultural snobbery; in fact, *Harper's Bazaar* was a cool reproach to his teacher's provincialism in the wake of the modern era.

BY THE TIME DICK left the merchant marine, at the age of twenty-one, he had acquired substantial experience as a photographer, both from the department store catalog work he had done for the Elliots as well as his editorial reportage in *The Mast* and *The Helm*. In 1944, while television was barely in its infancy, newspapers remained the most pervasive means of delivering the news of the world, and magazines defined cultural currents. There was an ever-growing need for photographers, and Dick had developed a practical skill with which he would easily be able to earn a living.

He had long concluded that the only magazine he wanted to work for was *Harper's Bazaar*, and that became his driving incentive for assembling a portfolio. With the Rolleiflex his father had given him when he enlisted, he took a series of "fashion" photographs of his beautiful sister, Louise, in Central Park. In one picture, she stands full length, her arm raised, her elbow at a sharp angle, the palm of her hand on her forehead as if to brush back her dark hair with her fingers. The horizontal stripes on her shirt create the only visual drama in the frame.

In a telling example of the young Avedon's drive, intelligence, and enterprise, he donned his sailor outfit (as he liked to tell it) and went to Bonwit Teller, an emporium of women's apparel not unlike what Avedon on Fifth had been, where he bartered the idea of making promotional pictures of women in Bonwit clothing to be displayed throughout the store in exchange for letting him borrow a few outfits. They agreed. Dick then hired Bijou Barrington, the highest-paid model in New York at the time, and photographed her at the beach. He might have been inspired by her picture on

the cover of a 1942 issue of *Harper's Bazaar* in which she wore sunglasses and a scarf, taken by Louise Dahl-Wolfe. Dick would tell a story, perhaps apocryphal, about hitchhiking to Far Rockaway beach for the shoot because he had so little money. Bonwit liked the pictures and displayed them in the store. "I rode up and down the elevators," Dick later wrote, "listening hopefully for customers' comments on my pictures. I didn't hear one." His first sale to Bonwit Teller was an image of a girl in a bathing suit, for which he got paid $7.50.

For Dick's generation, there were unspoken rules about what was required to succeed in the professional world and how to become an upstanding adult. Dick intended to follow those stepping-stones to a career in the world of culture he had targeted as his natural habitat, despite watching his friend Jimmy Baldwin proceed in utter defiance of those rules. In an interview later in his life, a British journalist asked Baldwin if he had felt disadvantaged when he started out as a writer—black, impoverished, and homosexual. "No," Baldwin said, smiling. "I thought I'd hit the jackpot." This might have been a glib posture on Baldwin's part, since certainly he suffered unconscionable prejudice and humiliating indignities while following his own course on his own terms. It never stopped him from thumbing his nose at convention.

Since Baldwin had two strikes against him—he was black and homosexual—freedom *was* just another word for nothing left to lose. Dick, by contrast, who had also suffered the prejudice of anti-Semitism and endured scarring ridicule for being, say, effeminate, was not so freewheeling. He had taken cues from his parents about how to transform himself into their version of a proper citizen.

He took a studio apartment on the parlor floor of a town house in the East Sixties, a fifteen-minute walk from the *Harper's Bazaar* offices on East Fifty-Eighth Street. He covered his walls with pictures by Martin Munkacsi, his favorite photographer at

*Harper's Bazaar,* torn from the pages of the magazine. Dick would later write an introduction for a 1963 book about Munkacsi, which included a story he often liked to tell: Twelve-year-old Dick and his father were walking down Fifth Avenue when they stopped to watch a photographer posing a model in front of the Plaza Hotel on Fifty-Ninth Street. "He asked her to lean against a tree, and in that dusk, whispered to her, changing the arch of her throat, the turn of her head, whispering until her eyes lifted, until he was satisfied." Only then did he photograph her. Years later Avedon realized that the photographer was Munkacsi. In that same introduction he offered this assessment of the photographer's achievement: "Munkacsi brought a taste for happiness and honesty and a love of women to what was, before him, a joyless, lying art." In 1944, as Dick sat in his tiny apartment and contemplated the pictures on his wall, he plotted his strategy for becoming Munkacsi's heir.

One day, leaving his apartment, he encountered a young woman on the stairs. "Do you know where Richard Avedon lives?" she asked him, mispronouncing his name. Dorcas Marie Nowell was a nineteen-year-old bank clerk and aspiring fashion model. She must have heard through the grapevine that Avedon was just starting out and hoped, perhaps, that he would be able to make test shots for her at very little cost. In fact, her timing was impeccable. "She was so beautiful I thought I must have dreamed her," Dick remembered of that first encounter.

He took her to Central Park and made the first in a group of pictures Doe eventually used to obtain representation from Harry Conover, one of the best modeling agencies at the time. According to Norma Stevens, "this was the only time he ever fell in love through the lens." Because her eyes were soft and beautiful, he started calling her "Doe," and she would become, in his own words, "my second muse, after my sister." Doe, orphaned by the time she was a teenager, had been very well brought up in the family of

a wealthy lawyer on Long Island who had employed her parents and then adopted her when they died. She was now living with a relative in Pelham, yet within weeks, whether it was because she was falling in love or she merely preferred the convenience of an apartment in better proximity to her job in the city, she moved in with Dick. In the evenings Dick would develop and print his pictures in the cramped bathroom as Doe read, which she loved to do, or made her own clothes with the sewing machine she had brought with her.

In mid-twentieth-century America it was scandalous for an unwed couple to be living together, but Dick and Doe felt like coconspirators deliciously living in sin. Still, Doe was increasingly fearful that her conservative, churchgoing relatives in the suburbs might discover that she was cohabiting with a man, and so Dick offered a solution: he married her. It's important to emphasize that the innocence of the era must be taken into account in considering the cavalier manner of Dick's decision—and her acceptance of his offer. In his book *Kafka Was the Rage*, a personal account of cultural life in Greenwich Village at the end of World War II, Anatole Broyard, a contemporary of Avedon who was for years the literary critic of the *New York Times*, offers a wry and worthy description of the almost incomprehensible innocence about sex in urban 1940s America:

> *The closest I can come to it is to say that sex was as much a superstition, or a religious heresy, as it was a pleasure. . . . Sex was like one of those complicated toys that comes disassembled, in one hundred pieces, and without instructions. It would be almost impossible for someone today to understand how far we were from explicit ideas like pleasure and gratification.*

Despite an unwavering trust of his own taste and judgment and a quick-study grasp of the way things worked, marriage would not

mitigate for Dick the turbulence within his own psyche. Trying to reconcile the anarchy of his insecurities and the force of his inscrutable ambition would be a lifelong struggle, and it began with treatment by his first psychoanalyst, whom he had started to see before meeting Doe. "I was all out of whack," Dick told Norma Stevens, describing what he meant in specific terms—the disdain he felt for his father, his overdependence on his mother, his resentment of Grandma Polonsky, and the guilt he experienced about his increasingly troubled sister.

As he might have anticipated, his parents registered their chagrin about his marriage to Doe: His father demanded to know how he planned to support her. His mother complained that she was not warm enough—perhaps a euphemism for shiksa. Around this time, Louise was becoming ever more remote, and soon enough she would be diagnosed with schizophrenia, explaining for everyone the depth of her childhood silences and mood swings. She was admitted to an institution, where she remained for the rest of her life.

Dick's oedipal triangle would have provided endlessly fertile soil for his lifelong psychoanalysis, but there were other fundamental issues of equal importance for him to marshal through. One was his complicated attachment to Margie, who had always asserted her will over him because she was older. She drew him in consistently because of her precocity and her imagination; she seduced him out of her desperate need for love and attention at such a young age that it seemed to render him powerless against her dominance. Did his profound intimacy with Margie distort the feelings he was developing for Doe? And what effect did that have on the marital bed?

There is also the issue of Dick's sexuality. Dick was not ignorant of this unwieldy beast, which he had kept at bay not only because of the stigma of homosexuality, but also as a result of the distortions of incest with Margie. There is no documentation that Dick's desires for men had surfaced in psychoanalysis, although he would

later tell Norma Stevens that that is why he began analysis to begin with. Periodic items in the newspapers reported the arrests of "sexual deviants" or "perverts," mentioning them by name, ruining their careers, destroying their lives. According to one study, "thousands of soldiers, many of them combat veterans, were drummed out of the military by psychiatrists beginning in 1943. Their dishonorable discharges made many homosexuals unemployable and ineligible for the government benefits that expanded the middle class after World War II even while it emphasized their presence in society." Without question, the cultural incentive for him to marry was overwhelming.

In a 1958 profile of Avedon in the *New Yorker*, Winthrop Sargeant noted that Dick had married a beautiful young woman and "nothing pleased him more than to dress her up to the nines and show her off in public." Sargeant offers the suggestion, oblique as it needed to be at the time, that the nature of Dick's relationship with Doe was platonic. When the *New Yorker* profile came out, they had been long divorced:

> *In retrospect, some of Avedon's friends are inclined to believe that he thought of [Doe] mainly as a lovely creation of his camera eye. Later, after consulting a psychiatrist, Avedon was quoted as saying, "I have to be a little bit in love with my models"—doubtless a true statement if "love" is taken to mean, in large measure, an emotion induced by professional delight at successfully recording the personality and charm of the woman in question on film. Pressed, not long ago, for an explanation of where he stands in this matter, Avedon thought somberly for a while and then replied, "It's like the feeling you have for kittens or puppies."*

In the legacy of fashion photography that was just taking hold, there was precedent for the photographer's wife to serve as model

and muse. Baron Adolph de Meyer, who had been the Paris photographer for *Harper's Bazaar* through the 1920s and 1930s, and
whom Cecil Beaton referred to as "the Debussy of photography,"
often photographed his wife, Olga. Dick would have seen those
pictures in the pages of the magazine throughout his adolescence,
though he would not have known the biographical details about
their lives, as chronicled in the online archive of the Metropolitan
Museum of Art today: "By all accounts, theirs was a marriage
of mutual admiration as well as convenience—de Meyer was gay
and Olga, herself likely bisexual, had already married and quickly
divorced a prince."

Dick, too, would photograph Doe over the next few years. The
pictures of her that ran in *Harper's Bazaar* established her reputation as a glamorous model and confirmed her role as Dick's
muse. Still, she had no illusions about the nature of their marriage. "You know that Dick was gay," Nowell Siegel, the oldest
of Doe's children, said. "I know because my mother told me. . . .
He and my mom were deeply in love and they were deeply close.
If it wasn't sexual, though, it was a friendship kind of closeness."

DICK HAD BEEN PLANNING all along to show his portfolio to
Alexey Brodovitch, the art director of *Harper's Bazaar,* a professional mission that for him carried the spiritual weight of a disciple's
pilgrimage to a great deity at the top of a mountain. The portfolio he assembled consisted of his attempts at fashion photography
with the model Bijou Barrington, his young wife, Doe, and his
sister, Louise, all shot in the style of the *Bazaar* photographers
he was emulating—Martin Munkacsi, Baron de Meyer, George
Hoyningen-Huene, and Louise Dahl-Wolfe. He also included his
photographic reportage from the merchant marine magazines, *The
Mast* and *The Helm.* He mounted every one of the photographs on

firm picture board, and, at the last minute, as if an afterthought and "for good luck," he added a picture of two merchant mariners—twins—one in focus and one out of focus, one smiling and the other not quite frowning, as if they were representing the masks of the ancient Greek Muses of comedy (Thalia) and tragedy (Melpomene).

As the art director of *Harper's Bazaar* for twenty-five years, Alexey Brodovitch was a monumental force on visual design in the twentieth century. Born near Saint Petersburg, Russia, in the final years of the nineteenth century, Brodovitch was the son of an affluent doctor who brought him up in comfort and provided him a good education. He dropped out of school at the beginning of World War I, making his way through officer training with the White Army. He got to Paris in the 1920s and lived in the swirl of creative fomentation that, today, is understood to have altered the course of art history. Brodovitch would absorb the philosophical stance and sober wit of Dada (Duchamp, Man Ray), the canny geometries of the De Stijl movement (Mondrian, Rietveld), and the pervasive Constructivist ideas based in structure and infused with social purpose that migrated from Russia into graphic design across all of Europe (Rodchenko, Lissitzky). As a cultivated Russian newly arriving in Paris, Brodovitch found work designing sets for Diaghilev's Ballets Russes. Then he was given graphic design commissions from the fashion houses of Patou, Poiret, and Schiaparelli. Eventually he accepted a job as head of the art department at a large Parisian department store, where he was relieved, finally, to have a steady income. There he designed all the signage and conceived the window displays.

In 1924, Brodovitch won a competition for innovative design with his poster for the Bal Banal, a grand party given by the Union of Russian Artists. His poster beat out Picasso's, which came in second. The visual influences of that fertile cultural moment could be seen in Brodovitch's playful design, in which an eye mask ap-

pears half in black and half in white, the letters spelling *Banal* dancing above it, and then, underneath, the letters spelled out in reverse. Brodovitch's poster was seen all over Paris, and his reputation among the avant-garde grew. He would come to know Picasso—despite his victory—as well as Nijinsky, Cocteau, Léger, Matisse, and Stravinsky.

In 1929, he was brought to the United States to teach in Philadelphia, and by 1933, the new editor of *Harper's Bazaar* sought him out to redesign the magazine. As the art director, he turned the *Bazaar* into his laboratory of graphic design: he drew on the visual precedents of the modern art movements he had been surrounded by in Paris as a foundation for his own spontaneous but glamorous style; he used typography, photographic imagery, and the architecture of shape to unprecedented graphic effect, creating pages that were at once unexpected, animated, and elegant. It wasn't long before he became an institution of one.

"Alexey Brodovitch was both a captive witness and an enthusiastic participant in the symphony of artistic experiments that was Paris in the twenties," Kerry William Purcell wrote in his definitive book about Brodovitch. Frank Zachary, the well-respected editor of *Holiday* and *Town & Country* in the mid-twentieth century, and a coeditor with Brodovitch on *Portfolio* magazine, seemed to view Brodovitch's designs in architectural terms, citing "the elegance and lucidity of design, the arrangement of the work," in an interview with Kerry William Purcell in 1999. "He takes that white sheet [of paper], it's like the side of a building, [he'd] pierce it with a couple of windows, and a door, and it's a beautiful façade, page by page."

Brodovitch had been at the *Bazaar* for over a decade when Dick began his campaign to show his work. "I'd have a weekly appointment to meet with him and he would cancel every one," Avedon said. For months, Dick would get dressed in jacket and tie, carry

his portfolio of prints mounted on big boards, arrive at the *Harper's Bazaar* office, and be told that Mr. Brodovitch couldn't see him. In exasperation, he delivered the portfolio to Brodovitch's residence on West Fifty-Seventh Street but received a call the next day from his secretary scolding him for his chutzpah. Dick had by then become friendly with the receptionist, who was on another floor, and she continued to set up appointments for him with Brodovitch's secretary.

Meanwhile, the Harry Conover modeling agency had sent Doe's fashion portfolio to the office of Alexander Liberman, the art director of *Vogue*. One day the phone rang and Dick, expecting it to be Brodovitch's office, heard the voice of Alex Liberman himself. "I've just seen this scrapbook you did for a model named Dorcas Nowell," he said. Liberman was calling not because he was interested in the model, but rather because Avedon's pictures had caught his eye. "Would you like to come and work for *Vogue*?" Dick did not even think to be encouraged by the offer. "No," he said, utterly resolute, although, given the fact that he was broke, his confidence game bordered on the delusional: "I'm going to be working for *Harper's Bazaar*." Coincidentally, soon after Liberman's call, Brodovitch finally deigned to see him.

"Alexey Brodovitch only wore one kind of suit," wrote Henry Wolf, offering a portrait of the man he succeeded as art director of the *Bazaar* in 1958. "It was gray, rumpled and one size too large. It seemed that just sitting there, all three buttons buttoned—his hands awkwardly clutching the pencil, a martini, or the Picayune cigarettes he was fond of—was agony. Only his eyes were loose, observing, editing, clarifying. His voice came almost as a footnote, an afterthought, a stage whisper with a heavy Russian accent."

Dick stood there as Brodovitch turned the boards over one by one with barely a pause between pictures. He stopped at the picture of the two twins, one in focus and the other blurred. "He dismissed

all my carefully wrought attempts at fashion photography," Dick said. "They were completely derivative. But if I could take some of the psychological power that was in the flatly lit yet complicated experiment with the twin brothers, and turn it into a fashion photograph, I might be ready to begin."

In a 1964 interview, Brodovitch was asked about his impression of Avedon's work the first time he saw it. "He just dropped in at my office and showed me very amateurish photographs, just snapshots," Brodovitch told Steve Frankfurt. "I had a couple of luncheons with him and felt he had enthusiasm." Brodovitch added that he hired Avedon not because of his photographs but because of his personality. "He was neurotic, but psychiatry straightened him out." Admiringly, Brodovitch said about Dick: "He had elbow."

Brodovitch signed Dick up for his "Design Laboratory," described in a New School catalog of that period in this way:

*The aim of the course is to help the student to discover his individuality, crystallize his taste, and develop his feeling for the contemporary trend by stimulating his sense of invention and perfecting his technical ability. The course is conducted as an experimental laboratory, inspired by the ever-changing tempo of life, discovery of new techniques, new fields of operation . . . in close contact with current problems of leading magazines, department stores, advertising agencies and manufacturers.*

The roster of photographers who passed through Brodovitch's design lab throughout the 1940s comprises what Jane Livingston, the renowned curator at the Corcoran Gallery of Art in Washington, DC, defined as "the New York School." Among them were Diane Arbus, Ted Croner, Louis Faurer, Saul Leiter, Lisette Model, and Garry Winogrand. She included in this genre the non-street photographers Richard Avedon and Irving Penn.

Dick remembered that the assignments had to be placed on a table anonymously and Brodovitch would walk around, often silent, and look at the work. He was not one to mince words, and everyone stood in fear of what he was going to say. Many photographers couldn't take it, because he never seemed to like anything. Irving Penn told Dick a story about one lab in which Brodovitch picked up Penn's anonymous drawings and showed them to the students: "Whoever did these drawings could probably have them published in the *New Yorker*, but not in *my* class," and threw them on the floor.

Ted Croner would make his best-known photograph while a student in Brodovitch's Design Laboratory: *Taxi, New York Night, 1947–48*. A torpedo-shaped automobile swoops upward in the frame, light streaking across the grille and along the side to register speed in motion, the lights of the city dancing in the space above. Croner amplified the graphic properties of the photographic medium by moving the camera during exposure at just the right moment, creating in this dramatic black-and-white image a kind of visual onomatopoeia. This picture was an exemplary solution to the enduring Brodovitch challenge to all his students: "Astonish me."

One assignment had been to design a neon sign. Dick complained to Brodovitch that he was a photographer and didn't know how to make a neon sign. Brodovitch thought for a moment and said: "Why not use spaghetti?" Dick was struck by the sheer imagination. "I took some pipe cleaners and made a neon sign. It was a seminal moment."

Lillian Bassman, then Brodovitch's assistant art director at the *Bazaar*, whom Dick would soon be working with, emphasized that the Design Lab was for professional photographers, and not for beginners. "All the young photographers at that time joined the class, and there was a lot of interchange of ideas, interest in gestures, what was going on in the world, what was in the theater, what was in the circus, what was on Broadway, a whole different

attitude that was beginning to germinate at that point, and Brodo-vitch was the spearhead of that." She knew at the time that her boss was a "terrific advocate for Dick," she said. "He was very interested in Dick and eager to promote him."

While Dick was taking the lab, Brodovitch would periodically invite him to lunch. "He would take me to a little French restaurant on West Fifty-Sixth Street, and in would walk Saul Steinberg," Dick told Calvin Tomkins in 1994. "He'd be sitting alone having lunch, having pot-au-feu. He'd whisper to the waitress and she'd bring out seven mustards. The seven mustards would go around the pot-au-feu and you'd watch him eat it so meticulously."

Dick was in thrall of this little corner of the world he was now entering, and yet deeply intimidated by Mr. Brodovitch, who was exotic in his worldliness but tortured, parceling out his comments in phrases that took on almost lapidary meaning. He told Dick a story about his father, who, two weeks after his birth, took him out in subzero temperature, put him on the ground, and shoveled snow over him. "Then he took me to dry out in the open fire and gave me some vodka," Brodovitch said. "I survived." It was Dr. Brodovitch's way of immunizing his infant son from childhood colds and pneu-monia. It had worked.

"He just had this tremendous dark side, his Dostoyevskian side," Dick said. "There was something about him and his addiction to excellence. And my feeling for him was so deep, I couldn't call him Alexey." At one of these lunches Brodovitch decided it was time to introduce Avedon to Mrs. Snow—the editor of *Harper's Bazaar*.

IT WAS NOT POSSIBLE to meet a more sophisticated woman than Carmel Snow—stately, modern, tasteful, and ever discerning. Her Irish brogue was always a bit of a surprise, as was her antic sense of humor, which softened the edges of her implicit authority.

While Mrs. Snow was steadfast in her mission as the conscientious editor of *Harper's Bazaar*, a highly regarded magazine aimed at what she called "the well-dressed woman with the well-dressed mind," she lived in anticipation of a good laugh—*and* a martini or two at lunch.

In the 1920s, in *her* twenties, when the flapper style lent itself to the new age of jazz and cigarettes and cocktails, Carmel White, then a young fashion editor at *Vogue*, attended parties that were thrown by the robber barons of the Gatsby age. Prohibition did not restrict the flow of champagne in the penthouses along Park Avenue or Riverside Drive; people would bathe in it at the storied bacchanals in the grand estates on the North Shore of Long Island.

Carmel was often in attendance at the swank dinner parties thrown by Condé Nast himself. Amid the many dozens of bouquets of fresh tulips or roses or peonies that lined the ballroom of his duplex penthouse on Park Avenue, she would sit wearing Vionnet or early Chanel and converse with the poet Edna St. Vincent Millay, or the composer George Gershwin, or the violinist Jascha Heifetz, or the industrialist John D. Rockefeller Jr., among the many other accomplished guests that gathered on any given evening in the most glittering salon in New York.

When Carmel was not traversing the dizzying heights of New York's fashionable intelligentsia, she would gather with her posse of friends at the darkened speakeasies in Greenwich Village or venture uptown to the jazz clubs in Harlem. Her friends composed a swell little circle that included Anita Loos and Clare Boothe, her coconspirators at *Vogue* and *Vanity Fair*—who would write, respectively, *Gentlemen Prefer Blondes* and *The Women*—as well as the young staff members of the newly introduced *New Yorker* magazine, who formed the Algonquin Round Table—Robert Benchley, Dorothy Parker, Alexander Woollcott—the "Vicious Circle," as they dubbed themselves. They would drink, philosophize about

life, gossip about the literary world, laugh at each other's snappy patter, and dance the Charleston.

At twenty-five, Carmel began collaborating with Edward Steichen, who was hired by Mr. Nast as a staff photographer at *Vogue* and *Vanity Fair* for more money than any photographer had ever been paid before—$35,000 a year, when the average annual salary was $1,500. "It was a tremendous coup to get a great artist like Steichen to photograph fashion," Mrs. Snow would later write. "And it was my first coup that Steichen and I immediately clicked."

And click they did. She chose the clothes he would photograph and the models to wear them. They worked together at the Condé Nast studios at West Fortieth Street, or, sometimes, at Mr. Nast's apartment—a well-appointed backdrop to showcase the latest fashions in *Vogue*. Her favorite model—and Steichen's, too—was Marion Morehouse, soon to become Mrs. E. E. Cummings, who personified modernity with her lanky elegance and easy manner. The Steichen picture of Marion Morehouse wearing a lamé dress by Lucien Lelong, taken in 1923, the year of Avedon's birth, was styled by Carmel White.

"When I started making photographs for *Vogue*, I had a great deal to learn about fashion," Edward Steichen once wrote. "So I have always felt grateful to Carmel [White] Snow for the real interest she showed in fashion photography and for her invaluable assistance at fashion settings." Years later he would tell Carmel: "If you enjoyed our work together, I enjoyed it twice as much. If you learned, I learned twice as much."

They would work together for almost ten years, and there was more than just rumor about his infatuation with her. In Steichen's 1925 portrait of Carmel, she stands virginal amid the branches and leaves of a tree, her arm across her waist and her hand fingering a leaf, her expression open, clear eyed, a hint of affection as if she were about to smile, a mere "dash of daring" in her eyes. Whether

or not Carmel had harbored romantic feelings for Steichen, it would have been an impossible match: she was Catholic and he was divorced, and, while she could be irreverent in a conversational way and even amused by stylish bad behavior in others, she was nothing if not correct. When Steichen heard about Carmel White's engagement to the older George Palen Snow, of a wealthy and snobbish social-register family, he stormed off the job, saying, "You surely don't expect me to work after *that* news!"

Dick could not have known her history on the day Brodovitch brought him to meet her, but surely her very aura was enough to counter the weight of the Strunskys in his aspirational mind. "Her hair was blue," he recounted to Calvin Tomkins. "Bright blue. And she wore a Balenciaga *watermelon* hat on her blue hair. *Melon.* The color of *cantaloupe*, with blue hair. It wasn't flamboyant. No, she had a great sense of style." He did not think of her as a towering presence, but rather as someone who looked simply wonderful. She was small boned and had a beautiful profile. Her office was intimate, not corporate, with a small white desk in the French provincial style, a cozy table lamp, and white curtains dotted with a delicate floral pattern. Magazine layout pages were spread out across the carpeted floor. He was scared to death.

Brodovitch announced their arrival as if she already knew who Dick was: "Mrs. Snow"—Brod always called her Mrs. Snow even though they were the same age—"this is the young photographer I told you about."

Immediately she made Dick feel welcome. "Anytime you want to come and meet with me or talk to me, just poke your head in the office. And if I'm in a meeting, I'll see you, and be quiet and just wait. And the minute I can break, you can come in."

It was part of office lore that Mrs. Snow had a unique intuition about people that some referred to as clairvoyance. She hired Brodovitch after seeing an exhibit of his graphic design work for the

first time at the Art Directors Club in 1933. She managed to get a peek before the show even opened and found Brodovitch putting the final touches on the installation. She invited him out for drinks. Within ten minutes she offered him the job of redesigning the magazine and assuming the role of art director. She just *knew*. This happened again with Martin Munkacsi, who had been working in Europe for a newspaper. Somehow, upon his arrival in America, she saw one of his pictures and wanted to meet him. She hired him on the spot, too. When Mrs. Snow first noticed Mrs. T. Reed Vreeland, the wife of an international banker, dancing at the St. Regis hotel in New York in 1935, it was clear to her even across a crowded room that the former Diana Dalziel was a born fashion editor. "It wasn't just her white lace Chanel dress with a bolero top that caught Carmel's attention, but that elusive thing called *style*," writes Penelope Rowlands, Carmel Snow's biographer. "She walked right up to her, asked her who she was, and said, 'Come work for me.'" And her spur-of-the-moment decisions always proved to be correct. "I've always been attracted by what I can, by some kind of Irish clairvoyance, *foresee* in an artist," she said.

This was true in her first encounter with Avedon. "A slim, dark, eager young man wearing the uniform of the merchant marine came into the art department" is how Mrs. Snow would later describe Dick's arrival at *Harper's Bazaar*. "Brodovitch opened his portfolio with the slightly jaded hope with which my fiction editor opened a manuscript by a new writer. What he saw—pictures of seamen in action—made Brodovitch ask the boy to try doing fashions in the same manner. And when I saw the results, I knew that in Richard Avedon we had a new, contemporary Munkacsi."

Brodovitch introduced Dick around the office, as he wanted to acquaint the editors with his new discovery. When Dick was introduced to *Dee*-ana Vreeland, the fashion editor, she called him "Aberdeen" and, to his consternation, continued to do so for years.

Vreeland stood out for her originality and eccentricity. For example, one of her first ideas at the magazine had been to eliminate handbags altogether. The inspiration came to her when she wore one of the first pantsuits by Chanel. The pockets were on the inside and not the outside. "That she had turned up at the office in trousers was in itself astonishing," writes Rowlands. "Bursting with excitement, Vreeland shared her inspiration with one horrified editor after another until Carmel quickly brought her entire train of thought to a careening stop. 'Listen, Diana, I think you've lost your mind. Do you realize that our income from handbag advertising is god knows how many millions a year?'"

Diana would strike her signature pose, very theatrical, clenching her throat, and, on another occasion, declare: "The whole issue must be about fuchsia." Carmel was very good at tempering Vreeland's bursts of inspiration, quietly responding: "Diana, we will do four pages on fuchsia." Vreeland was highly regarded nevertheless and immanently quotable, as in one of her more outrageous proclamations: "One cannot live by bread alone. One needs *élan*, chinchillas, jewels, and the touch of a master designer, to whom a woman is not just a woman but an illusion."

In the 1930s, Vreeland had a column in the magazine called "Why Don't You . . ." as in "Why don't you turn your old ermine coat into a bathrobe?" Or "Why don't you stick Japanese hairpins in your hair?" Or "Why don't you go serenely out in the snow in a court jester's hood of cherry red cotton velvet?" Why not, indeed!

Young Richard Avedon could not have been more elated. He had gained entrée into this inner sanctum and, much later, acknowledged that his professional family was a symmetrical reconstruction of his own. Brodovitch was "very *much* like my father, very withdrawn, disciplined, with very strong values," Dick said, adding that Brodovitch never offered a compliment. "I never believed compliments—even to this day—so I responded

to that kind of toughness, plus the aristocracy of mind and the standards." Carmel Snow and Diana Vreeland became "my new mother and my crazy aunt. Brilliant crazy aunt."

IN 1944, MRS. SNOW decided that the magazine needed to appeal to a new generation and conceived the idea of *Junior Bazaar*, a self-contained section at the back of *Harper's Bazaar* with fashions and features that aimed to compete with *Mademoiselle*. Avedon's first assignment from Brodovitch appeared in its October 1944 issue in a single spread entitled "I Wore the Prettiest Dress . . ." There were two pictures. In one, two teenage girls stand on a staircase in identical positions, one higher than the other, both in evening gowns, both looking up, and both holding ribbons attached to party balloons. In the second picture, a young woman in a "black marquisette with bands of white lace" looks radiant as she holds in both hands ribbons that are blowing out of the frame as confetti sprinkles from above. The sense of movement is the animating feature of the spread, along with Brodovitch's design, in which he created diamond shapes for both pictures. By today's standards the pictures are tame, even quaint, but the breeze blowing through the frames was very modern at the time—and refreshing.

Avedon is introduced on the contents page in the November 1944 mothership issue of *Harper's Bazaar*. He is pictured smiling in a sport jacket and an open-collared white shirt, looking every bit the debonair young man about town. His picture appears alongside those of the food writer M. F. K. Fisher, whose article in the issue is called "The Lively Art of Eating," and M. F. Agha, a design consultant who had been the art director at *Vogue*, with a feature called "Horseless Photography." A short story by Colette entitled "Paris from My Window" is featured in the issue as well. In Mrs. Snow's editor's note, she writes: "Richard Avedon is twenty-one years old.

'I want to be a fireman when I grow up,' he says. After two years in the merchant marine, he took up fashion photography last April: on page 108 he makes his first appearance in the Bazaar. Now he is off to Mexico, with a Rolleiflex over his shoulder and a dozen Bazaar dresses on his lap."

The trip to Mexico was not the success any of them had anticipated. It was supposed to be a fourteen-page feature on spring fashions, but Dick tried to make pictures in the manner of Louise Dahl-Wolfe. "This has nothing to do with what I expect of you," Brodovitch said when he saw them. Only five pictures from the shoot appeared in the February 1945 issue on a single spread called "Mexico Spring"; the pictures were anemic, the model standing in indistinct poses in front of columns, terra cotta steps, or seaside flora.

He redeemed himself with pictures of Doe, barefoot and without gloves. The fashion editor said that they couldn't be published, but Brodovitch loved their irreverence and insisted. When the magazine appeared, he offered a rare compliment, telling Dick that they were the best pages in the issue. This gave Avedon the courage to abandon any formula and begin to trust his own instincts.

One day, Dick spotted a teenage girl, perhaps fifteen or so, sitting with her father on a bench in front of the statue of General Sherman on Fifth Avenue at Fifty-Ninth Street. She was dressed in penny loafers and a sweater, with a long braid down her back. She had the kind of look he imagined a *Junior Bazaar* reader would like, and he approached her to ask if he could photograph her. He had by then made up business cards with the *Bazaar* logo and handed her one with the address of his studio. "Can you be there tomorrow at ten a.m.?"

Her name was Edilia Franco (the model ultimately known as Amy Richards) and she asked if they could make it noon. She didn't tell him she wanted to have her hair done. "Big mistake,"

she said. He was devastated when she arrived, since her braid was what had caught his eye to begin with. It's what made her seem "of the moment." He made pictures of her anyway, and the next day she sent them to a modeling agency. "By five p.m. I had a contract."

As Dick was getting his footing at *Harper's Bazaar*, in the spring of 1945 the magazine was all abuzz about a short story called "Miriam" just published in *Mademoiselle*, the first by a precociously talented twenty-one-year-old author. With her canny intuition, Mrs. Snow declared that his next story had to be published in the *Bazaar*. And so it was. "A Tree of Night" appeared in the October 1945 issue of the magazine, and Avedon would find himself in the same freshman class as Truman Capote.

They were coming of age at a moment of sweeping historic change. In August 1945, less than a week after the United States dropped atomic bombs on Hiroshima and Nagasaki, Japan surrendered and World War II was over. V-J celebrations took place everywhere, and, in Times Square, Alfred Eisenstaedt photographed a sailor kissing a nurse in a double helix gesture that appeared on the cover of *Life* magazine—a now iconic photograph that foreshadowed the collective exuberance and overwhelming joy that seemed to carry over into the postwar years in America, the most fertile era of cultural growth since, perhaps, the Enlightenment in Europe at the end of the eighteenth century.

That summer, Carmel Snow flew to Paris. She was enamored of the novelty of air travel in those early years of commercial aviation; she had always made her annual trips to Paris for the couture shows on ocean crossings, which could take more than a week in each direction. Mrs. Snow was known to smuggle cartons of American cigarettes under her coat for Marie-Louise Bousquet, her European features editor in Paris and dear friend. Penelope Rowlands writes that a *Vogue* editor saw Marie-Louise lunching with Carmel right after she had deplaned: they were having *omelettes aux fines*

*herbes* and martinis. "Think of it," one of them trilled, "we can have a martini in Paris and a martini in New York on the same day."

Mrs. Snow certainly enjoyed herself. She started inviting Dick to her parties. She lived in what had been dubbed the Black and Whites, a row of four town houses that stood at a perceptible angle facing the East River on the small cobblestone plaza at the end of East Seventy-Second Street. She and her husband had bought the four dilapidated houses, painted all four facades black and the doors and the shutters white, and transformed them into beautiful residences. Their house was the last one and yielded two exposures of the river.

At one of Mrs. Snow's parties that year, Mary Louise Aswell, the fiction editor, brought Truman Capote. Carmel, who had not yet been introduced to the new young writer, spotted this boyish creature standing by himself and assumed he was the younger brother of someone on her editorial staff. She offered him a glass of milk. In his high, nasally voice, Capote introduced himself. She burst into uproarious laughter at her mistake, apologizing profusely and fetching him a martini. She then introduced him around, repeating the story of her blunder to everybody, relishing the rounds of laughter each time. "The first of many [martinis] that Truman and I have downed together over the years," Carmel later said.

There is no question that Dick's ambition seemed to get *lift*—as air under the wing of a plane during takeoff—from the moment of his coming of age. He couldn't have known that Mrs. Snow and Mr. Brodovitch were tiring of the photographers they had nurtured over the years. Not that Louise Dahl-Wolfe and George Hoyningen-Huene had gotten stale, exactly, but the world was changing, and it was time for an infusion of new talent, new ideas, and new life to regenerate the magazine. That it was now the end of the war heralded an entirely new attitude about virtually everything.

One day Dick was entering the photographer's studio that *Harper's Bazaar* kept on the corner of Madison Avenue and East Fifty-Eighth Street. The tall and aristocratic George Hoyningen-Huene, who would ride his bike in all the way from Long Island, was handing his bicycle to the elevator man. It was known in the offices at the *Bazaar* that Huene was getting tired of fashion photography and was himself preparing to move to the West Coast to work with his great friend George Cukor as an adviser on his films. Dick stepped into the elevator and Huene said, "Are you the new photographer working on the *Bazaar*?" Dick nodded and smiled. "Too late," the veteran photographer crowed. "Too late."

On the contrary. It was only the beginning.

# 5

# EAU DE PARIS

(1946–1948)

I must tell you that we artists cannot tread the path of Beauty
without Eros keeping company with us and appointing himself
as our guide.

—THOMAS MANN

The waves broke in a soft, rolling crush and scampered to
the shoreline in rapid little fingers of foam. As the tide re-
ceded, the clouds, floating like wisps of cotton in a crystal-
blue sky, were mirrored in the smooth, glassy arcs that were left on
the sand. Dick and Doe had no idea what they were getting into
when they agreed to take a summer share with Lillian Bassman
and her husband, Paul Himmel, in Cherry Grove, a community of
bohemian intellectuals on Fire Island, ninety minutes from New
York City. The small weekend hamlet was dotted with scruffy and,
at times, ramshackle beach cottages framed by a range of white

sand dunes on one side and a dense beach forest, called the Sunken Forest, on the other. Cars were never allowed in the residential enclaves of this slender barrier island, adding a layer of inaccessibility to this refuge that people from the city have always treasured. No one ever seemed to mind the cathartic forty-minute ferry ride from the mainland, and then the rickety transport of groceries and travel cases on little red wagons along the narrow boardwalks woven throughout the scrub and the brush. During the day, when the sun is out, the shimmering reflections on the ocean to the south and the glassy waters of the Great South Bay to the north create a unique and astonishing kind of light.

That summer of 1946 was a fertile one for Dick, barely twenty-three and already absorbing the enormous benefits of his new friendship with Bassman, the art director of *Junior Bazaar*, with whom he was now working regularly, and Himmel, a talented photographer who also had studied with Brodovitch. The two couples occupied a bare-bones cottage in full view of the ferry dock. There was no electricity and no running water. They used kerosene lamps for light and pumped water from a well to wash their dishes and flush the outhouse toilet. The services in the island community were then so primitive that, on Sunday evenings, after a weekend of revelry, they buried their garbage in the dunes before heading back to the city. And yet the absence of modern creature comforts hardly mattered.

If the circumstances of Dick's new professional life had reconstituted his family with the echo of his father in Mr. Brodovitch and that of his mother in Mrs. Snow, then Lillian and Paul—unconventional, provocative, and culturally alert—provided more than an ample surrogate for Margie. He was now ensconced in an entirely new kind of symbiosis of work and play that challenged him with a corollary set of growing pains tantamount to a cultural repubescence. Lillian Bassman and Paul Himmel would turn out

to be of enormous influence on Avedon, both professionally and emotionally.

Dick and Doe would take the train out on Friday nights and have dinner with Lily and Paul at the Hotel—the only place in Cherry Grove with electricity and running water. "The stinger was a favorite drink—brandy and crème de menthe—a good, stiff, knockout drink," Bassman said. They would eat and drink and laugh and dance barefoot until three or four o'clock in the morning— the Lindy, the tango, one-steps—and then go swimming in the ocean. "Dick was amazing," Lillian said in a 2003 interview about that period. "He would come from work on Friday night. He took a ferry to Fire Island. He would be so hyper that he would order two dinners and go right through them. It was an extraordinary kind of hypertension, I guess, really joyful and fun, but at the same time, something else was going on inside him." Her implication was that Dick was confronting not only the rigors of his new working life but also a host of personal issues of a darker, more complicated psychological—and sexual—tenor.

It became clear to the Bassman-Himmels soon enough that Dick's relationship with Doe was one of romantic affection but not of physical passion, and Cherry Grove offered temptations that were exotic and deeply thrilling, yet, for Dick, ultimately dangerous and terrifying. "Paul and I were free spirits, and there were *dunes*," Bassman said, explaining that she and Paul would lie around naked, sometimes alone, sometimes with other friends, and everybody would run down with abandon to the water and swim. She remembers Dick and Doe being so abashed by the whole thing, so shy, taking almost half the summer before they felt comfortable enough to shed their inhibitions and, finally, most of their clothes. "I still have pictures of them, at least in my head, of the two of them, Dick and Doe, running down the beach in their jeans looking like two boys, arms around each other. She was a beautiful

girl and not masculine in any way, but they were both slim and young, and so I had this picture of the two of them looking like brother and sister more than . . ."

Cherry Grove was a summer beach community that attracted artists, writers, actors, and young theater producers, a place where the rules of polite society and mainstream convention did not apply; in fact, traditional thinking was actively—if theatrically— derided. It was a place where every stanza of the Cole Porter song "Anything Goes" would make a suitable anthem: The artist collective PaJaMa, for example, which consisted of the artist Paul Cadmus, who was the lover of Jared French, and French's wife, Margaret Hoening (PaJaMa deriving from the first two letters of their first names), along with another ménage à trois, George Platt Lynes, Monroe Wheeler, and Glenway Wescott, spent many summers in the nearby Fire Island community of Saltaire. Lynes, a contemporary of George Hoyningen-Huene, was for years a photographer at *Vogue* and thought to be the quintessential urbane homosexual of his generation: He lived in a closeted bubble of privilege protected by a traditionally stylish public veneer, surrounding himself with a group of artists, writers, and attractive dancers from the ballet. He regularly hosted parties in his Park Avenue apartment reputed to be as elegant as they were orgiastic. Lynes would make many photographs of PaJaMa at Cherry Grove, sometimes in the nude, positioned against the architectural framework of the lifeguard stands along the beach. "We walked to Cherry Grove when the sand was hard, eleven miles [both ways]," Paul Cadmus remembered. "It was a wonderful walk. We'd go to check out the gay life there." Glenway Wescott, the poet and novelist, offered this glimpse of Cherry Grove in his journal: "Just beyond these bungalows, just over the dunes, there lies heavenly landscape, sandscape, with delights of the flesh and the weather more selfish than anything in the world. Friday night when we arrived they took

me down to the beach, the harvest Moon had just risen. It seemed to have come up terribly excited, like a bull into an arena."

Bassman described Cherry Grove as "a very gay community, but at that time also very literary, you know, a lot of producers and directors and poets—Auden—people like that." Dick would soon photograph Auden at his house in Cherry Grove—where Auden's good friend Christopher Isherwood, author of *The Berlin Stories*, would sometimes visit. The artist Pavel Tchelitchew had a house there with his lover, Charles Henri Ford; Janet Flanner summered there, as did Benjamin Britten and his lover, Peter Pears. Truman Capote and Tennessee Williams, respectively, were regular visitors. Among the weekend guests who stayed with Dick and Doe and Lily and Paul were the photographer Karl Bissinger, whose romantic partner, Johnny Nicholson, would open Café Nicholson, on East Fifty-Eighth Street in the city. This popular gathering spot for the "New Bohemians" was documented most notably in a 1949 photograph by Bissinger of regulars Tanaquil Le Clercq, Donald Windham, Buffie Johnson, Tennessee Williams, and Gore Vidal at a table in the garden, and published in *Flair* magazine. Leonard Gershe, a young playwright who Dick got to know while in the merchant marine, shared the house with them one summer. William Alexander MacDonald III, a decorator, would come out and stay, too. "He always made champagne eggs on the kerosene stove," Bassman said.

Lily, who worked for Brodovitch, was technically Dick's boss. Through their natural rapport and playful collaboration she was able to coax out of him fresh and original visual solutions to their editorial problems. Her husband, Paul, also photographed over the years for the *Bazaar* and *Vogue* and brought a different set of winning—if at times brooding—qualities to the evolution of the friendship between the two couples. Paul was both literary and political. A voracious reader, he loved good conversation and could

be very witty. "I mean, my dad was killer sarcasm," Lizzie Himmel said. "He was an amazing speaker and teller of stories." He was handsome, too, almost dandyish, working out on a daily basis to keep his body in excellent shape. His sexuality was, say, fluid, and he seemed perfectly comfortable about it, which might have added to Dick's conflicted feelings about the lure of homosexual attractions in that environment. "My father was way less gay-shy than Dick was," Lizzie Himmel said. "I think that Dick was wildly in love with my mother, but I think he was very attracted to my father."

Bassman, who was then twenty-nine, and Himmel, three years older, had both grown up in politically progressive families in which atheism and Communism, respectively, gave them an existential resolve about living life in the present and also an egalitarian sense of justice. Their families had become intertwined when Lillian's mother married Paul's father, turning Lily and Paul into stepsiblings after they had already been teenage lovers. Eric Himmel, their son, writes that his grandparents "were freethinkers and socialists from Russia, and all had come to America in the first decade of the twentieth century as teenagers, leaving their parents behind." Lillian studied art at Pratt Institute and would eventually become a consequential fashion photographer; Paul's sultry photographs of city life exploited the romance of dark shadows, watery reflections, and patterns of light in a way that was consistent with his contemporaries Saul Leiter and Louis Faurer.

Separately and together, Lillian and Paul struck an unselfconscious posture of enlightened irreverence that Dick simultaneously reveled in and shied away from. For Doe, by contrast, their uninhibited behavior seemed more compatible with her own nature. According to Lizzie, the Bassman-Himmels were, by turns, "intellectual, discriminating, political, artistic, original, and, ultimately,

*restless.*" Her brother, Eric, corroborates: "Finally, inevitably, it was a worldview, a way of looking out at others that could seem infuriatingly smug to outsiders but had undeniable strength, valuing above all else creativity, productivity, and unconventionality." It was the beginning of a great relationship, Bassman said about the Avedons, describing how close the four of them were during those years and how much fun the two couples had together, sitting on the beach all day, swimming nude, playing chess or charades at night while they drank, partying all the time.

Dick and Lillian also used their time in Cherry Grove as if it were an ongoing editorial meeting in which they would dream up fashion features, generating much of the content for *Junior Bazaar*, since, in the new postwar era, there was not yet a burgeoning fashion industry to draw ideas from. They would talk about the magazine, how they would produce features, who they would use, and what the general viewpoint would be. "One time," she remembered, "sitting on the beach, Dick and I planned a whole issue around green: green vegetables, green nail polish, green clothing. So we sent the fashion editors out to find things that were green. We sent the beauty people out to get green nail polish made, and I made a layout with vegetables, these wonderful drawings of vegetables. Then Dick photographed all the girls and made it look like they were climbing through these fruits."

Lily and Paul made many casual pictures of Dick and Doe during those summers in Cherry Grove. In some, Dick looks scrawny, with a gawky appearance and standing with awkward, feminized gestures. Doe had distinct and beautiful features and such a natural manner that her entire affect is one of comfort and ease in her body. Some pictures capture the two of them sweetly affectionate and happily entwined, while in others Dick looks so young and frail that it's hard to imagine how the two of them could be a married couple. Yet in one casual portrait Paul made of Dick alone,

he looks like a man in his twenties, quite handsome and virile, his features filling out the structure of his face, his eyes opened wide, his gaze deep and liquid, his lips sculptural and sensual. There is a distinct eroticism to the portrait, yet whether it derives from amorous feelings in Himmel or Dick's honest gaze at the camera is unclear. Regardless, the connection between them is palpable. Karl Bissinger, too, another photographer who studied with Brodovitch and who visited them in Cherry Grove, made a more deliberated portrait of Dick in this period, his pose at once pensive and romantic as he gazes out from behind a leafy potted plant. In this picture, Dick seems to be actively willing the handsome good looks he is growing into and which many people throughout his life would acknowledge.

At *Harper's Bazaar*, Dick still felt that he had to prove his indispensability in every single issue. He measured himself against the already impossible professional standards of excellence at the magazine and brought an acute sensitivity to everything around him. He was overly excitable in his enthusiasms, and, equally, he catastrophized the simplest slight. His ambition, though, fueled a growing restlessness about his career, and his elbow, as Brodovitch called it, could be sharpened by the whiff of competition. As he was spending weekends at the beach in Cherry Grove, for example, Truman Capote was on assignment in New Orleans with the photographer Henri Cartier-Bresson for a feature called "Notes on N.O.," which ran in October 1946.

Of course, at Cherry Grove he was also absorbing an entirely new way of being, and the stimulus was overwhelming. He was meeting people unlike any he had known before and observing behavior that came from a new set of attitudes and ideas about how to construct a life. He was forced to navigate the open physical affection of gay men toward one another in that community and, in turn, confront a profound shame about his own attraction to the

naked men in his midst and perhaps, specifically, to Paul. It was a kind of desire that had no place in *la façade Avedon* with which he intended to earn professional respect, gain cultural standing, and establish financial security. Dick's driving ambition propelled him to ignore these subterranean impulses, or at least to try to suppress what he feared would become professional impediments.

There was a war going on inside him: the poet's finely tuned responsiveness to the sensate world all around him was in conflict with the censor's rejection of perhaps the deepest source of that sensitivity. "I must tell you that we artists cannot tread the path of Beauty without Eros keeping company with us and appointing himself as our guide," writes Thomas Mann in *Death in Venice*. Somewhere within that conflict Dick was able to locate inspiration to create a series of photographs out of his experience at the beach, a feature that ran in the August 1946 issue of *Junior Bazaar*. In the issue, before an editorial column called "Who's Teaching Where," with short profiles of Mary McCarthy at Bard College, W. H. Auden at Bennington, and Aline Bernstein at Vassar, Dick's fashion spread is titled "The Suit Beneath Your Skirt." College-age models stand in the sand dunes holding large red and yellow beach balls. The pictures show fall fashions in which urban skirts are worn over bloomers or leotards to create a modern bohemian style. One caption describes a full-length black leotard that is "double-breasted with silver buttons and worn under a printed green-wrapped skirt." Photographically, the large round colored balls strike a graphic punch against the dunes and add a sense of visual play to the models holding them with both hands and laughing. And yet the beach motif is irrelevant to the autumn fashions being shown—and implausible. Still, the pictures contain the first intimations of a nascent Avedon look—women who are casually made up in natural poses, engaged in spontaneous activity, and punctuated with gestures of dance.

Dick was more aligned with himself that fall when he photographed the fourteen-year-old Elizabeth Taylor for *Junior Bazaar*. She was about to appear in her first "grown up part," as the magazine describes her role in *Green Mansions* in the December 1946 issue, "one that will instantly make her the most envied young girl in the land—for her leading man is Van Johnson himself, none other." In one photograph, she appears in costume with a studio light in the background to indicate that she is on the movie set. But the full-page image following of Taylor in a bare-shouldered periwinkle dress possesses pure Avedon DNA: She is walking, as if on a street, and gazing up, as if at the stars, holding half a dozen pink roses in her white-gloved hands. Avedon blurs the movie set to foreground Taylor looking every bit the gorgeous young movie star, out and about on some atmospheric European street. Her spontaneous gaiety is a performance summoned by Dick, the director of this image, who might have been drawing on the memory of his mother in a buoyant mood with lilacs in her hand. Dick elicited the luscious and photogenic Tayloresque glamour, even at fourteen, and captured it as irrepressible innocence.

AVEDON'S GRADUATION FROM *JUNIOR Bazaar* occurred with his first official photograph on the cover of *Harper's Bazaar*, in January 1947. The picture must have drawn direct inspiration from Dick's summer in Cherry Grove, as it conjures a beach scene without hiding the fact that it was taken in the studio. Here the model Natálie Nickerson faces the camera straight on, head to toe, blond hair pulled tight behind her head, a slight impish smile on her face, a small scarf wrapped around her neck, the sleeves of her dark sweater pulled up to her elbows, hands cupped like an egg before her chest, bare legs spread apart in pastel short-shorts, and her bare feet planted firmly in second position on the sand-colored floor.

Behind her is a man in a bathing suit reclining as if on the beach, his back to the camera, his elbow propping him up as he stares out at the infinite ocean. (Some people claim the model to be Avedon himself.) The model's silhouette—a triangular stance like that of the Eiffel Tower—is cast in relief against the uncluttered white, seamless background, lit to suggest the glare of the sun against the sky. The paper drops from the ceiling and rolls under at the floor to form a horizon line that hints at the ocean's edge. Dick's first cover for the magazine introduces what will long become identified as the Avedon woman—slender, androgynous, natural and spontaneous, spirited, unselfconscious, a bit kooky, and utterly self-assured.

Avedon's cover debut is a distinct nod, in deference but equally in defiance, to an earlier photograph by George Hoyningen-Huene, called *The Divers, 1930*, an image that would much later enter the canon of fashion photography. *The Divers* was shot for a feature called "Swimwear by Izod" when it appeared in *Vogue* in 1930. Huene posed a man and a woman, each wearing a bathing suit, seated on a diving board, staring out at the horizon. The photograph is beautifully constructed, with the two figures, one in front of the other, balanced on the board side by side. Huene accentuated the musculature of the male model and the elegance of the female model, suggesting nothing less than Olympian figures in repose. The male model is Horst Bohrmann, Huene's studio assistant and longtime lover, who would later establish himself as Horst P. Horst, the prominent fashion photographer.

While Huene's *Divers* is a classical study in symmetry and proportion, Avedon's models are off center and appear unposed; there is no attempt to hide the fact that Avedon made his picture in the studio, unlike Huene, whose picture looks as if it were taken on the diving board of a swimming pool at the edge of a cliff overlooking the ocean. In a 1999 meditation on this Huene photograph, Cathy Horyn, a fashion critic for the *New York Times*, punctures

that illusion: "The diving board the couple is sitting on is, in fact, a stack of boxes," she writes. As for the hazy sea, "Huene simply took his subjects up to the roof of the *Vogue* studio in Paris and aimed his lights. The horizon line is actually the top of the building's parapet, and on the other side, down below, is the Champs-Elysees."

Dick's ersatz beach scene is a narrative dreamscape in which the male figure gazes away from the central female subject. She doesn't seem to care that his attention is elsewhere; she has plenty going for her without his acknowledgment. With this image, Dick seems to be incorporating the new set of social conditions introduced to him on Fire Island into a visual representation that is dramatically modern. In January 1947, this "fashion" picture was utterly radical for its visual simplicity, its unconventionality, and, ultimately, its depiction of a thoroughly independent woman.

There's more than a little bit of Doe in the model standing on the (ersatz) beach with her two bare feet planted firmly on the ground—*game* for some new excitement. Her unaffected spontaneity is a quality that came to characterize the "Avedon woman" throughout Dick's entire career. Later in his life, he often cited his sister, Louise, as the inspiration for the kind of models he chose, both for their physical mannerisms and their illusory affects, but Lillian Bassman disagreed: "Louise was no tremendous beauty. She was a rather pretty girl with no real presence, and he certainly didn't create these girls in her image." Louise, troubled spirit that she was, in no sense inspired Dick as profoundly as Margie, with her cunning imagination and her moxie. "Avedon's real fascinations," Bassman added carefully, "were androgyny and theatricality," referring specifically to her impressions of him at Cherry Grove, with its population of "artists, entertainers and homosexuals"—and its annual "Cherry Grove Follies." In fact, Dick created the *Harper's Bazaar* cover less than three months after his first summer in Cherry Grove with Doe, and it is not a stretch to suggest that the

narrative dreamscape it depicts is also an exacting portrait of his marriage.

IN FEBRUARY 1947, DICK was assigned to photograph Jerome Robbins, the choreographer, for a profile in the April issue of the *Bazaar*. Robbins had already been anointed a young nobleman of dance for his brilliant ballet *Fancy Free*, with music by Leonard Bernstein and inspired by a Paul Cadmus painting entitled *The Fleet's In*, a "typically erotic painting of sailors having a good time." It premiered at the Metropolitan Opera House in 1944, and the dance critic of the *New York Times*, John Martin, singled out Robbins as a first-class artist: "It was only Jerome Robbins' 'Fancy Free' that saved the season from being predominantly dull. This, to be sure, would have been a bright spot in any season, for it is a beautifully built little ballet, gay in spirit and genuine in substance." If Dick had not seen *Fancy Free*, certainly he would have known about it, as the ballet's run coincided with the end of his tour of service in the merchant marine, when he had been taking modern dance classes alongside Tanaquil Le Clercq (who would later marry George Balanchine) and John Butler. Dick would have recognized himself in the three sailors, and his eye would have been attuned to their graceful physical charm, which used pure gesture to articulate pride, bravado, infatuation, sexual desire, and jealousy. The dance was underscored by Bernstein's mournful music, with its urgent rhythms and strains of melancholy in what is essentially a modern mating ritual.

While Jerome Robbins and Leonard Bernstein were virtually unknown to the theatergoing public, on the morning of April 19, "these new kids on the block were overnight sensations, the proverbial talk of the town, stars of the brightest magnitude." Later that year, *On the Town*, the Broadway production that Robbins, Bern-

stein, Betty Comden, and Adolph Green created out of *Fancy Free*, opened on Broadway. Both productions would go on to become milestones in American musical theater, as well as the ballet.

Jerome Robbins, née Jerome Rabinowitz from Weehawken, New Jersey, a darling of the stage merely five years his senior, would serve as a kind of beacon for Dick's unbounded ambition, not least because he would find surprising similarity between the circumstances of their upbringings. Robbins had an unforgiving father, too, a small businessman who did not want him to go into the arts. He had to extricate himself from the family business in order to commence his study of dance, writes Terry Teachout. "I didn't want to be like my father, the Jew," Robbins would later write. "I wanted to be safe, protected, assimilated, hidden in among the Goys, the majority."

Dick also would recognize Robbins's self-contempt, and not only about his Judaism. "Robbins's attitude toward his 'queerness' (as he referred to it) was equally conflicted," writes Teachout. Though he readily declared himself a homosexual in order to avoid serving in World War II, he also had sexual involvements with women, then and later. "Please save me from being 'gay' and dirty," Robbins would write in a diary entry made in 1942, not long before his draft board classified him as 4-F. That didn't prevent Robbins from drawing inspiration from Paul Cadmus, an open homosexual, for *Fancy Free*, nor from Cadmus's real-life ménage à trois, PaJaMa, as inspiration for his 1946 ballet, *Facsimile*, also with music by Bernstein.

People close to Jerome Robbins and Leonard Bernstein acknowledged that their professional relationship was like a marriage; they were very close, and their interactions could be stormy. Both were bisexual, and it's possible that they were once, briefly, lovers. Dick would photograph Bernstein the following year, another beacon that brought the reach of his own driving ambition a little closer to

the realm of the possible. All three had grown up as middle-class Jews, each one driven by an internal imperative to create something of meaning out of their own exigent talents and give it significant cultural form. Dick's first introduction to this circle, which included Betty Comden and Adolph Green—all of whom would become Dick's lifelong friends—began when he photographed Jerome Robbins for the *Bazaar*. Only later would he discover that when he was photographing Robbins, the idea for *West Side Story* was already germinating as Robbins was trying to conceive a role for his young lover, Montgomery Clift. *West Side Story* would undergo years of gestation before it saw the light of the stage on Broadway in 1957, long after Robbins's relationship with Clift had ended.

The *Bazaar* featured Robbins on the occasion of his new production, *High Button Shoes*, with the headline "Young Man from a Sad Generation." Dick photographed him in his black leotards and ballet slippers; in a small picture on the opening spread, Robbins is kneeling on the floor and looking up, coiled tight, as if about to leap like a wildcat, a gloomy, almost aggressive expression on his face. Brodovitch, who designed the layout, made full-page use of a second picture, which he cropped for dramatic graphic effect: Robbins's head is in the top right corner, his arm extended, his weight on his hand on the floor in the left corner, the axis of energy crossing the page bold and dramatic. These are Avedon portraits of an early vintage, full of mood and gesture, made specifically for the Brodovitch page while incorporating so much of Dick's own tortured identification with his subject.

"THE NEW LOOK" WAS an offhanded phrase uttered by Mrs. Snow after viewing the Dior collection for spring in 1947, words that stuck in the air and came to identify the style of an entire era. Before the war, American fashion had taken all its cues from

Paris. Twice a year, buyers from the major retail emporiums such as Saks Fifth Avenue, I. Magnin, and Marshall Field's, along with the proprietors of discriminating small boutiques in New York and San Francisco, and a trifling coterie of journalists who covered fashion, would all make ocean crossings to view the designer collections. The retail buyers and small shop owners would decide from the respective collections which outfits they thought would most appeal to their clientele and hope that their choices would be written about in *Harper's Bazaar* and *Vogue*—the ultimate arbiters of the fashion season. It was an intimate ritual then, in which each collection was shown in the privacy of the designer's salon to the small fashion audience that gathered, as if in a private living room, to view the clothes on a handful of models. Each model would materialize from behind a curtain, stand still for a moment to present the outfit, then walk a few steps and turn around before her retreat. Those rooms were fraught with competitive tension. Choices were made clandestinely as each outfit was a limited edition—handmade—and the buyers had to place orders before the production limit was reached. Of course, the biggest rivalry was between *Vogue* and *Harper's Bazaar.* Each wanted to be first to determine the look of that season. Mrs. Snow's choices of outfits to feature, just as Edna Woolman Chase's, of *Vogue*, were highly classified, as if state secrets of the entire industry.

Mrs. Snow had been attending the fashion shows in Paris annually since she was in her late teens, initially accompanying her mother, whose dress shop on West Fifty-Seventh Street had been one of the finest in New York, catering to society women in the city who wanted exact copies of haute couture. When Carmel went to work at *Vogue*, in the early 1920s, she would continue to attend the Paris collections and, during those years, became great friends with Coco Chanel, who introduced her to the artists and writers that composed café society in the 1920s. She long considered Paris her

second home, yet World War II had eviscerated the joie de vivre so characteristic of the city that she loved. When the war ended, it was Mrs. Snow's goal to revive the fashion industry in Paris, which, according to her thinking, would bring back the cultural vitality and sensibility of the Paris she had known and loved.

Optimism and hope were contagious in the years just following World War II; these sentiments were fueled as much by the collective sense of relief that the war was over as by an expectation that the sky was now the limit. There was such excitement in New York about a slowly reviving fashion business in Paris that, on February 1, 1947, Trans World Airlines added an additional flight to accommodate all the people traveling overseas for the spring collections. Forty American buyers and journalists made the trip, fewer than the prewar number but much more than in the war years.

Christian Dior's debut had been the final show of the spring collections on February 12, 1947. "A huge crowd gathered outside his gray-awninged entrance. Seated on a fauteuil in the deeply, understatedly chic, gray and gold decorated salon, *Vogue*'s Bettina Ballard recalled being 'conscious of an electric tension that I had never before felt in the couture.' As always, Carmel took the place of honor, an elegant settee upholstered in gray velvet. '*Harper's Bazaar* was the sofa,' Dior wrote, as if describing a law as inviolate as gravity. . . . Lesser gods and goddesses perched on lesser peaks." Such hierarchical distinctions in seating assignment could exist only in France, where the difference between a seat in an armchair versus a gilt chair was of as much importance in that small salon as it might have been in the stagecraft of international diplomacy.

Each model walked out to applause that grew only louder and never seemed to stop. At the end of the show, Dior himself was shedding tears of surprise as much as joy. "God help the buyers

who bought before they saw Dior," exclaimed Mrs. Snow, as many American buyers had already headed home. "This changes everything," she said, and added, either then or later, "It's quite a revolution, dear Christian. Your dresses have such a new look."

By then Dick had been given a ten-year contract with the magazine, something that was rarely given to anyone, and later that year, in August 1947, Mrs. Snow brought him to Paris for the first time to shoot her choices from the Dior collection for the fall season. Dick quoted what Carmel Snow said to him as if verbatim: "Do you realize what we mean to the economy of France? What *Harper's Bazaar* and *your* work mean? We have to bring to the world, revive, in a place that has no luxury left, that's been destroyed of all of its great creative qualities, we have to give the illusion of that luxury—I don't want pictures in the studio. I want to show Americans what Paris looks like."

Dick was ecstatic recounting his first impressions of Paris: "The convergence of the happiness of being [twenty-four], being in love with the most beautiful girl, being sent to Paris, buying a bottle of champagne at the airport, driving into Paris in a cab whose roof was open." Paris, of course, exuded romance at every level, a city with buildings the color of butter, its elegant architectural uniformity so intelligently considered and visually refined that the logic is soothing, and, yet, surprises appear wherever you look—wrought iron filigree on the window balustrades; vast public gardens; intimate neighborhood squares that bring nothing but pleasure to an ambulating eye. And the statuary! The gods of allegory and myth brought down to earth and yet towering above the crowds, an inspiring expression of human grandeur in the midst of daily life.

Paris was an education for the eye, a treat for all the senses. The fragrance of tea rose, the wafting aroma of baking bread, the whiff of simmering coq au vin or *chocolat* or fines herbes—or Gauloises— permeating the streets. To hear a hotel maid announce *"le petit*

*déjeuner*" for the first time is to hear pure music. All the manners and methods of daily life that had over centuries been perfected by the French, whether the cuisine, the wine making, the rituals of service or of social behavior—and, in particular, the public comportment of the self. The French invented *la façade* and lived as if in service to its objective primacy. Richard Avedon, a New Yorker just arriving in Paris for the first time, was dazzled.

New York was not beautiful the way Paris was beautiful. New York was thrilling, full of exuberance and bombast and grit. The way of doing things was so expedient, immediate, and direct. New York was becoming an increasingly vertical city—masculine and erect, as if always at the ready for the next new thing. The apartment buildings where Dick had grown up were generally almost twenty stories tall, rows and rows of them along East Eighty-Sixth Street, or West End Avenue, where his grandparents lived, cutting off the horizon, blocking off the sky. Paris, by contrast, was low and horizontal, exotic and elegant and feminine. It represented *le vieux monde*, a sense of old Europe, an elegance and grace that characterized the most refined civilization on earth. For an aesthete like Dick, coming from New York, it also conjured a nostalgic ardor about a previous generation of artists and writers. The cultural direction of the twentieth century had taken shape in Paris in the 1920s, and Dick soaked up its lingering aura: "That was the convergence of the liberation after the war; I don't mean just for France, I mean the spiritual liberation, the creative liberation," Dick said in 1993. "And I was at that moment of my life when it was all beginning! You know, that's the age when you read Proust, Colette, Sartre, Camus . . . and they were *there!*"

Dick's assignment was to shoot Dior fashion, and the clothes were thrilling for him to photograph: the fluidity, the movement of the skirt, the shape and the volume, the little waist that gave a new drama to the female silhouette. He incorporated his own visceral

response to Paris in fulfilling the task. "Dior, at the time, was the beginning of an enormous modernity," he said. "Something was happening, and I seemed to be the expression of that."

Penelope Rowlands describes the clothes first introduced in Dior's spring show, which Dior had elaborated on for fall: "The Corolle was one line that had caused a sensation. It featured an extravagant full skirt—some measured as much as forty yards in circumference—rounded bust and hips, and an impossibly tiny waist." The accentuated pleats in the skirt began almost a foot below the waistline, and the hem was barely a foot off the ground. Dick's picture of this skirt opens a feature in the October 1947 issue of the *Bazaar* entitled "Paris: The New Fashion Is Traveling Fast." He photographed the model Renée—her full professional name—as if she had just pirouetted in place, the skirt twirling out and the pleats extended like the ribs of an umbrella being opened. The skirt billows and undulates around the wide circumference of the hemline, as if the motion proved an empirical test of symmetry in geometry. The model, in black heels, is standing in a plaza of concrete tiles, the twirling motion accentuated by long vertical bands of sunlight and shadow. The picture is both dizzying and dazzling. It conveys the various qualities of design that make the outfit unique—the narrow waistline, the pleats, the length, the wide circumference—adding to it a quality that can only be called the Avedon je ne sais quoi.

Another spread for the Paris feature focuses on the derriere: "For some time fashion has accented the stomach," states the copy. "Now there's news at the back of the skirt." Dick placed the model in the Dior fitting room and photographed her from behind. The dropped back and curved bustle at her derriere gives the dress a very sleek and slender hourglass profile. The model stands next to a naked mannequin, one on which the dress she is wearing had perhaps been made. The mirror effect of the mannequin and the

model is accentuated in the line of the model's right arm, extended out in a beautiful gesture, her elbow at the height of her head, her head tilted slightly as her hand adjusts her hair. Whether it is the line of Dior or the eye of Avedon, the contour of the model and her gesture, the Brancusi-like shape of the dress, and the mirror image of the mannequin all evoke the statuary in the gardens of Paris.

"[Avedon] started out with *Junior Bazaar*, which was fun, jumping, dancing, action, and he carried that kind of verve into his fashion for the *Bazaar*," Bassman said. "Also, he had a sense of the storytelling, not literally, but in the photographs that he did in Paris, for instance. There was always an element of what life was like for the rich and the famous and the beautiful. He had a terrific sense of elegance for someone that young and maintained a kind of movement, the body movement, the interest in the gesture, which hardly existed anymore with the *Bazaar*. So it was invigorating and exciting."

Among several other Avedon photographs in that issue, Doe is posed wearing a winter coat by Christian Dior bound all around in raccoon fur with a matching Cossack hat. She is leaning against a streetlamp at the Gare du Nord, and the caption begins: "Anna Karenina, 1947." One picture Dick did not take, however—claiming later in his life to regret not having had his camera with him—was a moment he observed at a nightspot in Montmartre, where he and Doe had gone to see a sex show at a cabaret he remembered as the Boule Bleue. Because it was August, the place was almost empty, so they were easily seated. They ordered a bottle of champagne. All of a sudden, a large party of deaf tourists arrived, all happily signing to each other before the show. Dick described the event as a standard striptease with bare-breasted women in spangles and plumage and musclemen in gold jockstraps. He was fascinated, though, by the deaf audience members and watched them during the performance. They couldn't hear the music, but they could feel it through

vibration. When it was over, the group was ushered out to their tour bus. "All but one," Dick wrote. "He stayed behind, looking lost, even trapped, and wandered over to the deserted orchestra pit, picked up a horn, and blew a sound on it—a strange, raucous, terrible sound that resembled his expression. For some reason, this scene reminds me of who I really was in Paris, with Carmel Snow. Taking these pictures of clothes."

The odd dissonant sound made by the lone deaf individual blowing the horn was equal to the awkwardness Dick had felt as an uneducated New York Jew who didn't speak French dropped into the center of cultivated Paris. "I was really painfully shy," Avedon recalled toward the end of his life. "I never graduated high school, and I would wake up in my late twenties with nightmares that everyone would find out." (Of course, the other reason for his sense of alienation had to do with being in the Boule Bleue, if that was the actual name, with his wife to begin with, when his interest in watching a striptease might have had more to do with theater and performance than sexual stimulation.)

DOE, WHO PROJECTED A wholesome glamour in fashion photographs, was dissatisfied with modeling. She was more interested in the stage, and over the next year found her way not only to summer stock on Cape Cod but also to Broadway in the small role of "Drucilla Eldridge" in *The Young and Fair*, directed by Harold Clurman, which opened at the Fulton Theatre in November 1948. During the run, Doe became friendly with Rita Gam, another actress in the cast. Rita was then married to Sidney Lumet, a young teacher at the new High School of Music and Art, who had spent his childhood in the Yiddish theater and on the Broadway stage. "Rita described going to the Avedons' apartment and her shock that they would walk around shoeless or barefoot," said Maura

Spiegel, Lumet's biographer. This would be the beginning of another lifelong friendship for Dick, with the director Sidney Lumet.

A full-page picture of "Doe Avedon," taken by Dick, appears in *Theatre Arts* magazine with a short introduction of the young actress: "Doe Avedon, briefly seen in the recent *The Young and Fair*, thrilled theater goers as much by her beauty as her striking performance. Of the latter, Brooks Atkinson wrote that she managed to dominate every scene in which she figured; and the usually reserved Richard Watts called her 'vivid and exciting,' lamenting the desertion to Hollywood inherent in the David O. Selznick contract, which she has held for two-and-a-half years. It was a chance meeting with Irene Selznick which led to the movie contract and her role in *The Young and Fair*—her first, remarkably enough."

Leonard Gershe, a friend of Dick's from the merchant marine who had shared the house with them in Cherry Grove, was a lyricist in the theater and, during this period, spent time with Dick and Doe in the city. As the Avedons had gone overseas to Paris in 1947, Gershe had made a crossing to London on the *Queen Mary* and stayed with Richard Addinsell, a British composer for the theater. The cables Gershe received on that crossing indicate that he and Addinsell were also romantically involved. On that trip Gershe and Addinsell wrote the lyrics for *Tuppence Coloured* for the London stage. While there, Gershe met Clemence Dane, the novelist and playwright who was collaborating with Addinsell on *Alice in Wonderland*, and told her about his friend Dick, an up-and-coming fashion photographer who was just then in Paris trying to turn his wife into an international fashion model—against her will. "That should be a play," Dane said. Gershe would soon begin writing "Wedding Day," which will have greater relevance to our story about Avedon in the coming years. So while Dick was beginning his international adventures in Paris with Carmel Snow, his friend Leonard Gershe was in London becoming something of the toast

of the town. On his return crossing, Gershe received a cable from Dick and Doe: "Cannot wait to see you and all the wonderful presents you brought us Love Kisses Doe and Dick."

By the summer of 1948, Dick and Doe's relationship was in a slow spiral toward its ultimate demise. He was trying to make her into something she was not, and she was increasingly unfulfilled in the marriage. This was made clear in the reminiscences of the Bassman-Himmels late in their lives. They had hired a studio assistant, Stephen Lipuma, to help them organize their archive, and Lipuma worked with them side by side while going through all their photographs of fifty years. Periodically, the Avedons would come up in the context of the Cherry Grove years, and Lipuma recalled Paul Himmel telling him about an episode, perhaps in that summer of 1948, in which Dick had had a sexual moment with a man. He came back and told Paul, who had recounted this to Lipuma, adding, "Dick was in such distress about the sexual relation with this guy that he was vomiting over it."

From the way Lillian and Paul spoke about that period and their own experimentation, it was Lipuma's impression that there might have been a sexual relationship between Dick and Paul as well. "I think Lillian had suspected it," Lipuma said, referring specifically to conversations while poring over Paul's unprinted negatives of himself and Dick on the beach together. Lizzie Himmel also suspected some kind of relationship between them and had asked her father about it on several occasions. "I think that Dick and Dad fooled around," she said. "I think that Dick was very scared, but very attracted to the gay lifestyle."

"We were all having a little bit of a problem that summer," Bassman said in a video interview. "Doe was becoming an actress and had a job in Cape Cod, where she met [Dan Matthews]. But I think there were problems before that."

Dan Matthews was a handsome, all-American young actor in

summer stock with Doe, and when the two met, they fell instantly in love. Nowell Siegel, Doe's son, spoke about the breakup of his mother's marriage to Dick: "The reason they got divorced is that my mother fell in love with someone else—Dan Matthews," he said. "It was a love-at-first-sight type of thing." While their marriage did not end immediately, Dick and Doe proceeded to make their separation as amicable as was possible. There was no doubt that Dick was crestfallen; he often said about the dissolution of their marriage: "I would have crawled to the Bronx on my knees to bring Doe back to me."

At the same time, Dick was wholly preoccupied with—and single minded about—constructing himself in the role of Richard Avedon. Before the collections of 1948, Dick approached Mrs. Snow: "Take me to Paris again or I'll go to *Vogue*," he said, a cheeky demand bearing all the audacity of a confidence man. He had been emboldened not only by the positive reaction to his pictures in the October 1947 issue of the magazine but also because of her evident affection for him. In fact, Mrs. Snow, who might easily have sent him on his way, thought it could be a good idea. Her loyalty and regard for Louise Dahl-Wolfe, who had been shooting the collections for the *Bazaar* for years, posed the biggest obstacle. Of course, she had no intention of replacing Dahl-Wolfe, her star photographer, but, like any good editor, she was attuned to the postwar shift in cultural temperament and recognized in Dick the potential to reflect the gestalt of a new generation for the magazine. Ever full of mischief, Mrs. Snow turned her decision to bring Dick to Paris into a secret mission—a caper, of sorts.

In late July 1948, after Dahl-Wolfe had flown over a week early, Avedon accompanied Mrs. Snow on their flight to Paris. She threw her coat over her lap and told Dick, "I don't button my seatbelt," and then added slyly, "Neither does General Eisenhower." That set the tone for the entire trip, in which Mrs. Snow was by

turns coconspiratorial and demanding, deliberating yet generous, warm, instructive, antic, playful, and, for such a dignified woman of standing, somewhat zany and irreverent. They stayed at the San Regis, where she always stayed, a chic and very discreet hotel on the Right Bank not far from the Grand Palais. The *Harper's Bazaar* studio was across the street. Mrs. Snow's suite was where the Führer had stayed when he was in Paris, a detail she would be sure to tell people, but only in terms of her shock and horror.

This was the first time Dick had spent an extended period of time with Mrs. Snow outside the office, and for the next few weeks, he attended the couturier shows seated umbilically beside her on the sofa or the settee, along with Marie-Louise Bousquet, the Paris editor of the *Bazaar*. Avedon described Bousquet as "wacky looking with her red-dyed wig" and others described her as naughty, witty, and tiny. Bousquet was a fixture of Paris, her salons drawing an entire international artistic community, from the Vicomtesse de Noailles to Ned Rorem, Thornton Wilder, and Truman Capote, who once had been spotted there sitting blissfully on the lap of Janet Flanner. Bousquet's role as Paris editor of the *Bazaar* was loosely defined as ambassadorial. She paved the way for introductions; sought out talent; soothed egos; but ultimately, she dined and drank—and even prayed in church—with Mrs. Snow during her sojourns in Paris. A picture of the three of them sitting on the settee, taken by Henri Cartier-Bresson, who was now in Mrs. Snow's editorial circle, shows Mrs. Snow in the center talking to Marie-Louise Bousquet while gesturing to Dick, who is seated to her right in a suit and tie, his hair combed back, looking pensive and intent. It might have been that very day that Dahl-Wolfe showed up at Dior, prompting Carmel and Dick to scramble for cover, hiding in the dressing room until the coast was clear.

"Carmel Snow taught me everything I know," Dick would say in later years, and it started in those discreet little showrooms in Paris:

"She was extremely—this is not a good word—human. She had an enormous warmth and wit and she was funny. She taught through gossip. We would be sitting there with boring dress after boring dress, and she would be telling me the gossip about everyone in the room. She'd talk about the *ménage à trois* of Mme Alix of Gres. It was all about what was going on—very Irish. She was completely Irish in her wit. And the joy, she liked to laugh."

It wasn't all frivolity, however. It turned out to be a most enviable kind of cultural education. She communicated her vision of what *Harper's Bazaar* ought to be by asking Dick if he had read this novel or that short story, or if he had met this author yet or that artist, and then she would proceed to explain why the novel had meaning or the author was of importance. "It was never academic," Dick said. "She brought me to meet Colette, that's how I read Colette," he told Calvin Tomkins, emphasizing his lack of education and his delight at the time about meeting such a mythical literary figure. Colette talked to Dick about Proust, and that's how he came to read Proust—a lifelong literary touchstone for him. "In other words, one would think what a drag to have to take this kid around who doesn't even speak French, who doesn't know anything. But, she loved it. She wanted me to be exposed to everything."

The schedule in Paris was rigorous. Ginette Spanier had just been appointed as the director of the House of Balmain and was first introduced to Dick on that trip in 1948. In her autobiography, she describes him then as "small, dark and electric with his own sort of vitality. Crackling. Sparks seem to fly out of him. He flashes his fingers like tiny rapid moths." She described the discordant experience of presenting the collections in the months ahead of the season the clothes were designed for and shooting winter clothes in the summer. "We are all wrapped to the chin in mink and tweed when our friends dart off in sweltering heat to St. Tropez."

When they weren't viewing the collections, Dick was shooting

in the studio throughout the night or on locations he had selected throughout the city during the day. "I never went about trying to revolutionize anything. I was developing my own instincts—what I'd call following my enthusiasm," Dick said about his early fashion work. "We all send out messages to one another. By what we say, by how we look at each other, by how we dress, by how we move. The static fashion photography of Louise Dahl-Wolfe and Huene, it didn't apply to my life."

Mrs. Snow's schedule was filled with lunches and dinners and private visits to the designers, and Dick was always running in and out of the hotel with layouts or pictures or contact sheets for her to look at. He described a typical meeting with Mrs. Snow in her suite in the morning before she left for the collections of the day. She would motion him in while sitting in bed and look at the pictures in her bathrobe. Then her maid would come in, and Carmel would stand up and let her bathrobe drop to the floor. "No embarrassment," Dick recalled. "She stood there in her slip, and barefoot, and would continue talking as the skirt went up, *click*. The jacket went on, *click*. The hat got plunked on, like *that*. And into one shoe, and into the other shoe, and she's talking to me the whole time. She reaches into her handbag for a pair of perfect white gloves, and she puts them on, and walks out as this vision. It was like someone going onstage with the speed of a theatrical change. No time is wasted. I'd be working with her right up to the elevator."

DORIAN LEIGH, A THIRTY-ONE-YEAR-OLD model, was new to the business. She looked ten years younger than her age and radiated a lustrous sophistication that seemed at once American and European. An intelligent woman who had studied mechanical engineering at New York University, she was also an adventurous one who thought nothing of leaving her young children behind to

be raised by her parents while she nurtured, for better or worse, a curiosity of another stripe. She had modeled only a short time when Dick hired her for the fall collections in 1948. "Europe!" she wrote about that first trip in her memoir. "The very word was excitement. And *Paris*, to anyone in the fashion world, was delirium."

Dick greeted Dorian, along with a second backup model, Thea, at the airport, his arms filled with flowers. He came in a taxi rented by *Harper's Bazaar* and repeated all over again the introduction to Paris he had had with Doe the previous year. They stood up through the open roof of the taxi all the way in from the airport as he poured glasses of champagne and cut fresh peaches to drop into them, the Eiffel Tower eventually coming into view. It was his intention to establish a rapport of shared delight for the city with Dorian that he hoped he could bring to the pictures.

It was a complicated endeavor to shoot the collections, incorporating all the secrecy and calculation of military hijinks on a time-sensitive schedule, all of which required an enormous amount of cunning and stamina. During the day, Dick, along with the buyers, magazine editors, and photographers, attended the collections at the couturier houses. Once he received the list of outfits Carmel had selected from the collections on view that day, a whirl of activity commenced to obtain the clothes that needed to be photographed overnight and into the early hours of the following morning. The selection was not only based on what Carmel might have wanted for the magazine, but also coordinated with the outfits that would be available in the United States, either as originals or copies. Carmel would engage in some very clever sleuthing to find out what the buyers had chosen. She had to cajole it out of them—or the designer—with champagne lunches and other enticements. And then she had to rely on her largesse with each designer to borrow the fashions during the night when they were not in use—and before *Vogue* could get to them.

Dick Avedon relied on the entire visual banquet of Paris for his photographic canvas, creating scenes in the streets and plazas all over the city, which meant that he ran the risk of exposing the designs to enemy eyes—spies from *Vogue*—in the middle of the night. "To protect the designers, we were wrapped in sheets wherever we went until we were in front of the camera," Leigh writes in her memoir.

Dick established a fine working relationship with Dorian Leigh, who acknowledged that it was hard work to appear utterly natural before the camera, acting like a woman wearing her own clothes, and allowing herself to relax into actual expressions and genuine reactions to the world around her. Leigh described how Dick was able to coax such spontaneity out of his models:

> *Instead of using the "still life" approach, which meant asking a model to strike a pose and freeze, he kept moving, sometimes moving around her himself with the camera in his hands, keeping up the conversation, explaining what he wanted her to feel and portray, always telling her how well she was doing, making her feel she was the most beautiful creature on earth. Dick has such a pleasant disposition and such a good sense of humor that working with him was always fun. Yet underneath the laughter and good times was a seriously creative man.*

The fall collections appeared in the October 1948 issue of the *Bazaar*, and Avedon's pictures dominate the magazine: There is Dorian Leigh standing in the middle of a courtyard in a fine Balenciaga pencil suit and a dark, wide-brimmed hat; she is leaning on the table of a street acrobat with one hand, her other on her hip in a rather exaggerated gesture. Behind her is an acrobat balanced upside down in the air on the hand of another while Leigh is fully absorbed by a muscleman holding up a barbell with one arm; a

crowd of people watches in the background, one of them hold-
ing a bouquet of flowers. It is a playful *tableau vivant* meant to
accentuate the silhouette of the suit, but, equally, it illustrates the
over-the-moon exuberance that Dick felt about being in Paris. In
a more believable street scene, Leigh stands on the sidewalk trying
to read a copy of *Le Figaro* as it billows between her two hands,
spread open in front of her face; she is wearing another sculpturally
tailored Balenciaga suit, this one checked wool. In a third scene,
she disembarks from a train in a Dior coat, fitted and belted to look
like a suit with a wide skirt, looking over her shoulder for a place to
put the several round hatboxes in her hand.

In a series called "The Gay Little Hat," Avedon photographed
both Dorian and Thea, respectively, against the graphics on the
signage plastered along the walls of Paris. He placed the model
wearing one fanciful Dior turban against a larger-than-life draw-
ing of Filochard, and another, with its feather at its crest, against
the other two characters from the French comic series, Riboul-
dingue and Croquignol. In a spread called "The Chic Little Shape,"
he placed the model in silhouette within a silhouette shape on the
wall in an advertisement for *Les intellectuels por la paix*—the World
Congress of Intellectuals for Peace. Dick was not without a social
conscience and, from time to time, it would filter through in sub-
liminal messages like this one splashed across a fashion spread.

The October 1948 issue of the *Bazaar* is a testament to Avedon's
rigor, creativity, and abiding infatuation with Paris, which, in his
photographs, does not reflect documentation of the city so much as
his reach for an idea. "'My Paris' never existed," Dick told Chris-
tian Lacroix in the 1980s. "I fabricated it—not out of whole cloth,
exactly, but out of swatches of Lubitsch, René Clair, Rogers and
Astaire movies, and Cole Porter songs, and out of the stories that
my mentor, Alexey Brodovitch, told me of the Paris he knew before
the war. It was my own elation that I was photographing, and it

got whipped up to the point where I was able to give an emotional dimension to the couture itself."

However, the singular picture to define the Avedon je ne sais quoi, taken during that trip in August 1948, appears in a Paris preview feature that made it just in time for the September issue. The preview focused on "The Turban," and among several of Dick's pictures of women in this variation of the modern hat is one of his most beautiful early fashion photographs. Elise Daniels is seated at a table in a glittery nightspot, a wineglass in the foreground, her makeup lean and tack sharp, a frothy turban made of tulle situated toward the back of her head, diamond drop earrings, bare-shouldered dress, her left hand molded against her left shoulder as if holding on to a wrap, her fingers fanned out just so. Something has caught her attention out of the corner of her eye, and she is looking beyond the picture frame, utterly entranced. Her male companion is leaning in beside her, equally captivated, as he seems to be breathing in her very essence—an *eau de parfum de Paris*. She resides in clear, crystal focus while suffused in a gauzy incandescence, the subtle blur of a string of lights above the bustle of activity behind her suggesting the excitement of a lively restaurant. We, the viewer, catch sight of her as if we were walking by her table on the way to our seats.

While Dick often said he was not capable of expressing in poetic verse what he may have instinctively understood about human experience, he expressed the poetics of his own enchantment with Paris in this image. In Avedon's entire body of work there is no better example of his poetic impulse to conjure genuine emotion out of lifelike description than this picture of Elise Daniels manifesting a fleeting moment of wonder. And what is it that caught her eye? For all intents and purposes, she is looking at the future.

6

# THE

# PROSCENIUM

# STAGE

(1948–1952)

The first issue of the ambitious quarterly *Portfolio*, pub-
lished by Alexey Brodovitch in January 1950, included six
bound-in samples of gift wrap paper; a tipped-in Bodoni-
type specimen sheet; and a lengthy feature entitled "Photography
in Fashion: Fashion in Photography," highlighting two young
photographers—Richard Avedon at *Harper's Bazaar* and Irving
Penn at *Vogue*. This public comparison between Avedon and Penn
was only the first, but it would follow them throughout their lives.
The publication introduced Avedon to the world outside fashion
with a telling description: "A clever, excitable young man with the
sharp, darting movements of a terrier, Avedon at twenty-six is a top
fashion photographer on *Harper's Bazaar*, and holds an editorship
on *Theatre Arts* magazine."

There has always been assumption about a professional rivalry between Avedon and Penn that accorded rumors of a lifelong bitter antipathy between them. In fact, throughout the second half of the twentieth century, both men would hover in the same rarefied atmosphere at the pinnacle of their profession and maintain an amicable regard for one another. They consulted one another from time to time on professional matters; they led workshops together; and they had been known to socialize on occasion. Many an armchair critic has called for the hierarchical supremacy of one over the other in terms of historical significance, and, to be sure, a comparison between Avedon and Penn is analogous in arts and letters to that of other twentieth-century giants: Picasso versus Matisse; Pollock versus de Kooning; Roth versus Updike. At that level, though, trying to rank such magnitude of accomplishment comes down to nothing more than an exercise in futility.

As a quarterly of design and the visual arts, *Portfolio* aimed to be a one-of-a-kind *objet* as much as a traditional magazine, yet because of its high production value and Brodovitch's uncompromising refusal to break up the visual flow and editorial purity with advertising, it survived only three issues. Its feature on Avedon and Penn placed the two photographers at opposite poles, contrasting Penn's evident exploration of form and design—"Precise, exacting, intellectual"—with Avedon's "emotionally inspired" fascination with "life in motion." Each of them was asked to provide a list of elements that characterized his respective artistic personality. While Penn's list includes his "comfort in looking at a baseball diamond" (ever the formalist) and his interest in "the metaphysical relationship of an object to its situation" in the work of de Chirico, Avedon cannily cites his "need for glasses at the age of six," which gave him an acute awareness of "the difference between sharp and fuzzy, in focus and out of focus." He also writes with surprising personal insight about the role of psychoanalysis in relation to his

work: "Without Sigmund Freud and psychoanalysis I doubt there would have been any progression in my work at all. Photography for me has always been a sort of double-sided mirror. The one side reflecting my subject, the other reflecting myself."

The *Portfolio* feature was a notable public endorsement of Avedon, one that capped off a year of soul-searching in which he had been contemplating his options outside the world of fashion. At just twenty-five, Dick found himself ensconced in a professional community of commercial and fashion photographers who worked in the vicinity of his own studio. Some had studios in the Grand Central Palace building at 480 Lexington Avenue at Forty-Sixth Street: among them was his contemporary Milton Greene (née Milton Greengold), who had also started out as a *schlepper*, in Yiddish parlance, in his case for Eliot Elisofon, and as an assistant to Louise Dahl-Wolfe at the *Bazaar*. In the late 1940s, Greene would start doing catalog work for Macy's and other retailers before going to work for *Life* magazine. Paul Himmel worked as an assistant to Jerry Plucer-Sarna, who started out illustrating fashion at the couturier shows for the *Bazaar* before becoming a studio photographer for the magazine. The Elliot brothers—Dick's first mentors—established a television production company in that building as well, called Elliot, Unger and Elliot, that would become very successful producing commercials. Karl Bissinger, the housemate of Dick and Doe and the Bassman-Himmels in Cherry Grove, was at first a stylist in the Condé Nast Studios; with Dick's help, he pursued photography and went to work for *Junior Bazaar* and then, later, *Flair* magazine.

On one occasion, in early 1949, Dick threw a bon voyage party for Lillian Bassman at his studio. As *Junior Bazaar* was slowly losing steam, Lily's position as a designer was in jeopardy. Brodovitch, encouraging her to pursue her interest in photography, convinced Mrs. Snow to give her a chance in Paris. Now it was her turn as the

backup photographer to Dahl-Wolfe and, regardless of how Dick must have felt about not being the one to go to Paris, he gave his dear friend Lillian a send-off party with his best intentions.

At the party, Paul Himmel introduced Dick to Evelyn (Franklin) Greene, who was in the throes of a separation from her husband, Milton. Evelyn and Milton Greene had been together since they first met at Abraham Lincoln High School in Brighton Beach, Brooklyn, marrying upon her graduation, in 1942, when Evelyn was eighteen and Milton was twenty. As Milton's career took off, Evelyn was increasingly debilitated, spending entire days in bed, either reading or sleeping, less and less able to function. Whether she was depressed because of the marriage or had emotional problems to begin with, the relationship had become unsustainable. Evelyn and Dick shared "divorcee" status in a kind of solidarity that established their immediate rapport.

Not only was Evelyn intelligent, she also was an avid reader, someone Dick was able to talk to about books and ideas—as he had with Margie, as he had with Doe. While she was elusive and shy, it did not escape him that Evelyn was the soon-to-be ex–Mrs. Milton Greene, which may have further predisposed him to her. Dick liked Milton, with whom he shared not only a physical resemblance but also a similar strain of professional ambition. Amy Richards—the professional name used by Edilia Franco, of "the pigtail," whom Dick had discovered sitting on a bench with her father when she was just fifteen—would, in 1953, become the second Mrs. Milton Greene. She acknowledged that Dick and Milton had similar physical characteristics, although Milton was slightly taller. "It's that black, or Russian, melancholia that surrounds people like Milton and Dick, which is fascinating to women, of course," she said.

While Dick was becoming acquainted with Evelyn, Doe was starring in her second Broadway play, *My Name Is Aquilon*, which

opened in February 1949. Dick wrote a very chatty letter to Lillian in Paris later that month in which he recounted the opening night, complaining that Doe waited until the last minute to tell him she had forgotten to reserve tickets for him and Paul (Himmel): "Natch," he wrote, as if this was typical of Doe, thus precipitating their scramble for tickets at black market prices. Reporting that Doe received good notices in the papers, he then launched into a critique of her performance, calling it "cringe-worthy—sort of like being caught naked a block from Times Square." Dick was by now alert to the need for monitoring his own professional reputation and fearful of any potential blemish to his name. Despite the decent notices, Doe remained the still-not-yet-divorced Mrs. Richard Avedon. Her less-than-brilliant performance exposed him by association—as if *he* were the one left naked a block from Times Square.

Dick's letter was full of double messages. He told Lillian, for example, that Paul was doing quite well without her—as if the news of her husband seeing "a great many people" and having "fabulous dinner parties" and "living a chic life, like never before" would be welcome information. In the final paragraph of the letter, Dick reports on the rapid progress of his new relationship with Evelyn: "My problem is a thing of the past," he writes to Lily, expressing his happiness and profound relief.

The "problem" to which he was referring is anyone's guess. "It could have been impotence," Eric Himmel suggested, or "some sexual wound that Doe left him with because of rejection. The 'problem' could have been an attraction to men. It's impossible to know." Dick had already been in psychoanalysis for several years, but not long after he wrote to Lillian about the resolution of his "problem," he began seeing a new analyst, Edmund Bergler, who came to be known in the 1950s as an "expert" on homosexuality, positing the hypothesis that the "condition" could be cured. This

was before the term *conversion therapy* entered the public lexicon. Of course, myriad clinical findings have long since debunked the legitimacy of such a therapeutic outcome, but not before untold numbers of people such as Dick suffered the indignity of added shame in search of this holy grail. "Freud himself, after all, saw homosexuals as regrettably arrested in the anal-aggressive stage or something," writes Edmund White in a characterization of his own torturous coming-of-age as a homosexual in the 1950s: " One psychoanalyst recommended to my mother that I be institutionalized and the key thrown away—'unsalvageable,' he said. I was just thirteen."

When Dick started seeing Bergler, the psychiatrist was already known to refute the findings of the newly published 1948 Kinsey report, which concluded that the scale between heterosexuality and homosexuality in the American male was more fluid than had been commonly understood. In a fervent public editorial debate, many of the arguments against the Kinsey report focused on the inadequate guidelines of the study itself, while only a few writers bothered to engage a more philosophical dialogue about the multiplicity of variations in nature. Dick started seeing Bergler with a specific goal in mind. "[Bergler] explained that my photography was just a form of infantile peeping, thanks a lot," Dick told Norma Stevens. "I hadn't gone to him to hear that. He was known for his 90% cure rate for homosexuality."

To be sure, Dick's torment about his sexuality was exacerbated by the cultural attitudes of the time. The realm of romantic desire stood for him in direct conflict with the presiding beliefs about how to construct a proper existence in twentieth-century America—marriage, home, family, schools, church, society. Uncounted gay men and lesbians across the country were forced to live in the closet, painfully isolated in their shame and obsessively protective of their own secret—a revelation, if exposed, that would almost

certainly ruin their careers and destroy their lives. The stigma of same-sex attraction was a tyranny that homosexuals either endured with a great deal of psychic anguish or eschewed in blithe defiance of convention.

While the closet may have been a roomy place in the upper precincts of urban cultural chic, for Dick the proximity—and audacity—of openly gay people like George Platt Lynes, say, or Truman Capote had to be discomfiting. Lynes and Capote lived in relative dismissal of the cultural prejudice about "their kind," proceeding more or less unscathed by dint of their talent, style, charm, and not a little hauteur. Capote, who was short, effeminate, and obdurately flamboyant, endured against all odds. When his debut novel, *Other Voices, Other Rooms*, came out in 1948, he was, at twenty-four, already a public prodigy, and the book became an instant *New York Times* bestseller. Reviews were good, but he was eviscerated for the homosexual theme: "The book is immature and seems calculated to make the flesh crawl," said *Time* magazine. "The distasteful trappings of its homosexuality overhang it like Spanish moss."

Gore Vidal, too, another writer in their midst, was derided for his third novel, *The City and the Pillar*, also published in 1948, a coming-out story about a handsome and athletic young Virginian who slowly discovers he is homosexual. The book caused a scandal, and Vidal was equally eviscerated. The *New York Times* accused him of being, ultimately, corrupt and pornographic; Vidal would later in his life claim that the homosexual-themed book sealed his fate with the literary and critical establishment. He had so much trouble getting subsequent novels reviewed that he started writing mysteries under the pseudonym Edgar Box.

There were other contemporaries of Dick's, like Leonard Bernstein, whose "bisexuality" was an open secret, or Leonard Gershe, who neither flaunted his homosexuality nor concealed it, men who were unique in their ability to let their talent guide their ambition

without damage to their expectations of high accomplishment—or to the foundations of their self-esteem. In 1950, Leonard Gershe would write a play called "Wedding Day," based on the failed marriage of his friend Dick Avedon, who tried to turn his wife, Doe, into an object of beauty to be regarded by the entire world against her will; simultaneously, Leonard Bernstein would write *Trouble in Tahiti*, an intimate opera about the difficulty that all husbands and wives endure in trying to reconcile their differences in any middle-class marriage in America. Both, perhaps, were indictments of the cultural pressure to marry.

Dick's friends and colleagues were addressing the subject of homosexuality ever more visibly in their work, and their fame was growing, both because of and in spite of it. They were the exceptions. At the time, for any homosexual, the mere mention of the word was enough to strike terror of exposure. Dick must have been quaking every time Truman Capote opened his mouth in public. Or when his high school friend James Baldwin, who was also unapologetic about his homosexuality, published his first short story, titled "Previous Condition," in *Commentary*. Baldwin would not publish *Giovanni's Room*, about a tormented homosexual relationship, for another eight years, but the painful truth of the homosexual in mid-twentieth-century America finds its veiled way into "Previous Condition" in this description of what it feels like not to belong:

> *There are times and places when a Negro can use his color like a shield. He can trade on the subterranean Anglo-Saxon guilt and get what he wants that way; or some of what he wants. He can trade on his nuisance value, his value as forbidden fruit; he can use it like a knife, he can twist it and get his vengeance that way. I knew these things long before I realized that I knew them and in the beginning, I used them, not knowing what I was doing. Then*

*when I began to see it, I felt betrayed. I felt beaten as a person. I had no honest place to stand.*

Dick's career was ascendant. He was becoming known in influential circles that could propel his notoriety beyond his field. Yet his talent, his winning personality, and his high-minded professional ambition could not mitigate debilitating insecurities that made him feel like Gregor Samsa—a cockroach, a beetle, or, in a more accurate translation of Kafka's native German, a "monstrous vermin." It was a daily struggle for him to feel, simply, *normal*—finding, in Baldwin's words, "an honest place to stand." More than anything, he wanted to be rid of his distracting and painfully consuming desires for men and the attendant *ickiness* of his shame—an obstacle he had to overcome before he could marry again and have a family. The light at the end of the tunnel would be relief: to feel normal; to no longer fear being found out; to gain ultimate respectability without faking it; to garner self-respect, at last; and, no doubt, in the deepest recesses of his profound unconscious discomfort, despite his mother's unconditional adoration, to gain the respect of his father.

IN THE LATE 1940S, after their respective books were published, Truman Capote told Gore Vidal that he was working on his next novel, about a beautiful New York debutante. "What on earth do you know about debutantes?" Vidal said. "Everything," Capote countered. "After all, I *am* one." Vidal wrote about this exchange in his introduction to a book of photographs by Karl Bissinger, in which appear respective portraits of Dick, Doe, Lillian Bassman, and Truman Capote. Vidal describes Capote as having "picked up a mannerism reminiscent not so much of debutantes as of the great models and other beauties, a total blankness of expression." Eli-

nor Marcus, soon to become the Baroness de la Bouillerie, was a debutante of that era and one of Truman Capote's earliest "best pals" in New York. On several occasions she went with him to visit a woman she described as the "actual inspiration for Holly Golightly," an unconventional blond who lived in a small studio in a brownstone near Capote's apartment on Lexington Avenue in the East Nineties. Elinor's older sister, Carol Grace, told people that *she* was the inspiration for Holly Golightly. After late evenings of rehearsal followed by wee-hour drinking in a private nightclub on West Fifty-Fifth Street, she and Capote would end up having coffee together in front of Tiffany's in the silvery light of dawn. "Every morning about 7:00, we left the Gold Key Club and walked to Fifth Avenue, where there was a man with doughnuts and coffee," she wrote in her memoir. "We'd buy some and continue to Tiffany's, where we would look in the windows and fantasize. The same guard was always there and sometimes we would bring him a doughnut and coffee, too."

Dorian Leigh, one of Dick's best models, believed herself to be the inspiration for Holly Golightly. She, like the fictional Holly, had left her husband behind and her children in the care of her parents in search of a glamorous, carefree life as a model in New York. She lived in Capote's neighborhood on upper Lexington Avenue, too, and picked up her telephone messages at the candy store across the street—whether from her modeling agency or "gentleman callers"—a ritual Truman often observed while buying his cigarettes. She claimed that being a model made her more attractive to the right kind of men. "It was far too easy for me to say yes to an invitation and almost impossible to say no," she writes in her memoir, as if channeling her fictional doppelgänger. "Consequently, I was always making dates that I couldn't keep, which meant that I had to be very inventive with reasons why I didn't show up. I got to the point where I couldn't bear to hear the phone ring, knowing I

would have to lie to an angry man who demanded an explanation." Capote himself started calling her "Happy Go Lucky" in the 1950s.

Ann Woodward, a model and fashionable showgirl in the 1940s, who married the very wealthy and socially prominent William Woodward Jr., a scion of a banking fortune, is cited as "another of the many Holly Golightly figures who make their appearances throughout Truman's *oeuvre*—beautiful, social-climbing waifs from the rural South who move to New York and re-invent themselves, not unlike Truman's own personal journey," as Sam Kashner wrote in a 2012 article about Capote's self-destructive act of publishing "La Côte Basque, 1965."

Capote always said that Holly Golightly was a composite of the many women he knew and observed in New York in this period, some of whom would come and go in Avedon's studio. In fact, the "idea" of Holly Golightly can be spotted throughout Avedon's work: Natálie Nickerson, who appeared in Dick's first cover for the *Bazaar*, stands as if a prototype of Holly Golightly in her orange short-shorts, legs akimbo and bare feet planted firmly on the studio floor. She arrived in New York from Phoenix and lived in virtual poverty in her first year in the city, until Eileen Ford took her on and made her a top fashion model almost overnight. She would eventually have her own personal stationery, first name only, "stylishly engraved without any capital letters: 'natálie, the barbizon, 140 east 63rd street, new york 21.'" Avedon would reinvent what a beautiful woman is, and the visualization of that idea, over and over and over again in his photographs, whether with Natálie Nickerson, Dorian Leigh, or, later, Dovima, no doubt influencing Capote in his own formulation of Holly Golightly in the decade to come.

The idea of Holly Golightly is relevant to a definition of Dick's sensibility. Manhattan in the late 1940s was a petri dish in which the cultural matter of the second half of the twentieth century was germinating—in art, literature, music, dance, and theater. Dick

was not only picking up on the spectacular newness of the ideas and attitudes in his midst, he was participating in the visualization of the cultural metamorphosis that was happening all around him. *Breakfast at Tiffany's*, like *West Side Story*, say, would not enter the collective unconscious for another decade, yet they both came out of this optimistic moment at the end of the 1940s in which Dick's creativity, too, was establishing new precedents that would prevail as resonant metaphors and abiding touchstones of mid-twentieth-century American exuberance and individuality.

In the late 1940s, everyone Dick knew was trying to reinvent him- or herself, whether it was the change of name from Jewish to goy, or from Dorcas to Doe, or, in his own case, the transformation of a struggling middle-class neurotic and closeted Jewish homosexual into an accomplished, eminent, and debonair man-about-town. In his fashion work he was inventing a visual iconography in which to put forward a thoroughly modern woman with a new, more carefree independence of mind and manner.

"Avedon's greatest creation has been a kind of woman," Irving Penn said in a workshop in the 1960s. "She's a definite kind of person. I know her. I'd recognize her if she walked in this room. She's sisterly, laughs a great deal, and has many other characteristics. . . . To me, this is a very great achievement. It's a kind of woman I'm talking about projected through one very powerful intellect and creative genius." Penn emphasized this point with a description of this new style of woman: "She's a very real woman and not to be mixed up with any other age. The way she stands—the curious stance of her feet planted wide apart was something unique—a revolution of the nice woman and the world has changed because of this. . . . As a photographer, I'm fascinated by Avedon's frozen instant of a laugh or an expression that comes about. As a moment in time, I'm very fascinated and touched and moved by these."

Despite the source of Capote's original idea of Holly Golightly,

her cinematic apotheosis in the character played by Audrey Hep-
burn in the 1961 film *Breakfast at Tiffany's* is, by every measure of
her spontaneity, idiosyncrasy, tomboyish figure, and sublime urban
chic, the consummate "Avedon woman."

IN JANUARY 1949, *U.S. Camera* published an article called "Rich-
ard Avedon: Photographic Prodigy." In it, Jonathan Tichenor writes,
"Certainly he is the most controversial figure in photography—
one either likes or dislikes his pictures; there is no middle ground."
The article describes the way Avedon took New York's fashion
world, shook it up, and added an entirely new dimension. "And
it is still seething over the shock." The feature includes several of
his portraits of Marlene Dietrich, in which the glamorous movie
star vamps it up in a dressed-down-to-her-bathrobe sort of way,
"lounging," as the caption describes it, on a prop brass bed in Ave-
don's studio, flaunting her legs to their best advantage.

Citing the similarity between Avedon's fashion pictures and these
decidedly early portraits, Tichenor concludes that the single thread
running through them in both genres is *life*. "Avedon's portraits are
not the common shots of head and shoulders, but, rather, the pictures
of living, breathing individuals. In his studio pictures the models are
not beautiful dummies, but actual women."

The portraits of Dietrich to which Tichenor referred were made
on the occasion of the release of *A Foreign Affair*, and one initially
appeared in the August 1948 issue of the *Bazaar*. It is uncharacter-
istic of what we know an Avedon portrait to be today. Images from
the entire shoot conjure the sexual bedroom, which was unprece-
dented for a fashion magazine in 1948: Dietrich sits at the foot of
the bed, her hands on the brass frame, her eyes mere slits as narrow
as her barely parted lips, a cigarette between them. She is wrapped
in a finely checked bathrobe, showing just enough leg. In others

she is reclining with a come-hither expression. Dick seemed to be intentional in presenting Dietrich on a bed in the studio setting, photographed with available light, the actress in a mock performance for the photographer. There is no attempt at verisimilitude. It is difficult to understand today how radical Avedon's approach was at the time. He was trying to capture the *act* of photographing, as if to underscore the point that what he was photographing was not real. He was "photographing" the medium of photography as much as he was photographing the subject before the camera, and this brings to his work a fascinating new dimension.

IN 1949, SURROUNDED BY other fashion photographers, Dick worried about being typecast within this professional ghetto. At that moment, photojournalism was ascendant. Cartier-Bresson was then preeminent in the field, and Magnum photographers and *Time* and *Life* photographers alike were setting a new gold standard for photography internationally.

In September 1947, *Harper's Bazaar* published the first in a series of photo essays about America by Henri Cartier-Bresson—this one called "Highway Cyclorama"—with an introduction that describes the photographer, along with the writer John Malcolm Brinnin, traveling across the country from New York, covering thirteen thousand miles in thirty states, collecting material for a book. The full-page opening picture shows a mother and her three children walking toward the camera on the shoulder of a four-lane highway. The editorial copy discusses Frenchman Cartier-Bresson's impressions while traveling across America, about which he was "struck by things so familiar to Americans that they forget them: the violence of the climate, the lack of obsequiousness, the friendly good manners, the fantasies of roadside publicity, the poverty in an abundant land." In the same issue of the *Bazaar*, September 1947,

two ordinary fashion pictures appear by the twenty-three-year-old Robert Frank, an émigré newly arrived from Switzerland. To be sure, the pictures that Cartier-Bresson made across America in the late 1940s would have prototypical resonance for the body of work Robert Frank produced the following decade as he, too, traveled across the country in the mid-1950s to create his masterpiece, *The Americans*.

"The great pleasure for my Leica was to have the spare elements of a collage suddenly jump from the street to the lens," Cartier-Bresson once wrote about the process of photographing the actuality of life. From that he would later coin a phrase, "the decisive moment," which, in the tradition of documentary photography, defines the impulse to strike an equal balance between the happened-on scene and the way the photographer observes it. "To me, photography is the simultaneous recognition, in a fraction of a second, of the significance of an event as well as the precise organization of forms [as they are perceived visually] which give that event its proper expression," Cartier-Bresson wrote. The result, then, is not just a moment in time caught by the camera but the timelessness of the moment expressed in visual form.

That Cartier-Bresson established the photographic trope "the decisive moment" is a worthy distinction, but in 1947 his role as one of the four founders of Magnum, the cooperative photo agency, is of greater historic significance. Along with Robert Capa, George Rodger, and David "Chim" Seymour, they formed the collective to wrest control from the magazines of their photographic subject matter, as well as the way their pictures were used, and also to determine where and the manner in which their work would be presented. Cartier-Bresson's series in *Harper's Bazaar* was one example of his control as a photographer over editorial content.

Avedon was aware of Cartier-Bresson not only from Brodovitch, but also from the issues of *Harper's Bazaar* in which their work

appeared at the same time. "He is the greatest photographer of the twentieth century," Avedon would proclaim to Charlie Rose about Cartier-Bresson in a 2000 television interview. "He is like Tolstoy was to literature. He covered all the ground, in a vast way—politically, socially—and with the most personal and complex insight into the human personality. He showed the movements of history."

In 1948, Cartier-Bresson was in India and visited Gandhi moments before he died. His coverage of Gandhi's death was published in *Life*, among other publications, and vaulted him to a new level of recognition in the world of photojournalism. His coverage of the postwar transformation of Asia over several years in the late 1940s exemplified the reputation he would gain as a photojournalist for "being in the right place at the right time."

In early 1949, the very fact of Cartier-Bresson—along with other photographers who traveled the world, identifying the historic moment—was making Dick restless. Fashion wasn't enough. He decided to take a year off from fashion—more or less—but his attentions were divided. On the one hand, he enrolled at Columbia University to take courses in philosophy, but then he also took a position as a staff photographer on a newly redesigned magazine called *Theatre Arts*, a full-size monthly that used high-production color photography on the cover and featured lengthy profiles of actors, reviews of plays, and coverage of the other arts as well. His masthead title was "editorial associate," and for almost two years he published multiple pictures in the magazine every month. Now he could see every play produced on or off Broadway, which for him was nothing less than transporting. He was obsessed with the theater, thrilled with the invention of life onstage—the narrative, the sets, the costumes, and, ultimately, the transformation of an actor into a character. The theater provided him something of interest to talk about with any cultural luminary he was assigned to

photograph, a perfect antidote for his insecurity about his knowledge of art and high culture. He had opinions about the theater and a growing basis of comparison to give his opinions weight.

The publisher was John D. MacArthur (of the eventual MacArthur Foundation) and the editor was his brother Charles MacArthur, a playwright married to Helen Hayes. Bob Cato was the art director; he had worked with Brodovitch as an assistant art director on the *Bazaar* and *Junior Bazaar*, which is likely how Dick was brought on staff. Other notable photographers, too, appeared in the magazine, including Henri Cartier-Bresson, Robert Capa, Lillian Bassman, and Martin Munkacsi. Before Dick was hired as the staff photographer, he had shot Henry Fonda in *Mister Roberts* for a cover story that appeared in the summer of 1948, before Bob Cato redesigned the magazine. Beginning in 1949, a banner year for the theater, Dick photographed Lee J. Cobb and Mildred Dunnock in *Death of a Salesman*; Mary Martin in *South Pacific*; Estelle Winwood in *The Madwoman of Chaillot*; Anita Loos, who wrote *Gentlemen Prefer Blondes*, and Carol Channing, who played Lorelei Lee. He would make portraits of Clifford Odets, W. H. Auden, George Balanchine, and Mae West.

Some of his portraits were dramatic and atmospheric, uncharacteristic of the graphic simplicity and forensic clarity he eventually arrived at as the defining signature of his later portraiture. These are portraits of actors, if not in costume and on set, certainly behind the scenes and *of* the theater. "At once elegant and gritty, they are on the one hand individual characterizations, images with some of the telling quality one wants in portraits, signaling through clothes, gestures, and above all facial expressions a truth about their subjects' identities," Jane Livingston writes in a 1994 Whitney exhibition catalog.

Bobby Clark, the vaudeville performer and comedian, was in a revue on Broadway called *As the Girls Go*, and Dick photographed

him for a feature that appeared on the cover of the September 1949 issue of *Theatre Arts*. In a playful and haunting picture across two pages on the opening spread, Clark stares into the camera, a painted-on black eyeglass rim framing one eye. His countenance, head and shoulders, takes up only a quarter of the frame; behind him is a strong geometric composition not unlike a Constructivist montage. Clark is in sharp focus while the background is softer, blurry, impressionistic. This portrait exemplifies the reference Dick made about putting on glasses for the first time, when he was six; the interplay between Clark, in focus, and the background, in blur, underscores the point. Dick achieved the blurred background effect in the darkroom, utilizing an unorthodox technique he learned from Lillian Bassman. "It might have something to do with my myopia," Avedon told Jane Livingston. "The details in the background always distracted me. Too much irrelevant information. So I used to get rid of them in the darkroom by putting tissue paper over the image and printing through that. Light would go through the tissue paper, and where the tissue was pressed tight to the image, it would print sharply—where the tissue paper was looser, it would create an out of focus quality."

Dick's work for *Theatre Arts* would not represent his only alternative to fashion. In the late 1940s, one August after the Paris shows, he and Doe traveled with Lillian Bassman and Paul Himmel to Italy, where Dick had made a series of documentary photographs in Sicily, as well as some set-up scenes made to look like documentary images. Sometime in early 1949, *Life* magazine called him with an offer he could not refuse. "They gave me $25,000," Avedon said, to do a magazine-length feature of photographs of New York. "I closed my studio and I worked for six months." But at the end of that period, dissatisfied with his own pictures, he returned the money to *Life*. He concluded that this kind of photography belonged to a tradition that already existed, citing specifically the

work of Lisette Model, Robert Frank, and Helen Levitt. "That was a certain school of photography, and I've never felt that I've been part of any school. I felt that my interests were different. It wasn't me."

In July 1949, *Life* did publish a six-page feature entitled "Broadway Album: Avedon Pictures Capture Season's Triumphs," which includes his portraits of Irving Berlin, Elia Kazan, and the picture of Bobby Clark described earlier (which would not appear in *Theatre Arts* for another month), as well as several full-page tableau-like group portraits of leading actors in full costume for *High Button Shoes*, *Kiss Me, Kate*, and *South Pacific*. *Life* magazine was the pinnacle of achievement for photographers at that time, and it was a notable cultural acknowledgment of Dick's prodigious talent, to be sure, to be given such a showcase for his theater pictures. But, equally, Avedon's name added top-of-the-moment luster to the magazine.

Although Dick was exploring his options outside fashion, it did not prevent him from going to Paris to shoot the collections for the *Bazaar*. While he claimed not to be good at seeking "decisive moments" out of real-life events, he would prove to be brilliant at constructing them from his imagination and giving them the look and feel of actual documented moments. One such example is *Dorian Leigh, Evening Dress by Piguet, Helena Rubinstein Apartment, Île St. Louis, Paris*, a variation of which appeared in October 1949: It is the picture of a woman in a spectacularly modern strapless evening gown standing—like a Brancusi—in a lavish bathroom, staring at herself in the mirror. Seen in profile, she is angled forward—shrugged shoulders, arms akimbo, hands on her waist—to take one last look for any finishing touches before going out into the evening. Everything in the frame is considered: her silhouette against a full-length white frosted window behind her; the bouquet of flowers in the corner; the bottles of perfume on one side of the luxe marble counter and a cotton swab on the other. The

shape of her arm in the context of the entire frame adds an element of sculptural grace to her gesture—the Avedon je ne sais quoi. As if we happened upon this scene, she is caught in a private moment of preening, an activity born as much out of feminine insecurity as social necessity. By capturing a moment of spontaneity in a simulacrum of reality, he was creating fiction, metaphor, imagery—in fact, a complete visual poem. Wilmer Stone be damned.

BY 1950, DICK HAD entered a new stage in his career, not only because of the publication of several magazine profiles about him, but also due to the people he was meeting and photographing, as well as his own friends who were becoming famous. He signed a lease on a large studio in a low-slung two-story building at 640 Madison Avenue that took up the entire block between Fifty-Ninth and Sixtieth Streets (until it was razed in 1954). It had been the studio of George Platt Lynes, who used it for not only his *Vogue* fashion work but also the many magazine portraits he made of the artists, actors, and writers of his day. As an artist, Lynes also used this studio to make his own work—male nude studies, often ballet dancers, positioned in mythical tableaux of his creation—which would not be shown in public for another thirty years.

The studio was on the second floor and faced a large interior courtyard. There was a sizable shooting area under an ample skylight and a huge electrical panel feeding 5,000-watt Saltzman lights. Dick had one office and his business representative had another; there was a photo lab, a darkroom, a dressing room for models, and storage space. It was in this studio that the business enterprise of Avedon Inc. would go into high gear and his income would now derive not only from his editorial work at the *Bazaar* and *Theatre Arts*; he was launching himself into the lucrative arena of advertising.

Dick had a new secret weapon for this venture: Laura Kanelous. Once again, he had Milton Greene to thank for an inadvertent introduction. Greene had introduced Dick to Laura's husband, John Kanelous, an illustrator at the department store B. Altman, and it was through him that she learned that Richard Avedon was looking for a business representative. John encouraged Laura to pursue the job, but she was reluctant. "I don't know how to sell anything," she said. "You won't have to," her husband replied. "Just show his work." Before she married John Kanelous, in 1945, Laura Greene (née Greenspan—and no relation to Milton) had been a superb student at Erasmus Hall High School in Brooklyn—a history and Latin scholar—and, for a while, long after she graduated, she was reviewing books. Dick hired her, and soon enough she proved her husband to be correct. As she made her way in and out of the advertising agencies up and down Madison Avenue, the work came in like an avalanche. "My mother was a very astute businesswoman," Helen Kanelous said. "She was the first female artist representative. She eventually helped start a union—the Society for Photography and Artists Representatives."

The separation of church and state between the editorial operation of any respectable publication, such as *Harper's Bazaar*, and the companies that advertised with the publishing company, such as Hearst Magazines, was more porous than it would later become. In the early 1950s, Dick would shoot the collections in Paris for the magazine, and then either provide a studio outtake or photograph a model in a couture gown from the collections against a seamless backdrop for Bergdorf Goodman to use in a full-page advertisement in the same issue. Avedon would get an agate-size credit on the side of the picture. So, in what for years has been considered in journalism to be a conflict of interest, he was being paid by the magazine and also, at an infinitely higher scale, by an advertiser in the same issue. Less than a year after Avedon photographed Dorian

Leigh in Helena Rubinstein's Paris apartment, and the picture appeared on the pages of *Harper's Bazaar*, he was shooting an advertising campaign for Helena Rubinstein cosmetics. Earl Steinbicker, Avedon's studio assistant for almost fifteen years, acknowledged this manner of logrolling between Avedon's commercial commissions and his editorial work: "Avedon was only able to exercise his real talent to its fullest because he had made a substantial amount of money through his advertising photography," Steinbicker later confirmed. "And the reason he attracted high-end advertisers was because of his innovative fashion photography for *Harper's Bazaar* magazine and, later, *Vogue* magazine. So, fashion opened the way for advertising, which in turn allowed him to devote time and resources to his passion for portraiture."

In those early years, the list of Avedon's commercial jobs kept growing as he juggled one commission after another. Dorian Leigh was his model of choice in 1952. She appears in a series of ads for Lilli Ann, a very smart boutique in San Francisco known for its elaborately designed suits and coats made with fine French fabrics. The ad campaign was modeled after the Bergdorf Goodman ads; they also ran in *Harper's Bazaar*, with a single full-page image and the logo of the store at the bottom left or right corner. At the bottom of the picture was the credit "Avedon photograph" in agate type.

His fashion advertising was interspersed among other types of accounts he was shooting, ranging from Alcoa to Clairol, DuPont, Jergens, Maidenform, Pepsodent, Revlon, and Tareyton cigarettes. By 1951, the studio was operating at full tilt, and Dick was shooting up to 150 commercial commissions a year. Pennies from heaven—in torrents.

INCREASINGLY, AS PART OF Dick's tutorial at *Harper's Bazaar*, he had been exposed to—and had come to expect—nothing less

than the best of everything. Certainly that was an underpinning of the entire *Harper's Bazaar* ethos. Dick was always surprised by the personal kindnesses Mrs. Snow bestowed on him when they were in Paris, always taking him along with some literary eminence or a legend of the stage to a perfect little French bistro for dinner, where she would insist he order something he had never heard of before and it would be the most flavorful meal of his life, or someone at the table would order a bottle of Chateau Margaux and the first sip was transporting enough to spoil him for anything less extraordinary. This is one reason Dick would say over the course of his lifetime, "Carmel taught me everything I know."

Mrs. Snow had dresses in her closet from every important designer going back to the 1920s—Poiret and Vionnet and early Chanel—and when she first met Evelyn Greene, Mrs. Snow would say, "Oh, I have the most wonderful Mainbocher that would look so good on you, Evelyn. I want you to have it copied. In gingham pink." A box would arrive the next morning with the name of the dressmaker who would copy it.

Whether Dick felt it was obligatory to be married to become a respectable member of society; or he believed it to be a requirement of his career; or, maybe, because Evelyn had garnered Mrs. Snow's approval; or simply because he felt comfortable enough with her to establish a partnership in marriage, Dick and Evelyn were married in his apartment on East Seventy-Third Street on January 29, 1951. Soon enough, "Mr. and Mrs. Richard Avedon" would move to a town house on Beekman Place at Forty-Ninth Street, where they would occupy three floors. As Michael Gross described it, there was a "ground-floor kitchen, formal dining room, an Etruscan-inspired statue of a dancing nude. Up the spiral staircase were works by Picasso and Braque." Beekman Place, a three-block stretch along the East River, is lined with prewar high-rises and charming brownstones. Because it was considered such a tony little enclave, people

for many blocks around would lay claim to living in the "Beekman Place area." Along with the discreet comings and goings of family members of American dynasties such as the Rockefellers and the Vanderbilts, the Avedons could count on more visible cultural figures, such as Irving Berlin, as neighbors.

As Dick was becoming more acquainted with producers, directors, playwrights, and the stars of Broadway, he was exposed to ever-more-discriminating tastes—custom-made shoes of Argentinean leather, or a table reserved in the private dining room of a notable popular restaurant, or season tickets in the parterre center box at the Metropolitan Opera. It seemed fitting, then, for Dick to be able to squire his new wife in Mainbocher out for an evening at the theater, followed by dinner, and then to return to the old-world charm of Beekman Place, so exclusive and genteel and poetic.

IN EARLY 1952, EARL Steinbicker, a high school senior from Allentown, Pennsylvania, with a strong interest in the technical aspects of photography, wrote to ten photographers in New York in search of a job as an assistant. He offered to work hard for little pay and emphasized his proficiency with large cameras and darkroom techniques. The Avedon studio was the only one to invite him to come in for an interview. His father brought him to New York in May. "When I first walked into the studio at age seventeen the glittery background [of the "Fire and Ice" campaign] was propped up against the wall, so I knew for certain that this is where I wanted to be instead of college," Steinbicker remembered. "He hired me on the spot." Steinbicker offers a kind of tutorial on his blog to young apprentice photographers today, distilling his own experience as Avedon's studio assistant of fifteen years as a highly gratifying great adventure on the one hand and, equally, an unforgiving hazing ritual on the other. Aside from the necessity to be knowledgeable

about all aspects of the photographic process, and to be hardworking, dependable, physically strong, able to follow direction, and in possession of a clean driving record, he enumerates the flip side of those requirements: be as invisible and unobtrusive as possible; be available at all hours of the day, sacrificing your own plans on the spot, if necessary; be quick on your feet and ever resourceful in doing whatever it takes to get the job done.

Dick had just completed the Revlon "Fire and Ice" campaign when he interviewed Steinbicker. Barrett Gallagher, a *Fortune* magazine photographer and the president of the American Society of Magazine Photographers (ASMP), was present during that shoot. The ASMP had been established, as Gallagher once described it, because "the magazines—especially *Life* and the big ones—were quite unfriendly to the whole idea of a union and quite unfriendly to making any commitment as to the day rate or the page rate or any other facts of life." Dick had already established enough of a reputation to command his own rates. Whether it was at the suggestion of Gallagher, or simply the business acumen of Laura Kanelous, every print that came out of the Avedon studio had a copyright stamp to protect it from use without credit or payment. This was way ahead of industry practice.

In the picture Gallagher made during the "Fire and Ice" shoot, Dick poses Dorian Leigh in front of an industrial-size sheet of aluminum insulation material hung against the wall like a roll of studio paper. She is wearing a silver sequined evening gown and wrapped in a shocking red overgarment with voluminous curves at the shoulder and the hip. The contrast between her hot-red lipstick with matching nail polish and the glacial silver dress and reflective metallic background illustrates the point of the Revlon campaign. The copy invites women "who love to flirt with fire . . . who dare to skate on thin ice . . . Fire and Ice . . . for lips and matching

fingertips. A lush-and-passionate scarlet . . . like flaming diamonds dancing on the moon!"

When Dick brought his picture to Charles Revson, the founder of Revlon, for his approval, Revson objected to the model's hand, held up to her face with her fingers fanned out to show off her red-painted nails. Not everybody was capable of the gestural agility or dexterity that Dorian Leigh possessed with her hands, and in this case, it was too extreme for Revson. He told Dick that no woman would do that with her hands and wanted the picture to be reshot. It is not known if this was the first time Dick had encountered an adverse reaction from a client, but he defied Revson, claiming that the picture was beautiful and there was no need to reshoot it. Revson insisted that it was unnatural and went looking for a woman in his office to prove it. It was after hours, and the only woman around was an elderly cleaning woman. Revson brought her into his office and asked her if she saw anything wrong with the picture. She didn't, and Dick smiled triumphantly. "Well," Revson said to the cleaning woman, "if you don't see anything wrong with her hand, let me see you do the same thing." The cleaning woman demurred, saying that she wasn't able to spread her fingers like that. Dick had to reshoot it, furious that a nonprofessional was the one to pass judgment on his picture. Regardless, the ad campaign was wildly successful.

Dick did not suffer indignities easily. As his reputation grew, so did his sense of authority about his work. He took his assignments and commissions very seriously, worked extremely hard, and believed that he—and not the client—was the final arbiter of the output from his studio. He was capable of being a savvy diplomat with his clients, and utterly professional, but, equally, if he did not have final say or if he was required to redo an image, his petulance could get the better of him. Over the years, he survived

the embarrassment of his occasional tantrums and the alienation of clients, inoculated only by the prestige of his reputation.

The altitude of Avedon's ambition was beyond comprehension in these early years, but the signs were everywhere. Not only was he maintaining a consistent presence on the pages of *Harper's Bazaar*, but he was also running as fast as he could to fulfill the onslaught of commercial commissions coming his way with as much creative integrity as he brought to his editorial assignments. On top of that, he was beginning to get commissions for private portraits, and so he was thinking about the nature of portraiture. He was also beginning to think about subjects of his own choosing to invite to sit for portraits.

One was Charlie Chaplin, the beloved actor and critically revered auteur. Months had passed since Dick had first written to ask if he could photograph Chaplin. He made several subsequent attempts but to no avail. Chaplin was married to Oona O'Neill, one of Dick's swans, but that did not provide an inroad. One day, though, in mid-September 1952, Avedon's studio received a call from Chaplin. When Dick came to the phone and heard Chaplin's voice, he thought he was being played. "Yeah, and I'm President Roosevelt," Dick said, and hung up. Chaplin called right back and convinced Dick of his identity. Dick canceled his appointments for the following day to give himself over to the session with Chaplin. Avedon later recalled that when the director walked in, he told himself: "This is Charlie Chaplin! There is a Charlie Chaplin!" Avedon sent all his helpers out of the studio and the auteur and the photographer worked alone. "I was a wreck," Dick said with nothing less than reverence. Chaplin was, after all, the idol of every moviegoing American in those early years of cinema, when, as an antic, accident-prone, nonsensical tramp, he kept audiences in hysterics. His exquisitely timed slapstick turned *Modern Times* and

*City Lights*, about the socioeconomic conditions in Depression-era America, into incisive and hilarious cinematic masterpieces.

"I did the pictures as simply as I could," Avedon said, photographing Chaplin against a white seamless backdrop. When he indicated that he was satisfied and had gotten the picture he wanted, Mr. Chaplin said, "Now, I could do something for you." He bent down, concealing his face, put a finger on each side of his head, and came up with a violently grotesque expression. Then he turned and smiled. A smiling devil. Dick took the picture.

After spending the entire afternoon in Dick's studio, Chaplin, his wife, Oona, and their four children that night set sail on the *Queen Elizabeth* for Britain, where his new movie, *Limelight*, was scheduled to open. While Chaplin was on the weeklong crossing, the US attorney general, James P. McGranery, announced that the "famed comedian" was being investigated and might not be able to reenter the United States. Several years earlier, the House Un-American Activities Committee investigating Communists had blacklisted Chaplin. When the *Queen Elizabeth* arrived at Southampton, Chaplin received "a rapturous greeting from fans and well-wishers, and later that day gave a press conference in London where he resolutely stated that he was not a Communist, but someone 'who wants nothing more for humanity than a roof over every man's head.'" In the end, Chaplin, a British citizen, had his US visa revoked and lived the rest of his life in Switzerland. He knew this might be the case when he spent the afternoon at Avedon's studio. Pointing out the devil ears Chaplin made with his fingers and his demonic smile, Avedon told an audience of students in Maine in 1991 that "this was his last message to America. The sitter offered the photographer this gift that arrives once in a lifetime."

# LE CIRQUE D'HIVER

(1953–1957)

Everyone knew Roz Roose from her legendary Sunday brunches on Central Park West. She was the kind of gregarious individual who maintained a loose tether on her proximity to the people she claimed as part of her orbit. She could stretch her relationship to anyone, as when she offered to help a sick friend by calling "my neighbor's brother who is Eleanor Roosevelt's doctor." It's anyone's guess who might have initially introduced Roz to Dick sometime in the late 1940s. Anna Avedon, Dick's mother, had been active in political causes while Dick was growing up, and she knew Roz Roose, who was then barely twenty-one, from standing on picket lines at anti-Fascist rallies during the Spanish Civil War. Lillian Bassman knew Roz going back to their art school days, when they organized sit-down strikes over labor disputes; once, they took off their clothes and picketed naked in front of the Art Students League. When Doe, who would have met Roz through Lillian, ran into her on the street, she was always *fatootsed*; on one occasion, she couldn't remember where she had left her kids.

Laura Kanelous, Dick's business manager, was one of Roz Roose's best friends. Laura's daughter, Helen, remembered her parties as being wonderful. "She was my 'Auntie Mame,'" Helen said.

Roz was a painter who in her early years had modeled for Reginald Marsh, Raphael Soyer, and Chaim Gross, bartering her nudity and her time in exchange for their artworks. She would later get her degree in social work from Columbia and, for a while, worked at Rockland State Hospital, where she met her husband, Larry, a psychiatrist. When they moved to a rambling Central Park West apartment in the early 1950s they started throwing Sunday poker games, and, soon enough, the ritual transmogrified into her weekly Sunday brunch—or salon—that would prevail for another forty years.

Dick Avedon was one of the regulars. Among the others who attended were Clifford Odets; John Garfield; Arthur Penn, the film director; the actress Estelle Parsons; and the poet Adrienne Rich, who lived next door. Zero Mostel, Louise Nevelson, Chaim Gross, and Robert Motherwell were part of the weekly menagerie. Anne Bancroft and Mel Brooks dropped by on occasion. René d'Harnoncourt, the director of the Museum of Modern Art, also lived in her building and would show up from time to time. According to Jane Kramer in her 1995 profile of Roz Roose in the *New Yorker*, she provided this feast so that "Central Park West's progressive bourgeoisie would not go hungry on Sunday morning." Roz always had ample smoked salmon from a "nova outlet" in Brooklyn, and shopped at Zabar's and Barney Greengrass, the Sturgeon King, for bagels, blueberry blintzes, smoked whitefish, and herring in sour cream. Dick said about the weekly brunch that "the spread was the key thing and the stuffed cabbage was the best in the world."

Roz had three children. Her youngest, Gina, remembers helping to "serve and smile and then kiss everybody goodbye when they left and that was my childhood," she said. "These people used to

come over all the time. I knew Dick Avedon as a photographer and this one as a director and that one as a writer and that one as a painter. I'd come to say hello to Dick and sit across the table from Alger Hiss. It's not until years later that you look back and say, 'That was a pretty interesting crowd.' But at the time, they were all just friends of my mother's." Gina remembered Dick as someone with very dark eyes and a wiry presence who was always animated, "exuding a kind of energy, not crazy, nervous energy but a kind of life force. He was always very sweet and thoughtful and lovely to my parents. He had this unbelievable world and milieu, but, to me, there was always a real decency about him."

With her artist's spirit and progressive politics, Roz, and her husband, Larry, together personified a set of values grounded deep in the balance of ethics and aesthetics. The Rooses' weekly Sunday gathering was a New York inner sanctum quite apart from the *Harper's Bazaar* variety of ordained exclusivity that gave people like Dick unique access to the latest trend, the best new restaurant, aisle seats on opening night. At Roz's brunch, the conversation often verged on argument, whether about Karl Marx in relation to Thorstein Veblen; Reichian therapy in the context of Freud; Ayn Rand versus Sinclair Lewis; integration in the wake of the Supreme Court ruling on *Brown v. Board of Education*; or the effect of Jackson Pollock's death on contemporary art. Of course, the McCarthy hearings were an ongoing conversational leitmotif throughout the 1950s: Who from their cohort had been summoned? Who talked? Who came away unscathed? Who was blacklisted?

Roz's family, like Dick's—the Avedons on one side and the Polonskys on the other—had emigrated from the same eastern European region at the intersecting borders of Poland, Lithuania, and Russia. Roz, with an imaginative, free-spirited approach to the structure of her life, practiced a brand of being Jewish that was by no means religious but was entirely pervasive on the Upper West

Side of Manhattan, worshipping at the altar of her own impassioned social conscience with all the generosity of her open heart and the conviction of a just world in her soul. Avedon, who was born on the Upper West Side and visited his grandparents on West End Avenue throughout his childhood, said that he went to Roz's because "the people there, the place, they *stood* for something." More than money or status or etiquette, this is what distinguished Roz's party from the more genteel gatherings across the park. The people she assembled composed a kind of intellectual and cultural conscience that was once the very essence of New York.

This is a part of Avedon's worldview that gets lost in the sheen of his glossy reputation. It's true that his life was becoming ever more lustrous and luxurious—and he worked very hard for it—yet he did not abandon an essential value system that was humanist at the core. Despite his swank East Side address and the expensive restaurants and the first-class travel, he was not, in the classist sense of the word, a snob. In fact, he complained, albeit discreetly, that while Diana Vreeland, the renowned fashion editor at the *Bazaar* with whom he worked for many years, was an amazing collaborator because of her sense of style—and he often acknowledged that he learned about the very architecture of dressmaking from her—on many occasions her snobbery and what he considered to be her anti-Semitism got the better of him. Once, when Dick was off to Paris, Vreeland—who always deigned to refer to Dick by calling him not Avedon but Aberdeen—said, "Oh, you must meet Pauline Rothschild." After describing who she was—the marriage, her social standing, her wonderful taste—Vreeland handed him a note of introduction. The envelope had not been sealed and Dick read the note, which said, "Dear Pauline, I want to introduce you to a business friend." He and *Dee*-ana had already been working together at the *Bazaar* for years, and he was so appalled at being described as a "business friend" that he tore up the note and never set up the

meeting. "I mean, that kind of snobbism," he scoffed. "She wasn't exactly nice in any sense of the word. I never felt that kind of condescension from Carmel."

Lee Friedlander remembered a story about the shoeshine man in the lobby of the building where Dick had his studio. Dick often took his shoes to him, and one day the man asked him what he did. Dick told him he was a photographer. A year or so later the shoeshine man motioned him over one morning as he entered the lobby, excited to let him know that his daughter was getting married. He then leaned into Dick and said, "I will let you be the photographer." Dick agreed and went to Long Island to shoot the wedding.

In his own incremental way, Dick fought for social justice. In 1955, Marian Anderson became the first African American soloist to sing on the stage of the Metropolitan Opera, in a performance of Verdi's *Un ballo in maschera*. Dick had known the story of Marian Anderson's 1939 debacle when she was denied the stage at Constitution Hall in Washington, DC, by the Daughters of the American Revolution (DAR) because she was black. Then–first lady Eleanor Roosevelt promptly resigned her membership in the DAR and convinced Harold Ickes, the secretary of the interior, to permit Anderson to perform on the steps of the Lincoln Memorial instead.

"I once made a portrait of Marian Anderson singing," Avedon later wrote about the 1955 studio portrait that marked the occasion of her Metropolitan Opera debut. This portrait would end up being one of the most lyrical in his entire body of work, full of emotion and symbolism and expression. Anderson's eyes are closed; her mouth is open, her lips rounded in concentration on her singing; her hair blowing softly, as if from the music, an example of the kind of visual onomatopoeia Avedon sometimes achieved in his imagery—in this case the viewer can almost hear the subject's voice in the picture. "After looking at the print of the entire negative I decided to crop it," he said. "I made the head much larger in relation

to the entire picture area and placed it high and off center. This cre-
ated a more dynamic composition that emphasizes the power and
vitality of the subject." Dick succeeded in getting the portrait of
Marian Anderson in *Harper's Bazaar*, perhaps the first photograph
of an African American to appear in the magazine. He considered
its publication his own small stand against racial discrimination.

IN 1953, AT THIRTY years old, Avedon found that the contours
of his life had fallen into place in ways that, in his wildest teenage
imaginings, he could not have anticipated. There he was, residing
at a level of sophistication symbolized by the Algonquin Round
Table. His career was soaring; his social orbit was expanding into
circles of influence that bore the glare of public notoriety; his cul-
tural life was deepening with the people of accomplishment he
was getting to know and the events he and Evelyn were attend-
ing almost every night of the week. And now, on top of all that,
he had arrived at the ultimate rite of passage into adulthood and
respectability—the birth of his son, John Franklin Avedon. When
Johnny was brought home from the hospital, Carmel Snow made
a point of coming to see the new baby. Dick was surprised by the
intimacy of her gesture but delighted by her kindness. She arrived
and walked very quietly over to the crib and just stared at him for
a very long while. "It was very hushed," Dick remembered many
years later. "It wasn't 'kitschy-kitschy-coo' or 'Oh, isn't he a beau-
tiful baby.' She just looked at him and looked at him and looked at
him, for at least five minutes. It was a very intense regard."

Throughout the 1950s, the young Avedon family was well en-
sconced in the town house on Beekman Place. And in 1954, when
the building that housed Dick's studio on Madison Avenue was
razed for the construction of a skyscraper, his studio assistants Earl
Steinbicker and Frank Finocchio found him a new one at Third

Avenue and Forty-Ninth Street, next door to Manny Wolf's Chop House, which would later become Smith & Wollensky, and across the street from Katharine Hepburn's brownstone. Dick could now walk to work. His days were filled not only with introductions to deified figures in arts and letters, as well as celebrities, who were coming to the studio to be photographed for the *Bazaar*, and, increasingly, for personal commissions, but also with the hard-driving enterprise of back-to-back commercial projects and advertising campaigns, for which he was constantly inventing visual scenarios. Dick seemed to thrive on the nonstop intensity of these daily challenges, as if the amount of work that was coming his way only fueled his unbounded energy.

During the cultural season, he and Evelyn would go often to the theater and to the ballet, followed by dinner. They went to concerts—Chet Baker, whose music Dick loved and played in the studio, at Birdland in 1954; Ella Fitzgerald when she brought down the house at Carnegie Hall in 1956; or Leonard Bernstein conducting the premiere of his concert version of *Candide* at Carnegie Hall in 1957. Dick and Evelyn went to see comedians such as Lenny Bruce and, later, Nichols and May. They were invited to parties and they gave them, too. One night in early 1955, the Avedons gave a dance at their house on Beekman Place in honor of Grace Kelly, who was in her heyday as a movie star before abandoning her acting career to become princess of Monaco. Dick had invited his friend Sidney Lumet, who had recently separated from his wife, Rita Gam. Having just photographed Gloria Vanderbilt, newly single again, too, for *Harper's Bazaar*, he invited her to the party with the enticement that there was someone he would like her to meet. "I was intrigued," Gloria wrote in one of her memoirs. "A director—maybe we could work together (Garbo and Stiller?). Fun to dream, isn't it? Why not?" She wore a short sleeveless dress made of satin, the color of framboise, with dyed pumps to match—one of

six identical dresses she had had made in an array of colors for the season. When Dick introduced them at the party, Lumet took her in his arms "like a teddy bear," and as they danced, she writes, "I could feel the energy of his heart and soul going right through me like warm honey." But then, Lumet had to leave for a brief meeting with an agent at Sardi's and promised to return in an hour. She was dubious. "Bet you a rose you don't," she said. But he did come back and handed her a rose the very color of her dress. Sidney Lumet would become her third husband and Richard Avedon had been their matchmaker. Soon after, the three of them attended the New York premiere of *East of Eden*, directed by Elia Kazan, at the Astor Theatre on Broadway on March 9, 1955, followed by dinner, which was a benefit for the Actors Studio. The premiere was televised, and as the camera scanned the crowd in the theater, the announcer claimed that this was "one of the most glamorous audiences ever to turn out for a premiere in New York City"—to date.

The following year, Dick and Evelyn attended a Christmas Day party given by the Vanderbilt-Lumets in their Gracie Square penthouse. Carol Grace, Gloria's best friend, was there with her children, Aram, who was thirteen, and Lucy, who was eleven. Aram Saroyan would become a writer and later write about the experience of meeting Dick that day. Aram had been sitting by himself on a side sofa in the living room. "I was joined by a slender handsome man who, while obviously an adult, had such an easy, un-daunting manner that he was like an impossibly well-mannered contemporary." Dick told him he was Jewish, a detail the meaning of which eluded Aram at the time, but possibly it was a way for Dick to divorce himself from the Christian holiday being celebrated. They began to play a word game called Ghost and had gotten into the thick of it when his mother, Carol, came around to say that they were leaving. Dick was soon leaving, too, and suggested that Aram call him when he got home to finish the game by phone, which

they did. "What had struck me most about him at the Christmas party," Aram writes, "was that he seemed to be happy in a way that I'd never seen before in an adult."

Aram was a member of the photography club at school, and a few days later Carol called Dick to ask if her son might apprentice in the studio. Dick hired Aram at a mere ten dollars per week, a sum that afforded Dick the right "to yell at me," Aram wrote, "when I goofed up." Mostly it was an after-school job in which he swept the floor and took orders from Hiro Wakabayashi, Dick's second studio assistant, a recent émigré from Japan who would later become a world-renowned photographer in his own right. Aram's eyes were wide open as he watched the way Dick worked, surrounded by fashion coordinators and magazine editors, or advertising executives and company representatives, all of whom would line up behind "Avedon" and remain perfectly silent as he photographed. Music would be playing, sometimes at full volume—Johnny Mathis, at that moment, but always Frank Sinatra or Ella Fitzgerald or Chet Baker or the Dave Brubeck Quartet, whose great jazz standard "Take Five" could have been written for the Avedon studio. "As he took the photographs," Aram remembers, "he would exclaim each time he clicked the shutter: "'sensational! . . . fantastic! . . . terrific!'"—a dynamic that ramped up the energy and brought the best out of the models, and thus a practical, not to say pragmatic, technique." Aram described it "like a shamanistic protocol," as if this level of energy and commitment were necessary to keep the entire house of cards from tumbling down.

In the summers, the Avedons spent weekends at their house on Fire Island, in Seaview, an easy ninety minutes from the city. While Seaview itself was something of a bare-bones beach community— rickety boardwalks and houses on stilts—their home was more civilized than the cottage in Cherry Grove that Dick had shared several years earlier with Lillian Bassman and Paul Himmel. There

was plenty of running water for the proper bathroom and kitchen, and a picture window through which you could look out on the bay at sunset. The house was, quite literally, a hop, skip, and jump to the beach—as pristine and beautiful a beach as anyone could ever possibly want. This was an intimate family community: The Kanelouses had a house there with their daughter, Helen. Steve Elliot and Georgia Hamilton had a house there with their kids. The Mike Elliots were in nearby Ocean Beach with their kids. And so were the Bassman-Himmels, now with a son, Eric, although the distance between Dick and Lillian and Paul had grown as a result of Dick's embrace of the more visible aspects of his accumulating wealth and his growing professional fame. The Bassman-Himmels maintained their bohemian grounding with a moral judgment about Dick's mainstream bourgeois indulgences, despite the fact that they, too, were becoming more successful. Their style and manner of living, though, always remained less materialistic and conspicuous. Still, it was painful for them to let go of a friendship that had been so intimate and vital.

Throughout the 1950s, the Avedons would spend a week every winter at Round Hill, the new and exclusive resort on the balmy Caribbean island of Jamaica, sharing a villa with Leonard and Felicia Bernstein and their kids. The spacious villas dotted the hills above an even more pristine beach than that of Fire Island, with calmer, transparent waters and intoxicating tropical breezes. Some of the villas were owned by the likes of Bill and Babe Paley, Noël Coward, and Adele Astaire. Truman Capote was often a guest at the Paleys'. Richard Rodgers and Oscar Hammerstein wrote part of *The Sound of Music* there.

Jamie Bernstein, Leonard and Felicia's oldest child, is the same age as John Avedon, and she remembers him during those sojourns at Round Hill as a rascal, "a loose cannon." Once, in the late 1950s, when they were maybe six, Johnny persuaded her to help him

poison her younger brother, Alex. Jamie watched as Johnny mixed a Coca-Cola with Evelyn's Laszlo sun cream and some perfume and anything else they could find. When they gave it to Alex to drink, he said it smelled funny and refused to drink it. "We got busted anyway," Jamie said, grounded in their rooms in the villa for the rest of the day. Throughout her childhood, she remembered, the Avedons were always around, whether at dinners in the Bernsteins' Park Avenue apartment and then later at the Dakota, or from their visits to the Bernsteins' on Martha's Vineyard. "Alexander [her younger brother] and I thought Dick was great," she said. "He was so ebullient and energetic and full of fun. He had that really infectious giggle. He loved telling stories. He was curious about stuff and he was a really fun grown-up to be around."

Dick and "LB," as his family and close friends called Leonard Bernstein, recognized in each other a kind of unstoppable energy, yet Bernstein also possessed an innate and obdurate confidence about his own genius, along with an attendant chutzpah that could be at times shockingly inconsiderate of his family and friends, and embarrassing to them as well. While Dick, too, registered an unflappable certainty about his own creative ability—his eye, his standards, and his ideas about his work—this certitude coincided in striking incongruity with his neuroses and almost frenzied insecurities, for which he continued his psychoanalysis. Only later in his life would he assume a chutzpah all his own—at times unattractively—that evolved in proportion with his renown. In the 1960s, Dick would write a tribute to Bernstein, a man "who has never stopped giving—that is to say, strengthening whomever he reaches," he said. "Because of his discipline and genius, and the fact that they happened in the 20th Century, he has brought more people to the power of music (it sounds extravagant to say this, but I know it's true) than any other man in the history of the world." Dick offered an example of the way LB, utilizing his encyclopedic

knowledge, could instruct and entertain with his ever-surprising élan: "We once shared a box at the Metropolitan for the Opera season—a pretty funny box, since my wife and I know as much about music as the Bernsteins know about photography," he writes. "He decided, one rainy Vineyard morning, to our joy, to give us a pre-season lesson we wouldn't forget. He played, sang and acted every role in 'Tosca.' It took three hours and ended with his stepping a full foot from the coffee table to the floor (the parapets of San Angelo) and breaking his ankle."

In August, it was always Dick's annual trip to shoot the fall collections in Paris. He and Evelyn would stay in discreet splendor at the San Regis, where they were given the same suite every year. After the grueling two-week shooting schedule for the collections, with the deadline pressure and the ongoing antics of cloak-and-dagger (fashion) espionage, they would fit in a trip to Italy or Spain or Switzerland. In 1953, Georgia Hamilton had been Dick's model for the fall collections, and that year the Avedons traveled to Italy with her and Steve Elliot. There is a picture of the four of them in Piazza San Marco in Venice, looking relaxed, Dick in shorts, Evelyn dowdier than usual, appearing against the statuesque beauty of Georgia more like a midwestern school librarian than the usually chic Mrs. Richard Avedon. Georgia stands, smiling, with a pigeon on her wrist that is eating out of her amused husband's hand.

IN 1954, MARILYN MONROE was already a Hollywood phenomenon. In her earliest cameo in the 1950 film *All About Eve*, Monroe's character is briefly introduced to Margo Channing, a grand diva of the stage played by Bette Davis, as Miss Claudia Casswell, a graduate, as her chaperone condescendingly quips, of "the Copacabana School of Dramatic Art." Miss Casswell is then

summarily dismissed, sent off in the direction of a big producer in the other room on whom she is expected to level her feminine wiles. In a ten-second cut, we watch the bit-part character becoming the outsize star who plays her. Monroe employs an arsenal of subtle optical adjustments, turning on an inner glow and flashing her most mesmerizing smile. Monroe's technique is on full display here and efficiently recorded in this inadvertent cinematic documentation of her transformation.

Three years later, Monroe's leading role in the film *Gentlemen Prefer Blondes* elevated her into a movie star. Her performance as Lorelei Lee is comedic and her rendition of "Diamonds Are a Girl's Best Friend" is, for better or worse, the pivotal moment in her career. That same year, a nude calendar picture taken before she became Marilyn Monroe was published as the first *Playboy* centerfold—providing the kind of "testosterone nip" for the collective male libido that served to catapult her to a level of international fame unequaled at the time.

The growing phenomenon of Marilyn Monroe did not escape Avedon's reading of the cultural moment. In 1954, aware that the wind was blowing in the direction of, well, that platinum "sex goddess" from Hollywood, he took Sunny Harnett to Paris for the collections. Harnett, a slender, nimble model whose blond hair could look strikingly platinum in black and white, was a departure from the dark-haired, toned-down, quietly simmering Dorian Leigh. After shooting Harnett in Paris for the collections, Dick traveled with her and his entourage of stylists and assistants about two and a half hours to the casino in Le Touquet Plage, on the northern coast of France, near Calais, the gateway for passage to Britain.

Avedon photographed Sunny Harnett at the casino in a variety of evening dresses from the major designers, including Dior, Balenciaga, and Balmain. Yet, in what would become one of his most enduring fashion photographs, he photographed Harnett leaning on

the edge of a roulette table in a creamy, sleeveless, figure-hugging Mme Grés gown, which *Harper's Bazaar* described as "a long, malleable cling." The décolletage cuts at a diagonal across her chest, her breasts swaddled in lustrous fabric, their contours delineated as she leans forward with her weight on her arms. Her gesture, in which the naked shoulder is inched into an almost unnatural forward shrug—so that both shoulders appear to be parallel to the picture surface—accentuates a choreography of bodily curves. The forward shoulder is an Avedon signature with roots in his love of dance. Of course, everything about her gesture, never mind the entire mise-en-scène—the roulette table, the hanging lights, the patrons in black tie in the background—is in service of the dress.

*Sunny Harnett, Le Touquet, August 1954* has the look of a film still in which a simmering Hitchcock blond, say, is waging a sly assessment of the croupier. She is a well-constructed femme fatale aware of her impact and in command of her prey. In all the pictures he made at Le Touquet, Dick would take advantage of Harnett's sleek and elegant contour with her almost elasticized bodily gestures that derive from the vocabulary of modern dance. While there is no documentation of the influence of the Monroe effect on Dick, he was acknowledging the "blond" cultural moment by using Sunny Harnett as his model and placing her in a high-toned, sexy setting.

Soon after Dick returned from shooting the collections in Paris, a publicity event was staged only blocks from his studio for the movie *The Seven Year Itch*. The famous scene in which Marilyn Monroe stands on a subway grate was the brainchild of Sam Shaw, a photographer who made publicity film stills, often shooting on the set during production. On the evening of September 15, 1954, at Lexington Avenue and Fifty-Second Street, a large crowd of fans and press gathered to glimpse Marilyn Monroe standing on a subway grate in front of the Trans-Lux movie theater as the skirt

of her white summer halter dress blew sky-high in the wind of a passing train. "*Oh*," Monroe declared over and over, as they reshot the scene at least fourteen times, her hands trying to keep her skirt from flying. "Do you feel the breeze from the subway?" she asked Tom Ewell. "Isn't it delicious?" Thousands of bystanders cheered as they watched, the noise from the crowd so loud that it rendered the footage unusable. The scene in the film was later reshot on a back lot in Hollywood. Pictures of Marilyn with her flying skirt were published the next day in the *Daily News*, as well as in newspapers in London, Paris, Berlin, and Tokyo. The event so infuriated Monroe's husband, Joe DiMaggio, who was present, that it precipitated the couple's divorce. For Sam Shaw, though, it was a great publicity coup—the "shot seen round the world."

Dick may have known Sam Shaw through Milton Greene, but it's possible, too, they first met in the theater community when Dick worked for *Theatre Arts*. Shaw was a DeWitt Clinton graduate, albeit ten years older than Dick, and throughout the 1940s, he worked for the magazines, shooting feature stories of his own enterprise and getting them published, intent on maintaining his independence and artistic freedom. But Shaw was restless and, in the late 1940s, after photographing and befriending stage directors and actors—Elia Kazan and Marlon Brando among them—and becoming a set photographer during the production of dozens of films throughout the 1950s and 1960s, he would become a film producer himself.

Shaw often conceived the entire publicity campaign for the films he worked on. The day before the subway grate scene, Shaw brought Marilyn Monroe and Billy Wilder, the director, to Avedon's studio to be photographed for *Harper's Bazaar*. Tagging along with them was Hedda Hopper, the gossip columnist, who was powerful enough to make or break careers with her strategic, if often enough nefarious, use of personal information. She understood the star

power of Monroe and loved the screenplay for *The Seven Year Itch*, a version of the 1952 Broadway play that had been sanitized to pass muster with the Motion Picture Production Code censors. Hopper was intent on using her platform to promote the film and its star.

Dick photographed Marilyn Monroe and Billy Wilder, and Sam Shaw documented the photographic session, as if he were making film stills of the publicity campaign itself. Marilyn is wearing a different white dress from the one she would wear on the subway grate and a white fur stole around her shoulders. She walks around the studio barefoot, since the shot would not include her from head to toe. In Shaw's pictures you can see Dick adjusting her hair and positioning her stole, laughing with her at times, or looking at her in mock exasperation. There is a fan on the set, perhaps to create the effect of wind blowing through her hair, simulating motion in a still image. In these behind-the-scenes pictures, it is striking how different Monroe looks when she is not performing for the camera. She is a rather pretty—if indistinct—young woman, but easily becomes "Marilyn" in front of the camera.

Avedon's picture of Marilyn Monroe and Billy Wilder appeared in the November 1954 issue of *Harper's Bazaar*: Wilder points at the viewer—us—as Monroe, her head tilted back, her face a radiant mask, smiles brightly amid a frothy dazzlement of platinum hair and white fur, appearing to take delight in what Wilder is pointing out—her viewers. The text identifies Wilder as the director and Monroe as the star of *The Seven Year Itch*, giving him all the credit for her transformation and slipping in a dismissive description of her in the process: "He is one in the long line of skillful illusionists who have helped a calendar pin-up girl parlay her own not inconsiderable resources into the image of the All-American Good Time Girl." In fact, *she* was the skillful illusionist of her own image: the deliberate construction of her persona is underscored with an anecdote often recounted by Susan Strasberg in which she and Marilyn

were walking down a Manhattan street in the mid-1950s, Marilyn in her civilian clothes—jeans, a baggy sweater, and sunglasses, hair covered with a scarf; no one noticed them until Marilyn turned to her friend and asked, "Want to see me *do* her?" Simply by removing the scarf, revealing her blond hair, and shifting her body rhythm, the anonymous pedestrian became Marilyn Monroe and, immediately, a rushing crowd surrounded them.

The photo shoot with Marilyn Monroe and Billy Wilder may have been the first time the Hollywood publicity machinery co-opted Avedon's prestige for its own purposes, even though it was a mutually beneficial arrangement. At this point in his career, Dick was an active participant in editorial choices about who was important enough or interesting enough to showcase for the magazine, and, at the time, Monroe may not have made his cut. Yet this Hollywood publicity portrait coincided with the beginning of Dick's introduction to the world of Hollywood that would soon enough project him into yet another layer of stratospheric fame.

WHILE DICK WAS NAVIGATING the workings of Hollywood, he was being given entrée to a very different arena altogether: *The Family of Man*, an exhibition of photographs, opened at the Museum of Modern Art on January 25, 1955. This was not just any exhibition, but rather a spectacle in the rarefied precinct of the art world. Avedon was included in the show with one photograph, as were Allan and Diane Arbus, Henri Cartier-Bresson, Louis Faurer, Robert Frank, Paul Himmel, Helen Levitt, and 265 other photographers from 68 countries around the world. The brainchild of Edward Steichen, the museum's photography curator, the exhibit broke all attendance records for an exhibition at MoMA, drawing over 300,000 people in the first weeks; the print run of 130,000 copies of the book sold out before its publication the following

June, putting it on the bestseller list for months. The show traveled to forty cities across the country and, under the sponsorship of the United States Information Agency, it toured in Europe, South America, and Japan.

The show was pedigreed from all angles: the installation at MoMA was designed by the architect Paul Rudolph, a spatial arrangement in which the multi-size photographs resided on floating surfaces throughout the galleries, each one an element in an elaborate modernist puzzle. Carl Sandburg, the poet—and the brother-in-law of Steichen—wrote a wall text for the exhibition and a prologue for the book, in which he concluded the collection of photographs to be "a camera testament, a drama of the Grand Canyons of humanity, an epic woven of fun, mystery and holiness—here is the Family of Man!"

Never before had photography experienced such a momentous day in the sun. According to a feature in the *New York Journal-American*, Steichen said he wanted to show that people are, by nature, the same, regardless of the country or culture they come from. "Maybe being in two wars made me feel it so deeply, who knows?" Steichen mused. "But I had to prove that there is an essential goodness, optimism and dignity in all men; that everyone has the same capacity for laughter and tears. Something, I thought, has to explain man to man."

Minor White, the photographer who founded the quarterly *Aperture*, devoted the entire 1955 summer issue to a meditation on *The Family of Man*, including essays by Beaumont Newhall and Dorothy Norman that place the exhibit in a historical context. Yet, with the derision of a purist, White dismisses *The Family of Man* as "a jolly good show, a statistical stopper, a box office success and for the critic proves how quickly the milk of human kindness turns to schmaltz."

In fact, critics and artists alike found the show to be sentimental and superficial. In 1956, Roland Barthes declared it to be a product

of "conventional humanism," a collection of photographs in which everyone lives and dies in the same way everywhere. "Just showing pictures of people being born and dying tells us, literally, nothing." Walker Evans registered his disdain for the show's "human family-hood" and its "bogus heartfeeling."

Despite the scorn of Steichen's historic peers, *The Family of Man* continues to be an exhibition of monumental significance in the history of photography and a springboard for scholarly debate about its relevance in the museum context. Avedon's inclusion gave him a footing in the arc of the discussion, even though his picture in the show is anomalous in his entire body of work—two young kids outdoors and shirtless, the young boy, about six years old, carrying the young girl, who is about four, in his arms. The boy may be trying to kiss the girl, who looks to be giggling. It appears in the show in the category called "The Magic of Childhood."

Early in his life, Steichen made photographs of historic merit not for editorial publication but in exploration of the properties of the medium and in expression of his own artistic imperatives. One of his most significant is *The Flatiron, 1904*. The Flatiron Building was radical at the time of its construction in 1902 because of its shape, its broad Beaux-Arts facades narrowing to a fine triangular point at the intersection of two thoroughfares, Fifth Avenue and Broadway. Steichen's picture might be considered an equally bold piece of work—a stark and beautiful urban study in lusty shades of black and gray, the branches of the trees in the foreground fashioning a delicate calligraphy against the solid, monumental geometry of the building behind. The picture exemplifies the Pictorial movement in photography, which Steichen was instrumental in establishing with his colleague Alfred Stieglitz, to assert photography as a medium as expressive as painting to a chauvinistic art world that considered it a craft, the camera merely a tool.

But in 1923, Steichen became the chief photographer at Condé Nast and rose to the top of his profession making portraits and fashion photographs for *Vogue* until the late 1940s. By the time he conceived of *The Family of Man*, his initial impulse to make photographs that reflected his painterly sensibility had been obscured by the editorial demands of his profession and the allure of his own success. There were those who believed he had sold out and that *The Family of Man* was proof that he had long abandoned the gravitas of his early achievement. Avedon, too, would soon be trying to strike a balance between his commercial work and his genre-changing portraiture, a treacherous path in reverse of Steichen's trajectory from artist to editorial photographer. Avedon began as an editorial photographer and evolved into a commercial one as well. That made it just so much more difficult for him to proceed from a foundation in commerce to a foothold in genuine artmaking. All the odds were against him.

IN AUGUST 1955, DICK was back in Paris to shoot the collections— this time with Dovima, a slender, dark-haired model who resembled Dorian Leigh more than Sunny Harnett. Sam Shaw invited him on the set during the production of *Trapeze*, a film starring Burt Lancaster, Tony Curtis, and Gina Lollobrigida. The film was being shot at Le Cirque d'Hiver—or the Winter Circus, a large oval wedding cake of a theater erected in the nineteenth century at the commission of Napoleon III. The Cirque d'Hiver is tucked in on a sliver of a square along rue Amelot, just off rue Oberkampf, near place de la République. Aside from the central amphitheater, there are animal holds in an outside portion of the structure, where the elephants and the horses are kept, and the lions and the snakes. When Dick arrived to visit the set, Sam introduced him to Emilien

Bouglione, a strapping young animal trainer whose family owned the Cirque d'Hiver. It was during this tour of the animals that Dick got the bright idea to shoot Dovima on site.

Once again, Sam Shaw documented the photographic session. Four elephants are lined up against the interior wall of the outdoor animal hold. The elephants must have been young, as they were not more than a few feet taller than Dovima, the name the model Dorothy Horan assumed professionally: *Do* for "Dorothy," *vi* for "victory," and *ma* for her mother. Before the shoot, Shaw caught her sitting on a bench beside one of the clowns, as Enrico Caruso, the hairstylist, fashions her hair into a tight and shapely Noguchi-like chignon. Then she is standing in front of the elephants in a floor-length black velvet evening gown with a long, flowing white satin sash, the creation of Christian Dior's young assistant, Yves St. Laurent. Emilien is walking around making sure the elephants hold their place. Dick, slender, with dark, short hair, looking casual in a dark T-shirt, khakis, and white tennis shoes, stands beside Dovima making small adjustments to her hair and the dress. When the shoot is over, Dick clutches Dovima's hand in his and kisses her on the cheek. History was made.

Two pictures from the shoot appeared in the September 1955 issue of *Harper's Bazaar* in "Carmel Snow's Paris Report," with the headline "Dior's Sinuous Evening Line." The more important of the two, *Dovima with Elephants, Evening Dress by Dior, Cirque d'Hiver, Paris,* is a vertical image: Dovima's head is lifted in profile in the manner of a ballet dancer, her arms extended, her hands gracefully touching the trunk of one elephant and the ear of another. Her black velvet gown follows the curves of her slender body, the white satin sash adding a beautiful flowing line that echoes the position of her leg and the trunk of an elephant. In the second horizontal image, she stands in a different Dior gown, her arm lifted in perfect echo of the elephants' raised trunks, and her gesture in parallel

with the elephants' raised front legs. The large, bulbous creatures compose the illusion of a stampede—a striking backdrop of un-harnessed animal instinct against which the strict organization of high fashion stands in elegant, dramatic relief.

*Dovima with Elephants* has over the years leapt off the page into the high-stakes international art market: One print of the enig-matic image, measuring $85^3/_8$ inches by $65^5/_8$ inches, commanded over \$1 million at auction in Paris in 2010. Sotheby's has called it "a monument in the history of fashion and advertising photography," going on to assert that "no other fashion photograph of the 20th century is as widely recognized, and no other image illustrates as fully Richard Avedon's profound gifts as a photographer of couture and of women."

Dick often introduced an element of surprise in his coverage of the Paris collections. In 1954, it was Sunny Harnett at the rou-lette table in Le Touquet Plage. And in 1955, it was Dovima's off-beat presence in front of the elephants. In another unexpected wild twist in that same issue, under the report titled "The Hats of Paris by Night," Marlene Dietrich appears wearing a satin turban by Dior—a full-page headshot, really, in which she is beautifully made up, with a cigarette in her mouth, being dramatically and se-ductively lit. She happened to be in Paris after a triumphant run at the Café de Paris in London, and Dick thought it would be fun to give her a cameo appearance in the magazine. "The shock-surprise in his photos is the ingredient that has always given his work fresh-ness and excitement," Alexey Brodovitch told *U.S. Camera* in 1956. "He has an amazing ability to spot the unusual and exciting qualities in each woman he photographs. This, combined with his tremendous creative imagination, makes his work so exceptional."

This is certainly the case in his photograph of Suzy Parker and Robin Tattersall skating together in the place de la Concorde in 1956. Suzy Parker was an exquisitely beautiful model—and one

of Dick's favorites, although he was skeptical when he first met her. She was Dorian Leigh's younger sister, and, in 1950, when Dick asked Dorian to model again for the Paris collections, she insisted that he take Suzy along as his second model. "In came this girl," Dick recalled in later years, "who looked utterly unlike the usual model type, wearing one of the most rebellious expressions I've ever seen on anybody. She positively glowered." To Dorian, he confessed his real fear: "I don't know if I can work with someone so beautiful. There may not be enough I can do to create something of my own." Of course, he did take her along, and she would continue to work with him for years.

One of Dick's apocryphal stories was his discovery of Robin Tattersall sitting alone at a Paris café. He was a young medical doctor from London who had attended Cambridge with Antony Armstrong-Jones, and, because of his classic good looks and elegant manner, made extra money modeling for Armstrong-Jones on a regular basis. Dick maintained that he had to sweet-talk Robin— tall, handsome, aristocratic—into modeling for him. Tattersall tells a very different story about his first encounter with Dick. Aware that models were well paid during the collections, in 1956 Robin tried his luck going to Paris and making a cold call at the *Harper's Bazaar* office. The receptionist gave him a once-over and said, "*Un moment.*" "So then out popped this little guy who looked so young I assumed he must be just an assistant," Tattersall said. "He peered closely at me, then disappeared into an adjoining room, from which he soon reemerged with this long-legged, redheaded beauty in tow. He said, 'This is Suzy—take her in your arms.' I obeyed orders. Then he peered at me again, this time through his little camera, and said, 'Okay you'll do.'"

Timing, of course, is everything. The male model who had been scheduled for the collections that summer was Gardner McKay, who had just cabled to say his ship was arriving a week late due

to an emergency rescue operation that required the ocean liner he had boarded to return to New York. So, because the Swedish liner *Stockholm* had collided with the Italian liner *Andrea Doria* off Nantucket, Tattersall ended up in Dick's now-famous picture of the skaters in the place de la Concorde. It wasn't easy shooting Suzy Parker and Robin Tattersall dressed for winter in August and skating effortlessly on the square. Parker was a natural athlete, but Tattersall could not skate at all. Dick had to send him off by himself to practice, putting the entire shoot on hold, but to no avail. In the end they faked it, Tattersall claimed, using invisible wires and strings to hold him up—although you would never know it from their apparent spontaneity and stunning equipoise in the balance of his outstretched arm and her flying scarf.

It was a very fertile period for Avedon professionally, and he seemed to be having the time of his life. He was revolutionizing fashion with his outdoor shots of models in situations taken directly from daily life. During the collections in 1957, Avedon made another of his signature photographs, this one of the graceful and statuesque model Carmen Dell'Orefice holding an umbrella and leaping from the curb to the street, elevated as she glides across the frame with balletic grace. He had borrowed the idea directly from Munkacsi, who had made an almost identical picture, called *The Puddle Jumper*, in 1934. Dick's picture wryly suggests that by wearing a Cardin coat, any woman can be made to feel as if she were walking on air. But how did he create such a beautiful leap? Was there an elaborate pulley system operating out of view? "Don't be ridiculous, we did our job then," a still-beautiful eighty-three-year-old Carmen Dell'Orefice said. "It wasn't that complicated. I jumped the puddle for two hours and somewhere in there he got the picture!" Dick later titled this picture *Carmen (Homage to Munkacsi), Coat by Cardin, Place François-Premier, Paris, 1957.*

"It was a radical departure for fashion," Judith Thurman said

about Avedon's fashion work in France in the 1950s. "Dick broke the very old, staid, in-house studio photography mode of shooting debutantes . . . He was very original." He was not only addressing the new era, he was defining it in visual form.

ON APRIL 7, 1957, the April in Paris Ball at the Waldorf Astoria was attended by 1,300 people. Senator John F. Kennedy and his wife, Jacqueline, were there, along with Winthrop Aldrich, the US ambassador to Britain. The Duke and Duchess of Windsor were the evening's guests of honor. When Marilyn Monroe arrived on the arm of Arthur Miller, however, the thirty or so publicity photographers who were swarmed around the duke and duchess flocked to the famous movie star and her accomplished husband—to the visible consternation of the duchess herself.

A week after the ball, in suite 28A of the Waldorf Astoria, Dick spent over an hour with the duke and duchess. They relied so intently on the edifice of their pedigree that their faces had ossified into an expression of all-purpose blankness, registering an attitude of noblesse oblige that was, in fact, implacable. Dick had come in contact with them several years earlier while on assignment at a casino in Nice, and he was aware of the sotto voce rumors about their Nazi sympathies. He claimed to have been struck by their "absence of humanity." Not predisposed to any semblance of respect for them, his difficulty in cracking what he called their *"Ladies Home Journal* cover faces" made him increasingly irritated. He tried posing them with their beloved pugs, who had been running around the hotel room—in violation of his own "no props" rule. When that didn't work, he preyed on their affection for their pets, resorting to a desperate—if clever—gambit. "You see," he told them, feigning an apology for being irritable, "on the way to this session, my taxi ran over a dog." They both caught their breath with a crack in the

facade, as Avedon had hoped, and he snapped the shutter. "They loved dogs," he later said, "more than they loved Jews."

Less than a month after that session, on May 6, Marilyn Monroe returned to Dick's studio for an entire evening alone with the photographer. Perhaps he wanted to "right the wrong" for his one-dimensional publicity shot of her several years earlier in *Harper's Bazaar*. She was by now living in New York with Arthur Miller; she had started a production company with Milton Greene; and she was enrolled at the Actors Studio. She wore the same sequined gown she had worn to the April in Paris Ball, the décolletage dropping between her breasts, a "malleable cling" that accentuated her curvaceous figure with lascivious implication. Dick described the session in this way: "Marilyn Monroe was an invention of hers, a genius invention that she created like an author creates a character. So, Marilyn Monroe put on a sequined dress and danced around the studio. For hours she danced and sang and flirted and did . . . she *did* Marilyn Monroe."

In some frames on the contact sheets, she stands with her arms out, as if she is following Dick's choreographic directions; in others she sits on a stool and purrs and giggles; in still others she is turned to reveal her racy backless dress. It is obvious that photographer and subject were each working hard but at cross-purposes. All the images were contrived.

Avedon believed that portraiture is performance—the kind of performance that reveals, rather than conceals, an essence. "I trust performances," he once wrote. "Stripping them away doesn't necessarily get you closer to anything." For him, the question wasn't whether the portrait is natural or unnatural, only whether the performance is good or bad. "The surface is all you've got. All you can do is to manipulate that surface—gesture, costume, expression— radically and correctly." Marilyn approached the camera as a mirror and was capable of turning her narcissism into nothing less than

art, but this did not work with Dick, who was going to have his own photographic way with her. While he may have enjoyed her effervescent spirit, he was immune to her brand of seduction, and, likely, bored by her particular performance. "And then there was the inevitable drop," Dick explained. "When the night was over, and the white wine was over, and the dancing was over, she sat in the corner like a child, with everything gone. I saw her sitting quietly without expression on her face, and I walked towards her, but I wouldn't photograph her without her knowledge of it. And as I came with the camera, I saw that she was not saying no."

In the one frame that Dick printed from that session, Marilyn Monroe is utterly deflated—all the air out of the balloon—an un-Marilyn that is striking. She is dressed for the evening, coiffed, and made up for the ball—yet despondent, as if in recognition of the overwhelming consequence of everything in her life that had brought her to that very moment.

"All my portraits are self-portraits," Dick was fond of saying, and there is truth in that about his portraits, as well as about the nature of all portraiture, whether in painting, photography—or even biography. In photography, consider Nadar. In his 1865 portrait of Sarah Bernhardt, the actress is seated before a blank backdrop leaning on a table, out of costume, neither performing nor emoting, but simply "being." It is typical of Nadar's lucid and concise approach to portraiture, in which he sees his subject with straightforward regard and precision of detail. Or Julia Margaret Cameron, whose portraits reflect the pre-Raphaelite ideals of her own circle. Cameron used her subjects to represent mythical figures or to illustrate emotional states of being. She would photograph a subject in period dress, bathed in a poetic light to evoke a distant history, a higher ideal. Her portraits reflect her own ethereal nature and poetic intentions more than the personalities of her

often highly accomplished subjects, artistic and literary giants of nineteenth-century Victorian England. The work of both photographers has come to define a time and a place, an attitude and a sensibility. Nevertheless, each body of work announces the distinct visual signature of its photographer. The same is true of August Sander, who chronicled individuals in German society in the early half of the twentieth century with an almost forensic objectivity that did not exclude his human connection to each one. His formidable achievement, *People of the Twentieth Century*, is equally the portrait of the photographer as of an entire society.

The 1957 portrait of Monroe is one of Avedon's most recognizable images. That he may have sensed in her a more extreme version of his own public facade is conjecture, but not unwarranted in this context. Andy Warhol's silk screen multiples of "Marilyn" exemplify this paradox built into the nature of portraiture itself: Haven't they come to be identified as Warhols first, before they are acknowledged as portraits of the movie star? The same could be said of Avedon's portrait of Monroe "unmasked." It may not represent the public image of the radiant movie star, but it has fallen in place historically as Avedon's "Marilyn"—a glimpse of the woman behind the mask. And, it is hard to think of *Dovima with Elephants*, which is not a portrait at all, as anything other than that exquisite Avedon.

# 8

## ON
## BORROWED
## WINGS

(1957–1959)

> Dick was so full of energy and enthusiasm. He was not like
> most people. He was enthusiastic about everything. He really
> lived every second. He made it important.

—STANLEY DONEN

Dick had fond memories of Radio City Music Hall, the
spectacular art deco theater in Rockefeller Center where,
as a kid, he had seen Fred Astaire for the first time in the
role of Jerry Travers, the smooth-talking, tap-dancing showman in
the frothy Hollywood musical *Top Hat*. Now, on March 28, 1957,
not yet thirty-four years old, Dick sat again in the same theater

at the gala premiere of the movie *Funny Face*, in which an older Fred Astaire was starring as the fashion photographer Dick Avery—a thinly disguised version of himself. Imagine the thrill. "It was all very strange," Dick said, describing the uncanny symmetry of working with Astaire as a consultant on *Funny Face*. "I'd learned how to be me by pretending to be him and then I had to teach him how to pretend to be me."

*Funny Face* is about Dick Avery (the Avedon figure), an urbane fashion photographer bored with the stereotypical models constantly sent his way. On the lookout for a new kind of woman, he heads to bohemian Greenwich Village, where he discovers Jo Stockton (Audrey Hepburn's character, loosely modeled after Doe Avedon) working as a clerk in a bookstore. Despite her protestations, he manages to lure her all the way to Paris, cajoling her at every step of the journey with luxe benefits and the sartorial splendors that await her in the world of fashion. Of course, her reluctance to model for the collections only fuels his romantic ardor, which is thwarted by an older French (Sartre-esque) philosopher with whom she becomes enamored during an encounter in a smoky cabaret on the Left Bank.

We watch, implausibly, as the debonair Dick Avery coaxes the bookish Jo Stockton away from *la vie bohème* with the fairy-tale luster of the haute couture. In the end, not only does Dick Avery transform her into an international fashion sensation, he succeeds in capturing her heart. It is hard to ignore the May-December aspect of this romance, less a feature of the story than the awkward effect of the casting: Fred Astaire was fifty-seven at the time of the production, Audrey Hepburn thirty years younger. Stanley Donen, who directed the film, had other thoughts about the casting to begin with. "Why not use Avedon himself?" he said, when he was first offered the story, an idea quickly rejected by Roger Edens, the producer. Donen tried to cast Gene Kelly in the role, with whom

he had codirected *Singin' in the Rain,* and who starred in *An American in Paris,* but Avedon was vociferously opposed to Kelly as his avatar.

*Sweet Smell of Success* and *Will Success Spoil Rock Hunter?* were among the other movies that opened in 1957, starring Tony Curtis and Tony Randall, respectively. Dick shared the same handsome Jewish features (Tony Curtis was born Bernard Schwartz; Tony Randall was born Aryeh Leonard Rosenberg), with black hair combed and parted to the side in the generic style of many leading men of the period. By then Dick looked the part of the prototypical man-about-town, even though he was not an actor and certainly not a star of such monumental stature as Fred Astaire, whose name recognition made him a box office draw. As a handsomely paid consultant, though, Dick loomed large in the production of *Funny Face.* He was given a prominent screen credit: "Special Visual Consultant and Main Title Backgrounds: Richard Avedon." The truth is that he and Donen worked privately together as if they were co-directors. "Avedon played a huge part in the aesthetic of the film," Donen explained, "in the dramatic as well as visual atmosphere." In fact, Dick's hand could be seen in so many aspects of the production that he rightly took pride in the Academy Award nominations in three categories: Art Direction, Cinematography, and Costume Design.

The movie received wide critical acclaim and did exceedingly well at the box office. Bosley Crowther of the *New York Times* called it "a delightfully balmy romance." The film's opening-day gross at Radio City Music Hall—$23,000—broke the house record, but a front-page story in the *Hollywood Reporter* a month after its debut reported the fourth week's take of $214,777 to be the "biggest one-week gross of any movie at any theater anywhere in the world in all history."

Features were written about the film and, in turn, about Dick.

Utilizing his well-cultivated network of influential contacts, he was able to arrange a *New York Times* story about his role in *Funny Face*, adding just that much more lift to the accelerating arc of his success. The article highlighted his influence on the entire look of the movie, as he had hoped, but the writer also mentioned the sources of his commercial work, a little-known secret that did not comport with the public image he had thus far crafted: "To anyone familiar with Avedon's work in *Harper's Bazaar*, 'Funny Face' expresses the same breathless spontaneity, fantasy, and beauty that makes his fashion photographs unusual," wrote the *Times*. "Mr. Avedon is one of a handful of fashion magazine photographers who garner their prestige through publications like *Bazaar* and *Vogue*, and their caviar from carpet firms and cigarette companies." The "caviar" was a quaint reference to the level of comfort Dick grew to expect as a requisite for *being* Richard Avedon. His contract with Paramount Pictures as "Visual Consultant" on *Funny Face*, for example, specified "first class airplane transportation for one (including berth if obtainable) from New York to place Employee is required to report for commencement of services and each subsequent time he is required to report in accordance with the schedule."

The contract stated that he was scheduled for eight nonconsecutive weeks in Hollywood and one in Paris—at $1,000 per week, although torrential rains in the spring of 1956 extended the shooting schedule in Paris an additional two weeks. On his trips to Los Angeles, Paramount put him up at the Beverly Hills Hotel, where each secluded bungalow suite is tucked discreetly into the trimmed shrubbery and vibrant bougainvillea of the meandering and well-manicured garden, and where being paged for a phone call while sitting by the pool was "a little bit of all right," as Diana Vreeland would say.

While it's not improbable to think that Dick had single-handedly conceived the idea of *Funny Face* and orchestrated the visual stamp

of his sensibility in almost every scene, in fact he had nothing to do with its genesis. The idea for *Funny Face* began in 1947, when Leonard Gershe, Dick's friend from the merchant marine and his Cherry Grove housemate, traveled to London to collaborate with the composer Richard Addinsell on the lyrics for two songs—"A Jabberwocky Song" and "Sing, Child, Sing"—for the theatrical revue *Tuppence Coloured*. One night at Addinsell's flat, Gershe was introduced to the novelist and playwright Clemence Dane and, for some reason, brought up his good friend the photographer Richard Avedon, who at that very moment was on his first trip to Paris in an effort to turn his wife, Doe, into a fashion model, even though she had no interest in such a career. According to Gershe, Dane responded by saying, "What a glorious idea for a musical—the fashion world, a fashion photographer, and a model who would rather be reading books. Why don't *you* write it?"

Gershe began writing "Wedding Day," based on the marriage—and, finally, its dissolution—of Dick and Doe, a musical with a score by Addinsell and a story that hewed close to the original idea of a fashion photographer (named Rick) turning his wife (Jo) into a fashion model against her will. In the early 1950s, Gershe moved to Los Angeles and began writing for the television show *Private Secretary*, starring Ann Sothern, and, also, writing material for Lucille Ball, Jack Benny, and Eve Arden. In 1952, he met Roger Edens, then a producer at MGM, with whom he would move in and establish a lifelong relationship. Edens was looking for new projects, and Gershe handed him "Wedding Day," a hard sell for the studio until Edens abandoned Addinsell's score and Gershe's lyrics, attaching it instead to several songs from the 1927 Gershwin musical *Funny Face*. That clinched the deal. With the studio behind it, Edens hired Stanley Donen as the director, who then cast Fred Astaire as Dick Avery, Audrey Hepburn as Jo Stockton, and Kay Thompson as the fashion magazine editor. Production began

at Paramount (where Hepburn had an exclusive contract) in 1956. Leonard Gershe arranged for Stanley Donen and Avedon to meet, which was how Dick came to be the visual consultant on the film.

Avedon and Donen first met in 1955, after Dick had shot an album cover for the Dave Brubeck Quartet in San Francisco. Dick's client for this shoot was Helena Rubinstein, who sponsored the album, which was named for a new lipstick, Red Hot and Cool. The album cover was a kind of product placement for the lipstick, and it was to be used in the Helena Rubinstein print ads; women who bought the lipstick received a promotional jazz single with their purchase. Dick photographed Suzy Parker wearing the "hot-red lipstick" and a striking red dress, draped over the edge of Dave Brubeck's piano as he plays and flirts with her at the hungry i, a legendary San Francisco nightspot. Dick used the same red filters and soft-focus light for the picture of Brubeck and Parker that he would later use in *Funny Face* for the smoky romantic mood in a Paris coffeehouse.

Dick had brought his wife, Evie, along to San Francisco. His assistant, Earl Steinbicker, who was also on the trip, described her as "floating in and out on her cloud," around but not really present, spending the days shopping for clothes. When they got to LA, Dick, operating on his best political instincts, arranged for the meeting with Donen to take place at Hearst Castle in San Simeon, sitting idle after William Randolph Hearst's death in 1951. This was before the 115-room grand architectural extravaganza was given to the state of California as a public monument. Dick utilized his ties to *Harper's Bazaar* and the Hearst Corporation to gain private access, knowing that the grand estate, with its Roman temple and an Olympic-size pool flanked by colonnades and statuary, would impress. Dick also called on his assistant to chauffeur him and Evie, along with Donen and his wife, the actress Marion Marshall, to San Simeon, several hours north of LA. "Donen was

most intrigued by the estate being the basis for *Xanadu*, the 'real' home of *Citizen Kane*, the classic 1941 movie by Orson Welles," Steinbicker said. Then commenced the meeting between the accomplished director and the glamorous fashion photographer. All of them were present as Dick made his impassioned plea to cast Fred Astaire—and not Gene Kelly—in the role of Dick Avery.

As the visual consultant, Avedon turned out to be more integral to the film—and his role more multifaceted—than his innocuous credit reveals. Not only did he contribute to the design of the title credits, he provided all of the freeze-frame stills in the "Think Pink" musical number. He must have had a hand in the design of the opening scene, too, in which the office of *Quality* magazine is composed of a row of doors lined up side by side across the screen in bright primary colors, a clean, graphic display of Josef Albers–like modernism that had Avedon's aesthetic written all over it. Dick advised Donen and Ray June, the cinematographer, on lighting, filters, and optical effects, though due to the rigid hierarchy of the Hollywood system he was forced to collaborate surreptitiously during the filming of the movie. The chain of command was clear and precise: the director may speak to his cameraman; the cameraman may instruct his camera crew and electricians; but the director's "visual consultant" could not so much as move a light, change a lens, place a scrim or filter without talking only to the director, who could then give the order. Donen and Avedon often spent half the night working out the details of the next day's shooting. While filming a scene on any particular day, they relied on their own private language of cues, utilizing "an elaborate system of precautionary signals—discreet coughs, hair smoothings, tie-straightenings and the like to indicate to each other when any of a hundred things went wrong on the set."

"The key moment of their collaboration was in the innovative way they froze the shots," Robert Rubin writes. "At that time, freez-

ing a frame was technically primitive and visually problematic. Taking the 35mm frame and filming it yielded grainy and imperfect results, and Donen was a perfectionist. In effect, he made an eight-by-ten fashion photograph freeze-frame by linking Avedon's eight-by-ten camera to the monstrous VistaVision camera with a set of mirrors, so that whenever Avedon clicked the shutter, he shot the exact picture that was being filmed, perfectly in frame within the running film." Avedon was fascinated by the results of this elaborate system of rigging and synchronizing his camera to the movie camera. Movement is often cited as an intentional characteristic of the Avedon fashion photograph, and here, he was photographing movement in synchronicity with the movie camera.

Ray June, the cinematographer, modestly described his job as "the practical realization of suggestions from Donen and Avedon." And Donen "generously" attributed the look of the film to Avedon. "He was an amazing, gifted, unusual, unique man," Donen said about Avedon. "I pumped him on everything—How would you light it? Why would you light it? Why wouldn't you do that? I wanted to know how he felt about taking pictures."

Never was there a woman who more perfectly embodied the Avedon gestalt than Audrey Hepburn. Her beauty had an almost breakable fragility and the timeless elegance of a gazelle that seemed to be the singular personification of Dick's aesthetic. She was a combination of his cousin Margie, his ex-wife, Doe, and his first important model, Dorian Leigh, rolled into one sophisticated creature who had studied classical ballet in London and retained a dancer's poise, posture, and grace throughout her life. She popularized the cool and casual style of black cigarette pants and ballet flats, a personal uniform in which she felt most comfortable. One of the most compelling sequences in *Funny Face* is a four-minute segment in which Hepburn's character Jo Stockton—in ponytail, black turtleneck, and cigarette pants—performs a wildly expressive

modern dance, enacting a ritual disentanglement from the strictures of convention with her own shoulder-shrugging, hip-genuflecting, arm-spreading rigor in a coffeehouse in *la Rive Gauche*.

Avedon and Hepburn developed a winning rapport that began several years before the making of the film, when he first started using her as a model. When Dick advised Donen and Astaire on the scenes in which Dick Avery is photographing Jo Stockton— holding balloons in front of the Arc de Triomphe or standing in a waft of smoke from a departing train at the Gare du Nord—he relied on his romantic ideas about Paris that were conceived on his first visit to the City of Light with Doe and sustained in his mind's eye as he made his best fashion tableaux there throughout the 1950s.

Never one to remain idle between takes, while in Los Angeles for the filming of *Funny Face*, Dick also created his first television show, "The Judy Garland Musical Special," for *General Electric Theater*, which aired on April 8, 1956. His title was "production creator." Garland sang old standards she had never before sung in public: "I Feel a Song Coming On," "Last Night When We Were Young," "Life Is Just a Bowl of Cherries," "Come Rain or Come Shine." (Ronald Reagan was the announcer; Nelson Riddle, the musical director; Joe Bushkin, the pianist; and the dancer Peter Gennaro was the guest.) Dick's hand is evident in the entire look of the show. When Garland, in a rather unflattering black cabaret-like peekaboo gown, starts to sing, she is bathed in a spotlight on the floor, and slowly, the camera pulls closer until her face fills the screen, evenly lit and isolated within an immersive black background. Her makeup is that of a model in a fashion magazine, the various shades and tones and outlines rendered to be viewed in black and white. She belts her mournful ballads in the infinite darkness. Dick managed to create a stark photographic portrait out of the light of a cathode-ray television tube.

It is notable that in the mid-1950s Avedon was given the opportunity to exercise his aesthetic talents in both television and film, and, in each case, he was associated with projects that were as prestigious as popular culture got. At the same time, he was acutely aware of the technical properties and visual potential of each medium—as distinct from photography but utterly informed by it—and he brought unwavering discipline, rigor, and enthusiasm to the expanded challenge of the moving image, as well as a level of creativity that was, at times, radical in its visual resolution. For example, for the darkroom scene in *Funny Face*, in which Astaire sings the title song to Hepburn bathed in a red light, Avedon "proposed adding the bright beam of the enlarging camera, literally transfixing Miss Hepburn to the wall as Astaire danced around her," Donen said, later adding that "if Avedon had made no other suggestion on the entire show, that single shot idea was worth his entire salary."

With Richard Avedon, it is easy to get swept away by the refracted glitz and glamour and the stratospheric dimensions of his social and professional orbit—and he loved nothing more than to be in the center of that swirl—yet there is substantial evidence that his intelligence and originality were always at play. His mind was constantly at work as he contemplated the endless possibilities in seeing and imagining and testing and extending the form. In his fashion work, in the visual representation of his career in *Funny Face*, and in the television bauble that was the Judy Garland special, he hoped to elicit a poetic response in the viewer, the same kind of response he expected the world he was living in to elicit from him on a daily basis. And, sometimes, just sometimes, it did.

Toward the end of his career, Avedon was asked why he never made films. "I had a choice around the time I worked on *Funny Face*," he said, invoking Stanley Kubrick as an example of one photographer who made the transition to become a director. "The

nature of being a director is so collaborative and I'm so used to thinking my own thing through myself. . . . There's some erotic exchange between myself and some of [my big portraits]. I can stare at them as long as I want. I can stare at every detail in a way that isn't permitted in life, and that never happens in movies."

DICK AND EVELYN SOON moved to 625 Park Avenue, at Sixty-Fifth Street, a fifteen-story limestone apartment building on the most elegant residential thoroughfare in Manhattan. In midcentury New York, a Park Avenue address reflected one's standing at the top of the food chain. Their six-room apartment was nothing less than grand, and while it may have seemed commensurate with Dick's newly expanded fame, there was an invisible—if socially treacherous—gulf between the cramped, Jewish ethos of his middle-class upbringing on East Eighty-Sixth Street and the aristocratic American lineage invoked by the very mention of Park Avenue. Certainly he could afford to live in baronial style; the average rent in New York City in 1957 was $350 a month, and even if his apartment rented at more than twice that amount, it was merely a bagatelle in the context of his annual income of $250,000 (in 1960, the average income was $5,600 a year in the United States).

Aram Saroyan, who was barely fifteen at the time, remembered having dinner in the Avedons' new apartment with his mother, Carol, and his sister, Lucy. "I was dazzled by the entry, with its red-and-white, large-squared checkerboard linoleum floor," he said. "It was flamboyance, color, and control all at the same time. Here was someone who had mastered the world, I thought." That was precisely the effect the Avedons were after. Evelyn, too, enjoyed being Mrs. Richard Avedon of Park Avenue. She shopped at Bergdorf, had her hair done at Kenneth (or Garren), indulged in spa treat-

ments, selected fabrics for the furniture, planned dinner parties, and avidly read good fiction.

Aram was about to enter high school and continued to work several afternoons a week at the Avedon studio. At dinner, Carol told the Avedons that, in keeping with the custody agreement of her divorce, William (Saroyan) was taking Aram and Lucy to Europe for the summer on an ocean cruise that made stops at six ports along the Adriatic and the Mediterranean. As a going-away present, Dick gave Aram a box of black-and-white film, twenty rolls of Kodak Plus-X, and a box of twenty rolls of Kodak color film. Aram photographed on the streets of Palermo, Naples, Venice, and Patras, and when he got back, all the film was processed at the studio. Hiro, Dick's studio assistant, thought several of Aram's pictures to be so good that he made prints. When Dick saw them, he agreed and arranged for Aram to meet Marvin Israel, the art director of *Seventeen* magazine. Israel—who in the following years would become one of Dick's closest friends and most valuable colleagues— liked them, as well, and designed a two-page layout with eight of Saroyan's pictures, called "Lens on Europe," for the January 1958 issue. The layout won an Art Directors Award for both Israel and Saroyan.

Dick could be enormously generous as long as there was no threat to his social standing or any semblance of encroachment on his professional turf. Saroyan was a teenager and Dick's encouragement was genuine. Dick was surprisingly generous, too, with Hiro (Yasuhiro Wakabayashi), who had come to the United States from Japan, studied with Brodovitch, and worked for several years as Dick's assistant. Dick had hired him initially because he felt "I would know my place," Hiro told Norma Stevens. But soon enough, Dick recognized Hiro's talent and ability and told him, "You are already too good to be working for me." Dick gave him a

portion of the sizable studio in which to develop his own clientele and to shoot his own accounts, some of whom were spillovers when Dick was too busy to shoot the commission himself. This was enormously beneficial to Hiro in establishing his reputation, yet Dick had no qualms about extracting a hefty share of Hiro's net profit as compensation. Still, Hiro believed Dick to be "the most brilliant of all the flashes that illuminated my professional path," he said, adding that he learned many lessons while working there. "His impatience was an inspiration in itself. The preparation he made for each sitting, the perfectionism—sharp, like a scalpel."

While Dick was kind to Aram Saroyan and made a great impression on the children of his other friends, too, such as Jamie Bernstein and Gina Roose, he was not a consistent presence as a father for Johnny, his own son. Dick's affection for Johnny came in staccato bursts of attention. He was an almost phantasmagorical figure who hovered about the house but never quite entered the child's room to provide constancy and a steady hand. "Johnny was a lonely child," Earl Steinbicker said, explaining that Dick and Evie often took trips without him. "There were servants"—referring to the Irish nanny Rose, who was with the Avedons for years—"and Dick's mother was always around."

Five years earlier, Jack Avedon, who had drummed into his son, Dick, the paramount obligation of a man to provide for his family, left his wife, Anna, absconding with their money and fleeing to Florida. He followed in his own immigrant father's deadbeat footsteps, as well as his father-in-law's, abandoning his wife with no explanation and leaving her virtually destitute. Eventually Dick's parents divorced, but not before Dick set his mother up in her own apartment on the Upper East Side, keeping her in close proximity and supporting her for the rest of her life. For years, Dick's father was dead to him, but his mother remained a steady and welcome presence in his life; in those years, she had a reason to be around,

doing what all grandmothers do, taking care of her only grandson when Dick and Evie were away—and, often enough, when they were at home as well.

"PARIS IS A BLAZE of color," Carmel Snow announced in the September 1957 issue of the *Bazaar*. There is "news at the beltline" and "hemlines are rising"; the new slender dresses have a "discreet perfection"; the Diors are "bouffantly feminine"; and Jacques Fath gives women a "faintly bustled Seurat look." These were Mrs. Snow's final dispatches, since earlier that year she had been informed by management that the October 1957 issue of *Harper's Bazaar* would be her last. She had been at the helm of the magazine for twenty-five years, holding such close reins on the very essence of its contents that she and the magazine had become inextricably one and the same. But her grip was slipping. The times were changing. She was drinking heavily. It was the right moment for her retirement, whether she was prepared to accept that inevitability or not. "She probably wanted the magazine to fold when she left," Dick told Calvin Tomkins in the 1990s.

Dick was in Paris with Mrs. Snow that summer, once again with Suzy Parker as his beautiful workhorse model. All his creative pistons were firing at full charge. He orchestrated at least a dozen cinematic freeze-frame "moments" in a fantasy narrative about a well-turned-out couple on a honeymoon-like weekend in Paris. Across sixteen pages of the September issue, there are pictures of Suzy running and laughing hand in hand with her beau through the Tuileries in a sumptuous checkerboard coat by Lanvin-Castillo, he in full Scot regalia, kilt and all; she is walking through the Moulin Rouge in a soigné Griffe evening gown with "a fluent evening line" as her escort glances at the seminude dancer climbing a stage ladder behind her; they are sitting at the base of a tree on the bank of the

Seine, his head in her lap, the leaves dripping toward the water as she gazes up in a pleasant reverie; in a fairy-tale moment, in the night light of the streetlamps on the Pont Neuf, she is a princess in her confectionary, tulle-tiered Patou ball gown dancing dreamily with her Adonis in a tux. Each one of these photographs required almost cinematic preproduction planning, not only with the hairstylist, the makeup artist, the stealth transport of each outfit to its respective location, the transport of the lights, the camera, the tripod, and the trolley, but also in hiring generator trucks to illuminate the streets at night, and obtaining the municipal permits and police cooperation to provide barriers around the bridge, or in the gardens, or by the river, to prevent pedestrians from walking into the middle of the shoot.

Dick had been doing this now for a decade. Undertaking so much preparation and employing minions (at the magazine's expense) to execute his ideas, he had become an impresario of the fleeting visual metaphor. The spontaneous moment Avedon had so painstakingly constructed for each one *appears* to be authentic, as if a fresh breeze were wafting through the frame. From this poetic impulse he created a revolution in the photographic image—despite the fact that it was in service of commerce. Avedon asserted into the world a "gesture" in the form of an idea about being alive—joyfully, pleasurably, beautifully—that would remain embodied in the implication of his name.

On the last day of the collections, Dick conceived the idea of shooting the models in front of narrow wooden planks he had had erected in the *Bazaar* studio. The models were leaning against the raw, hard-edged wood, which set off the soft, organic shapes of the dresses. It was the end of a grueling two weeks, and after that final shoot, he left the contact sheets at the San Regis for Mrs. Snow to review while he went off to dinner with friends. Upon his return, there was a note from Mrs. Snow to stop by her suite.

Dick entered her salon, as he had countless times before, and immediately saw her displeasure. "She was alone, sitting bolt upright in a chair facing the door," Dick said. "I didn't have time to say a single word. Looking straight ahead, she said, 'Not in *my* magazine. I will not have a distinguished dress photographed on a plank.'" As Dick later recalled, he was so well established by then that he would not have accepted anyone's demand for a reshoot when the pictures had already passed his own measure of quality. But this was Mrs. Snow, and because of his regard and affection for her, he grew circumspect. "For a woman to care that much at this moment!" he thought. "To sit up for hours waiting to let me have it because this was her last appearance as the editor of her magazine." He told her he would take the pictures over with pleasure. She thanked him and walked into her bedroom. "It was like the last thing between us," he said. "She knew she'd been fired. I wouldn't have dreamed of not obeying her to the letter at that moment."

Dick, inured to any criticism of her, often said about Mrs. Snow, "She taught me everything I know." But the best summation of her influence was his comment to a reporter earlier that year: "Mrs. Snow humanized clothes for me."

JOANNA (BROWN) BRODKEY WORKED for Dick as a studio manager between 1957 and 1959. She was another beauty, a Radcliffe graduate with an impeccable lineage that reached back to the Minutemen of Massachusetts Bay who fought in the American Revolutionary War. Joanna and her husband, Harold, who had published a few stories in the *New Yorker*, were part of a social circle of artists and writers, some more successful than others, although it was Joanna, with her breeding and fine education, who kept the couple in the social swim. On the occasion of the publication of *First Love and Other Sorrows*, a book of Harold

Brodkey's short stories, published by Dial Press in late 1957, all that would change.

In early 1958, Avedon photographed Harold Brodkey for the April issue of *Harper's Bazaar.* The full-page picture appears in a feature called "Young Writers": Brodkey "has lately joined J.B. [*sic*] Salinger as one of the literary admirations of the current college generation," *Harper's Bazaar* reports. "He lives in New York City, with the friend who shares the picture with him here." That "friend" is Brodkey's cat, who is walking on the ridge of his shoulders, a rare prop in an Avedon portrait. Another departure from Avedon's portraiture is Brodkey's smile—one that verges on frenzied delight. The camera is positioned at a slight elevation and Brodkey is looking up at us, up at Dick, his eyes opened wide, and piercingly so. His entire torso bleeds outside the edge of the frame. There is palpable contact between subject and photographer, and, clearly, in an almost aberrational reversal, Brodkey, as the subject, has taken control of the session, clearly having seduced the photographer, and, in turn, the viewer, as much as that is possible, for one cannot help but look at the picture and at Brodkey's almost demonic stare and be taken in. In this case, the picture is less a portrait by Avedon than a performance by Brodkey. They would become lifelong friends.

Later that year, *Life* magazine assigned Dick to photograph Marilyn Monroe dressed up as four fabled actresses for the December entertainment issue. Over the course of several days in his studio, Dick photographed Monroe as Theda Bara, the silent film era's singular sex symbol, sinking into lush animal fabrics across a bed and leering like a dominatrix in an elaborate headdress, a revealing metallic bra, and a midriff-high belly dancing outfit; Marlene Dietrich as a cabaret singer in top hat, suggestive undergarments, a black garter belt, bare legs crossed, and her classy high heels positioned like weapons of an erotic fantasy; Jean Harlow in

a sleek, body-hugging, white satin floor-length gown with a plunging décolletage, leaning back suggestively in a balletic stretch, her hand on a modern white couch behind her; and Lillian Russell in a grand wide-brimmed belle epoque hat with flowers spilling out over the top, sitting on a bicycle in her buxom finest with frills along the breastbone of a period bathing suit. Monroe embodied the role of each actress both in costume and makeup, likely as much at Avedon's direction as from her own instincts as an actor. "She read biographies of each star, studied old pictures," *Life* wrote in the introduction. "When photographer Richard Avedon asked her to rest her leg on a handlebar for [Lillian Russell], above, she refused, saying, 'Miss Russell just *wouldn't* have done that.'"

What an unstoppable moment for Richard Avedon! Not only was he in the unique and, to some, enviable position of photographing the most famous woman in the world, he was still basking in the glow of *Funny Face*. In 1958, Laura Kanelous's daughter, Helen, remembers, Dick arrived at their house one evening and said, "Let's go. I'm taking you all to see Lenny Bruce at Carnegie Hall." Life really was grand.

And, now, as if his reputation was in need of any further polishing, a lengthy profile about him appeared in the November 8 issue of the *New Yorker*. The title alone—"A Woman Entering a Taxi in the Rain"—invokes in perfect urban haiku the existential condition that defined an Avedon photograph.

In that era of an ever-flourishing and vibrant public discourse, when the creation of the public intellectual soon became a staple of the national conversation, the *New Yorker* "profile" was a unique kind of anointment into the cultural firmament. "The Avedon photograph—or, more broadly, the Avedon photographic style—has by now become a lively contribution to the visual poetry of sophisticated urban life," writes Winthrop Sargeant, the author, a music critic for the *New Yorker*, who, on occasion, would

single out someone to profile worthy of his contemplation outside his field of expertise, such as the filmmaker Vittorio De Sica, the anthropologist Margaret Mead, and the Zen philosopher D. T. Suzuki. Dick was in very good company.

Sargeant seemed to have a good bit of fun with his profile of Avedon, writing, for example, "Over the years, there have been many tales about his troubles with capricious models in Paris (they made up a good deal of the plot of 'Funny Face'), and most of them are true. Models *do* get lost and have to be tracked down through the mazes of boulevard night life; they *do* occasionally fall into the Seine; they *do* sometimes elope with wealthy playboys; and Dovima *did* nearly topple from the Eiffel Tower in an excess of dramatic fervor."

Sargeant's portrait of Avedon sails along enjoyably in this sardonic manner, but then, with a keen and perspicacious eye, he identifies a strain of insecurity that propels our protagonist toward an over-determined enthusiasm that borders on the obnoxious:

> *Formality is, in fact, just about the last quality that comes to mind in connection with Avedon. He may be, as many people suspect, fundamentally shrewd and calculating in his professional life, but, whether he is working or not, his manner is that of an eager youth, intensely preoccupied with those offhand, intimate forms of human communication that have been of such value to him in lulling his models into a mood of relaxed spontaneity. "I am always stimulated by people," he says. "Almost never by ideas." His candor about himself is so great, and so unabashedly exhibitionistic, that once, after being interviewed by a young lady from a newspaper, he sent her around to talk with his psychiatrist, to make sure that she had the whole story.*

Sargeant understood that, like all great artists, Avedon carried some riddle of existence that he would spend a lifetime trying to make sense of, trying to reveal.

"DICKABOO" WAS A TERM of endearment that Truman Capote used to begin some of his letters to Avedon, "Beloved collaborator" another. In 1958, Dick began work on a book of his portraits and asked Capote to write an extended essay that would include biographical "renderings," say, of Avedon, as well as some of his subjects in the book. Capote, who wasn't shy about calling Avedon "the greatest photographer in the world," readily agreed. The book project was a way to take inventory of the people of cultural significance Dick had photographed up to that point in his career, and, likely, a way to keep his name in the limelight by capitalizing on the cultural riches sitting in boxes and drawers in his studio.

Dick had asked Alexey Brodovitch to design the book, and, over the course of the year, he would lay out a floor grid of all the portraits he had shot over that decade to be considered. In his essay, Capote describes the scene when he visited the studio one day to find Avedon and Brodovitch walking on the pictures, kneeling here and there, moving the order around "like immense playing cards" and removing those that didn't make the cut: "Avedon was in his stocking-feet wading through a shining surf of faces, a few laughing and fairly afire with fun and devil-may-care, others straining to communicate the thunder of their interior selves."

Aside from the fact that Dick made most of these portraits for either *Harper's Bazaar* or *Theatre Arts*, usually on the occasion of a subject's new book or play or concert or film, the selection of portraits in *Observations*, published by Simon & Schuster in 1959, is somewhat arbitrary. While there are distinct categories of individuals in *Observations*, the portraits are not defined by any rubric but, rather, sequenced as if to follow the order of Capote's essay.

The random groupings open with Avedon's portrait of Charlie Chaplin, his fingers at the top of his head like devil's horns, followed by the directors René Clair, John Huston, and Alfred Hitchcock.

There are divas—Roberta Peters, Zinka Milanov, Marian Anderson. Actors—Judy Garland hugging four dozen long-stemmed roses to her chest, Bert Lahr emoting, Katharine Hepburn elocuting. And couples—Mr. and Mrs. Georges Braque; Mr. and Mrs. T. S. Eliot; Mr. and Mrs. Arthur Miller (Marilyn is here supplicant to her husband), and, of course, the Duke and Duchess of Windsor, who, among all the portraits, posit an *idea* about the monarchy more than they represent any semblance of accomplishment. They are hardly in the same category as, say, the writers whose portraits appear in the book: Isak Dinesen, Eudora Welty, Carson McCullers, and Somerset Maugham.

Among the other gods in the book, Picasso's face is unique, structured as a monument, the camera situated at the height of his chin so we are looking up at him, his deep, dark eyes peering out, over us and beyond. The mole under his eye, as well as every crevice and pore, is visible. "The Winner," Capote writes, as if to proclaim Picasso's stature above the others in Avedon's somewhat random pantheon of arts and letters. "Picasso was a child-prodigy who stayed one: that is, remained a prodigy and something of a child, a man inhabited by a boy's fooling-around impatience, hatred of system, fresh-eyed curiosity."

"I seldom see anything very beautiful in a young face," Dick is quoted as saying in the Capote essay. "I do, though, in the downward curve of Maugham's lips. In Isak Dinesen's hands." And, yet, perhaps the most arresting picture in the book—and the one most conspicuously out of place in this roster of accomplished individuals of the arts—is that of the young Emilien Bouglione, the animal trainer from the Cirque d'Hiver. Dick photographed him during his session with Dovima and the elephants in 1955. In his portrait, Bouglione stands shirtless, his muscular torso wrapped with the slithering body of a python, his virility most evident in his dark Italian eyes staring at us with a penetrating erotic intensity: he is

gently caressing the head of the python in his hand at waist level as if a Jungian surrogate for the male organ in sexual arousal.

By every measure, *Observations* is an objet d'art, a lavish, slip-covered, oversize coffee-table book printed in Switzerland, with eighty-two portraits, the final one being that of Capote himself, looking impish and stylish in a white shirt, his thumbs locked on his fine suspenders at his chest, a cigarette between his fingers, a winsome dandy. It is among the best portraits in the book.

While *Observations* received the kind of media attention expected of Avedon and Capote at that point in their careers, the critical reaction was not what they had hoped. The overdetermined, spare-no-expense quality of the book only underscored the impression that it was a splashy vanity project. And, with Capote's essay, which veered from a serious meditation on Avedon's photography to wild flights of metaphorical fancy, the intended intellectual gravitas went missing.

Minor White maintained a high-minded tone in *Aperture*, his journal of fine photography: "What other photographer has so persistently used cameras with such anti-photographic results?" he asked in a dismissive review of *Observations*. "Avedon wields his camera like a charcoal stick among the great men and beautiful women of today—drawing his crowsfoot deeper, that sarcasm deeper, this wrinkle more malicious, that grin more embarrassed."

While Avedon might have chafed at the slap-in-the-face rebuke from Minor White, he could find solace in a letter he received from Edward Steichen, then still at the Museum of Modern Art. "Hearty congratulations on your book—a real humdinger of a book!" Steichen's letter began, sent soon after *Observations* was published. He was writing to extend an invitation to Dick to give the museum a print of the Reverend Martin D'Arcy, who appears in the book, for the museum's collection. Avedon readily complied.

Today, *Observations* is a collector's item, a large-format, beautifully produced object of late-1950s elegance, encased in an upholstered jacket like a portfolio to be taken off the shelf and opened with reverence. It should be considered, rightly, a first draft in the long arc of Avedon's prodigious contribution to the genre of portraiture.

It is not too soon in the course of his story to submit that, across the history of the medium of photography, and, in the evolving clarity of the history of the twentieth century, Avedon advanced "the portrait" after August Sander. Sander and Avedon stand side by side in the twentieth century, one before World War II, the other following it. Sander made a copious record of individuals in German society before the Nazis came to power, codifying his subjects by geography, profession, or social identification over the course of forty years. His magnum opus, *People of the Twentieth Century*, composes with taxonomical organization the wave of migration of the agrarian in nineteenth-century German society to the vibrant urban center of Berlin in a rapidly industrializing world. Sander chronicled this transition as a portraitist, yet with the method, rigor, and focus of, say, a lepidopterist in the detailed study of butterflies and moths.

The Sander portrait is easily recognizable because of his straightforward approach, often photographing his subject full length, always in the environment of their trade or profession, rendered with optical precision and rich tonal description. The Avedon portrait is easily recognizable, too, as he advanced portraiture by stripping the picture frame to nothing but the subject against a white background, an innovation that speaks as much to the postwar nuclear age as it does to Avedon's clear-eyed acknowledgment of our collective existential condition. He, too, would make a forensic chronicle of various strata of American society, from the power elite and the culturally accomplished to itinerant individuals

in the American West—each and every one a specimen of a species capable of destroying itself.

As counterpoint to the professional success Avedon had attained by the end of the 1950s, another book of photographs appeared in 1959 called *The Americans*, by Robert Frank, published by Grove Press. It is small in size, an intimate visual chronicle of common people in ordinary situations drawn from several trips the photographer made throughout the United States, his adopted country, in the mid-1950s. While Frank's book was circulated within only a very small community of artists in downtown Manhattan, it carried an unspoken pedigree in the form of the three men who recommended Mr. Frank for the Guggenheim Fellowship that funded the road trips on which he produced the photographs in the book: they were Alexey Brodovitch, the reigning designer of the printed page in America; Walker Evans, the photographer—also the picture editor of *Fortune* magazine; and Edward Steichen, the curator of photography at the Museum of Modern Art. As a result of such substantial endorsement, Avedon would be all too aware of the publication of Robert Frank's book.

Until *The Americans* appeared, the hallmarks of good documentary photography had been sharp, well-lit, classically composed pictures, whether serious war coverage, social commentary, or homespun Americana. *Life* magazine photographers like Margaret Bourke-White, Alfred Eisenstaedt, and W. Eugene Smith had been setting a standard for the picture essay, as had Henri Cartier-Bresson, one of the founders of Magnum. Robert Frank would change that, but not before a small chorus of critical disdain rose from the few publications that bothered to write about *The Americans* on the occasion of its publication. *Popular Photography* magazine derided Mr. Frank's black-and-white pictures of isolated individuals, teenage couples, and groups at funerals for their "meaningless

blur, grain, muddy exposures, drunken horizons and general sloppiness."

Critics considered Frank's book an indictment of American society, and, in fact, Frank's pictures did strip away the veneer of breezy optimism reflected in many magazines, movies, and television programs of the period. Mr. Frank was twenty-three when he moved to the United States from Switzerland in 1947, and the America he discovered during his cross-country travels proved to be a much harsher place than Europe. "Here it seemed that everyone was sort of alone more," he said, in contrast with the more social Europe he remembered, where everyone was friendlier.

Twenty years after *The Americans* was published, Gene Thornton wrote in the *New York Times* that it ranks "with Alexis de Tocqueville's 'Democracy in America' and Henry James's 'The American Scene' as one of the definitive statements of what this country is about." Photographers, critics, and scholars have long since concluded that Mr. Frank liberated the photographic image from the compositional tidiness and emotional distance of his predecessors. The ordinary, incidental moments captured in his pictures—and their raw, informal look—paved the way for photographers like Diane Arbus, Lee Friedlander, and Garry Winogrand a decade later. Today Mr. Frank might be called the father of "the snapshot aesthetic," a term coined in the late 1960s to denote the spontaneous style and modest subject matter that came to dominate black-and-white photography of that period.

"People thought I hated America," Frank said about the reaction to *The Americans* when it was first published. Today, his émigré artist's perception looks like a chillingly accurate observation of the mid-twentieth-century American social landscape—an indictment, perhaps, but also a cri de coeur about the failed expectations of the great American promise.

The contrast between *The Americans* and *Observations*, while seemingly asymmetrical, presents an opportunity to survey what was happening in photography in the 1950s and to cast Avedon in the flow of that evolution. Frank believed Avedon to be a Sammy, a sellout, his public reputation a justification for the artificiality of his photographs, a commercial photographer who was thereby exempt from any consideration of serious intent as an artist. Avedon, too, lived with a sense of discomfort about the fact that Frank *was* the real thing, even though Frank's authenticity, in the end, would not invalidate Avedon's accomplishment. Still, Avedon did not do himself any favors by insinuating his work into the world with so much fanfare; the glare of the package always seemed to obscure the contents within it. Regardless, in photographic terms, the dichotomy between *Observations* and *The Americans* has to do with "the studio" versus "the street"—the constructed image versus the authentic, happened-on moment. Both are valid arenas in which to locate the impulse of the artist in the exploration and resolution of an idea. In the 1960s, "street photography" would take on greater currency in the evolution of the medium's worthiness on the museum wall; "the studio" was thought to be an artificial form of photography that failed to measure up to the authenticity required of real art. And *fashion*! That was never part of the conversation. It would be another thirty years before the scales balanced out between "the studio" and "the street," when the authentic moment ceased to be the essential criterion for assessing photography as art.

# THE NEW DECADE

(1960–1962)

How naïve I was in 1960 to think that I was an American
living in preposterous times! How quaint! But then what could
I know in 1960 of 1963 or 1968 or 1974 or 2001 or 2016?

—PHILIP ROTH

I n 1957, nothing made a cosmopolitan New Yorker feel more
sophisticated than to say he or she had just seen the comedy act
Nichols and May at the Blue Angel, a nightclub on East Fifty-
Fifth Street. Mike Nichols and Elaine May, in their mid-twenties,
had become an instant word-of-mouth phenomenon among the
tastemaking set, with their wry, improvised dialogues on taboo
subjects that had never before been addressed in so legitimate a
public venue—sexual behavior, adultery, American mediocrity. The
duo could make a mockery of highbrow self-importance with the
simplest dismissive colloquial phrase, or parody the psychological

dynamic between a mother and her adult son with pitch-perfect inflection and deadpan wit. While at the time Lenny Bruce had his own sophisticated following, many people were put off by the risk of a vice squad arrest in the middle of a show because of the profane language in his incendiary diatribes. In a 1996 PBS documentary about Nichols and May, Tom Brokaw, with his plain-speaking all-American newscaster logic, offered a simple explanation for their instant success in New York: "Because their act was so intelligent," he mused, citing their use of language, their appearance, and their style, "they had snob appeal." While their verbal sketches could pivot on a series of ironic twists, they did not rely on definitive punch lines, which distinguished them from the more obvious comedy acts on the radio or in early television; if anything, their dialogues played out like narrative versions of the proverbial *New Yorker* cartoon.

Avedon, who made a habit of attending any show he liked more than once, and sometimes over and over again, was particularly obsessive about Nichols and May, showing up at the Blue Angel with a stream of friends throughout the run—one night bringing Leonard Bernstein, another Betty Comden and Adolph Green, yet another Sidney Lumet. Following the Blue Angel debut, Nichols and May were swept into a media vortex for at least another year, appearing on TV shows hosted by Steve Allen, Dinah Shore, and Jack Paar, and performing in clubs around the country. It would not be until 1959 that Dick, in a gesture that exemplifies both his instinctive reading of a cultural moment and his savvy understanding of the sway of his professional reputation, called Mike Nichols, to whom he had not yet been introduced, with a proposition.

CBS was putting together a two-hour television special called *The Fabulous Fifties*, and Leland Hayward, the producer, told Dick that if he could convince Marilyn Monroe to appear on the show, Dick could direct the skit. Dick called Mike Nichols to ask if he

and Elaine May might be interested in writing the skit for Monroe. "The first time I met Dick was in his apartment at 625 Park Avenue," Nichols told Norma Stevens, describing the splendor of the Avedon living room, with its big white couch upholstered with a "field-of-poppies" fabric. Mike came alone, and he and Dick hit it off instantly, riffing, laughing, and free-associating as they developed ideas for the Marilyn skit. When Mike left, Dick walked him to the elevator, put his arm around him, and said: "I have a feeling we're going to be friends for life."

That premonition turned out to be true. Mike, who was taller and heavier than Dick, was not handsome, per se; because of an immune disorder that occurred early in his life, he had no body hair and wore toupees. And yet, it was not only his quick wit but his easy and fluid laughter that could register the gleefulness of a child in his infectious smile. Dick and Mike would establish a unique camaraderie in what became a lifelong friendship, both eventually hovering at equal altitude at the top of their professions. What Dick and Mike had in common and recognized in each other early on was the feeling that they were frauds: neither one could quite reconcile in themselves the damage done to their psyches as gawky and awkward children, terrible students, targets of ridicule by classmates, tortured by fathers with impossible standards; each of them proceeded through life with residual alienation in a lingering atmosphere of self-disgust. It was a puzzlement for them both to have started out, respectively, from such inauspicious beginnings and end up living grand lives with a level of fame, success, and wealth that epitomized the American dream. In the early years of their friendship, Dick was the mentor, instructing Mike on what to eat—caviar, for example—and how to eat it; how to order in a restaurant; how to travel; where to travel; and even how to dress. Dick exposed Mike to art—good art, Giottos, for example, hanging on the walls of a private palazzo in Venice where they had

been dinner guests soon after they met. Toward the end of his life, Mike described Dick's influence on him to David Geffen: "Richard Avedon taught me how to be a rich person."

Still, frauds, by definition, do not work as hard as each of them worked to achieve what they did, and yet it is easy to understand why they might have felt like poseurs: when you are so talented, when the ideas come so easily and you have such immediate access to your own creative reserves, this effortlessness can amplify the sense of fraudulence in the wake of so much public acclaim—in particular, when feelings of deficiency persist at the foundation of one's emotional anatomy.

A week after Mike's first visit to Dick's apartment, they went to see Marilyn Monroe and Arthur Miller, who lived in a penthouse off Sutton Place, just a few blocks from Dick's studio, now at 150 East Fifty-Eighth Street. They pitched their idea for the *Fabulous Fifties* skit, and Miller, to whom Marilyn invariably deferred, politely concluded that it wasn't quite right for his wife. This did not stop Dick from delivering Nichols and May to Leland Hayward, and then convincing Hayward to let him direct his own skit anyway, which starred Suzy Parker in a series of sketches that were send-ups of various recognizable advertising campaigns of the period.

The directors of *The Fabulous Fifties*, which aired on January 29, 1960, were the designers Charles and Ray Eames, as well as Norman Jewison. The show's host was Henry Fonda. Aside from a medley of songs from Broadway shows and Hollywood movies— *A Star Is Born*, *My Fair Lady*, *Gigi*, *Gypsy*, and *Around the World in 80 Days*—there were newsreel snippets of Elvis Presley, Frank Sinatra, and Sammy Davis Jr. The show starred, among others, Julie Andrews, Dick Van Dyke, Rex Harrison, Jackie Gleason, and Dick's friends Betty Comden and Adolph Green. The Nichols and May skit was called "Water Cooler Talk," in which they played

two employees discussing a recent scandal over *Twenty-One*, a very popular TV quiz show in which contestants who answered difficult academic questions correctly could walk away with sizable amounts of money. It turned out the quiz show was rigged and one contestant, Charles Van Doren, a handsome young man with sterling social and intellectual credentials, was compelled to testify before Congress about his complicity in the scam:

"The government is taking a firm stand," Nichols says, stopped at a water cooler and sipping from a cup.

"Well, they can't fool around with this the way they did with *integration*," May says.

"It's a moral issue," Nichols says.

"*Yes*, a moral issue," May says. "To me, that's so much more interesting than a real issue."

So began the new decade for Avedon, and that was only January. In February, he began photographing a half dozen socialites dressed as modern-day sphinxes, with hair designed by Kenneth, including Gloria Vanderbilt, Princess Stanislaw (Lee) Radziwill, Contessa Christina Paolozzi, and Marella Agnelli. The April issue of *Harper's Bazaar* featured a seven-page spread of these photographs entitled "the sphinx within"—the headline designed in ultramodern lowercase type. Perhaps the idea came to Dick because of reports that *The Life and Times of Cleopatra*, a 1957 book by Carlo Maria Franzero, was being adapted for the screen and would soon begin production. The magazine spread opened with a picture of Vicomtesse (Jacqueline) de Ribes, a mane of hair surrounding her face in the shape of a Cleopatra headdress, facing the camera and crouching on the floor like a wildcat ready to pounce. Nancy White, Carmel Snow's niece, was now the editor in chief of *Harper's Bazaar*, and Henry Wolf had replaced Brodovitch. This changing of the guard had given Avedon ever more latitude to let his imagination roam, but if the sphinx layout was any indication

of the adult supervision coming from the new masthead, then the decade was off to a fatuous start—at least at *Harper's Bazaar.*

In twenty-first-century terms, the sphinx pictures are patently humiliating to women—the picture of Lee Radziwill, for instance, crouched on hands and knees like a feline pet—would no longer be tolerated. Only Gloria Vanderbilt (Lumet) is photographed in the manner of a reigning socialite, standing regally in a striking gown of alternating black and white geometric patterns. The *Bazaar* layout generated a good deal of controversy: "Richard Avedon is a marvelous photographer," Suzy Knickerbocker wrote in the *New York Mirror.* "But in the current issue of *Harper's Bazaar,* in a series of photos titled 'The Sphinx Within,' Avedon plus his photographic subjects are just too much." Even "Suzy," the salacious society columnist, was incredulous: "The girls for the most part look like half Greenwich Village beatniks and half savage African headhunters." And yet, here was a perfect example of bad publicity being better than no publicity. The media response was a kind of benign finger-wagging; given the largesse of the socialite-models and the mere whiff of scandal to animate their impeccable names within the safe boundaries of the *Bazaar* pedigree, it only seasoned Dick's stature as a "bad boy" in the winkiest sense of the word.

As *The Fabulous Fifties* went into production, Truman Capote embarked on a serious excursion to the Midwest. He had read a small item in the November 16, 1959, issue of the *New York Times* about the cold-blooded murder of a wealthy farmer and his family, and convinced the *New Yorker* to pay for this reconnaissance mission to Kansas to see if there might be a deeper story to tell. There, he made contact with Alvin Dewey, the detective in charge of the murder case. Upon his return to New York, Capote wrote to Alvin Dewey and his wife, Marie, as a friendly gesture, to announce a firm assignment from the *New Yorker* and a book contract with Random House. "When we come back," he writes, "I will

very likely bring with me Richard Avedon, who is quite easily the world's greatest photographer." Of course, he hadn't yet asked Dick if he was remotely interested.

Between *The Fabulous Fifties* and the *Harper's Bazaar* sphinx pictures, Dick was consumed with a host of commercial campaigns from various advertising agencies: Pond's, Clairol, DuPont, Hertz, Revlon, Gordon's Gin, Schweppes, and others. And, in between those photo sessions, he had portrait sittings for the *Bazaar* with Nichols and May, François Truffaut, and Mary Martin. Among this string of portraits in early 1960 was that of W. H. Auden. Dick photographed him outdoors, on the street, in the snow. Auden is wearing a long winter coat and he stands, hands in his pockets, as if enduring the seasons—a monument—with a sense of his own place in history. The portrait is Avedon's "Balzac."

The enterprise of the Avedon studio was in full tilt, which was fine in terms of the income Avedon was happily generating, but the routine diet of commercial work was not always, as Dick liked to say, "his time of day." The idea of taking Capote up on a jaunt to Kansas to photograph two convicts was a welcome one—the kind of foothold in reality that Dick thought would earn him a bit more gravitas—particularly if the *New Yorker* was paying for it. On March 20, Avedon ventured to Garden City, Kansas, with his Rolleiflex, taking with him what Steinbicker thought were some odd film choices: 120 Agfa Record film, 120 TX, 35mm Hypan, 35 TX, 35 PX. Once there, Dick felt conspicuous, not only as a New Yorker but also as a Jew, yet he felt virtually normal in contrast to the ever-flamboyant Capote, who brought out a venomous strain of xenophobia in the local Plains folk. "I expected to find him in blue jeans and a blue jean shirt like every other farm hand out there," Avedon said about Capote. "But there he was in a fancy brocade vest. He was not going to be invisible. They would know he was there and have to deal with it."

One day Avedon and Capote walked into the courthouse in Garden City, where a group of rough, hard-bitten policemen were sitting around. Truman walked right up to Roy Church, a Kansas Bureau of Investigation agent, and, in his highest voice, said, "Oh, you don't look so tough to me." This prompted Church to put his fist right through the courthouse wall. Truman threw his hands over his head, hopping from one foot to the other, and screeched, "Ah'm beside mahself, Ah'm beside mahself." Miraculously, it defused the tension, and everyone, including Church, burst out laughing. "It was one of the most brilliant, physically inventive and courageous things I've ever seen in my life," Avedon told Gerald Clarke, Capote's biographer. "Truman would have survived in the jungles of Vietnam. He won that duel in the same way he won the town [of Garden City]."

Avedon was there to make portraits of the murderers, Dick Hickock and Perry Smith, whose trial took place on March 22. Both were ex-convicts who had met in prison. Once out on parole, they set out to rob the home of Herbert Clutter, a farmer in Holcomb, Kansas; when they couldn't find the safe they had been told about, they commenced the gruesome murders of Clutter, his wife, and his two children. According to Capote, when the wife of the case investigator saw Hickock's police mug shot, she was reminded "of a bobcat she'd once seen caught in a trap, and of how, though she'd wanted to release it, the cat's eyes, radiant with pain and hatred, had drained her of pity and filled her with terror."

The forensic evidence against the suspects was overwhelming, so the question was not whether Hickock and Smith were guilty or innocent, but whether the judge would give them life imprisonment or death. For Avedon, the essential question when faced with these two coldhearted murderers was not how they could have done such a vicious thing but why. Money alone was not an adequate enough answer for Dick, nor for Capote, who would spend another

five years weighing the question as he returned to Kansas innumerable times while writing *In Cold Blood*.

When Avedon photographed the murderers, he was confronted with an entirely new set of challenges. "When I approached them," he later recalled, "I kept saying to myself, 'Do not have a point of view. Be careful. Don't push this.'" Avedon did not have a lot of time to photograph them as he set up his white backdrop in the courthouse. He managed to make several individual portraits of Hickock and Smith. In one set, he clearly directed each one to show off the multiple tattoos on his biceps. He also made close-up portraits, as if police mug shots, of each of them. In the portrait of Hickock, the right side of his face is in sharp focus, the left in a slight receding blur, the ambiguity from one plane to the other mysterious and haunting. According to Capote, Hickock had always been self-conscious about his long, lopsided face. His nose juts out at a Picasso angle, and while his right eye meets Avedon's lens straight on, his smaller left eye veers off to the left. The portrait animates the separate planes of Hickock's face, echoing the early double portrait Avedon made of the merchant mariners—one in focus and the other out of focus—that first caught Brodovitch's attention in the early 1940s. The portrait of Hickock hung in a 2016 exhibit at the Metropolitan Museum of Art, with this label: "The mug shot–like portrait captures Hickock's sullen, lopsided face with mesmerizing clarity, as if searching for physiognomic clues to his criminal pathology."

Several years after his trip to Kansas, Avedon was in conversation with Irving Penn about their respective approaches to portraiture. "I'm not impressed with the *fact* of Eisenhower . . . it doesn't interest me that he was President of the United States, or that Perle Mesta is a hostess," Avedon said. "It interests me that they all have to face their death, and that that terror is in all of us, and in my portraits. That's the thing I see. That's the thing I've always worked

in relation to. . . . I don't think it's so important *who* they are, we're all born the same way, and all end up the same way."

IN THE FIRST FEW months of Dick's new friendship with Mike Nichols, they socialized regularly. Dick and Evie took Mike and his first wife, Patricia Scott, out to dinner on several occasions. Almost immediately, it became obvious to Dick that Mike's marriage was troubled, and, in mid-January, before *The Fabulous Fifties* aired, the Avedons took Mike, alone, with them to Round Hill in Jamaica, renting their own villa instead of sharing one with the Bernsteins, as they usually did. During that trip, on the occasion of Evie's birthday, on January 16, instead of the quiet dinner à deux Dick had promised her, he surprised her with a birthday party in the Avedon *grand geste* fashion. Among the guests surrounding a bonfire on the beach that night were the Leonard Bernsteins, the Bill Paleys, the Oscar Hammersteins, the Bennett Cerfs, Kitty Carlisle and Moss Hart, and Adele Astaire. Evie, expecting a quiet, intimate evening, was furious when she saw the bonfire and the assembled group, and, while gracious enough to put up a "birthday" front for a while, she left her own party before the cake arrived.

According to Nichols, Dick reasoned that he had a swank on-the-spot guest list at Round Hill and took advantage of his ability to impress them by throwing a spur-of-the-moment dinner party on the beach. That Bill Paley, the president of CBS, was someone Dick and Evie had socialized with at Round Hill for years may or may not have had anything to do with Dick's involvement with *The Fabulous Fifties*, but the timing of the spectacular beach party a week before the CBS special was scheduled to air on national television was, if nothing else, propitious. Avedon hired a band from Kingston and arranged a menu of Senegalese soup, rock lobster, and curried goat. The impromptu event seemed disingenuous not

only to Evie, the guest of honor, but to her friend Felicia Bernstein, who later told Dick that, given Evie's temperament, the surprise party was a "dopey idea." Certainly it was no surprise in this group that Paley, whose wife was known to be the most beautiful and socially prominent woman in New York, could not keep his hands to himself around every woman in his midst, including, on that occasion, the reluctant birthday girl.

For Nichols, it was an advanced tutorial in the bad behavior of the jet set. Dick, as exhibit A, was sullen about Evie's ingratitude, despite the fact that it was clear to her, and to others as well, that he had thrown the party for his own benefit. Soon after the trip, Dick told Mike that his analyst suggested Evie enjoyed being the victim of Dick's celebrity, which is how she justified her own "chronic bad behavior"—her vacant silences throughout dinner with friends as she sat and stared at her hands, or the hours she would spend behind the closed door of a closet in their apartment, alone.

Nichols had a different theory about Evie, which he put forward to Norma Stevens: "The thing about Evie was she always told the truth," he said. "For instance, she could see a piece of theater that everyone loved and see right away—and explain why—it was a piece of shit. She could also see through people and be quite blunt about what she saw in there." Winthrop Sargeant of the *New Yorker* spun a more anodyne version of Evie in his profile of Avedon several years earlier: "Mrs. Avedon is very canny at sizing up people, and has good taste in books, music, and photography, including her husband's, which she is perfectly ready to comment on, favorably or not, to him or to others," he writes. "She is very proud of his standing in his field, goes along unobtrusively on all his Paris expeditions, and talks over each new project with him before he sets to work on it. Friends of the couple also credit her with having given the Avedon ménage much of its stability by providing a tranquil refuge for her husband, one of those dedi-

cated men whose work is the principal—almost the exclusive—
end of existence."

Soon enough, Mike divorced Patricia. This coincided with the
divorce of Dick's friend Harold Brodkey, who had recently returned
from his yearlong fellowship at the American Academy in Rome,
from his wife, Joanna. Dick, ever the matchmaker, set Mike up
with Joanna Brodkey. They would become involved for another two
years and live together in a house in Connecticut. Mike even asked
her to marry him, but their engagement was short lived.

ON MAY 1, JOHN Cage, the composer; Merce Cunningham, the
choreographer; and Robert Rauschenberg, the artist—three men
who in 1960 represented the very essence of the avant-garde—
arrived at Avedon's studio to be photographed for a feature in
*Harper's Bazaar.* Their names were not yet known in mainstream
culture, although Cage had gotten a bit of attention in the con-
ventional press as something of a crackpot for his 1952 piece *4'33",*
a three-movement composition—or concerto—that calls for a
performer to stand onstage with a musical instrument, whether a
piano, flute, or cello, and do nothing for four minutes and thirty-
three seconds. The silent composition was influenced by Cage's en-
counter with the so-called white paintings of Rauschenberg—huge
canvases of undifferentiated white whose surfaces vary in the infin-
ity of shifting light. At the premiere of *4'33"* in Woodstock, New
York, in 1952, people in the audience were intermittently baffled
and offended. "They missed the point," Cage later said. "There's
no such thing as silence. What they thought was silence, because
they didn't know how to listen, was full of accidental sounds. You
could hear the wind stirring outside during the first movement;
during the second, raindrops began pattering the roof; and during
the third, people themselves made all kinds of interesting sounds

as they talked . . . or walked out." Cage's remarks about music—
"There is too much *there* there" and "There is not enough of *nothing*
in it"—represented a binding philosophy that many younger paint-
ers and sculptors at the time seemed to embrace.

Merce Cunningham, Cage's lover, was changing not just the
grammar of modern dance but the very language of interpretive
movement. Avedon had seen a Cunningham performance not too
long before this photo session, and he was struck by how separate
the dancers were from each other, and from Cage's music, and from
Rauschenberg's sets. "Everything just went along on its own, not
really intersecting," Dick said. "The dancers moved neither with
nor against the music or each other." Rauschenberg, in addition to
designing sets for the Merce Cunningham Dance Company, was
building his own canvases beyond the painted surface to include
found objects in what would become known as his Combines, be-
yond abstract expressionism, into a form all its own.

Together, Cage, Cunningham, and Rauschenberg were a force
field in the changing course of artmaking. On top of that, they
were homosexual. The "closet" was quite a well-populated place in
the New York art world of the 1950s and 1960s, habituated also by
many other artists who became prominent in later years, such as
Ellsworth Kelly, Jasper Johns, Ray Johnson, Cy Twombly, Andy
Warhol, as well as the poets Frank O'Hara and Allen Ginsberg,
the curator Henry Geldzahler, and, in Avedon's own sphere of in-
fluence, Truman Capote and Tennessee Williams—who did not
even bother with the closet, protected as they were by their vaunted
reputations. But Dick, fully aware of the construct of the closet,
maintained a professional distance from that aspect of their lives—
and also his own.

While Avedon proceeded at the crest of popular culture, Cage,
Cunningham, and Rauschenberg attacked their work completely
outside the social order. Yet Dick and this trio would find a com-

mon language in the photographs he made of the three of them that ran in the *Bazaar* in September 1960. Cropped in the Brodovitch mode, with strong graphic shapes within the frame that span a two-page spread, the three men appear as if they had been blocked choreographically, each one at a different distance from the picture plane. Cunningham stands at the center, emerging in the foreground almost monumentally, his chin jutted forward, his lips almost pursed, his eyes aimed beyond the frame to the right, the odd expression on his face one of distressed contemplation; on the left side of the image. Rauschenberg stands in negative space, his gaze aimed in the opposite direction, his expression intent and solemn. Cage stands behind Cunningham on the right side of the image, his face in profile, his eyes lowered, his mouth obscured by Cunningham's shoulder. Unlike the official Avedon portrait of Cage, Cunningham, and Rauschenberg, in which all three are facing the camera in jovial laughter, the mood in the published picture is quite grave, each one in the isolation of his individual thoughts, orbiting each other as planets in space.

Dick was eager to embrace the conceptual ideas of the avant-garde, while, at the same time, he was not averse to the elegant customs of the haute bourgeoisie. Dick could always be relied on to keep his fancy friends up-to-date and in the know, adding to their sense of inner-circle self-satisfaction. In these quarters, his reputation certainly depended on it. One afternoon in the summer of 1960, Gloria Vanderbilt and Sidney Lumet had a garden party at their Connecticut home, called Faraway House, a stone cottage tucked away on the Mianus River in Greenwich. It was a familiar crowd that included not only Dick and Evie, but Adolph and Phyllis Green, the recently married Carol (Saroyan) Grace and Walter Matthau, and a few society friends, such as Judy Peabody. Gloria had gone out of her way to make sure that everything was perfect, each table with a Porthault tablecloth and a bouquet of flowers, a

fine, lavish menu, and plenty of alcohol. "Gloria didn't really give parties to see her friends, so much as to allow her friends to see her," observed Aram Saroyan, as if it were family lore handed down from his mother. Gloria's guests were a group of people with "history." They had by now known each other for years, despite the fact that they were only in their mid-thirties. There would have been plenty to talk about. Sidney Lumet was at that moment directing *The Iceman Cometh*, a TV movie adaptation of Eugene O'Neill's 1946 play, with Jason Robards, for CBS. But even more relevant was his recent great success with the film *The Fugitive Kind*, adapted by Tennessee Williams from his play *Orpheus Descending*, which had opened to some excellent reviews only two months before.

The 1960 presidential campaign between Vice President Richard Nixon and Senator John F. Kennedy was a topic of conversation wherever Dick went. He must have known that Diana Vreeland had been secretly advising Jacqueline Kennedy on what to wear on the campaign trail. Avedon had it in his sights to photograph the Kennedys as the "First Couple," should that come to pass. In the meantime, the activities surrounding his best friends, whether Sidney Lumet, Harold Brodkey, or now Mike Nichols, kept him in the center of the cultural swirl. "The apotheosis of Nichols and May's performing career was *An Evening with Mike Nichols and Elaine May*," writes Sam Kashner; the show opened on October 8, 1960, at the Golden Theatre, on Broadway's West Forty-Fifth Street, a month before the presidential election. "Opening night was a gala, preceded by a buffet at Sardi's. Carol Channing, a young, skinny Richard Avedon, Sidney Lumet, and Gloria Vanderbilt were among the guests." As perks of the festivities, the producer arranged for an armada of Rolls-Royces to bring guests from Sardi's to the theater, one block away, and a Ferris wheel was set up in front of the theater to celebrate the opening; fans danced in Shubert Alley after the curtain fell on the first night. Nichols and May presented their

usual sketches and only one improv segment a night. When the audience threw out suggestions, Nichols and May were ready for every literary style—Faulkner, Beckett, Tennessee Williams.

ON JANUARY 1, 1961, Avedon arrived in West Palm Beach, Florida, with his assistants in tow, two days ahead of a very important assignment. He would be taking the first pictures of the new president and Mrs. John F. Kennedy and their family to appear in the February 1961 issue of *Harper's Bazaar.* It was the only formal photographic session the incoming First Family had agreed on before the inauguration. Not only was it a scoop for the magazine, it was a long-awaited coup for Dick. His pictures of the Kennedys would introduce a new feature in *Harper's Bazaar* in which Avedon himself was given a column in the form of a monthly picture essay: Dick's name would be prominent in the headline of the opening spread, including this first one: "Avedon: Observations on the 34th First Family." The feature was listed as "the first in a monthly series of observations by Richard Avedon on aspects of contemporary life."

On January 3, the day of the shoot, the weather in Palm Beach was seasonal, a tropical, breezy 75 degrees. It was the day the United States had officially severed diplomatic relations with Cuba, and the president-elect was absorbed for much of the afternoon with updates from the office of President Dwight D. Eisenhower. The Kennedy estate in Palm Beach, at 1095 North Ocean Boulevard, was a rambling affair, designed in the Mediterranean style. Dick's assistants were busy hanging the roll of white backdrop paper, loading his Rolleiflex cameras with $2\frac{1}{4}$-inch film, and positioning the piano bench on which the new presidential couple would be sitting. "As Avedon was setting up his portable portrait studio in the grand living room, Kenneth of New York was styling Jacqueline

Kennedy's hair," writes Shannon Thomas Perich about the scene inside the mansion. "Rose Kennedy was selecting clothes for Caroline and John Jr.; and aides, Secret Service, and other Kennedy family members came and went, relaying phone messages back and forth to the president-elect."

"When I took Caroline's picture with her father, he was dictating memos to his secretary," Avedon told a *Newsweek* reporter at the time. "When I'd ask him to look around, he'd stop dictating. But the moment I finished he'd start in where he left off. I've never seen such a display of mental control in my life."

While Avedon's name was significant in gaining access to the Kennedys, it was really Diana Vreeland to whom Mrs. Kennedy was paying a debt of gratitude. Vreeland had traveled in the same circles as Jackie's parents, the socialite Janet Lee and the stockbroker John Bouvier III, and, then, later, Janet and her second husband, the Standard Oil heir Hugh D. Auchincloss. In 1947, Jackie was anointed "the Queen Deb of the year" by Igor Cassini—Oleg's younger brother—who wrote a syndicated gossip column under the name Cholly Knickerbocker. Vreeland had met Jackie as a girl. "She had that wonderful pizzazz of youth," Vreeland said of her as a child, "something she has never lost."

In 1953, when Jacqueline Bouvier married Senator John F. Kennedy, whose father had been US ambassador to Britain, the wedding reception at the Auchincloss family home, Hammersmith Farm, in Newport, Rhode Island, was covered by Toni Frissell, a family friend and a photographer for *Harper's Bazaar.* The wedding was exactly the kind of social affair Carmel Snow believed to be good for the magazine, but at the last minute she pulled the pictures because of the amount of press exposure the wedding would have already received by the time the issue appeared.

Vreeland's influence on fashion and, in the larger sweep, cultural *style* in the second half of the twentieth century cannot be

overemphasized. Her deep knowledge of clothes, their structure, the drape of fabric, and the history of ceremonial fashion conspired with the alchemy of her *taste* to create the "Jackie" look. In August 1960, during the presidential campaign, Mrs. John F. Kennedy wrote a ten-page, handwritten letter to Mrs. Vreeland asking for help. "Jackie had no qualms about asking Mom for advice on what clothes to wear," Nicholas Vreeland said. She was being scrutinized in the media for her non-American style, and it was not playing well in the heartland. She feared she might be a liability to her husband's campaign.

"You might know exactly the right thing," she wrote to Mrs. Vreeland. "You are psychic as well as an angel." Aside from Jackie's prim New England education—Miss Porter's and Vassar—she was something of a Francophile and had an affinity for European fashion, such as Balenciaga, Chanel, and Givenchy, which gave her a decidedly Continental air. "I must start to buy American clothes and have it known where I buy them," she wrote. "There have been several newspaper stories . . . about me wearing Paris clothes, and Mrs. Nixon running up hers on the sewing machine." Mamie Eisenhower had been wearing gowns by the American designers James Galanos, Norman Norell, and Arnold Scaasi, but they were not for Jackie; in Mainbocher, she offered, "I just look like a sad mouse." Still, she wondered if Mainbocher might be the best choice for an inaugural ball. "It may be presumptuous to even be thinking about it now, but it's such fun to think about," she wrote. Vreeland agreed to advise her and did so throughout the campaign.

Oleg Cassini was Vreeland's answer. He had dressed Rita Hayworth and Joan Crawford, and Mrs. Kennedy named him as her official wardrobe designer. "She liked my Hollywood experience," Cassini told the *Bazaar* in 1994. "I was trained to work from a script to create a look and a personage." According to Cassini, it was Jackie, not her husband, who cultivated the vision of Camelot

that the Kennedy presidency came to embody. Cassini said, "She's the one who had the time, the desire, the taste."

The six-page Avedon spread on the First Family opened with a picture of Caroline, then three years old, with her cheek to her father's hand, which she is holding, the president-elect out of the frame. It is a surprisingly intimate and casual photograph of a "First Child," a window onto the youthfulness of the family that would set the Kennedy tone for the country and the decade. In a second picture, Caroline holds baby John Jr., barely five weeks old, in her lap, looking down at him as his hand—with a lucky Avedon gesture of extended fingers—is lifted to his face. The full-page picture of the president-elect and his wife serves the purpose of a formal portrait, upholding the dignity of the office and the couple alike, but they sit with inexpressive faces and a stolid demeanor—a picture more Bachrach Studios than Richard Avedon.

There are two pictures of the First Lady. In one, a heartstring-pulling image that is, in fact, anything but sentimental, she stands in profile holding baby John-John to her chest with an expression on her face so delicate and tender, the gesture of her hand to his head so protective, that it reaches toward the iconography of a Madonna and Child tableau. The feature's pièce de résistance, however, is the full-length portrait of Jacqueline Kennedy dressed in a thoroughly modern, elegant, ivory satin full-length Oleg Cassini gown that she would have worn, by the time of publication, at a preinaugural ball. The opera-length ivory gloves on her arms match the dress. She wears no jewelry in the photograph. Her hair is a stylish, minimalist bouffant, the length just above her chin, sculpted with a hint of a flip on one side. She faces the camera directly and stares with a steely resolve that is countered only by the comeliness of her features. Avedon seemed to have an instinctive understanding of what would fall in place historically, and he chronicled the moment, always with an eye toward its historic significance. This published

photograph of the new First Lady is the gift that Avedon made for Jackie—not a mere photograph but a society portrait worthy of John Singer Sargent. What the portrait lacks in color, brushstroke, and texture it makes up for in its iconic representation of a new chapter in American history.

SOMETIME IN THE LATE spring of 1961, Dick received a letter from Alen MacWeeney, an enterprising twenty-year-old photographer from Dublin, Ireland, accompanied by a box of photographs he had taken that included a wild card portrait of Orson Welles. MacWeeney had been exposed to very few books of photographs in Dublin, but one of them, *Observations*, by Avedon, had inspired him enough to seek an apprenticeship with the great photographer. "The possibility of [your] working in my studio interests me," Dick wrote back, "although your work as a photographer does not." Dick proposed that the young man meet him in Paris later that summer when he was there to photograph the collections. And so, MacWeeney made it to Paris and had his interview with Avedon at the San Regis, wearing a three-piece tweed suit in the sweltering heat of late July. "Dick was very nervous, very jittery," Alen remembered. "He didn't exactly interview me. He kind of stared—his eyes would be bugging out. . . . It was amusing, and I didn't know what to make of it. I didn't know whether I made a good impression or not." Dick spoke to him briefly, introduced him to Evie, and then to Marvin Israel, the new art director of *Harper's Bazaar*, and told him to be at the *Bazaar* studio, around the corner, at six p.m. Frank Finocchio, Dick's assistant, put MacWeeney to work the minute he arrived at the studio, loading film into the Rolleiflexes, handing the loaded cameras to Dick as he was photographing, taking the used ones and putting them on tripods,

repeatedly, the rapid-fire pace not unlike loading rounds of ammunition into guns in the middle of battle.

From MacWeeney's description, the *Bazaar* studio in Paris was a hive of activity that never stopped for the next two weeks. Marvin Israel was there every night, as were Nancy White, the editor of the *Bazaar*, and Gwen Randolph, the fashion editor. The models were China Machado and Margot McKendry. Loud music played throughout the evening—Frank Sinatra, Chet Baker, Henry Mancini, or, to the young MacWeeney's consternation, *show tunes*. Dick seemed always to be everywhere at once. One minute he was in the dressing room advising Alexandre de Paris, the hairstylist, on the model's hair; then he would be selecting the dresses to photograph from a designer's collection that had been secreted into the studio on that particular night; next he was upstairs, where the two editors were conceiving the magazine pages as Dick was shooting the collections. Marvin, despite his ornery demeanor, was still adjusting to his role at the magazine and seemed to follow Dick's lead. "Basically, Avedon took over," as MacWeeney described it. "He worked with the models. He wrote the copy. He told everyone more or less what was happening."

On several occasions during those two weeks, Dick took Marvin and his assistants out for dinner. One night he took them to the International Ballet de Cuevas as guests of its director, Raymundo de Larrain, whom Dick had photographed with Jacqueline de Ribes in his studio in May while they were in New York for the Embassy Ball at the Waldorf. In June, Raymundo de Larrain had brought the Kirov Ballet to Paris from behind the Iron Curtain to perform for two weeks. On June 16, as the Kirov boarded a plane at Le Bourget airport that was headed back to Moscow, the dancer Rudolf Nureyev defected. For a time, Nureyev was sequestered in hiding at de Larrain's Paris apartment. After his defection he danced for the Cuevas company in de Larrain's production of *The*

*Sleeping Beauty.* "He danced like a god, but he also had a spectacular story," de Larrain told Dominick Dunne. At one of his first performances the balcony was filled with Communists, who pelted the stage with tomatoes and almost caused a riot. People who were present that night remember that Nureyev continued to dance through the barrage, as if he were unaware of the commotion, until the performance was finally halted.

Before the performance attended by Dick and his assistants, de Larrain had asked Avedon to take publicity pictures of Nureyev as a favor. Dick saw an opportunity and offered to do them on condition that Nureyev pose for the magazine. Nureyev agreed, and the next day a dance studio was rented a few doors down from the San Regis, where Dick and his assistants were waiting. Almost immediately, Dick banished everyone from the studio and spent the afternoon alone with Nureyev. From the start, according to Julie Kavanagh, Nureyev's biographer, the young Russian dancer amazed Avedon with his intelligence and sense of wonder. "He was so open, and wanted to communicate, to connect," Avedon said. "He'd read *Catcher in the Rye*, which I found stunning." The admiration was mutual, Kavanagh writes: "In brilliant, boyish Dick Avedon, with his own Holden Caulfield vocabulary, Rudolf found a kindred soul with the same passion for the arts in all its forms, and the same endlessly voracious appetite to learn."

Avedon was able to establish an intimacy with Nureyev in which he captured a range of physical attitudes and facial expressions—first brooding, then coy, then seductive, then playful, and, even, finally, giggling—before reaching for the heights of a choreographic collaboration that led to his capture of breathtaking leaps, extensions, and gestures of pure transcendent beauty. It was Dick's practice to run along in tandem with his subject, camera in hand and shooting all the while, and here, his participatory photography must have encouraged his subject to perform at his best for his

audience of one: Nureyev here and there suspended in a preter-natural leap of ungodly poise to the heavens. After several hours, Avedon asked Nureyev if he would remove all his clothes. "Your body at this moment should be recorded. Every muscle. Because it's the body of the greatest dancer in the world," Avedon said. "Who better to do it than me?" Rudolf, who needed little persuasion, con-curred. He removed his tights, stopped moving, faced the camera, and stared into the lens. "As I went on photographing," Avedon told Kavanagh, "he slowly raised his arms, and as his arms went up, so did his penis. It was as if he was dancing with every part of himself. I thought this was the most beyond-words moment—too beautiful to be believed. A narcissistic orgy of some kind. An orgy of one."

The single full-frontal nude portrait that Avedon eventually printed is daunting, not only because of the perfect specimen that is Nureyev, but also for the unexpected proportion of his penis—formidable, if you will, by any measure. It is also a stolen image, as the day following the photo session Nureyev demanded all the negatives in which he was nude, recognizing the potential hazard they might pose to his reputation in the free world as a decadent; he didn't want to prove the colleagues of his who remained behind the Iron Curtain to be right. Avedon gave him all the negatives in which he was nude, except, perhaps unwittingly, those frames in the undeveloped film that had yet to be unloaded from the camera.

If fate, will, and circumstance compose the ingredients of des-tiny, then that recipe must account for Avedon's consistent inter-section with the historic events of his lifetime. At this particular moment of good fortune, it was his acquaintance with Raymundo de Larrain (fate), his presence of mind to structure the opportunity to photograph Nureyev to his own advantage (will), and his being in Paris for the collections when Nureyev defected in the summer of 1961 (circumstance). It is uncanny that the pieces of the puzzle

kept falling into place as they did for Richard Avedon. Even more to the point, he took intelligent advantage of that fact to chronicle the age in which he lived, at least in terms of the people of historic consequence who marked the progress of the era.

Less than two months after Nureyev defected from Soviet Russia, two intimate portraits of him from that session with Avedon were printed in the September 1961 issue of *Harper's Bazaar*, announcing the arrival of an unparalleled talent. "The world at large, while it either merely tolerates aspiring artists, or turns the creative life into a fashionable thing, cannot resist, cannot turn away, when there emerges a rarity which in itself can reinforce man's faith—a great and true artistic genius," writes the *Bazaar*. "Thus, the world awaits another Shakespeare, another Beethoven, another Nijinsky, knowing that there are few such men in a century. . . . Nureyev was bravo-ed and loved in Paris, where the press unreservedly applauded his dancing, his spirit, and his beauty, calling him the highest honor of all, 'the new Nijinsky.'" In a full-page close-up portrait that is nothing like a mug shot, Nureyev stares out from crescent eyes. His fleshy lips are pursed together in the spread of a smile that contains the flicker of amusement and a brief connection in their shared moment a barely contained smile, the glee in his face not only betraying the uniquely intimate connection between subject and photographer but, more important, evincing the young dancer's anticipation of the new world of possibility at his feet.

Alen MacWeeney, for his part, had a brush with the Avedon magic that summer in Paris, experiencing firsthand the way, in Dick's presence, everything could feel larger than life. So when Dick asked him to come work for him in New York, he said yes, with qualification; the enterprising young Irishman told Dick that he would work as an assistant for only one year and then go off on his own. Dick agreed, sponsored his green card, and within a month MacWeeney arrived in New York. Dick let him stay in his

apartment for the several weeks it took to find a place of his own. MacWeeney had never been to the United States and his orientation to New York was Avedon's twelfth-floor apartment at 625 Park Avenue. "Doorman, very conventional, traditional kind of Upper East Side apartment," he said, reflecting back to his first impressions. "The interior design, you know—round tables with floral tablecloths and glass tops. He had a big, big living room and a television set in a bookcase. There was a Marino Marini sculpture of a horse, which was very handsome." The rambling apartment had a smaller sitting room and at least four bedrooms. Alen stayed in a small maid's room in the back. From the perspective of a twenty-one-year-old Irishman new to New York, MacWeeney characterized the apartment as having "Jewish taste." Asked what that meant, he described it this way: "What's first class? We'll make it *better* than that. . . . It tends to gaudiness." This, of course, speaks as much to MacWeeney's prejudice as it does to an anti-Semitism that was still alive. In fact, while the Avedon apartment might have been overdecorated, Dick's professional reputation was defined by restraint and good taste—although it can't be denied that he was overly theatrical when throwing parties or giving extravagant gifts. But was that being *Jewish* or being *Avedon*? In personal manner and style, Evie Avedon was the model of understatement and refinement. MacWeeney found her to be very polite, but "kind of lonely, empty," he said, "whether it was just all withheld, or she was withdrawn." He found nothing atypical about the family: John was eight and mostly looked after by an Irish maid named Rose.

For Avedon, all his assistants were not created equal. Earl Steinbicker, who had just become first assistant after Dick fired Frank Finocchio, was a very reliable workhorse who managed all the carting and transporting of heavy equipment. "I was more the entertainment," MacWeeney said, which was true as long as he fulfilled his function, whether it was loading film and handing Dick cam-

eras while in session, or any of the other hands-on responsibilities during an active shoot. Clearly, though, Dick saw something unusual in MacWeeney, an artist who thought about his own work and about photography in philosophical terms and would go on to have a distinguished photographic career of his own. "Dick had a huge wall of books and a library of scrapbooks, which he showed me," MacWeeney said. "He introduced me to the work of Robert Frank. . . . We discussed photography at length, all the time."

They would go on jaunts. Once Dick took him to Hubert's Flea Circus in Times Square with Marvin Israel, who had introduced Hubert's to Diane Arbus. Another time he went to Coney Island with Dick, his son, Johnny, and Marvin, where they went on the rides and ate hot dogs at Nathan's. On the trip out to Coney Island, Alen offered Dick an insight about his work, observing, "The focus of all your portraits is really on your eye, your eye on the eye of the subject, and from there everything is . . . a self-portrait." It was audacious of a young assistant to offer an analysis of his boss's work. Dick could be tricky when it came to assistants and students alike—unusually generous in the moment, but, equally, he could turn and become mean and stingy. There were undetectable emotional land mines that could erupt if someone took a step in the wrong conversational direction and offended him, or if he overstepped the invisible hierarchical line between employer and employee. Still, Alen's observation held his boss's interest, and he was taken under Dick's wing with generosity.

In early 1962, Dick went to the Caribbean island of Antigua with Suzy Parker on a swimwear assignment for *Harper's Bazaar*, and brought Alen, instead of Earl, as his assistant. During that trip MacWeeney took some photographs of Dick on a sailboat and also running on the beach, in which he looks both movie star handsome and glowingly happy. They stayed in separate rooms at the hotel, but Alen would sit with Dick in his room at night on a pair of twin

beds chatting about that day's shoot specifically, or the details of the next day's shoot, or photography, in general, or life itself. Dick was not in the habit of socializing with his assistants, and being in Dick's hotel room every night of the trip was a particularly intimate situation for MacWeeney to find himself in. There were moments that felt charged to Alen; more than once he wondered if Dick was gay. "What will I do?" he thought, should Dick make a move. Nothing happened, though. "Dick implied that he may have tried it once, *once*," said MacWeeney, but that was the extent of the entire conversation.

ON MARCH 10, 1962, Nureyev's debut in the United States drew the crowds from Manhattan to the Brooklyn Academy of Music across the river. Nureyev danced with Sonia Arova, in a pas de deux from *Don Quixote*. Avedon sat in the first few rows with Evie, Gloria Vanderbilt and Sidney Lumet, and Leonard and Felicia Bernstein. George Balanchine was sitting not far behind them, as was Alexandra Danilova. The ovation that followed his final flourish was "a veritable Niagara roar," Avedon said. Dick made his way to the star's dressing room afterward to invite him to supper at his apartment on Park Avenue, where others were expected as well. Nureyev readily accepted, although he was obligated to first stop at the opening-night party. He didn't arrive at the Avedons' until midnight, after most of the guests had gone home, and found his host sitting in the kitchen with Sidney Lumet. When Rudi walked in, he said almost immediately, "Can you find out what Balanchine thought?" Dick, who did not know Balanchine well enough to ask him directly, said he would try to find out. Then he offered to scramble Rudi some eggs.

In 1962, Dick let Alexey Brodovitch use his studio in the evenings to continue his Design Lab classes. The people who attended

the Brodovitch lab were aspiring photographers, for the most part, a few of whom were in advertising. In the case of Joel Meyerowitz, then twenty-four years old, he had just left his job as a junior art director at a small advertising agency. He was really a painter who had been to graduate school for art history at Hunter College, studying with Ad Reinhardt. His boss at the advertising agency knew the photographers Robert Frank, Lee Friedlander, Garry Winogrand, and Saul Leiter, and threw them assignments as often as he could to help support them. One day, Meyerowitz watched Robert Frank photographing two young girls in Manhattan's Stuyvesant Town for a small advertising brochure. "I was so amazed by the fact that he moved as he photographed them," Meyerowitz recalled, being struck by the physicality of the activity. "I had no idea photography could do that. I left the shooting, ran out on the street, and the world was suddenly alive. I kept on seeing every gesture and wanting to photograph it. It was a revelatory experience." That's when he left his job at the agency, picked up a camera, and never looked back.

The new semester had barely started, though, when Brodovitch became too sick to teach and had to be admitted to the hospital. Avedon was obliged to take over the workshop, admittedly uncomfortable to be thrust into that position. "I'm not a teacher and I don't express myself so well," he told the class. But, according to Meyerowitz, Dick had definite opinions based on his experience as a commercial photographer, and, soon enough, Avedon and Meyerowitz were butting heads.

Avedon assigned the class to go to a photo booth—where, for a quarter, the machine takes four exposures and provides a photo strip with four images—and do something no one had ever done before. Meyerowitz chose a booth in his neighborhood, at Broadway and Ninety-Sixth Street, and asked a friend's girlfriend to pose. He hung some blankets inside, decorating the interior of the

booth to look like a brothel. His model had brought a feather boa and some hats and jewelry, and agreed to pose naked. He selected two of the photo strips, took them to a Photostat house on Fifth Avenue, and had each one blown up six feet high. When he tacked the photo strips up in class, Avedon, rather than commenting on Meyerowitz's enterprise, criticized the model, dismissing her as unworthy of the images. "She wasn't model-y enough, beautiful enough," Dick told him. As Meyerowitz described himself in those days, "I'm a guy from the Bronx. I was still wearing combat boots and a leather jacket." In class, he asserted to Avedon that the model was not the issue and demanded that Avedon assess the assignment on its merits, on his effort and his creativity. He'd done something in a photo booth no one had ever done before. Hadn't he fulfilled the assignment? Dick conceded, albeit reluctantly.

Soon after the workshop, Meyerowitz became very close to Garry Winogrand, and together they would shoot on the streets of New York, almost daily, for several years. "It was about leaping and lurching and dancing and twisting and turning and being in the right place at the right time to describe this fragment of perception that stimulated our consciousness," Meyerowitz recalls. Not only Winogrand and Meyerowitz, but an entire coterie of photographers in the middle of the twentieth century, defined by the art historian Jane Livingston as the New York School, were, as Meyerowitz characterized it, "in search of the poetry of the medium." Those photographers did not believe such poetry could be reached through any commercial assignment, and certainly not in the studio. These "street photographers" did not take Avedon, or any other fashion photographer, seriously.

The dismissal of Avedon by these young "artists with a camera" underscores a bifurcation in the history of photography between the emerging generation, who were asserting their intentions as artists, and the world of commercial photography. For these young

photographers, making their own work and determining their own subject was pure. Producing images for advertising or promotion was soulless. Yet photography wasn't so—well—black and white. A vast gray area in the range of editorial work in the field was based on the truth-telling tenets of journalism that didn't compromise an artist's integrity—as opposed to the collective lie perpetrated at the very foundation of advertising. At issue, ultimately, is a contradiction that harkens back to the early tensions between art and photography from the medium's inception in 1839. In the nineteenth century, artists repudiated photography as a mechanical form of image making. Machinery had no place in the higher precincts of artmaking, where the nobility of the spirit was found in the act of painting—the very soul of art. By 1960, the conversation about photography versus art had evolved from the camera as the enemy of artmaking to the intentions of the photographer in determining the worthiness of the image.

It is premature to introduce this discussion into the trajectory of Avedon's career at this point in 1960, and yet it is relevant if only to establish a foundation for the forces at work that would deny Avedon his place as an artist for most of his life. Surely his showmanship did not help his cause, but, at this stage, he had barely begun to do the work on which his towering stature as an artist of the twentieth century would come to reside.

*CLEOPATRA* WAS GETTING TO be the most expensive joke in Hollywood. Production on the epic film had started in early 1961, but by the spring of 1962 the budget overruns had almost bankrupted Twentieth Century Fox, and the studio had to be reimbursed with insurance money. A new director was hired, and several new cast members were brought in, including Rex Harrison to replace Peter Finch as Julius Caesar and Richard Burton

to replace Stephen Boyd as Mark Antony. During the production, the affair between Elizabeth Taylor, who was starring as Cleopatra, and Richard Burton, her new costar, became an international scandal and an instant tabloid sensation, as both of them were married—just not yet to each other. While shooting at Cinecittà in Rome, "Liz" and "Dick" could not escape the paparazzi, who stalked them everywhere, delirious as the press was in its avarice for any vicarious glimpse of the ever-glamorous couple.

Mike Nichols had become very friendly with Richard Burton while he and Elaine May were at the Golden Theatre on Broadway. *Camelot* was just down the block at the Majestic, starring Burton, Julie Andrews, and Roddy McDowall, and they all became good friends who would meet for drinks at Sardi's after the show. In 1962 Burton invited Nichols to visit him in Rome. "I'll be on the *Cleopatra* set most days," he told Nichols. "Perhaps you wouldn't mind escorting Elizabeth around to see the sights while I'm shooting? The press is driving her crazy." Nichols suggested that she don a babushka, and during that week, she walked with him incognito through the streets of Rome, going to museums and eating at little trattorias unrecognized. "Once," Nichols said wryly, "someone actually pointed at me and said, 'There's Mike Nichols.'"

According to Ruth Ansel, then an assistant art director at *Harper's Bazaar*, Nichols had shared the details of his sojourn in Rome with Avedon, precipitating the idea for "Mike Nichols and Suzy Parker Rock Europe," a ten-page photographic feature that Avedon produced and directed on the Paris collections that appeared in the September 1962 issue of the *Bazaar*.

"With Suzy and Mike, I decided to do a satire of Elizabeth Taylor and Richard Burton who were making *Cleopatra*, having all their fights in public, but also saying 'Why doesn't the press leave us alone?'" Dick told Michel Guerrin of *Paris Match* in 1993. "So

I took Mike Nichols, who was then a comedian, and Suzy Parker, who was my favorite model at that time, and we pretended to be making a film of 'Napoleon and Josephine in Paris.'"

Before the *Harper's Bazaar* team left for Paris, Ansel and Marvin Israel had bought every cheap Italian magazine they could find to look at the layouts. They placed them on the floor and she, Marvin, and Dick studied them as templates for the "Mike and Suzy" scenario. "The whole thing was shot in Paris," Ansel said.

"Mike Nichols and Suzy Parker Rock Europe" was shot to reference the look of tabloid journalism: there are pictures of the two of them running from the camera in the nighttime darkness, lit in the glare of a Graflex flash with caught-in-the-headlights expressions on their faces; in one picture, they are having a fight at a table at Maxim's, and, in another, laughing while descending the stairs after dinner; by day they are sitting in the first row at a Chanel runway show; by night they are caught in an intimate moment while walking in the park; in a dramatic climax, Mike fights off a paparazzo as they exit a limousine; finally, Mike and Suzy leave a hospital with bandages on her wrists. A sad story, indeed. "He had a talent to direct," said Alen MacWeeney, who was assisting Dick with the cameras in Paris. "It all has to look active, and using a Rolleiflex to do reportage is not the easiest thing to do."

"For 'Mike and Suzy,' I used all the paparazzi equipment, and Marvin Israel laid it out like an Italian paparazzi magazine," Dick told Michel Guerrin in 1993. "The whole thing was calculated and designed and constructed as much as possible." The flashbulb paparazzi grab shots imbued the look of the entire sequence with a layer of visual complexity, adding a tongue-in-cheek sophistication to the display of that season's new fashions. It was staged to look like an editorial feature about two famous movie stars captured in various states of flight from the media swarm, but the level

of verisimilitude Dick was aiming for reached comic proportion when, at a number of locations during the production, once Mike and Suzy had been made up to be photographed, Parisians began flocking to them for autographs, believing that they were actual celebrities—art imitating life imitating art—and interrupting the process. "From what I understand, the readers hated it," Ansel said. "They thought it was a spoof that had nothing to do with fashion, even though Suzy Parker was sporting new fashions from Dior, Nina Ricci, and Yves St. Laurent. They didn't get that it was a way of showing the collections."

In this period, Avedon began to infuse his editorial work with more cultural analysis. "Mike Nichols and Suzy Parker Rock Europe" was a playful, albeit critical comment on the nature of celebrity, the madness of fame—perhaps, above all else, an examination of the complicated feelings Avedon had about his own fame. It is uncanny how much this 1962 paparazzi fashion spread reflected the intellectual ideas then germinating about the media, and that would give definition to the zeitgeist of the 1960s: no less than pop art—Andy Warhol and his overarching observation of the media age, and also Marshall McLuhan's influential thinking in *Understanding Media* (1964) and *The Medium Is the Massage* (1967). This is only one example of the manner in which Avedon consistently reflected and anticipated the cultural tenor, repeatedly, throughout his oeuvre. "To orchestrate 'Mike and Suzy,'" Ansel said, "this is where his vision is profound. He always moved forward, and always made sure that he was aware of what was happening in social history . . . earlier than anybody else, and with as much inventiveness as anybody could apply."

The previous year, Marjorie (Lederer) Lee published *The Eye of Summer*, her first novel, a roman à clef about her childhood relationship with her cousin, Dick. He took the book jacket portrait of Margie, in which she appears in a simple black cocktail dress—sly,

urbane, modern, thoroughly Avedonian—made up like a version of Audrey Hepburn as Holly Golightly in the simultaneously released film version of *Breakfast at Tiffany's*. The review of her book in the *Times* did not mention the backstory of the author and her famous cousin, instead acknowledging respectfully the story she writes about Connie and Spence on its own fictional merits and allowing the novel its own reason for being. Richard Avedon was already famous for his own professional enterprise, but now there were two fictional versions of his life—*Funny Face* and *The Eye of Summer*—adding yet another layer of complication to his relationship with fame.

# FIRE IN THE BELLY

(1963–1965)

An artist paints not what he sees, but what he thinks about
what he sees.

—PICASSO

During World War II, barely twenty-one years old, Ave-
don sought "psychiatric help" to obtain a discharge from
the merchant marine, and, while he was at it, to broach
the inconvenient matter of his homosexuality. From that point on,
he took to "the talking cure" with an umbilical attachment that
would sustain him through a psychoanalytic hour every day, five
days a week, for the rest of his life—at least when he was in town.
Of course, his career took precedence, and on days when he was
unable to make it to his analyst's office, he would give his appoint-
ments away to friends, as he was obligated to pay for the sessions,

regardless. One could say that Avedon's elastic approach to this daily commitment was, at best, unorthodox.

Anatole Broyard, a contemporary of Avedon's and for many years the literary critic of the *New York Times*, offered a tidy explanation for the growing interest in psychoanalysis among the intelligentsia in mid-twentieth-century America: he reasoned that World War II had precipitated the relocation of the entire German psychoanalytic establishment to New York, and once the war was over, the trauma of so brutal a historic rupture compelled New Yorkers to seek their expertise for treatment. "In New York City in 1946, there was an inevitability about psychoanalysis," writes Broyard. "Psychoanalysis was in the air, like humidity, or smoke. You could almost smell it." What Broyard brought to his own brief encounter with treatment that year was "not a condition or a situation," he writes, "but a poetics. I wanted to discuss my life with [my doctor] not as a patient talking to an analyst but as if we were two literary critics discussing a novel. . . . I had a literature rather than a personality, a set of fictions about myself."

The perspicacity with which Broyard identifies the missing ingredient in his own brief analysis might well characterize the way Dick, the consummate aesthete, pursued his own; his psychoanalytic discourse may have dissected and disentangled neurotic conditions, yet the act of lying on the couch in the presence of his analyst was nothing so much as a daily rehearsal that equipped him to perform in the living theater of his life. Just as Broyard constructed a fictional persona of Anglo-Saxon erudition to mask his African American roots, Dick projected the cultivated charm of a bon vivant to mask his insecurities.

Marvin Israel was not a psychiatrist, but he held sway over Dick with an authority equal to the sum of Dick's analysts combined. Israel was an art director but also a painter who had studied with

Brodovitch in graduate school at Yale in the early 1950s. Despite his role as the art director of *Seventeen* magazine in the mid-1950s, Marvin was in tune with the avant-garde, sharing affinities with young photographers such as the yet-unknown Lee Friedlander, Robert Frank, Saul Leiter, and Garry Winogrand, and giving them work while understanding that their concerns as artists would be compromised when it came to fulfilling magazine assignments.

Avedon recognized the Brodovitch DNA in Israel—in his originality, his sense of design, and his artistic gravitas. The ongoing collaboration between them would be seminal in Dick's career, far outlasting Israel's short-lived tenure as the art director of *Harper's Bazaar*. Dick considered Marvin to be the antithesis of Brodovitch. "Both wanted to do daring things," Dick said. "I did my best work after Brodovitch with Marvin, but he could be irascible and wasn't meant to compromise himself in any way. He was a very interesting artist that did himself enormous damage in the art world because he had contempt for everybody."

While both Avedon and Israel shared a hefty dollop of weltschmerz, it manifested itself differently with each of them. Dick saw the world in stark, existential terms, but it didn't prevent him from being spontaneous and playful and extravagant. He could be unflinching in his acceptance of the hard truths, evident from the almost clinical observation and optical precision in his stripped-down portraiture, which could verge on cruelty, as in his 1958 portrait of the puffy-eyed Dorothy Parker, her bags containing a lifetime of tears, or a later 1972 portrait of Oscar Levant, his face a death mask, with his bottom teeth jutting forward in his open mouth. At the same time, Dick could crumble at a mere chink in the surface of the psychological deceptions he maintained to simply get through the day. "Dick was this wonderful combination of an artist who disdained phoniness, but who actually loved the phony life, or, let's say, the artificial life," Ruth Ansel observed.

Marvin's weltschmerz took a more self-destructive form. He could be grouchy, contentious, and pigheaded in his refusal to suffer fools, whether they held financial or professional sway over him or not. "We came from privilege," his sister, Bernice Jackson, said. Their father ran a very successful women's fashion retail business, a point of reference between him and Avedon, whose own father had owned a prominent women's retail department store. "We had a beautiful apartment with lots of help. We'd have dinner served to us at the dining room table every night." Perhaps the world after that never quite lived up to Marvin's expectations.

Marvin got excited when he recognized genuine talent, from Diane Arbus to Lee Friedlander to Walker Evans, and he asserted his appreciation of new and challenging work with his unselfconscious and almost invisibly pure design aesthetic. Soon after he was named art director at *Harper's Bazaar* he published the feature "The Full Circle," by Diane Arbus, her first photographs to appear in the magazine. The pictures had been commissioned by *Esquire*, but, because the editors felt that Arbus had misled her subjects, the magazine refused to publish them.

The Arbus portfolio was a provocation that reflected Marvin's compulsion to challenge the status quo. The photographs, absent the expected high-style flair of the magazine, were not easily definable or digestible in terms of subject. Equally, though, Israel's provocation was aimed directly at Avedon, who epitomized the status quo that was *Harper's Bazaar*. The "Editor's Guest Book" of the November 1961 issue listed Arbus not simply as "writer-photographer," but also as the wife of Allan Arbus and the sister of the poet Howard Nemerov. "Through a strong emphasis on picture content, her art is that of the observer. Always fascinated by unusual people or those that live apart from society . . . her ability to gain their confidence and friendship is an essential part of her talent."

All the portraits in "The Full Circle" present individuals in one form of masquerade or another, striking a discernible counterpoint in the magazine to the fashion pictures of models, also in costume, albeit of another stripe. "Each photograph for Diane was an event," Marvin said, speaking about her approach to her subjects. "It could be said, although it could be argued, for Diane the most valuable thing wasn't the photograph itself—the art object—it was the experience. . . . It was an incredibly personal thing." In that sense, Arbus would become a weapon that Israel lorded over Avedon quietly, persistently, sadistically. Over the years, he would point out to Dick that Diane was the genuine artist while Dick was merely a professional photographer. While Diane was envious of Dick's money—since she never seemed to have any of her own—and she admired the quality of his prints, she had sworn off commercial photography after working for years with her husband. Dick's ambition, self-promotion, and conspicuous consumption only reinforced the impression that he was in it for the money and the status and the fame, at the expense of artistic integrity.

NOW DIANE ARBUS HAD entered the *Harper's Bazaar* fold, and, without quite knowing what to make of it, Dick had to contend with her encroachment on his territory. More to the point, he had to learn how to assert his long-held preferential status at the magazine without inciting Marvin's perverse desire to undercut him. Dick's relationship with Marvin, while vital to the evolution of his career, was, equally, a perpetually tortured one. "In my grown-up world, if Carmel Snow was like my mother and Brodovitch, my father, then Marvin was a brother," Dick would tell Calvin Tomkins toward the end of his life. He told Jane Livingston the same thing, that they were like "two brothers who were opposites but of the same cloth," he said. "Completely linked and always at war.

Battling away until something was formed—we triggered the outlaw in each other."

At the beginning of 1963, when Diana Vreeland left *Harper's Bazaar* for the editorship of *Vogue*, Dick photographed the model Danny Weil in a classic Vreeland pose, a turban on her head, a lit cigarette in a cigarette holder between her lips, her smile cunning and conspiratorial. Dick and Marvin wanted to use it on the cover of the February 1963 issue, both in homage to and as a parody of Vreeland. When Marvin presented the cover to Nancy White, the editor, she balked, claiming the model looked like a man dressed in Vreeland drag. An argument ensued and Marvin, fed up with the white-gloved, churchgoing Miss White, said "fuck you" to her and stormed out of her office. The cover picture ran, but Marvin's contempt got him fired.

Before he got fired, though, Israel helped Avedon design the installation for his first museum exhibition, which opened in the Arts and Industries Building at the Smithsonian Institution in Washington, DC, in November 1962. Photography exhibitions in museums were rare then. They usually followed the traditional model of installation used for drawings and paintings; the photographs were hung side by side with little variation in size; they were uniformly matted and framed, or, less often, dry-mounted, on board. The 1955 *Family of Man* exhibit at the Museum of Modern Art, designed by the architect Paul Rudolph, was a departure in the use of freestanding partitions as an architectural motif and the variations in size of the photographs to animate the exhibition galleries. In the Smithsonian show, Avedon and Israel created a one-hundred-foot-long collage by pinning the unframed photographic prints to the wall, bulletin board style, layering and overlapping the images, which varied in size from eight by ten inches up to four feet tall. Some of the largest images were blown-up contact sheets; a blown-up portrait of Charlie Chaplin, with the devil horn

fingers above his head; Ezra Pound with closed eyes; a close-up portrait of Rudolf Nureyev smiling; and *Dovima with Elephants*. "I was there with Dick, Hiro, and Laura Kanelous to hang the show," Earl Steinbicker said. "I made the prints, including all of the giant ones, using a rented mural darkroom and roll paper specially ordered from Agfa in Germany for better blacks and brilliant whites." Hiro was there as a backup eye for Dick, and also to film the process. The Smithsonian is an archival history museum and not an art museum, yet Dick had the foresight to document the installation of this show as if it were the first milestone in his career as an artist.

Laura Kanelous, Dick's very stylish business manager, accompanied them to lend a gimlet eye to the promotional possibilities of such an exhibition, which she would soon exploit to generate business for Dick on Madison Avenue. "Laura had a bit of flash," Steinbicker said. In her notoriously droll manner, she might tell an assistant to "go ask Mr. Avedon if he is Jewish today." Once, she was in the studio as Dick was shooting a complicated ad campaign, and the exasperated client said to her, "I don't know how we're going to pay for all of this." Her response? "That's easy—through the nose."

In late 1964, Kanelous organized a replication of this show at the McCann Erickson advertising agency, replete with a splashy brochure to announce the cocktail preview: *Avedon 64: A Collage.* The purpose of this show, aside from drumming up new accounts for Avedon, which it succeeded in doing, was to promote his new book, *Nothing Personal*, which he was rushing to publish before Election Day in November. Some of the portraits on the wall were taken for the book, adding that many more pictures to those in the Smithsonian show. It isn't known how much of the Smithsonian show—or the version at McCann Erickson—reflected Israel's participation, although his signature is clear from the casual manner of presentation—photographs layered one overlapping the other and

pinned to the wall. Credit, for the most part, would go to Dick. "Avedon invented an exhibition whose sheer exuberance and wit established a context within which the images could echo a range of moods and subjects," wrote Jane Livingston thirty years later. She suggested that the exhibit set the stage for what artists would do in the next generation. "It would be a full twenty years before other photographers, such as Gilbert and George, Laurie Anderson, Cindy Sherman, and the Starn Twins, routinely printed their work in this kind of scale and presented it in similarly unorthodox ways."

IN NOVEMBER 1964, RICHARD Avedon published *Nothing Personal*, a lavish coffee-table book designed by Marvin Israel and composed of gravure-printed portraits of individuals who do not fit into any single classification: Allen Ginsberg, the poet, standing naked in a Buddhist pose on a page opposite George Lincoln Rockwell, the founder of the American Nazi Party; a young and earnest Julian Bond among members of the Student Nonviolent Coordinating Committee (SNCC); the officers of the Daughters of the American Revolution; Malcolm X; Governor George Wallace of Alabama; and William Casby, who had been born into slavery one hundred years earlier.

*Nothing Personal* was published only months after the passage of the Civil Rights Act, in the period of profound cultural soul-searching following President Kennedy's assassination. And yet, the genesis of Avedon's monumental project preceded those historic events by two years, when James Baldwin published an essay in the November 17, 1962, issue of the *New Yorker* called "Letter from a Region of My Mind," which set off a fierce intellectual debate and landed Baldwin at the center of a media firestorm just as the civil rights movement was gaining traction in America. According to

Congressman John Lewis, who at the time was about to become chairman of the SNCC, the essay "created one of the most compelling moral arguments for change ever published in this country."

In the first week of January 1963, Baldwin came to sit for a portrait in the Avedon studio. His *New Yorker* essay begins with a description of his search for spiritual guidance during his teenage years, when he and Dick had been students at DeWitt Clinton High School and worked together on *The Magpie*. As teenagers, Dick visited Jimmy at home in black Harlem, and Jimmy visited Dick on white East Eighty-Sixth Street. The warmth and affection between Dick and Jimmy's family is evident in the 1946 photographs he made of Jimmy with his mother and sisters at home. "Growing up, Baldwin had been a boy preacher; he had escaped into the church in an effort to escape his own sissy body, in a sense," Hilton Als writes. While Baldwin was mocked at school for his effeminacy, as well as his evangelism, Sol Stein and Emile Capouya defended him, and so did Avedon, who endured a similar brand of ridicule for his own "sissy body." "As Jews, the Avedons knew something about the face you present to the world, and the private face you only show others of your kind, or near your kind, like Baldwin."

By 1963, Avedon and Baldwin each had traveled a unique course that would bring them together again, now at the top of their professions—Baldwin, a consequential voice of his generation whose novel *Another Country* had recently been published, and Avedon, the definitive photographer of his time. The portrait Avedon made of Baldwin is intimately cropped, deep with anguish in the writer's eyes and etched like clef notes into the lines of his forehead. His chin is resting in the palm of his hand, his impatient fingers covering his left cheek. Baldwin's face takes up the entire frame, the full-page picture a direct confrontation in the April issue of *Harper's Bazaar*, appearing opposite another essay

by Baldwin commissioned for the magazine, entitled "Letter from a Prisoner," a message about the abject cultural circumstance of racism in America: "If you and I are white, then we're *Us*. If I'm black, then you're *They*—a fact that, if you're a white liberal, makes you sad: after all your trouble to be part of *Us*, to *Us* you're still *They*," writes Baldwin, who might as well have been speaking directly to Avedon, his rich, white liberal high school friend. Baldwin concludes his essay with a kind of spiritual wisdom that offers the promise of hope in the openness of love while recognizing, once again, the futility of the plight of the black American: "This voice speaks both for the *Them* and the *Us*, one nation indivisible, and it is red with human rage. It is repeating the one blasphemy that even a Christian must listen to. It is telling us the color of God. . . . Let *him* identify us to each other. He says: I am behind the color bar. Like you."

The earlier *New Yorker* essay was one of two Baldwin had written about racism in America on the occasion of the centennial of the Emancipation Proclamation, and which composed the book *The Fire Next Time*, published in early 1963. *Nothing Personal* had been Dick's idea, and Baldwin agreed immediately to collaborate, much in the same way that Truman Capote had collaborated with Dick on *Observations*. They agreed that the book would take on the comprehensive task of reflecting the contemporary American moment.

Dick wasted no time putting the project in motion. Marvin recommended Marguerite Lamkin, with whom he had worked at *Seventeen* in the 1950s, to help Dick identify individuals to be photographed, make the introductions, and handle the logistical arrangements for his intermittent odysseys through the South over the next year. Lamkin, who would soon marry Mark Littman, a British barrister, had made her way to New York from Monroe, Louisiana, in the late 1940s. With impeccable manners and antebellum charm, she landed in the literary center of New York, not as

a writer so much as a social muse. By 1963, she was the "star Condé Nast interviewer," according to the writer John Fowles, "a slim girl with dark glasses and neuroses worn like the best French scent, and a Louisiana accent like one long caress."

Dick's first excursion to the South was in February 1963, when he traveled with Marguerite to New Orleans to meet, among others on her roster, Judge Leander Perez. A protégé of Huey Long, Perez was the Boss Tweed of Plaquemines Parish in New Orleans, who, in his role as attorney general, garnered influence over the entire political landscape of the Deep South for more than thirty years. "The Judge," as he was called, had a political fiefdom as well as an empire: "The tremendous mineral wealth discovered during the thirties and forties gave rural and isolated Plaquemines the potential to play a role in state and national politics totally disproportionate to its size and population," writes Perez's biographer. "A political and financial magician of brilliance, resourcefulness, and unyielding determination, Judge Perez personally oversaw the development of oil, sulphur, and natural gas extraction in the lower delta and through finesse and inside knowledge became a millionaire many times over."

More than just another "Neanderthal segregationist," in his biographer's words, he assumed the role of kingmaker to political ideologues such as Strom Thurmond, Ross Barnett, Lester Maddox, Orval Faubus, and George Wallace. "Do you know what the Negro is?" he was quoted as saying in a 1965 article in the local paper. "Animals, right out of the jungle. Passion. Welfare. Easy Life. That's the Negro. And if you don't know that, you're naïve."

Because Lamkin's uncle had gone shooting with Leander Perez from time to time—"Not *people*," she clarified, "but pigeons, ducks"—she was able to arrange for Dick to photograph him. She gave Dick elocution lessons to affect a southern accent before going up to his office. Perez, whose tough veneer was a perpetual dare,

pulled out a thick file with "Detroit" written on it. "This is where I send niggers and Jews," he told them. "A one-way ticket." Then he eyed them both suspiciously. "Marguerite," he said, "what's a nice girl like you doing with this Jew boy?" Avedon, quick on his feet, deflected the tension, at least for the moment. "I'm not Jewish," he said. "I'm French Persian."

According to Marguerite, when they returned to New Orleans several months later, Dick received a death threat in the form of a phone call. "This man had his own army," she explained, referring to Perez. "He had guns. We might never have been seen again." They fled, driving to Baton Rouge, where she found a place for Dick to hide for several days, in the East Louisiana State Hospital. There he would make a series of pictures of terminal mental patients, surreptitiously, that are included in *Nothing Personal*.

No one knew the name Leander Perez outside Louisiana in 1963, but Avedon anticipated his historical significance as one of the seminal antagonists of the civil rights movement. In Avedon's portrait, Perez symbolizes the exclusionary hatred that placed a man like him at the center of his own self-importance, at the expense of an entire population. Scorn is the predominating attitude on both sides of the portrait, emanating from the subject, dripping from the photographer. Perez wears his cowboy hat as a crown, his pronounced scowl an edifice of disdain, the big cigar between his lips a nasty weapon. Dick, feeling indignation in the face of such ludicrous danger, let Perez portray himself as a caricature of a "dick-swinging" autocrat, holding him up as an enemy of the people.

A month later, Avedon returned to the South, this time to Atlanta. Earl Steinbicker drove him to Martin Luther King Jr.'s house. "We had breakfast with him. His young son was there. We drove them to his father's house, which is in the suburbs," Steinbicker remembered. "Dick never really liked those pictures very much. He didn't think they were very good." In the portrait Dick made of the

three generations, Martin Luther King is at the top of a pyramid formed by their three heads; while the faces of his father and his son are crisp, King is not quite in focus. It's surprising that Dick did not make another attempt at a portrait of King, who was the most influential black leader of his time, delivering the speech of a lifetime, "I Have a Dream," at the Lincoln Memorial on August 28, 1963, during the March on Washington, in which 250,000 people filled the mall in Washington, DC. Only a portrait of King's son appears in *Nothing Personal*.

The day after he photographed the Kings, Steinbicker drove Dick to downtown Atlanta, where he photographed members of the SNCC. Earl helped Dick locate a suitable place to photograph the group on a stretch of highway under construction. Dick placed the dozen or so men, women, and children, mostly black but with a few white faces in the crowd, in a loose arrangement. Julian Bond, the organization's communications director, who had been among the earliest black students to protest the Jim Crow laws with lunch counter sit-ins in the early 1960s, stands out in the portrait. "We got some shots before the state police arrived," Steinbicker said, explaining that Dick was questioned for photographing black and white people together. "The police demanded our film." Steinbicker had been squirreling the film away in the trunk of the car as they were shooting, anticipating such problems. "I handed the officer some empty film holders and they didn't know the difference." Then they fled for the airport.

Before returning to New York, Dick photographed William Casby, who had been a slave in the Deep South almost a hundred years earlier. Dick hung white seamless paper on the front porch of his house and made many pictures that day of Casby, alone and with his family. The picture of Casby that appears in *Nothing Personal* is a close-up, straight-on portrait of a man who had endured a barbarous life for almost a century, the sum of his burdened exis-

tence grizzled into his hardened expression, his eyes deadened, the whites faded to gray.

While it is risky to shuffle the deck by placing side by side two images that were not intended by the artist to be seen together, an improvised diptych of Avedon's portraits of Leander Perez and William Casby is edifying. The *Us* versus *Them* divide is clearly pronounced in this representation of the eternal racial struggle in America. What an economical reduction of white supremacy and black slavery in the blaring hatred on Perez's face and the seething rage on Casby's! Certainly, the two portraits compose a backbone, of sorts, for *Nothing Personal*, yet, in the book, the scowling Perez appears on a spread across from the faintly smiling evangelist Billy Graham; and the obdurately stone-faced Casby is on a spread with an inscrutably photographed Adlai Stevenson, the former presidential candidate. Before the book was published, Dick went to a photo booth and made self-portraits holding his portrait of Baldwin, one side of his face cut out, over half of his own face to create a portrait of their faces merged together.

Avedon had been so motivated by what he saw in the South that he set up training sessions in his New York studio for SNCC photographers who wanted to document the demonstrations and rallies in the region. Avedon would convince Marty Forscher, owner of a camera shop patronized by the best photographers in New York, to donate film and more than seventy-five cameras to SNCC over a three-year period.

The collaboration between Avedon and Baldwin, for its part, was encumbered, not only with the exigencies of their respective lives: while Dick juggled an array of commercial assignments on a daily basis and made intermittent trips to the South for the book, Baldwin was constantly being interviewed by the press due to the publication of *The Fire Next Time*. In May, *Time* magazine put him on its cover following the racial violence in Montgomery, Alabama.

On May 24, Baldwin organized a contingent of black leaders, including Lorraine Hansberry, Lena Horne, Harry Belafonte, Kenneth Clark, Clarence Jones, Baldwin's brother David, and Jerome Smith, a twenty-five-year-old who had been badly beaten on the Mother's Day freedom ride, to meet with Attorney General Bobby Kennedy and demand that the Kennedy administration take a moral stand against segregation. On June 11, President Kennedy made a televised speech to the nation calling for legislation protecting voting rights, legal standing, and access to public facilities for all Americans. The next day, Medgar Evers, the head of the Mississippi NAACP, was assassinated.

After reading Baldwin's initial essay in the *New Yorker*, Steve Schapiro, a *Life* photographer, immediately called his editor at the magazine to do a profile on Baldwin, with a focus on the conditions of blacks in America, and in 1963, he would accompany Baldwin on a speaking tour through the South. "To me, Jimmy was plagued with personal sadness, and always seemed lonely. But he had a tremendous inner strength and brought that to everything he did. He was a force with which to be reckoned," Schapiro writes. "Here was a towering intellectual, a brilliant man, and Black leader, who never seemed to forget the importance of relating to each other as human beings. He had a hunger for love and believed in its power."

In June, Dick went to Puerto Rico for a few days to confer with Baldwin, who was on vacation with his lover, Lucien Happersberger. They discussed the underlying concept of *Nothing Personal*, and, of course, the essay Baldwin would write, with the idea that each of them would work independently. It was one of several trips Dick was forced to make over the next year to coax the essay out of Baldwin, the longest and most harrowing of which was to Helsinki in June 1964. Jimmy was attending a conference and Dick had to cajole him into writing the essay, literally standing outside his door while he worked. That summer, it was rumored that Dick and Evie

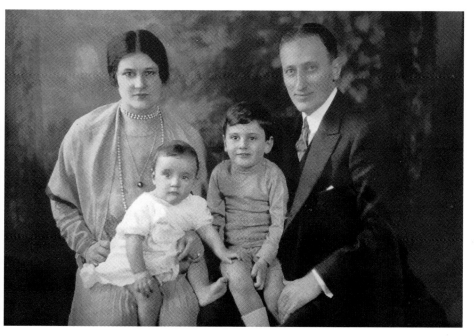

*Above:* The Avedon family, circa 1926: Anna and Jacob (Jack), with three-year-old Dicky on his father's lap, and his sister, Louise, beside him. *Below left:* Dicky, maybe ten years old, kneeling, holding an unidentified girl on his lap; leaning on the rail behind him is his cousin, Margie Lederer, and Louise, beside her. *Below right:* Margie, the provocateur—and prototypical "Avedon woman"—at sixteen years old, 1937.

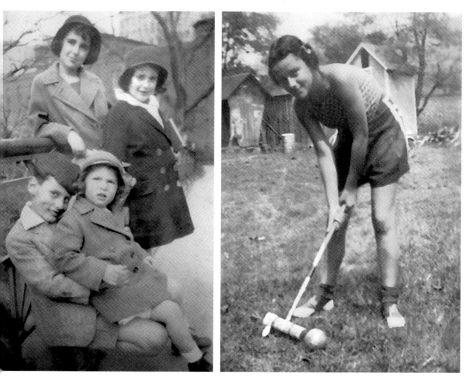

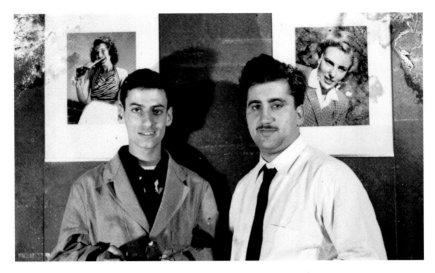

*Above:* Dick, at seventeen, soon after his reconstructive nose surgery, with Mike Elliot, his first employer and early photography mentor, in the Elliot studio, 1941.

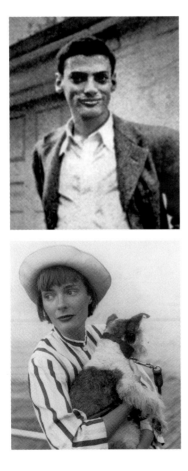

*Above left:* This portrait appeared in an editor's note marking Richard Avedon's debut in *Harper's Bazaar*, October 1944. *Above:* A sultry portrait of Avedon by Paul Himmel, Cherry Grove, ca. 1948. *Left:* Doe Avedon, Dick's first wife, photographed by Lillian Bassman, circa 1949.

*Above:* Dick and Doe traveled in Italy with Lillian Bassman (seated right), and Paul Himmel, circa 1947. *Right:* Alexey Brodovitch leading a workshop with his star pupil, Avedon, at right. Standing in pearls is Evelyn Franklin, soon to become Dick's second wife, circa 1950.

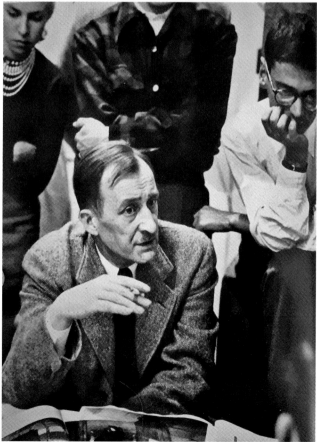

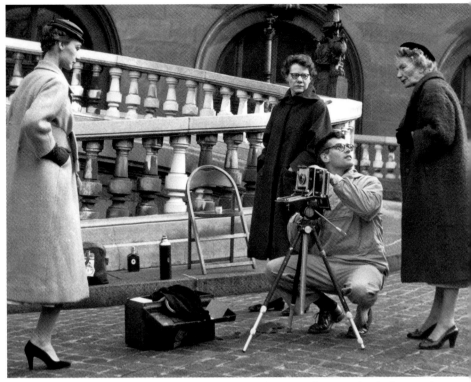

*Above:* Dick on a fashion shoot in Paris as Carmel Snow, editor-in-chief of *Harper's Bazaar,* looks on, late 1940s, photographed by Robert Doisneau. *Below:* Dick with Mrs. Snow (center) and Mary-Louise Bousquet, European Features editor of *Harper's Bazaar,* at Dior during the Paris collections, 1948, photographed by Henri Cartier-Bresson.

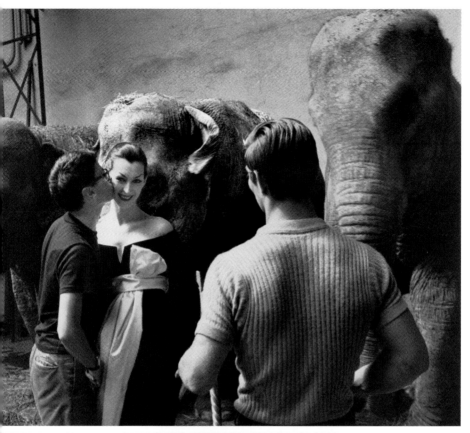

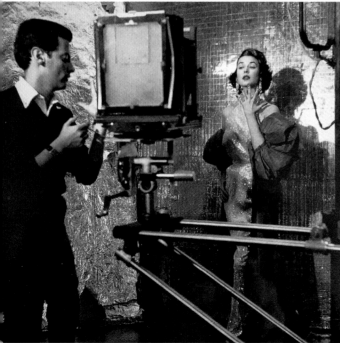

*Above:* Dick gives his model Dovima a "thank you" kiss after photographing her with the elephants at Cirque d'Hiver in Paris, as Emilien Bouglione, the animal trainer, looks on, 1955, photographed by Sam Shaw. *Left:* Dick photographing Dorian Leigh in his studio for Revlon's "Fire and Ice" campaign, 1952, photographed by Barrett Gallagher.

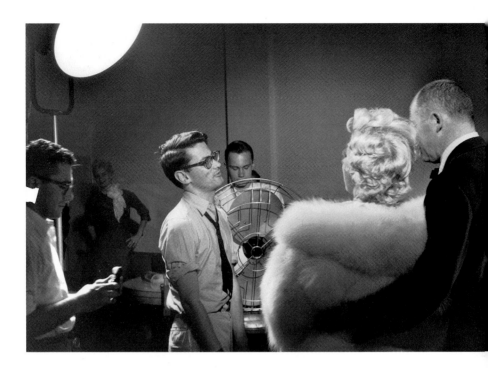

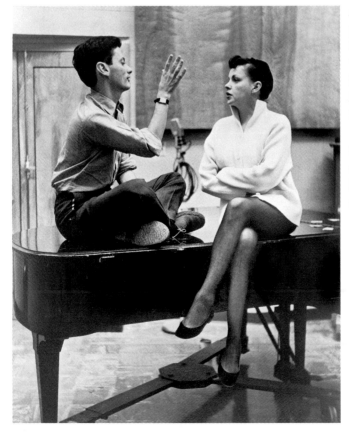

*Above:* Dick photographing Marilyn Monroe and Billy Wilder at his studio for a *Harper's Bazaar* feature on their movie, *The Seven Year Itch*, 1954, photographed by Sam Shaw. *Left:* Dick directing Judy Garland for her CBS television special in 1956.

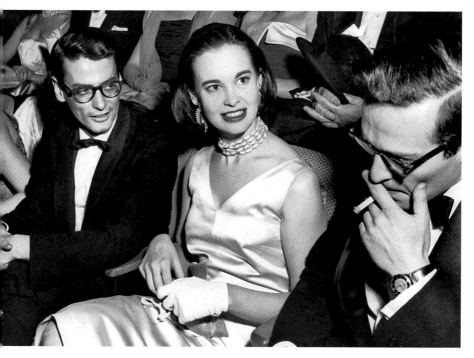

*Above:* Dick with Gloria Vanderbilt and Sidney Lumet at the gala premier of *East of Eden* at the Astor Theatre in New York, 1955. *Below:* Dick and his wife, Evelyn (Evie), photographed by Cecil Beaton during their visit to Reddish House, his estate in rural England, 1956.

*Above:* On the set of *Funny Face. From left:* Leonard Gershe, the screenwriter; Richard Avedon; Fred Astaire, who plays Dick Avery; Roger Edens, the producer; and standing, Stanley Donen, the director, 1956, photographed by Lou Jacobs, Jr. *Below:* Dick (right), standing on the set of the CBS television special *The Fabulous Fifties,* where he was directing a skit with Suzy Parker (seated foreground), talking to Dick's studio assistant, Frank Finocchio, 1959, photographed by Earl Steinbicker.

had rented a yacht for the three of them to sail in the Mediterranean, so Jimmy could finish his essay under Dick's watchful eye; a fire on the boat the day before they were scheduled to leave had thwarted that plan. By then, they were sprinting to meet the production deadline. "Baldwin wrote whatever came out of his heart or mind," Dick told Norma Stevens. "We worked together the way Walker Evans and James Agee had, on 'Let Us Now Praise Famous Men'—in other words, apart."

*Nothing Personal* came out in November 1964, with Baldwin's essay a cri de coeur of astonishing eloquence about the absence of common dignity in America. He denounced the false myths and damaging racial and ethnic hierarchies, pointing to the deep and abiding loneliness that underlies the glossy veneer of American optimism put forward by Hollywood and the media. His essay begins with a withering description of the television ads he is forced to endure while watching the news—ads that aim to sanitize, brighten, straighten, tame, and tweak the skin, hair, teeth, and bodies of "white" viewers into an impossible standard of perfection that positions the enemy to be, well, nature itself. These, of course, were the very companies that commissioned Dick for the print advertising of their products, from which he had become a rich man.

The portraits in *Nothing Personal* present a stark yet authentic counterpoint to the American image of eternal youth and anodyne good cheer, yet the book itself is an embarrassment of riches with too many points being made at once, thereby rendering it something of an incoherent mess. Avedon, who could not contain himself when it came to a presentation of his work, included photographs he had made long before the idea of this book surfaced, including his stunned Marilyn, his abject Dorothy Parker, and his double portrait of Jacqueline de Ribes and Raymundo de Larrain. He included full-length portraits of Fabian and the Everly Brothers, who are virtually interchangeable in appearance. The book opens

with portraits of couples getting married at city hall in New York; the book ends with the pictures he took in the mental institution outside Baton Rouge. One picture along the way shows a woman in Times Square holding up a newspaper with the headline "President Shot." If this collection of images was intended to represent mid-1960s America, it failed to register a single core idea about American hypocrisy, racism in America, or a country in mourning after the presidential assassination, instead providing a disparate collection of individuals who stand in for activities, attitudes, industries, and conditions that were intended to compose a unifying portrait of a time. "If 'Observations' was, by and large, about the certainty of the self and that self's show-business finish or fake-but-felt truthfulness," Hilton Als writes, "'Nothing Personal' was about the breakdown of that certainty."

With *Nothing Personal*, Avedon might have had in mind a dialogue with *The Americans*, by Robert Frank, published five years earlier—an artist's book that struck a sober note about the story America told itself versus the realities of daily life for its citizens. At the time, *The Americans* was little known outside New York art circles, but the book had a profound influence on photographers—including Avedon—and on the direction of photography itself. While Frank had traveled across the country to capture happened-on moments in ordinary life, Avedon's idiom was the portrait, with which he was equally intent on telling a deeper truth about America—despite his failure to do so with the coherence a book like that demanded.

The book's most resonant chords hover at a frequency detected in the balance of Avedon's austere minimalism and Baldwin's mournful jeremiad. Implicit in *Nothing Personal*, however, was the persistent threat to our existence, something the Cuban missile crisis in 1962 had brought that much closer two years earlier. Only one portrait in *Nothing Personal* bears a date, and it is telling: *Maj.*

*Claude Eatherly, Pilot at Hiroshima, August 6, 1945*. It refers not to when the photograph was made but to when Major Eatherly flew weather reconnaissance over Hiroshima and then gave the okay to drop the first atomic bomb, code-named Little Boy.

Avedon first contacted Eatherly to photograph him in March 1963. "For a long, long time I have felt a connection with you, as have my wife and many of my friends," Avedon wrote to him in Galveston, Texas, "because what happened to you is almost like a metaphor of what many Americans feel has happened to them." Avedon flew to Galveston to make his tightly cropped portrait of Eatherly, brow furrowed, and hand cupped over his eye as if to scrutinize the distant horizon.

Colin Westerbeck, the eminent photography historian, has argued that Major Eatherly is the central portrait in *Nothing Personal*, perhaps even in Avedon's entire career. He pointed out the absence of shadow and the blown-out background in Avedon's portraiture that left "every wrinkle, stubble, wen and nervous tick" on his subjects' faces strikingly visible. "When that bank of strobes went off in Avedon's studio—pfoom!—subjects must have felt as if they'd been caught in an atomic bomb blast," Mr. Westerbeck said.

That "bomb blast" would become the signature style with which Avedon created many series of photographs, including "The Family," sixty-nine portraits of the most powerful and influential Americans published in *Rolling Stone* for the country's bicentennial in 1976; and his 1985 book, *In the American West*, consisting of portraits of anonymous workers, drifters, cowboys, and random citizens made throughout the western United States over five years, a stark contrast to the pantheon of accomplishment and celebrity that characterized most of Avedon's earlier portraiture.

Unlike *Nothing Personal*, in which a hierarchy of significance and artistic judgment is telegraphed in the variation in size of the pictures on the page, Avedon would eventually give all his sub-

jects equal stature, shooting each one with strobe lighting against a white background. His stone-cold, corpse-like representation of individuals in the second half of the twentieth century remains the existential register of his portraiture. "Strangely," he wrote in his letter to Eatherly, "just as your experience, although in a way too horrible to be borne, made you see that we are all part of one another, the fact of you does the same for us."

Avedon was hardly alone in his existential dread in 1963, the year of President Kennedy's assassination. Just as he was writing to Eatherly, Garry Winogrand was thinking about a body of work in which American culture would be the focus of his camera. "Since World War II we have seen the spread of affluence, the move to the suburbs and the spreading of them, the massive shopping centers to serve them," he wrote in his 1964 Guggenheim Fellowship application. "Our aspirations and successes have been cheap and petty. I read newspapers, columnists, some books, and look at some magazines. They all deal in illusions and fantasies. I can only conclude that we have lost ourselves, that the bomb may finish the job permanently, and it just doesn't matter; we have not loved life."

Avedon believed that *Nothing Personal* was "his best work to date," yet, to his surprise and profound chagrin, the public reaction was swift and hostile. Writing in the *New York Review of Books*, Robert Brustein lashed out at the book's extravagant "snow-white covers with sterling silver titles" before excoriating the effort in his critique. "'Nothing Personal' pretends to be a ruthless indictment of contemporary America," Brustein wrote, "but the people likely to buy this extravagant volume are the subscribers to fashion magazines, while the moralistic authors of the work are themselves pretty fashionable, affluent, and chic."

Truman Capote came to Avedon's defense in a letter to the editor published the following month: "Would he rather it was printed on paper-toweling?" Capote asked. "Brustein accuses Avedon of dis-

torting reality. But can one say what is reality in art?—'An artist,' to repeat Picasso, 'paints not what he sees, but what he thinks about what he sees.' This applies to photography—provided the photographer is an artist, and Avedon is."

Brustein was hardly alone in his repudiation. "For over a decade, Richard Avedon's elegant, epicene high fashion pictures have set the slick tone for *Vogue* and *Harper's Bazaar*. Now it turns out that all along Avedon has been disgusted by the affluent American he celebrates," wrote *Time* magazine, which, in a sober assessment, granted him a single "masterpiece of self-satire"—the group photo of eleven "plump, prim, grim generals" of the Daughters of the American Revolution. Still, the verdict was not in his favor. "Avedon is possessed of a lens that is a subtler, crueler instrument of distortion than any caricaturist's pencil. Washington hostess Perle Mesta appears whiskered and wattle-throated; Dwight Eisenhower looks like his own corpse."

What Avedon intended as a "photographic polemic against racism" ended up a crankier and more American-centric version of Edward Steichen's 1955 *The Family of Man* exhibition at the Museum of Modern Art. Because of Avedon's reputation as a high-style fashion photographer and an established member of smart New York society, the book was dismissed as a gesture of privileged guilt.

Unfortunately, to repeat once again, the clarity of Avedon's reading of the cultural mood, the depth of his intentions, and the quality of his work were too often obscured in the glare of his own self-mythologizing tendencies. The flash and the glitz of *Nothing Personal* undermined its credibility, and Avedon's need to include too much of his work exhausted the book's potential for cohesion. While his large idea about American culture got lost, he had been driven by a sincere and high-minded imperative and endured some harrowing and life-threatening circumstances in the process of making several profoundly enduring images.

WHILE AVEDON HAD DEVOTED a great deal of time and energy to thinking about *Nothing Personal* and chasing James Baldwin around the globe, he was at the same time barreling along at his usual whirlwind pace, juggling the magazine assignments and ad campaigns that afforded his crusty french bread and creamery butter.

Among the portraits he made that year, whether those shot for *Nothing Personal* that didn't make the cut or features for *Harper's Bazaar*, were, again, the poet W. H. Auden; the composers Aaron Copland and Edgard Varèse; the opera singer Leontyne Price; the pianist Arthur Rubinstein; the writer Norman Mailer; the artist Willem de Kooning; the actors Steve McQueen, Elizabeth Taylor, and Richard Burton; and the film director Mike Nichols (during the development of the film *Who's Afraid of Virginia Woolf?*, which Nichols directed and Taylor and Burton starred in).

In the late summer of 1964, following the Paris collections, Dick went to Spain to shoot the design collections of the season, and while there, he and China Machado, a fashion editor of the *Bazaar*, went to the island of Ibiza to shoot a fashion feature called "The Illusive Iberians of Ibiza," which appeared in the January 1965 issue of *Harper's Bazaar*.

China Machado, who was one of Dick's favorite models and closest editorial collaborators, would become a fashion industry legend. Born of a Chinese mother and a Portuguese father, she grew up in Shanghai's wealthy French Concession. Her family escaped Shanghai and found its way first to Argentina, then Peru, and finally to Spain. When she was nineteen, Luis Miguel Dominguín, the most famous bullfighter in the world, spotted her at a bullfight and she went to live with him for two years, until he left her for Ava Gardner.

Machado became a house model at Givenchy in Paris for several years, and, one day, Oleg Cassini invited her to come with him

to New York to model in his show. The day after she arrived, she walked into Diana Vreeland's office; Vreeland immediately persuaded her to appear in a fashion show at the Waldorf the following morning. Coincidentally, several days later Avedon saw her at the Museum of Modern Art and lost no time getting her to his studio. He photographed her for an entire fashion portfolio for *Harper's Bazaar*, yet, when he and Diana Vreeland presented the pictures, the magazine's publisher flinched. "Listen, we can't publish these. The girl is not white." This was a new kind of prejudice Dick had not before encountered, and he got so angry that he threatened to leave the *Bazaar* if the pictures weren't published. Machado did appear in that portfolio in the February 1959 issue, along with an introduction in "The Editor's Guest Book," a distinction unusual for a model: "There is something about the quality of China Machado's good looks—the delicate Oriental cast of feature, the vivacity of expression—that has an electrifying effect wherever she appears in the world of fashion." Dick would later claim that China Machado was "probably the most beautiful woman in the world." She told him, "I never felt beautiful before you photographed me."

There is footage showing Dick among the palm trees and along the white sandy beaches of Ibiza wearing sunglasses and a black pullover sweater with white pants and tennis shoes one day, the next in a wide panama hat, looking as glamorous as one would expect of the top fashion photographer in the world on a jet-set destination island. Machado had discovered the twin sisters Ana-Maria and Nati Abascal, Spanish socialites, and Dick had discovered Helio Guerreiro, a Brazilian aristocrat, in New York. Once on the island, Machado had to fend off the persistent Helio for the entire week. It was Dick's idea, with the assistance of Machado, to create a fashion feature that possessed the narrative properties of a film, with, perhaps, an unwitting reference to *The Sheltering Sky*, by Paul Bowles, in this case a ménage à trois cavorting around an island

paradise with ever the hint of erotic mischief. In one image, Helio wears a white linen suit and is flanked by the women, also in white, as they stroll along a village street with the sun-bleached buildings surrounding them. In another, one twin is lying in the water in an inlet, fully clothed, with Helio, also clothed, by her side.

They shot at least a half dozen scenes in and around the island, sometimes waiting hours between shots, either for hair and makeup, or for the right time of day to get the kind of light Dick wanted. Sometimes they had to wait for Dick, who had been ill for months with a case of intestinal amoebas and was forced to lie down for an hour in between every shoot, always in immediate proximity to a bathroom. Despite his physical condition, Dick plodded ahead. In 1964, the idea of a ménage à trois was very modern and chic. Dick put one of the pictures of this *ménage* on the wall of his "collage" at McCann Erickson that fall, and, in the urban slang of 1960s New York, pointed it out to an ad exec. "Want to see something really *sick*?" he said.

IN THE MID-1960S, HOLLY Solomon, a short and swank platinum blond who lived on Sutton Place, was anointed in the press with the affectionate, if sarcastic, sobriquet "Pop Princess." She was known not only for her theatrical mannerisms and sartorial wit, but, eventually, in the 1970s, for her eponymous SoHo art gallery and her contemporary art collection. In 1963, when she decided to have her portrait done, she approached Avedon, who would later in his life muse about the people who commissioned portraits from him: "I often feel that people come to me to be photographed as they would go to a doctor or fortune-teller—to find out how they are," he said, perhaps justifying for himself the high prices he commanded.

Solomon found Avedon's fee of $12,000 to be unconscionable.

Since she already owned a Warhol Marilyn, she went to Warhol instead. Until Warhol's *Campbell's Soup Cans* was exhibited at the Ferus Gallery in Los Angeles in 1962—his first significant solo show—Warhol made his living as an illustrator of women's shoes for *Glamour* magazine and later as chief graphic designer for I. Miller. Warhol took Holly Solomon to a photo booth in Times Square. "I had twenty-five dollars in quarters with me, and he let me be, which was very smart, because I was an actress," Solomon said. "I wanted to be Brigitte Bardot, I wanted to be Jeanne Moreau, and Marilyn Monroe all packed into one." Warhol took one of the photo strips with four portraits, framed it, and gave it to her. In it she is wearing what was then a trendy new hair feature, a "fall," which was a partial wig, the same platinum blond as her hair, that fit on top of her head to add height, then dropped to her shoulders to add length. She wears a leopard-patterned fur coat, the collar wrapped close around her neck, and she strikes a different theatrical attitude in each frame. Today, the portrait resides in the permanent collection of the Museum of Modern Art.

What put her on the map as the "Pop Princess," though, was *Holly Solomon*, a nine-panel silk screen grid that Warhol made in 1965, in which he presented a single photo booth portrait of Solomon repeated nine times, in different colors. "What no one really understood about Andy at the time was that he was a great artist," Solomon later said. "When Andy did a photograph, when Lichtenstein did a painting or a drawing, they understood that medium and the new vocabulary that they were adding to it."

Since 1962, Dick had been assigning workshop students to go to photo booths and do something no one had ever done before. The point Dick wanted to make was that the camera is not what makes an original image; the artist does. By understanding the neutrality of the mechanical device, your imagination can then roam. Warhol, too, implicitly understood the relevance of mechanical devices

and procedures in artmaking and had begun to focus on their replicative abilities as a medium in itself.

In 1963, Warhol's first portrait commission had been Ethel Scull, who, with her husband, Robert, the owner of a taxi fleet, had become media darlings because of their conspicuous acquisitions of contemporary art: *Ethel Scull 36 Times* is a Warhol grid of thirty-six silk screens on canvas, each one a separate photo booth portrait of her. Scull imagined that Warhol was going to take her to a photographer like Richard Avedon to make a portrait that he would then paint on. She was surprised to be taken to Times Square instead. Andy said, "'Just watch the red light,' and I froze," Scull said. "I watched the red light and never did anything. So, he'd come in and poke me and make me do all kinds of things, and I relaxed finally." They ran from one photo booth to another, putting quarters in each one, making photo strips that were drying on every surface. When they were finished, he showed them to her. "They were so sensational that he didn't need Richard Avedon," she said. "I was so pleased."

Avedon used his Rolleiflex in a manner not unlike a mechanical photo booth camera. He would place his subjects in front of white seamless paper to remove them from any context so that they would come to symbolize, well, themselves. He would place each subject the same distance from the camera. He would wait for the right moment, and *click*. The camera was a mechanical device, and his replication of the same format for each portrait brings our focus to the individual, as opposed to any photographic style. It was an absence of photographic style he was after, despite the fact that that became a style in itself.

Throughout the 1960s, photography may have maintained a subordinate position in the realm of artmaking, but ironically, the supposedly lowly photograph was rapidly being absorbed into artwork of the highest visibility. In fact, the march of the photographic

image through the studios of the most prominent artists during that decade—Warhol, Rauschenberg, Baldessari, and Ruscha—becomes ever more notable today as, increasingly, we understand the effect of photography on what artists were doing then, as well as on the way we see the world today. A visible dialogue had begun between Avedon and Warhol, too, unwittingly or not, about how to use the photographic image.

In the May 17, 1963, issue of *Life* magazine, a layout about the Birmingham race riots warranted a public comment from President Kennedy about the racial tensions in America, in which he observed the events of the civil rights movement to be "so much more eloquently reported by the news camera than by any number of explanatory words." In 1964, Warhol used a picture from that *Life* magazine layout by Charles Moore—in which a police officer pulls at the leash of a German shepherd on hind legs as it attacks a black man trying to flee—and repeated it in a series of ten silk screens on linen, in different colors. At the time, Warhol gave several panels to Sam Wagstaff, the curator, who assembled four of them as a grid, which came to be known as *Race Riot*. In 2014, at a Christie's auction of postwar art, the gavel came down on *Race Riot* for $62.8 million.

What Warhol had done with *Race Riot*, the replication of a single image as a symbol of the entire civil rights movement, Avedon had tried to do with *Nothing Personal*. Both were aiming for a synthesis of ideas on a single plane in two dimensions that would outlast their era and define it at the same time.

AVEDON WAS RESTLESS. THE Kennedy assassination in 1963 had cut deep into the national consciousness; violence was erupting from the civil rights movement; the culture was on the brink of a sexual revolution; a new chic of marijuana and psychedelic drugs

was opening up a world of new possibilities. Besides, the response to *Nothing Personal* had been devastating. He acknowledged that he had been "torn to shreds" by the debacle, eventually getting to the point where, some years later, he would say, "Reviews no longer victimize me, define me, or elate me, or stop me from working." He found solace and satisfaction in the reward of being editor in chief of *Harper's Bazaar*—at least for one issue.

On April 4, 1965, a full-page advertisement that might be called "Richard Avedon Six Times" was published in the *New York Herald Tribune*, as well as in all the major magazines. Under a grid with a single portrait of Dick repeated six times—a Warholian gesture—is the declaration "We could fill a book with Avedon!" The ad announces that Avedon will be the guest editor of the April 1965 issue of *Harper's Bazaar*, in its entirety, for which he conceived all the editorial content and took every single photograph.

Dick would soon be leaving *Harper's Bazaar*, having accepted an offer he could not refuse from Alexander Liberman at *Vogue*, agreeing to a $1 million advance against his work for the magazine. "Then I vomited for about two weeks without stopping," Dick later told Michael Gross. "I learned everything at *Bazaar* and now I was going to the enemy camp." He was landing on familial enough ground, given that Diana Vreeland, his "professional crazy aunt," was editor in chief.

The April 1965 issue of the *Bazaar* is nothing if not a self-portrait, a document of Avedon's pitch-perfect reading of the cultural moment, a celebration of his sparkling imagination, and a template of his sophisticated sensibility. As David Michaelis would recall in *Vanity Fair* in 2009, "April 1965 was radiant with anticipation—America was preparing to marry the future, and the one man who could make the national wedding portrait was Richard Avedon."

On May 25, 1961, President John F. Kennedy had announced

before a special joint session of Congress the dramatic and ambitious goal of sending an American safely to the moon before the end of the decade. The April 1965 issue of the *Bazaar* had an obvious theme: To the moon—as if from President Kennedy's lips to the orbits of Avedon's imaginings.

For the April 1965 issue, Avedon worked with Jean Shrimpton for the first time, photographing her on three separate occasions—once for the cover; once for an opening spread in which she is wearing an actual NASA space suit that Dick had acquired for the occasion; and, again, in Fort Lauderdale at a construction company quarry amid mountains of white gravel that doubled as a moonscape—she was Earth girl wearing a clear bubble space helmet around her head.

The cover of the April issue is a headshot of Jean Shrimpton, photographed by Avedon, with a Matisse-like, Day-Glo pink oval cutout surrounding her face. This eye-popping graphic flourish was a small miracle of improvisation. When Dick decided at the last minute that he hated the picture of Shrimpton with a space bubble around her head, Ruth Ansel, then co–art director of *Harper's Bazaar*, saw a sheet of bright pink construction paper on the counter in the art department and, with scissors, cut it into an oval shape and, then, cut out the center, and placed it over the picture to frame the model's face and obscure the bubble helmet—a last-ditch attempt to save the cover image. Dick loved it.

If the Kennedy assassination had been a single event that unified the entire planet in collective shock and despair, then the Beatles came along at just the right moment as beacons of hope. They brought about the British Invasion, and mod unisex fashions from Europe were about to be birthed on the streets of New York. "It was a marvelous time," Diana Vreeland said about that period, when fashion, in particular, embraced wild patterns, swirling psychedelic prints, and vibrating neon colors. "In the '60s you were

knocked in the eyeballs. Everybody, everything was new." Avedon featured clothes with eye-popping patterns and playful accessories. He featured Courrèges, the visionary French designer, with his geometrical silhouettes, short hemlines, and futuristic fabrics.

And he featured the Beatles—two of them, anyway. On January 23, Dick flew to London and stayed at the Ritz. The next morning Sir Winston Churchill died; the entire city was lying in wait for a week, until his state funeral. On Tuesday, January 26, the shoot with Paul McCartney and Ringo Starr took place in the penthouse photo studio of Antony Armstrong-Jones—Lord Snowdon—who was married to Princess Margaret. Nicky Haslam, a British art director who was advising Dick on matters of the ultimate "nowness" in all things British, ushered Dick through a throng in front of the *Sunday Times* building on Gray's Inn Road, as word had leaked out that the Fab Four were supposed to show up there. John Lennon, who was at his home outside London, chose not to participate; neither would George Harrison. China Machado, the fashion editor on the shoot, said: "John [Lennon] knew what he was worth, and wasn't giving anything away. Dick was miffed. He always thought he could photograph anyone."

Still, the close-up portrait he made of Paul McCartney wearing the same NASA space suit worn by Shrimpton is nothing less than a Leonardo in the rendering of cherubic, beatific innocence, McCartney's eyes looking toward the heavens, his expression solemn, yet open, expectant. How *young* Paul was—and to have the entire world at his command. And, how inspired of Avedon to put him in a space suit—the person anyone on the planet at that moment would have wanted to be the first astronaut to land on the moon and take "one small step for man, one giant leap for mankind." In a separate spread, Ringo is dressed as Caesar, wearing a crown of leaves.

In *A Hard Day's Night*, Ringo is seen along the Thames, a Pentax

camera around his neck, brooding as he photographs the ducks. He agreed to this portrait session as long as he could photograph the proceedings. After Paul left the studio, Ringo, twenty-four years old, challenged Dick, then forty-one, to a drinking contest, recalled Earl Steinbicker, who was assisting Dick on that trip. "Whiskey," Earl said. "They were getting drunker and drunker and drunker, and, finally, Dick was lying on the floor, passed out." Ringo took some pictures of Dick, and, then, when he passed out, Steinbicker unloaded the film from his camera. Dick would not have wanted any evidence of his drunkenness to make its way to the press. China Machado said they had to get Ringo out of the studio. Aware of the Beatles fans out front, she made a few calls. Steinbicker carried the very limp Ringo to the roof, through the January snow, into a separate building, where he put Ringo on the elevator and delivered him to his handlers waiting at a secret door. Then Steinbicker took Dick home to the Ritz. "Amazingly, he bounced back the next day."

Dick selected two writers who were setting the cultural tone that very moment for his special *Bazaar* issue: Tom Wolfe, who was about to publish *The Kandy-Kolored Tangerine-Flake Streamline Baby*, a book of his essays that were among the first to herald the New Journalism, and Renata Adler, a young writer for the *New Yorker*, who wrote a short story entitled "Will You Speak to Anyone Who Answers?," in which the pronouns are reversed—Norma is a "he" and Richard is a "she," anticipating gender fluidity by a half century.

Included, too, is an August Sander–like portfolio with full-page Avedon portraits of men who were destined to live on in history: Bob Dylan, Jasper Johns, Robert Rauschenberg, Alex Hay, and Henry Geldzahler. These portraits are striking in Avedon's oeuvre as they are all full length, head to toe, made outdoors, without a white seamless backdrop. It's possible that Dick was trying something new after the reception he got for *Nothing Personal*, in this

case an attempt to render his subjects less as specimens and more as human beings with inner lives.

As Avedon portraits, they are uncharacteristic, and they are good. You want to look at them, not only because of who they are: a smiling Jasper Johns stands on a snow-covered street in a jovial mood, hand in one pocket, an endearing moment for someone who projected a more buttoned-down public persona; his portrait of Bob Dylan was taken on a Fifth Avenue sidewalk along Central Park, the poet-singer soon to release the generational anthem "Like a Rolling Stone." In Avedon's portrait, Dylan stands with hands in the pockets of his Carnaby Street coat, leather boots up to his knees, feet together with his weight on one leg, staring at the camera with an air of impatience around his mouth.

There is a portfolio of jumping models, including China Machado, and Donyale Luna, a slender young African American, the first black model to appear in the magazine. Born Peggy Ann Freeman in Detroit in 1945, Donyale Luna would famously reply to questions about where she was from with "I'm from the moon, darling." David McCabe, a young British photographer who had taken the Brodovitch workshop in Dick's studio, discovered Donyale Luna in Detroit while working on a Ford Motor Company advertising shoot. She was walking down the street wearing a Catholic school uniform. "She was gorgeous, stunning, nearly six feet tall," McCabe said. "I gave her my card and said, 'If you are ever in New York, call me. I can get you work as a model.'" She called him two years later. "The first person I thought of who could use her effectively was Avedon," McCabe said. "I called Dick because I knew he would appreciate her beauty."

From a twenty-first-century vantage point, the April 1965 issue of the *Bazaar* is a more concise and revealing time capsule of the trends and currents of the burgeoning "youthquake" of the 1960s than *Nothing Personal* was in its portrayal of a torn society. "Dick

immediately understood that this youth revolution was going on, and he wanted a piece of it," Ruth Ansel said. "He understood that it was a moment in time, because of what was happening—the sexual revolution, the youth revolution, the moon shot, rock and roll. It was a time like none other." Thirty years later, Vince Aletti, the photography critic, called this issue of the *Bazaar* "an Avedon style handbook and a witty time capsule, a coup of right-this-minute immediacy."

Reaction to Donyale Luna began before the April issue was even published. While the publisher had tried to stop the pictures of an Asian model from being published several years earlier, there was no public revolt like the reaction to a black model appearing in the pages of *Harper's Bazaar*. Advertisers with southern accents pulled their ads from the issue, and subscribers canceled their subscriptions. William Randolph Hearst Jr. expressed his displeasure to Nancy White, but by then Avedon had decamped to Condé Nast. Still, it was one small step for race relations in America: fashion history was made, and Avedon was the instigator.

# 11

# TUNING IN

(1965–1967)

There has never been a document of culture, which is not
simultaneously one of barbarism.

—WALTER BENJAMIN

F lorence Pritchett Smith, first a model, then a journalist,
led an enchanted life that included a serious romance with
John F. Kennedy in the 1940s. She would marry Earl E. T.
Smith, a member of the New York Stock Exchange, who became a
US diplomat, and then ambassador to Cuba under Eisenhower. In
the early 1960s, the Smiths were among an intimate circle of friends
who dined regularly with the Kennedys at the White House and in
Palm Beach. By 1965, Florence was writing a weekly food column
in the *New York Journal-American* and, in her last published piece,
she chronicled "one of the most chic and amusing luncheons" she
had ever been to, not a formal affair, but rather "a picnic" right in

the middle of Manhattan that took place almost every day of the week "at Dick Avedon's studio."

She described Avedon as a compact bundle of intensity, enthusiasm, and charm. His duplex photography studio on East Fifty-Eighth Street, with its double-height ceiling and warren of darkrooms and offices, was as meticulously organized as "an operating room." Jazz played as the "master photographer" traipsed around in "fur-lined slippers and a black turtleneck sweater," his manner "casual, friendly, disinterested." When he is photographing, she writes, "his dark eyes glittering through black rimmed glasses, he has a hypnotic effect on the subjects."

The studio "picnic" lunch was a collective daily ritual. On the afternoon Smith was there, several large picnic baskets arrived from Poulet D'or, which she described as "the poor man's Pavillon." Cold roast chickens were put out on a long wooden table flanked by white-lacquered benches, along with a Caesar salad and piping hot crusty french bread wrapped in blue-and-white floral Porthault napkins. A separate basket contained chilled fresh fruit and a tray of cheeses. Everyone ate off of blue plastic plates using fine, bamboo-patterned silver. Icy Pouilly-Fuissé was poured from Baccarat crystal. Smith listed the guests who might stop by for lunch—Dick's good friends Mike Nichols, Truman Capote, Gloria Vanderbilt (Cooper); the model he was working with that day, such as Jean Shrimpton; the subject of a portrait for the magazine at that moment, who might be Barbra Streisand or Sophia Loren or Dr. Linus Pauling; also "any of the young attractive people who are doing extraordinary things in New York." Sometimes Mrs. Avedon would join, too, and always Dick's assistants, who composed the core of this communal gathering of wits and "delightful conversation." Then the espresso was served, and, before you knew it, the picnic was over.

Meanwhile, eleven blocks south of the Avedon studio, another

gathering was marked with an equally gratuitous form of puffery. Grace Glueck of the *Times* covered a party at Andy Warhol's "Silver Factory" celebrating the launch of a book called *Pop Art*. The event was "by no means lacking in pop ingredients," she wrote. In a non-air-conditioned atmosphere "as thick as a can of Campbell's chicken gumbo," about three hundred guests were on hand to attempt the "frug" and "watusi." The food and drink came from a pushcart vendor Warhol hired off the street to serve frankfurters and beer. People shouted to each other over the peak-decibel volume of a live rock and roll band. Rudolf Nureyev was present, as were Judy Garland, Roy Lichtenstein, Claes Oldenburg, and Tennessee Williams. The only person who seemed to be missing was Andy Warhol himself. "Rumor had it that he had sneaked off to another party in an air-conditioned hotel." In contrast to the staid picnic at the Avedon studio, the Warhol party had a raucous glamour that telegraphed a raw kind of energy that was decidedly *new*.

Avedon and Warhol first met at an opening at the Museum of Modern Art in the summer of 1965. In a picture that documents the moment, they are both wearing tuxedos. Dick is standing on the left, his arms folded against his chest, his face pinched as he glowers at Warhol, whose platinum blond countenance, by contrast, strikes a congenial note.

David McCabe, who had discovered Donyale Luna, took the photograph. Warhol had hired McCabe to follow him around at public events and photograph him in the presence of artists and celebrities. "Andy was all about creating Andy," McCabe said, who hadn't even known Warhol's name when he was first contacted by him. "Who was this guy doing Campbell's soup cans and Brillo boxes?" McCabe remembered thinking. "People thought he was just an upstart window dresser who was trying to break into fine art."

That night at MoMA, Warhol gave McCabe the heads-up

whenever he saw someone he wanted to be photographed with. "Oh, there's Barnett Newman. Make sure you get a picture of me with him," McCabe recounted. Then Andy saw Dick. "Oh my god, there's Avedon," he said. Warhol was riveted to the idea of glamour, and of all the people Andy encountered that evening, Avedon was the ultimate *get*. "Andy engineered his way to him, giving me the heads-up to photograph them together," McCabe said. "I was just as impressed by Avedon as Warhol seemed to be. It was like meeting one of the gods of photography."

According to McCabe, Warhol, who always appeared mild mannered and soft spoken, was respectful and even complimentary to Dick that night. But, in the picture, Dick's body language makes it clear that the iron gate to *la façade* was shut. Clearly, Dick understood he was about to be eclipsed in fame and stature by an entirely new art world gesture—and a redefinition of glamour.

That first encounter with Andy occurred while Dick was in a particularly fragile state of mind. Something of a psychic black hole had formed when he didn't get the acknowledgment he expected on the publication of *Nothing Personal*. Criticism about the book had been painful enough, and now, several months after the publication of his *Harper's Bazaar* issue—into which he had poured his soul—the silence about it was deafening. The only professional attention he received in these months was a review of his McCann Erickson show, *Avedon 64: A Collage*, in the May 1965 issue of *Popular Photography*, which was, in effect, a trade publication. John Durniak, who wrote it, was the magazine's editor (soon to become director of photography for *Time* magazine, and, later, for the *New York Times*); yet his glowing review was a mere voice in the wind that would never be heard in the circles of influence that mattered to Dick: "Richard Avedon, photographer, iconoclast, and showman, produced what must be called (for the sake of accuracy) the most spectacular photographic show ever," Durniak wrote. "To call

Avedon one of photography's geniuses would not be sticking one's neck out." If only the review had appeared in the *Times*.

In August 1965, an exhibit opened at MoMA entitled *The Glamour Portrait*, and five Avedon images were included, a welcome acknowledgment of his work. He was in good company with photographs by Cecil Beaton, Adolphe Braun, Julia Margaret Cameron, Man Ray, Baron Adolph de Meyer, George Hoyningen-Huene, Martin Munkacsi, Irving Penn, and Edward Steichen. John Szarkowski, who organized the show, was early into his consequential tenure as the curator of photography at the museum and took something of an intellectual risk presenting work from the world of fashion. In his wall text for the show, Szarkowski maintained his own arm's-length distance by speaking in riddles about the photographs: "The imaginary beauties on these walls—from the make-believe shepherdess of Julia Margaret Cameron, as dreamily poetical as a Tennyson heroine, to the arrogant and queenly waif of Richard Avedon—almost persuade us that they have in fact existed." The Avedon pictures in the show included Gloria Vanderbilt, Brigitte Bardot, Dolores Guinness, Jacquetta (Lady Eliot), and a portrait of Contessa Christina Paolozzi—the first topless model to be published in *Harper's Bazaar*, in 1961 (thanks to Dick). The bare-breasted countess appears on the wall at MoMA less than one-quarter the size of the other Avedon pictures. Propriety was still the order of the day when it came to nudity in photography in the mid-1960s.

In 1965, photography had yet to be regarded as an art world equal, and, while Avedon was well aware of his unique prominence as an editorial photographer, he had not yet focused on garnering art world recognition, never mind something as unobtainable as historical relevance. The question of whether photography is art reared its head periodically throughout the medium's short life, from its inception in 1839; it gained the most traction in the early

twentieth century, with Alfred Stieglitz and Edward Steichen making the best case; but the idea had receded in the wake of photojournalism, never mind abstract expressionism. Now, once again, in the 1960s, as artists were employing the photographic image in works of a more conceptual nature, the question of whether photography is art was nascent. But Avedon's attention was aimed at a different stratosphere of accomplishment altogether.

SEVERAL OCCURRENCES WOULD ADD to Dick's psychic tailspin over the next year. His friends had been reaching for excellence; now they were arriving at greatness. Dick had to contend with several successes at once: the publication of *In Cold Blood*, written by Truman Capote; the release of the film *Who's Afraid of Virginia Woolf?*, directed by Mike Nichols; and the premiere of the *Chichester Psalms*, composed by Leonard Bernstein.

In October 1965, assigned by *Life* magazine, Avedon once again traveled to Garden City, Kansas, with Capote, this time to photograph him for a feature on the occasion of the publication of *In Cold Blood*. Avedon's picture of Capote appears across a two-page spread in the January 7, 1966, issue of *Life*, above the headline "Horror Spawns a Masterpiece." Capote stands in the middle of a long dirt road that narrows into a flat, distant horizon behind him, a barren landscape near the farmhouse where the Clutter family was murdered six years earlier. Capote, wearing a military field cap, stares unflinchingly into the camera.

"Not since Thomas Wolfe lugged the immense manuscript of *Look Homeward, Angel* with him to cocktail parties in 1929 has any American book excited as much advance notice and excitement as Truman Capote's *In Cold Blood*." And so begins the *Life* magazine article foretelling the fate of Capote's most consequential book, a nonfiction novel that would alter the course of literature and come

to serve as a standard for the New Journalism. "Although the book will not officially be published until next week in one of the biggest initial printings (100,000 copies) ever ordered by Random House, thousands of people have already read it serialized in the *New Yorker*, and millions more are about to encounter it as a Book-of-the-Month Club selection, a paperback, and a movie."

To celebrate his ascension into the upper reaches of the social and intellectual firmament, later that year Capote threw a party for the ages, his legendary Black and White Ball, at the Plaza Hotel. The pretext of this masked ball was to honor Katharine Graham, the publisher of the *Washington Post*, but, in fact, it was the coming-out ball Capote had always dreamed of having for himself.

Despite the many grande dames in attendance, from Lauren Bacall to Elizabeth Taylor, Gloria Vanderbilt, Rose Kennedy, or Kay Graham herself, it has been widely written that the belle of the ball was a sixteen-year-old girl named Penelope Tree. She was draped in a sleeveless, V-neck, black floor-length tunic she had designed herself with Betsey Johnson at Paraphernalia. Her midriff was completely bare. "I am one hundred percent proof that wearing the right thing at the right moment can change your life," Tree said. If ever there were an alternate-reality debutante, it was Penelope Tree—more Pippi Longstocking than, say, Tricia Nixon. There, in the midst of such high-wattage dazzlement, Dick first laid eyes on her and knew immediately that he had found his next Avedon woman. But we will get to that.

Meanwhile, Dick's good friend Mike Nichols, who was also in attendance, had long ceased to be a comedic performer. Not only had he proved himself to be a very worthy theater director with *The Odd Couple*, the wildly successful 1965 Neil Simon play on Broadway, he was at this moment basking in the glow of an unusually high-toned level of approval from the New York cognoscenti after the summer release of the film *Who's Afraid of Virginia Woolf?*, his

debut as an auteur. Bosley Crowther of the *Times* called the film "a magnificent triumph of determined audacity."

Dick's friend "LB" had been busy, too. As the electrifying conductor of the New York Philharmonic, he brought Mahler back into the repertory with his impassioned conducting of the composer's symphonies, all of which he recorded with the Philharmonic, as well as several with other international orchestras. He proved himself a compelling educator as well, with his very popular ongoing Young People's Concerts on public television.

In 1965, Walter Hussey, dean of Chichester Cathedral in Sussex, England, commissioned Bernstein to compose a new piece for the Southern Cathedrals Festival. Bernstein put six psalms to music in an extended choral composition sung in Hebrew, including the twenty-third psalm, sung by a young boy. Alex Ross, music critic of the *New Yorker*, refers to *Chichester Psalms* as Bernstein's "choral masterpiece from 1965," in which he folds "vernacular melodies and street rhythms into an atmosphere of sacred purity, a kind of athletic innocence." The piece had its premiere with Bernstein conducting at the New York Philharmonic in July 1965. Even Dick acknowledged Lenny's greatness on this occasion: "You stand alone," he told him. "Terrifying, but true."

Despite Avedon's own wild success and notoriety, measured against his venerated friends, he was still just a fashion photographer. Compared with art, literature, and classical music, fashion photography was barely even a trade. Norman Podhoretz, in his 1967 memoir, *Making It*, offers a glimpse of the anxiety someone in Dick's social orbit experienced as ever-fluctuating tallies were being silently calculated on any given day about their place on the food chain in relation to their contemporaries. "Every morning," Podhoretz writes, "a stock-market report on reputation comes out in New York. It is invisible, but those who have eyes to see can read it. Did so-and-so have dinner at Jacqueline Kennedy's apart-

ment last night? Up five points. Was so-and-so not invited by the Lowells to meet the latest visiting Russian poet? Down one-eighth. Did so-and-so's book get nominated for the National Book Award? Up two and five-eighths. Did *Partisan Review* neglect to ask so-and-so to participate in a symposium? Down two." Or as Gore Vidal would later famously note, "Whenever a friend succeeds, a little something in me dies."

WHILE DICK HAD BEEN working on *Nothing Personal*, he and Evie moved from the grandeur of their Park Avenue residence to the more intimate luxury of Riverview Terrace, a narrow cobblestone street on a private gated block just north of Sutton Place Park, between East Fifty-Eighth and Fifty-Ninth Streets. A mews in the middle of Manhattan, the street is lined with six town houses on one side and a lush, tree-filled rectangular garden on the other that yields a spectacular view of the East River. Evie brought in Billy Baldwin to design the interiors of their four-story town house, and Dick, now ascending to baronial self-importance, for the first time hired, in addition to a maid and a cook, a butler. One day Ruth Ansel had to drop off some contact sheets for the magazine. "My jaw dropped," she said. "I mean, talk about luxury."

Riverview Terrace was where Avedon was living when *Nothing Personal* came out. The opulence of his residence only underscored the hypocrisy for which his book was so summarily dismissed. Dick could be very generous in some ways, as with the daily studio ritual of providing an abundant staff lunch—although if he was shooting for an advertising campaign, the client footed the bill. He was generous with SNCC, opening up his studio to their photographers for training sessions. Yet for all his generosity of purpose and his winning charm, Avedon could be equally parsimonious and, at times, patently cruel. "Dick's liberal tendencies did not include supporting

his staff," Freddy Eberstadt, one of Dick's assistants, said. "Every summer when he and Evie went to Paris for the collections, followed by a honeymoon-length vacation, he would not only suspend studio salaries but fire his domestic servants, so he wouldn't have to pay them. Then, he hired a new staff when he got back."

For years Avedon had been operating by sheer force of his intelligence, an entity partitioned from the realm of insecurities and painful emotions that made him human. All of that could be addressed in his daily visits with his analyst. As for the demands of a marriage he had chosen as a cover for the erotic life he denied himself, the rhythms of his relationship with Evie had fallen into pro forma irregularity. They enacted the rituals of their increasingly high-toned social milieu, perhaps compensating with extravagance in the absence of meaningful contact. But if she was walking into darkened closets for an hour at a time and behaving strangely in social situations, there were problems that a spectacular four-story town house on Riverview Terrace could not remedy. Dick just wasn't around that often. "Evelyn and I came together to have a child, a life together," Avedon told a reporter in 1994, something he would say on more than one occasion. "But what's happened is I'm married to my work." After meeting Avedon for the first time, Warhol, who had been nothing if not fawning, whispered to McCabe, "Do you think he's gay?" That seemed to be the sotto voce question that trailed Dick throughout his life.

Avedon's income was his reward for the injustices that had scarred him in his youth and the inadequacies that tormented him over a lifetime. And yet, despite the excess, the structured ease of his daily life also enabled him to hover at a level of cognition that absorbed, processed, and translated the cultural tenor and mood of his time, which he would eventually turn into a body of work that placed him comfortably alongside his friends in the pantheon. At those heights, who had time for the tedious domestic toils of daily

life? And, at that moment, he was attuned to the tremors of the youthquake and he had to find a way to represent it with a lucidity of visual form.

"You are not supposed to give people what they want," Mrs. Vreeland would say. "You're supposed to give them what they don't yet know they want." Certainly that was Dick's mandate—and mantra—at *Harper's Bazaar* for all those years; he was calibrated to think one step ahead of the culture in which he was living. And yet, deeper ambitions were driving him. The "poetic impulse" that had been so thwarted by his teacher Wilmer Stone in high school, but which he had been tapping all those years for editorial and commercial purposes, must have felt to him misused. He had a broad view of the species and its discontents, and he was looking for a way to establish a more consequential portrait of an era—as August Sander had done with his *People of the Twentieth Century*. This was a nascent idea, one he had been gravitating to all along, yet it would not crystallize for him with the clarity of his artistic inevitability for several more years.

IMAGINE A TIMELESS CARAVAN in the snowy mountains of Japan. *Vogue* loved to immerse its readers in just such a fantasy, and in the October 15, 1966, issue, "'The Great Fur Caravan,' a fashion adventure starring the girl in the fabulous furs" appeared, the result of a five-week photographic escapade through the snowcapped mountains and rocky valleys and ancient monasteries of Japan earlier that year. The production was not unlike that of a feature film, with Avedon as the director; the budget was proportional to that of a Hollywood movie. First, Dick had to choose his star. At six foot two, Veruschka was at that moment the tallest model who had ever worked in fashion. Dick had barely noticed her the first time they were introduced in Paris, in 1962, when China Machado brought

her into the studio one day. "I was highly impressed to see him there, so active and always in movement," Veruschka said. "The way he looks at you with his eyes, it's a little bit like Picasso." Dick would not begin working with Veruschka until he got to *Vogue*, almost four years later. He photographed her once or twice, both for Revlon and for the magazine, before casting her for this feature; she would become another of the models he periodically called "the most beautiful woman in the world."

In the studio, Dick would talk with Veruschka about the music she liked to listen to or the movies she had seen; in the dressing room, they would discuss her makeup, which she always applied herself, and, together with Ara Gallant, the hairstylist, they discussed styling for a particular shoot. Dick's assistants made Polaroids during the actual sessions, and he and Veruschka—or any of the models he photographed—would look at them together for reference, and discuss her facial expression, the angle of an arm or a leg, the placement of a hand, before trying again for the desired effect. Dick often encouraged his models to move around, and he moved along with them, aiming for the effect they had just discussed while he hoped for something spontaneous and unexpected to occur in the process. Dick had an easy bedside manner with models, garnering their trust and, in so doing, their desire to please him. "I don't think it was just me," Veruschka said, dismissing the idea that the connection was personal. It was his way of cultivating a connection that was site specific, for the sake of the photographic session, just as a film director coddles an actor to get the desired performance.

With her great height, chiseled bone structure, and lush, sculpted lips, Veruschka was the ideal snow princess for this romantic story. In Japan, their real-life caravan consisted not only of Dick and Veruschka, but also Polly Mellen, the fashion editor; Gideon Lewin, Dick's assistant; Ara Gallant, the hairstylist; a

Japanese male model; and an additional Japanese photo assistant. All of the clothes were chosen by Mellen and had to be made to fit Veruschka before they were shipped to Japan—"all fifteen trunks with furs and clothing," Mellen said. "And at least a dozen hatboxes."

Polly Mellen, who had worked at the *Bazaar* with Dick in the early years when they were both young, had left her budding career to have children and raise a family. In 1966, Vreeland brought her back into the fold as a fashion editor for *Vogue*. Mellen, knowing how territorial the other fashion editors could be, had been nervous in her first weeks at the magazine, confessing to Mrs. Vreeland that she had no friends on the staff. "Who needs friends, Polly?" Mrs. Vreeland said, dismissing her insecurity. "Get on with it." And, with that, Vreeland sent Mellen to Japan. "My first shoot at *Vogue*, and I'm given *this*," Mellen said. "Can you *imagine*? I got the plum assignment. *Divine* woman." Before the trip, Vreeland had given Mellen a copy of *The Tale of Genji* to read for inspiration. Mellen pored over it to get ideas for the fashion spread, and went back to Vreeland, appalled. "This is one of the dirtiest books I have ever read," she told Vreeland, who simply shrugged. "I wouldn't know, Polly," she countered. "I've never read it."

Dick and Polly flew first-class, and everyone was put up at luxury hotels throughout the five-week trip. The first order of business once they got to Tokyo was to find a Japanese male model taller than Veruschka. Dick and Polly spent the first week going from one sumo wrestling stable to another before they found "the Giant," as he is referred to in the magazine, a slender seven-foot-tall nineteen-year-old Japanese sumo wrestler who spoke no English. He smoked a lot, according to Veruschka, "drawing in so much smoke every time he inhaled that it only took two deep puffs before he finished one cigarette and lit another."

Their caravan included several cars for their entourage, and trucks for the fifteen trunks, the hatboxes, and the photographic

equipment—cameras, tripods, lights, generators. They traveled across Japan to Hokkaido, staying at beautiful resorts along the way. The sumo wrestler was so tall and his legs so long that the front passenger seat in his car had to be removed. In several hotels, the beds were too short for Veruschka and the sumo wrestler, and extra cushions had to be stacked at the ends for their feet. Masseuses giggled because they were both too tall for the massage tables. Polly was constantly shopping for special-size shoes for him.

Among the many excessive expenses were Dick's regular long-distance phone calls to Vreeland in New York, at exorbitant cost in 1966. He was filling her in about the locations they were discovering, seeking her thoughts for the evolving narrative, and discussing which of the most expensive fur coats on the planet they had brought with them should be highlighted and in what context. Once, Vreeland tried to explain to Ara Gallant the kind of hairstyling she wanted in this mythical tale of mountains and snow, repeating a sound that he wasn't able to translate. *Whoosh. Vroosh. Schwoo.* Veruschka was able to interpret Vreeland and explained that her hair had to look like the wind.

In one layout, Veruschka is seen wearing a sable toque and toss by Halston as she stands on a fog-infused hill in the Valley of Hell; in another, at Yuzawa, she kneels in profile as a geisha in the snow wearing beige EMBA mink; the "Giant" kneels and prays for a good harvest before a young tree tied with rice cakes. "It was an erotic thing without ever being sexual," Veruschka said. The erotic charge, she said, was between her and the lens. And, out of that charge, Dick created one visual fantasy after another in a mythical narrative that had, at its core, one purpose: selling expensive mink coats to wealthy women. For Dick, it was a job. It was fun. He could be creative. It honed his obsession "to astonish." And the *amazing* adventure was restorative. Still, he was merely biding his time.

IN THE SUMMER OF 1963, John Szarkowski mounted a show of work by Jacques-Henri Lartigue at the Museum of Modern Art. The photographs, made in the early years of the twentieth century, compose an intimate visual diary of the daily activities of the bourgeoisie in belle epoque Paris. Lartigue was still a child when he made his photographs of people in fashionable dress engaged in activities of the leisure class, either promenading at the Bois de Boulogne, attending the races, riding in early automobiles, or strolling under umbrellas on the beach at Villerville—what Colette called "the bustling life of people with nothing to do." The pictures possess a spontaneity that is uncharacteristic of the photography of that period. In the exhibition's wall text, Szarkowski writes that Lartigue's work is "remarkable both as a document of the time and as a photographic achievement. Lartigue intuitively grasped the new potential for the hand camera. His pictures, concerned with movement and the continually changing image it creates, suggest the work done a quarter century later by Cartier-Bresson, yet were done the same years in which Eugene Atget documented Paris with the techniques and photographic approach of the nineteenth century."

A small book was published with the show, and in the introduction, Szarkowski offers a simple insight about photography that is hard to argue with. "It is easier for an old photograph to be interesting than it is for a new one," he writes. "To show clearly the life of our own time and place demands acute perception, for our eyes grow accustomed to everyday miracles. But it would seem that the pictures in an old album need only to have been sharply focused and clearly printed, in order to reveal the sense and spirit of their past time."

Several months before the show was mounted, Szarkowski gave the Avedons a private viewing of the Lartigue photographs. "I can't begin to thank you for the pleasure you gave Evelyn and me on Friday," Avedon wrote in a letter to Szarkowski, thanking him for

the privilege. "The pictures echo and can never be forgotten. The other joy was meeting you and feeling at last there is someone at the Museum I can 'talk' to."

Szarkowski responded ten days later with an equally gracious letter: "Watching you look at the Lartigue pictures was *my* pleasure," he wrote. "I'm quite serious—showing great pictures to people who really know what they are looking at is one of the delights of this job. . . . I hope that next time you and Evelyn will have time for the martinis."

Soon after his introduction to Lartigue's work in 1963, Avedon sent the photographer a letter in Paris: "The other day Mr. Szarkowski of the Museum of Modern Art in New York City showed me your photographs," Avedon wrote. "It was one of the most moving and powerful experiences of my life. Seeing them was for me like reading Proust for the first time. You brought me into your world, and isn't that, after all, the purpose of art."

In one photograph, *Anna la Pradvina, Avenue du Bois de Boulogne, 1911*, an elegant woman draped in furs walks her two small, over-bred dogs on a Paris street. For Dick, this picture—which he would later own—represented the Paris that hadn't yet vanished when he first discovered the City of Light in his own early twenties, the city that he had so romanticized from the memories Cocteau shared with him, the stories of Colette, and the anecdotes of Mrs. Snow. This is just the kind of picture Avedon might have taken in his early years at the *Bazaar*. It's no wonder that Dick responded to Lartigue's work with such enthusiasm.

In 1966, a larger book of work by Lartigue was published in Switzerland, a nostalgia piece with an oxblood cover and tipped-in photographs that tried to replicate Lartigue's own boyhood albums. When Dick saw it, he fell in love all over again, and wrote to Lartigue, then well over seventy years old, on the rue de Longchamp in Paris: "Your book is ravishing, a lift to the heart. I have bought ten

copies and sent them to my friends." This would mark the launch of a new project for Dick, who convinced Lartigue to let him edit a comprehensive and definitive book of his work. Dick brought in Bea Feitler, the young Brazilian co–art director of *Harper's Bazaar*, who would collaborate with him in designing and editing it over the next four years.

In January 1967, staying at the Ritz hotel in Paris, Dick and Evie visited the Lartigues on the rue de Longchamp for the first time. Madame Lartigue cooked for them and they stayed until three in the morning. In a chatty typewritten letter Dick wrote to his son, John, then fourteen and attending the Dalton School in Manhattan, he described his excitement at the unpublished pictures Lartigue showed them from the years 1902 to 1910. "His first bicycle was made of wood," Dick wrote. Then he described a picture Lartigue had taken a year earlier, in 1966, in the South of France, of someone gripping a water ski rope attached to a speedboat with an open parachute strapped on his back. When the boat took off, he started to ski, and then lift into the air. "Air skiing," Dick writes. "It looks like terrific fun." He wanted to show John "how young at heart someone of seventy-six can be." He described their whirlwind visits to the Picasso show, the Cartier-Bresson show, and a show of Bonnard paintings. "In each case, we have seen the lifework of a single man," Dick wrote. "It's so overwhelming. All those years of work in one gathering. Picasso's is like the entire history of modern art. Cartier-Bresson's a visual history of humanity for almost forty years." Dick must have been giving thought to these retrospective exhibitions in the context of the book he planned to assemble on the lifework of Lartigue.

STEPHEN SHORE, ONE OF the most consequential photographers of his generation, was a precocious and enterprising child in New

York who began taking pictures when he was nine—in 1956. "I felt very early on that photography was my medium," he wrote in 2015. "I had started doing darkroom work and making prints when I was six."

Growing up on Sutton Place, Shore had the confidence and sense of entitlement of his milieu, and in 1961, when he was fourteen, he took his pictures to Steichen, the ultimate arbiter of the medium of photography before Szarkowski succeeded him at the Museum of Modern Art. Steichen encouraged Shore, even acquiring a few images for the museum's permanent collection. Handed a museum fact sheet to fill out, Shore answered one of the questions—"What is your philosophy of life?"—as if channeling Seymour Glass in *Franny and Zooey*: "I don't have a philosophy of life. I'm fourteen years old."

Stephen's father, Fred Shore, knew Avedon from the merchant marine, and sometime in 1966, he called Dick to ask if he would look at his son's photographs. By then Stephen was working as an unofficial intern at the Warhol Factory, assisting the Velvet Underground, the rock band founded by Lou Reed and John Cale. Stephen would get dressed every morning in jacket and tie and go to the Factory, where he waited around to be given things to do. While waiting, he set up a white seamless backdrop against one wall and started photographing anyone who was around—Mama Cass or Gordon Baldwin, or Andy's assistants, or anyone else who came in.

Dick singled out the portraits taken at the Factory, which were similar to his own in their unadorned, straight-on simplicity. "If you do this with everyone who comes in," Shore remembered Dick telling him, "you will have a great record." Avedon was generous with Shore, whose portfolio, in turn, provided Avedon a stealth glimpse of the comings and goings at the Factory.

Dick was always interested in discovering new talent. In early 1967, following in Brodovitch's footsteps, Dick and Marvin Israel

created a master class for promising photographers at the Avedon studio. According to Gideon Lewin, who was assigned the task of documenting the sessions, students were pressed to "create their own style of visual expression that was not an imitation or interpretation of others' work." The class took place once a week over the course of two months.

Among the group of students were Peter Hujar, Deborah Turbeville and Chris von Wangenheim. Dick and Marvin gave them assignments: self-portraits; portraits of others; fashion assignments; and reportage. Each week, invited guests including Diane Arbus, Bruce Davidson, Ben Fernandez, Hiro, Danny Lyon, and Lucas Samaras would present their own photographs and critique the students' work.

Diane Arbus was the guest critic on the day after the opening of the exhibit *New Documents* at the Museum of Modern Art, which included her work as well as that of Lee Friedlander and Garry Winogrand. Dick had gone to the opening with a great big bouquet of yellow roses for Diane. Long since regarded as a landmark exhibition in the history of photography, *New Documents* identified a radical new direction: pictures that seemed to have a casual, snapshot-like feel and subject matter so apparently ordinary that it was hard to categorize what the pictures were about. In the wall text, John Szarkowski suggested that until then the aim of documentary photography had been to provide proof, or documentation, of a specific subject. Often, the underlying purpose was to expose the world's ills and generate interest in fixing them, such as in Walker Evans's photographs of southern migrant workers. But this show signaled a change: "In the past decade a new generation of photographers has directed the documentary approach toward more personal ends," he wrote. "Their aim has been not to reform life, but to know it."

No definitive subject could be identified in any of the three bod-

ies of photographs, and critics were skeptical. "The observations of the photographers are noted as oddities in personality, situation, incident, movement, and the vagaries of chance," Jacob Deschin wrote in a review of the show in the *New York Times*. Today, the work of Arbus, Friedlander, and Winogrand is considered among the most decisive for the generations of photographers who followed them, precisely because their work presented a generational "rupture" between the documentary practices of the past and individual exploration as artists of the world around them. The new photographic style, which had been pioneered a decade before by Robert Frank, in *The Americans*, combined the unselfconscious informality of the family snapshot with the authenticity of documentary photography and the immediacy of a news shot.

When Szarkowski began his curatorial career, photography was commonly perceived as a utilitarian medium, a means to document objects, individuals, and events. More than anyone else, he was instrumental in changing that perception. For him, the photograph was a form of expression as potent and meaningful as any work of art, and as director of photography at the MoMA for almost three decades, he was perhaps its most impassioned advocate. Two of his books, *The Photographer's Eye* (1966) and *Looking at Photographs: 100 Pictures from the Collection of the Museum of Modern Art* (1973)—both of which include portraits by Avedon—remain syllabus staples in art history programs today.

Over the years, Szarkowski was self-effacing about his role in mounting the *New Documents* show. "I think anybody who had been moderately competent, reasonably alert to the vitality of what was actually going on in the medium would have done the same thing I did," he said at the end of his life. "I mean, the idea that Winogrand or Friedlander or Diane were somehow inventions of mine, I would regard, you know, as denigrating to them."

In those years, Diane Arbus was coming around to the Avedon

studio fairly often, "sometimes two or three times a week," according to Sebastien "Chick" Chieco, Avedon's bookkeeper, from 1963 to 1991, either for one of the studio's "picnic lunches" or just to watch a shoot. Arbus's star turn in the master class brought a discussion of *New Documents* to the table that would set the tone for the entire course, with ongoing discussions about the purpose of a photograph versus the intention of the artist, or about commercial practice versus personal expression. One overarching question had to do with whether the subject of a photograph was less important than how the subject was seen. "The atmosphere was charged," Lewin recalled. Marvin Israel played devil's advocate as he directed the discussion, "which could get heated and even, at times, volatile." As early as 1965 Arbus began to print her pictures with irregular black borders that show the complete, uncropped negative. "The borders called attention to the fact that the print is an image on a two-dimensional sheet of paper rather than an objective, window-like view onto the subject," Sandra Phillips would note a half century later.

Marvin Israel had invited Danny Lyon to the master class as a guest to talk about his work. At twenty-five years old, Lyon was already a notable young photographer. Not only had he photographed early SNCC demonstrations in the South, but, in 1967, he joined the Chicago Outlaws, a motorcycle club, with whom he traveled on the road photographing the way they lived, with the idea, according to Lyon, of "recording and glorifying the life of the American biker." When he came to speak at the master class, *The Bikeriders* had already developed a cult following in photography circles and would be published as a book the following year. But that isn't what he showed in the master class.

"I had a carousel of slides I had made in Cartagena, Colombia, in 1966, color pictures of prostitutes, set to music," Lyon remembered. He used Ricky Nelson's song "Hello Mary Lou" as one track

because it was very popular among the Colombian sex workers at the time. "Avedon just savaged it," Lyon said. "He was vicious." Dick made a point of comparing the work to *The Bikeriders*, and talked about Lyon's SNCC pictures, referring to them both as good bodies of work, while dismissing the sex worker slideshow because the images seemed false to him and the music was not syncopated. He turned to Lyon and said, "Who is the real Danny Lyon?" which only provoked the brooding photographer. "It was this total bullshit speech as if he was my therapist," Lyon said. "I was so upset by this public humiliation at the hands of Avedon that I went home and destroyed the slideshow."

Peter Hujar, then in his early thirties, was relieved to have won a coveted spot in the master class. He had submitted a series of nude, running self-portraits, each one full length, in which he is frozen in frenetic motion by a strobe light, all of them positioned far enough from the camera to see the empty space of the studio. In a catalog essay for the 2018 retrospective of Peter Hujar's work at the Morgan Library & Museum, the curator Joel Smith observed about this series of self-portraits that Hujar "could summon sensational effects capable of holding a magazine page, even reflecting the influence of Avedon's own mentor, Brodovitch, who emphasized movement, spontaneity, and visual surprise in photography."

Hujar lived a bohemian existence downtown. He was tall, slender, and handsome—if not obdurately unpolished—and had a quiet sophistication that came through with his thoughtful observations and amusing, if at times nihilistic, provocations. Peter was not shy about calling Andy Warhol one of the "few genuinely original artists of the era." In 1964, Hujar sat for several Warhol screen tests, holding so still that Warhol referred to him as "the boy that never blinked." Warhol included one Hujar screen test in a series he titled *Thirteen Most Beautiful Boys* and *Thirteen Most Beautiful Girls*. The screen tests were shot in the manner of still

photographic portraits, despite the passing of time in the moving image.

Hujar and his once boyfriend Paul Thek personified an attitude and a style consistent not only with the disaffected artist but in particular with the stigmatized urban homosexual. Irony was the lingua franca of the roomy homosexual closet in mid-twentieth-century Manhattan, where a lexicon of words with double meanings became a way for homosexuals—through innuendo—to signal to one another in "straight" company. In this period, for example, to ask whether someone was a "friend of Dorothy" was to inquire whether he was gay. Dorothy refers to Judy Garland's character in *The Wizard of Oz*, who lost her innocence on discovering that the Wizard was not a deity but a small, ordinary man. All of this would have held deep fascination for Dick, who would never acknowledge that he was "a friend of Dorothy."

Hujar would go on to photograph his many accomplished friends, lovers, and acquaintances, drawing on some balance in his portraiture between Avedon's existential minimalism and Diane Arbus's psychological complexity. "Peter saw himself as a portraitist and believed that the camera could see things about people that the naked eye could not," Stephen Koch said. The master class was a worthwhile experience for him, and he valued his friendship with Avedon. After the class ended, for a period of a year or so, Avedon and Hujar had regular late-night telephone conversations. While it isn't certain what they discussed, according to Stephen Koch, "they shared an unusual bond and their phone conversations would sometimes last until dawn." But soon enough Avedon turned his attention elsewhere, and Hujar felt dropped, and hurt, in the wake of Dick's peripatetic curiosity and his quicksilver enthusiasms about the next new thing.

ON MARCH 20, 1967, Lesley Hornby, the seventeen-year-old British fashion model known as Twiggy, arrived in New York, wreaking havoc at Kennedy airport. She was already something of a phenomenon in London, and a press conference had been called, which drew the kind of swarm of reporters and photographers one might have expected for the arrival of the Beatles. The next day the *Times* published an eight-column photo layout of Twiggy, asserting that "London's mini-bosomed fashion model of the year looks just like your next-door neighbor, if he happens to be a skinny, twelve-year-old boy." Several weeks after her arrival, *Life* magazine published a fashion feature about her and *Newsweek* ran a cover story. Twiggy was an instant and unwitting (by nature of her age) pop media star.

As a result of the *Newsweek* cover story, Twiggy's modeling fee doubled from $120 to $240 an hour. Yet Justin de Villeneuve, her manager, turned down a great many commercial modeling requests at that high fee in favor of a long series of sittings for *Vogue* with Richard Avedon. "One of the reasons we came to America was to have the chance of working with Richard Avedon," Villeneuve told Thomas Whiteside, the author of a *New Yorker* profile of Twiggy. "Avedon is the greatest. He captures something—I can't fathom it. And there's something about Twiggy that no photographer has caught yet." Villeneuve was concerned that, despite her meteoric fame, in some quarters Twiggy was perceived as a joke. "I think that Twiggy being photographed by Avedon can change that."

On the first day of the *Vogue* shoot, Avedon let Twiggy onto the set, which consisted of his usual white paper backdrop hanging on a long cylinder. A single strobe light with a silvery umbrella-like reflector was aimed at a plain black stool that stood in the center of this makeshift proscenium.

After several sessions, in which Dick was shooting Twiggy for multiple fashion spreads to appear in a number of *Vogue* issues that year, he spoke at length to Whiteside about working with her. "One thing you have to realize about Twiggy is that, relatively speaking, she has hardly been photographed," Dick said, contrasting her brief experience in front of the camera to that of Jean Shrimpton, who had done fifteen magazine covers before anyone took much notice of her. Dick wasn't sure of what to expect of Twiggy, and yet, "the moment she was under the lights she performed as all the finest models do," he said. "For her to have developed that amount of control is extraordinary."

Twiggy brought her own vinyl records to the sessions with Dick— the Supremes, the Kinks, Wilson Pickett, and Tim Hardin—and Avedon asked her what she wanted to hear while they worked. She chose the Kinks to start with. While Gideon Lewin mounted a Rolleiflex onto the tripod, Dick asked Twiggy to stand there for a few moments just so that he could look at her. Then he asked her to sit on the stool. She was wearing a simple black dress and black net stockings. "Avedon exercised meticulous control over his model, almost as though he were working from a blueprint," Whiteside reported. "Nearly half an hour of the time Twiggy spent sitting on the stool was devoted to adjusting a band of silvery material around her hair." Polly Mellen, the *Vogue* fashion editor, assisted, and Twiggy responded to her instructions, patiently and with interest.

"At our first sitting, we spent three-quarters of the day making preparations—working with make-up and so on," Dick explained. "I was trying to get used to her face—and then she went in front of the camera and it was as though we've been working together for months. Lots of models come to the studio and do things they think the photographer wants. Twiggy presented herself quite honestly to the camera."

One of Avedon's most enduring photographs of Twiggy ap-

peared on the July 1967 cover of *Vogue*. Twiggy is presented as an icon of the "flower power" moment that would mark the "Summer of Love." In the Avedon studio, Giorgio di Sant' Angelo, the fashion designer, painted on Twiggy's face "an Eyeflower that blooms just one night," according to the *Vogue* caption. Using makeup, Sant' Angelo painted a flower around Twiggy's right eye, the pale violet petals on her face lined with pink, the stem a delicate yellow-green arc that travels down her cheek toward her dewy, fresh, hot-pink lips. Her pert orange earrings contain bright yellow orbs that add a circular motif to the still-life serenity of her face. Her hair is tidily coiffed close to the shape of her head, a counterpoint to the wild-child hair of the counterculture bubbling up at that moment. Large pink flowers are sewn into the green mink turtleneck she is wearing in the approximate position of her breasts.

Among Avedon's most arresting and enigmatic fashion pictures is another of Twiggy, her face in profile, hair cut short, her back to the camera and fully exposed under slinky cross-straps attached to the deep swooping backline of a metallic minidress. One bare shoulder holds steady, the other is thrown into a Fosse-like shrug, and her arm drops deadweight straight. She stands with such utter insouciance, and yet her stance has magnificent structure. The caption states: "Twiggy takes a back-dive and finds this cross-strapped little tank dress terrific for a dip into night—with silver-gold chain-mail stripes barely making it to the thigh. Evening dress by Roberto Rojas." This image represents a paradigm shift in fashion: skin as the canvas, as opposed to the contour of the body, and a shape of unisex androgyny.

"The best pictures I've taken of Twiggy have been those in which she did the least. Those pictures seem to be truer to herself, truer to my work," Dick said. "Women move in certain ways that convey an air of the time they live in, and Twiggy, when she is in front of the lights, is bringing her generation in front of the camera. I think

what's involved is the stripping away of certain affectations about what is beautiful. Twiggy is made for that." The Twiggy shoots with Avedon went on for days, during which time Whiteside asked her how she liked working with Avedon. "It's wonderful," she said. "He makes you *feel* beautiful."

Twiggy and Penelope Tree emerged in the same fashion breath, representing a new kind of androgynous woman. While Twiggy was a natural in front of the camera, she was uneducated, spoke with a Cockney accent, and did not have an identifiable style of her own. Penelope Tree was more recognizable to Dick. She was a debutante about to attend Sarah Lawrence, and Dick discovered her at the Black and White Ball. Yet she was the antithesis of a conventional Upper East Side princess, and that's what Dick loved about her. She loved working with him, too. When she went to his studio for the first time, "I adored him on sight," she recalled. He was in his midforties and she was eighteen, but "it felt like he was my age. He made you feel there was magic in the air, that you had entered into a special world with him." Penelope possessed the face of an extraterrestrial, and her height and her grasshopper-like legs were the qualities that Dick had such great fun exploiting in purely graphic terms with the clothes of the period. He used her elongated body to geometric effect with the shape of a floor-length skirt, for example, that formed an off-center triangular tent over the position of her legs. He played with distorted proportion by dressing her in ill-fitting clothes. For Dick, working with her was, in a locution of the era, "a gas."

"The wistful waif with the long straight hair is, believe it or not, the most talked-about model of the year" is how *Life* magazine described Penelope Tree after her October 1967 fourteen-page *Vogue* layout by Avedon was published. *Time* magazine also acknowledged the fashion-defining shift in the appearance of both models in *Vogue* that year: "After the Twig, the Tree?" the *Time* headline

posited. "Her mother calls her 'Legs,' which is, after all, as good a nickname as any for a girl whose 5-ft. 10-in., 105-lb. body is supported on what appear to be stilts, moored at the bottom to size 8½ feet. With a physique like that—and an oval face with fathomless, huge brown eyes to go with it—it was perhaps inevitable that Penelope Tree, 17, emerge as the brightest new model and the likely successor—at least conversationally—to Twiggy."

Penelope Tree and Twiggy both resided on the page in counterpoint to Edie Sedgwick, the Manhattan "It" girl of the mid-1960s. Edie was a WASP debutante from California with short blond hair and a heartbreakingly beautiful smile. She had a post-Marilyn effervescence, absent the femme fatale curvature of Monroe. In fact, Edie's presence, too, was somewhat androgynous. She had arrived at the Warhol Factory as a groupie of some Harvard graduates who were attracted to the Warhol mystique. She became Andy's female doppelgänger and accompanied him wherever he went. Sometimes she modeled, but ultimately she became a pop media staple.

Now, two years after his initial meeting with Dick, Warhol had become the exemplar of popular culture. It was no small feat that Warhol had established an entirely new movement in contemporary art. Certainly Dick could not refute that; in fact, he could only respond to it. One could say that, in 1967, Avedon's "Flower Twiggy," albeit a magazine cover, had resonances of Warhol's *Gold Marilyn Monroe*, which had already been exhibited, twice, at MoMA.

Avedon was always aware of his position on the Manhattan chessboard. He would not have been looking over his shoulder at Warhol alone. He had always been neck to neck with Irving Penn, no longer his competitor at a rival publication. As colleagues at *Vogue*, they were subject to the same management oversight. He and Penn had always advised each other on contract negotiations at their respective magazines, both of them aware that, since they

were the only ones at their level of accomplishment, no one else was able to give them solid advice. And now they were in direct competition for funds that drew from the same corporate source. They were in competition for the plummiest assignments, and for space on the page, and for hegemonic prominence. Colin Westerbeck, a onetime curator of photography at the Art Institute of Chicago, had acquired a body of Penn's work for the museum and organized several Penn exhibitions. "Regarding Penn's attitude toward Avedon," Westerbeck said, "when Avedon was brought in at Conde Nast, Penn was alarmed and discouraged." Soon enough, though, Westerbeck said, he realized that Avedon was doing a lot of fashion work, with which Penn had grown increasingly less interested. "I must say I'm tired of the faces of man," Penn complained in one workshop session with Avedon and Brodovitch soon before Avedon came to *Vogue*. "And I'm pretty tired of girls, and attitudes, and dresses."

Penn's reputation was secured in the middle of the twentieth century, along with Avedon's, primarily as a photographer for *Vogue*. He is regarded for his meticulously crafted, utterly soigné, optically titillating pictures, and, equally, for his portraits of notable figures, as well as villagers in remote regions, and his still-life images and collages. A true story characterizes his perfectionism: after being presented with five hundred lemons from which to select the singular best of the bunch, he had to take five hundred photographs of that one lemon to arrive at *l'image juste*.

For years, Penn produced impeccable negatives for pictures he sometimes did not see until they were printed in *Vogue*—printing over which he had no control. In the early 1960s, as the printing quality of commercial publications declined with the growing cost consciousness of publishers, Penn's dissatisfaction with the way his pictures were printed led him on a personal artistic exploration of the platinum printing process. Not an easy task, since manufactur-

ers had stopped making platinum paper after World War I due to the prohibitive cost. By making platinum prints of some of his own best images, Penn would give his photographs an afterlife well beyond the magazine page. "Penn realized that Alexander Liberman was freeing him up to do other things, including projects of his own invention," Westerbeck said about Avedon's arrival at *Vogue.* In the end "he felt that Avedon's role enhanced his own, rather than limiting it."

Meanwhile, Dick continued to fulfill assignments for the magazine, some of them generated according to the vagaries of the fashion calendar and others coming from his own enterprise. One pleasurable detour that year was a trip to Los Angeles to photograph on the set of *The Graduate*, a movie his friend Mike Nichols was directing. He and his assistant Gideon Lewin stayed at the Beverly Hills Hotel. One day while Dick was poolside, he was paged several times, and the phone was brought to his chaise longue. He explained to Gideon the social and professional benefits of being paged by the pool at that particular hotel and divulged that some people would have themselves paged just so their name would be announced on the loudspeaker. The next day Dick had an appointment and told Gideon he would be back for dinner. Not half an hour later, Gideon was paged, and the phone was brought to him by the pool. Dick was on the other end in a riot of laughter at his own practical joke.

Nichols had arranged with the film studio to pay for publicity stills by the illustrious photographer Richard Avedon. With Gideon, Dick set up the shots with "Benjamin" in boxer shorts and "Mrs. Robinson" in leopard-skin-patterned bra and panties, in various positions on the bed. Dick also made portraits of the film's young stars, Katharine Ross and Dustin Hoffman, which appeared in the "People Are Talking About . . ." section of the December issue of *Vogue,* just in time for the release of the film. While there

is no documentation of Dick's role in any aspect of *The Graduate*, Lewin remembered Dick and Mike having dinner together almost every night while they were in Los Angeles, and whether it was by osmosis or not, Anne Bancroft projected into her utterly bored yet profoundly chic character, Mrs. Robinson, the swank insouciance of an old-school Avedon woman.

Dick had been in a gestation period for several years after the *Nothing Personal* debacle, and it wasn't only the competition with Penn that triggered his anxieties and upped the ante. Arbus, too, was catching up. The *New Documents* show had given her a new luster in the art world, and while he had the utmost respect for her work, it made him nervous, in particular because Marvin Israel never missed an opportunity to remind Dick of his belief that she was the truer artist among them. Other than the book of Lartigue's work he was editing, Avedon had not yet arrived at a new project of his own that would bring more universal purpose to the intensity of his efforts. He continued to develop stories for the magazine, reaching, at times, for the precincts of high art. One of them, "Nureyev: A Photographic Study of the Human Form in Action," was not tethered to an occasion or an event or a trend; rather, it resides outside time, an observation of beauty that hovers in its own universal mien. Once again, Avedon photographed Rudolf Nureyev in the studio, naked, and, in the context of magazine publishing, this suite of photographs constitutes by any measure a small celestial masterpiece.

The six-page portfolio opens with a full-page portrait of Nureyev in profile, head to toe, fully nude, his body in a taut crescent stretch, arched toward the sky as he reaches upward, his arms lifted, V-shaped, one hand toward the heavens, the other falling toward earth. He balances on the ball of one foot while his other leg is lifted just enough to hide his genitals. On each page is a small drawing by Michelangelo, to which Nureyev's physical perfection

is compared, and against which his balletic accomplishment is measured. Avedon photographed Nureyev in gestures that seem to represent the sum of humankind reaching for the top of its potential. "The everyday miracle of man," the text reads, "made suddenly memorable and rare by the exultant stretch of Nureyev's body." It continues: "Nureyev, here in agony of action, could have been the source and inspiration for many of Michelangelo's sublime realizations of the human form."

On the following page, a still life of Nureyev's foot *en pointe* has the weight and proportion of marble, his arch of such arresting beauty that the comparison to a figure carved out of stone by Michelangelo is entirely fitting. "Fearful ecstasy of Michelangelo's Jonah, call me between heaven and the abyss." In 1967, it was bold of *Vogue* to publish Nureyev nude, despite the provocation of his barely hidden genitals. This was a gift—both in pure visual resolution and with utter resplendent joy—that provided the readers of *Vogue* a semblance of Avedon's own reason for being.

In December 1963, Avedon had made a series of portraits of the renowned Beat poet Allen Ginsberg, bearded and with long hair—before hippies had surfaced in the public consciousness—with his lover, Peter Orlovsky, also a poet. They are both staring at the camera, also nude; in some of the frames, their arms are around each other. One portrait is of Ginsberg, alone, facing the camera directly, his groin covered with his left hand in a Buddhist mudra, or hand gesture, and his right hand raised, palm out, in *Abhya Mudra*—a gesture of reassurance. Dick included the picture in *Nothing Personal*. In 1967, Ginsberg was on a national tour of poetry readings, and in May, *The Vanguard*, the Portland State University newspaper, published Avedon's picture of Ginsberg nude on its front page in anticipation of Ginsberg's arrival for his reading at the university. Ginsberg was well versed, so to speak, in controversy: in the mid-1950s, the first publication of "Howl," his epic

poem, was seized by authorities for one line in particular—"who let themselves be fucked in the ass by saintly motorcyclists, and screamed with joy"—and his publisher, Lawrence Ferlinghetti, was arrested. The subsequent obscenity trial brought national attention. Ginsberg and his book of poems weathered the storm, and by 1959, he was reading portions of "Howl" on national television, in an appearance on *The Steve Allen Show*; in 1965, he filled the Royal Albert Hall in London for a poetry reading. In 1967, when the Portland State school paper ran a nude picture of Ginsberg on the front page—one that Robert Frank acknowledged was among Avedon's best pictures—college administrators ordered the remaining copies of the paper to be destroyed. The Oregon state legislature praised the university administration for taking appropriate measures against nudity. The *Oregonian* ran thirteen articles about the "scandal," prompting Ginsberg himself to write a letter to the editor in defense of the school paper—and his reputation, citing the administration's hypocrisy for censoring his portrait that bore no more nudity than advertisements for bathing suits or shower soaps in glossy national magazines.

Avedon supported Ginsberg's entire antiestablishment stance, and he was fully compliant when *Salted Feathers*, a countercultural "rag," requested use of his picture of Ginsberg and Orlovsky standing together nude. Yet it would be another decade before any male nude would be exhibited on a New York gallery wall, in the works of Peter Hujar and Robert Mapplethorpe.

In 1978, Hujar and Mapplethorpe were both included in a group show called *The Male Nude: A Survey in Photography* at Marcuse Pfeifer gallery on Madison Avenue, only blocks from the Whitney Museum. The male nude had been a threatening subject in mid-twentieth-century America, still ineluctably bound to a puritanical ethic. The Comstock laws, which made it illegal to send photographs of the male nude through the US Postal Service, were not

changed until 1965. But even as late as 1978, Pfeifer's choice to exhibit photographs with full-frontal male nudity was perceived as threatening. The critics were particularly hostile.

Disavowing the male nude as a viable subject for aesthetic contemplation only underscored an American taboo about homosexuality, which remained powerfully in force near the end of the twentieth century. Even John Ashbery, the eminent poet, who would have a lifelong relationship with David Kermani, leveled a disparaging opinion, which might have reflected the attitudes of the era more than his own evolving thinking on the subject. "When is a nude not a nude? When it is male," he wrote in his review in *New York* magazine. "Nude women seem to be in their natural state; men, for some reason, merely look undressed."

For Avedon to have made nude photographs of Allen Ginsberg and his lover in 1963 was brave, if not prescient, and to publish the one of Ginsberg nude in *Nothing Personal* in 1964 was daring. More to the point, his choice to photograph Rudolf Nureyev naked and publish the suite of pictures in a major national magazine, exquisitely beautiful though they are, with genitalia covered just enough not to shock, was a radical gesture in December 1967. It was as if the leap that Avedon so artfully captured of Nureyev in his reach for artistic nobility had been his own.

# A WALK ON THE
# WILD SIDE

(1968–1970)

The medium is the message.

–MARSHALL MCLUHAN

O n the January 9, 1968, cover of *Look* magazine, John Lennon changes color before our very eyes—psychedelic red-orange on one side of his face, black-light purple on the other, his features outlined with a quicksilver streak of solarized light, all against an electric-yellow background. A swirl of undulating stripes vibrates within the frames of his round glasses, leaving the illusion that either he is tripping on LSD, or we are. While Lennon's features are abstracted in a wild hallucinogenic display of color, at that cultural moment he was immediately recog-

nizable. Still, the magazine identified him as "Beatle John Lennon by Avedon." Not *Richard* Avedon. Simply Avedon.

Inside the magazine is a double foldout with full-page psychedelic pictures of each Beatle. Paul McCartney's pastel countenance appears next to a bouquet of melting flowers; George Harrison, staring toward the heavens, holds his hand up in a spiritual pose, an eye drawn playfully on his palm; and Ringo Starr sits with a white dove perched on his finger.

Once Dick accepted the assignment, he and the *Look* editors met to figure out how he should photograph the Fab Four. The magazine wanted to reflect what was happening in contemporary life, especially with the younger generation. The Beatles, according to Avedon, had brought about a revolution in visual thinking: "The Art Nouveau influence, op-art, Eastern influences, painting bodies—these and many more elements were what we wanted to get into the pictures," Avedon explained. "I went to England with this concept in mind but no specific idea of how to carry it out."

Before the Beatles' first trip to New York, in early 1964, their youth, their charm, their antic behavior, and their long hair had already set off a profound hormonal trigger for an entire generation of American girls. The combination of the group's elementary rock and roll music, innocent love songs, catchy tunes, and refrains, along with their sweet harmonic voices, struck the precise anodyne note the world needed after the assassination of President John F. Kennedy.

Four years later, on August 11, 1967, Dick photographed the Beatles in the studio of Antony Armstrong-Jones in London. It was not the first time he had photographed them, and he was struck by how enjoyable these sessions were, as each Beatle was more delightful and cooperative than the last. Their music continued to evolve into groundbreaking territory with each new album. *Sgt. Pepper's*

*Lonely Hearts Club Band*, their "trippiest" music to date, had been released earlier in the spring, changing, as it were, the collective tune around the world. All to say that the stakes for Avedon were also close to insurmountable.

Dick photographed them separately, each sitting lasting about an hour. The portraits were characteristic of his typical headshot style, photographed in black and white. Only Lennon was lit from the side, with one half of his face in shadow. Avedon had a rule against props in his portraits, but, in this case, he thought it made sense: op-art glasses for John; flowers for Paul; Indian Tantric symbols for George; and a dove for Ringo. Yet in the end, he was not happy with the results. "What I came back with was not what I call very interesting photography."

He knew he had to do something, so Dick and his assistant Gideon Lewin embarked on an elaborate, four-month process of technical discovery. Once Dick gave Gideon his selection of the four portraits to work with, Gideon was darkroom-bound for days at a time, trying out a variety of wild card techniques to make the pictures more interesting. Lewin rephotographed the black-and-white prints with eight-by-ten Ektachrome color sheet film. He made tests with a variety of color filters. Every day he and Dick would discuss the inadequate results and consider other options. Lewin began experimenting with solarization, a process that Man Ray had discovered by accident in the early 1920s when he was processing film and someone opened the darkroom door; the flash of light on the developing film left a penumbra outline that appeared at the edges of the subjects in his pictures—the birth of the Rayograph. Lewin exposed the color negative sheets to flashes of light as they were being developed, resulting in tonal reversals, light streaks, and penumbras. The effects were exciting but unpredictable, and it took Lewin some time to figure out how to exert greater control over where the solarization occurred on the faces of each Beatle.

Next they played with the additional dimension of dye-transfer printing. The dyes used in this four-color process are the same as those used in fabric. Four plates are involved to make a single dye-transfer print, in which three color separations are transferred onto the paper. This technique yields the richest color and the most depth of any photographic printing process. While time-consuming and expensive, it gave Gideon the most control over the results. Lennon's eyeglasses posed the gnarliest problem: the black-and-white stripes did not have the op-art effect in the context of the color image. Eventually, they combined a black-and-white negative and a color negative, so that the curved lines within the glasses were edged with green, just slightly off register. In the final dye-transfer, the pattern in the glasses was stripped in, creating a vertigo effect in the image. Avedon's exacting vision required just this kind of vigilance, perseverance, and surgical rigor to achieve the astonishing effect.

Dick had never been interested in the technical minutiae of the photographic process and rarely, if ever, spent time in the darkroom with any of his assistants during their laborious experimentation. But he was always eager to see the results, and he was intricately involved in directing his assistants to lift the printed image to its highest possible resolution. "We were like a family working hard all the time for his creations, and that's what we were there for," Lewin said. "There was no such thing as 'it can't be done.' He would tell me to go think about it again so we could talk tomorrow."

Soon after the Beatles spread appeared in *Look* magazine, Dick published a poster with the four Beatles pictures in a single grid. The poster became ubiquitous in dorm rooms around the country, setting the tone for other rock posters, including the Woodstock rock festival poster in 1969, and seemed to be a lucrative, ongoing revenue stream that lasted for years.

Avedon's sittings with the Beatles took place in August 1967,

the same year Warhol made ten untitled Marilyn silk screens on canvas. Avedon was not copying Warhol so much as absorbing the very nowness of Warhol's visual gesture, in this case creating perceptual dislocation with technical experimentation in the dark-room as Warhol had done by skewing the image with the silkscreen process on canvas. There is not a more visually articulate image to define the sex-drugs-and-rock-and-roll ethos of that period than Avedon's "Psychedelic John Lennon," in the same way that his "Flower Twiggy" had absorbed the peace-and-love movement of the same era. Of course, Avedon was solving an editorial prob-lem while Warhol was—well—making art. Yet Avedon was being pushed into new territory, and one could say that his next body of work—which would aim for a much purer brand of technological hijinks—was nascent.

That same year saw the publication of *The Medium Is the Massage: An Inventory of Effects*, by Marshall McLuhan. By then, McLuhan's epigrammatic statement had already been infinitely parsed in the academy and in the press. The critic Harold Rosenberg referred to McLuhan as "a belated Walt Whitman calling the body electric with Thomas Edison as accompanist," while Arthur M. Schlesinger Jr. derided him as "a chaotic combination of bland assertion, as-tute guesswork, fake analogy, dazzling insight, hopeless nonsense, shockmanship, wise cracks and oracular mystification."

Avedon might well have been McLuhan's exhibit A. He, too, saw the mediums of the twentieth century—photography, cinema, television, and print journalism—as the driving agents of human evolution more than the ideas, stories, and visual representations conveyed in each form. Dick was vigilant about the optical detail in his photographs, and he had no compunction about pushing his assistants to bring the image to the furthest limits of what the medium could do. In the legacy of his achievement, he created "Avedon's Marilyn" instead of Marilyn Monroe by Richard Ave-

don, "Avedon's Nureyev," and "Avedon's Charlie Chaplin," in the same way Andy Warhol created his "Warhol Marilyns" or "Warhol Jackies" or "Warhol Lizzes." Form is content and content form; the medium is the message.

"I trust performances," Avedon once wrote. "Stripping them away doesn't necessarily get you closer to anything. The way someone who's being photographed presents himself to the camera and the effect of the photographer's response on that presence is what the making of a portrait is about." The question wasn't whether the portrait is natural or unnatural, only whether the "performance" is good or bad. "The surface is all you've got," Avedon often said. "All you can do is to manipulate that surface—gesture, costume, expression—radically and correctly."

Andy Warhol, too, was interested in the surface. As Warhol famously said (to *ARTnews*): "The reason I'm painting this way is that I want to be a machine, and I feel that whatever I do and do *machine-like* is what I want to do." Warhol was referring to his newfound process of silk screen printing. This act of undermining any evidence of the artist's hand in favor of a mass-produced look appealed to Warhol—despite the fact that his canvases were silk-screened in artisanal fashion, by his own and his assistants' hands. Once he discovered the process and the implications of working with silk screen, the content of his output as a painter became inextricably linked to the process by which he created his art.

Avedon would soon begin with clear artistic intention—beyond the printed page—to photograph subjects of cultural significance and of his own choice with as much technical articulation and optical detail as the medium itself could yield.

IT ALL BEGAN WITH one set of mink breeders in the Great Lakes region of the United States. The black minks they had been

cultivating were considered to have the richest and most lustrous fur in the world. The Great Lakes Mink Association (GLMA) wanted to spread the word, and in 1968 they approached Jane Trahey, who owned her own advertising agency on Madison Avenue, to launch a national promotional campaign. Out of the color of the mink, black, and the acronym of their regional organization, GLMA, Trahey came up with the brand name "Blackglama" and conceived a tagline for the national ad campaign—"What Becomes a Legend Most." Henry Wolf, who had briefly replaced Brodovitch as art director at *Harper's Bazaar* in the late 1950s and who worked closely with Avedon during that period, was Trahey's art director. Together they created the successful campaign in which great stars of the stage and screen were adorned in luxurious black mink coats, a status symbol in keeping with their stature as legends. And who better to photograph these grande dames than Richard Avedon?

Peter Rogers, of the Trahey agency, was the account executive for the entire campaign. "What Becomes a Legend Most" consisted of a new full-page ad each month, each legend wearing a mink coat under the tagline, in a campaign that ran in all the major magazines. Each grande dame received a custom-made mink coat as payment.

The Trahey agency considered Dick to be as legendary as the women it wanted to include in the campaign. "We knew that if he took the photographs, the stars would all say yes, because they all *wanted* to be photographed by him—and of course they had all *been* photographed by him," Rogers said. He was responsible for "casting" the legends, and Lauren Bacall was the first to be photographed. Others included Marlene Dietrich, Judy Garland, Bette Davis, and Barbra Streisand. "Once the first five ran, the phone never stopped ringing with women wanting to be in it," Rogers said. "The only women who ever turned me down were Jackie Onassis and Katharine Hepburn."

It was not easy for Rogers to navigate the demands of so many divas. He picked up Lauren Bacall in a limousine, and on the way to Dick's studio he showed her the contract. It stated unequivocally that she was to receive her mink from Alexandre, but, in the middle of the park, she seethed, "If the coat doesn't come from Maximilian, you can turn the car around right now."

When they got to the studio, she was, of course, a perfect angel. She and Dick had known each other forever, and he was friendly and nonchalant. Dick was getting only $1,000—about $7,000 in today's terms—per shoot, each shoot taking not more than half an hour. As the campaign took off, his fee increased to $1,500—closer to $10,000 today. In the picture of Bacall, she stands wearing the coat in profile, her arms crossed, her face turned directly at the camera, her expression one of Medusa-like hauteur. In fact, the photograph is the result of pre-Photoshop studio wizardry. When the film came back to the studio, Bacall looked terrific but the coat itself was uniformly black, lacking definition and texture. Since it was an advertisement for the mink coat, it had to be rephotographed, but asking Bacall to come in for a reshoot presented too many problems. Gideon figured out a way to light the coat to reveal the hairs in the fur, and then Dick photographed the coat on his secretary, Sue Mosel, posing her in the exact position of Bacall. Dick gave the negatives of Sue Mosel and Lauren Bacall to Bob Bishop, his meticulous retoucher, who stripped Bacall's head onto Mosel's body. Now the fur was articulated and the hairs visible. Once this trick is revealed, one can see that Bacall's head is larger than it should be in proportion to the body in the coat.

Rogers was present at all the sittings, not only delivering each star to the Avedon studio, but then working with Dick to get the right pose. Rogers found Dick to be easy to work with and at times surprisingly cooperative, given his reputation for exactitude and, at his worst moments, megalomaniacal control. "We weren't

photographing a design. We were photographing a style," Rogers said. "And Dick was very important in establishing that campaign style." Dick had photographed Marlene Dietrich on several occasions, going back to his first years at the *Bazaar*, and when Rogers brought her into the studio, she and Dick had an almost intimate rapport. She posed for a while, but it wasn't quite working. Finally, she said, "Bring me the mirror," and Dick, uncharacteristically, seemed willing to comply. His assistant brought out a full-length mirror and she looked at herself, then said, "Bring me the stool." She sat down, crossed her legs, pulled the fur coat back, and voilà. "Everybody fainted," said Rogers, indicating that it was not only a classic Dietrich posture, but perfect for the picture. Dick photographed her in just that seated pose, the fur coat draped to the floor like a curtain around her legs, one crossed over the other, with silver-tipped heels on her feet. That was the picture that appeared in the Blackglama ad. "It's so great to have such famous legs," Rogers said to her after the shoot. "They're not so famous, darling," she replied. "I just know what to do with them."

Rogers embarked on an encumbered odyssey to locate Judy Garland for the campaign. He could never reach her on the phone, and she would never return his calls. Then, one night, quite serendipitously, he was at a lesbian bar with friends on the Upper East Side called Three. "I had been trying to find Garland everywhere, and all of a sudden, there she is standing at the bar," Rogers said. "She was coming down every weekend from Boston and singing in this bar for a hundred dollars a night." By then she was on several prescription drugs, and Rogers remembered her behavior as more than a little manic. She agreed to be in the ad campaign and then proceeded to call him collect from Boston at least twice a day in anticipation.

He picked her up at the airport on the evening before the scheduled session. She got off the plane wearing a red sequined pant-

suit. He had made a reservation for dinner at the Colony, a society restaurant in New York, thinking that it would please her, but she was not interested. "No, we're going to hear Tony Bennett at the Waldorf," she said. She ordered one vodka after the other and sipped them throughout the evening. She sent Bennett a note with a rose from the vase on the table and when he came out, he said, "Before I sing, I must tell you all that the fabulous Miss Judy Garland is in the audi—" According to Rogers, she leapt up to the stage, took the mic out of his hand, and did an entire set. "It was astounding," he said, meaning both her audacity and the performance. Later, they went up to Bennett's suite, and around midnight Rogers reminded her that they had a shoot in the morning. She didn't want to leave.

The next morning, he picked her up at her hotel, and the concierge told him she had ordered five hundred dollars' worth of Carven perfume from the hotel drugstore, which he had to absorb as an expense for the shoot. Finally, he got her to Dick's studio. Dick and Judy were old friends and the shoot went very well. In the ad, under "What Becomes a Legend Most," she reclines in a leisurely pose, leaning on one arm, the plush fur collar wrapped elegantly over her shoulder. Dick made her look radiant, impeccably made up, wearing fine drop earrings, appearing every bit as glamorous as one would expect of Judy Garland.

"What Becomes a Legend Most" was wildly successful, within a year or two turning Blackglama mink into the most desirable fur in the world. The campaign continued for almost twenty-five years. Eventually, they ran out of true legends, although in the first few years the roster was impressive: Joan Crawford, Maria Callas, Elizabeth Taylor, Lena Horne, Beverly Sills, Diana Ross, Lucille Ball, Peggy Lee, Brigitte Bardot, Sophia Loren, Carol Channing, Lillian Hellman, Rudolf Nureyev, Diana Vreeland. Dick, who was so instrumental in the success of the campaign, stopped photographing the legends after the first year.

WHILE DICK TRAVERSED THE heights of celebrity in his studio, his family life was becoming increasingly problematic, with tragedy nipping at the barricades. The last time Dick would ever see his sister, Louise, was in January 1968. Her skin was ashen, her face bloated, her hair thinning and knotted. She had long been on a daily cocktail of Thorazine, Stelazine, and a half dozen other drugs. "Be a good girl," he told her as he waved goodbye. Louise had entered the Rockland State Hospital as a permanent resident soon after Dick and Evie were married, in 1951. She had been diagnosed with schizophrenia, and the hospital specialized in electroshock treatment and lobotomization. Dick's mother, Anna, whose older sister, Sally—Margie's mother—suffered from serious mental instability that may never have been properly diagnosed, remained vigilant about visiting her daughter twice a week, taking the bus from the city to Orangeburg, New York, and sitting with Louise in a unit where the door had to be locked from the outside so the patients would not run out into the hallways; in warmer weather, Anna would take Louise for walks on the hospital grounds. Healthier patients resided on the lower floors of the ward, and, at one stage, when Louise showed a little improvement and was told she might be ready for the ground floor, she had a relapse. It seemed that she felt safe at Rockland State, where, over the years, her condition deteriorated to the point that she had to be spoon-fed.

In the early years of her treatment, Louise was permitted occasional daylong visits home. Dick would send his mother to the hospital with a car and driver to retrieve his sister and bring her into the city. "I would meet them at Rumpelmayer's," Dick said, the once popular ice cream parlor on Central Park South. Anna would complain about Louise's long silences on the drive down, and shrug in despair. Louise always ordered the same thing—a

banana split—and then would wander off to a corner of the shop to pet the stuffed animals. Dick and his mother did not linger on the false hope of success with her treatment, but they huddled in reassurance that the hospital was the best place for her to be. Eventually she would wander back to the table and eat her banana split, licking the ice cream off the plate. They might take her for a brief stroll in Central Park before Anna made the trip back to the hospital with her and returned again to the city, alone.

Over the years Louise was diagnosed as low functioning, and eventually she spoke in nothing but a string of random obscenities. Visits were curtailed. One morning a couple of weeks after Dick's final visit, Louise was found unresponsive in her bed. Dick and his mother were notified of her death with the unofficial conclusion that she must have had a heart attack. The hospital wanted permission to perform an autopsy, but Dick's memory of photographing an autopsy in the merchant marine, and fainting afterward, put him off the idea. The cause of death seemed irrelevant, and he said no.

"Louise's beauty was the event in our house," Avedon told Helen Whitney in 1994. "Her shyness was never examined. My mother used to say: 'Louise, with skin like that and eyes like that you never have to open your mouth.' When I began to photograph in my adult years, all the models that I was drawn to and all the faces that I was drawn to were memories of my sister." Dick would lament about his sister's death that she was only forty-two. "I'd already done enough to Louise. I hadn't done enough *for* her." In a moment of enlightened self-awareness, he added: "I don't think I ever really wanted to help her—I had my hands full trying to help myself."

Louise's death occurred at a time when things at home had been quietly, painfully unraveling. Parallels between Evie and Louise were mounting. While Mike Nichols considered Evie to be very attractive, citing her elegance and her great laugh, he told Norma Stevens that, as Evie became increasingly troubled,

she reminded him of Nicole Diver, the mentally unstable wife—and former psychiatric patient—of Dick Diver, the protagonist of F. Scott Fitzgerald's *Tender Is the Night*.

Mike Nichols claimed that he was Avedon's best "non-strategic" friend, and during this period, Dick divulged to him the troubling condition of his marriage: He told Mike about a recent evening in bed when Evie was absorbed in the biography of Zelda Fitzgerald. Suddenly she put the book down and asked Dick if he thought she was going to become like her. (Zelda was diagnosed with schizophrenia by the time she was thirty and lived the rest of her life in a psychiatric hospital. Nicole Diver was based on Zelda.) Dick dismissed the comparison, but Evie challenged him. "How do you know? Are you F. Scott?" That night Evie told Dick she had been thinking of leaving him. "I decided to call her bluff," Dick told Mike, saying to her, "Okay, let's give it a try." She said, "There are men around who've given *me* a try," dropping the name Goddard Lieberson, who worked with Bill Paley at CBS, and then rattling off the names of several of her psychoanalysts as well. Dick said he didn't know if any of it was true, but he was left with a sense of relief. "It let me off the hook," he told Mike.

Evie's behavior had become progressively erratic and disagreeable. Dick felt that she was trying to embarrass him in front of their close friends, but her behavior was, more likely, beyond her control. By then, Evie was a patient of Dr. Lothar B. Kalinowsky, a psychiatrist and pioneer in electroshock treatment. One evening the Bernsteins were coming for dinner, and Dick got home early to find Evie in the kitchen making the final preparations for the meal. She was still in her nightgown, and he asked her what she was planning to wear for the evening. "I'm dressed," she answered. He told her to go upstairs and get properly dressed. After half an hour, the Bernsteins arrived and Evie made her entrance in a housecoat hanging open over the nightgown. Her hair was uncombed, and

her face was without makeup. Dick turned to Lenny and, in front of Evie, said, "You see how my wife hates me. She blames me for the emptiness of her life in the fullness of mine." Meanwhile, Evie was saying to Felicia, "Dick dressed me tonight especially for you." Lenny called him the next day to ask what they were going to do about Evie. Dick assured him that he was doing everything that could be done, describing Dr. Kalinowsky and his electroshock therapy, even complaining about the cost.

One could say that Dick's relationship to fatherhood was self-referential. He always provided the very best for his son, John, doing so in sweeping flourishes of magnanimity. John Avedon started talking about wanting to be a writer when he was eleven. He had read *The Lord of the Rings* and J. R. R. Tolkien was his current hero. That year Dick brought Evie and John along to Europe while he was shooting the fall collections, and, while in London, he learned that it was Tolkien's birthday. "C'mon," Dick said to John, "we're going to Oxford." Dick bought a cake and they were driven to Tolkien's house. "To my complete chagrin and humiliation," John would later tell a reporter, his father rang the doorbell. Tolkien was caught off guard by the unexpected strangers at his door, and at first claimed to be indisposed with a terrible cold, but soon enough, he was charmed by Richard Avedon and so touched by his son's adoration that he invited them into his study, where he sat with them for half an hour to talk about writing.

Dick was consumed with his work, often traveling for periods of time, whether on a *Vogue* magazine shoot in the snowcapped mountains of Japan for almost six weeks, or to London for *Look* magazine, or to the Caribbean for a quick, three-day advertising shoot. When he was in town, he worked all day, and at night, it was always the theater, or the ballet, or the premiere of a friend's new movie, or the opening night at the opera. He was not a consistent emotional presence for his son, nor, it turned out,

was Evie a stable one. But Dick was just terrific at the fatherly *grand geste*.

In 1969, Dick provided a car and driver, courtesy of *Vogue* magazine, for Johnny, barely sixteen, to go to the Woodstock music festival, two hours north of the city. The poster promised "An Aquarian Exposition: 3 Days of Peace and Music." In fact, hundreds of thousands of shirtless college-age kids sat on the ground for a rain-soaked weekend as the sweet, pungent smell of marijuana lifted the collective audience into a throbbing and hypnotic purple haze. Kinetic energy rippled through the crowd, all bobbing heads and swaying shoulders, as Jimi Hendrix; Joan Baez; the Grateful Dead; the Who; John Sebastian; Country Joe and the Fish; Blood, Sweat and Tears; and Ravi Shankar performed. Sometimes, it was great to have Richard Avedon as a father. And sometimes *not*.

That year, John had had enough of Phillips Exeter Academy, his boarding school in New Hampshire. According to Harry Mattison, an older friend, he and John had commandeered Dick's study on the top floor of the Riverview Terrace house to map out plans for a free school. "This was the time of post-Summerhill educational effervescence—the idea of a different kind of pedagogy was in the air," explained Mattison. They wanted to call it Robin Hood Relearning. He made a sensible case to his parents for a school for him and other children of his parents' friends, and they agreed, as long as he would raise the money himself. "John was really onto something and rearing to go. But then his father stepped in and took it over—the whole thing, not just the fundraising part—and that took the wind out of John." Regardless, the money was raised and a teacher was found and John did not have to return to boarding school; instead, he, along with fifteen other students, took classes at home in his town house on Riverview Terrace for an entire school year. So while Dick had taken over the enterprise, John got what he wanted.

With Louise's death, along with the slow disintegration of his marriage, Avedon undoubtedly grew more introspective. Maybe that is what inspired him to make a series of portraits of his father, Jacob, in the waning years of his life. In August 1969, Dick took John with him to Sarasota, Florida, and made a portrait of the three generations of Avedons: Jacob, standing between his son and grandson, wears a white shirt, a striped tie, and a checked houndstooth jacket. He stares into the camera with a proud, close-lipped smile on his face. John, just sixteen, with long hair and beard, looks solemn, a wild child of the 1960s. Dick appears in a partial view, the right side of his face peeking into the frame, his right eye a piercing bullet.

Dick grew to hate his father early in his life. Was it for thwarting his individuality with tedious conventional goals that did not apply to who he was? Tyrannizing him with impossible expectations? Making him feel like a failure at every turn? In his father's eyes, nothing was ever good enough, and his constant taunt about Dick being a "no-goodnik" was damaging. Now, of course, the balance of power had shifted. Not only was Dick *not* a no-goodnik, he had more money than his father could ever have imagined in several lifetimes. Not only was he *not* a failure in the arena of intellectual pursuit, he was respected by the great thinkers of his time and he could count among his good friends the venerated writers and artists of his generation. In keeping with his father's ethic about the obligations of manhood, Dick took seriously his responsibility to his family. By every outward measure of those bedrock conventions, Dick was a faithful husband and a caring father, which was more than he could say for Jack, his own father, who had struggled to support his family while Dick was growing up, eventually leaving his mother and moving to Florida in 1952. Having proved his father wrong many times over, he could level a sober and calculating eye on the parent who once had loomed so large.

What a Shakespearean undertaking it was, then, to attempt a series of clear-eyed portraits of his father in the deteriorating stages of his life and eventual death. While these portraits would become among the most significant series in his entire body of work, the existential exercise of staring his father in the eye over five years of visits was clarifying and, likely, motivating, too, for it was in this period that Avedon's work came into artistic focus. Years later, toward the end of his own life, Avedon was circumspect on his motivation to make the father portraits. "I was in analysis then, off and on, and it occurred to me many years later that maybe photographing him was an act of hostility, shooting, killing him with my camera, watching him die with my camera." Dick recalled one supposition he had floated by his analyst: "Could it possibly be that I was telling myself it was a kind of love, when, really, it was a kind of murder?"

IN THE LATE 1960S, several junior assistants—those who reported to Gideon Lewin—passed through Dick's studio. One of them was Claude Picasso. Dick had photographed Claude and Paloma, Pablo Picasso's children, in Paris in 1966, and when Claude, who wanted to be a photographer, ran into Dick in London in early 1968, Dick invited him to come work for him. "New York is the place to be," Dick said. Claude worked for the Avedon studio for a year doing menial tasks as well as darkroom work—sweeping the floors, setting out breakfast for the staff, printing contact sheets from film that was couriered overnight from Paris while Dick was shooting the collections. And, because he spoke French, Claude was enlisted to translate the letters Dick received from Lartigue.

By 1968, Dick's Lartigue project was going full tilt. "All my spare time in the past few months has been spent editing and working on the layouts of a new book by Lartigue," he wrote to

John Szarkowski in the summer of 1968. "I arranged to have all of his pictures printed, then went to Paris to edit from thousands of them. The book will be divided into seven decades—it's absolutely incredible the amount of work he has done and the beautiful photographs buried in his files. You realize, of course, that it was you who brought us together, and I can't thank you enough. When the book is completed, I'd love to show it to you."

Viking Press was interested in the book, and Dick had begun working with Bea Feitler on ideas for sequence and design. Dick wrote to Lartigue on March 28, 1968, explaining the fluidity of his working process with Feitler: "We think, we talk, we changed our minds. We are excited one day about a layout and two days later make it better. It is the nature of our working together, and a habit that has come to us from years of working on *Harper's Bazaar* and on the Beatles posters and many other projects." He wanted to convince Lartigue to "let us follow our dreams about your work to the end. On the other hand, as we work together we must all agree." Avedon could be saccharine in his cheerleading and audacious with his demands, at one point explaining to Lartigue that the only way to sequence the book properly was to bring all of Lartigue's negatives and contact sheets to New York. His argument was that it would be vastly less expensive to make copy prints in his studio than to pay Photostat houses or printing labs. In that same letter, as a further lure, Dick blithely reported to Lartigue that someone had given him an idea for the title: "Diary of a Century." "I don't think that's a bad idea at all," Dick wrote. "They explained to me how a book of Alfred Eisenstaedt's called 'Witness to Our Time' sold 50,000 copies, because it was promoted as an historical book rather than just a collection of photographs."

Another studio assistant that year was a young Brit named Neil Selkirk. Gideon hired Neil for a week in London, where Dick was scheduled to photograph John Huston's wife and children at home

on Maida Avenue. Dick knew Ricki Huston quite well, the former Enrica Soma, a principal dancer at the New York City Ballet under George Balanchine in the late 1940s. When the Avedon team arrived at the Hustons' house, Selkirk, barely twenty-one, was struck by the unusual artifacts and mementos on the long refectory table in the middle of the director's living room. African figurines sat on shelves; voodoo dolls hung on the walls; shelves of Indian pottery lined the dining room; and a photograph of a nudist family was framed on the wall in the corner. It was unusual to see a picture by Diane Arbus in anyone's home in 1968, and Selkirk didn't know who she was at the time. "I am not a person who is devastated by art," he said. "I have never been moved by anything in my life before or since as much as I was by looking at this picture. I was ravaged."

Dick made environmental portraits of Ricki and her children—Anjelica, Tony, and Allegra—and within an hour he was off to the next assignment. As they drove away, Gideon told Dick that Mick Jagger was not able to be photographed while they were in London, and Dick said, dismissively, "Well, he'll just have to come to New York, then." The young Selkirk was amazed at Dick's nonchalance about photographing Jagger, who, by that time, had already achieved international rock star fame.

Selkirk would work briefly for Avedon in New York, but ultimately he became Hiro's assistant. Dick's larger studio was on one side of the building, and Hiro's on the other. The agent Laura Kanelous represented both of them. The financial arrangement was lopsided in that Hiro paid 25 percent of his commercial income to Kanelous, just as Dick did, but Hiro also paid the Avedon studio a sizeable percentage of his income for use of the space and in-kind services.

Dick, who was working more than seems humanly possible, considered his commercial work the means with which he could

fund his own work. He was obsessive about doing whatever it took to make as much money as he could squeeze out of every commercial or editorial project he accepted. To this end Avedon and Hiro had the cosmetics industry completely wrapped up, with advertising accounts for Chanel, Coty, Max Factor, and Revlon. Avedon might have been making twice as much money from Hiro's labors, but Hiro, too, was making twice as much money as he would have on his own. He knew it would be professional suicide to leave and try to compete with Avedon for those accounts.

In 1969, Harry Mattison, initially Johnny's friend, who eventually became a "son" of the Avedon household, began working as an assistant in Dick's studio. He was a student at Fordham attending classes at night and needed a job. Dick offered him a job to be supervised by Gideon at $48.59 a week. "The first time I walked into the studio I was dazzled by all the white—it was like walking into a frosted lightbulb," he said. "There were rolls of paper on the floor everywhere, and Dick shooting in the soft explosions of the flash were like that final spray of fireworks on the 4th of July."

Soon after Harry started working at the studio, Dick was setting up another epic fashion excursion for *Vogue*—this one on American fashions, to be shot in the romantic Irish countryside. Not long after he photographed the Hustons in London, Ricki Huston was killed in an automobile accident. "Dick sent us violets," Anjelica Huston said. "He was very sweet and attentive after she died. He loved my mother very much. You know, I think also because she was a swan, and he loved his swans." Anjelica, who spent most of her childhood at her parents' estate in Ireland, where she attended school, was seventeen, and soon after the accident, she left London for New York. Dick, who had watched her grow up, had done a modeling test of her when she was fifteen. She had already modeled for several other fashion photographers in London, and now following Ricki's death, Dick called Anjelica and asked her to be

the model for the twenty-five-page fashion romance in the Irish countryside for *Vogue*.

Dick had photographed several male models to be considered as the male romantic figure in the Irish fantasy, including James Taylor—before his breakthrough single, "Fire and Rain." In the studio Avedon also had taken notice of Harry Mattison, who was twenty-one, tall, blond, and handsome. He asked Harry to sit for some test shots, and then showed them, along with pictures of James Taylor, to Anjelica Huston. She picked Harry, and off they all went to Ireland for two weeks of shooting, in an entourage with Dick, Gideon, the two fashion editors Polly Mellen and Babs Simpson, and Ara Gallant.

The feature ran in the October 15, 1969, issue of *Vogue* as a series of romantic idylls amid the poetic Irish landscape, with scenes of Anjelica holding an open umbrella while riding a bicycle in the rain; Anjelica and Harry huddled in a painted tinker's wagon pulled by white horses; the two of them in languid repose in front of an ancient castle, romping in the fields, strolling along the beaches, staring longingly at each other, reading aloud to one another. In one picture, Anjelica wears a long wool cape and holds a majestic eagle, with wings spread, on her gloved hand. In one jarring moment on that trip, Dick and Harry had gone to the house of the falconer from whom they had rented the eagle. There in the glass case of his living room was a glaring display of Nazi memorabilia. "Dick was clearly shaken," Harry recalled. "When we left, he mumbled something about calling Simon Wiesenthal right away."

Dick liked to play games, Anjelica remembered, silly games to pass the time. "What would it be like if you had the biggest penis in the world?" he would say, throwing the question out as a challenge. And someone would take the bait. "Oh, it would be fabulous. You'd have such a great time." He would counter with, "But wouldn't it be a nightmare?" Anjelica thought he was being provocative. "I always

felt that he came at it as an observer, not as a participant," she said. "There was a certain kind of collegiate, gray-cashmere thing about Dick, a correctness about him, and, also, a kind of cool."

For Anjelica, there was nothing like modeling for *Vogue* with Dick, Diana Vreeland at the helm. "It was just fantastic," she said, speaking of this extended adventure in Ireland. "There was no folly too great. No extravagance too much. Hundreds of pairs of shoes, thousands of scarves, belts, gloves, dresses, editors running around all highly emotional. Polly Mellen, the most emotional of all." Anjelica's description of modeling for Dick is consistent with that of other women, who also experienced the unique "addiction," as Huston characterized it. "It's really an extraordinary thing when that synergy happens, because it's so exciting. It's like flying. You get into a rhythm and you see what he wants and you understand, and you're giving it back to him and it's . . . a wonderful two-way conversation."

She preferred it when he used the Rolleiflex instead of the Hasselblad, which took forever to load. She had to freeze in position while the magazine (film holder) was changed. She felt more spontaneous in front of the Rolleiflex. "I remember, at one point, he had us chasing around some haystacks and rolling around in the hay. You know, there was no room for self-consciousness."

Aside from a few dissonant moments, as with the falconer, it was a lovely trip for all of them. Anjelica remembered beautiful drives on country roads as they listened to music as diverse as Vivaldi's *Four Seasons* and Bob Dylan's "Lay Lady Lay." Harry remembered drinking Irish whiskey in one town with locals who had gathered to watch the moon landing on a small television on the bar. Dick must have felt a kind of camaraderie with Harry, because the two were in a pub alone late one evening and, according to Mattison, he unburdened himself about the tensions between him and Evie. "Dick shared with me a lot of his terrible ambivalence about this

marriage. He told me that he was suffering, and that Evie was, too, which I already knew from her. He just wanted me to know that he was trying to come to a decision and that it was very difficult. And in fact he didn't leave Evie until a couple of years later."

The trip to Ireland proved to be a great success in the halls of *Vogue*. Just before the issue was published, Mrs. Vreeland sent a note to Dick, as well as to Babs Simpson and Polly Mellen: "I think it looks so divinely beautiful. All the romance of the countryside is within the pictures. I think the clothes were so beautifully selected, so beautifully used. From every point of view everyone involved in this gets the warmest and highest congratulations. I'm absolutely thrilled with it."

WHILE THE FANTASY ESCAPADE in Ireland had been business as usual at *Vogue*, America was being torn apart. The year before—1968—had been tumultuous. Two assassinations—Martin Luther King Jr. and Robert F. Kennedy—plowed into the tender moral fibers of the national conscience. Outrage and despondency, both, propelled mass demonstrations and inner-city riots across the country, erupting with parallel and sometimes overlapping intentions—civil rights demonstrators on one side, antiwar protesters on the other. The 1968 presidential election would be a bitter referendum on the Vietnam War, which was escalating even as resistance to it grew ever more visible, vocal, and militant. With the antiwar movement taking hold, demonstrations became larger and more frequent; and the militarized police reaction would have an adverse effect, like throwing oil on a fire.

In August 1968, the Democratic National Convention in Chicago attracted thousands of antiwar protesters, including members of the more militant activist groups: the Youth International Party (the Yippies), Students for a Democratic Society (SDS), and the Black

Panthers. The convention was televised, and so was the apocalyptic clash between the protesters and the Chicago police, who used tear gas and billy clubs to beat back the crowds of student-age demonstrators whose parents—along with the entire world—were watching in abject horror.

This may or may not have been the incident that crystallized for Dick a clear path out of what he felt to be an artistically fallow period. Certainly he had been successful at upping the ante as a fashion photographer, each new year bringing another set of visual innovations to the pages of *Vogue*. His creative intelligence kept him in the spotlight and continued to attract commercial clients. But since the hostile reaction to *Nothing Personal*, he had found himself at an aesthetic crossroads. His portraiture felt stale. "I had this block," he later recalled about that period. "I couldn't photograph—well, I could photograph, but I couldn't do anything that meant anything to me for a great number of years."

John Szarkowski, the curator of photography at the Museum of Modern Art, who had organized the *New Documents* show with Diane Arbus, Lee Friedlander, and Garry Winogrand, made several visits to Avedon's studio in 1968. A man not easily impressed, or persuaded, he must have thought well of Avedon's work because he offered him a show at the museum, arguably the most prestigious platform for photography anywhere in the world. This might have been exactly the impetus Dick needed to bring focus to the next stage of his work. He even said as much to Szarkowski: "I can't tell you how grateful I am for your offer," he told the curator. "It comes at the most needed moment." Yet he was also circumspect, telling Szarkowski that he thought it would be best to wait and show a body of work that he had not yet even begun. To that end, the photographer and the curator began a dialogue about the work in progress that would last another five years. In one of the first conversations they had, which was in written correspondence, Dick's

enthusiasm got the better of his circumspection, as it was wont to do: "You know my compulsion about not doing any formal presentation of my work until I complete the 'room' for you," he writes to Szarkowski. "Well, I am beginning to think I need the discipline of a deadline, and so, have accepted a large retrospective show at the Minneapolis Institute of Arts for the fall of 1970, which means that I will have your show of new work done before then." He goes on to say that the Minneapolis museum will assume the expenses for all the prints and the framing of his work that will be returned to him when the show is over. It took Szarkowski several months to respond, apologizing for the delay, expressing delight that Dick was doing serious thinking about "our show," as he called it. It is possible to read a facetious note between lines here, as Szarkowski could speak in double meanings that were always couched in decorum: "Let us get together for lunch as soon as we can, so that you can re-energize me with your good ideas." That Szarkowski needed to be "re-energized" at all suggests the beginning of a weariness about Avedon himself, if not his work.

Alert to the upheavals occurring not just in the United States but also in Paris with the student riots, and in Eastern Europe with the Prague Spring, Avedon believed that a significant political shift was taking place, and he wanted to document it, or, more in keeping with his chosen genre, *portraitize* it—with a new style that was conceptually matched to what Paul Roth, a former director of the Richard Avedon Foundation, described as "the disruptive and transgressive energies then animating and shaping American culture: a series of portraits documenting the American counterculture and radical left."

There is no question that Marvin Israel was egging Dick on toward a freer and more confrontational visual style. In 1969, Israel recommended that Avedon hire the young writer Doon Arbus, the daughter of their mutual friend Diane Arbus, to help him with this

new venture. Doon had gone to Reed, an intellectually rigorous progressive college in Oregon, but left after her freshman year. She worked as an assistant to Gloria Steinem, then wrote a few pieces for the *New York Herald Tribune* Sunday magazine, and now, at the age of twenty-four, she was writing for *Cheetah*, an alternative publication. Dick hired her to assist in targeting and scheduling subjects for him to photograph, and to conduct interviews with the sitters that would accompany the pictures. Avedon assigned a working title to his new project: "Hard Times." Years later, in a recorded interview with both of them, Doon recalled the way Dick first described the project to her: "You were clear on what you wanted to do," she remembered. "It was an emotional thing and also something political. . . . You wanted to photograph people who were putting themselves on the line. As it evolved, it got less and less structured by that. But that was the initial thought."

Dick was never shy about promoting his projects, and somehow, barely a month later, an item showed up in the *Village Voice* announcing that Richard Avedon "now wants to turn his lens on something funkier, and more responsible, than the Paris collections. He and writer Doon Arbus have begun compiling an anthology of portraits of members of the Movement. 'The quality of life is what we are researching,' Avedon told the *Voice*. 'Not just the Movement . . . survival, how people survive and what they consider important to themselves right now.'" The article reports the working title, "Hard Times," and described their idea for a MoMA show "to mount all the photos (at least 1000) to the same size and cover the walls with them."

On February 16, 1968, well over a year before the idea for "Hard Times" surfaced, Dick photographed Senator Eugene McCarthy, a Democratic presidential candidate who was running on an antiwar ticket. A "Talk of the Town" piece in the *New Yorker* reported on the presidential hopeful's day in New York, describing the session

in Avedon's studio, as well as a press conference and a fundraiser. "There are no standard photographic props—no floodlights, spotlights, tripods or tangles of wire," according to the piece. Dick wore a brown sweater and gray flannels and stood with his Rolleiflex flanked by three assistants: one held a gray umbrella with a small pale light attached; a second held a sheet of cardboard, shielding the camera from the light; and the third held a freshly loaded Rolleiflex ready to hand to Dick when it was needed. McCarthy, "handsome in the style of a cowboy movie actor," wore a gray suit, a white shirt, and a black tie with blue stripes. He sat on a stool and faced the camera, his hands folded on his knees. The senator and the photographer talked quietly, Dick asking questions and McCarthy answering softly in his usual temperate manner, while Dick clicked the shutter and the umbrella light flashed each time, illuminating the senator's face. The session continued for less than an hour as Dick conversed with the presidential candidate, making several dozen exposures. This would be one of the last of a breed of stationary portraits before Dick embarked on his new approach—a more intentionally activated form of portraiture.

As Avedon embarked on his "Hard Times" project, the shift in his style can largely be attributed to his adoption of a new Deardorff eight-by-ten view camera. Until then, he had made most of his images—fashion and advertising as well as portraiture—with a Rolleiflex medium-format camera. Over time he tired of the smaller twin-lens camera, which required him to look down through the viewfinder and away from the subject. He felt it had become a barrier: "They couldn't see my eyes, and I couldn't see them. I saw them as a picture. And I felt as if the human connection was lost." The Deardorff, by contrast, allowed Avedon more direct eye contact with the subjects. Standing to the side of the large camera, freed from technical matters by the presence of an assistant, he was able to forge a more immediate and intimate relationship with

the person he was photographing. He could thus direct the sitting, subtly controlling facial expressions and body posture, and capture, in his words, "a kind of tension . . . a particular quality of proportion within the frame and the kind of spatial balancing and emotional tone."

At the Democratic National Convention in August, Vice President Hubert Humphrey, not Eugene McCarthy, was nominated for the presidency. Outside the convention center, after the violent clashes with the police subsided, eight political activists were arrested for inciting the protests. The defendants included David Dellinger of the National Mobilization Committee to End the War in Vietnam; Rennie Davis and Thomas Hayden of the SDS; Abbie Hoffman and Jerry Rubin, founders of the Yippies; Bobby Seale of the Black Panthers; and two lesser-known activists, Lee Weiner and John Froines. They would become known as the "Chicago Eight."

A year later, and a month after Dick's return from his fashion shoot in Ireland, he went to Chicago to attend the trial of the Chicago Eight, which began on September 24, 1969, in the courtroom of Judge Julius Hoffman (no relation to Abbie, one of the defendants). The group had been charged with conspiracy to cross state lines with intent to incite a riot. All but Bobby Seale were represented by William Kunstler, who, among other distinctions, was at the time the director of the American Civil Liberties Union, and Leonard Weinglass, a cochairman of the National Lawyers Guild. The trial, presided over by Judge Hoffman, turned into a national platform for the defense attorneys; aware that it was being covered on national television news nightly, they attacked Nixon, the war, racism, and oppression in their defense arguments. Their tactics were disruptive in a courtroom already riddled with conflict and chaos. At one point, after Judge Hoffman refused to allow Bobby Seale to hold his own counsel, Seale declared before the jury that

the ruling was illegal and unconstitutional, citing US Supreme Court precedent. Judge Hoffman ordered Seale to be gagged and strapped to his chair, and Seale could be heard in muffled sounds as he struggled to get free. Finally, the defense attorney Kunstler declared, "This is no longer a court of order, Your Honor, this is a medieval torture chamber."

When the trial ended in February 1970, Judge Hoffman found the defendants and their attorneys guilty of 175 counts of contempt of court and sentenced them to terms of between two and four years. Although declaring the defendants not guilty of conspiracy, the jury found all but Froines and Weiner guilty of intent to riot. The others were each sentenced to five years and fined $5,000. However, none served time, because in 1972, a court of appeals overturned the criminal convictions, and eventually most of the contempt charges were dropped as well.

On the second evening of the trial, Dick set up a white backdrop in his Chicago Hilton hotel suite and organized a fundraiser, inviting the defendants, their attorneys, and anyone else he and Doon could rally to contribute to the legal defense. He photographed people talking to each other with drinks in their hands as they stepped into the frame, trying for as much spontaneity as possible given the confines of a timed exposure on the structured makeshift white "proscenium." In one portrait, William Kunstler and Leonard Weinglass stand in profile in conversation, their hands almost meeting between them as Kunstler aims his finger at Weinglass to make a point. During the party, Avedon made characteristic straight-on portraits of some of the defendants—David Dellinger, Rennie Davis, Lee Weiner, John Froines, Abbie Hoffman. He had already photographed Hoffman and Jerry Rubin in New York before the trial began. "Dick was looking at people forensically," said Paul Roth. "Doon was interviewing the subjects, often at the same time as Dick was photographing them. Sometimes people were

walking in and out of the frame. Sometimes you see Doon's microphone sticking into the frame."

Back in New York, Dick participated in an antiwar protest at Riverside Church, where he appeared among a roster of public figures and political activists to read aloud the names of 44,000 American soldiers killed in Vietnam since the war had begun. "The Vietnam Memorial Reading was born of the conviction that we cannot remain silent for one more day," said one official of the event. The *Times* reported it as a solemn reading of the names of American soldiers killed in Vietnam "that will continue at Riverside Church 13 hours a day until the war ends." Among the many readers were Avedon, Leonard Bernstein, Lauren Bacall, Leontyne Price, Republican senator Charles Goodell of New York, and a young representative, Edward I. Koch.

Avedon returned to Chicago to make what constitutes his first official wall-size mural portrait: *The Chicago Seven: Lee Weiner, John Froines, Abbie Hoffman, Rennie Davis, Jerry Rubin, Tom Hayden, Dave Dellinger, Chicago, Illinois, November 5, 1969.* He had sketched out their positions beforehand for what would be a triptych by any other name, three frames in which several of the seven subjects at a time straddle the lines between one frame and another, effectively uniting the images and making them of a piece, with the continuity of a frieze—or a ragged police lineup.

Lee Weiner and John Froines occupy the first frame, with half of Abbie Hoffman's body spilling into their visual space. In the center frame is Rennie Davis sandwiched between Hoffman on the left and Jerry Rubin on the right. As if in a narrative stutter, Rubin's right shoulder and arm glide into the last frame. There is an empty space between Rubin on one side and Tom Hayden and Dave Dellinger on the other. According to Avedon, the space was intended for Bobby Seale, the original eighth defendant, a cofounder and chairman of the Black Panther party, who was unavailable because

he was in jail. "For many observers," Louis Menand writes in an essay about the mural, "Seale's name on the indictment confirmed a suspicion that conspiracy was simply the longest statutory rope the government could find to lasso every prominent dissident who happened to be in Chicago at the time of the convention and drag them all into federal court."

As Menand concludes about Avedon's portrait, "the defendants known as the Chicago Seven look like ordinary men. They don't seem mad, or bad, or dangerous to know. They're not threatening or defiant. They look tired and sad, a little geeky, people you might run into in the teacher's lounge or at the laundromat. . . . They had experienced one of the most spectacular judicial railroadings in the history of a nation that has seen a few of them." When Avedon exhibited the mural-size image of the Chicago Seven the following year, he called them "heroic," and said that they made him feel ashamed about his own failure to be more politically active.

On January 14, 1970, a private gathering at Leonard and Felicia Bernstein's elegant Park Avenue duplex in New York would have lingering reverberations for the various progressive movements erupting across America. The Bernsteins' fundraiser for the Black Panthers was memorialized by Tom Wolfe in a *New York* magazine cover story entitled "Radical Chic: That Party at Lenny's," a scathing indictment of the moral and financial support being offered to "radical" social causes by "New Society" liberals, those socially prominent—and mostly Jewish—wealthy "arrivistes" on the Upper East Side. Wolfe turned his lacerating wit, precision-cut observations, and, perhaps, his not-so-subtle anti-Semitism on the hypocrisies he perceived to be emanating from these quarters: "Do the Panthers like little Roquefort cheese morsels wrapped in crushed nuts this way?" he ponders, describing the Black Panthers in attendance with their leather pieces, their Afros and shades as they

are served canapés "on gadrooned silver platters by maids in black uniforms with hand-ironed white aprons."

Among the ninety guests were Dick and Evie Avedon, the Sidney Lumets (Sidney was remarried to Gail, the daughter of Lena Horne), Adolph and Phyllis Green, Jason Robards, John and D. D. Ryan, Gian Carlo Menotti, Schuyler Chapin, Goddard Lieberson, Mike Nichols, Lillian Hellman, Larry Rivers, Aaron Copland, Milton and Amy Greene, Lukas Foss, Samuel Barber, Jerome Robbins, Stephen Sondheim, Betty Comden, and Charlotte Curtis, the very social style reporter for the *New York Times* whose article the following day, "Black Panther Philosophy Is Debated at the Bernsteins," was the dirty bomb that wrought unpleasant havoc for anyone who was giving parties not only for the Panthers, but also for the farmworkers' union and Friends of the Earth.

A day after Charlotte Curtis's piece, the *Times* weighed in with a lead editorial, in which they declared in high moral dudgeon that "the group therapy plus fund-raising soirée at the home of Leonard Bernstein, as reported in this newspaper yesterday, represents the sort of elegant slumming that degrades patrons and patronized alike. It might be dismissed as guilt-relieving fun spiked with social consciousness, except for its impact on those blacks and whites seriously working for complete equality and social justice."

It might seem like a victory that the controversy did not prevent others from planning fundraising parties, but the recriminations did not cease. Leonard Bernstein was getting booed while conducting the Philharmonic. The entire episode was complicated with paradoxes at every turn. *Limousine liberal* is the term coined by Tom Wolfe to describe the hypocrisy of asserting sincere good intentions about social justice while maintaining a lifestyle that exploits the underclass, and the Bernsteins and the Avedons and their entire cohort, in Wolfe's incorrigibly damning essay, were

exemplars of this crime. Still, it is too tempting not to give the last word to Randall Jarrell, the poet and literary critic, not as justification, but rather as a kind of philosophical aside: he suggested that you first have to arrive at a level of moral sophistication "where hypocrisy is even possible."

WHILE *THE CHICAGO SEVEN* was Avedon's first completed wall-size group portrait, he had already begun another group portrait that would take longer to complete. In April 1969, Avedon made a portrait of Andy Warhol that showed the gunshot wounds from his attempted murder by Valerie Solanas, who a year earlier had walked right into the Factory and shot at him three times. One of the bullets tore through his body and almost killed him. Avedon photographed him in a manner quite similar to that of the Blackglama campaign portraits. Warhol stands in front of a solid gray backdrop and faces the camera, dressed in a leather jacket unbuttoned from the bottom up. Displayed is one nipple aligned directly below Warhol's face and two diagonal sets of dark stitches on the tender white flesh of his belly. One hand pulls the line of his underwear down enough to reveal a small, deep gash in his lower abdomen; his other hand rests awkwardly on his hip. The expression on his face is one of astonishment, his eyes staring directly into the camera and his mouth gaping open, as if he might be mocking the very reaction of the viewer looking at his wounds. One might easily call the Avedon portrait "The Martyrdom of Andy Warhol."

Early into his thinking about the "Hard Times" project, Dick felt that members of the Warhol Factory might prove an ideal surrogate for the sexual revolution. The flamboyance of the Warhol coterie had by then long attracted relentless media attention, in particular because of their comings and goings at Max's Kansas City, a restaurant and nightclub made famous precisely because of

regulars like the Andy Warhol "superstars" Viva, Candy Darling, and Holly Woodlawn. At the time, pop art was focused on the iconography of popular culture. Given that Max's had become a nexus of artists and rock and roll musicians, nightlife in the club's legendary back room was a Satyricon-like display of sexual antics and after-hours revelry. The Warhol retinue was instrumental in paving the way for what would become known as the LGBTQ community—lesbians, gays, bisexuals, and (much later) transgender and queer (or questioning) people. The seductive, sexually frank tone of the song "Walk on the Wild Side," written by Lou Reed of the Velvet Underground, a band associated with the Warhol Factory, is a paean to this transgressive group in the back room at Max's.

"I wanted to start with the Warhol group," Avedon said, "because I felt they were professionals and they loved their exhibitionism, and they love to pose, and they would cooperate." On August 14, 1969, Warhol arrived with an entourage of thirteen people. Avedon tried to pose the entire group as they milled about the set. Above them, at the top of the frame, he incorporated his studio lights, fitted with umbrellas as reflectors. "One of the things I would try to do was show the studio," he later explained, in an attempt to break the fourth wall. His intention to break the fourth wall—or, in this case, the surface—was a radical idea in photography, something that can never actually be done, although Dick's exploration is an attempt to test the capacities of the medium, and equally challenge the nature of perception.

Avedon made ninety-one exposures at this first session with Warhol and his entourage before realizing that the sitting was a failure. Yet it would not stop him from further exploring the actions of individual Factory members: Brigid Berlin, for example, stripped off her shirt at the start of the session; Candy Darling, Jay Johnson, and Joe Dallesandro had, as Paul Roth writes, "provided

unimagined varieties of beauty and sexuality" that Dick wanted to further explore. He kept moving the subjects around on the set, directing them and switching them around as would a stage director and choreographer. Still, he was unsatisfied and asked them to return for a reshoot.

On August 29, Warhol returned with some of the first group and a few new Factory faces. While Dick felt that there were too many people, he started photographing them in smaller groupings, and making pictures of certain individuals alone. This sitting, too, was a failure insofar as it did not yield a single good image, but he considered it progress because of the ideas it generated. As individuals, they were exotic, some more overtly erotic than others, and all of them together composing an exhibitionistic lineup representative of the red-hot *nowness* of the era. He was struck by their casual nudity. He wanted to play with "the beautiful garbage of clothes that are dropped" when they strip, elements he hoped to incorporate into the final picture.

He started to think about paintings throughout the history of art, in which groups are presented in ceremonial situations, sometimes lined up across the canvas, such as a painting by Frans Hals and Pieter Codde called *The Meagre Company*, a Dutch militia group portrait (1633–1637). The soldiers are not in uniform; rather they pose in flamboyant finery in an informal lineup, rendered full length, some peacocking in haughty postures, others talking among themselves, the entire group rendered with a casualness at odds with formal seventeenth-century painting.

Avedon was not known to reshoot his subjects, but he conceptualized these first two sittings with the Factory as if casting sessions that allowed him to determine which members of the entourage would best represent the character of the group. In the third sitting, on October 9, he focused on only the center panel of the triptych, inviting a select group back to the studio to experiment: Brigid

Berlin, Joe Dallesandro, Gerard Malanga, Taylor Mead, Andy Warhol, and now Viva, who had not been at the previous sessions. These would become the key figures in the Warhol Factory mural. He began to make dozens of exposures with all of them alternating positions, Warhol always at the end on the right holding a microphone, in keeping with his artistic stance of holding up a mirror to the world. Dick was starting to see results.

Pleased with the central grouping, Avedon then focused on a separate panel that addressed male beauty and sexuality, a core theme of the Factory's ethos, many of Warhol's and Paul Morrissey's films, and one that Dick had not really addressed before with such direct intention. In a fourth session, on October 14, he invited Jay Johnson, Warhol's boyfriend's twin brother, and Eric Emerson, Tom Hompertz, and Gerard Malanga to the studio.

Between that session and another one, on October 25, he posed Malanga in various groupings so that he would appear in one section and then another. Then he photographed Emerson, Johnson, and Hompertz as if to echo the grouping of the Three Graces. "Take off your shoes, your shirts," Johnson recalled Avedon saying, slowly, one step at a time, as if in a game of strip poker. Dick later claimed to be fascinated by their movements and by the graphic quality of their clothes as they fell from their bodies. "Eventually, we were nude," Johnson said, remembering that Dick asked them to first put the clothing in front of them and then to the side. "The nudity was premeditated, but I wasn't aware of what was happening. Avedon was impersonal." In the final portrait, Avedon would use the three of them in the central panel, fully nude, later explaining that without their nudity, "it would not have been about the Warhol Factory in that moment. And one of the coins of that time was . . . beautiful males."

In yet a further sitting, on October 30, he invited Viva to the studio for dinner. "I'll send over a limousine to get you," Viva recalled,

describing the way he enticed her, not only for that sitting, but for several others as well. "And I'd say, "Well, grab me some caviar and champagne, too."" Avedon spent time photographing her alone as a possible single panel. Then, later in the evening, Paul Morrissey, Joe Dallesandro, and Candy Darling arrived to be photographed for another panel.

Avedon was interested in presenting Candy Darling nude, a pre-operative transsexual at a time when intentional gender reassignment was perceived as degenerate. The Factory was known for its open celebration of gender fluidity. Dick made many portraits of Darling alone in various stages of undress, but he became increasingly frustrated by her preening and posturing. He waited patiently until he was able to capture her in a position that seemed authentic, "a portrait, a beautiful portrait," he later said, "of this bizarre confusion and thing that Candy Darling had to deal with in her life, what she felt to be her flaw"—her penis.

After poring over hundreds of exposures from the half dozen sessions, shuffling them, so to speak, like playing cards, placing them side by side in multiple combinations, and even considering collaging portions of some frames into other frames, he finally composed the mural with the configuration that now constitutes *Andy Warhol and Members of the Factory, New York, October 30, 1969.*

The choreography of casual posture, the rhythm of gesture, the empty spaces that lead you into an ambiguity of space, and the multiframe composition evoke the sequential panels of a classical frieze, "as if the figures progressing around the belly of a Greek vase had paused for the photographer's camera," wrote Maria Morris Hambourg, the curator of photography at the Metropolitan Museum, in 2002. Her reference to classical antiquity is further suggested by the "satiric charade of the three male (as opposed to female) graces" enacted by the three male nudes in the central panel, and a subtle "play of hands owing much to Renaissance painting."

The multiple sittings with the members of the Factory transpired over months, in which Avedon photographed them as if he were chiseling a group portrait out of his own intuition, methodically, relying on his interactions with the individual subjects during each session, allowing his eye to lead him to its full realization. He had never done anything like that before—seven sessions, and if you include the mural-sized print, one and a half years to complete. *Andy Warhol and Members of the Factory, New York, October 30, 1969* was groundbreaking, "one of the signal achievements of Avedon's career," writes Paul Roth, "a work of aesthetic radicalism that perfectly reflected the preoccupations and ambitions of its subject and maker."

# CLOSE TO HOME

(1970–1971)

I used to think consciousness itself was a virtue, so I tried
to keep it all in my head at the same time, past, future, etc.
Tried even to feel bad when I felt good and vice versa as if any
unawareness was a marie-antoinette sort of sin.

—DIANE ARBUS

D iane Arbus was having the time of her life. Earlier that
day, she had blown up almost 150 multicolored balloons
with Avedon's face stamped across each one, and then her
daughter Doon, along with Marvin Israel and Ginny Heyman,
Dick's secretary, tied the balloons to the chairs and tables on the
patio surrounding the pool. They were all gathered at the Ambas-
sador Resort Motor Hotel in Minneapolis, their home away from
home during the installation and the opening of the Avedon exhibit
at the Minneapolis Institute of Art. Now Diane, Doon, and Helen

Kanelous stood with the group of Dick's colleagues, collaborators, studio hands, and friends in the King's Courtyard, where a grand solarium dome rose high above the Olympic-size indoor pool. They were all holding masks made from an Avedon portrait by Gideon Lewin, who printed it in multiples, cut out the faces, and mounted them on sticks, and they waited in anticipation for the man of the hour to arrive. When Dick finally walked through the door with Marvin, the crowd bobbed their Richard Avedon masks and burst into wild cheers. "Oh, no," Dick said, so embarrassed and overwhelmed that he jumped, fully clothed, into the pool.

The Minneapolis Institute of Art is an encyclopedic museum designed by McKim, Mead and White, a formidable example of the Beaux-Arts institutional architecture of the early twentieth century. A grand exterior staircase ascends to the entrance, flanked by six Ionic columns under a classic pediment. The museum's collections are broad in their range, from painting to photography, prints, African art, Asian art, and the decorative arts. Among the paintings in its permanent collection are those by Sir Joshua Reynolds, Lucas Cranach the Elder, Chardin, Murillo, Manet, Signac, Gauguin, Pissarro, and Van Gogh.

Avedon's show, which opened on July 2, 1970, was his first official museum exhibition, the largest one-man show of photographs any museum had ever mounted. Ted Hartwell, the museum's photography curator, had initially conceived the show to give equal focus to Dick's fashion pictures and portraiture, but Dick and Marvin had summarily hijacked the exhibition, turning it into a retrospective of portraits only. "We were all working for Marvin," Ted Hartwell said, having ceded control of the exhibition. "Marvin was the boss, the foreman of the whole crew," Hartwell explained, adding that even Dick deferred to Marvin, who was a genius at visual presentation.

It was an unusually hot summer and the air-conditioning system

at the museum was faulty, but it didn't stop Dick and Marvin from flying back and forth to Minneapolis throughout the month of June, working day and night under sweltering conditions to lay out the exhibition. Marvin's way of hanging the show was fluid, employing a work-in-progress approach, playing with the size of the prints and varying them on the walls with the intent of giving the show a feeling of spontaneity and optical rhythm. "Nothing stayed where it started," Paul Corlett, a curatorial assistant, said. Marvin and Dick were calling Gideon in New York a half dozen times a day asking for portraits to be reprinted, at sometimes twice the size. "Even whole rooms changed occasionally," Corlett said.

The exhibit included 250 portraits spread across six galleries, the walls of five of them painted in metallic silver. All the portraits were mounted without borders in aluminum-edged Kulicke frames, their varying sizes like notes in a melody that traveled throughout the suite of galleries. The final room was set up as an inner sanctum; visitors had to pass through a black velvet curtain into a darkened space where the carpet and the walls were black and eight-foot-tall portraits of the Chicago Seven were printed on photographic paper, glued to unstretched canvas, and hung loose on the walls, with spotlights aimed at each one. The voices of each defendant, elicited from interviews conducted by Doon Arbus, could be heard on audiotape recordings projected on loudspeakers placed throughout the gallery. Years later, Hartwell would speak generously about Marvin's accomplishment. "I have to attribute the coherence of the exhibition and its power to Marvin," he said. "To Marvin's genius."

Avedon's nude double portrait of the poets Allen Ginsberg and Peter Orlovsky—a gay couple—was printed on the opening-night invitation, a dangerously provocative gesture of nose-thumbing defiance in 1970 when the "sexual revolution" stood up against the rabid "silent majority"—a term that had been coined by President

Nixon to categorize a wide demographic swath of his constituency that represented wholesome, middle-class, all-American virtue. Describing the photograph of Ginsberg and Orlovsky and its implications in that social moment, Avedon would later say, "Getting undressed, getting naked was a political act."

On the day before the opening, Dick and Marvin drove around town with stacks of invitations and handed one out whenever they saw someone remotely interesting, unconventional, bell-bottom clad, or under twenty-one. As a result, they packed the opening on July 2 with a broad cross section of Minneapolis society, from museum trustees to college students, vagrants, and other individuals wholly uncharacteristic of a museum crowd. In the last room, with the towering portraits of the Chicago Seven defendants, a woman with an operatic voice known to be part of a local theater company burst, full volume, into "God Bless America" and, soon enough, everyone in the galleries joined in: "It was the most electrifying experience I had ever had in a museum," Hartwell said.

The retrospective included more portraits than it was possible for anyone to look at in one viewing, going back to the beginning of Avedon's career, from the Broadway actor Bobby Clark (1949) to Charlie Chaplin (1952), Humphrey Bogart (1953), Marian Anderson (1955), Truman Capote (1955), Marilyn Monroe (1957), Dorothy Parker (1958), Brigitte Bardot (1959), Rudolf Nureyev (1961), Perle Mesta (1963), William Casby (1963), Bob Dylan (1964), and on and on. A little would have gone a long way, and yet Avedon often overdid it, plain and simple, beating his bravura accomplishment over everyone's head to create a spectacle that often obfuscated the very potency of the work.

Israel designed the exhibition catalog not as a book, but rather as an objet trouvé, a kind of silver-coated print portfolio binder with flaps that had to be untied before viewing the individual sheets of coated paper inside. Each sheet had to be unfolded like a map

to view the portrait grids printed on them in their entirety. Doon Arbus essentially ghostwrote Dick's catalog essay, clarifying in her crisp writing style the ideas and observations that he authored in conversation with her. The essay is significant as a blueprint of tropes about his career that he himself would repeat and amend over the years. One was about "borrowed dogs," which would later reappear in a quotable passage in an essay Dick published in *Grand Street* in 1989, with language added by then with the help of Adam Gopnik. In the Minneapolis essay, Dick says that, as a child, photography was a "real event" in his household. He had the realization then that you could "*make* a photograph instead of just discover it." Family snapshots became a ritual. "We planned it. We dressed up. We made compositions." The Avedons did not own a dog, but it became essential to include one in the family photographs. They would dress in English clothes and stand in front of someone else's Packard. "Every one of the photographs in the family album was built around . . . some sort of lie about who we all were." In the 1989 essay, one more phrase was added to that last sentence: "and a truth about who we wanted to be."

Another trope had its source in Dick's catalog essay, an observation about the surface. "My photographs don't go below the surface. They don't go below anything. They're readings of the surface. I have great faith in surfaces. A good one is full of clues." This idea finds a parallel in an epigrammatic Oscar Wilde observation: "It is only the shallow people who do not judge by appearances." Dick signed his essay in the catalog on his birthday, May 15, 1970, perhaps as a symbolic gesture, as if to honor his first museum exhibition as a birthday present to himself.

While Avedon had already begun to make portraits for his "Hard Times" project, the only ones he included in the Minneapolis show were those of the Chicago Seven. He felt compelled to show these because of their relevance to the tumultuous countercultural

moment, citing in his essay a collective statement the Chicago defendants made after the trial's verdict: "Everyone who opposes the war in Vietnam—and everyone who advocates the liberation of black people—everyone with long hair and a free spirit—everyone who condemns the existence of poverty here and throughout the world—all have been found guilty by this verdict."

Almost thirty years later, on the occasion of the publication of the book *The Sixties*, the long-delayed result of the "Hard Times" project, Dick explained to Charlie Rose how he had gone about pursuing individuals who represented the era he was then trying to portraitize: "I followed my enthusiasms. The time was so electric, everyone had something to say and they were proud of what they were saying. There were serious things going on in the country— the civil rights movement, the antiwar movement. It was the first time there was a theater of politics, a theater of revolt." He was proud of his choice to include the Chicago Seven pictures in the Minneapolis show, which he felt compelled to explain in the catalog essay: "It was my original intention not to show them for another two years as they are, in a sense, rough sketches for a future exhibition at The Museum of Modern Art in New York." John Szarkowski, however, was not one to be preempted, and the choice to include the Chicago Seven would have an adverse effect on the fate of the MoMA show.

The Minneapolis show received mixed reviews. *Vogue*, of course, gave it a well-placed mention on its "People Are Talking About . . ." page in the August 15, 1970, issue, announcing the largest show of a single photographer in any museum, and claiming that Avedon, one of its own, "reads a face like a cardiogram."

John Lahr, who would later become the renowned theater critic of the *New Yorker*, reviewed the Avedon show for the *Evergreen Review*, which published a portfolio of Avedon's work with the nude double portrait of Ginsberg and Orlovsky on the cover: "In present

postwar America, normality has become the nation's most oppres-
sive fantasy," Lahr writes, going on to deconstruct one of Dick's
most symbolically incendiary group portraits: "Avedon's image of
the Daughters of the American Revolution (complete with neoclas-
sic symmetry) documents how society tries to dummy up a sense of
its past to cope with a history it no longer understands. Swathed
in the paraphernalia of patriotism, the DAR are fossils of a society
which once conceived of itself as revolutionary."

Gene Thornton begins his *New York Times* review by focusing
on the nude double portrait of Ginsberg and Orlovsky, "enough to
intimidate me and many of the good people of Minneapolis," he
writes. "I found it hard to go right up and look at it. Far easier to
stand at an angle some distance away from it and sneak a peek out
of the corner of my eye." He explains the reason for "all this embar-
rassment," which is due to not only the male nudity, but also "the
failure of the photographer to connect with any ordinary human
feelings." Thornton applies this absence of humanity to most of the
pictures in the exhibit. "It was wicked fun to look at these pic-
tures, to see so many famous people brought so low by these harsh,
unflattering close-ups, these oddly distorting angles, these pitiless
lights." He asserts that Avedon rendered Eisenhower, the former
president, as "a whimpering idiot"; Marilyn Monroe looks like "a
slack-jawed, dull-eyed trull from the Ozarks"; Truman Capote is
"thin as a plucked chicken."

Of course, in 1970, photography was not even considered a
medium worthy of critical observation. Gene Thornton held very
conventional views about what constitutes a good photograph, and
today his review of the Minneapolis show registers a surprising na-
ivete and lack of sophistication. His descriptions of Avedon's sub-
jects are petulant, even puerile. Dick's portrait of Marilyn Monroe,
for example, is one of the most honest and haunting images of any
celebrity in the history of the medium. Making people look their

best was never the point of Avedon's portraiture, whether he was creating editorial content or aiming for a more universal idea.

Avedon's straightforward, unadorned representation of individuals, each of whom is brought to the same frequency of forensic clarity, is similar in his gaze to that of Bernd and Hilla Becher, who documented relics of industry—blast furnaces, gas tanks, water towers, or coal tipples—throughout the changing urban landscape of the late twentieth century, in both Europe and the United States. The weight of their achievement is grounded in a tradition of photographic observation and documentation that is scientific in method and ostensibly mundane in its choice of subject. Each structure is photographed and codified with exacting fidelity, resulting in images as true in description of the-thing-itself as the medium of photography is capable of delivering.

Avedon did the same thing with individuals—subjects as objects of scrutiny. His intention was not to get at human emotion or to render the human connection between subject and photographer; rather, his vast project of photographing individuals as specimens of a species was a forensic exercise in visual contemplation as much as an aesthetic determination to achieve the highest resolution that could be had from the medium. His portraiture was in service of a noble ambition to declare proof of our existential condition as human beings—a species with the ability to annihilate itself.

Two weeks before the Minneapolis show opened, Dick sent a letter to John Szarkowski inviting him to see the show. "I'm about to impose on you," Dick writes, offering to fly John out to Minneapolis and suggesting that John's secretary arrange it through the Avedon studio. Dick wrote that the installation of the Chicago Seven, along with the audio recordings, "might be very valuable to us when we get down to our final work," referring to his proposed show at MoMA in the not-too-distant future. "Believe me, I know that it's a pain in the ass to visit Minneapolis, but I really feel that

many things about this exhibition bear on decisions that we'll have to make later."

There were times when Dick's enthusiasm eclipsed his better judgment and, in this case, he clearly overstepped. Certainly Szarkowski would not obligate himself to any artist for the sake of an airline ticket, the very offer itself an affront to the curator's integrity. Not to mention that it was a huge misstep for Dick to include the Chicago Seven pictures in the Minneapolis show when they were intended to be shown at MoMA. Szarkowski's canny reply to Dick's offer did not indicate any displeasure, per se. He apologized for his tardy response, claiming Dick's letter came when he was "lost for two weeks in the bowels of the New York Criminal Court, serving, as they say, as a potential juror for my peers." Read as if a poem, "the bowels of the criminal court" could be interpreted as Szarkowski's way of saying he was digesting his indignation, and describing himself as a "potential juror for his peers" implied the judgment he was leveling at Avedon. He goes on to cover any trace of the affront, acknowledging that he is "very eager to see the show," and will "get to it on my way to Wisconsin in August," on his *own* dime. Then he offers the highest compliment of all about the Minneapolis show: "Diane [Arbus], among others, said that it is simply beautiful, and she, as you know, is a tough critic."

"Dick's show is terrific" is how Arbus described it to her daughter Amy in a letter she wrote from Minneapolis. And after the trip, she again wrote Amy: "Minneapolis was so much fun," she said. "I loved the show and doing little tasks for it so that Doon and I felt very part of it, not just audience and Marvin was funny and splendid." In fact, Arbus had been "fizzy with excitement" in Minneapolis, according to Arthur Lubow, her biographer, not least because Marvin's wife, Margie, who was in "delicate health," could not be there for the festivities. Diane had been romantically involved with Marvin for years, aware all along that his deeper allegiance

remained with his wife, also a serious artist, to whom he had been married for twenty years. In Minneapolis, then, Diane had Marvin to herself—more or less. It is not clear when Marvin's romance began with Doon, further complicating an already dangerous alchemy in a familial matrix of emotional attachments in which jealousy, betrayal, and longing would become inevitable ingredients. Yet in the group picture Arbus would take of the Avedon entourage at the hotel, none of these ancillary dramas were in evidence: Dick is holding his mask and flanked by Evelyn, Doon, Marvin, Hiro, Laura and John Kanelous and their daughter, Helen, Ginny Heyman, Gideon Lewin, Harry Mattison, Peter Waldman, Ara Gallant, Kitty D'Alessio, and various other unidentified people who were there for the three-day Avedonfest. The group portrait is a fine document of a milestone in Avedon's career, the period when his work—in particular, the Chicago Seven individual portraits and group mural—begins to reflect serious art-historical purpose.

DURING HIS PREPARATIONS FOR the Minneapolis show, Avedon produced a portfolio of portraits, the first set of editioned prints he would make with an eye to a photography market that did not yet exist. There had been only one photography gallery in New York—the Limelight Gallery—in the 1950s, which also doubled as a West Village coffeehouse. Helen Gee, who owned it, never really sold much work and had to close the gallery in 1961. During the landmark *New Documents* show at MoMA in 1967, Diane Arbus, Lee Friedlander, and Garry Winogrand all received inquiries from a guard at MoMA to buy their pictures. "Diane and Garry and I talked about it because we didn't know what [to do]," Friedlander said. "We'd never sold a print. We decided that twenty-five dollars was right. And that was the only sale we made." Lee Witkin would not open his gallery until 1969, the only photography gallery in

New York for several more years; his first exhibition introduced several emerging photographers: Duane Michals, George Tice, and Burk Uzzle. Their prints were priced from fifteen dollars to thirty-five dollars. Only three were sold.

The *Minneapolis Portfolio*, which is what Avedon called it, contained eleven twenty-four-by-twenty-inch portraits in an edition of thirty-five, including his greatest hits to date: Marilyn Monroe, the Duke and Duchess of Windsor, Charlie Chaplin, Isak Dinesen, Dwight D. Eisenhower, Marianne Moore, and Ezra Pound. He included, as well, a few notable Hollywood stars: Humphrey Bogart, Jimmy Durante, Buster Keaton, and a cinematic legend, René Clair. Marvin Israel designed a clear plexiglass box to contain the portraits, which made the portfolio an unusual object in itself. Several of the portfolios were available for sale in Minneapolis at $1,500, with the idea that some of the revenue would benefit the museum.

Arbus, too, had been working on a portfolio—*A Box of Ten Photographs*—for which Marvin also conceived a clear plexiglass box to contain the fourteen-by-eleven-inch prints, each separated by a sheer piece of vellum with the name of the images written on the surface. Initially, she intended the portfolio to be in an edition of fifty, priced at $1,000 each. She was making the prints herself, and there were delays due to problems in the production of the box. After returning from Minneapolis and spending a weekend with Doon at Dick's beach house in Seaview, on Fire Island, Arbus wrote to Allan, her ex-husband, to say that the first *Box of Ten Photographs* was purchased by Avedon. For Dick, she crossed out the word *ten* in the title and wrote in her own hand *eleven* with the note "especially for RA." The eleventh print, *Masked Woman in a Wheelchair*, distinguished the portfolio Dick bought, as it was created uniquely for him. Dick also bought the second portfolio in the edition as a present for his friend Mike Nichols. "It looks good," she wrote to her ex-husband. "He was very moved."

Perhaps in a gesture of friendship or respect—or gratitude for the eleventh print—Dick gave Diane a print of Dwight D. Eisenhower, which she put up in her apartment at Westbeth. In October she wrote Allan again to say that there were still issues with the portfolio boxes, and that Bea Feitler was also buying one. "And that's just Dick's public relations," she writes. Bea Feitler's edition was numbered 5/50 and, just as Arbus had done for Dick, she crossed out the word *ten* and wrote *eleven*, adding an additional print, and noting "especially for BF." In her lifetime, she would only produce eight *Box of Ten Photographs*.

After an encounter with the Arbus portfolio, Philip Leider, then editor in chief of *Artforum* and "a photography skeptic," admitted, "With Diane Arbus, one could find oneself interested in photography or not, but one could no longer . . . deny its status as art." In May 1971, she was the first photographer to be featured in *Artforum*, which also showcased her work on its cover. "Leider's admission of Arbus into this critical bastion of late modernism was instrumental in shifting the perception of photography and ushering its acceptance into the realm of 'serious' art," writes John Jacob. In a seesaw balance between Arbus and Avedon, anchored by MoMA, the institution, and Szarkowski, the singular arbiter, Arbus, who had already been exhibited there, was, in Avedon's fiercely competitive eyes, ascendant. Now *Artforum* had ordained her work in the precincts of Art, with a capital *A*. The race was on.

IN DECEMBER 1970, *Diary of a Century: Jacques Henri Lartigue*, the name embossed on a gold cover, was published by Viking Press. The name appears again on the title page, and a second title page is given to Richard Avedon, editor, and Bea Feitler, designer. Lartigue dedicated the book to "Florette," his wife of thirty years, thanking her for giving him "four hands, two hearts, and sometimes two

minds," and also to "Richard Avedon; without his incomparable friendship I would never have been able to realize this book." The truth is that the book had been Avedon's labor of love from the beginning; it would never have been published without the sheer force of his will, his enterprise and vigilance over four years, his editorial acumen, visual judgment, financial support, connections in New York, and obsessive belief in Lartigue's work.

*Diary of a Century* is Avedon's love song to a Paris he first discovered in his twenties. In Lartigue's photographs, we are given authentic glimpses of life in the Paris of Proust, the backdrop for the novels of Colette. It was the Paris that Dick's mentors Carmel Snow and Alexey Brodovitch had experienced in their own coming of age during the culturally fertile moment when automobiles and airplanes and electricity were all, still, thrilling novelties. Lartigue, who grew up in one of the wealthiest families in France, captured from an early age the lingering nineteenth-century rituals of his bourgeois family and their circle as they adapted, sometimes comically, to the modernity of a new century.

In a journal entry dated April 1968, Lartigue writes: "Dick wants to see everything: all my albums, all the loose photos, all the negatives of photos not printed. More than 10,000 photos in order to choose perhaps 200, perhaps 150 for the projected book." Dick and Bea Feitler arrived that May and stayed almost ten days, looking through everything. Lartigue acknowledged in his diary that it was a painful experience: "Ten days of unpacking memories and setting them on the table." Dick and Bea departed Paris with heavy suitcases full of some of Lartigue's albums, taking them to America. "Half of my photos saved from so many years of my life. Yes, it pulls at my heart."

The trail of Dick's correspondences with Lartigue over four years attests to his commitment to the artist and his belief in the joy, the wonder, the spontaneity, and the authenticity in the images. In the

final year before publication, Dick wrote to Lartigue almost every week. If two weeks went by, he was apologetic:

> *Please forgive me for not writing to you more often and more completely. I have been working at a terribly hard pace on a new book of my own, as well as a large show at the Minneapolis Museum of 25 years of my work as well as "Diary of a Century" and Vogue and advertising and at the same time trying to be a father and a husband and a friend to the few friends I have left.*

Avedon goes on to describe in subsequent letters the detailed stages of the editorial process: hiring an assistant to begin the mechanicals layouts; hiring a translator for Lartigue's text; beginning to set the type. He assures Lartigue that he and Bea Feitler are "not letting a day go by without being involved with the book."

In another letter written two weeks later, he employs a more histrionic tone, claiming nothing less than catastrophe in the quality of prints that have come from Paris, and suggesting that Lartigue send his negatives to New York so Dick can have the enlargements made in his studio under his own supervision. He offers to pay the printing expenses and asks Lartigue's advice about how to get the negatives to New York. "I don't trust anyone except Florette to make the trip with the negatives on her lap," Dick writes, but if that was an impossibility, he was willing to send someone from his studio in New York to Paris to pick them up. In fact, Lartigue and his wife did come to New York. "Chick," the bookkeeper, recounted that the Lartigues came to the studio during part of the editing process and joined the staff for lunch. "He was a very pleasant Frenchman with a twinkle in his eye."

In a string of almost breathless letters, Dick declares the interest he has garnered from Thomas Hoving, the director of the Metropolitan Museum of Art, for an exhibit of Lartigue's work. Dick

charts out in incremental stages a roller-coaster ride through the discussions, considerations, and obstacles in mounting the show at the Met. Finally, after everyone at the museum had agreed, external forces interceded: a public relations crisis for the museum over a photography exhibition called *Harlem on My Mind* propelled them to cancel the proposed Lartigue show. All before publication of the book.

A month later, though, Dick was once again gushing with excitement: "This will be the most beautiful book in the world thanks to your great work," he writes. And in March 1970, he reports that the final mechanicals and "retouched perfect prints" are on their way to Switzerland to be printed. "I didn't spit on the package because there will still be proofs to correct when they come from Switzerland. Can you believe that we are almost to the end of this odyssey? All my love."

A breach of trust occurred when Dick saw the French edition of the book, which was published first. Absent was Richard Avedon's name as editor and Bea Feitler's as designer. Dick was in a rage, and on April 29, 1970, he wrote a furious letter to Lartigue listing the costs of the book that he himself had incurred, all the way down to the typesetting, the retouching, the assistant for the mechanicals, and all photographic services. He asserted that Bea Feitler was the most conscientious collaborator and had absorbed expenses, too, for the sake of the book. She had not designed the book for the prestige, he wrote; that she already had. It was because she genuinely loved Lartigue's work. They both felt betrayed.

"There was very little money for the project," Feitler would later write in her own book. "I dedicated, oh, about two years on it, 1,000 pages. It was a labor of love and what I wanted was credit. From then on, I have insisted that every book I designed must have a credit on the title page." Soon after the book came out, Diane Arbus sent a postcard to Bea, saying, "I love the Lartigue book. I look at it for hours."

Avedon begins his afterword with a philosophical meditation on the prejudice against photography that he will spend the rest of his life trying to eradicate. He writes:

*Photography has always reminded me of the second child . . . trying to prove itself. The fact that it wasn't really considered an art . . . that it was considered a craft . . . has trapped almost every serious photographer. Made them fall for some formalized ideal of . . . what was beautiful. . . . As if there were some tacit agreement among photographers to remain within the provinces of painting in the hope of assuring their position as artists. I think Jacques-Henri Lartigue is the most deceptively simple and penetrating photographer in the short . . . embarrassing history of that so-called art. While his predecessors and contemporaries were creating and serving traditions he did what no photographer has done before or since. He photographed his own life.*

"Lartigue's celebrity in America took root in two very different contexts," writes Kevin Moore, an independent curator and scholar, who wrote his dissertation on Lartigue while at Princeton. The first was Lartigue's exhibition at MoMA in 1963 and then the publication of his photographs in *Life* magazine. "MoMA had catalyzed an art world interest in Lartigue, presenting his work as a sign board for concepts germane to photographic modernism. *Life*, by contrast, treated Lartigue as a messenger from a beautiful lost world, a treatment indicative of a general nostalgia for the *belle époque* during the 1960s."

With *Diary of a Century*, Avedon gave Lartigue a third way into his celebrity in America, one that was as literary as it was visual, one suffused with a reverence for the simplicity of his daily chronicle, and awe at the metaphorical dimensions of his work.

Anaïs Nin, writing in the *New York Times Book Review*, called

*Diary of a Century* "a family album illustrated by a keen, mischievous, and surrealist observer." She recognized in the photographs so many aspects of the Paris she knew intimately, rendered so personally and imbued with the customs, the fashions, and the activities of a time and a place that "one has a clear vision into the world of Proust," she writes. "This is a moving and beautiful book, proving once more that the camera requires the vision of the artist, the poet and the lover of the world."

Several weeks after the Lartigue book was published, Dick, who had not heard from John Szarkowski since the Minneapolis show, and might have sensed a chill in the silence, wrote to praise an exhibit John had just mounted: photographs of prostitutes in New Orleans during the belle epoque, by E. J. Bellocq. "I have just finished seeing the Bellocq exhibition and enjoying the book," Dick wrote. "His work is so superbly and lovingly presented, and the text brings it all so close." Lee Friedlander had discovered the Bellocqs while on a trip to New Orleans in 1966, and Dick might have felt a camaraderie with Friedlander in his advocacy of an unknown photographer of another era. "It was a particularly empty Sunday until I got to the museum and the Bellocq room where I began to feel, once again, that maybe the world was possible."

John responded a week later, with, yes, a distinct chill in his greeting: "Dear Richard," Szarkowski writes with uncharacteristic formality, given that he had been calling him *Dick* since they first met. "I think the Lartigue book could not have been better," Szarkowski writes. "It is a wonderful and beautiful thing to have done, and all the rest of us are deeply in your debt. . . . Thank you also for your kind words about the Bellocq book which were very heartening."

TO SAY THAT AVEDON had been productive at the beginning of the new decade is to understate the magnitude of his transforma-

tion as an artist. While "Hard Times" would not reach fruition in book form for another thirty years, the work he was beginning to do with the Chicago Seven and the Warhol Factory murals signified a shift from the early portraits that had defined him as a portrait photographer—Charlie Chaplin, Marian Anderson, Marilyn Monroe, the Duke and Duchess of Windsor—to a more monumental documentation of contemporary history.

In the early 1970s, the Vietnam War remained the most persistent preoccupation of America's youth movement, the daily television news reports of the atrocities fueling collective outrage and spurring massive organized demonstrations across the country. In early 1971, Dick went to Vietnam, not on editorial assignment, but rather to photograph for his "Hard Times" project what he considered to be the most nefarious group of United States officials, stationed at the American embassy in Saigon, who were informing the decisions that would result in the loss of fifty thousand young American lives, as well as the untold thousands of civilian casualties in Indochina.

Dick was in Vietnam for more than six weeks, bringing with him an assistant, Larry Hales, an eight-by-ten Deardorff camera, a large supply of eight-by-ten film plates, and a twelve-foot-long roll of white backdrop paper. While he was there, he would travel with Gloria Emerson, the intrepid *New York Times* reporter based in Saigon during the war; Denis Cameron, a photojournalist for the *Times*; his assistant; and an interpreter. "My reason for coming to Vietnam," he told Emerson, "is that all the people I have photographed in the last year and a half have been affected by Vietnam—as has all of American life. Vietnam is an extension— oh, unfortunately—of every sick thing in America."

Dick's equipment had been held up at customs for almost a week until adequate financial incentives facilitated its release. He and Hales were staying at the Continental Palace, the loveliest hotel in Saigon, a white wedding cake of a building on one of Saigon's

main thoroughfares. The center of town was "not threatening" in those days, according to Hales, who wrote, "Saigon seems to be a safe place. No incidents have occurred since we have been here. Across from my balcony is the Vietnamese legislature in the old French opera house and it's perpetually surrounded by Vietnamese soldiers with M16 rifles. Barbed wire is everywhere or coiled up on street corners for ready use. . . . Really, it isn't as bad as it may sound because within all this the civilians are carrying on their daily business."

The ground floor of the hotel was a warren of interior courtyards and dining rooms, and a large veranda bar was open to the street and always filled with patrons drinking café au lait, pastis, citron pressé, or wine. "There you met friends and made them; there information, rumors of war, telephone numbers, money all changed hands . . . a scene from *Casablanca*."

While waiting for his equipment to be untangled from the customs bureaucracy, Avedon spent his first few days getting to know the place, the people, the journalists, and the politics. His calendar includes the names of many prominent American journalists and US officials. Dick was, by the testimony of the people he met there, "a delightful man, good-looking, exuberant, enquiring, seductive." He would have had a thoroughly engaging time in endless conversations with a succession of new acquaintances and contacts on the veranda.

The hotel's rooms were large, with white walls, high ceilings, and simple brown wooden desks. Dick photographed a string of foreign correspondents in his hotel room, which doubled as a studio with his white paper backdrop and his Deardorff on the tripod. There, as well, he would photograph several Vietnamese women he had encountered as beggars on the streets, all of whom were victims of napalm, with severe burn marks across their bodies, and vacant eyeballs where they had been blinded. Each stood in front

of the white paper backdrop and faced the camera without emotion, without a sense of even being photographed. Avedon believed it was with dignity that they stood before the camera, "without an ounce of self-pity." While visiting a municipal hospital for the diseased and insane, Dick came upon a forty-nine-year-old leper, whom he later smuggled into the hotel heavily disguised in a long raincoat, a wide fedora, and large, dark glasses. The staff was told that Monsieur Avedon had a very important visitor who had to be incognito.

While in Vietnam, Avedon was dropped into the jungle, where he joined an American infantry platoon in forward position. He photographed several GIs at Camp Eagle, setting up his Deardorff and a white sheet as a backdrop. Denis Cameron photographed Dick in the helicopter, AVEDON stamped across the pocket of his fatigues, in some pictures a conspicuous white kerchief tied around his neck, which seems an odd conceit for someone roughing it in the war-torn jungle—unless it was there to wave as a white flag of surrender.

"I went to Vietnam for a number of weeks with *one* particular image in mind: 'The Mission Council,'" Dick told Michel Guerrin in 1993. "This was the Stanley Kubrick–like name for the men who were in charge of the war in Vietnam. Believe it or not, they were a Public Relations team for the war." The men met every Thursday in the embassy in Saigon, and Dick waited seven weeks as they kept canceling the appointment to be photographed. Finally, on April 28, 1971, he went to the American embassy in Saigon and made the photograph. He had drawn out in advance the precise placement of each member within the camera frame, and then, knowing he would be given little time to shoot, he worked fast, placing them in groups of two or three and photographing them head to toe, standing formally or casually, in suit jackets or holding their jackets in their arms. "I was amazed to see him put these stiff officials at ease," Hales recounted.

Dick characterized himself in retrospect as "a card-carrying anti-war activist" who had already photographed the Chicago Seven—in fact, publicly calling them "heroic"—and it had been a relief at the time that the American diplomats agreed to let him in to make the photograph. "The fact that I might have had a political opinion didn't cross their minds *because* I was a *Vogue* photographer."

Dick photographed the sequential frames with the idea of assembling the four panels to create a mural of the eleven individuals, as he had done with the Chicago Seven and the Warhol Factory. "I photographed every day for seven weeks in Vietnam, and this is the only photograph I'm willing to show," Avedon said, referring to *The Mission Council, Saigon, South Vietnam*, a wall-size mural portrait of the very sober diplomatic officials who not only asserted great influence over US involvement in Vietnam, but also controlled the message about the war as if it were an advertising campaign to sell its importance to the American people. Avedon considered *The Mission Council* his definitive portrait of American power.

Dick invoked Hannah Arendt's "banality of evil" to describe his own conclusion about the routine activities of the members of the Mission Council: "I know these men," he later said about Ellsworth Bunker, the US ambassador to South Vietnam; Samuel D. Berger, his deputy; and the others. "Those are the men who work on Madison Avenue, those are the men who work for the big corporations I work for. And I have worked for them all my life. I look at their faces and I know how much they drink, I know if they cheat on their wives, I know why they're in Vietnam, I know what their relationship is to Asian people. I understand it and then I can photograph it."

*Time* magazine would publish the picture several years later, listing all the men on the council, describing the role they each played during the war in Vietnam and where they had landed afterward. "A police line-up of suspected criminals?" is how the article began,

although Avedon insisted that that wasn't the impression he had intended to create. There is a rhythm to the lineup formed by the height of the individuals. Among the eleven men, several were by then administrative officials or press information officers; several were policy coordinators and economic development experts; Ellsworth Bunker, near the center of the lineup, became an ambassador at large at the State Department. Samuel D. Berger retired after the war.

A week before *Time* published *The Mission Council*, the *New York Times* ran an op-ed column by Gloria Emerson, who was then at work on a book about the war. The picture, *The Mission Council*, was spread across six columns, with Avedon's credit above the image, in type larger than Emerson's byline. She describes Ambassador Ellsworth Bunker as a man who always looked "unmoved by life itself." Her column was an indictment of the men in the Avedon picture, who "kept the myths about the war fresh and alive for us," maintaining a public relations charade for the American people—and the world—about how well the war was going and how well Vietnamization was working.

"None of it was true," she writes. "[Vietnam] was a country of deep, festering disorders that could not be ignored or concealed any more than the gangrenous wounds of a soldier." Emerson ends her column with a specific memory of Bunker at the embassy in Saigon. He had just returned from his fifty-fifth class reunion at Yale and told her that the "class of 1916" supported the war. "What the class of 1916 felt did not matter much to the GIs," she writes. She reports that Bunker, while in Vietnam, organized the Yale Club of Saigon, and in December 1971, months after Avedon had returned to New York, Bunker invited thirty-three members of the Yale Club to his villa. "They sang verses of 'The Whiffenpoof Song' and 'Bright College Years.' It was an evening he so enjoyed. This is what I remember when I think of him," Emerson writes,

concluding on a note of moral disdain, echoing Avedon's decision to photograph the Mission Council to begin with.

CIRCUMSTANCES OF A PRACTICAL nature facilitated Dick's decision to go to Vietnam for that long a period. The building at 150 East Fifty-Eighth Street, where his studio had been in operation for a decade, was being demolished for new construction on that site, and the Avedon studio was forced to move. Everything had to be put in storage. Gideon was searching for a new studio while Dick was in Asia.

Soon after returning from Vietnam, Dick took another of his fifty-some-odd trips to Sarasota, Florida, over the next few years for his ongoing chronicle of his aged father. It was a reckoning with a breed of power quite apart from that of the Mission Council; Dick was facing the power of "the father," which had mythic implications on his personhood and which bored deeply and insidiously into the emotional framework of his being. In Lartigue, in Dick's own words, he was brought to the "joyous part" of himself and recognized the same "burst of humor and life" that he experienced in his own life. Most of all, he said, he found "a father in photography." His relationship with Jack Avedon would never bring him to the joyous part of himself; rather, standing face-to-face with his father and looking him in the eye was a confrontation with his own hatred for the man who tormented him as a child, and who failed him as an adult.

In 1952, when Jack deserted Anna, he moved to Florida and started selling mutual funds. "We couldn't even reach him when there were crucial decisions to be made about Louise's care," Dick told Norma Stevens. "I tried to get him to contribute something to my mother's support, and when he refused, I told him he disgusted me. He said it was all none of my business. I told him, 'If you want

to run away from home that's *your* business but expecting *me* to support *your* wife makes it *my* business." If there was one lesson from Jack that Dick had taken to heart, it was the paramount responsibility of a man to support his family. Here it was against Jack's moral failing that Dick could find some satisfaction in the measure of himself as a man.

Dick would set up his white backdrop and photograph Jack with his Deardorff camera. Jack would strike a formal pose, affecting a benign and gentle air, with an enigmatic smile on his face as if to project the wisdom of the ages. The sessions would go on long enough for the "portrait face" to wane and something truer to emerge, and afterward, Jack always insisted on seeing the pictures. Dick didn't want to show them to him, because he knew his father wouldn't like the way Dick had caught him, impatience replacing his intended calm. "I love the quality in him, but seeing it would frighten him," Dick wrote after one session. "He isn't interested in the fact that he looks his age, eighty-three, and is still fantastically vibrant and angry and hungry and alive. He's much more interested in looking sage. So, my sense of what's beautiful is very different from his."

RICHARD AVEDON AND DIANE ARBUS were, by now, tethered in what appeared to be a familial circle of friends and colleagues, although it was essentially through Marvin Israel, the paterfamilias, that they sustained their respectful friendship. They also had each other's photographs up on their walls. "I do terribly admire Avedon's work," Diane told *Newsweek*. "It's influenced me terrifically." Deborah Turbeville, who had taken the Avedon workshop, remembered that Arbus thought "he was the greatest photographer." Dick felt the same about her work. In his later years, he would say that "[Arbus] made the act of looking an act of such intelligence

that to look at so-called ordinary things is to become responsible for what you see. If a photograph doesn't grapple with that it's of no interest to me." He understood and respected Diane's precarious financial circumstances, and helped her out when he could, sending commercial assignments her way, and even advising her on how much to charge. Marvin had been romantically entwined with Diane for almost a decade, so social occasions brought Diane and Dick together as well.

Arbus had a history of depression. While she could be inordinately charming and beguile people with her offhanded wit and her quirky insights, she could also disappear into long periods of catatonic debilitation. "The worst is I am literally scared of getting depressed," she once wrote a friend. "And it is so goddamned chemical. I'm convinced Energy, some special kind of energy just leaks out and I am left lacking the confidence to cross the street."

Aside from the similarities in Avedon's and Arbus's backgrounds—both were Jewish; both grew up in Manhattan; both their families established fashion emporiums (Avedon on Fifth and Russeks); both worked editorially and commercially; both made portraits—there were significant differences. Dick lived a glossy life versus Diane's obdurately bohemian one, and their artistic intentions were diametrically opposed in terms of the deeply psychological and curiously empathic quality of her portraits versus the cold and clinical characteristics of his. Yet there was a strain of recognition between them that went well beyond the fierce ambition that drove them both. The women in Dick's family endured a mercurial range of emotional disorders—his sister Louise's schizophrenia; his aunt Sally's odd behavior, which, according to her grandson, Robert Lee, included running naked in the streets espousing wild theories of espionage to no one in particular; and his wife, Evie, who, at the time, was having wild delusions, slinging, for example, accusations at Dick of having an affair with Lee Radziwill, and had

begun to receive electroshock treatment. In other words, Dick was not afraid of Diane's depressions.

In late July 1971, Diane Arbus took her life. Doon was in Paris interviewing Catherine Deneuve for a series of Chanel commercials Dick was shooting, and was working on another project for him as well; Diane's younger daughter, Amy, was in summer school in rural Massachusetts; Marvin Israel and his wife, Margie, were spending the weekend at Dick's house on Fire Island; and Dick was in Manhattan, packing up his studio. On the evening of July 28, Marvin, who had been trying to get Diane on the phone for two days, let himself into her apartment, where, according to the medical investigator's subsequent report, "she was found dead . . . crunched up in bathtub, on left side . . . wearing red shirt, blue denim shorts, no socks." Israel immediately called three friends— Larry Shainberg, Jay Gold, and Dick. They all dropped what they were doing and met Marvin at Arbus's apartment at Westbeth, on Bethune Street in the West Village. While Marvin talked to the police officers, Dick and Larry Shainberg stood next to the closed door of the bathroom, where her body had been found and not yet removed. "I'm going in," said Dick, and he did. The coroner's report would later conclude that her death was by suicide: "Incised wounds of wrists with external hemorrhage. Acute barbiturate poisoning."

Avedon put everything else aside and flew to Paris to tell Doon. She was staying in a friend's apartment. He went first to the Hotel San Regis to check in, then stopped at La Maison des Centraliens just down the street from the hotel, in the building where the *Harper's Bazaar* studio was housed, and where Chris von Wangenheim was shooting the fall collections. Neil Selkirk was assisting Chris and remembers Dick walking in, pulling Chris aside, telling him about Arbus's death, and abruptly walking out. Dick arrived at the apartment where Doon was staying and did not mince words. He looked directly at her and said, simply, "Diane killed herself." Doon

then gathered her things and went with Dick back to his hotel, where he picked up his luggage, and they took the first flight they could back to New York.

Amy, seventeen, remembers that, perhaps after the funeral, she and Doon and some others went back to Dick's house on Riverview Terrace. Dick's son, John, had a one-year-old English springer spaniel named Rune (from the runic alphabet, a writing system of the early Vikings used by the Dwarves in *The Hobbit*). Amy, who had ridden horses and loved animals, fell in love with the dog. John mentioned that he had to give Rune up since he was about to go to college, and Amy wondered if she could have her. Because John had planned to send Rune to the country where he could imagine her running free and wild, he said no. Dick got angry: "Her mother just died, for Christ's sake. Give her the dog." And he did.

"My family really thought Dick was the greatest," Amy said of her mother and father, both. "And I knew how close he and Doon were. He really came through for me, and I will never forget him for that."

# FATHERS AND SONS

(1970–1974)

What we think is less than what we know. What we know is less than what we love. What we love is so much less than what there is. And to that precise extent we are so much less than what we are.

—R. D. LAING

Whit hen the Manhattan Project's production of *Alice in Wonderland* opened in the fall of 1970, the director, André Gregory, was stunned by the immediate success of the play. "We called our theater company the Manhattan Project because we were sure *Alice* would be a *bomb*," Gregory said with characteristic humor. They had rehearsed for almost two years before *Alice* was finally staged at a small off-off-Broadway theater on Park Avenue South, and Clive Barnes's effusive review in the *Times* made it an overnight phenomenon. He predicted that

everyone in New York even remotely interested in theater would be clamoring for the one hundred seats in the house throughout the run. "There is probably going to be blood found outside the box office," he wrote.

Gregory was further taken aback when, one night early into the run, Richard Avedon appeared backstage and introduced himself. He professed his love of the performance and expressed an interest in doing a book on the production. Dick, who was in the habit of seeing multiple performances of a single play, proceeded to see *Alice*, according to Gregory, *forty-two* times. "Being Dick Avedon," Gregory said, "he managed to get an impossible ticket for every performance."

Soon after their first meeting and throughout the run, Dick arranged for Gregory and his ensemble of six actors to spend twelve daytime sessions in his studio to enact—and reenact—the uproarious stage antics of the play. There is a hallucinatory quality to Lewis Carroll's story of Alice; her "trip" begins as she tumbles down the rabbit hole into a world gone topsy-turvy—up is down, forward is backward, big is small, animals talk, social rituals wreak more havoc than order. Gregory, an experimental theater director, coaxed the actors to find their way into unscripted and unpredictable roles with techniques that are rigorous in method and structure. "I think there's a great misconception about improvisation," Gregory said in talking about his approach. "It is often understood as self-indulgent. Play without purpose." But his technique employed a strict physical vocabulary, utilizing "specific gestures [as starting points for an action], a wide variety of them, but very precise. It is a true discipline."

At the same time, Gregory drew on the psychodynamics of the consciousness-raising groups of the period: throughout the rehearsals, the actors' interactions were deeply personal, confessional, and emotional, which established a communal bond among

the members of the group that could be applied to their improvisational skills onstage. The process made it that much more of a family affair during the Avedon studio sessions, as the ensemble ran through the entire performance—over and over again—for their audience of one, and his camera.

For Dick, it was an ideal marriage of subject and artist. The absurdist comedic storytelling lent itself to the economy of a minimalist's imagination and enabled Dick to hop right in and use the improvisatory aspect of the performance as the very subject of the pictures. He exploited the production's spontaneity to arresting visual effect: limbs and appendages fly; hair whips across the frame; faces contort; figures sprint. He entered the scenes as if the camera itself were part of the improvised moment, photographing the action as if looking out from the center of it. The resulting pictures spring to life with compelling kinetic vigor and the unlikeliest sense of compositional order.

The ensemble had willingly agreed to perform the entire play, repeatedly, yet they did not know how grueling it would be to spend entire days performing for Avedon's camera, and then at night to do it again onstage for a live audience. "It *was* all catered," according to Gregory, describing lavish daily feasts in the studio, the one pleasant consolation for their labors, since they were not being paid for any of it.

Despite the well-constructed fashion tableaux that define Avedon's early work, in which women appear caught in medias res with expressions and gestures drawn from an illusion of real life, nothing in his body of work is so active with motion and sustained with such precision, emotional expression, and visual narration as his *Alice in Wonderland* pictures. Here he captures the feeling of vertigo in Alice's fall, the air deflating from the Balloon Princess, the caterpillar transforming into a butterfly—all in wild gestural configurations against a white background, without any props or

costumes. Between January and September 1971, before and after her mother's death, Doon Arbus interviewed each actor separately, and then edited the stories and quotes to appear in the book as a seamless conversation among the ensemble members about the process of making the play.

Dick might have thought of his *Alice in Wonderland* documentation in the context of his "Hard Times" project. He photographed the actors walking in and out of the frame, not unlike the figures in each section of the Warhol Factory mural, as if he were freezing consecutive frames of a movie. In *Alice*, though, the figures are not just standing, but emoting.

*Alice in Wonderland: The Forming of a Company and the Making of a Play* was published by Merlin House in 1973. A picture of the screaming, sidelong face of Alice, a twinkle in her eye, is on the cover. Avedon's name appears only on the title page, and third in alphabetical order after "Ruth Ansel: Designer" and "Doon Arbus: Text." The book may be Avedon's best and most integrated project to date in 1973, surprisingly modest for an Avedon *artifact*, yet electrifying in photographic terms. "Here the photographer and actors seemed to be operating in a gale force wind, or, more accurately, some sort of psychic storm," Jane Livingston wrote about the project in 1994. "This successful photographic experiment is essentially isolated in Avedon's career."

THE GERMAN PHOTOGRAPHER THOMAS Ruff once talked about his work in relation to the "New Objectivity" of the early twentieth-century photographers August Sander and Albert Renger-Patzsch. "The difference between them and me is that they believed to have captured reality and I believe to have created a picture," Ruff says. "We have all lost bit by bit the belief in this so-called objective capturing of real reality." He wasn't challenging

the veracity of the photographic image so much as underscoring a distinction between what reality is and what a photograph is, regardless of the optical precision with which photography is capable of rendering a subject or an object "true to life."

Ruff came out of the Düsseldorf school in Germany, which was known to approach photography as a medium of precise documentation. "If you use photography," his teacher, Bernd Becher, once told him, "you should always reflect the medium. And this reflection should be represented in the photograph." In the hands of Bernd and Hilla Becher, who set the tone for the Düsseldorf school for almost a half century, this was not simply a flat-footed dictum about impeccable technical fidelity by Teutonic photography instructors; it was an idea about making artwork of the highest conceptual order—creating images with regard to a precise articulation of form and description of subject in the same way a writer chooses carefully the exact wording for a precision of meaning that sharpens an idea or tweaks a metaphor.

Avedon's regard for the optical precision in his photographs— what the photo historian Colin Westerbeck once described as "every wrinkle, stubble, wen and nervous tick" evident on his subjects' faces—is in keeping with the Bechers' concerns about camera-based artmaking. Avedon was not only making portraits of individuals with as much articulation of detail as the camera could deliver; he was also creating images that challenge the eye to verisimilitude. Out of a fleeting moment's flash in the life of the subject, Avedon left a meticulous imprint of the individual that could be observed as a remnant of a time, a place, an era. That the images are also "photo-graphic" is undeniable.

Dick took a final set of pictures of his father a week before he died, just before his eighty-fourth birthday, on September 1, 1973, following a two-year bout with cancer. In the early pictures in this series, before he was diagnosed, Jacob Israel Avedon assumed the

countenance of a dignified elder statesman in jacket and tie, his face taut with controlled authority as he stared into the camera. Over the course of five years and literally dozens of trips to Florida, Dick documented not only his father's aging process but also the nature of time itself on the interaction between them. In the late pictures, Jack looks neither male nor female in his hospital gown, neither at peace nor in agony, his fragility approaching something close to a sense of wonder. In one image, he looks into the camera with an expression that is elsewhere, his mouth agape, his eyebrows lifted, searching, whatever anxiety and pain that had contorted his features in some of the earlier pictures no longer in evidence.

Dick would later describe the "event" of making serial photographs of his father as analogous to the act of photographing any of his subjects. "I was using, with my own father, everything I had learned from photographing strangers," he said. While Jack's allegiance was not to Dick so much as to the stature he wanted to project, Dick's goal was to try to see his father not through the feelings of a son so much as with a consciousness about what it is like to be anyone. "At first, he merely agreed to let me photograph him, but I think after a while he began to want me to. He started to rely on it, as I did, because it was the way we had of forcing each other to recognize what we were"—father and son.

Jack had felt the early pictures to be unflattering, and he dismissed them as terrible photographs. At one point in the middle of the process, Dick wrote him a letter to explain what propelled him to make these photographs, hoping that by putting it in writing, Jack would take him more seriously: "What I love about you is that you are in your eighties, you're hungry, you're avid for life, you're buying marinas, you're on the telephone with a kind of vitality, and pain, and excitement, and all the complex things that I know, and I love that in you, and that's who I love and that's what I want to photograph." Jack never answered the letter, but after he died, Dick

found it folded in the breast pocket of the jacket that he wore all the time.

Collectively, these are intimate portraits by nature of the relationship, but whether the connection between Dick and Jack is visible in the pictures—and whether it should have remained, as some people thought, a wholly private matter—is not the issue. They compose as universal an inquiry about the imponderability of life on the occasion of a parent's death as might exist in any form, with all the traces of an emotional trial that had lasted a lifetime. "I understood that there were always going to be those who would say, 'How could you do it?'" he told Norma Stevens. "And I knew that my answer will always be, 'How could I not!'"

"I used to think that those photographs of his father dying were [Avedon's] most important body of work, because there he really tried to feel something," said Barbara Rose, a colleague of Dick's at *Vogue*, where she was an art critic for many years. "He was one of the smartest people I ever met—brilliant, probably a genius," she said about Avedon. "But he was not a great artist." Rose had thrown the weight of her credentials as an art historian at this comment, and then offered a telling clue about her conclusion: she believed that Dick was incapable of feeling much of anything. "I don't think Dick was ever fooling himself—he knew that he was essentially anesthetized. But he *wanted* to feel—he wanted desperately to be able to—and he just couldn't. And there's a lot of pathos to be found in the combination of his inability to feel and his desperation to feel. He had a wall around him, and a moat around the wall."

Rose may be in a diminishing minority in her dismissal of Avedon's significance as an artist; to be sure, a chorus of critics, curators, and scholars believe him to be a consequential artist and acknowledge his towering achievement in twentieth-century art history. But she was right about the extent to which Avedon kept his feelings under lock and key, as it were, as if they constituted a

fatal disease that he had to keep in deep quarantine because the very hint of exposure just might do him in. And yet, while Rose was astute about Dick's layers of self-protection, it was the precise distance he kept from his feelings that enabled him to get through his daily life with such daunting productivity. Isn't it likely that, like so many artists, the anatomy of his sensibility resided in that very chasm—or moat—as a perpetually irascible set of primal conflicts that propelled his unique vision of the world and drove him to accomplish what he did as an artist? He relied not on the humanity of his feelings to make his art but, above all, on his *eyes*, guided by the clarity of his fully charged intellectual curiosity to register with rigor and consistency a mature recognition of the pointlessness of our existence in an infinite universe. No wonder he regarded Samuel Beckett as one of the great writers of his time.

DESPITE THE PROFOUND EFFECT of Arbus's death on Dick, his way of dealing with it, as with any emotionally painful situation, was to throw himself further into his work. In the two years between Arbus's suicide and his father's death, Dick was running as fast as he could, and while his obsessive approach to his projects, as well as, say, to theatergoing, may have been a cover for an emotional life that he held at bay, he *did* finish his *Alice in Wonderland* book; he *did* travel back and forth to Florida to make a prodigious body of work about his father; he *was* shooting one ad campaign after another, whether for Revlon, Chanel, or Jun Rope—for whom he became an auteur of a series of short films; and, for *Vogue*, he continued to fulfill the editorial obligations of his contract.

At fifty, Dick still looked like a thirty-year-old—rail thin, lithe, a shock of black hair, a flinty energy. His financial acumen cannot be overlooked in the calculus of an artist who was always mining new ways to subsidize his work, although, clearly, his genius at

making money preceded the imperative for him to apply it to his own artmaking. Until the late 1960s, the cross-pollination between Dick's editorial work and his own projects might have compromised the clarity with which he would later proceed to make serious work as an artist. While *Observations* had been a record of his sometimes great portraits of the 1950s—and, ultimately, a beautifully produced vanity project—*Nothing Personal* was his first authoritative attempt at "portraitizing" a set of ideas about America; yet the project was compromised by the limitations of an editorial mindset and the interruptions of his advertising commissions. In the late 1960s, with the not yet fully formed idea of "Hard Times," Dick had begun to develop a much clearer sense of his own imperative as an artist, a more direct commitment to a visual approach, and a deeper connection to his philosophical assumptions about, well, our life on earth.

In April 1972 Avedon traveled to Los Angeles to make photographs for an indeterminate project of his own that he referred to as the "Old Lions of Film," among them Jean Renoir, Groucho Marx, John Ford, and Oscar Levant. The burden carried by any portrait photographer is the expectation of capturing the totality of an individual within a single image, but that was not what Avedon was after. He was more interested in how his subjects performed for him as they stood before the camera, whether they attempted an authentic facial neutrality or assumed the "character" of themselves that they projected into the world, or, ideally, something wholly unexpected resulting from the interaction between photographer and subject. He subscribed to the notion that the photographer cannot be seduced by the sitter's idea of their best self, and as a result, the process of portraiture afforded something of a contest. He recalled one Sunday on that trip when he photographed Jean Renoir, a *god* in his eyes, whose films *The Rules of the Game* and *La Grande Illusion* he had worshipped when he was growing up. "For many years

I felt I couldn't make a portrait unless it was crucial to me, unless it could stop my heart," Dick told an audience at the Whitney in 1994. "My heart would pound at the beginning of a sitting, out of fear of failure, fear that I couldn't make it happen. Then I realized it wasn't real fear. It was something I was doing and transmitting to the sitter, a certain quality of anxiety within me." He was in touch with this anxiety when he went to photograph Renoir.

While the auteur's house was in Beverly Hills, he remembered it to be something out of the South of France. On the wall was a portrait by his father, the impressionist Pierre-Auguste Renoir. Sunshine poured across a big table in the middle of the room that had been set for lunch. Dick was ushered into Renoir's bedroom, where the ravages of his nearly eighty years were evident on his naked body as he got dressed. Renoir, unselfconscious, soon led him out into the garden to set up the portrait. Renoir posed with patience and generosity, opening himself up to the portrait session, giving himself to Dick. Afterward, Renoir invited Dick to stay for lunch. The actress Leslie Caron arrived with a Czech film director; someone else came and put a bottle of vodka on the table with lemon rind inside; another guest brought a Sunday cake. The conversation was lively and soon turned to cinema with a capital C. All of them were experts of one kind or another whose knowledge far exceeded Dick's. It left him feeling inadequate and insecure, paralyzed, unable to speak, trying to hide his discomfort as an outlier at an intimate Sunday afternoon repast that was almost too good to be true.

When Renoir got up to use the bathroom, Dick saw the opportunity to take his leave. He thanked Madame Renoir, shook everyone's hand, and headed toward the front door. Just then, Renoir stepped out of the bedroom and blocked Dick's exit. Dick reached for his hand to thank him for the portrait session and the lovely lunch. "He looked me straight in the eye and said: 'It's not what is said; it's the feelings that cross the table.'" Dick was amazed that

Renoir had sensed his discomfort, touched by his elegance and tenderness. "Of course I went to the car and started to weep."

Dick photographed these legends of film while in the middle of his ongoing chronicle of his father, who was roughly the same age as Renoir. While Dick's anecdote was intended to describe the silent communication in a portrait session, more potently it revealed the longing of a son to be seen and be acknowledged by his father. Jack was not capable of seeing Dick beyond his own rigid expectations of a son, regardless of Dick's huge worldly success—not in the way Renoir had seen him and accepted his vulnerability in a matter of hours. That it took Dick the three-thousand-mile distance from his father and a portrait session with a cultural surrogate, in a manner of speaking, to be able to weep in a parked car is a telling example of how truly removed he was from feelings that eventually surfaced nonetheless, if not in direct response to their source.

A day after photographing Renoir, Dick made an irrefutably controversial portrait of Oscar Levant, later referring to the session as "the best, most powerful sitting I ever had." Levant was a brilliant, witty, and neurotic public figure who, increasingly in his life, became reliant on psychiatric medication. He started out as a concert pianist in George Gershwin's inner circle, and later became known as his greatest interpreter. He was serious enough to have studied with Arnold Schoenberg in Los Angeles. Levant became a household name in the 1940s and 1950s not as a concert pianist, however, but as a radio and television host, a game show panelist, an actor, a songwriter, and even a bestselling author. On talk shows, he could be jittery and hilarious: "Strip away the phony tinsel of Hollywood and you'll find the real tinsel underneath," he would say, in parallel affinity with one of Dick's adages: "Scratch the surface and, if you're lucky, what you have is more surface." Eventually Levant lamented that "I don't want to be known as a wag; I want to be known as a serious musician." His disappointment

led to his emotional deterioration, and he lived the final years of his life in comfortable seclusion.

When Dick arrived at his house on North Roxbury Drive, Levant came downstairs ready to be photographed in his pajamas and bathrobe. In the most reproduced of Dick's portraits from that session, Levant looks like a madman, his mouth opened in what appears at first to be a scowl, and, then, a mask of wicked amusement, his bottom teeth jutting out from under his lip in a crude and grotesque display one would expect to find on an ogre living under a bridge. "There was enough of the artist in him to want to give me the thing itself," Dick said. The thing itself, as described by film critic David Ansen in his profile of Dick in *Newsweek* in 1993, was "that psychological 'fine line' that so haunts Avedon. . . . Pain and hilarity blur in this photo, anguish coexists with joy, sanity flirts with its opposite. . . . It is possible to consider the Levant portrait cruel (those teeth!); just as possible, and more to the point, to see it as a study of drowning heroism."

Not everyone saw the Levant portrait with such high-minded generosity. One letter to the editor in the *Times* referred to the portrait with disdain: "I remember Oscar Levant in Carnegie Hall, a brilliant and talented pianist," wrote one *Times* reader. "Why didn't the highly overrated Richard Avedon take a picture of him then?" Today, Dick's portrait of Oscar Levant comes closest in his body of portraiture to the kind of disturbance so often ascribed to an Arbus subject. Arbus was predisposed to the otherness in people, about which she felt a kinship, and one of the resonances of her work is the intimacy of that weirdness because of her identification with it. Avedon was after the sameness in all of us. It was as if Oscar Levant had at that moment stepped out of a ghoulish portrait by Arbus to be reconsidered through the clinical lens of Avedon.

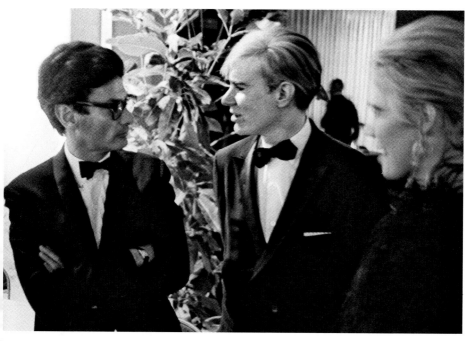

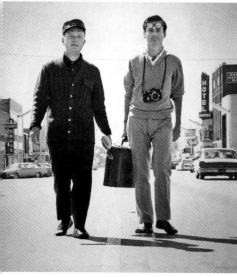

*Top:* Avedon meeting Andy Warhol for the first time at a Museum of Modern Art reception, as Edie Sedgwick looks on, 1965, photographed by David McCabe. *Below:* Dick with his assistant, Alen MacWeeney, while on a fashion shoot in Antigua, 1962.

*Above:* Dick with Truman Capote on Main Street in Garden City, Kansas, while on assignment to photograph the author for *Life* magazine on the eve of the publication of *In Cold Blood*, October 1965.

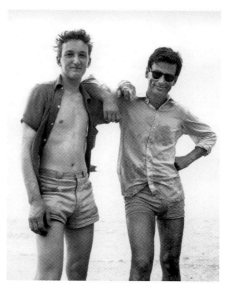

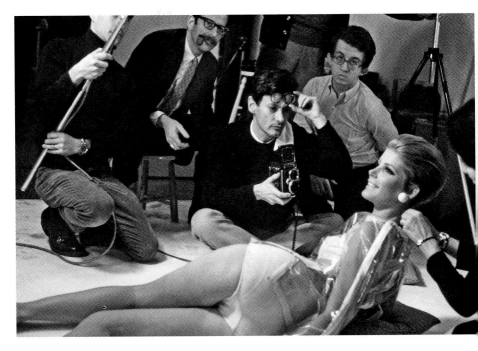

*Above:* Dick photographing the supermodel Veruschka in his studio, 1966, photographed by Burt Glinn; and *below:* inspecting tan lines on his models for a *Vogue* fashion shoot in Cabo San Lucas, Mexico, early 1970s, photographed by Gideon Lewin.

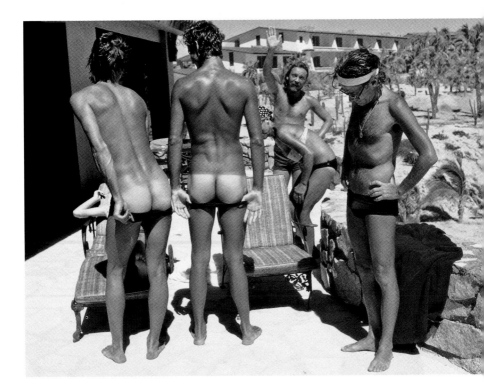

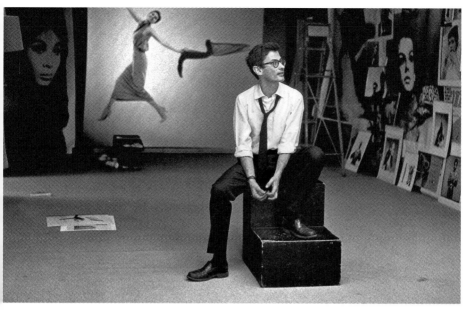

*Top:* Dick after installing his work for a unique exhibition at McCann Erickson, the advertising agency, in 1965, photographed by Gideon Lewin.

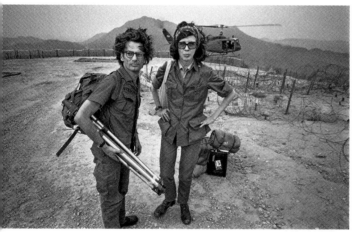

*Above:* Avedon went to Vietnam during the war to photograph the Mission Council, here with Gloria Emerson, the *New York Times* correspondent, in 1971, photographed by Denis Cameron. *Right:* Dick in Atlanta to photograph Martin Luther King Jr., as well as members of the Student Nonviolent Coordinating Committee, for his book *Nothing Personal*, 1963.

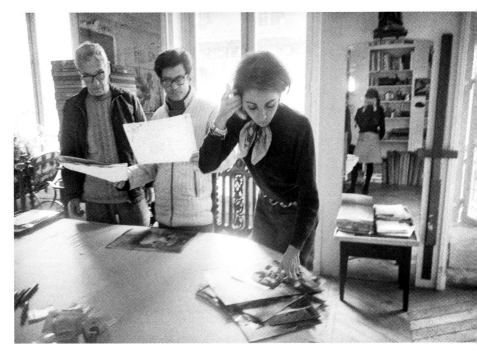

*Above:* Avedon with Jacques-Henri Lartigue (left) and Bea Feitler (right), while selecting work for the book *Diary of a Century,* at Lartigue's house in Paris, circe 1968, photographed by Florette Lartigue. *Below:* Dick talking with museum visitors about his Chicago Seven portraits in the gallery at the Minneapolis Institute of Art, 1970.

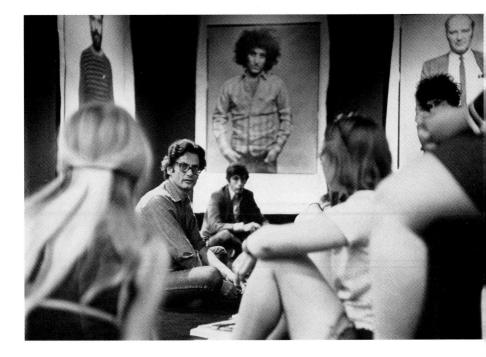

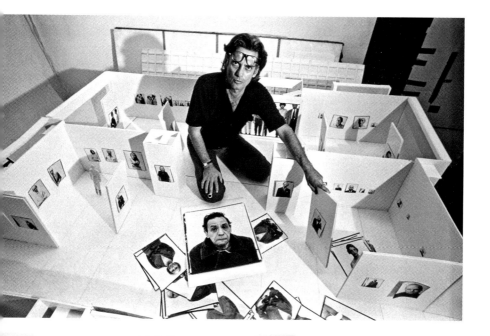

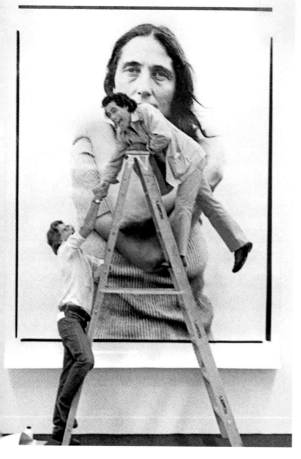

*Above:* Avedon seated in his scale model of the Marlborough Gallery during the design phase of his exhibit, 1975, photographed by Jack Mitchell.

*Left:* Dick congratulates Gideon Lewin, his studio manager, after hanging the final picture—his portrait of June Leaf—for his exhibition at the Metropolitan Museum of Art in 1978, photographed by Adrian Panaro.

*Left:* After the opening of his Metropolitan Museum show, Dick celebrated at Studio 54 with Elizabeth "Betti" Paul, Doon Arbus, Marvin Israel (with beard and sunglasses), and his son, John (in tuxedo), 1978, photographed by Alan Kleinberg.

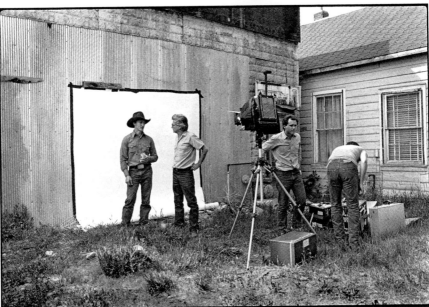

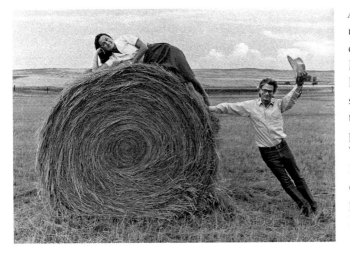

*Above:* Dick setting up a portrait with a cowboy in Augusta, Montana, his assistant Ruedi Hofmann standing next to the camera, 1983, photographed by Laura Wilson. *Left:* Dick with Laura Wilson reclining on a bale of hay, photographed by Ruedi Hoffman.

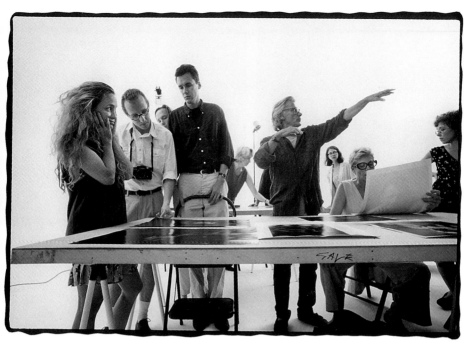

*Above:* Dick reviewing work during his Master Class in the early 1990s with students, from left: Eileen Travell, Nelson Bakerman, Mark Lyons, and, seated, Susan Olken; photographed by Maggie Steber. *Below:* Dick, his arm around Nicole Wisniak, talks to Mike Nichols at a gala dinner in Avedon's honor at the New York Public Library; in the foreground are John Richardson, Diane Sawyer, and Harry Evans, 1993, photographed by Ron Galella.

*Left:* Dick with his godson (and first cousin twice removed), Luke Avedon, after Luke's high school graduation from St. Ann's, 2002, photograph by Elizabeth Cox Avedon. *Above:* At a Council of Fashion Designers Awards ceremony with Polly Mellen, 1993. *Below:* Dick in a rare moment of repose at his house in Montauk, mid-1990s, photographed by Eileen Travell.

LAUREN HUTTON DID NOT get off to a promising start with Richard Avedon. Back in 1966, soon after arriving in New York from Florida and concluding that modeling would be the most efficient way for her to support herself, she made several "go-see" visits to the Avedon studio, only to be summarily dismissed by a factotum. She found her way to the Eileen Ford agency, who sent her to the *Vogue* offices, then still in the swank Graybar Building at 420 Lexington Avenue, to watch an editorial viewing of a runway show. It took place, Hutton remembered, in a long, large red room with seats built into the windows, dozens of clothing racks, and four models. All the *Vogue* editors were there—Babs Simpson, Polly Mellen, Gloria Schiff, and Diana Vreeland, who wore white gloves and sat like an empress in a high-back chair at the end of the room. Hutton slinked into the only available window seat, nearest to Mrs. Vreeland. When the run-through was over and everyone was about to leave, Mrs. Vreeland pointed a white-gloved finger at Hutton and said, "You!" Hutton turned to look behind her before realizing that she was the target of Vreeland's attention. "You have quite a presence," Mrs. Vreeland announced, and held out her hand for Hutton's portfolio. After flipping through it, she picked up the phone at a table beside her that had a direct line to the Avedon studio—a scene as if lifted directly from the movie *Funny Face*—and told Dick she had found the perfect model for an eight-page feature she was planning. Hutton thought of it as a right place, right time moment. The resulting shoot with Avedon would be Hutton's first appearance in *Vogue*.

By 1973, Hutton, whose natural girl-next-door quality was given unexpected sophistication by her gap-toothed smile, had long become one of Dick's favorite models. They worked together regularly, his photographs of her appearing on more than a dozen

*Vogue* covers; they spent two weeks at a time in the Paris studio to shoot the collections; she modeled for twenty-five-page spreads in *Vogue* on new trends; he had her jumping and gesticulating, twisting and crouching; for a swimwear shoot in Eleuthera he photographed her baring one breast; in another image from that shoot, her head was thrown back as she inhaled a joint. Those pictures, in particular, generated just the right amount of controversy at the time to further animate their "daring" reputations.

"Dick was like another kid in the sandbox, the kid you wanted to be with," Hutton said about working with him. "You never thought he was older, you always thought he was exactly your age." Avedon understood that, in order for her to relax in front of the camera, he had to keep her talking, and they talked about everything—the play he had seen the night before; the book she had just read on an obscure African tribe; her adventures with the diamondback snakes that slithered through the swamplands of her childhood in Florida. "Dick knew what kind of music I liked, and it would always be playing during our shoots."

One day after reading about a contract dispute between Catfish Hunter and the Oakland A's in the paper, Hutton had the bright idea that working "on contract" would be more profitable than the paid-by-the-hour day-to-day assignments then standard for models in the fashion industry. "When I told Dick, he kind of hopped around," she said, describing a typical mannerism of his, a kind of random dance he did while he was thinking. After a moment he blurted out: "A contract with an *exclusive*," and explained that "exclusivity" would be the selling point for the likeliest target—the cosmetics industry. "You only work for one house." He came up with the $200,000-a-year figure, which she thought was too much money for any cosmetics company to spend, but Dick turned out to be right. In 1973, Hutton signed a $200,000-a-year contract to be the exclusive face of Revlon's Ultima II, a $2 million campaign that

included full-page magazine ads and TV commercials. "Hutton has now signed a contract with Manhattan's Charles Revson, Inc., that will make her one of the highest-paid women in U.S. business" is how *Time* magazine described it. "Unprecedented in terms of the sum paid to a model." Dick, of course, was not only thinking about Hutton's success; he was also calculating his own arrangement with Revlon, which would increase his own fee in comparison to that of the model.

In 1973, Dick took Hutton to a party at André Gregory's. She acknowledged her shyness in public and her discomfort in talking to strangers. Since Dick told her to expect a lot of writers at the party, she brought along two friends from her various trips to Africa—Anglo Africans who were prominent zoologists in their countries—who would serve as social protection for her among the lofty guests. Dick introduced her around, and as she was talking to André Gregory and Wallace Shawn, someone interrupted them and looked into Hutton's eyes: "If there were an encyclopedia of national faces, you would be the face of the American woman. Because you have all the good and all the bad in your face." The man, she said, was Jerzy Grotowski, the innovative Polish theater director whose improvisational methods Gregory had borrowed for *Alice*. "He was making a pass," Hutton said. "This was during the time of Polish jokes, and I reacted, 'Do you know how to break a Polack's finger? You punch him in the nose.'"

That was typical of Hutton's saucy hauteur. That year, Dick was hired by the Japanese label Jun Rope to do a series of short films for a television ad campaign that was aired only in Japan. He applied his auteurist hand to this modest cinematic enterprise, with nods to Fellini and Antonioni—and to Doon Arbus, who created the scenarios. The campaign was called "Casual Elegance," and in the first commercial Lauren Hutton appeared as herself, sitting in the model's dressing room and being tended to as a grand diva:

her makeup is being done at the mirror; a TV crew interviews her about her first feature film; flowers arrive; champagne is opened; a telegram is delivered; a young Lothario flings himself into the room to kiss her. Avedon, as himself, walks in, hates the dress she is wearing, and tells her to change it. She pouts. In a new dress, she is having her hair done and Dick comes in again, furious about the amount of time she is taking to get ready. "Let's go, Lauren," he barks. "This is not *War and Peace* and you're not Garbo." Finally, she is in front of the camera, a turban on her head, tended to by the makeup artist and hairstylist and the fashion editor all closing in on her as they make her camera ready. The cinematographer zooms in to suggest her claustrophobia. "I can't stand this, Dick," she screams, flinging off the turban, pulling down her hair, undoing hours of preparation. "Lauren, that's fantastic," Dick shouts. He takes a few shots, which are freeze-framed in the film, jumps up, and runs to her, gushing as he gives her a big hug.

The film is a perfect metaphor for the entire Avedon mystique— the intricately constructed fashion model who, in a moment of heightened pique, rips off the bodice, as it were, and creates just the kind of improvisational gesture that defines an Avedon fashion photograph. He would do three other short films for the Jun Rope campaign, with, respectively, Anjelica Huston, Jean Shrimpton, and Veruschka, each one a different brand of cinematic narrative. None was about the clothes so much as asserting an attitude and a sensibility of transgression of one sort or another: Anjelica Huston, reclining, delivers a dreamlike reminiscence about her mother's fatal car accident before being kissed on the lips by a woman—maybe even her mother's ghost; in the case of Veruschka, she is dressed as a man in a tuxedo who stands at a dressing room mirror and removes the hat, untapes the moustache, unbuttons the tux, and reveals her womanly breasts. In the next scene she is a woman in a beautiful gown with flowing hair. Each of the four commercials

reflects Doon Arbus's impulse to straddle the border of transgression with narrative economy consistent with Avedon's visual minimalism.

With the four short films he did for Jun Rope, as with so much of his commercial output, Avedon's creative range often touched on virtuosity. His imagination, like his energy, was unbounded, and he was constantly pinballing ideas off of Doon or Marvin, or against the play he had just seen or an exhibit he had just attended, trying to figure out the solution for a commercial assignment that synthesized the cultural moment. He was like a magazine editor or a film director who surrounded himself with people who could help him capture the zeitgeist. That's how Avedon first became a brand name, and, now, with Marvin as a secret weapon, and also Doon, he continued to sustain his reputation, exploiting his native instinct for "nowness" in an industry that was willing to pay a fortune. When he turned seventy, Dick was asked publicly why he never became a film director. "I had a choice around the time I worked on *Funny Face*. Kubrick did it; he was a still photographer," he said. "The nature of being a director is so collaborative, and I'm so used to thinking my own thing through myself. It never occurred to me then that directors get great writers and great editors and great musicians and great actors and put them all together and it's a totally different thing." And yet, he relied on the same kind of collaboration with his fashion work. He had Doon as a copywriter, Marvin as a designer, hairstylists, makeup artists, fashion editors, all in tow as he directed the model, chose the clothes, approved the backdrop or mise-en-scène, relied on the wizardry of his printers, and conducted his shoots as all the people and the elements came together to create a single image.

DIANE ARBUS WAS BECOMING much larger in death than she was in life. In 1972, when John Szarkowski announced a posthumous

retrospective of her work at the Museum of Modern Art, Avedon might have construed it as a message that his own retrospective was being preempted, perhaps even canceled. Of course, Szarkowski was not thinking of Avedon when he made the decision to give Arbus a show; it was based on his deep regard for her work and the opportunity that her death had occasioned for such an exhibit. Still, Dick's resentment must have simmered as he watched Arbus's legacy being secured before his very eyes.

For years Marvin Israel had been rubbing it in that he considered Arbus the greater artist, and now Szarkowski seemed to be giving institutional sanction to that assessment as well. For years, it would irk Dick that Arbus's suicide created a patina of fragility about her that masked the truth of her ferocious ambition. In fact, Szarkowski recognized her ambition early on, and discussed it with Doon in an interview around the time of the MoMA show. When Arbus first brought her portfolio to the Museum of Modern Art, Szarkowski claimed to be less impressed with the work than he was with her:

> *They were a lot of the early freak pictures and the early eccentric pictures. I didn't really like them but they were very forceful and you really felt somebody who was just enormously ambitious, really ambitious. Not in any cheap way. In the most serious way. Someone who is going to stand for no minor successes. . . . There's something untouchable about that kind of ambition. . . . You can't manhandle it. . . . I think she wanted every word she said, every picture she took, everything she did, I think she just wanted it to be perfect—for some great revelation to come through. Terrifying.*

Avedon, too, was unbounded in the urgency of his own ambition. He, too, was propelled to bring his work to a level of perfection for which the measure was calibrated by standards distinctly his

own. He, too, was in pursuit of revelation in the making of his work, from which he expected insights about the collective "us." For all of Dick's actual and professed insecurities, underneath was a foundation of steely confidence about what he "knew," based on that essential combination of cognition and sensation. He had always been a man in a hurry. It's just that his "elbow" sometimes got in the way.

His relationship with Szarkowski had begun a decade earlier on very solid footing—their shared regard for the work of Lartigue; a recognition about photography as a medium of visual expression equal to its art world siblings; and Szarkowski's evolving interest in Avedon's work, which led to their initial discussions in 1968 about his proposed retrospective at MoMA. But Dick's consuming need to take control of the enterprise would not sit well with John, who had his own territorial imperatives. While Avedon was wholly cognizant of the weight of his name in the world—and he exploited it to his benefit whenever he needed center-aisle theater tickets or impossible-to-get dinner reservations or an urgent favor from a professional colleague—he could not tamp down his sense of entitlement in his dealings with Szarkowski, for whom a modicum of deference and humility would have taken him much further. "John [Szarkowski] was a testosterone giant, and he and Dick had a difficult relationship; it was just bad chemistry" is how Peter Galassi, who succeeded Szarkowski as curator of photography at MoMA in 1991, characterized the tenor of their relationship over the years.

In January 1972, Szarkowski conveyed his interest in including Dick's image of Dovima and the elephants in a book he was putting together that would become *Looking at Photographs*. Dick, not content with Szarkowski's choice, wrote to say, in effect, he did not want to be identified with an image from his fashion work and offered several alternatives for John to consider, "which I feel

to be representative of my particular contribution to portrait photography." They included his portraits of Isak Dinesen, either the close-up or the full-body one; Dwight D. Eisenhower; the Daughters of the American Revolution; or Coco Chanel. Dick offered to make a print of the one Szarkowski selected to contribute to the museum's permanent collection.

Dick was always vigilant in monitoring his reputation, and, once again, his attempt to shape his own legacy succeeded. Avedon is represented in *Looking at Photographs*, today a seminal book in the canon, with his portrait of the great writer Isak Dinesen. And yet, while Szarkowski had capitulated, Avedon, by countering his request, had only further alienated the single most important arbiter of the medium of photography in the second half of the twentieth century. In the one-page essay accompanying Avedon's portrait of Dinesen in *Looking at Photographs*, Szarkowski makes no mention of the image at all as he writes with an air of derision about Dick's fashion work:

> *Even in the early years of his work as a fashion photographer, Richard Avedon was much interested in motion, or rather in the sense of motion, since his interest was not analytical but hortatory. As a young photographer in the early fifties Avedon seemed to think that motion was intrinsically a good thing. It is possible that Avedon was in fact one of the architects, unwitting or otherwise, of the Jet Set concept, which was based on the premise that people with style do not alight.*

Szarkowski's condescension was barely hidden in his assertion that Avedon was instrumental in the creation of a fatuous lifestyle for which Szarkowski had no patience or respect. Szarkowski goes on to acknowledge the breadth of Avedon's portraiture, and yet, perhaps because of his own discomfort about the relationship

between Avedon's commercial work and his work as an artist, he holds out on the final measure of Avedon's importance, leaving the conclusion about the significance of the work to "time":

> *The importance of Avedon's work lies in the fact that it constitutes a coherent and challenging composite portrait of many of the mythic figures and spear-carriers of the worlds of art, style, and higher salesmanship during the past twenty years. The character drawn in that composite portrait is of a piece, persuasive, and less than reassuring. It remains for time to determine whether that character is the product of Avedon's insight or of his fancy.*

It was while Szarkowski was working on his book *Looking at Photographs* that he mounted the Diane Arbus retrospective at the Museum of Modern Art, another landmark show that might well be considered a coming-out party for photography in the art world. In the early 1970s the idea of photography as an art world equal was just taking root, and the Arbus exhibition was a tipping point—perhaps the first and most visible photography exhibition to be taken seriously by art critics.

Arbus had made intimate portraits of strangers and acquaintances in their homes or on the street. Viewers were appalled by the unflattering aspects of her portraits and yet fascinated by their powerful emotional resonance. A debate lingers still about whether she sought to exploit the grotesque in her subjects; certainly, her pictures reflect her own emotional and psychological experience of the people she photographed. Her subjects were for so long referred to as freaks or oddballs or societal castoffs, but she did not see them that way. She brought the same level of respect, if at times also her quirky sense of humor, to photographic sessions with individuals that could take hours and, in the process, merge with them—sometimes having sex with them, seeking a kind of grounding in

the wilds of their realities that brought her back to herself and made her feel less like an alien in her own body.

"Freaks was a thing I photographed a lot," she is quoted as saying. "It was one of the first things I photographed and it had a terrific kind of excitement for me. . . . They made me feel a mixture of shame and awe. There's a quality of legend about freaks. Like a person in a fairy tale who stops you and demands that you answer a riddle. Most people go through life dreading they'll have a traumatic experience. Freaks were born with their trauma. They've passed their test in life. They're aristocrats."

Szarkowski levels greater certitude about Arbus's work than he did about Avedon's in the wall text of her MoMA show, which opened in November 1972: "Diane Arbus's pictures challenge the basic assumptions on which most documentary photography has been thought to rest, for they deal with private rather than social realities, with psychological rather than historical facts, with the prototypical and mythic rather than the topical and temporal. Her photographs record the outward signs of inner mysteries."

Hilton Kramer, the art critic of the *New York Times*, who was nothing less than hostile to the idea of photography in the realm of the fine arts, acknowledged that few contemporary photographers had had as strong an impact on the practice as Diane Arbus. The retrospective "brings us a body of work that is at once classic and a matter of controversy," Kramer wrote in his review of the MoMA show. "For many connoisseurs of photographic art, especially for the younger generation of photographers on whom Mrs. Arbus has been a decisive influence, the exhibition is a summary—and vindication—of a new aesthetic attitude. For others, less familiar with the imperatives of her style and less prepared for the shocks it contains, the exhibition is likely to be, at the least, a revelation."

Following Arbus's show, a dialogue about an Avedon show at MoMA did, in fact, continue, although the subject of the show

changed several times, according to Dick's peripatetic musings, until Szarkowski finally put his foot down. In August 1973, in the weeks before Jack Avedon died, Dick sent a letter to Szarkowski proposing a show called "The Avedon Woman," to be scheduled to accompany a book he wanted to publish on the subject, one that did not in the end materialize. On August 28, 1973, four days before Jack's death, John responded to Dick's latest exhibition idea by saying, "Of the several projects we have discussed . . . I like very much your idea of doing something on the cumulative portrait of your father," and offered a single gallery on the ground floor of the museum. On September 5, Dick wrote to John: "My father died last week. . . . You may have the exhibition whenever you want it."

*Jacob Israel Avedon*, by Richard Avedon, an exhibition of eight portraits of his father in the last years of his life, opened at the Museum of Modern Art on May 1, 1974. The exhibit was installed by Dick and Marvin Israel in a single gallery with dark gray walls on which the prints, one of which was six feet square, were hung bare, without frames. In the wall text, Szarkowski wrote: "Photographic portraiture, pursued with the high ambition that tradition suggests, is an enormously difficult art. It is most difficult when the photographer and the subject know each other well; in such cases each recognizes and nullifies the other's little tricks of style—the stuff of our personae. In these circumstances only acceptance and trust can succeed. Richard Avedon's portraits of his father are the deeply moving record of such a success."

The night before the opening, Dick went out to dinner and then home to bed. At two in the morning he had severe chest pains, called his doctor to declare he was dying, and was rushed by ambulance to New York Hospital, only blocks away. It was not a heart attack. Instead, he was diagnosed with pericarditis, an inflammation of the sac that cradles the heart in place. The condition was treated with cortisone, and Dick had to spend several weeks in the hospital

recovering, thereby missing the opening of his only one-man show at the Museum of Modern Art, the culmination of a dream.

A week into his hospital stay, the reviews began to trickle out. Someone brought Dick the Sunday *Times*, but he aimed for what he considered to be "mensch-hood," a state of grace in which he wanted to avoid reading the reviews of his show. Still, later that night he couldn't sleep and his curiosity finally wrestled down his resolve to ignore the review. "These pictures are taken in Avedon's ugly, distressing style in which every wrinkle and blemish is magnified and the subject is caught—or so the viewer suspects—in moments of wholly atypical dopeyness," wrote Gene Thornton in the *Times*. "The average viewer (whose voice I try to be) is bound to ask what kind of son it could be who would take such pictures of his dying father, yet."

Dick lay there in bed distraught, and after a while, he got up, went into the bathroom, and lit a match to the corner of the *Times'* Arts and Leisure section. Several days later he sat in his hospital room and recounted to Owen Edwards, who was doing a profile on him for *Playboy*, how the fire grew out of control: "Panicking," writes Edwards, "he stuffed [the burning paper] into the toilet. Fire billowed volcanically from the bowl, filling the room with black smoke and flakes of charred newsprint. There he knelt, world-famous glamorous person Richard Avedon, flushing the toilet again and again, forcing down the soggy glob of paper until he was elbow deep in intimate plumbing. Finally, with a gurgle, the cremated remains started off to sea." Dick then wiped the walls clean of soot with damp toilet paper, washed his hands, and went peacefully to sleep.

A month later, Hilton Kramer gave Avedon the gift of a good, and even insightful review in the *Times*, allowing him his due: The portraits of Avedon's father constitute "a pretty harrowing experience," he began, concluding that "there is a dignity in this

unabashed enterprise that is finally more affecting than the undeni-
able sense of shock that we feel on our initial encounter. We see the
elder Avedon, in all his anguish and resentment, with such clarity
and precision that the very absence of evasion softens our horror
and transforms our response into something more than morbid cu-
riosity. We feel ourselves, oddly enough, intensely in touch with
life—and with a side of life that rarely, if ever, is captured in the
art of any medium." He draws comparison between Avedon and
Arbus: "Mr. Avedon has brought a similar courage and affection to
his 'forbidden' subject and the result will forever alter the way we
think about such subjects in the future."

Finally, in July, Szarkowski wrote a genuine if strictly pro forma
letter, acknowledging the success of the exhibit: "Dear Richard,
I am tardy in writing to thank you for the pleasure and satisfac-
tion that you have given us by making it possible to do the Jacob
Israel Avedon exhibition. . . . I am very happy that we were able
to play a small part in making this show possible." That would be
the beginning of an arm's-length relationship between Avedon and
Szarkowski that would last for the rest of their lives.

15

# THE CLOSET DOOR

(1974–1976)

Investigate some fact of real life—even one that at first glance
is not so vivid—and you will find in it, if you have the capacity
and vision, a depth you won't find even in Shakespeare.

—FYODOR DOSTOYEVSKY

Sometime during the preparations for Dick's exhibit in Min-
neapolis and his trip to Vietnam, the Avedon studio was
forced to relocate. Gideon Lewin, Dick's studio manager,
was deputized to find a new space, a search that spanned three
months before he was shown a four-story, seven-thousand-square-
foot redbrick carriage house at 407 East Seventy-Fifth Street. It
was being sold by a Los Angeles–based graphic designer and com-
mercial photographer who had transformed the main floor into a
double-height studio with a built-in cyclorama—a curved wall that
yields an ambiguity of space for photographic flexibility within the

picture frame. A town house in a residential neighborhood was not what Dick and Gideon had been looking for in terms of a professional studio. It was well outside the Midtown district of advertising agencies and magazine offices, but there was an allure to an unexpected address off the beaten track, combined with a skylight in the studio, a darkroom in the basement with built-in features, and a separate apartment on the top two floors that could bring in rental income.

Dick bought the carriage house for $147,500; hired an architect, a contractor, and Billy Baldwin, who had designed the interiors in his house on Riverview Terrace; and embarked on a major renovation. Gideon was put to work customizing the studio, creating office spaces and dressing rooms, tailor-fitting the darkroom downstairs, and turning the small apartment directly above the studio into a private hideaway for Dick. Soon enough, Dick would rent out the two-floor apartment upstairs to Richard Benjamin and his wife, Paula Prentiss, both of whom had appeared in Mike Nichols's film *Catch-22* and with whom he would become good friends.

By early 1972, the Avedon studio was in full operation at its new address. One morning Dick arrived with a packed Louis Vuitton bag. "I've left home," he announced to Gideon, who was in the studio before everyone else had arrived for work. "I'm going to live here." Dick's relationship with Evelyn had been deteriorating along with her hold on reality. Before he finally moved out, her erratic behavior had become untenable. André Gregory remembered a weekend afternoon at Mike Nichols's house in Connecticut when they were all having lunch. "She started putting out cigarettes in the palm of her hand," Gregory said, believing it to have been an act of defiance because she was not getting the attention she wanted. It wasn't the first time he had witnessed her abnormal behavior. When Dick and Evie spent a weekend at the Gregorys' small cottage in Southampton, she stayed in her bedroom the entire time.

"She had a good mind and she was amazingly well dressed," Gregory said. "But, she was just nuts." He cited one argument in which she was intelligently dismissive of Peter Brook's *A Midsummer Night's Dream*, which he and Dick had loved. "Sometimes," he said, "she was right."

Dick seemed delighted to set up a makeshift home in the small apartment above the studio, asking Gideon to create for him "a very spartan kind of bedroom" with only a carpeted platform, in keeping with the industrial minimalism being popularized in the 1970s. Dick put the Riverview Terrace house on the market and set Evelyn up in an apartment with a view of the river at the UN Plaza, a very chic address with famous residents such as Johnny Carson, Walter Cronkite, and Truman Capote. Dick would continue to support Evie and see her for dinner once or twice a month for the rest of their lives. She was never shy about imposing on the studio to order for her a loaf of bread from Orwashers or smoked salmon from Zabar's to be couriered over to her apartment on the spur of the moment. Dick and Evie were never officially divorced.

John Kanelous, Laura's husband, compiled a book called "The Little Wisdoms of Richard Avedon" that he had ceremoniously given to Dick at the party after the opening of the Minneapolis show. One of Dick's little wisdoms is: "He sleeps fastest who sleeps alone." When Dick left Evie and moved into his little aerie above the studio, he claimed never to have been happier in his life. "I'm better at photography than I am at marriage, and from now on I'm going to be married only to my work."

Everyone considered Dick and Renata Adler to be so close that there were rumors about them as a romantic couple, but Adler claimed that not only were they never sexually intimate, she was actually closer to Evie. Around the time Dick left home, Evie still was convinced that he was having an affair with Lee Radziwill and wrote about it incessantly in her diary. Adler, who never under-

stood where Evie had gotten the idea to begin with, one day saw an item in *Women's Wear Daily* reporting Lee Radziwill's affair with the photographer Peter Beard. "What kind of friend am I if I don't bring this to Evie's attention?" Adler rationalized to herself. When Renata showed her the clipping, Evie accused her of conspiring with Dick to place the item in the paper as a ruse to throw her off the scent. Sometimes Renata would accompany Evie to her shock treatment sessions, or occasionally meet her afterward at home. After one treatment, Evie was looking through her diary when Renata arrived. "What's all this stuff I've written here about Dick and Lee Radziwill? I must have been *crazy*," she said to Renata, who was, at that moment, relieved that "Evie seemed sane enough to realize she had in fact been crazy."

Avedon had met Renata Adler in 1964 at a screening of Sidney Lumet's film *The Pawnbroker*. She was then a young writer at the *New Yorker*, and in the coming years, she accepted an appointment as film critic for the *New York Times*, for which William Shawn, the editor of the *New Yorker*, granted her an official leave of absence. By then Adler's precision-cut sentences and searing insights had earned her prominence and high regard in the intellectual firmament of New York.

In 1971, Ashton Hawkins, a mutual friend of both Dick and Renata, organized a reading group with a former Harvard classmate. It was formed on the occasion of the centennial of Marcel Proust's birth. "My friend and I had both taken a course at Harvard called 'Proust, Joyce and Mann,'" Hawkins recalled. In the first class of the semester, the professor assigned the first two volumes of *Remembrance of Things Past*, warning the students that if they failed to read the entire seven-volume masterpiece by the time they graduated, they could not claim their proper place "in the company of educated men and women." Hawkins, who was in his thirties and held the position of in-house chief counsel for the Metropolitan

Museum of Art, was compelled to start the reading group because he had never read all seven volumes.

In the hierarchy of great literature of the twentieth century, Dick had understood since his first visits to Paris in the 1940s that Proust hovers above everyone. He had been introduced to the "idea" and "ambience" and "nuance" of Proust by no less than Colette herself and Cocteau himself. Dick jumped at the chance to join the reading group, along with Renata. Hawkins claimed that Dick and Renata attended the meetings for only a year because, he surmised, "the group did not seem intellectual enough for them—or at least for *Renata*." No one will ever know whether Dick made it through all seven volumes, although one night not long after he left Evie, he invited Stephen Sondheim for dinner. "I think we ate potatoes in jackets with caviar," Sondheim said. The two of them talked easily and casually about music and art and movies, and Sondheim enjoyed the conversation, considering Dick to be great company. "I remember him telling me I should read Proust," Sondheim said. "I'm a terrible reader and I don't much like reading. I told him I was one of the many thousands who couldn't get past page fifty and Dick said: 'You have to get past page fifty. Everything in life is in that book.'"

In 1973 Dick and Renata were invited by Ashton Hawkins and his then boyfriend, Tim Husband, a young curator at the Metropolitan Museum, to spend a week at their house in Patmos, a little jewel of a Greek island in the middle of the vast Aegean Sea where time itself slows down. "It is a magical island," Husband said. "We had bought two contiguous houses, one dated back to 1634. The village is extraordinary, architecturally the most interesting of all those small islands, with a heavy Venetian influence, the only one in Greece that falls under the protection of the archaeological society." The days on Patmos were languid and easy, spent in bathing suits, sailing from one little inlet to the next. "Our housekeeper

would make a picnic lunch and we'd find a little cove and eat on a blanket, snooze, play backgammon, that sort of thing," Husband said. In the evenings they had long, lingering dinners on the terrace.

While Renata and Dick were in Patmos, Dick offered to do her portrait. She knew that he could make her look glamorous—or the opposite. The picture, now famous, appears on the cover of her book, *Speedboat*, which came out several years later, and shows her in an unbuttoned white shirt and jeans, her hands in her pockets, sunscreen on her lips, the gravity of her long thick braid over her shoulder representing a modern-day Athena. Renata claims to have been mortified by the portrait. "I look like a hijacker of a plane that I wouldn't want to be at the mercy of," she told Dick. He said, "Don't worry about it. I've taken one of myself which is exactly like that." Maybe that is why she sometimes referred to Dick as "her twin." "We helped each other a lot. He helped me much more than I could possibly help him, because he was Avedon." Of course, he felt the same way about her because she was Renata Adler.

Dick returned to Patmos the following year, alone this time, to visit Owen Edwards, a journalist who began writing regularly about photography and had written a profile on him in *New York* magazine before the one in *Playboy*. "I was so in thrall of Dick, he being so persuasive and charming," Edwards said, acknowledging the extent to which his enchantment with the illustrious Avedon had clouded his reporting. For example, Dick told Edwards that Irving Penn, his colleague at *Vogue*, was semiretired and living out on Long Island. "I had no reason not to believe him, so I didn't fact-check it," Edwards said. "I just wrote it down." Not long after, Edwards met Irving Penn, who told him that, contrary to what Dick said, Penn was at the height of his career and working all the time.

Edwards, too, had been going to Patmos since the mid-1960s, and, when he learned that Dick had been on the island the previous

year, he extended an open invitation for him to visit Edwards and his wife, who were renovating a large house. One day in the summer of 1974, a cable arrived from Paris to say that Dick was on his way. He stayed for a week. "He was the dream guest," Edwards said, "always directing us to have a great time." One day Dick had taken a walk down the hill into town by himself and returned to announce that he was throwing a party on the occasion of the full moon that night. In the early evening, three local men arrived with donkeys loaded with food, blankets, and bottles of retsina, and Dick, along with the Edwardses and several other couples, trekked up the steep path to the top of the mountain, where the Church of the Prophet Elijah, an abandoned monastery with a courtyard garden, stood at the highest point on the island. Edwards described "a Fellini-esque scene" on the full moon with an extensive Greek banquet, plenty of wine, and dancing to the music of local musicians. "To this day, I have no idea how Dick arranged it," he said. "He didn't even speak the language." Yet Edwards believed it to be characteristic of Avedon to pull off such a *grand geste*, if only to gain pleasure from everyone's enjoyment of a special evening that he created exclusively for them. Several weeks later, the Edwardses received a handpainted poem from Dick in gratitude for the weeklong stay, rhyming to the tune of "Thanks for the Memory."

When Dick was at home in Manhattan, on the evenings when he wasn't at the theater, he would invite people over for dinner, one-on-one. "I would go over a few times and have dinner with him," Hawkins remembered, which was usually not before nine, as Dick worked late almost every night. Sometimes he would complete the preparations of a meal from ingredients left for him by his cook; or he would order in from a local restaurant. "He was rather lonely, I think," Hawkins said. "He was separated. His son was sort of a problem. We just gossiped and chatted. He was very loyal to me and I was loyal to him."

Although Dick had floated the idea to John Szarkowski for an exhibit about the "Avedon Woman," since 1971 he had simultaneously been developing this concept with John McKendry, the curator of prints and photographs at the Metropolitan Museum of Art. Ashton Hawkins, aside from being chief counsel to the Met and a friend and colleague of McKendry's, was a dashing social figure at the intersection of New York society and art world philanthropy, and over the next few years he would become increasingly helpful in shepherding the plans for an Avedon exhibition at the Met.

John McKendry, the Met curator, and his socially prominent wife, Maxime de la Falaise, a former fashion model who was at the time a food columnist for *Vogue*, were known for their legendary dinner parties. At their uptown table, one could find an assortment of titled Brits, chic Parisians, and well-placed New Yorkers, as well as artists, writers, magazine editors, and last-minute invitees who arrived "by association." The writer Steven M. L. Aronson remembers seeing Dick at the McKendrys' table more than once. "I would venture to say that he enjoyed those occasions mainly as a form of anthropology," Aronson surmised. "For the most part, it was John's position at the Met that had drawn him, but also, he and Maxime went way back." As Maxime de la Falaise would write several years later about her husband, "Especially, he loved fashion photographs and the idea of giving a one-man show to his friend Dick Avedon was something that he cared about a great deal."

In 1972, one new arrival at the McKendrys' table was the twenty-five-year-old Robert Mapplethorpe, an attractive, poetic waif from the downtown netherworld, who would be invited back again and again for reasons that became increasingly complicated, or what was termed in those days "sophisticated": McKendry, in his early forties, who had succeeded in changing the name of the Department of Prints and Drawings at the Metropolitan Museum to

the Department of Prints and Photographs, fell hopelessly in love with Mapplethorpe, losing his dignity as he made a public spectacle of himself with his ardor long after the young Mapplethorpe insisted that a romance was out of the question. A chic cinematic parallel to McKendry's situation had arrived in theaters that fall: *Sunday Bloody Sunday* told the story of an accomplished middle-aged doctor who falls in love with a much younger, emotionally uncommitted bisexual sculptor. The first mainstream movie to address bisexuality with frank intelligence, the film dramatized how the doctor's pursuit of the younger man becomes increasingly abject and futile.

On December 15, 1973, the American Psychiatric Association voted to remove homosexuality from its list of psychiatric disorders. This shift in policy was reported on the front pages of newspapers across the country. On the streets, in bars, at restaurants, movie houses, Broadway theaters, and on the subway, the gay male gaze, now no longer psychiatrically pathologized, roamed ever more freely. The veil of fear about being discovered, much less arrested, was beginning to lift. Nonetheless, for many gay men who had for so long internalized the fear of discovery, New York City continued to serve as a big open closet in which they proceeded to live out their fantasies while at the same time hiding in plain sight from parents, friends, and employers. Mapplethorpe exemplified this paradox: one of the most visible gay men in Manhattan, he kept his sexuality a secret from his parents a mere borough away in Queens—to such an extent that he maintained a charade, for their benefit alone, that he was married to Patti Smith.

One could say that the combination of social pedigree, artistic accomplishment, and wild card flamboyance at the McKendrys' dinner parties left cracks in the closet door. Certainly, the host's overtly obsessive attraction to the young Mapplethorpe was an unexpected departure from conventional behavior. Yet John Mc-

Kendry was not the only one letting down his guard in the public sphere of New York society; he had company among Dick's good friends. Leonard Bernstein, who by this time had all but abandoned the charade of his heterosexual persona as husband and father, began to cavort unabashedly with his boyfriends. Harold Brodkey, another close friend, was living in a ménage à trois with two male lovers. Ashton Hawkins, the very model of high WASP breeding, who never purported to be heterosexual, was quite comfortable in his sexuality at the McKendrys. It is hard to say how Avedon felt in a social milieu in which the boundaries between strict heterosexual behavior and homosexual innuendo became ever more porous. This is precisely where Dick's self-constructed "moat" protected him most within his fortress.

When Owen Edwards interviewed Dick for the *Playboy* profile in 1975, asking him why he didn't photograph some of his friends or closest colleagues, his answer revealed more, perhaps, than he intended. He explained that an intimacy develops in a good sitting unlike any intimacy between friends, "an intimacy with no past and no future." Dick then used the analogy of "a sexual encounter with a stranger in a darkened room" to explain that "a portrait sitting can leave both participants with a feeling of embarrassment if they should meet later on the street."

In 1975, in New York City, the rise of gay liberation and the visibility of a street culture in the gay community in Greenwich Village was evident in the proliferation of gay bars, some of which had darkened back rooms where strangers would engage in active, anonymous sex. The embarrassment some gay men experienced should they later encounter a stranger with whom they had had a brief sexual interlude derived from the shame of bringing their sexuality into the light of day or the fear of being recognized and "outed" as a homosexual.

The only venues for such encounters were gay bars, the baths,

or the Ramble in Central Park, and Dick's very specific reference to this scenario belies a knowledge that can have come only from actual experience. In her 2017 memoir about her life as Avedon's business manager and loyal aide-de-camp, Norma Stevens recounts an intimate late-night conversation with Dick in 1979 in which he ostensibly divulged his homosexuality. After a fine dinner and a good bottle of wine at Chez Panisse, they were sitting in his room at a small inn in Berkeley, California, and he confessed to being in the closet all these years for reasons that are not difficult to understand, given his generation and the stigma of homosexuality in America in the era in which he grew up. In 1970, Joseph Epstein, the essayist and later the editor of *The American Scholar*, published an influential essay in *Harper's* magazine, entitled "Homo/Hetero: The Struggle for Sexual Identity," giving voice to the predominant attitude about homosexuality in America: "Private acceptance of homosexuality, in my experience, is not to be found, even among the most liberal-minded, sophisticated and liberated people. Homosexuality may be the one subject left in America about which there is no official hypocrisy," writes Epstein. "Cursed without clear cause, afflicted without apparent cure, they [homosexuals] are an affront to our rationality, living evidence of our despair of ever finding a sensible, an explainable design to the world." In 1944, as Dick was just starting out and reaching for a career at *Harper's Bazaar*, he had little choice but to adhere to the conventions of marriage and family.

According to Norma, in the 1970s, he had had furtive, fleeting, occasional homosexual encounters with strangers, yet the risk of discovery—which added to the thrill—had nonetheless been debilitating. If this were not enough of a confession, which had not really surprised her, he then shocked her with a "secret" he had managed to maintain for years—his clandestine romance with Mike Nichols. When Stevens's book was published, the revelation

about Dick and Mike predominated the coverage. The famous photographer and the illustrious filmmaker had done such a fastidious job of covering their tracks that evidence of their long-term affair is not only scarce but virtually nonexistent. However, once Stevens revealed it, in retrospect it looks as if they, too, were hiding in plain sight. Dick and Mike were in Paris together in 1962 for Avedon's six-page fashion parody of the Taylor-Burton affair in *Harper's Bazaar.* "I look at these photos and they seem as immediate as the last time I fell in love," Mike Nichols wrote almost a half century after they were taken, in a tribute to Dick several years after he died. "I see Dick and Suzy showing me Paris for the first time as we conspired to shoot a layout for *Harper's Bazaar.*" Dick made Mike look like a leading man playing a sleuth in trench coat and sunglasses, an echo, perhaps, of the secrecy of their relationship. The whole enterprise of the "fashion shoot" was an impressive cover for the clandestine nature of an affair. In 1963, Mike was with Dick in New Orleans as he was making portraits for his book *Nothing Personal.* "We stayed at the Royal Orleans in the Quarter," Marguerite (Lamkin) Littman, who was helping Dick with the project, said. "Dick and Mike went off by themselves a lot—lunches and dinners at Antoine's and Galatoire's, you know." And in 1970, Dick bought Mike a very expensive—and personal—gift, the *Box of Ten* portfolio by Arbus. "I'm sure you have a friend who cannot be described—someone who is so much a part of your thinking and your life that he or she is no more accessible to words than the air you breathe," Nichols wrote, a reflection of the intimacy of his unique friendship with Avedon.

Asked if he has found any confirmation of the decade-long affair between Dick and Mike, Mark Harris, who is writing a biography of Mike Nichols, replied to the question in this way: "I remain very skeptical about the assertion in the book that any kind of affair

lasted for 10 years," he said. "But could there have been an affair? Sure. I think it's absolutely possible."

As Stevens writes, Avedon's homosexuality remained a deep, dark, agonizingly painful, lifelong secret. It was only in the last years of his life that he would acknowledge that the social stigma about being gay had finally lifted. "The thing is, I don't want it defining me—the gay photographer," he told Norma, "as if I were a professional homosexual."

Dick was successful at maintaining a reputation of utter professionalism in terms of his work. If his personal life got in the way of his evolving reputation as an artist, it was only insofar as people perceived him to be too much of a public figure, mostly because of his wealth and the source of it—the fashion industry. In the mid-1970s, Dick may have been surrounded by people like Leonard Bernstein, Harold Brodkey, and John McKendry, who were crossing the moat, so to speak, but he was neither uncomfortable around them nor ready to stand with them in their defiance of the presiding strictures on homosexuality. Dick always had his eye on the prize, and that was greatness. He was cultivating his reputation as an artist with the best ammunition he had—his work. In February 1974, months before his show at MoMA, Dick sent a letter to John McKendry, letting him know that, while photographing Thomas Hoving, the director of the Metropolitan Museum, they discussed the proposed exhibit of his fashion work. "He seemed to feel strongly about [the show and the book] coming out at the same time, with the book published by the museum," Dick wrote. "Of course, he could have been bullshitting, but maybe not." In the same letter, he claimed that Marella Agnelli wanted a show of his work to come to the Museum of Modern Art in Turin, Italy, perhaps after the Met show. "Now we *know* she has money," he added, signing the letter, "Love, Dick." Unfortunately, and sadly, John McKendry, the essential champion of the proposed Avedon

exhibit at the Metropolitan Museum, died of cirrhosis of the liver in 1975. He was forty-two.

A BEGRUDGING KIND OF acknowledgment was being paid to photography in the art world, not least because of the success of the Diane Arbus show at the Museum of Modern Art in 1972, which changed the minds of at least a few important critics. At the same time, a small but serious group of collectors were buying up nineteenth-century photographic prints from the auction houses in London.

Paul Katz was a young painter in New York who supported himself by photographing paintings and sculptures for the archival records of the Guggenheim Museum and select art galleries. In 1974, Katz organized a historical survey of "the portrait" in photography at the Robert Schoelkopf Gallery. One of Katz's clients, the Marlborough gallery, took notice and offered him a job to develop a photography program. "I was a very unlikely person to be working at Marlborough," Katz said. "I was so unslick." He offered a plausible explanation for Marlborough's interest in photography at that moment: The gallery had been struck with a very public lawsuit from the Rothko estate; the economy was in a recession; and impressionist paintings weren't selling. Photography was in the air—a prospective source of revenue that had yet to be tested.

When Avedon had his first gallery exhibit at Marlborough in 1975, he endured judgment for his hubris as a photographer—never mind a *fashion* photographer—in choosing a blue-chip gallery on Fifty-Seventh Street. But it had not been his idea. In fact, Marlborough approached him to do the show. One day in April 1975, Katz was reading the *Times* on the subway and saw the full six-column picture of the Vietnam War Mission Council by Richard Avedon. "It wasn't a passion I had for Avedon," Katz said. Rather,

at that moment he realized that an Avedon show would garner exactly the kind of attention the gallery needed for its first foray into photography. "I called up Avedon and he was very friendly," Katz said. "No discussion about what kind of show it was going to be. The minute he agreed, he immediately took control. After that, I wasn't that much involved."

Katz was taking a chance with Avedon because he surely understood what luminaries in photography such as Robert Frank and André Kertész thought of Avedon's work. Katz recalled a visit he made to Robert Frank's house in Mabou soon after Dick's show at Marlborough gallery. Coincidentally, while he was there, a letter arrived for Frank from Avedon. The gist of the letter, according to Katz, was: "I'd rather be you than me. I've always admired you so." Katz described it as a fan letter, and then recounted Frank's reaction to it. "Can you believe this guy?" asked Frank, who considered the letter to be disingenuous since Avedon had created a public persona of such glamour, a reputation of wealth and conventional success. Why, all of a sudden, would he be showing a self-effacing side? "Ultimately," Katz said about Frank's view of Avedon, "he believed that you couldn't do both—be an artist and also be a successful commercial photographer."

This conviction of Frank's was further confirmed by Ralph Gibson, who, in a remembrance of Frank following his death in 2019, recounted a conversation he had had with Frank soon after they met, in the late 1960s. "I was complaining about being in love with a girl who definitely was out of my league financially," Gibson recalled. Frank was circumspect: "'The way I see it is you have two choices. You could become successful quite soon commercially or you could do what I did and become an artist.' Then, turning to me, he continued. 'But you really only have one choice.'"

According to Katz, André Kertész was a perfect example of how a photographer of the older generation regarded Dick. "Kertész detested Avedon," he said. "He thought Avedon had basically stolen Munkacsi's soul. He had stolen the idea of movement from Munkacsi. He felt Avedon was a phony. He wasn't authentic."

Katz, who would leave the gallery world—and New York—several years later and move to Vermont to live a quiet life as a painter, had given Avedon a remarkable gift. Aside from his instrumental role in setting up the show at Marlborough gallery, he understood the conflict between the generations, and also the misconceptions that led to some disparaging conclusions about Avedon, the all-too-famous Machiavellian "fashion" photographer. Dick couldn't understand why so many people were unconvinced of his sincerity as an artist. The problem was that his insecurity led to his overcompensation, and the sincerity of his intent was so often obfuscated by the implications of his name. Katz acknowledged that Dick knew what a good photograph was: "Dick championed Diane Arbus; and he knew how great Robert Frank was." In fact, the only photographer of his generation whose opinion mattered to Dick—now that Arbus was dead—was Robert Frank.

After Katz invited Avedon to show at the gallery, Dick, being Dick, dealt only with Pierre Levai, the director. Katz was more amused than offended by being sidelined, as it was his first real lesson about the channels of power in the hierarchies of New York. Dick brought in Marvin Israel to design the show much in the same way he had in Minneapolis, and then he went into high gear to create an exhibition of portraits that had nothing to do with the world of fashion. "I think he thought he would enter the public consciousness in a Warhol-like way," Katz said. Avedon's interest in being recognized in the art world, aside from the native ambition of any artist to be regarded, ultimately, by his peers, was also

prescient. It wasn't until 1977, for example, that Sotheby's Parke-Bernet in New York would establish an autonomous photography department, certainly a signal from the marketplace that new value of an aesthetic nature was being ascribed to the medium.

Between April and September, Dick made eighteen new portraits for the Marlborough show, traveling as far afield as Buenos Aires to photograph Jorge Luis Borges; Mabou in Nova Scotia to photograph Robert Frank and his wife, June Leaf; and Washington, DC, to photograph President Nixon's former secretary Rose Mary Woods. That summer, he made a surprisingly tender portrait of Evelyn. It's possible that, with his portrait of Evie, he was striking a comparison between her and June Leaf, who had become for Avedon the new model of woman, completely unselfconscious, unadorned, and absent any vanity. "That's a beautiful woman," he later said of June Leaf. "In my portrait, she's the muse; she's the other. She's the earth mother. She's gorgeous in her 'give' and her lack of cosmetic artifice and her generosity with her 'self with a capital S.' . . . She's a very rare, extraordinary creature, and a sexual one and a womanly one, and she presides over my life." In his portrait of Evie, she, too, is casually dressed and appears summery and natural, with little or no makeup.

Despite what Dick told Owen Edwards, the intimacy of a portrait session did not preclude his interest in photographing close friends or professional colleagues; several portraits of his intimates did appear in his Marlborough exhibit, including Harold Brodkey, Renata Adler, Polly Mellen, and, of course, Evie. Dick implied to Norma Stevens that his relationship with Brodkey over the years was too complicated to discuss—they were very close, but the friendship was often gnarly. In 1975, Brodkey, who, for several years, had been living with two men, was now living with only one of them, Doug Gruenau, a science teacher and nature photographer

thirteen years his junior. Brodkey and Gruenau visited Dick in his studio in the months before the show to look at the scale model of the Marlborough gallery, in which Dick had placed thumbnail versions of the pictures on the walls. "Harold was interested in ideas and the way they flowed," Gruenau said. "He had some strange notions. His relationship with Dick was an intellectual one."

Regardless of the ornery reviews from the leading art critics, the Marlborough show, which opened in September 1975, was a huge popular success and generated a great deal of media attention. The opening alone brought three thousand people. And while the glare of fame caught the attention of the press on opening night, obscuring the serious intent of the work, many of the boldface names were there in genuine support of Dick: Thomas Hoving, the director at the Metropolitan Museum, who was considering an exhibit of Dick's work; Harold Brodkey; Gloria Vanderbilt; Truman Capote, who had started at *Harper's Bazaar* with Dick twenty years earlier; Polly Mellen, his favorite associate at *Vogue*; Lauren Hutton, his model du jour; and Andy Warhol.

Dick had a habit of visiting his own exhibitions, standing around incognito, and listening to the comments about his work. One Saturday afternoon he was at the Marlborough gallery and Muriel Rukeyser, the poet—and one of the subjects in the show—walked in. Earlier that spring, he had heard her give the commencement address at his son's graduation from Sarah Lawrence, so he walked right up to her in the gallery and told her how much he enjoyed her speech. Then, in a preemptive move, he said: "I just want to tell you before you look at your portrait the way I feel about it. It's like a great comforting storm coming at me." Her reaction to her portrait did not go as well as he had hoped. Years later he would conclude his anecdote about running into Rukeyser that day with this rueful comment: "Women who are photographed by me have an expecta-

tion since they think I photograph beautiful fashion models, but I don't think Muriel Rukeyser expected to be seen the way she looks in my portrait," Dick said.

Dick did not have the benefit of hearing *this* welcome comment about his show that would have been of particular resonance to him: "I found it magnificent," Irving Penn told Robert Stevens, a graduate student who, in 1978, interviewed Penn for his master's thesis on Avedon at the Visual Studies Workshop. "It was a new way of presenting photographs; exhibitions of photography will never quite be the same. Avedon dared to break through the conventional scale; those pictures were not just blowups—they reached their full meaning in the large scale." It is of historic note that, two years later, Penn had a show of photographs at Marlborough in which the size of his prints equaled those of Avedon's, the subject of which were cigarette butts he had collected off the streets of New York.

The Marlborough show, despite the uneven reviews, had been a milestone in Avedon's career, though the last months of 1975 were imbued with sadness. Laura Kanelous, who had been Dick's business partner in all but name for more than twenty-five years, kept her diagnosis of cancer secret until the last weeks of her life. With her unique urban sophistication, business acumen, wit, style, and unbounded loyalty, she was nothing less than Dick's ambassador to Madison Avenue, someone on whom he could always rely and who helped make him a very rich man. "Laura and Dick were very good friends," Chick, the studio bookkeeper, said. "They grew up together in this business. Dick visited her every day at Mount Sinai hospital in the last month of her life." Laura died on Christmas Eve. "Dick was with me and my father when Mom died in the hospital," Helen Kanelous said. "We didn't have a funeral—Mom had a horror of them, she thought they were morbid. Instead we had a memorial *celebration* or *reception* held at the St. Regis Hotel

in New York." Helen described it as neither a party nor a formal memorial. There were no official speakers, per se. "Instead, most of the guests—friends, family, and colleagues—spoke to me and my father and to each other. Of course, Dick was there, and I think he was quite nearly as devastated as me and my father."

RICHARD NIXON'S IGNOMINIOUS RESIGNATION from office in 1974 was occasion enough to warrant the collective soul-searching during the 1976 presidential campaign, but it was also the year of the US bicentennial, which only underscored the tarnish of a derailed presidency on the country's legacy. "I had been trying to figure out how to cover the election in 1976," Jann Wenner, the publisher of *Rolling Stone* magazine, said, pointing to the success of Hunter S. Thompson's gonzo campaign coverage for the magazine in 1972 and the resulting book, *Fear and Loathing: On the Campaign Trail '72*, as an example of his editorial aspiration. Wenner wanted to reach new journalistic heights, but he wasn't sure how to do that. He knew Avedon enough to call him up and ask if he would make portraits of the candidates over the course of the campaign, to be published in consecutive issues of the magazine leading up to the election. He knew it would be worthy and add prestige to the magazine, but it was by no means a groundbreaking idea.

Dick accepted the assignment, but within days, he called Wenner back to say he had a large idea that required a conversation at greater length. Wenner was invited to lunch at the studio, where a big feast had been laid out; Dick opened a bottle of wine. "It was just Dick's style—his flair and drama and craft in salesmanship," Wenner said. Dick wasn't satisfied with only making portraits of the candidates. He thought that the greater historic subject was the bicentennial, an occasion that might better be marked with a sweeping look at "the whole power structure of America." He

proposed to do a series of portraits of the most influential figures in government and industry as a portfolio for a special issue of the magazine. Certainly, it was an unprecedented approach, and, undoubtedly, it would break new ground. "Overall it was a much better, deeper, richer, profound idea than I had presented to him," Wenner said, acknowledging his excitement about the prospect and his willingness to let Dick run with the idea. "It was so much fun working with him because he had, very Dick-like, complete control of the project."

Avedon set out to create an inventory of individuals who, like each member of the Mission Council, stood before the tribunal of his camera to be held accountable. History alone would judge how well they represented the idea of democracy in America, how well they served the good of the American people. But who were the most powerful individuals in American society across government and industry?

When Dick got a list of possible subjects from *Rolling Stone*, he called Renata Adler to help him organize the project, research the subjects, and make the contacts. Just as Marguerite Lamkin had helped him find individuals in the South to photograph for *Nothing Personal*, and Doon Arbus helped him find subjects to interview for his "Hard Times" project, now Renata would help him identify the people who both typified and symbolized the predominating network of power in America. Renata brought a unique expertise to this project, as she had sat in on the 1974 Nixon impeachment hearings.

When Dick called Renata about the *Rolling Stone* project, "I was very depressed at the time," she recalled. "I was staying in my parents' barn in Danbury. . . . You see, I get these lazy depressions and I don't do anything—for weeks or months or years." Dick wanted her to look at the *Rolling Stone* list because he felt it to be inadequate. "Yes, I think there's something very wrong with their list,"

she told him. It was a roster of people the magazine considered im-
portant, but Dick and Renata composed another, more trenchant
list, and then set out to arrange the sessions. Between January and
October 1976, Dick photographed sixty-nine people. The entire
October 21, 1976, issue of *Rolling Stone* was given to the portfolio,
opening with the Joint Chiefs of Staff across a two-page spread. A
partial list of the other subjects is categorized here, although they
were sequenced without categories in the magazine: presidential
candidates past, present, and future (Gerald Ford, who was in of-
fice, and Jimmy Carter, who was about to be elected; Ronald Rea-
gan; Eugene McCarthy; Hubert Humphrey; George McGovern;
George H. W. Bush); members of Congress (Bella Abzug, Tip
O'Neill, Barbara Jordan, Thomas Eagleton, Shirley Chisholm);
union leaders (Leonard Woodcock, George Meany, Cesar Chavez,
Frank Fitzsimmons); and media executives (William S. Paley, the
chairman and CEO of CBS; A. M. Rosenthal, the executive editor
of the *New York Times*; Katharine Graham, the publisher of the
*Washington Post*; and I. F. Stone, of *I. F. Stone's Weekly*).

The portfolio did not constitute photoreportage but rather studio
portraiture made for the scrutiny of the eye and aimed at history.
"There is nothing particularly partisan in the portraits contained in
*The Family*," writes Will Blythe in *American Photographer*, using the
title of the series of photographs that ran in *Rolling Stone*. "Instead,
their detail turns viewers into modern-day phrenologists, scruti-
nizing faces and bodies as if they were secret maps of character."

While all the portraits are set up the same way—white backdrop,
straightforward gaze, the figure cropped at the waist—some stand
out more than others, but not necessarily because of the identity
of the subjects. Sometimes the generic and the specific interact in
ways that make a portrait larger and more universal than its sub-
ject, such as that of Katharine Graham, who, a decade before, was
forced to assume her husband's role of publisher of the *Washington*

*Post* after he committed suicide. She is the model of composure in her portrait, a combination of stone-faced calm and dignified vulnerability. Her glasses are perched on her sleeve as if she is about to head into a meeting, enduring with polite impatience the tedious distraction of having her portrait made. Her dress is buttoned all the way down the front, the fabric expensive but the style quite plain; her hair is well coiffed, absent any flourish. She could be an average middle-class housewife, a headmistress of a girls' school, or a prosecuting attorney. She stands without affect, without "performance," taking our measure as much as we are taking hers.

Rose Kennedy, wife of the former US ambassador to Britain and matriarch of a political dynasty, was eighty-six years old when Avedon photographed her, and the weight of tragedy in her life is countered by a regal stoicism in her face. She is dressed beautifully, as if for a portrait by John Singer Sargent, tastefully appointed, elegantly coiffed, her simple couture gown layered with fabric that crosses her chest and folds into sleeves over her arms, which hang straight at her sides. Roger Black, the art director of *Rolling Stone* in the 1970s, said that Avedon intended "The Family" as a novel. "You'd pore over a face like a page of prose." His portrait of Rose Kennedy might well typify the manners in the novels of Edith Wharton and symbolize the epic Greek tragedies of Aeschylus. In order to convince her to be photographed, Dick had sent an assistant to Hyannis Port, on Cape Cod, via seaplane, to hand-deliver a box of long-stemmed chocolate-dipped strawberries to her directly. He billed it as an expense to *Rolling Stone*.

Avedon's picture of Daniel Patrick Moynihan, US senator from New York, is unlike so many of his portraits. Despite the unadorned white background, Moynihan's gesture comports with the pyrotechnics of his eloquent oratory, his hands on his hips, his elbows butted up against both sides of the frame, his eyebrows hovering high above his eyes, his lips in a tight impish grin, the fabric

of his suit jacket pulled by his arms as if a curtain opening on his dandyish bowtie. Moynihan's assertion of will—and visual wit—contradicts the strict discipline of Avedon's frame, establishing his singularity among his senatorial peers—and among Avedon's subjects. Avedon's son would marry Maura Moynihan, the senator's daughter, in 1990.

One name Dick did not know was Mark Felt, the deputy director of the FBI, and he couldn't understand why Adler insisted on his qualification for this pantheon. "Dick, I can't explain it, you just have to go down there and see him, and you'll see why," Renata told him. Felt was bitter because Nixon had not appointed him director of the FBI after J. Edgar Hoover's death. "So, there's Mark Felt, and Dick came back by helicopter and said, 'I've never seen anybody like that in my life!'" Renata remembered. It was not until after Dick's death in 2004 that Felt confessed to being "Deep Throat," the secret source of information about the Watergate break-in reported by Carl Bernstein and Bob Woodward in *All the President's Men*.

On June 2, 1976, when Henry Kissinger, the secretary of state under Nixon and Ford, and arguably the most powerful man in Washington, arrived to be photographed, he said to Avedon in beseeching understatement, "Be kind to me." Dick's portrait of him is neutral. Kissinger, a canny intellectual with unique expertise on global affairs, had a gravelly baritone voice that resonated gravitas. He stands in suit and tie, his expression opaque, his entire physicality as stiff as a column at the Lincoln Memorial. While he wielded inordinate authority over world affairs, he looks as if he may not have fared well in the schoolyard as a child. "Power is the ultimate aphrodisiac," he famously said, describing his own experience, but also characterizing the undefinable magnetism that made him so attractive to women. In Avedon's portrait of Kissinger, it is hard to separate the knowledge of the man from the figure presented in the

picture. And yet there it is, a "history portrait," with the relevance of world events adding dimension to a nondescript individual.

Dick wanted Renata to write short biographies of all the subjects, but, given the complexities of describing someone like Mark Felt, she thought it would be too confusing and suggested, in service of neutrality, publishing instead their *Who's Who* biographies—the Wikipedia of its day—which is what *Rolling Stone* did.

Avedon went to Saint Louis to oversee the printing of the *Rolling Stone* issue. "Now, I had changed something in the introduction, the editor's note that Dick had written," Wenner recounted. "I changed something about Renata's role in it, a modest change. Dick freaked." He called Wenner, apoplectic, demanding that he stop the presses to restore the editor's note, which had given credit to Renata Adler for her contribution, but the rolls with vast sheets of paper were already flying by in streams at 150 miles per hour, the magazine being printed before Dick's eyes. They couldn't change the plate until the end of the first print run, but that did not satisfy Dick. He went upstairs, stood next to one of the immense rollers, and with his hotel room key, sliced into the paper as it was speeding through the vast labyrinth, which, like cutting a taut rubber band, sprung the reams loose and brought the rollers, flapping with sheets of paper, to a halt. "He sabotaged the press run," Wenner said. "It cost a pretty penny. I knew the press had broken down but Dick didn't tell me for almost a year that he [was] the one who sabotaged it." Avedon was proceeding from the injustice of depriving Adler proper acknowledgment for this collaboration.

Within his close circle, Dick was known to be, at times, as vindictive as he was generous. Gideon Lewin, Dick's studio manager, had to endure Dick's peremptory acts of revenge on more than a few occasions. He was always satisfying Dick's spur-of-the-moment needs and far-flung ideas, whether finding him a new studio, custom-building his apartment, or staying until midnight to

print images over and over again to bring them to Dick's level of perfection. He also managed the daily studio and supervised the studio assistants and the darkroom technicians, who were paid so little that they were barely able to support themselves. At one point, Gideon lobbied Dick to give the staff a raise, but as far as Dick was concerned, his assistants were lucky to be working in his studio, given the level of knowledge they were gaining. They were being fed during the day, sometimes with grand feasts and sometimes in the company of remarkable people. Dick thought they should be grateful. One day, in utter exasperation, during a studio lunch in front of the staff, Gideon brought up the subject of a staff raise to Dick. Dick kept his composure and reluctantly agreed to a 10 percent raise. Then he called Gideon into his office and let him have it. "How dare you," he seethed, accusing Lewin of ambushing him. "Okay, they get raises, but I am cutting your salary by ten percent."

In the case of Adler, it was not with total selflessness that Dick stopped the presses to preserve her honor. He had always aligned himself with the best writers of his generation: Truman Capote had written the essay for *Observations*, James Baldwin for *Nothing Personal*; Dick wanted to showcase Renata Adler's name because it added intellectual weight to his portfolio in *Rolling Stone*, an alternative magazine that may not have been quite up to his standards. And yet despite his doubts, "The Family" would become one of his most enduring bodies of work. All sixty-nine portraits in the portfolio now reside in the collection of the Metropolitan Museum of Art.

# MUSEUM PIECE

(1977–1980)

> In the room the women come and go
> Talking of Michelangelo.

—T. S. ELIOT

The bright blue banner above the entrance to the Metropolitan Museum of Art unfurled to a depth of thirty feet, with Avedon's name printed almost fifteen feet across it in the casual script of his own signature. In 1978, not only did the prominence of *his* name on the facade of *that* museum give more symbolic weight to photography in the precincts of high art than all the scholarship about the medium until that point combined, but the media attention generated by the show grounded the idea of photography as art into the public imagination. *Avedon: Photographs, 1947–1977*, which opened on September 14, was the first retrospective exhibition of a living artist at the museum; the first

exhibition of its size (more than 185 pictures) and scope (thirty-three years) by a single photographer; and the first exhibition that featured fashion photography in depth at any major museum.

On the occasion of this milestone, *Newsweek* published a cover story called "The Avedon Look," in the October 16 issue. In a self-portrait Dick stares out under the *Newsweek* logo, his glasses hovering on his forehead, his dark eyes penetrating, his expression alert and intent as he stands beside his Deardorff camera. "Fashion work has long attracted photographers who shadowed the fine arts like bloodhounds," writes Charles Michener in his profile of Avedon, listing examples such as "Baron de Meyer, who drew from the gauzy pictorialism of Whistler; Edward Steichen, who appropriated art deco; surrealists like Man Ray; neo-Victorians like Cecil Beaton; open-air realists like Munkacsi. . . . Avedon's work shows debts to so many of these styles, but he did something unique: he democratized fashion."

The exhibit was seven years in the planning, going back to 1971, when Dick and John McKendry first discussed doing a show of Avedon's fashion work. After McKendry died, in 1975, Ashton Hawkins guided the project through the administrative bureaucracy of the museum, playing an instrumental role in bringing the show to fruition.

As a lawyer for the Met, Hawkins was a kind of rainmaker, serving a unique role between curatorial interests and society patronage. He once accompanied Bill Lieberman, a curator at the Met, to Santa Fe, where he was working on a project with Georgia O'Keeffe. When she came to New York, everyone wanted to meet her. "So, I had a party for her in 1977 or '78," Hawkins said. "Jackie [Onassis], Lillian Hellman, *Dick* and Andy [Warhol] and Diana [Vreeland] all came to my house for dinner one night. No one talked but everyone listened to Georgia O'Keeffe, who held court the entire evening." This successful gathering was his version of community relations.

Hawkins could be seated next to someone at dinner who would fund an entire exhibit or get a former Harvard classmate to put up the money for a major acquisition. For the Avedon exhibit, he wrote letters to friends soliciting support, and he succeeded in obtaining the funds from Mitzi Newhouse, whose foundation put up $85,000 to pay for the show. "It was so much more familial then, friendly, elegant, artful," Johnnie Moore Hawkins, Ashton's husband, said about the process of raising money. Of course, while Mitzi Newhouse was genuinely enthusiastic about the idea, the arrangement was incestuous: the Newhouse family owned Condé Nast, the publisher of *Vogue*, Avedon's employer.

In his role as in-house counsel, Ashton Hawkins negotiated the terms of the exhibit, representing the museum, but equally his good friend Dick. The final letter of agreement gave Avedon inordinate control over his own show at a renowned institution where curatorial deliberations took place as if they were Supreme Court proceedings. "All decisions regarding the content of the show (number, size and subjects of the photographs) will be made by Mr. Avedon subject to final approval of the Museum's Department of Prints and Photographs," states the agreement. And while the museum had final say over the mounting and lighting of the show, as well as all publicity and promotion, these elements were also subject to Avedon's approval.

Colta Ives was the curator in charge of the Department of Prints and Photographs at the museum. There were people at the institution who felt it to be inappropriate to show a living artist, much less a photographer, never mind a *fashion* photographer. "But in the curatorial circles I was in," Ives said, "there was no prejudice against photography whatsoever." While the amount of control Avedon had over his show raised eyebrows, Ives was unfazed. She was happy to honor the memory of her mentor, John McKendry, and the Avedon show, she said, was "fulfilling one of John's dreams."

"I was in the galleries every day while Dick was hanging the show," Ives explained. Avedon had definite ideas about the photographs he wanted to include and where they should go, often consulting Elizabeth "Betti" Paul, his young designer, and relying on her judgment about the sequence and the size of images, perhaps in the absence of Marvin Israel, who had recommended her, and with whom he had worked so closely on his previous exhibitions until their falling-out over the Marlborough show—when, last minute, Dick had Marvin's name as the exhibition designer removed from the marquee wall on the day of the opening. Of course, he consulted Ives, too. "Dick was courtly in his respect and collaborative spirit, even though, in the end, he was making the decisions," she said. "He seemed so delighted by the whole enterprise." Ives believed that Dick's artistry was in setting the stage, an awareness she recognized as a quality of his fashion images as well. She considered his sense of space and staging to be a strength of the show and spoke of an atmosphere of excitement during the entire installation.

John McKendry's widow, Maxime de la Falaise, was also gratified by the realization of this exhibit. "For me to be finally present at the opening of this show was a strange experience, with feelings of loss and of triumph and pleasure that something [my husband] started was completed," she wrote. "I had modeled for one season for Avedon and knew the clothes in the show so well I could almost point to the spot that was too tight or loose on me, remember the color and the feel of the wool on a Schiaparelli suit, the tiny landscape on the hand-painted button."

The opening of the Avedon exhibit started at nine p.m., following a private dinner, and the line of people spread down the front steps of the museum into the street. Stephen Koch, author, educator, and, also, director of the Peter Hujar Archive, attended the opening with Hujar. "If Peter was going to be ignored by Avedon, he did not want to endure the humiliation alone," Koch said, describing

Hujar's discomfort about seeing Dick after a decade-long silence that followed a year of intense, intimate, late-night phone conversations between them. "It was jammed, one limo after another, and in the big hall Avedon was at one end, and all of New York society lined the corridor. Peter was quite stiff and worried. We walked about ten feet in and Avedon threw out his arms and yelled 'Peter!' then ran toward him and embraced him while camera flashes went off. I never saw Peter again for the rest of the night."

The show was divided into five rooms, in which the work was presented consecutively, each room representing a period in Avedon's evolution as a fashion photographer, and then, in the final room, selections from his portraiture. The pictures grew in size from one room to the next, from small and conventionally framed to the final individual portraits that hung loose on the wall, as if photographic tapestries. "On one level, the progression from small to big mockingly traces the photographer's rise from modest beginnings as an eager toiler at *Harper's Bazaar* to his current status as the biggest and richest and most celebrated fashion photographer in our galaxy," writes Janet Malcolm in her *New Yorker* review. "On another level, and, quite seriously, it expresses Avedon's sense of himself as an expanding artistic consciousness. Finally, it is a kind of meta-statement about the almost monstrous complexity of Avedon's late vision of art." While Malcolm suggests that Avedon was, at times, trying too hard, she acknowledges his success at achieving a new style: "His shrewd recognition of the fact that to join the ranks of the masters he must do more than imitate them drove him to lengths of artifice that fashion photography had hitherto not seen. These ruses and tricks were so persuasive, the inventions and ideas so ingenious, that to this day Avedon's reputation for naturalness and spontaneity is undimmed."

As for his portraits in the show, all of them women unknown to the general public (June Leaf, Renata Adler, and Loulou de la

Falaise, daughter of Maxime), Malcolm remarks on the difference between his published portraits, which seem more human and accessible, and those on the wall, whose monumental size forces the viewer to contend with images of strong women. With the Met portraits, she concludes, "Avedon continues the work that commenced with the great, unbearable studies of his dying father, about which there is 'nothing personal' (to borrow the telling title of Avedon's second collection of photographs), and in whose implacable objectivity lies a description of photography as well as of our common fate."

The idea that Avedon's work is about "a description of photography" is seminal to an understanding of his oeuvre. All artists deconstruct the form in which they are working—whether unconsciously or deliberately—to reveal what Owen Edwards once referred to, in Avedon's case, as "the shadow of his meaning." In Avedon's portraiture, in particular, the choice of camera, the consistency of format, the moment of exposure, its optical precision, his forensic presentation, the quality of the print, and the size of the image are all photographic properties to which he paid exacting attention. These portraits, his subjects ranging from the most celebrated to the least known, would not be as significant to portraiture itself without the technical and aesthetic challenges Avedon threw at the medium to advance the art of photography itself.

Over the years, critics dismissed Avedon's portraiture as too formulaic to be anything more than high stylization. It's true that he stripped his portraits to nothing but the figure in the frame, the subject staring into the camera, "every wrinkle, stubble, wen and nervous tick" visible on a face; but it is a mistake to conclude that his uniformity of style is a mere formula that lacks the substance of artistic insight, the promise of revelation. The utter simplicity of format is the message: All of us lost our innocence when we arrived at the ability to annihilate ourselves. The stark outline of

the individual against the postnuclear white backdrop is worthy of our contemplation, whether we get lost in the complexity of the individuals' faces, the mythology of certain subjects, or the somber mood that is consistent through the sum of his portraiture. Avedon pushed the technology of the photographic process to its very limits to enable us a clear-eyed, uniform look at ourselves—honestly, directly, soberly. The camera is a machine that sees us more clearly than we can see ourselves. Avedon knew that. Warhol knew that. "The photographs have a reality for me that the people don't," Avedon said. "It's through the photographs that I know them."

In 1977, Susan Sontag published *On Photography*, a collection of essays she had written throughout the 1970s for the *New York Review of Books*. In April 1978, Avedon photographed Sontag for an upcoming feature in *Vogue* by Elizabeth Hardwick, who called Sontag "a romantic of the intellectual life." Three months later Sontag wrote a meditation about Avedon's work in the same magazine on the occasion of his exhibit at the Met. Called "The Avedon Eye," the *Vogue* feature opens with a portrait of Dick taken by Irving Penn, in which he is holding his hand over his face, his forefinger and middle finger spread to reveal the penetrating intensity of his left eye. The picture echoes another Penn portrait, of Picasso, in which the artist's eye is the focal point around which the rest of his face recedes into shadow. Sontag writes about fashion photography in philosophical terms: "Fashion is an acute mentalizing of the erotic," she asserts. "Its subjects are beautiful women, and women comprise most of the audience for these images when they first appear in magazines: women scrutinizing images of women— for an idea of the erotic." She follows an evolution of fashion over time from the royal court to the drawing rooms of "society" to the eventual democratization of style. "This ongoing transformation of fashion, its so-called death and its rebirth as a much larger subject for photography, explains much of the shape of Richard Avedon's

prodigious and varied activity," Sontag writes. "Endlessly know-
ing about and loyal to fashion as spectacle (the theatricalization
of beauty; the erotic as artifice; the stylization of appearances as
such), Avedon has taken pains to show that fashion photography is
not limited to fashion—a development that now seems inherent in
fashion photography itself."

In Avedon's early period, the designers all came from Paris.
While he was always aware of the architecture of the clothing—
the geometries of Dior; the structure of Chanel; and, later, the
space-age materials of Courrèges—he would create an entire ethos
around the model, whether on a cobblestone street or in the Tui-
leries Garden. He invented moments of poetic regard by coaxing
his models to perform, and he captured the scene in medias res, in
effect constructing the appearance of authenticity. This inspired ap-
proach was aptly described by the haiku-like title of the early pro-
file about him in the *New Yorker*: "A Woman Entering a Taxi in the
Rain." Leading up to the 1960s, he started developing sequences
in which each fashion shot served as a "film still" in a grouping
that tracks a cinematic narrative: Suzy Parker and Robin Tattersall
on a honeymoon escapade in Paris; Suzy Parker and Mike Nichols
escaping the paparazzi in a high-drama European caper; or the
Spanish Abascal twins in a ménage à trois with a Brazilian aristo-
crat in an island idyll out of *The Sheltering Sky*. Each continuous
narrative exists solely as a platform for the clothes.

Bill Cunningham, who chronicled the intersection of fashion
and culture in New York for nearly a half century, had two weekly
"photographic columns" in the *New York Times* that presented both
street fashion and the ceremonial formality of evening wear. Before
he took up the camera, though, he wrote expertly about the history
of fashion and the evolution of style, and, in 1978, he wrote a full-
page review of the Avedon show in the *SoHo Weekly News*:

"Seventy-five years ago, Edward Steichen started the chain of

events that has culminated in photography being thought of and looked at as art. It is ironic at this time, when the Steichen vision appears full-focus, that the main event should be fashion photography," writes Cunningham. "Fashion pictures have long been considered by museums and purists as commercial fluff and an insult to serious photo exhibitions. The critics fail to see that fashion photography, while seemingly frivolous, and often retouched, like a painter repaints his canvas, can mirror just as accurately the real world."

A lavish publication accompanied the exhibition at the Met, *Avedon: Photographs, 1947–1977*, with a ponderous essay of unfortunate incomprehensibility by Harold Brodkey. The selection of pictures underscores the fact that not all of Avedon's fashion work survives the migration from magazine page to book format or museum wall. Some do, however, such as Renée pirouetting in a Dior skirt in the play of sunlight on the place de la Concorde; Dorian at the mirror in the marble bathroom of Helena Rubinstein's apartment on the Île Saint-Louis; Dovima and the elephants at the Cirque d'Hiver; Sunny leaning on a roulette table at Le Touquet; Suzy backstage at the Folies Bergère; Carmen leaping across a cobblestone curb. These photographs transcend their original purpose and reside today with enduring resonance as defining examples of "a way of being" at a twentieth-century moment of infinite possibility.

By turns, the better book—and the more vital publication in the conversation about Avedon's historic significance—is *Portraits*, published in late 1976 following the Marlborough show, with an essay by the art critic Harold Rosenberg, a serious rumination on the nature of portraiture in photography in the context of art history.

*Portraits* opens with Avedon's first portrait of Renata Adler, taken in 1969. His portrait of Evie is in sequence after June Leaf. There are more portraits of writers in the book than artists, among them

Jorge Luis Borges, Gabriel García Márquez, Henry Miller, Isak
Dinesen, Carson McCullers, Truman Capote, Harold Brodkey,
and William S. Burroughs. Artists include Willem de Kooning,
Jasper Johns, Andy Warhol, and Robert Frank. Among several
unexpected portraits in this pantheon of arts and letters are John
Szarkowski, curator; R. D. Laing, psychiatrist; and Dr. Lothar
Kalinowsky, Evie's psychiatrist and the advocate of electroshock
therapy; Herbert Marcuse, professor of philosophy; Joe Babbing-
ton, the caterer across the street from his studio; and Rose Mary
Woods, presidential secretary. There are several foldouts for the
mural portraits: the Chicago Seven, the Warhol Factory, the Mis-
sion Council.

*Portraits* is arguably Avedon's most lucid book of photographs.
Modest in size—eleven by fourteen inches—the work is presented
in a uniform, straightforward manner, one picture per page. In
late 1975, Avedon hired Alicia Grant Longwell, a young woman
who had worked in the registrar's office at the Museum of Modern
Art, to establish and maintain his archive of noncommercial pho-
tographs. "Dick would have certainly discussed with his intimate
circle whom he should ask to write the essay," Alicia said about the
choice of Harold Rosenberg. "To have the leading critic of Abstract
Expressionism bring his cachet to the project was key. Dick sought
this art world connection." The studio made an initial contact with
Rosenberg, who was not only the art critic for the *New Yorker*, but
also at that time teaching at the University of Chicago. In a mission
Alicia described as "*very* Dick," he dispatched her on a plane to
Chicago armed with a mock-up of the book. "I rang the doorbell
and was graciously received," she said. "Harold Rosenberg spent a
thoughtful hour looking at the dummy and then acquiesced."

In his essay, Rosenberg, who in the early 1950s ascribed the term
*action painting* to what Jackson Pollock, Willem de Kooning, and
Franz Kline were doing, later to be called *abstract expressionism*,

suggests that the difference between painting and photography in their relation to reality could be "summed up in the notion that painting as an art has been freed of its 'literary' aspects by the advent of the camera." He quotes Picasso, who believed that photography had reached the point where "it is capable of liberating painting from all literature, from the anecdote, and even from the subject." While painting had become nonrepresentational, Rosenberg posited, "'stories' had become the province of the photograph."

He raises an interesting paradox about portraiture in the early days of photography, when sitters were posed before the camera in the same way they had sat for painters. "In turn, painters depended on photographs for more accurate likenesses," he writes. "In most of the painted and photographed portraits I have compared, the photograph is superior in credibility and depth and in uniqueness of expression. The often-reproduced daguerreotype of Poe is far more mysterious and intriguing than the etching by Manet." Rosenberg asserts that in order for a photographer to achieve anything approaching the truth, it is necessary to curtail his resources. "Avedon is difficult as a photographer, in the same way Barnett Newman and Clyfford Still are difficult painters. Like them, Avedon is a 'reductionist,' that is, one who purges his art of inessential or meretricious elements. . . . He meets each individual head-on; he is allowed only such grace as may come through the vacant stare of the lens."

IN EARLY 1976, SOON after Laura Kanelous's death, Dick asked Norma Stevens to come work for him as his business manager. Norma had been in advertising, worked as a creative director and copywriter, and understood the anatomy of salesmanship. She was married to Martin Stevens, a creative director at Revlon who presided over the cosmetic company's advertising department, and

with whom Dick had worked on the brand's major ad campaigns for years. Not only was Norma a Madison Avenue insider who brought stealth expertise to her representation of Avedon in the advertising world, she was also a firecracker—savvy, fun-loving, kind, with a laser-focused intensity when it came to driving hard bargains. She turned out to be a perfect fit for Dick in her ability to navigate his cool and calculated business expectations and his wildly mercurial creative demands. Over the years, Norma would become as close to Dick as a spouse in terms of their deeply entwined day-to-day engagement as business coconspirators, and, equally, as parents of the studio household.

"*Work* was not the only four-letter word that made the studio tick," Norma Stevens wrote. "*Food* was the other." Every morning, breakfast was provided on the studio's budget by the assistants, who took turns picking up breads from one bakery or pastries from another, the local choices being, of course, first rate, whether William Greenberg, say, or William Poll. "Dick would usually pop downstairs in time to pick most of the pecans off everybody's pastries," she writes, "then help himself to a spoonful or two of jam straight from the jar that he had brought back from Paris and to a couple of slices of apple slathered with Skippy peanut butter."

While Dick could be enormously expansive in his generosity and informal and inclusive with his staff—one working premise of the studio was "the family that eats well together works better together"—he could, unexpectedly, throw a tantrum at the least imagined offense or some incidental disappointment. Stevens describes in her memoir a dizzying array of capers and adventures as Avedon's sergeant at arms: for more than a quarter century, she brought in a steady and abundant stream of lucrative accounts, solved interminable and wide-ranging studio problems, and served as much a business adviser for Dick as a personal confidante. While there were spectacular rewards—flying first-class

to Paris, attending opening nights in parterre seats at the opera, cavorting with Dick's accomplished friends, having her clothes made directly by designers—they came with a retributive share of irksome injustices. Dick could be *divine*, but he exacted a price for all of the goodwill whenever he woke her up at two a.m. to share a spur-of-the-moment bright idea, or if she was forced to cancel important personal plans with her young children at the last minute whenever his needs—personal or professional—dictated.

Owen Edwards experienced the unpredictability of Dick's behavior after five years of what had been a thoroughly delightful and affectionate friendship. In the late 1970s, Edwards decided it was time "to write *my* piece about Dick and not *Dick's* piece about Dick." His profile of Avedon appeared in *American Photographer*, where he was then the executive editor, in a sequence of profiles of leading photographers over three consecutive months. "In it I wrote that Dick was a control freak and he wanted people to live the lives he wanted them to live—as opposed to who they are," Edwards explained. "Of course, he wanted to see it before it came out, but that wasn't possible." When the piece was published, a case of Dom Pérignon arrived for Edwards in the lobby of his doorman building, with a note from Avedon: "Wonderful article. I grovel. Dick." It was verboten for a journalist at a major news organization to receive gifts from the subject of an article, but the ethical conflict was more ambiguous in the context of trade publications, and Edwards was more than pleased to receive Dick's extravagant present. Yet ten days later, when his colleague Sean Callahan, the editor of *American Photographer*, asked Avedon to make a cover portrait of Hiro for a subsequent issue, Avedon refused: "Owen Edwards writes gossip instead of truth," Dick scoffed. "I will never do anything for you people again." Edwards and Callahan were both left scratching their heads. Edwards returned the remaining bottles of Dom Pérignon to the Avedon studio with a note say-

ing, "You didn't really mean to send these," and then received from Dick a nonvintage ordinary magnum of champagne with a note: "You wrote what you needed to write. I said what I needed to say. And, now we can move on."

Meanwhile, the studio was in an upward transition in the mid-1970s. As Dick's reputation as an artist grew, his awareness of his legacy demanded a new kind of attention. "Dick had a long view of his career," Alicia Grant Longwell said. Her first task as the studio archivist was to make sure there were edition prints of the images Avedon had given to the Smithsonian when he had his show there in 1962. "My recollection is that the prints had been made at the time of the gift and just never 'editioned,' i.e., signed and numbered—never closely reviewed, in fact," Alicia said. Some of the prints were inferior, and Dick ordered those destroyed and new ones made. "Dick could not have foreseen the scope of the art market for photography as it increased in the 1970s, but he believed enough in himself and in his work to know that the gift to the Smithsonian valorized the photographs." That was only the beginning of a symbiotic process in which his gifts to museums over the years would not only "valorize" his work, but also increase its value in the marketplace.

In the years between his 1975 exhibit at the Marlborough gallery and his 1978 show at the Metropolitan Museum, Dick continued to go to the theater religiously. He would have been among the first to see *A Chorus Line*, at the Public Theater downtown, before it went to Broadway; Bob Fosse's *Chicago*; *Equus*, starring either Anthony Hopkins or Richard Burton; and his friend Stephen Sondheim's *Pacific Overtures*. One of the most important theatrical events in the mid-1970s, however, was the five-hour avant-garde opera *Einstein on the Beach*, at the Metropolitan Opera, in 1976, a premiere not unlike that of *The Rite of Spring* by Stravinsky, in Paris in 1913, that caused a riot as people stormed out. Some people

walked out of *Einstein*, too, in part because of its length, but also because of the trancelike, synthesizer-based music that was so radical at the time. Still, theater critics and music critics found it more palatable than an opera-going audience.

Dick photographed the creators of *Einstein on the Beach* in his studio for *Vogue*, and the picture ran above a lengthy caption that read: "Is the vanguard dead? No—not while theater-man Robert Wilson collaborates with composer Philip Glass, choreographer Andrew deGroat, and a pride of actor-singer-dancers ranging in age from 10-year-old Paul Mann to gorgeous Lucinda Childs to almost-octogenarian Samuel M. Johnson. . . . *Einstein* is already being hailed as a maximum-minimalist masterwork of twentieth-century art."

Avedon's picture of the *Einstein* team has all the elements of his multiple mural portraits in a single image. Here the figures do not appear in a lineup across multiple frames; instead, they compose a single tableau of spatial choreographic gesture: they are posed against a white background of indeterminate depth in an ambiguity of space created by the cyclorama. Philip Glass and Robert Wilson stand full length, facing each other and stepping forward, as if to frame the three other figures behind them, respectively sitting, lying across a table, and standing on a stool, their limbs in acrobatic suspension. This portrait is most resonant of Avedon's 1960 photograph of John Cage, Merce Cunningham, and Robert Rauschenberg—clearly the *Einstein* team's avant-garde antecedents. Once again, Dick documented history in the making.

Meanwhile, a drama of another stripe unfolded in real life in the summer of 1977, one with characteristics of the Theater of the Absurd, had it not been more tragic than it was perverse. The Avedon studio began receiving intermittent phone calls from unknown women who claimed that Dick had promised them studio sessions with the intent of turning them into fashion models. It was a mys-

tery with a pattern, and soon enough Dick notified the police. He began working with detectives quietly to capture a "rapist" who had been preying on unsuspecting women outside New York by impersonating Richard Avedon.

On September 17, an item appeared in the *New York Times* with the headline: "Suspect in Rape Called Impostor of a Celebrity." The police in Washington, DC, arrested a man "suspected of impersonating Richard Avedon, the fashion photographer, to pick up women to swindle and sometimes rape. . . . The suspect is Oscar Edward Kendall, 33 years old, who is baldish, 6 feet 5 inches tall and weighs 220 pounds." Kendall, who looked nothing like Avedon, had approached over thirty women in cities around the country, introducing himself as the famous fashion photographer and promising them careers in modeling. In an age before the Internet, they couldn't know that the impostor in no way resembled Dick, despite the fact that most of them had recognized his name.

Aram Saroyan recounted an evening not long after when he and his sister, Lucy, were visiting Dick in New York, sitting in "his luxurious cave, with books piled in stacks on the floor," and Dick delved into the story of his would-be doppelgänger. "Dick had managed to contact the man, meet with him, and do studio portraits of them both in similar poses," Aram wrote in a small-press memoir about his friendship with Avedon. Dick showed them the pictures, which Saroyan described as being Avedon-like portraits of them both from the waist up, shirtless, their belts unbuckled to the top button of their trousers. When Saroyan mentioned something about the seminakedness, Dick nodded, making a puerile reference to his curiosity about comparing "cocks," but having stopped short of going through with nude portraits.

In the summer of 1978, the Marcuse Pfeifer gallery on Madison Avenue mounted a photography exhibit called *The Male Nude* that roused a great deal of critical controversy in the press. A review

in the *Village Voice* disparaged the male nude as a valid subject of aesthetic contemplation, characterizing the male genitalia visible in many of the figures as "phallic symbols between the legs," thereby claiming it was a show about homosexuality—despite the fact that many of the seventy-five photographers represented were heterosexual, and a portion of those were women. Peter Hujar's picture *Bruce de Sainte Croix*, presenting a man sitting naked in a chair contemplating his own erection, ran with the review of the show in the *Voice*, the first time a picture of a man in flagrante had been published in a mainstream, albeit alternative, newspaper. The picture wasn't even in the show, although edition prints of the image were available in the gallery. One day, Avedon's car was double-parked in front of the gallery while he went inside and purchased the Hujar picture. Over time, Dick purchased several important pictures by Hujar—many years before Hujar's work would be regarded as perhaps even more significant than that of Robert Mapplethorpe.

IN THE SUMMER OF 1977, Dick had gone on a luxurious excursion of sorrowful purpose. His dear friend Felicia Bernstein, to whom over the years he had become even closer than Lenny, was being treated for breast cancer. While she was in remission, Dick took her to the island of Patmos, one of the most beautiful places he could think of, where there was an expanse of blue ocean and white hillsides, and good friends, and good food, and leisurely activity, and a contemplative kind of quiet. They stayed at the Grikos Hotel, a small, simple, comfortable, open-air hotel in the sleepy harbor, just down the hill from Ashton Hawkins and Tim Husband, where Renata Adler was also staying, and, during the day, either they would all go out on the boat, or Dick and Felicia would walk up to Owen Edwards's house—pre–Dom Pérignon— and work in the garden. Felicia loved to garden and, for years after

that trip, Edwards said that he and his wife referred to their hill-side courtyard as the "Felicia Bernstein memorial garden." "Dick took an amazing photograph of my mother," Jamie Bernstein said about that trip to Patmos. "It's very meaningful, and you can tell how warm the whole relationship was." Felicia died in June 1978. Many years later, Dick and Mike Nichols—also a close friend of the Bernsteins—instituted an annual dinner for Jamie, Alexander, and Nina, a get-together to pay homage to Felicia, their mother. "It was always in a good restaurant," Jamie remembered, "Babbo or Craft." Dick and Mike always treated.

It had to be very soon after Felicia's funeral, and during the final preparations of his show at the Metropolitan Museum, that Dick had a second flare-up of his heart condition. The doctor prescribed a period of rest, and Dick spent several weeks recovering at a ranch in Montana, in which he had invested as a part owner. The only people he saw while he was there were the foreman of the ranch—Wilbur Powell—and his wife. "I was like one of the cows on the ranch that he checked on every day," Dick said. "He'd walk into the kitchen to see how I was doing, there'd be a pot of coffee on the stove, we'd exchange a few words, then he'd leave." At the end of Dick's stay, he asked Wilbur if he could photograph him, and Wilbur agreed. "The Powells were so very special, and kind, in a completely undemanding way," Dick recalled. "I began to feel that this cowboy, this cow ranchman, is no different from me. He has the same concerns, in a different atmosphere."

*Wilbur Powell, Rancher, Ennis, Montana, July 4, 1978* is a portrait like all Avedon portraits—the figure appears straight on, half length, staring into the camera against a white background. There are differences as well. While Powell's hands are on his hips, his right arm juts out of the frame, his elbow cropped, in the position of some of Avedon's mural figures that seem to be exiting one frame and entering another. In Wilbur's case, he is simply standing off

center. He wears a cowboy hat, also cropped out of the frame at the top. His expression is pinched, a bit of a line drawn in the sand.

Wilbur Powell's portrait appeared in the *Newsweek* cover story "The Avedon Look," on October 16, 1978, likely because it was the most recent portrait Dick had made, and the subject was unique and unexpected in his body of portraiture. Mitchell Wilder, the director of the Amon Carter Museum of American Art in Fort Worth, Texas, which was founded on its namesake's collection of paintings of the Old West by Frederic Church and Charles M. Russell, saw the portrait of Dick's "Western cowboy" in *Newsweek* and called him up. Wilder was interested in developing a contemporary body of work on the American West and, along with a museum adviser named Robert Wilson (no relation to the director), flew to New York to meet Richard Avedon and explore the possibilities of an artist's commission.

While Wilder posited an initial idea about a series of women of the West, Dick persuaded him that it had to be broader and more exploratory. It would require Avedon to be able to spend periods of time away from the studio over the next four or five years, and the museum was in a position to endow the project. "I can't guarantee what I'll find," Dick said, "but you know my vision is not a romantic one. You know my work. You've looked at my portraits."

Robert Wilson's wife, Laura, a photographer, came on board to serve as a researcher and coordinator for the project just as Marguerite Lamkin had with *Nothing Personal*, Doon Arbus had with "Hard Times," and Renata Adler had with "The Family." They would spend the next five years on mostly summer adventures out West over a week, or sometimes a month at a time, visiting cattle auctions, rodeos, oil fields, mining towns, and any local events unique to the geography of a particular region. Their first venture was in March 1979, a kind of test shoot at a "rattlesnake roundup." Dick flew into Dallas, and they drove two hundred miles to Sweet-

water, Texas. This annual event had a practical purpose to rid the countryside of snakes that burrowed into the grasslands and rocky ledges of western Texas. Farmers and ranchers and local kids spread out across the plain to hunt the snakes, and the local Jaycees paid four dollars per pound for them—as long as they were brought in alive, since a dead snake is hard to skin and the meat spoils. Some years the hunters brought in seven thousand pounds. "They bring thousands of rattle-snakes into a big arena, cut them up, sell the rattles and the venom, and fry the meat," Dick said. "Tastes like chicken. That weekend, I began to establish many of the themes that I developed over the next few years."

They wandered through the crowd for people to photograph. His two assistants from New York had set up the Deardorff camera on a tripod in front of a nine-by-twelve-foot piece of white seamless taped to the shady side of the Sweetwater Coliseum. His first subject from that series was Boyd Fortin, one of the rattlesnake skinners, an adolescent cherub with curly locks, in white overalls, holding up a rattlesnake whose head he had just sliced off, maybe six feet long, in the grip of his two hands. He stares into the camera like a mythological figure. Laura Wilson was struck by Avedon's way of working. "He was alert, buoyant, inquisitive, and full of visceral intelligence," she said. "What distinguished him in person was the focus and intensity he brought to a conversation. His observations were disarming and he was quick in the extreme to respond to those around him. And I remember his conspiratorial approach. He would make a side comment or witty remark, or just give a glance to draw you closer."

ONE DAY IN LATE 1978, Jim Elliott, the director of the University Art Museum at Berkeley, asked his curators to draw up a list of twentieth-century artists they considered to be household

names: Picasso, of course, was at the top of the list, followed by Warhol. Avedon's name was also included. Soon after, Elliott saw the Avedon show at the Met and began preliminary discussions about bringing it to the Berkeley museum.

The University Art Museum was one of the best examples of Brutalist architecture in the country, its raw concrete exterior handsomely modulated with receding stepped-back levels that housed multiple exhibition spaces, all of which extended out from a central core gallery. While Jim Elliott had a retiring New England veneer from his years as the director of the Wadsworth Atheneum in Hartford, Connecticut, he was known to embrace the most contemporary currents in art, and he was particularly enthusiastic about photography. Only the year before he had mounted two shows of photographs from the personal collections of Sam Wagstaff, the predominant private photography collector at the time, and Robert Mapplethorpe, who collected alongside Wagstaff.

"We started from scratch and put everything together," David Ross, the museum's deputy director, said about the Avedon show. "We took every show that Dick had already done," which included his portraits of his father from the MoMA exhibit; the entire show of portraits from the Minneapolis Institute of Art; all the fashion photographs from the Metropolitan Museum of Art show; the *Alice in Wonderland* series; and more recent portraits from the Marlborough show. "The entire museum was given to Avedon," Ross said. "Of course, Dick controlled *everything*."

They worked on the show for almost a year and a half. Dick had scale models made in his studio of every gallery at the museum, and he would fly out to the Bay Area for weeks at a time, staying at Grandma's, a bed-and-breakfast off Shattuck Avenue in Berkeley, an easy walk to the museum. During the day he and David Ross would stand in the galleries and look at the photographs as Dick considered what to include in the show and how to block out

the sections. It was during these informal conversations that Ross began to formulate his own conclusions about Avedon's respective bodies of work: "I came to understand that his fashion work constituted a very personal critique of both the nature of the aspiration to glamour and the effects of that on the so-called fashionable woman—I mean the hollowness of that life," Ross said. "And those photos he took of his father, by the way, a man who, to hear him talk, was just terrible—mean, harsh, unforgiving—constitute one of the most compelling portrait series in the whole twentieth century. Because they were taken with *honesty*, which is more important than love or hate."

While Dick was working on the show, he spent time with the Berkeley luminaries of that period. Alice Waters was creating a new, healthier American cuisine at Chez Panisse, where Dick ate almost every other night. He and Waters became friends, and one night she offered him fresh sea urchin, then a rare delicacy, which he dared not refuse to eat and liked more than he expected to. Dick spent time with Jann Wenner, the publisher of *Rolling Stone* magazine, the bible for rock and roll, and his wife, Jane, whom Dick referred to as the "real Bianca Jagger." He spent time with Francis Ford Coppola, who lived in San Francisco and had a vineyard in Napa Valley. While Dick was working on his exhibition, Coppola was making *Apocalypse Now*.

"In that time, I fell in love with Dick," Ross said. "He became like my second father—so warm and thoughtful and understanding. And he identified with me because he was also an autodidact. We had the same insecurities." They would walk into a record store and Dick would whisper, "I don't know anything about classical music"—which was not true—and buy $1,000 worth of records, and then they might get stoned and spend hours listening to the music. "He liked to smoke pot," Ross recalled, "but really only in Berkeley."

In the weeks leading up to the show, Dick summoned more and more of his studio staff to Berkeley to assist him. Of course, Norma was there. Betti Paul Avedon, his designer—now also his daughter-in-law and pregnant with Dick's first grandchild—was there to design and install the show with him. Marvin Israel was there, too, as an adviser more than exhibition designer, as he and Dick were taking incremental steps toward a rapprochement. Alicia Grant Longwell was called out to Berkeley before the show opened to avert a potential catastrophe. "They found mold on several of the plexiglass sandwich frames from the Marlborough show," she said, and it was her job to conserve them.

In the buildup to the opening, the activities surrounding the Avedon show escalated. Stanley Donen and his wife, Yvette Mimieux, came up from Los Angeles for an exclusive evening in which *Funny Face* was screened for the University Art Museum Council, followed by a conversation with Stanley and Dick. Later that week Dick was the guest of honor at a luncheon in the home of Ann and Gordon Getty, several doors away from the Coppolas, in Pacific Heights.

Several days before the show opened, Harold Brodkey received a frantic call from Dick imploring him to fly out to San Francisco to help him write the speech he was obligated to deliver the night of the opening, where he was to receive a citation for distinguished achievement from the university chancellor. Brodkey said he could just as easily write the speech in New York and fax it, but Dick insisted. "I need you here," he said. "The situation is fluid." Ellen Brodkey remembers first-class airline tickets arriving at their apartment within hours, and the next morning a limousine waiting downstairs to take them to the airport. When they arrived, Dick confessed to Harold that he had lost his confidence. He didn't think he could stand before so many intelligent people in one place and give a coherent speech.

The day before the opening, Dick took a suite at the luxurious Stanford Court hotel in San Francisco, and that night, in extravagant Richard Avedon style, threw a pajama party–poker game for his close friends who had flown out for the occasion. Everyone was required to wear pajamas: André Gregory; Harold and Ellen Brodkey; Walter and Carol Matthau; Lucy Saroyan; Stanley Donen and Yvette Mimieux; Marvin Israel; and, of course, Norma. And David Ross from the museum.

*Richard Avedon: 1946–1980* opened on March 5, 1980. Whatever anxieties Dick may have had about the exhibit were cushioned by the spectacle of the evening, a black-tie dinner dance attended by the Coppolas, the Gettys, the Matthaus, the Donens, the journalist Herb Caen, and the romance novelist Danielle Steel, among a buoyant and glittering San Francisco crowd. "I know I look like a Polish wedding cake," Carol Matthau, in Yves St. Laurent, said to her son, Aram Saroyan, when he arrived. Dick had his posse of studio regulars close at hand, along with his speech, written by one of the great writers of his generation, to bolster his confidence at so heady a tribute to his accomplishment.

"For more than two decades Richard Avedon has been recognized internationally as a significant and highly original fashion and portrait photographer," writes Jim Elliott in the exhibition introduction. "As photography has gained greater and greater recognition during the last decade as having a legitimate place as one of the fine arts, Avedon has also come to be recognized as one of the United States' contemporary masters in the medium."

John Russell, the art critic for the *New York Times*, did not know what to make of photography, nor did he formulate any conclusion about Avedon's work in his review. "It is difficult to believe that anyone, anywhere, has ever put a photograph by Richard Avedon in his wallet," his review begins. "Mr. Avedon's images need size, and they need space. Where other people's photographs ask to be

taken in hand like hamsters, his get up and stare us down from no matter how great a distance." It didn't bother Russell that the show was an "Avedon omnibus," as he called it; he credits David Ross, in concert with Dick, with "maximizing the spectacular opportunities" for the installation to which the "grim, granitic affair" that was the museum's architecture gave rise. He singled out the first picture of the American West series, the photograph of Boyd Fortin, and imagined what Dick might have said to himself about it: "What if this person were the only human being left alive? And if he were, what would be most worth saying about him?"

John Russell came close to the core of Avedon's larger art historical gesture without quite understanding how original and insightful it really was. In the postnuclear world in which Avedon came of age, everything had changed. Life became more dire. The anxieties underlying daily existence affected the way the species experienced itself. This is what propelled Avedon to make a systematic chronicle of *Homo sapiens*, clear eyed and straight on, with no extraneous distractions.

Offering another clue about his broader intention, Dick would later write about the white backdrop, the Deardorff camera, the head-on, half-length uniformity of his portraiture: "These disciplines, these strategies, this silent theater, attempt to achieve an illusion: that everything embodied in the photograph simply happened, that the person in the portrait was always there, was never told to stand there, was never encouraged to hide his hands, and in the end was not even in the presence of a photographer."

While the reviews of the show at the University Art Museum at Berkeley acknowledged the virtuosity of Avedon's achievement, only Roland Barthes addressed his work in serious art-historical terms. Barthes wrote that what you see when you look at an Avedon portrait is "the paradox of all high art: the extreme finish of the image opens onto the extreme infinity of contemplation,

of *sideration*"—an obsolete word that means "planet-stricken," or "suddenly paralyzed." Barthes observed that Avedon's portraits "manifest the opacity, the hardness, the gloom of the American establishment, everything which turns the successful man into a closed body, the body which has granted too much power and not enough pleasure." It is among the most astute acknowledgments of what Avedon captured in his sweeping portraiture, and in turn revealed about himself in the process: "All my portraits are self-portraits," he said often enough for it to become a kind of refrain.

During the run of the Berkeley exhibit, *Andy Warhol and Members of the Factory*, the ten-feet-high and thirty-one-feet-long mural, was vandalized. A statement to the museum staff reported that on Wednesday, April 30, at approximately 4:45 p.m., it was sprayed with a discoloring liquid, which left marks in the area immediately surrounding the figure of Andy Warhol at the extreme right of the photograph. "It was a senseless and wanton act of vandalism," said Jim Elliott. "Although the damage is relatively limited in area, there appears a good chance that it will in effect destroy the entire mural, one of the most moving and perceptive in an exhibition full of great photographs."

Eric Weill, forty years old, described as "a tall, gaunt man who often dressed like Abraham Lincoln," was arrested and charged with vandalism for spraying iodine on a work of art in a museum.

"What the hell am I supposed to say at a time like this?" Dick said. "I can understand that a picture about gender confusion might upset someone fragile. But it was a kind of masterpiece and he killed it. It's not replaceable. In six months' time I can achieve a print of that scale, but never of that quality and anyway, I don't have six months."

That was an unfortunate coda to what had to have been a gratifying tribute to his career. Dick had been having the time of his life in the San Francisco Bay Area. There was a joyous kind of ease

about the place, and particularly at that moment at the end of the 1970s, when San Francisco was the gay capital of the United States. Evidence of the playfulness in the ethos of this city, in the years before the AIDS epidemic, could be seen in the name of the most popular gay disco, Dance Your Ass Off, or a local hamburger place in the Castro called Hot and Hunky, or another restaurant on Folsom Street called Hamburger Mary's. It isn't known whether Dick explored that side of San Francisco, but he was obviously comfortable enough to open the gate just long enough to divulge to Norma late one evening after a luscious meal and a bottle of wine that he had been living a lie to protect a lifetime of guilt and shame about his sexuality. Perhaps it was seeing the breadth of his lifework all in one place, or spending time with people who were imaginative and productive and freer in their views of the world than their East Coast counterparts, or looking at the bougainvillea in bloom in March that enabled him to simply acknowledge in words to another person who he really was.

# A BALANCE
## OF OPPOSITES

(1981–1985)

It isn't about the West. It's about a photographer who went west
to do Avedon portraits.

—RICHARD AVEDON

I n the 1980s, Avedon proceeded with his Western project,
taking more than a dozen road trips across the vast Western
plains, into the majestic Rocky Mountains, the desert, and
through cattle country in search of individuals to photograph for
his Amon Carter Museum commission. "The beginning of this
project coincided with an oil boom in the West," writes Laura
Wilson, who, one day in the middle of June 1980, was in the car
with Dick and his two assistants as they headed toward Yukon,
Oklahoma. Oil derricks rose in the landscape as they spotted a

scruffy figure ambling along the shoulder of Interstate 40 carrying a bedroll on his head. Dick asked his assistant, Jim Varriale, to slow the car down and pull alongside him. Bill Curry was a drifter who claimed never to have stayed in one place for very long, sleeping on the ground wherever he happened to end up at nightfall. "I can hear a blade of grass move," he told them. "I'm never completely asleep. I always keep a knife." Dick asked if he could photograph him, invited him into the car, then drove several miles before finding a roadside diner with an exterior wall large enough to tape up a white seamless backdrop.

In one of the pictures Laura Wilson took as documentation of the five-year Western project, Dick stands facing Bill Curry, the drifter, their arms crossed in the same way. "I realized that Dick often stood exactly the same way as his subject," Laura writes. "He mirrored the person's posture unconsciously. I think it was one of his ways of connecting." Dick made a few small adjustments—asking Curry to take off his jacket and tuck in his soiled, short-sleeve sweatshirt—before making a series of exposures. In the final picture, a smudged and unkempt Curry stands just off center in the frame, his would-be handsome features offset by haunted eyes, his arms folded across his slender frame in the same way Dick had mirrored before the shoot. Curry reminded Dick of the son in *Long Day's Journey into Night*, who says to his father, "I will always be a stranger who never feels at home, who does not really want and is not really wanted, who can never belong, who must always be a little in love with death."

Only a month before, Dick had whisked his friend Harold Brodkey and Brodkey's soon-to-be wife Ellen off by limousine to Philadelphia to see a major retrospective of work by August Sander at the Philadelphia Museum of Art. In the first decades of the twentieth century, Sander made portraits of archetypes of the German people—the farmer, the bricklayer, the banker, the

artist—systematically documenting individuals as the population itself was slowly migrating from its agricultural roots in the countryside to urban centers during the years of the Weimar Republic. These Sander portraits are assertively straightforward, descriptive, and precise; the subjects are often presented in a heroic head-to-toe manner, whether sitting or standing. Dick, with Harold and Ellen, spent two hours looking at the 248 portraits in the show. "Sander is one of my greatest influences," Dick told them.

According to the mythology about August Sander, his magnum opus, the highly ambitious enterprise entitled *People of the Twentieth Century*, was born a priori of artistic intention and sprung whole as a lifetime project from early adulthood. Yet Sander started out as a photographer with a commercial practice, with commissions from publications, businesses, and private individuals. One of his best-known images, *Bricklayer*, was actually made while on assignment for a construction company. Not until his forties did Sander look back through his portraits and conceive the idea to codify his subjects by profession or trade. From then on, as the concept took hold, he began the systematic process of targeting and grouping his subjects into typologies. While he is known for the portraits of individuals photographed in the context of their work—the baker with a bowl in his hand standing next to his stove; the blacksmith with his heated iron and forge; the potter with his wheel—some of Sander's typological subjects, such as composers, architects, and writers, stand against the white solid backdrop of his studio wall, which removed them from the context of their work, abstracting them from daily life. Sound familiar?

Avedon's photographic enterprise in the American West—in search of people endemic to the labor of the region, whether cowhands, coal miners, oil field workers, or roadside waitresses—must be understood in the context of August Sander. When put into perspective within the entire body of his own portraiture,

Avedon, too, systematically photographed the archetypes of American society in the second half of the twentieth century— the writers, the artists, the actors, the politicians, the industrialists, the philanthropists, all from major urban centers—and now he was doing the same with a swath of anonymous individuals, otherwise unaccounted for in history, as he crossed the vast Western landscape.

Dick returned to Texas in September 1980, where he, Laura, and his assistants drove to the oil fields of the Austin Chalk, a geological region in Central Texas. There, more than two hundred drilling rigs were in operation. They went from rig to rig looking for individuals with "the right combination of force and vulnerability," as Laura Wilson described it. They brought with them copies of the *Newsweek* issue that featured Avedon on the cover as calling card proof that his request to photograph them was grounded in something of importance. They found Roberto Lopez, a rig worker, resting beside his truck in 103-degree heat after working a forty-eight-hour shift. Laura approached him with the issue of *Newsweek* to ask if he would agree to be photographed, but he was shy and resistant. A fellow worker overheard their request and offered himself up as a subject for the camera instead. He was bare chested, and from the way he flexed his muscles and contorted his body, he thought of himself as the cock of the walk. Dick figured that by letting him stand in front of the seamless and pose before the camera, it would entice Roberto to join him.

Eventually Roberto agreed to stand in front of the stationary camera with his shirtless amigo, whom Dick slowly and methodically inched out of the frame. Dick didn't direct Roberto so much as watch him from his usual spot beside the camera, according to Wilson, invoking the kind of patience that Eudora Welty described as "a story-writer's truth," as if waiting for the moment in which the subject revealed itself and he was ready, within himself, to see it. In the resulting picture, Roberto, black hair flickering against the

white backdrop, oil-stained cheeks, and bare chested under overalls, enters the frame from the left and stares at the viewer with glazed eyes through almond-shaped slits, a kind of apparition at once menacing and eternal. His is "a face," as Dick would say, "that can hold a wall."

Dick bought a big Chevy Suburban for the many long trips he, his assistants, and Laura Wilson would take in the next few years, a vehicle large enough to hold all his photographic equipment and comfortable enough inside to endure the seven-hour stretches on the open road between one vast region and another. Sometimes Dick would read aloud to pass the time, from either the short stories of Raymond Carver or *The Last Cowboy*, a book of literary journalism about a rancher in Texas, by his friend Jane Kramer. Once, as they were driving through Kansas, they stopped at a bookstore and Dick bought a used copy of *In Cold Blood*, which he read aloud in the back seat. He even insisted that they make a detour to Holcomb to drive down the same road that the killers Dick Hickock and Perry Smith had driven down two decades earlier—and which Dick had walked with Capote while photographing him there for *Life*—to show them the Clutter family home.

One day in early 1981 Dick was sitting in Laura Wilson's kitchen in Dallas when her oldest son, a seventh grader, came home from school, excitedly describing a visitor to his class that day— a man wearing a beard of live bees. Several days later, the image appeared to Dick in a dream. He woke up and made a sketch of a man covered with bees. The idea had intrigued him enough to post an advertisement in several beekeeping journals in search of a model willing to pose with bees. The studio received several dozen replies, many with pictures of beekeepers wearing gear such as helmets and veils that obscured their faces. One, though, stood out: Ronald Fischer, a six-foot-three accountant from Chicago and a Sunday beekeeper, who managed a hive of his own bees,

was hairless, perhaps the result of alopecia, an autoimmune skin disease, and Dick thought him to be the perfect candidate. After some research, a meeting was set up with an entomologist at the University of California, Davis, which housed multiple bee farms for biological study and agricultural instruction.

In early May 1981, Dick arranged a rendezvous, flying Ronald Fischer out to California from Chicago, Laura Wilson from Dallas, and arriving with his two assistants from New York. They found a location on a farm in Yolo County. White seamless paper was taped against the corrugated steel wall of one of the farm buildings, the camera was set up, and the entomologist arrived with 120,000 bees. Once Fischer was placed shirtless in front of the seamless, the entomologist took a small bottle filled with fluid containing the pheromone scent of a queen bee, and, with a dropper, began dabbing it on one side of Fischer's face, his neck, his shoulders, and his chest, in keeping with Dick's drawing of where he wanted the bees to collect. The scent attracted the bees and also prevented them from stinging Fischer—for the most part, anyway. In the first session, the entomologist released one thousand bees, and, as expected, they swarmed onto Fischer's flesh. The entomologist stood beside him to swat them away from Fischer's eyes and his lips.

It was an excruciatingly stressful process, a test of Fischer's trust and a trial of his endurance. "Avedon said to me, 'Now, *listen*, you can't move, because any movement will cause a blur,'" Ronald Fischer remembered. "There were five hundred to eight hundred bees on my chest. I got stung twice. We all got stung." He stood stone-cold still for the camera, suppressing the natural impulse to swat the bees away as they landed on his skin, or to scratch wherever their movement caused itching. In several tense moments, the entomologist diverted them away from his nostrils as Fischer held his breath for fear of inhaling them. Fischer endured three separate sessions on two separate days as Dick made 121 exposures.

"The Beekeeper," as the Avedon picture is often referred to, is a balance of opposites. It is skin crawling to see the bees collected on the pate of Fisher's bald head, the crown of his ear, a swarm on his neck, his shoulders, under his arm, and on both sides of his torso. Fischer resides in celestial calm, but the contrast of so many dark, sharp-winged bees and their razor-thin legs on his tender alabaster skin is flinchworthy. The photograph is so technically precise that every single bee is delineated for our scrutiny, yet it would take a level of patience equivalent to Fischer's visible self-possession to count beyond fifty without feeling spooked. Fischer's imperturbable expression and his gesture of tranquility pose a lesson in spiritual transcendence. The portrait is a Zen koan.

"The Beekeeper" is virtuosic proof of Avedon's photographic acumen, showing the technical ability of the camera to record with a fidelity of description that at times eclipses the capability of the human eye. It is also a daunting creation of religious iconography. "In the end, I made two pictures of Ronald," Avedon said of two separate exposures. "One was what I called a picture of Christian martyrdom. You feel his suffering from the stings of bees and his expression. He resembles Lazarus coming back from the dead covered with worms. And then the other one, in which he removed himself, is more of a Buddhist image of a man quietly enduring the trials of the world."

RUEDI HOFMANN, WHO WOULD become Dick's main assistant, spent a lot of time behind the wheel while traveling with Dick and Laura. "When we were out West, Dick became more relaxed and more personable," Ruedi said. A natural bond between them had taken hold and for those long stretches of time in the car, they would get stoned and listen to music, sometimes country and western, sometimes opera, Ruedi and Richard Corman, the assistants,

up front, Dick and Laura in the back seat, all of them lulled into a kind of silent wonder at the landscape flying by. Once, driving through Montana after a very long day on the road, Dick asked Ruedi to put on a tape of *Der Rosenkavalier* at full volume. It was sunset and Ruedi was barreling down the open road at ninety miles per hour, and the combination of the speed and the grandeur of the music and the dramatic cloud formations in the wide-open Western sky created a shared mystical moment for all of them. "But then, on the plane back to New York, Dick would find his seat in first class, disengage, and become 'Richard Avedon' again," Ruedi said. "By the time we got to baggage claim, all the protective skin was back in place."

Soon after the beekeeper shoot in Northern California, Dick was on a plane again to Los Angeles to shoot a ten-page *Vogue* feature on the young actress Nastassja Kinski, the twenty-year-old daughter of the German actor Klaus Kinski. She had already starred in *Tess*, directed by Roman Polanski, and was currently filming *One from the Heart*, directed by Francis Ford Coppola. *Vogue* titled the feature "The Spirit of a New Age" and presented Kinski as a new kind of beauty: "Our yardstick for beauty is not vastly different from what it ever was," the magazine states: "Blond, even-featured, dimpled Mary Pickford was pretty; blond, even-featured, dimpled Goldie Hawn is pretty; dark, bold-featured, arrogant-looking, sensuous-looking Nastassja Kinski is something more than pretty— a beauty—even though her look is stronger than an audience of sixty years ago might have found acceptable in a romantic leading lady."

Dick photographed Kinski wearing Agnès B., Perry Ellis, Ralph Lauren, Giorgio di Sant' Angelo, and Bill Blass. In one picture she is doing a somersault with her legs scissoring out to highlight her bold black-and-blue-checked harem pants; in another, she stands with legs apart in a wide stretch, her hands on her head, wearing

a short cashmere cardigan and camel wool knickers. In a third she wears a white shirt and knotted man's tie—à la *Annie Hall*—under a long, cashmere sable cardigan. These outfits and her gestures portray the idea of a freethinking iconoclast, which is more than confirmed on the next page: she is lying naked on the floor across the two-page spread entwined with a boa constrictor seemingly a foot thick, longer than the length of her body, with a silvery sheen on its teal-blue and honeycomb-patterned skin, slithering up between her legs, around her waist, across her torso, its head resting on her shoulder and its needle-thin tongue reaching toward her ear. Across the bottom of the picture is ribbon copy that offers a breathy description typical of *Vogue*: "Charming a snake, Nastassja Kinski, spellbinding in her role in 'One from the Heart'; she juggled, rode an elephant bareback, made friends with the animal handler, who brought this snake to our sitting. The picture, as you see it, was Nastassja's idea. The rapport was immediate, intimate. 'It's a wonderful feeling, the way it moves, very graceful and sensual,' she said."

Before Dick got the shot, Nastassja had spent at least two hours on the cement floor of the studio, naked, everyone in terrified silence as they watched the snake slither on and off her body. The snake handler had to anchor the snake between her feet and wait to see where it would go. At one point, one of the assistants accidentally stepped on it, and everyone panicked. "Don't worry," the handler said. "It just ate, so it won't attack."

Kinski rolled back and forward to direct the snake's movement as the trainer indicated a trail for it to follow with his hands, Dick all the while making exposures, waiting patiently for a moment when the handler was out of the frame and the snake's position was configured to his liking. "I wasn't afraid," Nastassja later said. "I love animals." After what felt like an eternity to the gathered crew, the snake slithered slowly around to her legs and then coursed its way up her torso toward her face. Everyone watched, dumbstruck.

"And when it got to her ear, it kissed her with its tongue and Dick got the picture," Polly Mellen said, in awe even as she recounted it. "I was crying. I couldn't speak. It was extraordinary, sexual, seductive, special, a rare moment."

Dick, too, was struck by the convergence of fate and circumstance. "Nastassja rose to the moment; the snake rose to the moment; I rose to the moment," Dick told Helen Whitney in 1994. "It was one of those absolutely magical things that happen when nothing you planned could equal the random accident of something like that." The picture was such a success when it appeared in *Vogue* that the Avedon studio produced the image on a poster, and it sold over two million copies.

The nude portrait of Nastassja Kinski and the snake was made only a month after Ronald Fischer and the bees. Both subjects project unnatural calm in the face of danger, recalling the 1955 picture of Dovima, staving off a stampede of elephants. But while Dovima was staged as a fashion tableau, Nastassja and Ronald were constructed with greater symbolic intention. "The Beekeeper" was the realization of an idea sprung from Dick's subconscious imagination and created for his artistic enterprise, while Nastassja and the snake was the result of a serendipitous sequence of events in the execution of an editorial fashion spread.

The cross-pollination between Dick's ongoing commission from the Amon Carter Museum and his position as a *Vogue* staff photographer presents an interesting conundrum about his work. While Dick made a living working first for *Harper's Bazaar*, and later *Vogue*, as well as from the untold numbers of advertising campaigns for large companies, "he always felt that if he wasn't also working on a very personal project," Adam Gopnik told Norma Stevens, "he was letting *them* win. . . . Anything that put you in a combative relationship with orthodoxy, anything that shocked and scandalized a little bit, he thought was positive."

The naked Nastassja Kinski and her boa managed to avoid the kind of controversy that erupted from an advertising campaign shot by Dick the previous year. Calvin Klein launched his jeans in 1978, becoming the first high-fashion designer to introduce a denim line. A year later, the company had sold $70 million worth of jeans. His jeans were so tight that some stores in Manhattan installed sofas for customers to lie down on while zipping them up. When asked about his marketing approach, Klein famously said, "Jeans are sex." He added, "The tighter they are, the better they sell."

In 1980, Klein, who was directly involved in all aspects of the advertising and marketing of his clothes and fragrances, hired Avedon to shoot the jeans campaign, both the print ads and the television commercials. It was just a matter of finding the right model. Brooke Shields was not Calvin's first choice, but at Dick's suggestion, he met with her and her mother, who managed her modeling career, and found the young woman delightful and extremely beautiful. Shields had already received critical acclaim for her role as a child prostitute in the film *Pretty Baby* by Louis Malle. "I was fifteen and already an old hand modeling," she said, explaining that, at five feet nine inches by the time she was thirteen, she had been modeling adult clothes for years. "I first met Dick when I was eleven and had already worked with him so many times and done so many *Vogue* covers with Polly Mellen."

"Doon Arbus was a very important part of the process," Klein said, describing her role in writing the taglines for each of the commercials. "It was the first time I had worked with Dick. Dick and Doon were very close, and each time Doon had written a new line Dick would call me up and want me to hear it. I was at his studio every night. They would act out the line. Often it was hilarious. We just had a lot of fun. And then we'd have vodka and it became a party, every night."

The commercials straddled a fine line between pure innocence

and erotic provocation, and Brooke, at fifteen, had exactly the right combination of each—she was dewy and winsome but also sensual, her long brown hair adding a mysterious, if not salacious, dimension to her appeal. In a half dozen TV spots, Brooke appears in expensive blouses and skintight Calvin Klein jeans, against a blank seamless background, most often sitting or lying down, and offering clever Doon Arbus–isms—curt, paradoxical, and suggestive. In one, Brooke is reclining while reading aloud from a nineteenth-century romantic novel, the camera traveling slowly up her leg. When it reaches the book in her hands, she puts it down, stares into the camera, and says: "Reading is to the mind what Calvins are to the body." In another, she is on her back, her legs in the air as she counts out loud. Then she looks at the camera and says, "Whenever I get some money I buy Calvins, and if there's any left, I pay the rent." But, in the ad that caused the controversy, the camera slowly pans from Brooke's expensive boots and up her Calvin Klein jeans–clad leg as she whistles "Clementine"; the camera then pans back to reveal Brooke sitting on one leg, her other leg akimbo, brushing her hair aside, and speaking directly to the viewer: "You want to know what comes between me and my Calvins?" she asks. "Nothing."

The implication was that Shields, fifteen years old, was not wearing underwear, and it got the prompt attention of the censors. ABC and CBS banned the ad from their television networks. "I did not anticipate the controversy at all," Klein said, relishing its silver lining. "It got the attention of the media and the press, and that turned out to be very good for sales."

In the case of Calvin Klein, the Avedon studio was functioning like a full-service advertising agency—not only shooting the spots but coming up with the idea for the campaign. The commercials were shot in a studio in Astoria, Queens, that had the necessary movie equipment. Klein was there for every shoot, and Dick worked directly with the cinematographer, always with Doon and his as-

sistants close at hand. "Everything had already been thoroughly planned out by the time I got to the set," Brooke remembered, "so he didn't waste any time for the actual shoot."

For each thirty-second spot, they did multiple takes, sometimes as many as ten in a row. "I was such a perfectionist myself that I was a good soldier, and of course I wanted his approval," she said, adding that she and Dick communicated well, but once the shooting began, he went into an unreachable zone. And while he always proceeded with certitude, Brooke observed a certain insecurity about him, too. She thought his need for perfection was so strong that he feared dropping into a deep abyss of failure if he did not reach it. "He had a darker side," she said, "that dark, sad side of him."

Another ad campaign generated by the Avedon studio during that period was known as "The Diors." It had all the properties of an episodic drama in which each new ad was a sly caper in a series about a very soigné ménage à trois—André Gregory as "the Wizard"; Kelly LeBrock as "the Mouth"; and Vincent Vallarino as "Oliver." Over the course of the three-year campaign, the Diors—full of fanciful mischief and elegant hijinks—cavorted in chic private rooms and grand public verandas straight out of a Noël Coward play. The ads were ubiquitous in national magazines, and in New York, on billboards and across the sides of buses. "One of the most talked-about campaigns of the last year has to be the Christian Dior print advertising," the *Times* wrote. "Christian Dior has been dead since 1957, and this advertising is intended to make the news he can no longer make himself." According to the article, credit was due largely to "the same man who is responsible for one of the other much-talked-about campaigns, the television commercial for Calvin Klein jeans—Richard Avedon . . . aided and abetted by Doon Arbus, a copywriter."

"There's no downside to my commercial photography," Dick said in a 1995 *American Masters* documentary about him. "It's fun, the

food is good, the thing is silly. The respect that I have for the hairdressers, the art directors, the account executives and what they live through with their clients who don't get what they're trying to do. . . . It's like a little circus of intention, of hard, difficult, crafted work to sell—this is a capitalist country—to sell the products that are made that people seem to want."

In the kind of white-tiled bathroom that graced a suite on the grand ocean liners of the 1930s, Oliver "Dior" sits naked in a large tub with the captain's cap on his head, a cigar in his mouth, smiling at the Mouth, dressed in a floor-length black skirt and white satin coat and holding a glass of champagne while the Wizard, standing beside her in a tux, wags a finger at Oliver. "When they were good they were very, very good," goes the copy, "and when they were bad they were gorgeous." In another elegant tableau, the Mouth, in a black velvet pantsuit with plummeting décolletage, strikes a posture of boredom as the Wizard holds open a picture book called *Lulu in Hollywood*; Oliver leans over the book while staring at the Mouth. The copy: "They loved armadillos, the American flag, and they disliked all their friends equally." The ads were meant to project an air of naughtiness that was acceptable because they were so very Continental.

AT THE BEGINNING OF the Reagan era, as Dick was intermittently photographing out West and juggling features for *Vogue* and ads for Calvin Klein, Dior, and, now, also, Versace, an exhibit of sobering poetic resonance opened at the Museum of Modern Art in October 1981: *The Work of Atget: Old France*, the first of four exhibitions mounted by the museum on Eugène Atget's oeuvre. The exhibit elevated a heretofore unknown figure to the stature of a deity among artists. In attitude, rigor, and scope, as well as in the purity of its emotional ambience, the body of Atget's photographs of Paris

and environs over thirty years is a comprehensive documentation of the streets, buildings, village squares, monuments, chateaux, their gardens and statuary, all with unadorned description, precision of detail, and arresting subtlety of mood and atmosphere, composing a portrait of late nineteenth- and early twentieth-century France.

The Atget exhibition was a benchmark moment for photography as its ascension in the art world was gaining momentum. For Avedon, his own work on Lartigue and the publication of *Diary of a Century* had given him insights into the French sensibility in the medium of photography, too, and while the significance of Atget was unquestionable, the show necessarily sidelined Lartigue as a lesser figure and consequently echoed Dick's own stature in the hierarchy of Szarkowski's canon building.

"Atget represented to John the very best of photography for many reasons, not least of which is that Atget seemingly saw a purpose for his work that had nothing to do with creating art, but rather, a moral purpose," said Susan Kismaric, who worked with Szarkowski as a curator in the photography department at MoMA. No better testimony to this conclusion exists than in the poetic description put forward by Szarkowski in his introduction to the Atget exhibition catalog:

> *As a way of beginning, one might compare the art of photography to the act of pointing. All of us, even the best-mannered of us, occasionally point, and it must be true that some of us point to more interesting facts, events, circumstances, and configurations than others.*

Here Szarkowski revealed something of the foundation of his own thinking about the nature of photography, no matter who is making the photographs. In this next passage, speaking specifically of Atget, he says:

*The talented practitioner of the new discipline would perform with a special grace, sense of timing, narrative sweep, and wit, thus endowing the act not merely with intelligence, but with that quality of formal rigor that identifies a work of art, so that we would be uncertain, when remembering the adventure of the tour, how much our pleasure and sense of enlargement had come from the things pointed to and how much from a pattern created by the pointer.*

Despite the lucidity of Avedon's comprehensive achievement and the formal rigor of his work, Szarkowski refused to acknowledge what he was "pointing to" because his artistic imperatives were obscured by the glitz of his commercial prominence. The glamour of Avedon's name and the gloss of his notoriety made it impossible for the Szarkowskis of the world to trust the sincerity of his intentions.

"Among young, so-called serious photographers, Richard Avedon didn't play a part," remembered the photographer Joel Meyerowitz, who spoke as a later convert and a friend. "In my circle of friends—Garry Winogrand, Lee Friedlander, a handful of others—Avedon's work didn't have much influence. We were looking at Robert Frank, Cartier-Bresson, Walker Evans . . . Avedon was in commerce, not art." While this attitude tormented Dick, it motivated him, too: "Alongside MoMA's trajectory of the history of photography from Eugene Atget to Walker Evans to Robert Frank and Diane Arbus, Avedon invented a parallel universe: Lartigue, Brodovitch, and Avedon," writes Robert Rubin in *Avedon's France.* There is no doubt that Brodovitch was every bit the arbiter of photography in the twentieth century as Szarkowski, and certainly, Dick had Brodovitch in his camp to prove that he was the real thing.

The final slap in the face from Szarkowski, though, was the Irving Penn retrospective he mounted at the Museum of Modern Art,

which opened on September 13, 1984. This was the show Dick had envisioned for himself after years of discussion with Szarkowski a decade earlier. The exhibition was a survey of Penn's long career and featured his work in portraiture, fashion, and advertising, as well as his nude studies, his ethnographic subjects, and his still lifes. "Unlike the elaborate orchestration of earlier fashion pictures—by de Meyer, Beaton, and others—in which the dress and its model appear to act out a role, Penn's 1950 pictures ignore plots and dream worlds," states the MoMA press release. "They are not stories, but simply pictures," writes Mr. Szarkowski—as if "stories" were somehow a superfluous distraction in photographic imagery. With this statement about the absence of "stories" in Penn's work, Szarkowski might have intended to distinguish Penn from his fashion world peers—in particular, Avedon—whose constructed scenes were, in the curator's calculation, artificial, commercial, and pretentious. According to the Szarkowski doctrine, documentation was the backbone of photography: authenticity was of paramount relevance. In his fashion photography, Penn did not "construct" scenes with the look and feel of real life; there was never any doubt that his images were made in the studio. Szarkowski would never embrace the "look" of an authentic moment in a photograph—as opposed to the actual moment—as a valid use of the medium by an artist. As Avedon created—invented—metaphors, Szarkowski saw Avedon's invented stories as untruths, dismissing the work as void in moral terms, and, by association, dismissing Avedon's portraiture, too.

Of course, for every Picasso there is a Braque, for every Pollock, a de Kooning. Avedon and Penn were rivals who vied for pages, position, and subject matter. They even made portraits of the same people at different times. While the two of them kept upping the ante in terms of imagination, style, and technique, each one succeeded in establishing a distinct visual signature. In portraiture,

Avedon distilled the picture frame to nothing but his subject against a white backdrop—wrinkles, bad teeth, and all. Penn may not have made himself a student of his subjects, but their stature is what he always seemed to render with a preternatural eye to history— theirs, and perhaps his own. Yet, the similarities between Avedon and Penn are uncanny. Both were born in or near New York seven years apart; both were Jewish; both studied with Brodovitch; both married twice; both had one son. One worked at the *Bazaar* and the other at *Vogue* before both ended up at *Vogue*. They were colleagues and competitors who respected each other and found themselves together, alone, at the top of their profession. "Those guys! Those poor guys," said Peter Galassi, who succeeded Szarkowski as chief curator of photography at MoMA. "They were just fated to end up in the same sentence all the time. What a horrible burden for both of them. Each of them deserves his *own* sentence."

DICK, NOW SIXTY-ONE YEARS old, continued to be in constant motion, pulled in too many directions in an unrelenting barrage of professional commitments—which was how he always liked it. Yet it was beginning to take a toll on his stamina and his psyche. He was resorting to amphetamines and sleeping pills, a dangerous combination that wreaked some havoc on his demeanor, creating at times uncharacteristic sloppy behavior that was more erratic and revealing than he intended. One night soon after he and his crew had returned from a trip out West, Ruedi Hofmann and several other studio hands went to dinner at a neighborhood restaurant. They didn't expect Dick to walk in, nor did they imagine that he would patently ignore the professional family with whom he worked every single day. They were stunned when he walked right past their table. It may have been a result of the pill taking, but, just as easily, it could have been his cruel habit of reminding them

about the invisible boundaries of the hierarchic divide. But sometimes, too, his generosity knew no bounds. Alicia Grant Longwell, his archivist, was going on maternity leave. On her last day she arrived at the studio at noon. It was not until 1981 that the surgeon general issued an advisory for pregnant women to avoid alcohol, so it was natural that Dick thought nothing of waiting for her at the front door with a shot of vodka. Inside, the table had been set up for a proper luncheon, with linens and a large bouquet of flowers. Everyone in the studio took a seat and the feast began. Dick had obtained from her mother a picture of Alicia as a toddler, in her birthday suit, and he'd had it blown up and put on the wall. After lunch, a multitiered cake was brought out and Hiro's Japanese assistant popped out of it wearing a G-string. Then, prepped in advance with a rehearsal by none other than Dick's close friend Twyla Tharp, Dick and Norma did a Fred-and-Ginger tap dance to "Isn't This a Lovely Day?" from *Top Hat*.

When Ruedi Hofmann, Dick's main assistant for four years, left to start a studio of his own, Dick had a party for him at Primavera, an excellent Italian restaurant in the neighborhood. As Hofmann recalls, "He got the room downstairs and Norma and about twenty people from the studio came. He flew my parents up from South Carolina and they surprised me by popping out of a big box in the center of the room." The elaborate going-away parties were a ceremonial way for Dick to acknowledge his appreciation for the rigorous hard work of his employees, and, equally, a *grand geste* with which his genuine affection for these employees in particular could be safely contained and packaged.

With Marvin Israel, however, it would be a sadder and more painful departure. Dick had known Marvin for nearly thirty years. They had done some of their very best work together. On more than a few occasions, Dick spoke of Marvin as part of the psychological core of his professional family: in the hierarchy of an

almost familial trust he placed in his talent and judgment, after Brodovitch, the father figure, "Marvin," he acknowledged, "was a brother." Certainly, they had had their sibling-like differences, their cold wars. Norma Stevens was by no means fond of Marvin, calling him "impossible, feisty, angry—*really* angry, all the time." On the other hand, she acknowledged he was "smart and gifted and full of value."

Dick brought Marvin in, once again, to design the book for *In the American West*, and also the exhibition at the Amon Carter Museum. Marvin made a rough maquette of the gallery spaces, just as he had done with the Marlborough show a decade before, and in early May 1984, over a year before the show was scheduled to open, the two of them flew down to Fort Worth to take more accurate measurements of the galleries, and to get a clearer sense of how the pictures would interact with the space. Marvin loved horses, keeping his own horse in a stable in Central Park, and when they got to Texas, he asked Laura Wilson, who lived in the Dallas–Fort Worth area, where he might go riding. She said that Dick was expecting him at the museum. "I don't care," Marvin told her. He had his own priorities.

Marvin managed to work on the show one day and ride the next, until he complained of severe chest pains. Laura and her husband rushed him to the hospital, where he was told he had had a heart attack and had to submit to urgent tests. Doon Arbus flew down from New York. She and Marvin watched the Kentucky Derby on television in his hospital room. Laura, with whom Dick and Doon were both staying, brought an Audubon print to put on the wall of Marvin's room to cheer him up. In less than a week, Marvin was dead. He was sixty-one years old. At the crack of dawn on May 8, 1984, Dick called Norma in New York. She heard only an audible sigh on the other end of the phone and thought it was a crank call.

Before she could hang up, finally Dick said, "Marvin died. I can't speak."

FROM 1979 TO 1984, Avedon traveled through 13 states and 189 towns, from Texas to Idaho, conducting 752 sittings and exposing 17,000 sheets of film through his eight-by-ten-inch Deardorff view camera. Ruedi Hofmann and David Liittschwager began working for almost two years to print the 123 selected portraits for the ensuing exhibition and catalog. Hofmann made an entire set of sixteen-by-twenty-inch prints that Dick rejected as too dark and too full of contrast. It was hard for Ruedi and David to follow Dick's directions for reprinting the series when, according to Laura Wilson, he would say "Make the person more gentle" or "Give the face more tension." The final 16 × 20 prints became the template for the larger 56¼ × 45 exhibition prints, which had to be made in a rented studio with a customized horizontal enlarger on a track with wheels, the large sheets of photographic paper placed against a metal wall with magnets to hold them in place during exposure. They had to purchase a dryer large enough to accommodate the size of the prints. A single print could be the result of five days of toil. Avedon gave a complete set of the exhibition-size prints to the Amon Carter Museum to fulfill the terms of the commission, valued at the time over $1.5 million. The return on the initial investment of $500,000—$100,000 per year for five years—was not only the 123 photographs that have appreciated in value exponentially since they were made in 1985, but, equally, a body of work well beyond measure in the history of photography.

The exhibition, *In the American West*, opened at the Amon Carter Museum of American Art in Fort Worth, Texas, on September 14, 1985. "Despite competition with a Bruce Springsteen concert

and the Lone Star Chili Competition, public interest reached near-fever pitch," wrote Suzanne Muchnic in a feature about the show in the *Los Angeles Times*. It attracted five thousand viewers the first weekend and three thousand on consecutive weekends.

The Amon Carter Museum, designed by Philip Johnson in 1961, is an International Style building with a two-level glass facade behind several arched porticos of white Texas shell stone across the front. "Never before had so many photographic prints of such scale and quality been seen in the museum," wrote Laura Wilson. Ten larger-than-life portraits—$78^1/_8 \times 64^1/_2$ inches—were installed on walls that faced the exterior front of the museum, visible through the glass facade outside on the plaza.

"In focusing on the West's unsung laborers—as well as the disinherited, the freaks, the jailbirds and the nut cases—[Avedon] has touched a chord of familiarity that most observers don't want to remember but can't stop looking at," Muchnic wrote. "The grizzled, wizened, dirt-caked adults, the freckled, pock-mocked adolescents and the tousled children are all too believable."

*In the American West*, the exhibition catalog published by Harry Abrams, is a meticulously printed book, eleven by fourteen inches in size, simply designed as if it were a portfolio of photographs for easy viewing, one picture per page, each one with signature film holder borders. The simple titles provide the names of the subjects and their lines of work or existential identities: factory worker, coal miner, housekeeper, day laborer, drifter, nine-year-old. In the foreword, Avedon writes:

> *I use an 8 × 10 camera on a tripod, not unlike the camera used by Curtis, Brady, or Sander, except for the speed of the shutter and the film. I stand next to the camera, not behind it, several inches to the left of the lens and about four feet from the subject. As I work I must imagine the pictures I am taking because since I do not look*

*through the lens, I never see precisely what the film records until the print is made. I am close enough to touch the subject and there is nothing between us except what happens as we observe one another during the making of the portrait.*

Over the course of two years, the show traveled from the Amon Carter Museum to the Corcoran Gallery of Art in Washington, DC, the San Francisco Museum of Modern Art, the Art Institute of Chicago, the Phoenix Art Museum in Arizona, the Institute of Contemporary Art in Boston, and Atlanta's High Museum of Art. In some quarters the work was met with outrage. Avedon was accused of privileged voyeurism and the exploitation of his unwitting subjects. With Avedon, "style has always been understood as political expression, and the will to style but a reflection of the will to power," writes Max Kozloff, the art historian, indicting Avedon's overdetermined use of the eight-by-ten camera for its optical potency.

If Dick was hoping to sway John Szarkowski with this body of work, he was likely, once again, disappointed: "Avedon's West is not the West as I know it," Szarkowski said, dismissively. Others, though, eventually acknowledged Avedon's work as a formidable achievement. Maria Morris Hambourg, who, in 2002, as the curator in charge of the photography department at the Metropolitan Museum, would organize Avedon's definitive portrait show there, which included portraits from *In the American West*, concluded about the totality of his work: "Laureate of the invisible reflected in physiognomy, Avedon has become our poet of portraiture."

While some of his subjects in the West series—or their families—were distressed by the way they looked in their pictures, equally there were those who were thrilled to see their own portraits so large on a museum wall. Although some members of the public raved about the exhibit, "more often than not they would

emerge from the gallery awed but disturbed by it," reported the *Chicago Tribune*. One viewer, a law professor at Loyola University in New Orleans, was thoughtful in his comments after seeing the show. "The guy, he's good. It's depressing but graphic," Bill Crowe said. "It's a fine line between desperation and hard living. . . . I don't know what his purpose is. . . . Maybe he's the Thomas Wolfe of photographers, a manic depressive of sorts."

Avedon insisted that "it is a fictional West" he was presenting, no different or more conclusive than the mythologies put forward in the name of American history, such as in the Westerns that featured John Wayne, in which the cowboys were rendered as the good guys, or in the portraits by Edward S. Curtis of a Native American population that had suffered the trauma and indignity of having their lands seized and their way of living destroyed.

When interviewed about this body of work by Michel Guerrin for *Le Monde* in the early 1990s, Avedon was asked if he thought he had stolen something from his subjects. "Stealing their souls?" he countered. "Stealing implies a crime. No harm is done here. I've just recorded their faces in the way that I see them. I give it my soul, and they give it their surface," he said, referring to the way a face appears on the two-dimensional plane of the photographic print. Guerrin asked him how he reconciled the fact that he sold the images for $14,000 each, which is more than his subjects made in ten years. "The sitter doesn't make the photograph," he replied, with a degree of insensitivity that served the argument so many people made at the time about the coldness of his pictures and their absence of humanity. "The sitter for these pictures is no more than the model. If they agree to be photographed in exchange for a print—which has value—in exchange for their being in a book, in a museum show, and being invited to see it, that's why they do it. So, why should I share? You know . . . would Cézanne pay the apples?" It was just this kind of statement that made people question the sincerity of his intent.

When a *Times* reporter asked Dick if he manipulated the subjects in his series on the West, he asked if he could submit a written answer. "It's trivializing to make someone look 'sage,' 'noble,' or even conventionally beautiful, when the real thing is so much crazier, contradictory and therefore fascinating," he wrote, making the case that the kind of candor he was after required a certain amount of contrivance. "It's in trying to direct traffic between Artifice and Candor, without being run over, that I'm confronted with in the questions about photography that matter most to me. . . . Do photographic portraits have different responsibilities to the sitter than portraits in paint or prose, and if they seem to, is this a fact or a misunderstanding about the nature of photography?"

Dick made a simpler and more honest point to the *Washington Post*. "This is about class," he said, referring to a population that resided in the shadows of cultural awareness. "It's about very hard times, very long hours, hard work, unrewarding lives with very little expectation of upward mobility." Aram Saroyan wrote that Avedon's pictures in the American West reversed the circuitry of his celebrity portraits, "taking subjects from the social and economic underside of Reagan-era America," and bestowing his fame on them by rendering each in the now iconographic white-backdrop, black-and-white template of the Avedon portrait.

"While stopping shy of Surrealism, Avedon's portraits of people west of the Mississippi seem more idiosyncratic than documentary—which, it turns out, is to the credit of the pictures," Andy Grundberg, then photography critic of the *New York Times*, wrote. "In the West Avedon seems to have found a subject equal to his ambitions."

The discussion about whether the wealthy and famous Avedon had exploited his subjects versus the sincerity of his artistic intent transpired in the press, as well as in art chat among the cognoscenti.

Regardless, it is irrefutable that by then Richard Avedon had created a serious opus.

His entire body of portraiture included individuals of great celebrity and accomplishment as well as anonymous individuals with no distinction other than the daily toil of survival. Except for slight variations over the years, he photographed almost all his subjects in the same way, and the consistency of format and originality of vision provides a unique view of the human being: We are all of us individuals of a species whose nature is determined by its structure—we have two eyes, a nose, a mouth; hair that varies in texture and color; skin that changes tone with age; bodies of varying shape; gestures that suggest mood and attitude. The single, persistent gaze of Avedon's camera across the swaths of humanity provides a stunning document of our sameness as it scrutinizes to forensic exactitude the distinctions that make each of us unique. It's a formidable observation of who we are as a species, for better or worse, and also a subjective one, which makes it that much more arresting, and unsettling.

"They stand like bent ramrods, twisted pokers and charred fence posts. Ravaged by time and molded by hard labor or unfortunate circumstance, these miners, cowboys, carnies, waitresses, rattlesnake skinners and drifters have submitted to the will of one of America's most celebrated photographers," Suzanne Muchnic wrote, and then she quoted Avedon about the project: "I discovered that we have in common everything that matters: wanting our children to have betters lives than we have, worrying about our aging parents, trying to make the most of ourselves," he said. "If I have one goal for these photographs it's that people will pay attention to them and say, 'That could be me.'"

# 18

# THE YEARS
## OF HIS DISCONTENT

(1986–1992)

Only connect.

—E. M. FORSTER

O n June 19, 1986, President François Mitterrand of
France named Leonard Bernstein and James Baldwin
Commanders of the Legion of Honor—France's highest
award—at a ceremony honoring them both at the presidential
palace in Paris. Mitterrand saluted them for contributing, in their
respective bodies of work, to "a fundamental solidarity between
men, which we would be poorer without." He acknowledged Bern-
stein as "a man whom we esteem, whom we admire, someone who
has often shown himself a friend of our country and whom we un-
derstand." And Baldwin he hailed as a compatriot and "a defender

of human rights." The two men were flanked by family and friends, including Betty Comden, Adolph Green, and Lauren Bacall.

Conspicuously absent among them, however, was Richard Avedon, who knew the honorees intimately, their lives inextricably entwined across the years. Whether it was due to a scheduling conflict that obligated Dick to fulfill a fashion shoot for Dior in New York on the same day, or simply his refusal to be witness to this tableau of exalted acknowledgment for two lifelong friends, the truth is that *he* would never receive a Légion d'Honneur, and it rankled. "Avedon's constructed hagiography elides bitter disappointment at the lack of recognition in his lifetime from those places and institutions that mattered most: the New York art world, especially MoMA, and France. He took it all very personally," Robert M. Rubin wrote.

Avedon had done everything humanly possible to garner acknowledgment in the loftiest precincts of the civilized world, an ambition that required some very hard choices early in his career that were not always compatible with his nature. Now, at the age of sixty-three, he could look back on a formidable list of accomplishments: he had published six books of photographs; he was honored with an equal number of exhibitions, two at the citadels of art in America: the Metropolitan Museum of Art and the Museum of Modern Art; his long associations with two of the most prestigious national magazines in the country brought him fame and fortune. And yet, as a photographer, Dick was still beating his head against the granite columns of the pantheon. The prejudices confronting his chosen medium were not the only problem. Dick had been tormented his entire life by the *fact* of his sexuality, seeking lifelong psychiatric counsel to try to remedy what he—and society—considered his affliction. He made the decision to marry—*twice*—and to have a family and live a traditional life in accordance with conventions that had been bedrock require-

ments for a successful career and a constructive existence. And yet, here were his lifelong friends—Baldwin, who had never denied his homosexuality, and Bernstein, who had been openly gay by then for more than fifteen years—receiving the most distinguished honors of achievement in the most civilized country in the world. Their homosexuality turned out to be incidental in their path toward accomplishment, and perhaps even an ingredient in the inscrutable alchemy of their talent to begin with.

Baldwin published *Giovanni's Room* in 1956, the story of a young American expatriate in Paris caught between his loyalty to his fiancée and an illicit desire for Giovanni, a handsome Italian bartender, with whom he sustains a tempestuous affair sequestered within the confines of the bartender's humble lodgings—a single dark room. Baldwin's protagonist describes the street Giovanni lived on as respectable, with modern apartment buildings: "The street ended in a small park. His room was in the back, on the ground floor of the last building on this street. We passed the vestibule and the elevator into a short, dark corridor which led to his room. . . . He locked the door behind us. . . . I thought if I do not open the door at once and get out of here, I am lost." Giovanni's "room," tucked away in the back of a building at the end of the street, is a metaphor for the "closet," in which passion can be unleashed as long as it is contained within the confines of its four walls, quarantined from the rest of one's life. And even then, it was not unburdened by guilt and shame.

Sometime in the early 1980s, Dick attended a theater benefit at the Waldorf Astoria and "locked eyes with a young man," as Norma Stevens described it in her memoir. "He fell in love" is how she characterized it. Robert (Bob) Reicher was a young lawyer—a graduate of the University of Pennsylvania and Columbia Law School—who worked at Proskauer Rose, a white-shoe law firm. Reicher had never heard of Richard Avedon, which made him just

that much more of an enticement for Dick. While not classically handsome, neither was he unattractive. Aside from being Dick's height, they had several other things in common. One, he was Jewish; two, they both had lived in Cedarhurst, Long Island, as children, albeit over thirty years apart, as Bob was younger than Dick's son, John. The third was a shared passion for the theater. Bob had every *Playbill* from every production he had ever attended, seventy-nine binders full by the time he met Dick. "I see myself in him," Dick told Norma soon after they met. "He's exactly like me."

Their romance, which lasted, give or take, for a number of years, resided for the most part in "Giovanni's room." While Norma knew about their relationship, Dick was vigilant about sequestering Bob from every aspect of his life. Dick's personal studio assistant, who arranged the intricate details of his daily schedule for twenty years, and occasionally finalized transportation or dinner plans with Bob by phone, did not know the nature of their relationship. "Dick was a very private person and I respected that, and I appreciated the fact that Dick was able to keep at least some things in his life private, since all the staff was so aware of his every move throughout 80% of every day," Bill Bachmann said. On those evenings at the theater, Dick insisted that he and Bob sit several rows apart. If they were standing together in the lobby at intermission and someone Dick knew came over to say hello, Dick introduced Bob as one of his lawyers. Dick made sure that they dined in out-of-the-way restaurants to avoid running into friends or acquaintances. Bob lived in an apartment on First Avenue in the East Nineties, where Dick would often spend the night, but always, early in the morning, he was back at the studio, appearing to have awakened in his own bed, a cup of coffee in his hand before the junior assistant arrived at eight o'clock to hose down the sidewalk and sweep out the studio.

A week before the opening of *In the American West* at the Amon Carter Museum in Texas, Dick decided that Bob should be there,

and arranged for him to stay in a hotel across town. Bob was introduced to people at the opening as the lawyer who worked on the contract for the traveling exhibition—which was true, yet Dick barely even acknowledged him. Laura Wilson did not remember meeting Bob despite the fact that she and her husband threw a large party for everyone involved in the exhibition at their house following the opening. "Dick feared that his embracing Bob publicly would be not only bad for business but disastrous for his relationship with his son," Norma said. This was the life of the closet for Dick's generation of peers, a life of terror about being found out, a life of shame about feelings that are as natural to any individual as smiling. Even though Dick allowed himself this relationship with Bob, the secrecy surrounding it was its own attendant burden; ultimately, and sadly, the machinations to protect "the private affair" left a trail of humiliations with psychic costs to them both.

IN THE MID-1970S, AT Marvin's recommendation, Dick hired Elizabeth "Betti" Paul, an attractive young woman from Texas, as his in-house designer. Following Dick's cold war with Marvin regarding the Marlborough show, Betti completed the design of the 1976 *Portraits* book; worked with Dick on the installation of the Metropolitan Museum show and the design of *Photographs, 1947–1977*; helped design the Berkeley show in 1980; and, after Marvin's death, completed the design of the installation of the *In the American West* show in Fort Worth and the book of photographs that accompanied it. Dick's son, John, met Betti, who was five years older than him, in the studio and by 1978 they were married. By 1984, they had two young children, Dick's grandsons, William, then seven years old, and Matthew, four. Dick had a tepee in his apartment nine feet tall that he had bought in Arizona for the young boys to play in.

After graduating from Sarah Lawrence in 1975, John worked for a short time as a reporter at *Newsweek*, then briefly as a freelance journalist, before writing a novel, which was never published. John had been exploring Buddhism since 1972 and, by 1980, had decided to write a book about "the secret holocaust" of the Chinese in Tibet. He spent four months in Dharmsala, India, where the Dalai Lama was in exile. "It was one of the last refuges for all the flower children in the '60s, so there were wild dancing parties," John told a reporter for *People* magazine. "But, mostly in moments of sadness at being away from home, I'd sit and drink hot lemonade at Khunga's Cafe and watch reruns of The Mary Tyler Moore Show broadcast from Pakistan." John got to know the Dalai Lama, whom he would later accompany on a six-week US tour. "The Dalai Lama," he said, "is very similar to the present Pope in many ways. On the one hand, he's a man of incredible intellectual ability, the head of the faith. On the other, he's a real backslapper who's constantly saying, 'Just talk to me as a human being.'"

John Avedon's book *In Exile from the Land of Snows* was published by Knopf in 1984. The book concentrates on the period between 1950, when the People's Liberation Army of the People's Republic of China first appeared on the Tibetan plateau, and 1983, the year before the book's publication. John told the *New York Times* that the main themes of his book "are the destruction of Tibet by the Chinese, including the razing of thousands of monasteries, and the preservation of Tibetan culture by the Dalai Lama and 100,000 refugees in India, where they have built new monasteries, medical schools, libraries, and other institutions." Jonathan Mirsky, the Chinese expert assigned by the *New York Times* to review the book, writes, "The author supplies a respectable history reaching back 1,500 years, together with substantial accounts of exile life and policies, religious practices and traditional medicine."

Soon after publication of *In Exile from the Land of Snows*, John was approached by the Dalai Lama to write his official biography. "I'm just so dazzled to be his dad," Dick would tell people, thrilled that John was being recognized as a writer and a scholar. When Dick attended a screening of a documentary about the Dalai Lama, in which John had been interviewed, people came up to him afterward and said, "Oh, you must be John's father." Dick claimed to feel pride in his son, gushing that "finally, people are saying that." And yet it was always a double-edged compliment, as Dick was not capable of taking second place for very long.

Dick and John did not have an easy relationship. Dick's generosity toward his son knew no bounds, yet his grandiose displays of affection had the effect of exuberant overcompensation in the absence of his consistent down-to-earth contact with John throughout his childhood. As Ingrid Drotman, Dick's secretary in the early 1970s, categorized it, there were two kinds of people in Dick's life—those empowered by Dick's megawatt energy, and those who were so eclipsed by it that it left them defeated. "I had the feeling that that's what happened in the case of his wife and son," Drotman said. "John didn't come to the studio very often, but, when he did, he seemed angry." While John spent three years writing *In Exile from the Land of Snows*, Betti was supporting them with her job at the studio. Of course, Betti was on Dick's payroll, so in effect, John was being supported by the family business. Mike Nichols recounted to Norma Stevens an argument he and Dick had had regarding John the very last time they saw each other, over dinner in Dick's apartment. "I said something to the effect that we were each unlucky to have a kid who had no sense of what it meant to earn money," Mike said, and, then, described Dick blowing up in a rage. "Maybe that's *your* offspring, but it certainly isn't mine," Dick protested. "John writes these very important books and I'm more

than happy to underwrite them." And yet, John never seemed to pay deference to his father with the natural affection or gratitude or easy rapport that Dick longed for from his son.

SOMETIME IN THE MID-1970S, Dick received a call from Keith Avedon, a twenty-five-year-old first cousin once removed, who, unbeknownst to him, had grown up in Forest Hills, Queens. Keith's father, Arthur Avedon, was Dick's first cousin, a decade older, who, ironically enough, made his living in Queens as a photographer, providing ID portraits for high school yearbooks and local businesses. Dick and Arthur had known each other when Dick was young, but they had lost touch. When Dick was first starting out at *Harper's Bazaar*, he rented studio space from Arthur, on Fifth Avenue and Forty-Eighth Street. Arthur didn't think much of Dick's work at the time, but that was before the fates turned. Arthur turned out to be the kind of father to Keith that Jack had been to Dick—punishing, dictatorial, all work and no play. When Keith expressed his interest in studying classical music, his father promptly sold the family piano. Despite his father's disapproval, Keith made his own way to the Manhattan School of Music and became a classically trained pianist. By the time he called Dick, he was becoming a songwriter and had started to compose music with synthesizers, which were new at the time, while also playing in a band. Dick invited Keith, and his fiancée, Elizabeth "Betsy" Cox, for Sunday brunch in his apartment above the studio and they spent the afternoon sharing war stories about the various members of the Avedon clan. Betsy, a descendant of John Jay, the first chief justice of the United States, as well as Cornelius Vanderbilt, and also the niece of Archibald Cox, the Watergate special prosecutor, had been in the class behind John Avedon at Dalton. She knew him in high school only by reputation as "one of the radical revolution-

aries who was organizing the buses down to Washington to protest the Vietnam War."

Keith, it turned out, resembled Dick more than anyone else in the family. Dick made sure to stay in touch with Keith and Betsy, who lived in Manhattan, and in 1980, so impressed with Keith's talent, Dick made a short audition video of him performing several musical compositions to present to Calvin Klein for the proposed jeans ad campaign on television. When Calvin met Keith, he admired his jeans, asked what brand they were, and smiled when Keith said, "Levi's." For the next few years, Keith composed the music not only for Calvin Klein jeans, but also for several other ad campaigns Dick worked on. In May 1984, when Keith and Betsy's son, Luke, was born, they asked Dick to be his godfather. During his baptism, Dick anointed Luke with a drop of vodka on his forehead.

In 1985, Dick went to Rome to shoot a commercial for Coco, a new fragrance from Chanel. Keith, composing the music for the new ads, was in London all set to conduct the London Philharmonic and to record the sessions at Abbey Road Studios, but one night in his room at Brown's Hotel he collapsed and had to be rushed to the hospital. Dick had just returned to New York from Rome, but when he heard about Keith, he turned right around and flew with Betsy on the Concorde to London. Betsy recounted to the doctors that Keith, in the months before the collapse, endured a series of infections—persistent coughing, diarrhea, intermittent fevers, hepatitis—that led them to conduct tests that concluded, at the age of thirty-seven, he had AIDS. Upon hearing this news, Dick had Keith flown back to New York, reassuring Betsy that he would take care of all of Keith's medical expenses from there on out. While the diagnosis of AIDS made clear that Keith had been living the double life of "the closet," which she describes in her 1990 book, *Thanksgiving: An AIDS Journal*, the urgency of his treatment took precedence over the revelation of his sexuality.

Soon after Keith had been diagnosed, *The Normal Heart*, a play written by Larry Kramer, the cofounder of Gay Men's Health Crisis, opened at the Public Theater in New York. A political screed of operatic intention, the play was a very welcome and badly needed acknowledgment of the rage and fear about AIDS, the new disease that everyone was talking about, particularly since inadequate media coverage turned the entire gay community into pariahs. Calls for a kind of national quarantine of those infected hailed from the conservative elite: "Everyone detected with AIDS should be tattooed in the upper forearm, to protect common-needle users, and on the buttocks, to prevent the victimization of other homosexuals," wrote William F. Buckley Jr. in an op-ed column in the *New York Times*.

Dick and Bob Reicher went to see *The Normal Heart*, and, as usual, they were seated several rows apart. One of the unfavorable dynamics in their arrangement was that if Dick did not like the play and got up to walk out, Bob was expected to follow. Bob was absorbed in *The Normal Heart*, when, maybe a half hour into the play, Dick rose from his seat and rushed hurriedly past him toward the exit. Livid, but dutiful, Bob followed. Bob was about to let his indignation fly, but he caught his tongue when he saw the expression on Dick's face. The play had summoned not only his overwhelming fear of being exposed to AIDS, but also his deep sadness about Keith's impending death. "Dick said that Keith was the only member of the family he actually liked," Betsy recalled, adding her awareness of his penchant for hyperbole. On Keith's deathbed, Dick promised him that he would take care of Betsy and Luke. And that, over the years, he did.

AS PART OF THE media campaign for *In the American West*, each Condé Nast fashion magazine was required to send a writer and

a photographer to do a feature on Dick, the kind of publicity that served Avedon as well as the magazine empire that employed him. Mary Shanahan, who had known Dick from her days as art director of *Rolling Stone*, was now the art director at *GQ*, a Condé Nast publication. She and Dick had established a rapport during the occasional covers he shot for *GQ*, and she had been moonlighting for him as a graphic designer on his ad campaigns for Revlon. In July 1985, the editor of *GQ* assigned a fragrance copywriter from the magazine to interview Dick for the feature on the forthcoming show *In the American West*. Since Mary knew that Dick would be offended by a writer with no affinity for art or photography, she asked the editor if she might also bring along another young writer at the magazine, Adam Gopnik, then twenty-eight years old, who was something of an aberration at *GQ*. A doctoral candidate in art history at the Institute of Fine Arts at New York University, he worked at the magazine several days a week writing copy.

The three *GQ* musketeers arrived at the Avedon studio, and Dick was eager to show them the book of his Western portraits, "as he always showed everyone everything—not grand and distant, but intimate and peering, leering, right over your shoulder," Gopnik wrote in his 2017 memoir about his early years in New York. "As [Dick] turned the pages, he twitched nervously, waited for you to say the right thing. He smelled faintly, richly, of limes." On that day, Gopnik looked at the pictures and began to invoke August Sander, Francis Bacon, the Norman Mailer of *The Executioner's Song*, and even Goya. He dropped these names with an accuracy of knowledge about their relevance to Avedon's portraits, and then observed Avedon's reaction: "[Dick] started like a man with electrodes attached and activated at hidden spots of his torso—he twitched and reacted more actively than anyone I have ever seen," Gopnik wrote.

Mary Shanahan's instincts could not have been better. Adam had barely returned to his desk at *GQ* that afternoon when the phone rang. It was Dick, inviting him to dinner that very night.

Thus a love affair began—not of a romantic nature, but rather one that struck a platonic ideal between a mentor and his protégé, in which the wisdom of experience and worldly sensibility was readily exchanged in the context of genuine knowledge and insight about art and literature—*and* musical theater. Gopnik could be likened to a character out of the fictional Glass family of J. D. Salinger, a precocious child of academic parents who espoused a kind of intellectual modernism in their household. He would be the only one of his four siblings not to hold a PhD, as he would eventually abandon his doctoral studies for a career as a writer (at the *New Yorker*). Adam, whose wife was away on a visit to her family, arrived at Dick's studio that evening not knowing quite what to expect or what was expected of him. Dick made dinner and they talked in a kind of euphoric animation so characteristic of Dick when he was enthusiastic. "His motive for asking me up for dinner, I soon realized, couldn't have been simpler . . . or more touching," Gopnik said. "He wanted a friend to talk to about books and pictures." Gopnik remembered Dick saying, "Intellectuals don't like to talk about ideas . . . and art historians never talk about art." Artists gossiped. Writers talked about real estate. And theater people, well, aren't they always masquerading with other people's words? Sometime around ten p.m., the color drained from Dick's face, quite suddenly, his energy visibly fading, and he ushered Adam politely toward the door. "I'm having such a drop," Dick said. "Forgive me."

Gopnik thought he had failed to live up to the expectations of "Gandalf"—as he would later affectionately describe Avedon's role in his life—but first thing the next morning the phone rang, and Dick apologized for the sudden change in his mood. He then invited Adam and his wife, Martha, to dinner the following week.

After that, as Gopnik would write in his memoir, "Richard Avedon became our surrogate father, a best friend, a mentor of a kind—our introduction to the world of power and glamour in New York, and, in another way, the source of our first disillusion with those things."

One of Gopnik's important mentors at the Institute of Fine Arts was Kirk Varnedoe, who, in the context of his comprehensive art historical expertise, was knowledgeable about photography as well. He had given a series of lectures on the subject at the Institute, and, of course, he was conscious of Avedon's work. He loved Dick's fashion photography of the 1940s, and he taught it "with great animation and affection," according to Gopnik. In 1986, Varnedoe, two years before he was named chief curator of painting and sculpture at MoMA, organized a show at the museum entitled *Vienna 1900*, with works by Gustav Klimt, Oskar Kokoschka, and Egon Schiele. He invited Dick to see the work on the walls before the exhibit had opened. "Dick's eye was matchless, and his appetite for art was extraordinary," Gopnik said, explaining that Dick would fly anywhere to see a show of Rembrandt or Bacon or Velázquez. He had not been very familiar with Schiele's work, and he was knocked out by it. "The use of the bare background, the isolated figure, the language of hands, and that strange attenuated agitation that is so much part of Schiele obviously spoke to the condition of Dick's portraits," Gopnik explained. Dick wanted to know everything he could about Schiele, so Kirk rattled off what amounted to a thumbnail master's course about the artist off the top of his head.

When Kirk put together a symposium on *Vienna 1900*, he invited Avedon to talk about why Schiele had come to mean so much to him. This kind of attention from the world of the mind was gratifying to Dick, and it brought with it even greater meaning because it was at MoMA.

Dick's talk that day, called "Borrowed Dogs," was about the nature of portraiture. He begins with a description of the family

snapshots of his own childhood, in which the Avedons are always dressed up and posing in front of expensive cars that were not theirs, parked at the entrances to elegant buildings inhabited by others, always holding someone else's dog to complete the picture. "I will contrast Schiele's candor and complexity with the entire tradition of flattery in portrait-making," Dick stated. "I don't think you find portraits of white backgrounds before Schiele. . . . A dark background fills, a white background empties, a gray background does something to refer to a sky, a wall, some atmosphere of comfort and reassurance that a white background doesn't permit." He was speaking about his own work as much as Schiele's portraits. "The new language of gesture, the reversal of fashion, the daring white background, are elements that excite me about Schiele's work. But, frankly, what really excites me in Schiele's work is what he does with sex." He then says something that is certainly more germane to his own work: "There is an element of sexuality in all portraiture. The moment you start to look, you've been picked up."

Just as Dick would seek help from his writer friends in putting down on paper his own genuinely original insights, whether Doon Arbus in the Minneapolis catalog essay, or Harold Brodkey, who wrote Dick's speech for the honors he received at Berkeley, Gopnik was more than just the ghostwriter of his talk at the *Vienna 1900* symposium. "Borrowed Dogs" was later published in *Grand Street*, the literary journal, in 1989, as an autobiographical essay authored by Richard Avedon. In fact, Gopnik would fall in place in a trajectory of the close, personal friendships Dick had with significant writers of his generation—Truman Capote, James Baldwin, Harold Brodkey, Renata Adler—each of whom had a voice of such original literary timbre that their insights resonated well beyond an observation of their era.

In all the surrogate children—Bob Reicher, Keith Avedon, Adam Gopnik, and, to a lesser extent, several of his assistants—

Dick saw something of himself, a way to review who he had been in his youth, a way to learn about the new cultural developments that would keep him in touch with the times, and a way to establish a bond across generations that went both ways, as opposed to the lopsided relationship he had with his son, John. He started out wanting to be the father to John that his own father was not capable of being for him. But, in the end, he brought the same intensity of expectation to that relationship. Dick would describe his fatherly encouragement by recounting the potentially apocryphal scene in which the young Johnny would leave for school every morning and Dick would yell out the window, "Be creative!" The enormity of his father's creative genius hovered above that encouragement like a deadweight. With Bob or Keith or Adam, each one eliciting a different set of paternal impulses, that particular tug-of-war was not at play.

IN THE 1985 ISSUE of the French magazine *Egoïste*, Richard Avedon stares out from the cover casually dressed in an open-collar black shirt, sleeves rolled up, his jeans secured on his slight frame by a belt with a Western buckle. His expression is stern; his eyes are laser-focused at the viewer; his forearms, faintly blurred, hover above his shoulders with his hands suspended in midair—as if "conducting" this self-portrait. Dick made this picture in Provo, Utah, in 1980. The feature inside the magazine includes an interview with him by Nicole Wisniak, the publisher of *Egoïste*, entitled "A Portrait Is an Opinion," and a portfolio of photographs from *In the American West* that opens with Boyd Fortin, the thirteen-year-old rattlesnake skinner, holding a snake. "My portraits are much more about me than they are about the people I photograph," Dick told Nicole in an oft-repeated refrain about his work that rings truer with the years. "A portrait is not a likeness. The moment an

emotion or fact is transformed into a photograph it is no longer a fact but an opinion. There is no such thing as inaccuracy in a photograph. All photographs are accurate. None of them is the truth."

At the time, *Egoïste*, with only 35,000 readers worldwide, was something of a magazine phenomenon, conceived and designed solely by Wisniak and published annually in the manner of an editioned portfolio. The entire magazine was printed in black and white, the quality geared to the very best photographic reproduction possible on luscious thick paper the size of a small broadsheet, in signatures that were folded, not stapled, and fit, one inside the other, to be turned as pages, slowly, and savored as individual works of art or literary meditations. Sometimes Wisniak would have pages of *Egoïste* reengraved eight or nine times just to get the contrasts right. The ads, also conceived and designed by her, served as editorial amuse-bouche: in one full-page ad for Banque Commerciale Privée, a woman lights her cigarette with the flame of a burning check for $50,000; another shows three turtles crossing the pavement under the pointed beak of a towering Air France Concorde, the fastest plane in the world.

For Wisniak, it was a coup to get Avedon to agree to an interview for the 1985 issue and to be granted first magazine rights to publish photographs from *In the American West*. "I wrote to him for years," she said, and he declined every single request. She feared it would be a disaster if he found out that she put the entire magazine together herself, but one day, he called her. "It was like the pope calling," she remembered. "'Why didn't you tell me you were doing all this alone?' he said."

"Every year I start from scratch," she told the *Chicago Tribune* in 1988. "Doing 160 pages means one every two days. It is lonely, difficult. Fighting every day. I do it alone, as an artisan. I rarely go out. I work on the phone. What I want is not to be ashamed of any issue when it's over." The only other publications to come close in sensibility would be a combination of the short-lived *Flair* of the

early 1950s; Andy Warhol's *Interview* of the 1970s, before it suc-
cumbed to Reagan-era, money-driven glamour; and, conceptually,
*Visionaire*, which began publication after *Egoïste*, in the 1990s. The
editorial content of *Egoïste* surveys the world of culture—art,
literature, philosophy—as if the reader is attending a rarefied din-
ner party at which every guest seems to have unexpected insights
and unusual anecdotes about the artists, writers, and thinkers at a
particular juncture of the avant-garde and the culturally ordained.
"I do the magazine I want to read. I want to be amused. The idea is
to try and catch a smile, to make it like light conversation," she said.

Wisniak, with a wild mane of reddish-brown hair that she of-
ten swept off her face to emphasize a point or twirled in her hand
as a kind of punctuation, conducted the interview with Dick in
September 1984, their first meeting and the beginning of what
would become a long, intimate, and productive relationship. De-
spite Wisniak's marriage to Philippe Grumbach, the former editor
of *L'Express*, who was by then on staff at *Le Figaro*, and the birth of
their daughter in 1984, Nicole would begin an alliance with Dick
that defied category or definition. She shared Dick's determination
to get things right, and they worked closely together on *Egoïste*.
They traveled together often. They shared hotel rooms. She accom-
panied him to social events in Paris and New York. Over the years
she would lobby him passionately to move to Paris.

There were those who believed their relationship to be romantic—
people often referred to Nicole as Dick's "girlfriend"—and Dick did
not disabuse anyone of that impression. But Renata Adler arrived at
a different conclusion: *predatory* was the word she used to describe
Nicole. Renata met Nicole only once, with Dick, at a small dinner
party at Joan Didion and John Gregory Dunne's. "[Renata] came
away feeling that Dick wanted—needed—Nicole to believe that he
and Renata had been romantically involved," Norma Stevens said.
Norma, who knew Dick better than anyone in the world, drew her

own conclusion: "I'm positive that theirs was an *amitié amoureuse* rather than a *roman d'amour*." If the scheme of Dick's relationships in his life had precedents in his family, Nicole—irreverent, provocative, imaginative, intelligent—comes closest to his coconspiratorial childhood relationship with his cousin Margie. As Dick would tell Nicole in the *Egoïste* interview: "It was only with [Margie] that I could breathe freely." Years later, Dick would say that "*Egoïste* is the only magazine in the world to give me a completely free expression."

Following the publication of the *In the American West* portfolio in *Egoïste*, Avedon wrote to Wisniak: "You must understand and accept the fact that when it concerns my work, I do nothing out of blind enthusiasm or because I'm a nice fellow. . . . [I chose] *Egoïste* for the first viewing of the photographs . . . because I could see what uncompromising care and quality you brought to your work. I was right. The issue is exquisite and the engravings are the equal if not better than my own book."

On the cover of the following issue of *Egoïste*, number 10, in 1986, is Avedon's portrait of Andy Warhol showing the scars on his torso, and, inside, the Warhol Factory mural from 1969, printed beautifully in an eight-flap foldout. There are several portraits of an aged Chet Baker by Avedon as well. And, no doubt at Dick's suggestion, Adam Gopnik has an essay called "Innocence Is Not Enough." In a subsequent issue, Avedon photographed Marella Agnelli and Twyla Tharp for respective profiles, two people he delivered to Nicole for the benefit of the magazine. "Acutely fashion-conscious, yet with an unmistakable, diamond-hard taste of its own," writes the *International Herald Tribune* in 1987, *Egoïste* is "starting to gain an international audience for its cocktail of froth and substance."

IN 1988, ANNA WINTOUR became the editor of *Vogue* and mandated an entirely new approach to the magazine. For Avedon's first

cover under her reign, she insisted that the photograph be shot out of doors, as opposed to in the studio, which Dick was forced to succumb to, albeit begrudgingly, and without success. Wintour ordered him to reshoot it—*twice*. In the end, his picture was not used on the cover. Nobody, with the exception of Carmel Snow, ever ordered Avedon to reshoot anything, and he resigned—but not before he negotiated a deal with Condé Nast to buy out the remaining two years on his contract.

*Vogue* was never for Avedon what *Harper's Bazaar* had been, although he did regard Diana Vreeland, the editor who brought him to the magazine to begin with, as a singular beacon of originality and style. "Diana Vreeland just exploded with imagination," Dick would say about her late in his life. When she died, in 1989, four hundred people attended her memorial at the Metropolitan Museum of Art. Dick was one of the speakers and described her as a creator of fashion: "She used to say, 'I know what they're going to wear before they wear it, what they're going to eat before they eat it, and where they're going to go before it's there,'" he recalled to laughter.

By the time Anna Wintour arrived at *Vogue*, replacing Grace Mirabella, Dick's tolerance for the magazine had more than run its course. He had not gotten along well with Mirabella, either, who replaced Mrs. Vreeland as the empress of *Vogue*, and reigned for almost seventeen years. Mirabella, in her memoir, would have harsh words for many of her colleagues at Condé Nast, describing her successor, Anna Wintour, as "cold," "suspicious," "autocratic"— "a vision of skinniness in black sunglasses and Chanel suits" who was "playing the movie version of a fashion editor *a la* 'Lady in the Dark.'" She excoriates Alexander Liberman for the iron will behind his "honey-soaked delivery," and his "ego the size of the Newhouse fortune." The photographer Richard Avedon is, she says, a "royal pain" who, she erroneously concluded, "achieved

some of his best effects with girls who were utterly strung out on dope."

When Dick left *Vogue*, he was still actively cultivating his own "aristocracy of mind." His apartment above the studio was filled with stacks of books and videotapes. Framed photographs covered the walls—original prints—from Julia Margaret Cameron to Irving Penn and Peter Hujar. A Beckett poem was framed on the bathroom wall above a volume by the philosopher Isaiah Berlin. His appetite for serious culture had grown only more voracious: in 1988, Avedon had become so in thrall of a Swedish production of *Long Day's Journey into Night* directed by Ingmar Bergman that he made four trips to Stockholm during the run, taking friends with him each time, and saw it seven times. "There's no movie I can see seven times, but when a great living performance captures me, I could go every night forever," Dick said about the Bergman production.

He was not lacking in professional challenges to satisfy his overabundance of creative energy: While working on a Revlon campaign with Audrey Hepburn, he began to develop a series of television ads for a new fragrance from Calvin Klein called Eternity. Dick assumed the role of a theater director, flying several stage and screen actors of his choosing over from Europe to audition for the campaign, which included ten TV spots the first year. Among them were Rupert Everett from London and Lambert Wilson, a classically trained theater actor from Paris. Wilson remembered being given several scenes from a play to read for the audition. Auditioning for Dick—in the presence of Doon, who was once again writing the dialogue for the campaign—was no different for Wilson from trying out for a play. He got the part and signed a five-year contract for the Eternity campaign.

While Dick had his heart set on a German actress for the other half of the couple, Calvin insisted on the eighteen-year-old Christy

Turlington instead. Dick was not happy, but, as Sam Shahid, Calvin's art director, facetiously noted: "Dick did get Calvin to spend something like eighty-five thousand dollars on voice lessons for her." They shot ten commercials, first rehearsing every morning at the Avedon studio before going across the river to shoot the scenes at the Silvercup Studios in Long Island City. Dick, as the director, was thinking about Bergman's *Scenes from a Marriage* and *Fanny and Alexander* for the commercials, which Wilson described as formal, staged, and emotionally gothic. Sven Nykvist, the cinematographer for Bergman's films, shot the Eternity ads.

Dick took an interest in Lambert Wilson, the twenty-nine-year-old French actor, who was strikingly handsome. During the three-month duration of the Eternity production, Dick took Wilson to the theater more than a few times. They saw *Into the Woods* twice. Lambert found Dick to be extremely enthusiastic about almost everything he did, which was infectious, although, in Wilson's Gallic eyes, a little excessive, too. "I felt surprised that he should take the time to take me out," Wilson said, wondering why he wasn't also taking Christy Turlington out with them at the same time. After the theater, they would go to dinner, once traveling all the way to the River Café in Brooklyn under the Brooklyn Bridge, one of Dick's favorite restaurants, with its beautiful view of the Manhattan skyline. "I had the impression he had an embryonic gay fascination for men," Wilson said, "maybe because of the relationship he had with me. Nothing ever materialized, but it was a sensation I felt about him. I think he enjoyed the presence of a young man. I was twenty-nine years old, and I think he wanted to educate me, to open my eyes. He sensed I was a willing pupil, and I was grateful." The Eternity TV spots that Dick shot never ran. When Calvin saw them, he said, "They're a caricature of everything I stand for, which is sexuality and sensuality." Calvin hired Bruce Weber to do them instead.

In 1988, Marc Royce, twenty-two years old, a recent graduate of Kenyon College, heard about a job at the Avedon studio and called to inquire. He was interviewed by Ling Li, then Dick's main assistant and studio manager, and, an hour later, by Dick himself. The interview was brief; Dick was more interested in knowing about his family and schooling than about his technical knowledge of photography. Royce was hired as a tertiary assistant, who was expected to come in every morning at eight o'clock to do grunt work—rinse off the sidewalk, get breakfast danishes and lunch for the studio, and carry equipment on assignments. One of Royce's responsibilities was to shred a decade's worth of negatives—assignments for *Vogue*, *Self*, and other Condé Nast publications. Dick did not want any of that material to be confused with his legacy. Several years earlier, Bill Bachmann was hired as Dick's personal secretary. Because of Bachmann's overzealous penchant for meticulous organization, he spent a year secretly codifying every single assignment, commission, and ad campaign Dick had ever worked on. When he proudly presented this catalog—later called the studio "Bible"— Dick was horrified at the documentation of so many of his commercial jobs that had been anything but glamorous. Dick wanted no record of this aspect of his career to be incorporated into his legacy and insisted that the "Bible" remain a secret document for studio use only.

Marc Royce had grown up in Princeton, New Jersey, and his mother, who was French, had taught him how to cook. He started preparing lunches in the studio kitchen, and Dick, as well as the staff, loved his cooking. This made Marc ever more indispensable, until a strange confluence of events soon led to Marc's even greater fortune at the studio. John Avedon had recently divorced Betti. When Dick became suspicious of a growing alliance between Betti and his studio manager, Ling Li, he fired him, making Marc Royce his new studio manager and first assistant. Royce had to

learn on the job in a fast-paced and high-flying tutorial that could easily have overwhelmed anyone. Dick whisked Marc off with him on assignments, sometimes on the Concorde. On regular flights, Dick was in first class and Marc and the second assistant were in coach. "Dick would bring a huge tin of caviar from Petrossian on the flight, and, at some point, he would bring the uneaten half of the tin and blinis back to us and say, 'I can't eat anymore. Enjoy.'"

While on assignment in London, Dick took Marc to see *Uncle Vanya* and bought him a suit beforehand so he would look present-able for the performance. Afterward Dick took him to Harry's Bar, where he was "starstruck" dining with Tilda Swinton and her boyfriend. Following the assignment in London, they flew to Italy to stay with Gianni Versace at his home on Lake Como for a week-end before shooting a Versace ad.

Marc would become a master printer for Dick and print many of the pictures for his 1994 Whitney show. Soon after, Marc left the studio to begin a career of his own. As a going-away gesture, Dick took him and his parents out to dinner at Chanterelle, then one of the best restaurants in New York.

THE COVER OF *EGOÏSTE*, issue 12, published in 1992, is arresting—the very handsome six-foot-four French tennis star Yannick Noah is suspended, head to toe, in midair, his balletic gesture as if a shrug about his stark nudity, still then quite provoc-ative on the cover of a magazine. The portfolio inside conjures the photographs Avedon had taken of Rudolf Nureyev when he de-fected to Paris in 1961, and again for the 1968 portfolio in *Vogue*. The difference between 1968 and 1992—or, perhaps, between Diana Vreeland and Nicole Wisniak—was the full exposure of male genitalia on display in the *Egoïste* portfolio. Yet two other portfolios inside that issue stand out as unique in Avedon's career,

one of photographs taken following the fall of the Berlin Wall in 1989; the other chronicling the Volpi Ball in Venice. "Both are chaotic, operatic, and a bit overwrought," writes Vince Aletti, the photography critic. "Both find Avedon in photojournalistic mode—out of his comfort zone but plenty game."

The Berlin Wall photographs were shot on New Year's Eve as passage between East and West Berlin was fully opened for the first time since the wall had come down. It was a frantic six-hour shoot during which the night sky was filled with rockets and pistol fire, young Berliners climbing walls and signposts. Some people fled in horror. "Kids were climbing the scaffolding to get up on the top of the bridge, and it fell—three people died," Avedon recalled. "They were throwing bottles and cherry bombs or something. Bottles were crashing down with the excitement of it, and it was really dangerous. And you can see that in some of the faces."

"When the stroke of midnight came, 1990 ostracized the Iron Curtain to the realm of history," writes Michael Radou Moussou, who was a guide for Dick and Nicole through East Berlin that New Year's Eve. He described walking with them along the largest boulevard in the world, its monuments and edifices leading toward the Brandenburg Gate, the timeless symbol of German history. "For the first time, the passage was open in both directions," Nicole said. "We walked through the crowd together, East Berlin to West Berlin, on Unter den Linden. He held my arm with one hand, and his camera with the other."

The individuals Avedon photographed on the street that night appear to be shaken, as if face-to-face with something akin to the apocalypse. "Avedon seized this collective gasp of freedom after a continuous choking period of more than three decades," Moussou writes. In one picture in the *Egoïste* portfolio, a young man, on top of a pole of Pariser Platz, the dividing line between East and West under the shadow of the Brandenburg Gate, drinks from a bottle

after having cried out loud in ecstasy. "Avedon saw beyond the excitement of the moment to an anxious, uncertain future and the pictures," as Vince Aletti writes, "offer little hope."

"I wanted him to go to Berlin. I thought it would fascinate him," Wisniak later said. "We talked about politics often. He always said: 'It has to mean something.' He always wanted there to be a certain subtext with photographs—a jumping-off point for further reflection. For many, the event, the fall of the wall—was a harbinger of hope. But what he photographed above all was doubt, confusion, anxiety."

The 1991 Volpi Ball in Venice was a storied event, one of the last great aristocratic rituals of old-world elegance and style in Europe. It was Nicole's inspiration to assign Dick to photograph it. "Avedon was obsessed with Proust. It's obvious that the Proustian angle was in his mind when we went to the Volpi Ball, the last Ball," she said. The final remnants of old European aristocracy were on display, their boredom about having to put on one more set of diamond earrings or one more bow tie and float through a haze of social decorum was evident in Avedon's pictures, which nod to the photographs taken by Lee Friedlander and Garry Winogrand at social events in New York in the 1960s, or by Larry Fink in the 1970s and 1980s. Yet to freeze in a flash of a second that kind of organic social interaction isolates facial expression from emotion, gesture from attitude, and mood from the spirit of any event. Sometimes, in the hands of an artist, the very abstraction yields deep insight. But while Dick was a keen social observer, he was not a photographer of the authentic moment, at least not without the structure of a studio to create a context for spontaneous surprises to occur. His pictures of the Volpi Ball are not uninteresting, but neither do they convey the feeling Avedon had about the event. "You really felt the sinking ship," Avedon said. "You just felt that this would never happen again."

While Dick and Nicole were in Venice, they went to a Jewish synagogue on the Giudecca. They walked in during services and slinked into one of the last rows. Synagogues made Dick uncomfortable; his bar mitzvah debacle had turned him into a secular Jew. He had just motioned to Nicole that he wanted to leave when the rabbi descended the pulpit, walked down the aisle, stopped in front of him, and reached for his hand. Dick looked at Nicole and then at the rabbi, utterly perplexed, and said, "But I'm not Jewish." The rabbi smiled. "Come with me," he said in English, and Dick followed him all the way up the aisle and onto the pulpit. The rabbi wanted Dick to hold the Torah, and he placed the scrolls in Dick's hands. "It was as if lightning struck and went right through me," Dick told André Gregory. "Now how do you explain that?"

"I think it's years of denying you're a Jew," Gregory, himself a secular Jew, told Dick. "Hashem came to get you."

In her interview with Dick when they first met, in 1984, Nicole asked him if he had regrets in his life. "I never felt anything I ever did was good enough and frankly, a large part of me still thinks exactly that way about everything I do—it is not good enough—nothing is ever even near good enough," Dick responded. Was this the curse of Jack Avedon visited upon the life of his son, or the eternal burden of the Jew to live up to his full potential? Regardless, the lightning that struck him in the synagogue that day was a novel blessing—real, metaphorical, or apocryphal though it may have been.

# RENEWAL

(1992–1996)

In photography, as everywhere, there are those who know how to see and others who don't even know to look; there are those with taste, and there are boors, men of conscience who are merchants nonetheless, as in every trade.

—NADAR

In the summer of 1992, Tina Brown was appointed editor of the *New Yorker*, news that sent tremors through the collective conscience of American journalism. The *New Yorker*, a discreet yet resonant voice in the media cacophony, represented a standard of cultural excellence and a touchstone of ethical judgment across the arc of the twentieth century. By contrast, in the 1980s, Tina Brown—British, brassy, and culturally carnivorous—had turned *Vanity Fair* into essential reading for the moneyed classes of the Reagan era, delivering savory "dish" about misbehaving

socialites, spy-novel intrigue inside family dynasties, and scandalous malfeasance in the most respectable executive suites, all in a monthly aphrodisiac composed of snappy patter on glossy pages with splashy—and sometimes naughty—photographs. The New York intelligentsia feared that Ms. Brown, with her predilection for "just deserts," would scramble the impenetrable calculus of moral probity that was the *New Yorker* and, well, cheapen it.

Together, Si Newhouse, who owned Condé Nast, the parent company of both the *New Yorker* and *Vanity Fair*, and Ms. Brown asserted "emphatically that she would not bring to the *New Yorker* the kind of glitz she used so successfully in *Vanity Fair*," reported the *Times*. "Her most famous cover was a nude picture of the actress Demi Moore, who was seven months pregnant at the time." The article described a meeting between Ms. Brown and editors at the *New Yorker*, who were assured that "she would not be adding photos or changing the magazine in the ways we had feared."

Yet before the year was out and despite Ms. Brown's promise, an only slightly less shocking tremor rippled through the same journalistic circles when the *Times* reported the appointment of Richard Avedon as the first staff photographer of the estimable magazine— proof to die-hard believers that the magazine's DNA was, indeed, being altered. "I've photographed just about everyone in the world," Avedon said, addressing the challenge of his new role. "But what I hope to do is photograph people of accomplishment, not celebrity, and help define the difference once again."

David Remnick, then a staff writer at the magazine, recalled Brown's "full court press" to hire Avedon: "The plan was to use him to establish photography in the magazine as a form," he said. "It would be as if you were introducing poetry by having only W. H. Auden." Asked many years later to reflect on how she arrived at the decision to hire Avedon, Brown was circumspect. "I thought there was one photographer only whose work could leap out of the pris-

tine walls of Caslon typeface and that was Dick Avedon," she said. "So clean, powerful and dramatic. Plus, his own archive would mean we could use his images for historical pieces about authors, artists, dancers, political figures. And it turned out even better than I hoped. Wherever we had a subject it seemed Dick had taken a picture or was willing to take one."

Although the magazine had survived for more than fifty years with nary a photograph, it was not long before the Brown regime won over its readership. Not only did she infuse the stale and airless editorial thinking at the magazine with some badly needed oxygen, she instilled a sense of cultural urgency that sharpened the stories and the profiles without quite abandoning the magazine's underlying gravitas. Avedon's portraits, too, breathed new life on the page. "His photographs, in their epigrammatic compression of a whole subject into a single black-and-white image, were *New Yorker* profiles in miniature," Adam Gopnik said.

Dick spent a lifetime working for magazines, bringing to his role of photographer an editorial voice as much as a visual signature. So many of his early fashion photographs in *Harper's Bazaar* were narrative entities in a single image that evolved from his own literary imagination and with which he provided editorial solutions to what had always been considered visual problems. He had been an editor of his high school literary magazine; an editor at *Theatre Arts*; a photographer at *Harper's Bazaar* and *Vogue*; an editorial co-conspirator at *Egoïste*; and now, as the sole photographer at the *New Yorker*, he fit seamlessly into the role of a "contributor" who generated singular editorial "content" beyond the simple illustration of other writers' stories. "He required somebody to bounce ideas off of," said Pam Maffei McCarthy, the deputy editor of the *New Yorker*. "He would call me at exactly one minute past nine every morning. It was always an exhausting call—his level of energy was superhuman. He would usually want to talk about whatever piece

of theater he'd seen the night before, and his ideas for the critics' section. He supplied so many of them he was like an unofficial editor of the theater pages."

One of his earliest subjects for the *New Yorker* was Breyten Breytenbach, the South African poet, for a profile entitled "An Afrikaner Dante," by Lawrence Weschler. Breytenbach had been imprisoned in South Africa for seven years, from 1975 to 1982, for the alleged crime of treason. As a young artist and poet in Paris, he married a Vietnamese immigrant. As his poetry gained recognition in his native country, he received a literary award in South Africa that he wanted to accept in person. He applied for a travel visa for himself and his wife, only to have it denied, as South Africa considered his marriage to an Asian woman illegitimate. Swept into the social currents of the 1960s, Breytenbach became increasingly active in political causes in Paris as his writings became more incendiary toward the apartheid policies of South Africa, and when he set foot on South African soil again in 1975, he was arrested and jailed. It took seven years of internal pressure and international protests to get him released from prison, and in 1983, he made his first painting as a free man, a self-portrait in which he stands with his eyes closed and his hands at his waist, palms up, one above the other. In the 1993 Avedon portrait, Breytenbach strikes the same hand gesture. In this portrait, Weschler believes Dick to have been had. "When I say that this is the one time I saw the subject defeat Dick, compare Breyten's self-presentation in the portrait with Breyten's first self-portrait after prison, an image Dick had not seen (I am almost positive) when he took the photo, which is to say that Breyten was completely in command of his (self-ironizing) hagiographic self-presentation."

Perhaps Breytenbach did assume more control over his image than was usual for an Avedon, but it does not negate the potency of this epigrammatic portrait: Breytenbach's attitude in the picture is

one of indifference, his expression filled with resignation, his hand gesture in the form of a Buddhist *Dhyana Mudra*, mystical and imbued with possibility.

In another portrait, this time under the rubric "Showcase by Richard Avedon," Fiona Shaw, the Irish actress, sits topless, her hands to her chest holding the fabric of her shirt just over her breasts, her expression of wild amusement at the border of raucous madness. In this portrait the solid background is not white but gray, which sets the white pants she is wearing in relief, unbuttoned and turned down at the waist. "She's like Joan of Arc, only the flame's inside," Avedon is quoted as saying upon first meeting her. This "Showcase" is an example of a shift of importance between words and images in any magazine, and, as well, representative of Avedon's authority over the use of his photographs. While John Lahr, the magazine's theater critic, wrote the column accompanying the photograph, listing Shaw's recent appearances in a variety of very high-minded productions of *Electra*; *Hedda Gabler*; *Richard II*, in which she played the king; and "The Waste Land," by T. S. Eliot, he gives a portion of the column over to a description of the way Avedon photographed her, in which she is cast "in the improbable role of glamour puss," yet "her sense of fun and irony shine through."

In 1995, Dick photographed Ralph Fiennes, then thirty-two years old, on the eve of his Broadway stage appearance as Hamlet. He had made his name on the screen in *Schindler's List*, for which he was nominated for an Oscar. "A sizable slice of the audience, I suspect, will be made of moviegoers tempted away from the multiplex and into the spit-and-cough of live performance by the prospect of observing an idol in the flesh," Anthony Lane writes in his profile. In Avedon's portrait, there is a demonic edge to Fiennes's haunted expression, his deeply handsome features framed by his dark, shoulder-length hair and imbued with an intense combination

of curiosity, vulnerability, and manic turmoil. His shirt is ripped; his hands are lifted to his chest self-defensively. The portrait is striking in the simplicity with which Fiennes appears in a performative gesture filled with emotion instead of technique.

During Avedon's tenure at the magazine, which would last until his death in 2004, any one of his many photographs of the cultural figures of fin de siècle America serve to exemplify his unique editorial contribution to the magazine. "I recognize that most portraiture is ennobling in one sense or another, and maybe mine is too, if the definition of nobility includes a struggle with ambivalence," Avedon told Michel Guerrin of Le Monde. "To put it simply, a photographic portrait is a picture of someone who knows he's being photographed, and what he does with that knowledge is as much a part of the picture as what he's wearing or how he looks. He's implicated in what's happening, and he has a certain real power over the result."

Lisette Model told Dick that she considered his photographs of his father, for example, to be "performances." He agreed. "We all perform," he said. "It's what we do for each other all the time, deliberately or unintentionally. It's a way of telling about ourselves in the hope of being recognized as what we'd like to be. I trust performances. Stripping them away doesn't necessarily get you closer to anything. The way someone who's being photographed presents himself to the camera and the photographer's response to that is what the making of a portrait is about."

Dick seemed less interested in rendering the individual than he was in capturing the moment of interaction between him and the subject. That is why he often claimed his portraits to be self-portraits. Perhaps that is why he so loved the theater, in which moments transpire between the actors onstage and the audience that are alive and palpable—and why he would go repeatedly to the same play, because that interaction is different with each per-

formance, just as a portrait of any of his subjects would be different at each sitting.

IN 1993, DURING HIS seventieth year, Avedon signed a ten-book deal with Random House in partnership with Eastman Kodak Professional Imaging, described by the publishing house as the "co-publisher" on these projects, for a purported $10 million. "Avedon says the Kodak grant is 'not anywhere near that amount,'" reported Kay Larson in the *Washington Post*, "but a Kodak executive who requested anonymity says that $10 million is 'the figure heard all over Kodak.'" A ten-book contract was unprecedented for any writer, much less a photographer, in particular one who by all measures was at an age when most people were slowing down and thinking about summing up. Yet at seventy, Dick retained the energy and expectation of a man easily twenty years his junior, juggling his position as the sole photographer for the *New Yorker*, producing books for Random House, and fulfilling his ongoing, wildly lucrative contract with Gianni Versace and other fashion labels to shoot their ad campaigns.

Raymond DeMoulin, a vice president in charge of professional photography at Kodak, had vast resources to throw at promotional projects, and it was his idea to cultivate two photographers of solid reputation on which to shower his corporate beneficence: one was Sebastião Salgado, who was invited into the Magnum membership for his searing documentation of the world's laborers, and the other was Richard Avedon. "Saint Ray," as DeMoulin was called in the loftier precincts of discreet curatorial fundraising, gave Avedon a career boost worthy of a major artist. The $10 million "grant" would cover an exhibition at the Whitney, plus the ten books to be published by Random House. The arrangement served Eastman Kodak in equal measure, as their imprimatur would appear on all

the books that Avedon published—one brand name in service of another.

*An Autobiography* was the first Avedon book to be published under this contract. It *was* something of a summing up, with 284 photographs taken over the course of his career, many of them portraits, as well as his early fashion work and his attempts at reportage. "It was the first book that brought all of his work together," said Mary Shanahan, who designed *An Autobiography*, although she was quick to point out that Betti Paul Avedon, Dick's ex-daughter-in-law, had begun the initial selection of pictures in the late 1980s and put in place the basic structure, until Betti and John were divorced and her involvement with the project ended.

"This book tracks the path of three crucial illusions in my life," Avedon writes in his two-page introduction. "The first section is about the illusion of laughter, and a young man's discovery of the fine line between hilarity and panic. The second section is about the illusion of power. The third is about the loss of all illusions." He explains that the pictures of his family—his mother, father, and sister; his wife and son and grandsons—are "all about the dream of building a happy family amid the denial of past unhappiness." He describes other portraits of individuals either "running from unhappiness or hiding in power . . . locked within the reputations, ambitions, beliefs, even within the forms of their own earlier happiness." The contradiction between the reality of Dick's experience as he describes it—the perpetual flight from unhappiness—and the presentation of power in the form of, say, public glory is a theme that permeates this autobiography, although the picture choices and the layouts by no means represent a clear-cut depiction of this dichotomy.

"It was a deliberate choice to make unexpected connections between pictures," Shanahan said. One self-portrait—taken in 1964 in a photo booth in which Dick covered half his face with a cutout

mask of James Baldwin's face—is paired with Stephanie Seymour, his favorite model in the 1990s, who stands up straight in a form-fitting black sheath so sheer that her breasts are visible, lifting the hem above her waist, exposing her naked crotch, her pubic hair trimmed for the occasion. While each of these images is strong in its own right, bifurcation might be the visual factor that unites them. Dick is half black, half white in his self-portrait with the James Baldwin mask; Stephanie is the epitome of elegant restraint above the waist, intentionally shocking and exhibitionist below.

While the date of Avedon's seventieth birthday was May 15, 1993, the publication of *An Autobiography* was the occasion for an official black-tie dinner celebration thrown in Dick's honor by Random House and the *New Yorker* at the New York Public Library on September 27. Aside from the husband-and-wife hosts—Harry Evans, editor in chief of Random House, and Tina Brown, Dick's corporate colleague at the *New Yorker*—the paparazzo Ron Galella photographed the many luminaries in attendance, including Dick's close friends Lauren Bacall, Betty Comden, Adolph Green, and Phyllis Newman. Shirley MacLaine was there, as well as Gay and Nan Talese, Nora Ephron and Nicholas Pileggi, Jann and Jane Wenner, Peter Brant and Stephanie Seymour, Barry Diller and Diane von Furstenberg, Liz Smith, Stockard Channing, Kate Moss, Donatella Versace, and Liza Minnelli. The *Times* reported that the hosts, along with Adam Gopnik, offered "a mixed bag of encomiums." In one picture, Diane Sawyer, by then married to Mike Nichols, sits in the foreground with John Richardson, the art historian and Picasso biographer; Dick is standing behind them looking ever the eminence in his tuxedo and with his shock of gray hair, his arm around Nicole Wisniak, sharing a moment of hilarity with his dearest friend Mike Nichols. They are at that moment the very picture of worldly success.

For Dick's seventieth birthday, Bill Bachmann, Dick's personal

assistant, surreptitiously solicited over one hundred Happy Birthday video tributes from Dick's close friends, professional colleagues, and meaningful acquaintances, and assembled them into a two-and-a-half-hour videotape entitled *To Be 70*. In one video recording after another, the people in Dick's life offered heartfelt wishes, many with charming originality, recalling either a unique moment between them or their shared history or their like-minded sensibilities. Perhaps the most telling tribute of all was from Evie, on whom, despite their years-long separation, he had always kept a tender and protective eye. "Happy birthday to the sweetest man in the whole world," she says to him.

"Dick was totally surprised," Bachmann said, adding that he always protested the notion of celebrating *any* of his birthdays. Yet Bachmann succeeded in delighting Dick with his video surprise. "He and the entire staff gathered in his studio to view the video in its entirety." On the occasion of his actual birthday, Dick and Nicole Wisniak celebrated in Venice. "On the afternoon of my seventieth birthday," Dick later recalled, "I sat on Atilla the Hon's throne in Torcello and thought about the fettucini at Harry's Bar." That evening Nicole presented him with a framed original letter by Proust and a bottle of Grand Vin de Lafite Rothschild 1923, the year of his birth. It wasn't easy to take Richard Avedon's breath away.

ON JULY 22, 1990, John Avedon, thirty-seven years old, the divorced father of two small boys, and Maura Moynihan, thirty-two years old, joined hands in marriage at the Avedon family compound in Montauk situated on a promontory overlooking the vast blue sea. The bride was the daughter of US senator Daniel Patrick Moynihan of New York. When she arrived in New York after graduating from Harvard, she worked closely with Andy Warhol, conducting inter-

views for his magazine by day and socializing in his luminous orbit at night. Meanwhile, her interest in Eastern religions—Buddhism and Hinduism—deepened, and in 1989, when she began to work with Tibetan refugees, she met the Dalai Lama. It was in this context that she attended a benefit for Tibet House one evening and met John Avedon, whose book *In Exile from the Land of Snows* she held in high regard.

Among the two hundred people gathered at the wedding were Senator Moynihan and his wife, an architectural historian; the brother and sister-in-law of the Dalai Lama, who traveled all the way from Dharmsala; and a broad swath of friends not only of the bride and the groom, but also of the groom's father, whose outsize circle of intimates included plenty of boldface names including Mike Nichols, Diane Sawyer, and Renata Adler. Dick had built the Montauk house a decade earlier, designed by the architect Harris Feinn in the relaxed New England shingle-style characteristic of the conventional architecture of the East End, with a gabled roof and dormer windows and sweeping views of the ocean. The house was designed as a comfortable family gathering spot and used primarily by John and his young family. One wing was set aside for Evie's use whenever she wanted to visit. There was a small guest cottage, too, where Dick preferred to stay when he was there, which was not often.

Maura recounted Dick's singular attentiveness to his mother, "whom he adored," she said. Dick's lifetime support of his mother, and of his wife, Evie, underscored his bedrock sense of family responsibility, regardless of his shortcomings as a husband and father. "Dick included Evie in everything," Maura said about her in-laws, adding that Evie's apartment was filled with books and Evie was always giving her new books to read when she visited. "Dick loved Evie very much. At our wedding, she came, and they sat together." Dick also supported John and Betti while they were married and

continued to provide financial support for his grandchildren after the divorce.

Dick and Senator Moynihan "genuinely admired each other," Maura said about her father and her father-in-law. "They were both Depression-era boys, and they recognized the same qualities in one another: they were both driven; they shared a love of the theater; they drank champagne together and talked about Rogers and Hammerstein. My father's favorite movie was *Duck Soup* and Dick loved Groucho Marx."

Betti, John's ex-wife, was Elizabeth *Paul* Avedon and Betsy, Keith Avedon's widow, was Elizabeth *Cox* Avedon. Their names seemed to be the only thing they had in common. One was the mother of Dick's grandchildren, Matthew and William; the other the mother of his godson, Luke. When Dick's grandchildren came over to play at the studio, Luke, who was a year younger than Matthew, would join them. And because Betti and Betsy both lived downtown, the children played together—skateboarding or Rollerblading—in Union Square Park.

One month after the publication of *An Autobiography*, Dick was slapped with an ugly lawsuit. Betti, his ex-daughter-in-law, accused him of exploiting nude photographs of his grandchildren and behaving in sexually inappropriate ways. Dick was devastated when he read the accusation, and indignant. He opened the documents in the evening, and he called Norma to come over immediately. He issued an official denial through his lawyer, Martin Garbus: "The statements made about me are false and slanderous. . . . It is a tragedy for my grandchildren that Elizabeth would try to gain a financial benefit by launching this kind of attack." For people who knew Dick well, the charge did not seem remotely plausible. Everyone rallied to his defense. Dick's mother said she knew he could never do a thing like that. His son, John, the children's father, came to Dick's rescue as well, quoted in the press as saying that "only a

vindictive and troubled woman could misuse her children and lie so blatantly about my father for financial gain." Despite Betti's claims, Betsy Avedon remained confident about Dick's positive influence on Luke. On October 26, 1993, the *New York Post* ran an item with the headline "Angry Avedon Denies Sexual Accusations," reporting that he was being sued by his former daughter-in-law for $5 million.

According to Norma, Matthew and William "were inured to nudity"; their parents were never self-conscious about being naked in front of them—something Dick had cautioned them about—and it was not unusual for the boys to run around the house without their clothes on. After all, Dick was a grandparent—and a photographer. When his grandchildren were at play, whether running around the house naked or throwing a ball on the lawn in their shorts, he took pictures, as any grandparent would. The pictures in question were six years old and had been used in the custody trial.

The lawsuit came on the heels of the publication of *An Autobiography*, which had come out a month before and about which there were numerous articles in the press—including the announcement of Avedon's ten-book deal for $10 million. Mary Shanahan was given prominent design credit on the title page, essentially obscuring Betti's early role on the project. At the same time, the accusation of child abuse had copycat resonance as Mia Farrow's accusations about Woody Allen's behavior toward her daughter, Soon-Yi Previn—and the subsequent trial—were just then dominating the media.

John and Betti's marriage ended in the late 1980s after John learned of her affair with a famous actor. The divorce had been messy, and the child custody battle ugly. When Betti learned about John's engagement to Maura, her behavior became vitriolic. One day Maura appeared in the Avedon studio to be photographed before the wedding, and Betti, who was still on the studio payroll as

a designer, was visibly shaken. In early 1991, John and Maura had a son, Michael. Dick bought them a house in Washington, DC, where they could be close to Maura's parents, "which was good for my son," Maura said, while John was working on a book about the Dalai Lama. "We did go to the Montauk house in the summers," she added. "I have very happy memories of my son playing with Dick and his half brothers in the Montauk house."

On January 5, 1994, a court order was signed by both parties that concluded "there are no findings of misconduct on Mr. Avedon's part." It was determined at the trial that Dick's pictures were no different from family pictures taken by any grandparent. Both parties signed a confidentiality agreement. Dick was not ordered by the court to make any payment, but, according to conversations Norma Stevens recorded in her book, he paid Betti $500,000 to put an end to the ordeal.

IN THE EARLY 1990S, conversations began between Dick and the National Gallery of Art in Washington, DC, about a retrospective of his work. Sarah Greenough, curator of photography, remembers that her department was just beginning to collect photographs by individual artists "in depth," a curatorial term to describe the acquisition of multiple pieces by an artist to be able to reflect the essential vision driving the work. The National Gallery wanted to do an exhibition of Avedon's work from all his previous museum shows—the Minneapolis Institute of Art; the Museum of Modern Art show of photographs of his father; the Marlborough gallery show of portraits; the Metropolitan Museum of Art fashion show; and the Amon Carter Museum commission of the American West. All the work exhibited would then be given to the National Gallery for its permanent collection. It seemed like a worthy tribute to Avedon's career and, as the country's official museum in the

nation's capital, a logical destination for the work: the museum's curatorial regard for photographic prints was unparalleled, its conservation expertise first rate; and inclusion in the collection was tantamount to an official acknowledgment of the work as a national treasure. Negotiations ended, though, when Dick expected curatorial control over the exhibition and authority over any and all museum publications of his work. This did not comport with institutional policy, and the National Gallery said no.

Soon after those talks fell apart, discussions began about an Avedon retrospective at the Whitney Museum of American Art. In 1991, David Ross was named director of the Whitney, which, at the time, was housed in a Brutalist architectural masterpiece on Madison Avenue, designed by Marcel Breuer. "It was the first show I wanted to do," Ross said about an Avedon retrospective.

The rapport first established between Dick and David Ross at the University Art Museum in Berkeley in 1980 evolved into a lifelong friendship, one that proved to be significant in the circuitous route that led to the Whitney show. Ross was hired away from the Berkeley museum to become director of the Institute of Contemporary Art (ICA) in Boston in 1982. Before Ross moved to Boston, he accompanied Dick on one of his road trips through the American West. He watched as Dick made his portraits in southern Colorado, observing firsthand the way he charmed absolute strangers into performing for his camera. "I believe that his work advanced the form of portraiture in photography," Ross said. "He was an enormously inventive artist. . . . His giant portraits were literally his own invention, as was his understanding of the ways in which reading a photograph on the wall was so different from reading photos in magazines or books. That is why he did both so well, and in many ways, revolutionized the display of photographs in gallery spaces."

When Ross arrived in New York, the Whitney's curatorial staff

didn't consider photography very important. Even though the museum had mounted a large Mapplethorpe show in 1988, it did not yet possess a photography collection. Instead, artists like Cindy Sherman were in the painting collection. "I believed that Dick had not gotten his due," Ross said. "I remember well my lunch with him and his frustration at being only considered for his fashion work in his hometown, and his pleasure when we agreed to the exhibition project." When Ross told Leonard Lauder, then president of the board of the Whitney, about his intention to do an Avedon show, Lauder quietly uttered, "It couldn't be Penn?"

Ross brought in Jane Livingston, a long-distinguished curator at the Corcoran Gallery of Art in Washington, DC, who had left that museum to work on her own projects. Jane and Dick, along with Mary Shanahan, his designer, installed the show. The Avedon studio brought in bright halogen lights to replace the Whitney's more sedate lighting system, which is the kind of thing they might not have been able to afford had it not been for Kodak's deep pockets.

The Whitney show, called *Richard Avedon: Evidence, 1944–1994*, opened in March 1994. There were three private events before the official opening on March 29. On March 18, a very select group had been invited for an evening walk-through with drinks and hors d'oeuvres, for which Dick could not stop himself from sending a personal invitation to John Szarkowski, perhaps one last desperate attempt at seeking approval from the by then former curator at MoMA: "I'm going to have a private viewing of my exhibition at the Whitney for the people I care about, and before anyone else sees it. It will be just me and my work, and I would love it if you and your guest could be there." Szarkowski responded only after the event had taken place, and if only to apologize for having been away. The grander, star-studded events on March 23 and March 29 were featured in the *New York Times*.

One gallery in the show presented four facing mural portraits:

the Chicago Seven, the Mission Council, the Warhol Factory, and Allen Ginsberg's family. Another gallery was painted black with pictures of the Berlin Wall on New Year's Eve, hung in the same manner as his Chicago Seven mural portraits at the Minneapolis Institute of Art in 1970. He included a set of the Vietnamese women who had been monstrously scarred from napalm. There were drifters and field hands from the American West series that seemed to "walk out of the pages of 'The Grapes of Wrath'—their eyebrows are diabolical fringes, their eyes windows onto a universe of misery," writes Kay Larson in her *Washington Post* review of the show. "Truckers, coal miners, housewives are on an equal footing with the famous—George Wallace, Dwight Eisenhower, Francis Bacon." Larson describes the entire fourth floor as "a gallery of police mug shots taken by a brilliant camera master who sees through his subjects' souls with the pitiless candor of God. Avedon does deserve the moniker 'artist.'"

Very few critics agreed. The show was pilloried. "Richard Avedon has the instincts of a great court painter," wrote Mark Stevens in a review in *New York* magazine. "His style is essentially a court style, his way with the camera worldly, fluid, knowing. His particular court, rather than being a fixed place, is more like *un idée fixe* shared by many people—call it smart and powerful New York. There's no king, but stylishness itself reigns."

Stevens makes a case for Avedon's right to photograph the downtrodden people of the American West, and while he considers a few of the portraits to be of significance, in totality, they "are flawed by self-congratulation. They're so immodest in their portrayal of modest or broken lives—completely without the tact, like perfect pitch in music, of a Walker Evans or Robert Frank."

Arthur Danto couldn't have agreed more in a four-page denunciation of the work in *The Nation*. "Given the distance between the world in which [Avedon] attained his great success and the world

whose conspicuous problems are so clearly of concern to him, there is a lived tension in his work that is of an almost tragic dimension, particularly in view of the disproportion between the undeniable artistic merit of his best commercial work and the largely undistinguished quality of what he doubtless regards is his real art"— his portraiture. Danto dismissed the blank white background as Avedon's "signature and his crutch," concluding that it serves as "a wall against the real world, for which even the most vivid photographic imagination is a paltry substitute."

Vince Aletti, in the *Village Voice*, bestowed greater regard on the artist and the work: "His photos from the last two decades are increasingly the work of a despairing, often pessimistic social observer, a man who sees, finally, through life's sad, corrupt masquerade. It's the damned human condition staring us down again— from both sides of the camera." Aletti is critical of the show because it fails to present what he considers to be Avedon's liveliest work, his fashion images. "For Avedon to reduce his own fashion photos to a career footnote is, if nothing else, perversely pleasure denying."

In the *Times*, Michael Kimmelman, the chief art critic, focused on the conspicuous conflicts of interest that abetted Avedon's apotheosis into the art world firmament. "It was hard not to notice that last week *The New Yorker*, where Mr. Avedon is the staff photographer, was especially chockablock with Avedon photographs. The co-publisher of the exhibition catalogue, with an essay by *The New Yorker*'s art critic, Adam Gopnik, is Random House, which is owned by S. I. Newhouse, who also owns *The New Yorker*."

Kimmelman was justified in excoriating the shameless promotional bloc composed of the prestigious entities for their single employee. Yet when Kimmelman finally turns to the show, he, too, bemoans the absence of the fashion photographs: "If you expect Dovima and the elephants at the Cirque d'Hiver in Paris, forget it. Forget Sunny Harnett leaning over the roulette wheel at the casino

at Le Touquet. I don't know whether the closer analogy is a Picasso retrospective without Cubism or a Woody Allen one without the comedies, but in either case, the disservice is to Mr. Avedon." Which leaves the portraits, the most fertile soil for Kimmelman's final assessment of Avedon as an artist: "The problem with his rogues' gallery of drifters and factory workers from the American West isn't that they're meanly exploitative, as critics have moaned. The problem is that the theatricality of Mr. Avedon's portraits isn't absorbing." Ultimately, he concludes, with his own jaundiced eye, that they are too hollow to constitute "art."

In the collective judgment of the reviewers, Avedon had overstaged himself at the expense of the work, and the work he put forward did not conform to their view of who he was as a photographer. While he wanted to position himself as an artist apart from his fashion work, his fashion work was so good that he became, in his own mind, a victim of his own attributes.

*Evidence, 1944–1994*, the catalog for the Whitney show—and the second book of his ten-book deal—skews very heavily into autobiography, to the point of self-aggrandizement. Nearly half the book is designed with a chronological graph of every picture in the show above a red line, keyed to a biographical record of Avedon's life in pictures below the red line. Once again, the artist can't help himself, insinuating his own life story to such an extent that it obfuscates the work.

The Avedon catalog includes an essay by Jane Livingston in which she methodically anatomizes Avedon's career and asserts his importance: "Avedon didn't feel obliged to worship the 'integrity' of the medium or to follow the rules of camera format, the constraints of photographic paper, or the classic traditions of the craft itself." She makes a case for the radical experimentation he employed, and about which the critics so often missed the point, as the imagery he created was so clearly original, and impossible to

ignore. "Permission to break all the rules," she writes, "at least since the advent of Robert Rauschenberg and Andy Warhol, and passed on through Cindy Sherman and her many confrères and imitators, has somehow been granted only to those artists whose declared intentions are comfortably outside of the defined limits of 'straight' photography."

Adam Gopnik contributed an essay to *Evidence*, as well, entitled "The Light Writer," in which he explains for the ages the significance of Avedon's work: "It is not so much that each portrait makes an inarguable case about each sitter—each is really, truly like this—but that each makes a general case about the intensity of human character: that to be human, at least in Avedon's time, is, in effect, to first *become* a character. It scarcely matters what this character is, or who invented it, photographer or subject. To burn through against a white background is to become a member of a disturbed family of the spirit."

Avedon used to say about his portraits that it didn't matter "who" they were, "just look at their faces." The subject, of course, particularly one of public notoriety, was aware of the act of being photographed—an "act," to be sure—and their presentation was never intended to be "genuine," in the sense of capturing the truest essence of their nature. As Gopnik argues, "They require a complicity between the subject and the photographer not about the 'authentic self,' but about the power of concentrated performance to express psychological intensity."

Every major publication reviewed the Whitney exhibit. There were features in magazines like *Newsweek*, *People*, and *Vogue*; there was a program of public panels about the exhibit at the museum; and Avedon appeared on several television talk shows. "I think he expected poor reviews and I don't think he cared," Mary Shanahan said. "Dick loved the show, and he spent much time at the museum interacting with the viewers, who were very positive." Still, Dick

never took criticism easily, and the reviews from serious critics rankled, whether he acknowledged the wounds to anyone or not.

Yet Ross was onto something with the Avedon show. Problematic though it was for the grandiosity of its presentation and the overbearing media attention, it was the right idea at the right time. By the early 1990s, despite the prejudices that lingered in some quarters of the art world, photography had gained respect in the fine arts, so much so that postmodern artists and critics were compelled to rip the medium apart.

The instrument itself—the simple dumb machine that is the camera—is capable of providing profound existential evidence that deepens our understanding of our very experience of being. Avedon's output with that instrument only continues to make the case for photography as an art form—and his own work in that medium is among the best in the twentieth century. "Photography is the common language of modern history," Holland Cotter once said. "It's everywhere; and everyone, in some way, understands it."

IN EARLY 1992, AVEDON offered a master class through the International Center of Photography. It was advertised as four weekend sessions, one a month, over the course of a semester, yet because of Dick's wide-ranging commitments and fluid schedule, as well as a generosity of intention, the master class turned into a tutorial that stretched into many more intermittent weekends over several years. Out of 250 applicants, Dick accepted 16 students. Among them were Diane Arbus's daughter Amy, who, by then in her late thirties, had been photographing regularly for the *Village Voice*; and Lizzie Himmel, the daughter of Dick's early confreres Lillian Bassman and Paul Himmel, also in her late thirties, who had a successful career as an editorial photographer, shooting for many publications. "I was bored with what I was doing, and my

mother said, 'Take the class with Dick,'" Lizzie said, recalling her motivation for applying to the workshop.

The class took place at Dick's studio, and the students were required to fulfill assignments he gave them from session to session—in the genres of the family snapshot, portraiture, fashion, and reportage—and then to discuss and critique the results. In the first session, Dick went around the room and told every student why he had selected them out of the swarm of applicants. Chris Callis, an editorial and commercial photographer with regular assignments from *Esquire* and the *New York Times Magazine*, was thrilled to have been accepted. He remembers Dick saying, "If I had to light the Empire State Building, I would get Chris to do it," the point being that Dick regarded Callis's technical creativity as his photographic strength.

The first step of the "self-portrait" assignment occurred in class. Dick went around the room and asked each student to describe a photograph that might represent a portrait of who they were. Half the students described pictures with water. Amy Arbus referred to a picture of a swimming horse "with crazed eyes," by Sylvia Plachy, and decided on the spot that she would photograph herself in water. Given that she was in the city, the only water available to her was in the bathtub. She remembers being so distracted by the technical obstacles, trying to situate the tripod on the sink and balance the camera, that she wasn't thinking about the implications of the picture. "Then, when my toe hit the water, I realized that my mom died in a tub," she said. She proceeded to make a series of pictures of herself naked in the tub with the camera suspended directly above her. When she showed them in class, Dick, who had witnessed her mother's dead body in the bathtub, was flabbergasted. He asked his assistant to blow up Amy's pictures as large as possible on the copier and put them up on the wall. He took Amy aside and said, "Can I tell the class?" They decided not to discuss

the circumstances of her mother's suicide until the students could react directly to Amy's pictures. "There were two incredible things about them," Amy said. "One is that I look like I'm seventeen"— Amy's age when her mother died—"and the other is that they were very intense and emotionally upsetting."

In fulfilling the class assignment, Amy left the influence of her mother behind, and Dick would later write about her bathtub series in *Aperture*: "[She] went to a place that had no precedent in her own, her mother's, or anyone else's work. . . . In these portraits, she appears to me to be simultaneously the one giving birth and the one being born as her fully realized self."

"It was incredibly cathartic and poetic and moving, and the fact that it was Dick who got me to do this," Amy said, not only about her self-portraits, but also about the workshop itself. "I was so knocked out because he did so much for me; I mean, he changed my life. It's not an exaggeration."

For the class on fashion photography, Dick had arranged for all the students to observe a daylong shoot in his studio with the model Stephanie Seymour, after which they were assigned to make a fashion photograph. The full Avedon operation was in attendance: Polly Mellen, the fashion editor; Oribe, the hairstylist; and Glenn Marziali, the makeup artist. The picture, in which Seymour stands in a sheer black sheath and lifts the dress to reveal her naked crotch, was being shot for *Egoïste*, which was footing the bill for the entire day, estimated by Lizzie Himmel to have cost $100,000. "I wasn't bored, because I got to do the reflector for the crotch shot," Himmel said. "The dress was transparent. I'm sure Dick thought a lot about the transparency and a lot about shock value and a lot about the fact that he wanted to shock the class."

In early 1993, only a few months after Dick's appointment to the *New Yorker*, the magazine had issued a press release: "Avedon's Master Class to Contribute to the New Yorker: "In a move to create

a new generation of photographic talent, Richard Avedon will supervise a group of sixteen photographers for editorial work in the *New Yorker*, it was announced today by Tina Brown." Shortly after, Chris Callis received a call from the magazine: "Are you available right now to photograph Sheikh Omar Abdel-Rahman?" The sheikh was the leader of a mosque whose members were being charged with the World Trade Center bombing. The *New Yorker* sent a car to pick Callis up, and he was driven to a gas station in New Jersey, where a stranger approached them and searched the back seat to confirm that Callis was a photographer with photographic equipment. He was then driven to an undisclosed location where the sheikh was in hiding. Callis's photograph ran a quarter page in size in the April 4, 1993, issue of the *New Yorker*. "The only rule Dick had about his students working for the *New Yorker* was that none of their pictures could run full page," Callis said.

Eileen Travell, then twenty-six, had studied painting and photography at Bennington, and was working as a staff photographer at the Metropolitan Museum, making photographic copies of works of art for the museum archives. "I was just transported," she said about the master class. "Dick could talk about a picture for hours. He loved Julia Margaret Cameron. He could talk about our pictures, always relating them to art history." Eileen became something of a favored student, and on weekdays she would sometimes stop by the studio and have coffee with Dick before going to work. Dick drew her in emotionally, but then he would impose icy, almost eerie distances between them. In early 1994, Dick assigned Eileen to photograph Harold Brodkey and his wife, Ellen Schwamm, for an autobiographical piece Brodkey had written for the *New Yorker*, in which he divulged that he was dying of AIDS while also brushing away, as if virtually nonexistent, his homosexual past. Dick chose not to photograph Brodkey himself because of their often-volatile friendship. "Harold is like barbed wire," Dick

told Eileen. "The closer you get to him, the more he'll cut you." Her double portrait of Brodkey and his wife ran in the February 7, 1994, issue of the magazine. Years later, it finally clicked for her: "Dick was talking about himself when he was talking about Harold."

ON JANUARY 24, 1996, the *American Masters* documentary *Richard Avedon: Darkness and Light* aired on national television. It had been the brainchild of Susan Lacy, the show's executive producer, who chose subjects for the series based on their cultural significance. "If you were to make a book about the ten most important photographers in the twentieth century, Avedon would be one of the chapter heads," she said. She hired Helen Whitney, a veteran television news documentary filmmaker, to direct it. Lacy sent Whitney to Dick's studio for an initial meeting to see if it was a good fit. "We had one of those magical lunches, beautifully served, over several hours, with Norma present," Helen said. "It was fun, there was laughter, and he was completely on board." Production began while Dick's exhibit was still up at the Whitney Museum. The film took about a year to complete.

"He gave me free rein, let me look at all his contact sheets," Whitney said. "I prowled around the studio. He trusted me seeing personal letters, things he had written." But then, she would set up a shoot with him, arriving with her equipment and the crew, and he would keep them waiting, either because he was suddenly in the middle of something else, or he was in a less-than-perfect mood, or he had to prepare himself for the "performance" before he would let her film him in seemingly spontaneous action. "We had a difficult midperiod, as I recall," she said. And yet, she described what seemed to be a genuinely affectionate relationship. He took her to dinner, and to the theater, and gave her tutorials on the history of photography. "He was a great listener, and he would pull things

out of you," she said. "He was sympathetic, and yet his seductive powers were also strategic."

Dick could be disarming as he exhibited a kind of vulnerability one does not expect from a man of his generation; he had a way of revealing things about himself that seemed so personal: "I have to be in touch with my fragility—the man in me, the woman in me, the child in me, the grandfather in me," he says in the documentary. "All of these things have to be kept alive." By no means is this insight about himself false, exactly, but neither was he consistent in his adherence to the truth of such self-knowledge. He was, in fact, quite fragile, perhaps even more so than he wanted to reveal, yet around his fragility had grown a carapace with the sharpest of edges. He could level peremptory judgments, shut people out without warning, drop the conversation, or turn his attention elsewhere so quickly that the people around him were left reeling, at times cut to the quick.

"It's something about madness, rage, and energy that connects us," André Gregory says about their friendship in the documentary, standing with Dick under the apple trees on Dick's property in Montauk. "I don't have many men friends who I can talk to about anything and everything, where there is no macho competition going on." Dick smiles, agrees, and confirms the depth of their friendship, but then undercuts it with a sharp-edged retort. "I just don't want you to be more successful than I am."

The documentary received mixed notices. "Why is it that once commercial photographers or illustrators get really rich and famous, they suddenly start thinking about being regarded as fine artists instead?" wrote Christopher Knight, the art critic for the *Los Angeles Times*, in his review. "Richard Avedon is a notorious example of the phenomenon—one of the greatest fashion photographers ever, responsible for an industrywide overhaul in how mod-

ern fashionability would henceforth be represented, who in recent decades has noisily insisted on 'upgrading' his stature to Artist."

While it's true that Avedon had spent years trying to be taken seriously as an artist, the fact that every one of his exhibits was generated by curatorial interest from within an exhibiting museum or gallery—and not proposed by the artist—was often overlooked. Ted Hartwell at the Minneapolis Institute of Art approached Dick to do the show in 1970. It was Paul Katz's idea at the Marlborough gallery to do an Avedon show in 1975. The Metropolitan Museum show in 1978 had begun in John McKendry's imagination six years earlier. Jim Elliott invited Dick to have the show at the University Art Museum in Berkeley. The Amon Carter Museum sought Dick out for the commission of the American West photographs and the subsequent show. The National Gallery in Washington had approached Dick about doing the retrospective that was never realized. And David Ross was intent on Avedon being his first show at the Whitney in 1994. In each case, the curators already believed in him as an artist.

By 1996, the attitude that Avedon was still an arriviste in the art world was simply a prejudice he could not shake. Christopher Knight's dismissal of Avedon's achievement by claiming he was interested in "upgrading his stature to Artist" spoke volumes about the taint of commerce that still hovered around the Avedon name. No wonder Dick didn't want to place his fashion work alongside his portraiture in the museum setting; he understood that "fashion" was a ghetto within the world of commerce, so he was doubly scarred. And yet, none of that even mattered in the context of the prejudices against photography itself. Despite the fact that, in 1991, Avedon had won the international Hasselblad Award—the highest honor for any artist in the realm of photography—photography was still not fully accepted as an art form.

In the documentary, Dick discusses the pictures he took of his father before he died: "I was in analysis then, off and on, and it occurred to me many years later that maybe photographing him was an act of hostility, shooting, killing him with my camera, watching him die with my camera." Dick said to his analyst years later, "Could it possibly be that I was telling myself it was a kind of love, when really, it was a kind of murder?"

The camera cuts to an interview with Dick's son, John—handsome, self-possessed, and well spoken—as he disparages his father's disturbing pictures of his grandfather. He calls photography "an invasive art." Just as Dick posited to his analyst the possibility that his motivation in taking the pictures of his father was a form of murder, John Avedon asserts his own brand of annihilation of his father, one oedipal rivalry following another.

Upon seeing the filmed interview of his son, Dick offered a defense of his work: "It's just strange to me that anyone would ever think that a work of art shouldn't be disturbing or shouldn't be invasive. That's the property of a work of art; that's the arena of a work of art. To disturb is to make you think, to make you feel. If my work didn't disturb from time to time, it would be a failure in my own eyes."

One night during a weekend filming session at Dick's house in Montauk, Helen Whitney chose a book from the shelf, Kafka's *Letter to His Father*, to take with her to bed. In it, Kafka first sets out to describe the condition of their relationship: "To you it seemed like this: you had worked hard your whole life, sacrificed everything for your children, particularly me, as a result I lived 'like a lord,' had complete freedom to study whatever I wanted, knew where my next meal was coming from and therefore had no reason to worry about anything; for this you asked no gratitude." Kafka goes on to then indict his father for proceeding through life with an attitude of impunity about the power dynamic of their relationship. "This,

your usual analysis, I agree with only in so far as I also believe you to be entirely blameless for our estrangement. But I too am equally and utterly blameless. If I could bring you to acknowledge this, then—although a new life would not be possible, for that we are both much too old—there could yet be a sort of peace, not an end to your unrelenting reproaches, but at least a mitigation of them."

In the morning Whitney left the book out on the dining room table. That night, Dick read it and, the following morning, he told her he hadn't been able to sleep—addled as he was by grief.

# THE ELEGANT
# DENOUEMENT

(1998–2004)

In any case, he knew that in the long run, he would win every
battle in posterity. He was aware of the quality of his work.
Sooner or later, it would become obvious that he was unique,
that his work is unusually diverse, timeless, and universal.

—NICOLE WISNIAK

I n the rarefied atmosphere of quiet connoisseurship, Peter
MacGill, owner of Pace/MacGill Gallery, might be consid-
ered the classicist among photography dealers, and Jeffrey
Fraenkel, whose eponymous gallery in San Francisco is of equal
stature, the modernist. Pace/MacGill represented Avedon in the
1980s and had been successful in placing his *Rolling Stone* "Family"
portfolio in the permanent collection of the National Portrait

Gallery in Washington, DC, and in selling thirty-two prints from *In the American West* at $14,000 each, at a time when even the best Cartier-Bresson print barely commanded $5,500. Yet revenue was not the only thing that mattered to Dick; he was concerned with who was buying his work and where it was being placed. "I am always happy when important work goes to public institutions," said Shelley Dowell, the Avedon studio archivist in those years, who kept a curatorial eye on the edition prints. "Dick's work was not well represented at the time, and we were all thrilled with the placement of the 'Family' portfolio." Despite that, Avedon ended his arrangement with Pace/MacGill because he had not been satisfied with the installation of his "American West" show at the gallery.

Dick would not find a "suitable" gallery again until 1998, when Jeffrey Fraenkel agreed to represent him. Not often do you hear one photography dealer professing an ideal marriage between a rival colleague and the artist that got away, but Peter MacGill acknowledged the Avedon-Fraenkel relationship to be "exemplary." While the Fraenkel Gallery is based in San Francisco, Jeffrey had, over the years, successfully cultivated an international reputation for his discerning aesthetic sensibility, rigorous scholarship, and canny business acumen. As the sole representative of the Diane Arbus and the Garry Winogrand estates, Fraenkel hewed his stable of artists, for the most part, to the photographic canon as it had been established by the Museum of Modern Art.

Dick's subtle courtship of Fraenkel began in the mid-1990s, when occasional issues of *Egoïste* started arriving at the gallery with brief notes from Norma Stevens, or a book would be sent with compliments of the Avedon studio. In early 1998, a more direct overture came from John Silberman, a well-known art world attorney. Over lunch one day in New York, Silberman asked Fraenkel if he had ever thought about representing Richard Avedon. Fraenkel, very clearly the lord of his own shop, expressed reluctance. "I didn't

really want to work with him, because I had been so turned off by the Whitney retrospective," Fraenkel told Silberman. "I felt the show itself got in the way of the pictures." Fraenkel could see the "übercontrolling mastermind above every curator in that exhibition," and, as a gallerist, he was fastidious and resolute about hanging his artists' shows himself. "I didn't want to be told what to do." Soon after his lunch with Silberman, though, during a rainy weekend at home in San Francisco, Fraenkel began looking through his Avedon books, one by one. "My god," he remembered thinking about the photographs themselves. "This guy is really great."

Jeffrey set up a meeting with Dick the next time he was in New York. "It was hot and I thought, 'I'm just going to dress like I'm not trying,'" Fraenkel said, laughing about how carefully he actually thought about every single detail. "So, it was jeans and a white shirt." When he arrived at the studio, in an auspicious sign, Dick was wearing exactly the same thing.

Before they went to lunch, an assistant from the *New Yorker* arrived at the studio to show Dick proofs of the following week's issue. They were placed on an easel, and Dick made a big show of approving the quality of some prints and dismissing others. Fraenkel felt this bravura display had been orchestrated entirely for his benefit, which only confirmed his initial weariness. Then Dick and Norma took him to lunch at Primavera, around the corner, and they bonded over their mutual love of the theater. Fraenkel liked Avedon more than he expected and called Silberman afterward to assert a few ground rules: "If he can allow me to hang the shows the way I want, then let's give it a try," Jeffrey said.

During one of Fraenkel's early visits to the studio, Dick showed him a series of pictures he had made for the 1997 Pirelli calendar, a promotional tool for the Italian tire company that had evolved over thirty years into a benchmark for brand advertising with photographs of beautiful, often naked, women by famous fashion pho-

tographers. The theme of Avedon's twelve pictures of international models—one for each month—was multicultural beauty. Dick asked Jeffrey if he might be able to do something with the Pirelli pictures in the gallery, and Fraenkel's heart sank. "When Dick hinted how easily the gallery might convert them into banknotes, I couldn't figure out if it was a test, since the answer seemed so obvious," Fraenkel said. "The pictures were more than a little cheesy, even if they were the classiest pinups money could buy. He must have known curators and collectors wouldn't take them seriously, right?"

In the midst of Dick's enthusiasms, he didn't always exercise the strictest discernment about his own work. Not only was he conflating his glossy commercial photographs and polluting his work as an artist, but Fraenkel was alarmed to learn that Dick and Norma had been selling pictures directly out of the studio and pricing them arbitrarily depending on who was buying the work and what their mood was that day. "No wonder the work wasn't taken as seriously in the art world as it deserved to be," Jeffrey said, adding that he was single-minded in trying to separate the art from the commercial chaff, and forthright in pointing out the difference. Dick was surprised, but because of Jeffrey's reputation, and the fact that his own legacy was at stake, he listened.

"He had been shooting himself in the foot," Fraenkel said. "Dick thought of himself—though with tremendous self-doubt—as a peer of people like Jasper Johns, Rauschenberg, and Ellsworth Kelly, and he *was*—truly." But it required Fraenkel's vigilance and disciplined eye to mine Avedon's lifework for the most consequential images; and it required courage to stand up to Dick, who was so easily sidetracked by his own digressions into commercial or editorial experimentation. Fortuitously, their mutual obsession with the theater enabled an ongoing dialogue between them about the performances they attended together whenever Jeffrey was in New

York. They shared such a deep affinity for Sondheim, for example, that when the Kennedy Center in Washington, DC, programmed a Sondheim celebration over a series of weekends, Jeffrey and his husband flew back and forth from San Francisco to Washington to meet Dick and Norma and her husband for every performance.

*Richard Avedon: Early Portraits*, which opened at Fraenkel Gallery in San Francisco on December 2, 1999, was a taut curatorial selection of some of Dick's finest portraits, ranging from Marilyn Monroe (price on request) and Isak Dinesen ($12,500) to the Igor Stravinsky triptych ($18,000) and the Warhol Factory group portrait—the eight-by-thirty-inch version ($28,000). The press release was carefully worded to reposition Avedon in strict art world terms:

> *Fraenkel Gallery is pleased to announce its representation of Richard Avedon with an exhibition of early portraits from the late 1940s through the early 1970s. Portraiture has always been at the core of Avedon's work, and this exhibition re-examines, primarily through vintage prints, both well-known and entirely unfamiliar images that set the tone for much photographic portraiture of the late twentieth century.*

As a way to attract attention on the East Coast, the gallery placed a provocative full-page ad in the December 1999 issue of *Artforum*, featuring Dick's full-frontal nude portrait of Rudolf Nureyev taken a month after his defection from the Soviet Union in 1961, an arresting photograph not only for the breathtaking specimen of male musculature and proportion—standing as if sculpted in marble against a white background—but equally for his formidable endowment.

The exhibit was successful, and Dick was pleased, not only with its revenue performance, if you will, but also with the quality of the

collections in which the prints were placed. Among the half dozen Avedon images acquired by the J. Paul Getty Museum were the Warhol Factory group portrait, the Francis Bacon diptych, and the portraits of Dick Hickock and his father. The San Francisco Museum of Modern Art acquired several pictures, too, as did a German bank with a first-rate corporate art collection. Several versions of Marilyn sold at different sizes, including an early square-format print for $50,000—a first for an Avedon photograph at the beginning of the twenty-first century.

IN MAY 1999, MARJORIE Lederer Lee's obituary appeared in the *New York Times*, identifying her in the headline as a poet and novelist. "In her youth, Ms. Lee was the constant companion of her first cousin Richard Avedon, the photographer," said the *Times*, underscoring the point with a quote from Dick: "She was the source of my energy, the front-runner of everything intellectual, inventive and original in our most formative years." In fact, she was daring and iconoclastic, stylish and attractive—the Avedon woman inchoate—long before the idea had found visual manifestation in his groundbreaking fashion imagery.

After Margie's emotionally encumbered youth with her schizophrenic mother—Dick's aunt Sally—she graduated from Sarah Lawrence in 1944, married Robert Lee, and moved to Bryn Mawr, Pennsylvania, where she and her husband raised five children in a rambling old mansion. Early on, she was the poetry editor of the *Ladies' Home Journal*, eventually publishing a book of her own poems entitled *What Have You Done All Day?* She wrote three novels, among them *The Eye of Summer*, about her childhood with Dick, all of which were respectfully reviewed, and she helped support her family with the dozen or so pop psychology books she published under a pseudonym, with titles such as *Games Analysts Play*. At the

age of seventy-eight, Margie died of complications from Alzheimer's disease.

No doubt Margie's death stirred in Dick the deep-seated feelings of attachment that formed at the beginning of his life. He began to pursue a closer family friendship with her son, John Lee, who was by then forty years old and the owner of John Post Lee Fine Art, a gallery in Chelsea. Soon after Margie died, Dick asked John if he could stop by his loft on lower Fifth Avenue. He brought flowers and they ordered Chinese food. John said, "Finally he was talking about my mother and confessed something about their being involved romantically when they were young. Of course, that was pretty much the conventional wisdom of their relationship in our family."

John soon became another of Dick's late-night phone companions. "He was like family, and at the same time he was, you know, pretty glamorous, and fun," John said. He appreciated Dick's sense of humor. They would talk for an hour or so, sometimes about the art world, and sometimes about his mother. At one point, Dick expressed to John his loss of respect for Margie over the years because of the pop psychology books she had written, at the expense of her genuine talent. "Your mother lost her nerve as an artist," he told John.

Dick was judgmental about his original muse, despite the fact that her life had been creative, interesting, and meaningful. Along with the novels she published and a single book of poetry, she raised five healthy and productive children. Perhaps Dick dismissed her achievements relative to his own worldly success. Yet Margie had been courageous in ways he was not, leaving her husband, for example, in a convention-defying decision to live an open and honest life with a woman.

Ultimately, the scale of Dick's judgment was insurmountable. How could Margie compete with the respective Margie surrogates

he had surrounded himself with over the years: Doon, who supplied the keenest intelligence and the darkest wit; Norma, whose constancy and canniness got him through the day; Renata, with her intellectual brilliance and brio; and Nicole, perhaps the most recognizable of all in her impulse toward instigation, creative imagination, and cultivated originality, all of which Dick had been exposed to in the early years of his life with Margie?

AT THE END OF the twentieth century, Dick was increasingly focused on his legacy as an artist. Throughout the 1990s, his assistants were assigned the task of shredding a lifetime of prints and contact sheets made for commercial assignments and advertising campaigns that he did not want anyone to later associate with his name. He would send them to his storage facility in Long Island City, where multitudinous boxes of test prints and contact sheets and account files had accumulated over the years. Eventually, when the inventory was scaled down, a decision was made to consolidate the remaining editorial work into Avedon's archive at the Center for Creative Photography in Tucson. In the process of culling the work, Dick came upon a carton that contained twenty-seven engraver's prints from fashion shoots he had made for *Harper's Bazaar* between 1955 and 1959. "I'd forgotten them," he told Judith Thurman.

The prints were quintessential examples of the finest black-and-white imagery of the mid-twentieth century—razor sharp in focus and articulated with lush tonal ranges and gradations of light that registered every detail between the texture of fabric and the surface of skin, with deep shadows that gave volume to the figures and the dresses in every picture. The images were printed on velvety Portriga Rapid paper by a master printer employed by Dick during his annual trips to Paris for the collections: Suzy Parker strolling

backstage at the Moulin Rouge in a Jacques Griffe gown in one, playing pinball at the Café des Beaux Arts in Lanvin-Castillo in another; Carmen Dell'Orefice dancing with Robin Tattersall on the Pont Alexandre III in Dior; and, of course, Dovima and the elephants at the Cirque d'Hiver. They exemplify Avedon's redefinition of fashion photography after World War II as he created these winsome and enigmatic narratives within a single frame. The pictures are imbued with an atmosphere of adventure, glamour, and romance, while always highlighting the dress—itself a sculptural form that defined the cultural moment.

Aside from their relevance to fashion history, these engraver's prints were unique because of their value as authentic artifacts. The original typed-out editorial captions described the dresses in detail on the back of every print, including the designer's name, the name of the photographer and the date of the photograph: "Dior 100: 'Musique de Nuit'" was written by hand in pencil on one print: "Long dinner dress in smoke or elephant gray faille" was typed out beside it. "Note that although this is a full décolleté dress, sleeves reach to below the elbow. . . . This elbow sleeve is in many Dior evening dresses. Paris Office, Harper's Bazaar, August 12th, 1956." The lower portion of the back of each print contained a *Harper's Bazaar* stamp with the date of publication. On the front of the prints, in the margin, the page numbers were written in red pencil after the images appeared in the magazine.

Because the prints included the "historicity" of the images, they were one-of-a-kind vintage objects. Certainly Jeffrey Fraenkel thought they had value. "As an afterthought to some other project we were working on, Dick pulled out the *Harper's Bazaar* engraver's prints he was about to consign to storage, and that was a real eye opener," Fraenkel remembered. "Not only was he a sharper, more inventive artist in the 1950s than he was around 2001, but the objects we were holding had a weight and authority, and a near-

magical aura, that was worlds away from the Pirelli prints, an entirely different species."

Avedon and Fraenkel agreed that the images warranted exhibition, as well as an opportunity for a limited-edition book. Who better to write an essay about the significance of these rediscovered Avedon prints than Judith Thurman, a colleague of Dick's who was then covering fashion for the *New Yorker* and had written two esteemed biographies, of Isak Dinesen and Colette. Dick began taking Judith out to lunch in restaurants such as Petrossian to talk about the essay. "He liked to spoil people," Thurman said, observing Avedon's perfectionism not only professionally but personally. He would order caviar and they would drink champagne and he could make Thurman feel like she was Suzy Parker at the Café des Beaux Arts. "We talked about fashion," she said. "I complained about the collections. We agreed on how mediocre they were. He was an oracle to me, infallible." Because of her own deep associations with Paris, he would describe for her what it was like in that period of renewed optimism just after the war; they talked about the palpable anti-Semitism in France; she told him stories about Colette, whom he had met, and he told her stories about Chanel, whom he had photographed, and they talked about Proust, whom they both regarded as seminal to a particular literary sensibility that defined their shared understanding of Paris.

The exhibit *Richard Avedon: Made in France* opened at Fraenkel Gallery on November 1, 2001, less than two months after the September 11 attacks, an event of such consuming historic proportion that, for months, everything else seemed utterly irrelevant—specifically, a show of fashion photographs from a half century earlier. Still, the slender book of the same name published by the gallery in a limited edition is, today, a rare artifact, designed as a found folio of twenty-seven eleven-by-fourteen prints, with the actual markings on the front and back of the images. On the cover,

Suzy Parker stands in front of the Paris studio backdrop, its edges visible on all four sides, the studio skylight above radiating natural light. She is wearing the Dior dress called Musique de Nuit, with a floor-length wrap the same shade as the wall covering, as if she had torn the fabric off the backdrop behind her. Her arms are spread out as if they might be wings, forming the shape of a pyramid out of the stiffened wrap.

Thurman pointed out in her essay that "the history of fashion is really the history of fashion photography because it's pre-selected for us; only the great pictures survive." There is a side to Balenciaga, for example, that she considers inferior, almost "tacky," but the designer's place in history has been established by the Penn and Avedon photographs of only his great dresses. "Dick Avedon really has determined, in part, with a few other people, what the history of fashion is and how it will be remembered."

Of Avedon's initial impulse to be a poet, Thurman acknowledged that it was likely to have "deeply influenced his sensibility and his attunement to imagery, to metaphor, to visual metaphors, to unexpected relationships." Dick is quoted in the essay recounting that moment in the mid-1950s when he switched from photographing with a handheld Rolleiflex—which he described as if "the camera is taking the picture"—to the eight-by-ten format. "You set up your photograph, then stand to the side of the tripod directorially, gauging the discrepancy between the image in the viewfinder and the scene as your eye perceives it," he said, adding that something poetic occurs in that perceptual anomaly similar to the distortion of the line of a pencil from one end to the other when dipped into a glass of water.

"Avedon's performance photography," Thurman writes, "is less documentary and more psychologically astute than his forerunners' about that elaborately choreographed performance called femininity."

IN 1992, MARIA MORRIS Hambourg was named curator of the Department of Photographs at the Metropolitan Museum of Art, a new department she had been instrumental in establishing, independent of the Department of Prints, to which photography had been tethered for many years. Hambourg first distinguished herself in the field of photography as John Szarkowski's researcher and then his collaborator on the monumental Atget exhibitions and publications at the Museum of Modern Art. In 1998, the *New York Times Magazine* singled out Hambourg for her influence in garnering respect for the medium as an equal among the fine arts. "The Met is emerging as a superpower in photography, as is Hambourg herself," Deborah Solomon writes. "A scholar of the first rank with a passion for all things French—including the photographs of Edgar Degas, a show of which opens this Friday—she also excels at the art of the deal. Her talent for charming vintage prints out of the hands of prickly connoisseurs and into the vaults of the Met has helped fill in the gaps in its photography collection, which is now considered world class."

Not long after Jeffrey Fraenkel agreed to represent Avedon, he was confronted with some raised eyebrows about the association from colleagues on both coasts, which only strengthened his conviction. It gave him an idea. "You've had your show of fashion work at the Met," Jeffrey told Dick soon after his first exhibit at Fraenkel Gallery: "I think your most profound work, the most important for the long run, are the portraits grounded in the 1975 Marlborough show." Fraenkel knew Maria Hambourg and had long held her in high esteem. He told Dick he was thinking of proposing an exhibit to the Met that focused specifically on the portraits from the Marlborough show. Of course, Dick loved the idea and allowed that all 115 photographs from that show were stored at the Center for

Creative Photography. Fraenkel's next bargaining chip was more delicate, potentially explosive: If Hambourg were to agree to the show, would Dick be willing to give that work to the Met? "He was not used to giving anything away," Fraenkel said, fully mindful of the value of those images. Dick's initial reaction was not favorable, but neither was he indignant. He thought about it and, eventually, agreed—*tentatively.*

It was on just such a tightrope that Fraenkel had to balance the intentions of his glossier-than-life artist and the institutional purity of the august Metropolitan Museum of Art. Jeffrey proposed to Hambourg the idea of an exhibit that resurrected the Marlborough show in exchange for a gift of the portraits for the museum's permanent collection. While she was predisposed to the work, she was cognizant of Dick's unrelenting control over its presentation, as well as his often overexuberant need to foreground work that was not always his best. Maria, too, said she was open to Jeffrey's proposal—*tentatively.*

The first order of business was to look at the photographic prints themselves, which required a trip to Arizona. So, in the first year of the twenty-first century, Maria Morris Hambourg, Richard Avedon, Norma Stevens, and Jeffrey Fraenkel descended from both coasts on the Center for Creative Photography in Tucson and spent an afternoon looking at the work. Maria was so impressed with the quality of the images that she extended her trip for several more days to look at the broader body of Avedon's portraiture in storage there.

Several months later, a decision was reached that was newsworthy enough for the *New York Times* to write a column about it: "The photographer Richard Avedon has given the Metropolitan Museum of Art 115 of his portraits, including those of the Duke and Duchess of Windsor, Marilyn Monroe, the physicist Robert Oppenheimer, the playwright Edward Albee and the artist Wil-

lem de Kooning. . . . The gift, which includes all the photographs that were in the Marlborough exhibition, improves the museum's holdings substantially." The article reported that the museum was planning to mount an exhibition of the work in 2002. For Jeffrey Fraenkel, it was an art world coup; for Richard Avedon, Jeffrey had performed nothing less than a mitzvah.

In a statement published in the *Times* article, Philippe de Montebello, the Met's director, likened Avedon to Nadar, the nineteenth-century French master of photographic portraiture. Just as Nadar "made telling portraits of rare individuals and in doing so captured the creative genius of his generation," he said, "so Mr. Avedon, a century later, collected the key players and directed them in a brilliant portrait of an era that is questioning, unruly and self-consciously alive, like all periods of radical growth."

Between their first meeting in Tucson and the opening of the Metropolitan Museum exhibit in 2002, Dick and Maria established a rapport that went beyond mutual respect. "I loved his vivacity, his extravagance of feeling, his enthusiasm and warmth," Maria said. "With me, he seemed to have nothing to prove." Dick became enamored of Hambourg in the way he sometimes did with women of keen intelligence and consummate professional integrity. "Dick trusted her eye, he trusted her judgment, she was a beautiful writer, and for him, that was very important," Mia Fineman, who cocurated the exhibition with Hambourg, said, remembering a general assumption among her colleagues that Dick was in love with Maria, "which was true, in a way, in the platonic sense." Their genuine delight in one another extended to the weekends Dick spent with Hambourg and her family in Croton-on-Hudson. He came to be considered part of her family, even putting her children's drawings up on the walls of his apartment above the studio.

In the process of conceiving the exhibition, Dick had a scale model of the designated Metropolitan Museum galleries built in

his studio—as he had with the Marlborough show—and thumbnail prints in various sizes of the portraits being considered. As he also had done with the Marlborough show, he made new portraits to be included in the Met show. Hambourg's organizing principle for any exhibition took narrative into account. After all, people walk through an exhibition from one end to the other, and a chronological progression eases the viewer's ability to absorb the work. Dick, perhaps because of his magazine background, believed that juxtaposition created a dialogue among pictures. This dialectical conversation between Hambourg and Avedon formed the basis of their collaborative decisions in hanging the show. "He instinctively yielded to the collaborative spirit to try to put together a superior show of work that might be judged worthy in the grand halls of the Metropolitan," Hambourg said. Fineman underscored the point, explaining that the show had expanded beyond the Marlborough portraits to include his other series in juxtaposition as well: "The overall structure of the show was chronological, with some pockets devoted to particular projects," she said, such as a wall-size grid of the *Rolling Stone* pictures, called "The Family," and a room with the photographs of his dying father. "But within the overall structure, the juxtapositions between particular works will create sparks when they're good. We had both of those things going on."

At one point during the curatorial process, which transpired over the course of almost two years, Hambourg wanted to understand how Dick actually made his portraits, which he demonstrated by making a portrait of her. She got "on the set," as he called it, and once the session was completed, she expressed her surprise at the unadulterated attention he had directed solely on her. "He was a virtual membrane of relation, completely absorbing and mirroring you, giving back these infinitesimal responses to any shift in gesture or facial expression that he had gotten out of you."

On September 26, 2002, *Richard Avedon: Portraits*, consisting of

180 photographs, opened at the Metropolitan Museum of Art. It was the right institution, the right curators, and the right moment in photography for this exhibition. The show was a carefully crafted and elegantly installed distillation of his best portraiture—nothing less than the apotheosis of Avedon's career. The opening-night reception was grand, and star studded, as to be expected, yet the quasar flash and glamour of the event did not eclipse the lingering gravitas of the exhibition itself. The show drew consistent crowds, and the exhibition catalog of the same name, which was sold in the museum's bookshop, became its own phenomenon. Designed as a simple white, slipcased, eight-by-ten volume with one portrait per page, the book had pages attached as an accordion that could be folded out and laid on the floor as a gallery of images side by side. On Saturdays, Dick would hover around the museum bookstore, offering to sign copies of the book. At one point, the museum asked him to stop coming by, because his presence caused the books to sell too fast for additional print runs to replenish the supply.

"Whatever debt Avedon may owe to mid-sixties minimalism, his signature white background style is fundamentally the graphic expression of a peculiarly modern affect," Maria Hambourg and Mia Fineman wrote in the catalog essay.

*In the stark, featureless world of these photographs, the individual stands alone, bathed in a shadowless light that makes no effort to palliate the harsh realities of aging and the simple fact of mortality. The pictures convey a sense of the uneasy isolation and free-floating anxiety that pulses like a bass note through the film and literature of the post-war European avant-garde: its vibrations can be felt in the novels of Camus, Sartre, Malraux, and Robbe-Grillet, in the absurdist drama of Beckett and Ionesco, and, later, in the French New Wave and Italian neorealist directors like Godard, Resnais, de Sica, Rossellini, Fellini, and Antonioni. Avedon shares with*

*these artists a painfully lucid apprehension of the ambiguity and*
*absurdity of the human situation, combined with a staunch faith*
*in the redemptive consolation of art.*

Philippe de Montebello, the director of the Met, writes in the
foreword that while Avedon had set a new standard for fashion
photography early in his career, "an equal achievement has been his
reinvention of photographic portraiture."

While the mainstream reviews were not exactly glowing, for the
first time the critics acknowledged Avedon as an artist to contend
with. Their reviews took the work seriously, possibly because the
show was organized with rigorous scholarship, and perhaps also
because photography had been finally accepted in the art world
by that time. The platform of the Metropolitan Museum gave the
medium, as well as the artist, further legitimacy. Of course, the
*New Yorker*, Avedon's employer, reviewed the show; Anthony Lane
gave art-historical circumspection to his assessment: "The show un-
folds, majestically, in the cavernous hangars of the Tisch galleries,
which previously housed an array of Renaissance tapestries," he
writes. "Photography need no longer bide its time, or bite its nails,
in underground dens or unvisited wings of the major museums; it
is right there in the throne rooms, and in order to reach Avedon's
Groucho, say—balding, black-sweatered, solemnly dreaming of
something off-camera—you have to stride through a vista of Ro-
dins."

Mark Stevens of *New York* magazine was almost contrite about his
earlier dismissal of Avedon as an artist: "This show of portraits . . .
is less 'the portrait of an era' than a monument to a certain New
York sensibility that reveres, above all, the figure of the modern
artist; that viscerally distrusts businessmen, politicians, and soldiers;
that was excited by the dreams of Beckett and by a passionate op-
position to the Vietnam War," he writes. "In the past, Avedon's

celebration of his milieu—a comfortable Establishment that some-
times identifies itself too readily with the hard-won achievements
of an earlier time—made me uneasy. He seemed to honor its
existential conventions too faithfully, never more so than when ap-
pearing artless or when commemorating the ruins of a great man's
face. I preferred something more critical and less seamless, but I
think I was wrong. Many great artists of the past have celebrated
their milieus with a bravura style. Why shouldn't Avedon be a
modernist version of Bernini or Van Dyck? Why not glory in his
fluency?"

Michael Kimmelman of the *Times*, who was more begrudg-
ing, begins his review with a quibble about the installation—the
Andy Warhol Factory mural faces the portrait of William Casby,
the one-hundred-year-old former black slave, which he impugns as
a fatuous stare-down between the social classes. "Otherwise, the
show is gorgeous: a pitch-perfect mix of modest-size, big and un-
believably big prints, each an exquisitely made object," he writes,
acknowledging an indelible tension in the work between style and
substance that lingers in our imagination before leveling his with-
ering conclusion: "Mr. Avedon is not Sander."

In fact, despite Kimmelman's dismissive proclamation, in the
history of photography Avedon necessarily falls in place as nothing
less than heir to August Sander, who made his "catalog of human-
ity" in the beginning of the twentieth century, before it was divided
in half by World War II. Sander's world was of another time, an
empirically different place, before the atomic bomb was dropped,
absent the persistent visual transmission of human activity in tele-
vision and Technicolor that became a condition of daily life in the
second half of the twentieth century, and a further abstraction of
human experience. Avedon's "catalog of humanity" was informed
by the circumstances of his own era that transformed our under-
standing of existence. The first quarter of the twenty-first century

only confirms how visionary Avedon was in his artistic imperative to document the people of his time with such daunting optical clarity and economy and uniformity—anticipating the visual landscape of "social media," with its own myriad "catalogs of humanity"—all for better or worse.

Despite the forensic insistence of a straight-on headshot against the nuclear white Avedon backdrop, the range of emotion in his portraiture is in full evidence in the facial expressions of, say, the contemplative Harold Bloom; the musical Marian Anderson, the howling Ezra Pound, the manic Oscar Levant, the reverential Marianne Moore, the protective June Leaf, the wistful Groucho Marx, the bereaved Marilyn Monroe. While emotion is not exactly the point of Avedon's "catalog of humanity," certainly the range of facial expression and physical gesture, wardrobe and hairstyle—and performance—distinguishes one individual from the other, and, collectively, registers a range in human responses forever circumscribed by the uniform structure of the human species. We cannot discern variation in mood, behavior, or emotion from one species to another; each is programmed to do the thing that it does. One deer, for example, is as interchangeable to us as the next. Not that this is Avedon's point about human beings, per se, yet his "catalog of humanity" certainly underscores our incontrovertible samenesses as a single species in order to identify the distinguishing characteristics between one specimen and another. That, alone, is a remarkable collective observation—a large artistic gesture across the American century.

Perhaps the tension between style and substance is the very reason Avedon has always been so controversial when assessing the weight and breadth of his work. His portraiture identifies the discrepancy between style and substance not as a conflict, but rather as a paradox, one that defines a condition of being in the second half of the twentieth century, so brilliantly anticipated with sagacity

and foresight and wit by Oscar Wilde at the end of the nineteenth: "It is only the shallow people who do not judge by appearances," he intoned, an incantation that resonates more and more in a world of flat-screen technology.

Maria Hambourg was struck by the name on Avedon's doorbell—Dr. Aziz, the soulful character in *A Passage to India*, which conjured for her E. M. Forster's epigraph for *Howards End*—"Only connect." As far as she was concerned, the blood of Forster, Beckett, Chekhov, and Proust was running through Dick's veins. "He told me that he had been more influenced by literature than by anything visual," she said. "The European intellectual tradition was so much a part of how he had learned to see—it was what his appreciation of the world was channeled through. And he was able to bring all of that to bear as he worked behind and then next to a camera all those years, expressing the absolute values of human beings, which is what creative artists do. They see—and can build—worlds for us that are symbols of our condition." Fifteen years after the show at the Met, Hambourg was never more certain of her decision: "He is one of the greatest portraitists of all time, so for me it was a great honor to work with him."

"Dick always grapples with concerns that most of us turn away from or at least partly away from. And he always looks it right in the eye," Mike Nichols, his closest friend, said in the *American Masters* documentary about him. "His photographs don't come to any ultimate conclusion. They never close the issue. There are things always left open, undecided, things not yet dealt with, things for later, things for us to think about. I think that's his essential act, to walk up to what gives him pause and say, Snap!"

DICK WAS SPENDING A good deal of time with his godson, Luke Avedon, as he was unable to see his own grandchildren, with

whom Luke was in school at Saint Ann's in Brooklyn Heights. Luke had played with Dick's grandsons until the lawsuit, when his mother, Betsy, put an end to her relationship with their mother, Betti. Over the years, the subject of Dick's grandsons would come up. "I knew there were allegations of sexual abuse, but I thought it seemed impossible," Luke said, referring to Betti's lawsuit and remembering how distraught Dick had been about the absence of his grandchildren in his life. Luke believed that, in the closeness between them, Dick was making up for his complicated relationship with his son, John, and the estrangement with John's kids that followed the accusations—"That catastrophe," Luke said. "Dick would tell me: 'I don't believe in cousins; I believe in godfathers.'"

Dick was a dream mentor for Luke. "He was into being a famous artist and believed he had the perfect amount of fame," Luke said, laughing about Dick's ability, say, to get last-minute aisle seats for any concert whenever he wanted them or to get a good table at the best restaurants on the spur of the moment. "I really lucked out, as I was desperate for a father figure and Dick was the magic portal for me."

Dick recognized himself in Luke, not only from the uncanny family resemblance—as if he could have been Dick's own son—but also because Luke's attitude about schoolwork echoed Dick's own academic negligence at DeWitt Clinton so many years before. Despite Luke's grandfather's position as chairman of the board at Saint Ann's, it was not incentive enough for him to excel as a student. "I did not want to go to college and Dick was obsessed with me going to college," Luke said, describing Dick's strategy during their ritual Sunday afternoons together. Luke would come over and watch a movie in Dick's apartment above the studio. "I would bring over a girlfriend, and the minute I would disappear, like to go to the bathroom, Dick would conspire with her: 'How are we going to convince Luke to go to college?'"

Aside from being a mentor to Luke, Dick assumed the roles of godfather, grandfather, and friend in equal measure. He always asked Luke about the music he was listening to—death metal bands like Cannibal Corpse. "Dick didn't like the music but he was trying to understand me," Luke said. "He wanted me to take him to a heavy metal concert." Dick encouraged Luke to read, constantly giving him books, among them *Franny and Zooey*, which he considered a favorite, while allowing the concession of his own insecurity about reading because he had been a slow reader from childhood. Dick took Luke to the theater, and afterward, at dinner, they would talk about the play they had just seen, not only in terms of parsing the story, but also about structure and form. At the time, Dick was in thrall of the tap dancer Savion Glover and took Luke to see him whenever he was performing.

Dick would take Luke and his mother, Elizabeth "Betsy" Avedon, to good restaurants for dinner. "Dick was like knowing the sun," Luke said, describing how his mother looked forward to those evenings. "He was always bouncing off the walls; excited was his natural way of being." Luke described the energizing effect of being with Dick, which was, at times, almost too much to bear because he was "such a manic person. With every problem he would get more excited, thinking of fun solutions, and he could be very charismatic. Then he would have downswings into manic phases and exhaustion."

When it was time for Luke to complete his college application, he spent several days living at Dick's studio, enduring chronic nosebleeds throughout the torturous process of writing his essay. Dick was forever correcting his grammar and became an unforgiving editor as he marked up Luke's essay with copious notes. When Luke didn't get in to Sarah Lawrence, Dick insisted that he go to the campus unannounced, knock on the admissions officer's door, and *beg*. Stanley Bosworth, headmaster at Saint Ann's, conspired

with Luke, driving him to Sarah Lawrence in Bronxville, New York, and accompanying him to see the admissions officer. "Pure gumption," Luke said about Dick's advice, while acknowledging he was right. In a perfect anatomy of privilege at work, Luke was admitted. "Dick paid for my college education."

Dick had been resolute about his deathbed promise to Keith Avedon, Luke's father and Dick's first cousin once removed, to take care of his godson, and he did. His family ethic was inviolate, despite the fact that he had not been a consistent daily presence for Evie or John. "Family is not the part of my life I am successful in," Dick would say to Luke, who felt Dick's profound sense of responsibility and generosity, nonetheless. One of the last portraits in Dick's exhibit at the Met was of the eighteen-year-old Luke Avedon. "It is the most honest portrait I have ever made," Dick told Sam Shahid when he walked with him through the show. One could construe Dick's use of the word *honest* as "heartfelt."

Luke remembered Dick talking about Evie all the time. She was in and out of the hospital by then. There were constant scares. Dick visited her every weekend. "He definitely loved Evelyn and felt obligated to take care of her without ever considering it a successful marriage," Luke said. "I was with Dick when he got the phone call that Evelyn died. We were watching *Lord of the Rings* with my girlfriend at the time. He was completely shocked. I gave him a kiss on the forehead. He later told me he would never forget that."

Evelyn Franklin Avedon died peacefully in her sleep on March 13, 2004. "Her grace, beauty, and loving heart will be missed by all who knew her" was the description in the paid obituary in the *New York Times*. While Dick photographed Evie over the fifty-three years of their marriage, he made only one "Avedon" studio portrait of her, in 1975. "I did the most exquisite portrait of my wife, I think," he told an audience at the Whitney in 1994. "She was at a very vulnerable moment, the contradiction between the delicacy

and beauty of her hands and her gesture and the kind of paranoid quality of her expression. I was photographing her the way I photographed anyone. Evelyn said it's the most terrible thing that's ever happened to her to see that picture in my book. . . . Even when I thought my photograph of someone was completely beautiful, they hated it."

IN THE SUMMER OF 2004, Dick hired Laura Wilson, his compatriot on the American West project, to work with him on an extended assignment for the *New Yorker*. It was a presidential election year, and he had embarked on what was going to be a multipage photographic portfolio entitled, simply, "Democracy," that would fall somewhere in ambition between the "Family" portfolio in *Rolling Stone* and the scope of *In the American West*. "The energy and ambition I had witnessed when I first worked as his assistant had not diminished," Laura Wilson later wrote. "To me, Dick always looked 55, his age when we first met. . . . But recently, each time I saw him, the reality of his age hit home. His gunmetal gray hair had turned white. His dark eyes, which had always governed his face, seemed larger now."

Pamela Maffei McCarthy, the deputy editor of the *New Yorker*, worked with Avedon directly on the "Democracy" portfolio, receiving endless ruminations from him about the range of subjects to "portraitize" in terms of political affiliation, profession, ethnic background, and social subject. "Do we do, as we say, African-Americans, Chinese-Americans, Irish-Americans, Polish-Americans, Korean-Americans? Henry Kissinger, Secretary of State, German-American," he wrote in one communiqué. "We must represent, as much as possible, the melting pot." For all his enthusiasm, McCarthy said, "he was a worrier. He worried a lot about people in trouble. He had enormous sympathy and compassion. He worried

about us as a country. Looking back on his faxes, it's striking how so many of them remain the big issues today," she said, citing, for example, gun violence and immigration. In one message after he photographed a Sikh limo driver based in Queens, "he wanted to make the point that not everyone looks the same, but that we're all Americans," she said, and quoted him, saying, "We are all refugees."

Dick and his entourage—Laura; his studio manager, Daymion Mardel; and an assistant, James Martin—traveled around the country in those summer months looking for subjects. He would photograph a broad swath of Americans, from delegates at the Republican National Convention in New York to a ninety-four-year-old candidate for the US Senate at the Democratic National Convention in Boston. At a gun show in Winnemucca, Nevada, he photographed a young couple with a newborn baby in a pink blanket in the mother's right arm, her left hand resting on an AK-47. "[Dick] said he was thinking of Grant Wood's iconic painting American Gothic," Laura said, and he added, "I never could have scripted the pacifier on the mother's finger."

In late September they traveled to Fort Hood, in Killeen, on the plains of Central Texas, a US military post with 45,000 infantry-men who were either returning from the war in Iraq or in train-ing before deployment. Dick and Laura spent two days walking among rows and rows of hulking Bradley Fighting Vehicles, inside which young soldiers were receiving instruction. "In the blistering hot sun, out on the hot concrete, the fumes from all the running vehicles gave us headaches," Laura said. She complained about the unhealthy air to Dick, who shrugged it off dismissively. "If any-thing happens to me, I'm ready to go," he told her. On their last day there, Dick photographed seven soldiers, all having returned from Iraq, in full combat gear with M16s and M4s cradled in their arms.

They left Fort Hood and drove to San Antonio, stopping in Aus-tin for Mexican food. Dick was excited by news he had received

that day confirming the availability of several top government officials—Donald Rumsfeld, secretary of defense; William Rehnquist, chief justice of the Supreme Court; and Alan Greenspan, chairman of the Federal Reserve—to be photographed in Washington the following week. On Friday, September 24, they visited Brooke Army Medical Center, the US military's largest medical facility. There Dick photographed a young sergeant whose face and hands were covered in third-degree burns from a chemical explosion in Baghdad. His face had been completely reconstructed with a silicone mask. That evening Dick, Laura, Daymion, and Jim had dinner in the garden of a Mexican restaurant just a few minutes from the Alamo in San Antonio. The next day he was scheduled to photograph an unwed teenage mother of two, who was seven months pregnant and trying to finish high school.

On the morning of September 25, Laura, Daymion, and Jim gathered for breakfast in the hotel dining room at nine o'clock, as planned, and waited an uncomfortable forty-five minutes for Dick. Finally, he paged Laura and asked her to come to his room. The door was opened; he was still in his pajamas. Laura noticed he was a little unsteady, and when he spoke, he was slurring his words. He wanted to go over some layouts he kept in a notebook for the "Democracy" project. After twenty minutes, as if nothing were wrong, he got up to take some Tylenol, complaining of a terrible headache. "I urged him to lie down in bed and left the room to speak to Daymion," Laura said. Daymion came in and pressed him to see a doctor. Dick, insisting he was fine, began discussing the arrangements for shooting the pregnant teenager. In Laura's room, they had begun calling for a doctor. It was Saturday morning; they had no contacts in San Antonio; and time was running out.

When Laura returned to Dick's room, "everything had changed," she wrote. "Dick lay still in his bed. The sun no longer seemed to be shining through the windows." She sat down beside him and

took both his hands in hers. She chose her words carefully as she told him they needed to go to the hospital. "He looked directly at me with such intensity and said he wanted to do the portrait first— 'Tell the boys to wheel me there,'" he said. Laura beseeched him to see a doctor first, just to check. "He looked away. We were both silent. Then he turned to me and said: 'I couldn't sleep last night, Laura. I kept seeing the burnt faces of the soldiers, even the ones I couldn't see.'" Moments later he lost consciousness. These were Dick's final words.

At the hospital, he was diagnosed with a cerebral hemorrhage. They performed surgery but he never regained consciousness. He remained on life support until his son, John, could get there from New York and Norma Stevens could deliver the power of attorney. Richard Avedon died on October 1, 2004, at Methodist Hospital in San Antonio, Texas. He was eighty-one years old. Two weeks later, John Avedon would send a letter to his father's friends and colleagues saying that there would be no memorial. There was a front-page obituary in the *New York Times*, and a tribute appeared in the October 11, 2004, issue of the *New Yorker*. "To know Dick Avedon was to know the sun," wrote Adam Gopnik, as if delivering a eulogy. "He radiated out, early and daily, on a circle of friends and family and colleagues, who drew on his light and warmth for sustenance."

Lauren Hutton recalled a conversation with Dick many years earlier in which they discussed how each of them wanted to die: Dick told her he wanted to go "with my boots on," meaning that he wanted to be taking pictures. On November 1, 2004, the *New Yorker* published a posthumous thirty-two-page portfolio entitled, simply, "Democracy 2004: Portfolio by Richard Avedon," perhaps the most fitting tribute of all. Dick not only died with his boots on, he also got the last word—in pictures.

# ACKNOWLEDGMENTS

If the history of photography has anything approaching a brain trust, then I have been fortunate in my proximity to those individuals with deep knowledge of the medium's evolution and a genuine regard for its legacy. First, I want to express my gratitude to Shelley Dowell and Susan Kismaric, respectively; each provided unique contributions to my research, as well as factual clarity and invaluable support.

Among other elder statesmen in the field to whom I am indebted in myriad ways are, in alphabetical order: Vince Aletti, Quentin Bajac, Ellen Brooks, Owen Edwards, Mia Fineman, Jeffrey Fraenkel, Vicki Goldberg, Sarah Greenough, Maria Morris Hambourg, Virginia Heckert, Eric Himmel, Peter MacGill, Lesley Martin, Sandra Phillips, Shelley Rice, David Ross, Paul Roth, Carol Squiers, Elizabeth Sussman, Brian Wallis, Colin Westerbeck, and Richard B. Woodward.

Among the photographers I would like to thank for their insights about artmaking and the camera are Bill Jacobson, Richard Learoyd, Alen MacWeeney, Duane Michals, Neil Selkirk, Stephen Shore, and James Welling.

So many people who knew Richard Avedon, either personally or professionally, provided firsthand knowledge, offering both perspective and encouragement, and I would like to thank them for their time, generosity, and memory. To the art directors who worked with him over the years on a daily basis: Ruth Ansel, Yolanda Cuomo, Mary Shanahan, and Greg Wakabayashi; to his assistants: Earl Steinbicker, Gideon Lewin, Ruedi Hoffman, and

Marc Royce. And, singularly, for his wit, wisdom, and intimate knowledge of the studio and how it functioned: to Bill Bachmann.

Among Avedon's lifelong friends: Renata Adler, Doon Arbus, Andre Gregory, Ashton Hawkins, and Cynthia O'Neal.

Selected family members were helpful beyond measure, and I am indebted to them for their memories, insights, and the many artifacts they scrounged from closets that served to verify the details. In particular, I want to thank the heirs of Margorie Lederer Lee—John Post Lee, Steven Lee, Robert Lee, and Alison Teal; Elizabeth Cox Avedon; Luke Avedon; Valerie Avedon Gardiner; and Maura Moynihan. Several people who knew Dick as the children of his friends or colleagues were generous with their memories: Amy Arbus, Jamie Bernstein, Bob Elliot, Steve Elliot, Lizzie Himmel, Helen Kanelous, Edie Marcus, Tom Penn, Gina Roose, Temi Rose, Aram Saroyan, and Meta Stevens.

Others were helpful to me in so many ways and the last on this list in no way diminishes my gratitude: Deborah Bell, Eric Boman, Frish Brandt, Joan Juliet Buck, Chris Callis, Bill Goldstein, Amy Green, Doug Grunuel, Mark Harris, Johnnie Moore Hawkins, Lauren Hutton, Anjelica Huston, Alicia Longwell, Mark Lyon, China Machado, Pamela Maffei McCarthy, Polly Mellen, Kevin Newbury, Stephen Koch, Marguerite (Lamkin) Littmann, Kevin Moore, Penelope Rowlands, Julian Sander, Ivan Shaw, Ira Silverberg, Maura Spiegel, Melissa Stevens, Bradley Sumrall, Judith Thurman, Eileen Travell, Laura Wilson, Jann Wenner, Helen Whitney, and Alice Zimet.

I want to thank my editor, Gail Winston, for her clear-eyed guidance and keen editorial judgment; my agent, Adam Eaglin, for his steady encouragement; and the team at Harper for their diligence: Alicia Tan, Caroline Johnson, Bonni Leon-Berman, Rachel Elinsky, Sarah Lambert, and Diana Meunier.

Thanks are in store to the many institutions that yielded valuable information and to those who facilitated my research within them: Megan Feingold at the Museum of Modern Art; Casey Riley and Heidi Raatz at the Minneapolis Institute of Art; the Fashion Institute Library; the New School for Social Research Library; the Parsons School of Design Library; Jeff Roth at the *New York Times*; Marion Perceval at the Donation Lartigue, Paris; and Marianne de Gaumillard at the Bibliotheque Nationale, Paris.

Finally, and deeply, thank you, Richard, my husband, who listened, tweaked my thinking in just the right places, and believed.

# NOTES

## INTRODUCTION

xi  *"Who are we?"*: Parul Sehgal, "At 82, Glenda Jackson Commands the Most Powerful Role in Theater," *New York Times Magazine*, March 27, 2019.

xi  *"just look at their faces"*: Carol Lawson, "Richard Avedon—An Artist Despite His Success?," *New York Times*, September 7, 1975.

xi  *"My portraits are much more"*: Nicole Wisniak interview with Richard Avedon, "A Portrait Is an Opinion," *Egoïste* 9 (1985).

xiii  *"'women are a foreign country'"*: Judith Thurman, "Hidden Women," in Richard Avedon, *Made in France* (San Francisco: Fraenkel Gallery, 2001).

xiii  *"Avedon was like Fragonard"*: Author interview with Fred Eberstadt, December 12, 2018.

xiv  *"one of the major photographic artists"*: Author interview with Mia Fineman, July 30, 2019.

## CHAPTER 1: PICTURES AT AN EXHIBITION (1975)

1  *"His best portraits"*: Neil Selkirk, "Avedon: Another Angle," letter to the editor, *New York Times Book Review*, October 29, 1993.

1  *"This is the place"*: Enid Nemy, "Avedon: The Place to Be Seen," *New York Times*, September 11, 1975.

2  *"Avedon took great care"*: Christopher Bollen, "Avedon Exposed," *Interview*, May 2, 2012, https://www.interviewmagazine.com/culture/avedon-exposed.

3  *"paralyzed and somnambulant"*: John Gruen, "Beyond Appearances," *SoHo Weekly News*, September 11, 1975.

3  *"flashes kept going off"*: Author interview with Lee Marks, May 30, 2014.

5  *a jaw-dropping figure*: Souren Melikian, "Old Photos Making a Hit," *International Herald Tribune*, October 19–20, 1974.

6  *"Borges and I"*: Carol Lawson, "Richard Avedon—An Artist Despite His Success?," *New York Times*, September 7, 1975.

7  *"an artist and live on Park Avenue"*: David Ansen, "Avedon," *Newsweek*, September 12, 1993.

7  *"Avedon was a Sammy"*: Author interview with Robert Frank, October 22, 2015.

8  *"this knockout of a person"*: Lawson, "Richard Avedon."

8  *"It was cold that day"*: Author interview with June Leaf, October 22, 2015.

8   *"June is one of the most beautiful"*: Lawson, "Richard Avedon."

10  *In November 1975*: All quotes in this paragraph come from "Is Photography Art?" *Interview*, November 1975.

11  *"I never once"*: Author interview with Gideon Lewin, April 17, 2018.

12  *"The show bristles"*: Janet Malcolm, "Men Without Props," *New Yorker*, September 22, 1975, 112.

13  *"Godzilla down the hall"*: Jane Livingston, "The Art of Richard Avedon," in Richard Avedon, *Evidence, 1944–1994* (New York: Random House and Eastman Kodak Professional Imaging, with the Whitney Museum of American Art, 1994), 36.

14  *"The danger is"*: Owen Edwards, "Richard Avedon Will Sell You This Picture," *Village Voice*, September 15, 1975.

14  *"Avedon walked to within"*: Edwards.

14  *"reference to classical antiquity"*: Maria Morris Hambourg and Mia Fineman, "Avedon's Endgame," in *Richard Avedon Portraits* (New York: Harry N. Abrams and the Metropolitan Museum of Art, 2002).

15  *"I kind of got sick"*: Bollen, "Avedon Exposed."

15  *"After a certain forgiving age"*: Edwards, "Richard Avedon Will Sell You This Picture."

16  *"with Mr. Avedon's work"*: Hilton Kramer, "Avedon's Work Leaves Us Skeptical," *New York Times*, September 21, 1975.

17  *"I often feel"*: Janet Malcolm, *Diana and Nikon* (New York: Aperture, 1997), 53.

17  *"the camera confirms"*: Anatole Broyard, "The Buzzard's Eye," *New York Times*, July 2, 1980.

## CHAPTER 2: KEEPING UP APPEARANCES (1923–1936)

18  *For* weeks, *he told her*: Author interview with Lauren Hutton, April 22, 2016.

19  *"The truth is a fountain"*: Author interview with Hutton.

20  *Dick's bar mitzvah anecdote*: Author interview with Gideon Lewin, April 17, 2018.

21  *"I'm such a Jew"*: *Richard Avedon: Darkness and Light*, directed by Helen Whitney, *American Masters* documentary, PBS, 1996.

21  *Dick's father, Jacob*: Logs, Hebrew Orphan Asylum of the City of Brooklyn, courtesy of Valerie Avedon Gardiner.

21  *Lomzha*: Press release, Museum of Modern Art exhibition, *Jacob Israel Avedon: Photographed by Richard Avedon*, New York, May 1–June 16, 1974.

21  *province of Grodno*: "Gradno," https://jewishvirtuallibrary.org/grodno.

22  *To explain a devil logo*: Author correspondence with Steven M. L. Aronson, May 11, 2018.

22  *413 Grand Street*: Press release, *Jacob Israel Avedon*.

22  *"cradle of hate"*: Budd Schulberg, *What Makes Sammy Run?* (New York: Vintage Books, 1990 [1941]), 226.

23  *Avedon's Blouse Shop*: Press release, *Jacob Israel Avedon*.

23  *Avedon on Fifth*: "Opening of Avedon's New Specialty Shop Scheduled for April 1st," *American Cloak and Suit Review* 21 (March 1921): 126.

23    *announcement of their engagement*: "Social Events," *American Hebrew and Jewish Messenger*, November 18, 1921, 23.

23    *Rebecca Schuchman*: Author interview with Alison Teal, daughter of Marjorie Lederer Lee, June 24, 2016.

24    *Anna's father, Jacob Polonsky*: Author interview with Teal.

24    *Jack and Anna Avedon were living*: "Born," *New York Times*, May 19, 1923, 13.

26    *"In their every contact"*: Matlack Price, "Character and Consistency to Appear to Women," *Printer's Ink Monthly*, 1926.

26    *"Avedon has built up"*: "Fifth Avenue Shop to Open Branch Here," *Hartford Courant*, September 24, 1928, 4.

26    *largest Jewish population*: Karen Levitov, "Picturing the Streets of New York," in Max Kozloff, *New York: Capital of Photography* (New York: Yale University Press and the Jewish Museum, 2002), 5.

27    *"According to 19th-century science"*: Levitov, "Picturing the Streets," 3.

27    *"a class of people"*: Max Kozloff, "The Three New Yorks," in *New York: Capital of Photography*, 14.

27    *253 Villa Place*: Department of Commerce, Cedarhurst Village, Nassau County, New York State Fifteenth Census of the United States, 1930.

28    *"climbing over the wall"*: Charles Michener, "The Avedon Look," *Newsweek*, October 16, 1978.

29    *"The only way he knew"*: Michener, 70.

29    *Dicky got so upset*: Michener.

29    *"He wanted me to be prepared"*: Nicole Wisniak interview with Richard Avedon, "A Portrait Is an Opinion," *Egoïste* 9 (1989): 49.

30    *Anna Avedon's older sister*: *American Hebrew and Jewish Messenger*, July 2, 1920, p. 195.

30    *"We were so close"*: Adam Gopnik, "The Light Writer," in Richard Avedon, *Evidence, 1944–1994* (New York: Random House and Eastman Kodak Professional Imaging, with the Whitney Museum of American Art, 1994), 108.

31    *it was described respectfully*: Martin Levin, "A Reader's Report," *New York Times*, November 19, 1961.

31    *"They were really like siblings"*: Author interview with Teal.

31    *"From the very first day"*: Marjorie Lee, *The Eye of Summer* (New York: Simon & Schuster, 1961), 18.

33    *"jiggled once"*: Lee, 67–68.

33    *"I was deeply in love"*: Wisniak interview with Avedon.

33    *"Margie and I went"*: Gopnik, "Light Writer," 107.

34    *"The connection they had"*: Author interview with Steven Lee, son of Marjorie Lederer Lee, June 17, 2017.

34    *"I started taking photographs"*: Michel Guerrin unpublished interview with Richard Avedon for *Le Monde*, 1993, provided to author by Guerrin.

34    *"I was nine years old"*: Guerrin interview with Avedon.

35    *"Her beauty was the event"*: *Richard Avedon: Darkness and Light*.

35    *"My mother used to"*: Gopnik, "Light Writer," 112.

36    *"I was that young man"*: Gopnik, 112.

37    *"I was eleven years old"*: Richard Avedon, foreword to *Martin Munkacsi*, eds.,

F. C. Gundlach, Klaus Honnef, and Enno Kaufhold (New York: Thames and Hudson, 2006).

38  *"The minute he started practicing"*: Guerrin interview with Avedon.

38  *"Rachmaninoff stopped and stood"*: Guerrin interview with Avedon.

39  *"When I was a boy"*: Richard Avedon, "Borrowed Dogs," in Ben Sonnenberg, ed., *Performance & Reality: Essays from* Grand Street (New Brunswick, NJ: Rutgers University Press, 1989), 17.

41  *"The first time I saw Fred Astaire"*: David Ansen, "Avedon," *Newsweek*, September 12, 1993.

41  *"If you don't watch"*: Winthrop Sargeant, "A Woman Entering a Taxi in the Rain," *New Yorker*, November 8, 1958.

42  he had had *"stirrings"*: Norma Stevens and Steven M. L. Aronson, *Avedon: Something Personal* (New York: Spiegel and Grau, 2017), 262.

42  *"On the big night"*: Stevens and Aronson, 262.

42  *"I can only speak for myself"*: Videotape, Richard Avedon in public conversation with David Ross, Whitney Museum of American Art, New York, April 25, 1994, Whitney Museum archives.

43  *in a state of hysteria*: Author correspondence with Margaret Ross, May 13, 2016.

43  *"I got the message"*: Michener, "The Avedon Look."

## CHAPTER 3: PREMATURE SOPHISTICATES (1936–1942)

45  *Several of Margie's poems*: "Marjorie Lederer Lee, 78, Poet and Novelist Who Wrote Songs," obituary, *New York Times*, May 9, 1999, 38.

45  *"Summer heat, like sodden cotton"*: Winthrop Sargeant, "A Woman Entering a Taxi in the Rain," *New Yorker*, November 8, 1958.

45  *studied the works*: Sargeant.

46  *"This verse is a verse"*: Richard Avedon, "Some Fawn, Eh Kid?," *The Magpie* 25, no. 1 (January 1941): 8.

46  *"Dicky's new nervous habit"*: Insert, Margie Lederer's diary, January 31, 1937, courtesy of Robert Lee, Marjorie Lederer Lee's son.

46  *She would remind Dick*: Richard Avedon to Margie Lederer Lee, October 11, 1989, courtesy of Robert Lee.

47  *"It has been decided"*: Insert, Margie Lederer's diary, February 11, 1937.

47  *In one rather mean scenario*: Author interview with Robert Lee, March 27, 2018.

48  *"My mother was not mean-spirited"*: Author correspondence with Robert Lee, April 6, 2018.

48  *"not merely a calling card"*: Author correspondence with Robert Lee, April 7, 2018.

49  *an endless source of longing*: Author interview with Steven Lee, son of Marjorie Lederer Lee, June 17, 2017.

49  *Jack Post would storm around*: Insert, Margie Lederer's diary, February 22, 1937.

50  *"One should not marry"*: Insert, Margie Lederer's diary, January 8, 1937.

51  *"the world's two most premature sophisticates"*: Marjorie Lee, *The Eye of Summer* (New York: Simon & Schuster, 1961), 86.

51 *"See, I was Dick"*: John Kanelous, "The Little Wisdoms of Richard Avedon," unpublished, 1970, courtesy of Helen Kanelous.

52 *The doors of its new building*: Gerard J. Pelisson and James A. Garvey III, *The Castle on the Parkway: The Story of New York City's DeWitt Clinton High School and Its Extraordinary Influence on American Life* (Scarsdale, NY: The Hutch Press, 2009), 62.

52 *"Our identity was represented"*: Pelisson and Garvey, 64–65.

54 *"grim, authoritarian and unkind"*: Author correspondence with Robert Lee, April 9, 2018.

54 *Avedon was an admirer*: Truman Capote, "Comments," in Richard Avedon and Truman Capote, *Observations* (New York: Simon & Schuster, 1959), 5.

55 *"I got her autograph"*: Videotape, Richard Avedon in public conversation with David Ross, Whitney Museum of American Art, New York, April 25, 1994, Whitney Museum archives.

55 *For his fourteenth birthday*: Margie Lederer's diary, May 15, 1937.

55 *Dick tracked Salvador Dalí*: Charles Michener, "The Avedon Look," *Newsweek*, October 16, 1978, 70.

55 *"I have the wildest collection"*: Avedon conversation with Ross.

55 *"I tuned out completely"*: Michener, "The Avedon Look."

56 *"When the* New Yorker *came out"*: Avedon conversation with Ross.

56 *"The great Jewish intellectual family"*: Avedon conversation with Ross.

57 *"I was thinking of them in bed"*: Lee, *Eye of Summer*, 153.

57 *"They were involved romantically"*: Author interview with John Lee, son of Marjorie Lederer Lee, May 24, 2017.

58 *Students commuted daily*: Pelisson and Garvey, *Castle on the Parkway*, 61.

58 *"One's commitment to the greater good"*: Pelisson and Garvey, 71.

58 *English teacher named Abel Meeropol*: Pelisson and Garvey, 74.

59 *"How can I whip the willow"*: Richard Avedon, "The Realist," *The Magpie* 24, no. 2 (Spring 1940).

60 *When Anna Avedon learned*: Hilton Als, public panel, "Avedon's America," Guild Hall, East Hampton, New York, August 19, 2017.

61 *a journalist named Milton Smith*: Sara Blair, *Harlem Crossroads: Black Writers and the Photograph in the Twentieth Century* (Princeton, NJ: Princeton University Press, 2007), 19.

61 *"The name came from him"*: Blair, 170.

61 *"the son of an anti-Semitic Jew"*: Norma Stevens and Steven M. L. Aronson, *Avedon: Something Personal* (New York: Spiegel and Grau, 2017), 138–39.

62 *It was Mike Elliot*: Author interview with Bob Elliot and Steve Elliot Jr., May 17, 2018.

62 *"He was in the office"*: Author interview with Elliot and Elliot Jr.

63 *"Mike always expected"*: Author interview with Elliot and Elliot Jr.

63 *"young and somewhat sensitive beauty"*: "Oona O'Neill Chaplin Dies at 66," obituary, *New York Times*, September 28, 1991.

63 *"Why can't you be nice"*: Author interview with Elliot and Elliot Jr.

64 *It was Jonesie who nurtured*: Author correspondence with Robert Lee, April 9, 2018.

65  *"I have said it"*: Marjorie Lederer Lee to Anna Avedon, March 18, 1993, courtesy of Robert Lee.

66  *"who was then a poet"*: James Baldwin and Sol Stein, *Native Sons: A Friendship That Created One of the Greatest Works of the 20th Century:* Notes of a Native Son (New York: One World, 2004), 4.

66  *"What went on in that tower"*: Joseph Berger, "A Literary Friendship in Black and White," *New York Times*, September 13, 2004.

66  *"another stony-faced, rigorous"*: Avedon conversation with Ross.

66  *"That's what's wrong"*: Baldwin and Stein, *Native Sons*, 5.

66  *"To find oneself"*: Richard Avedon, "Sight Sore," *The Magpie* 25, no. 1 (January 1941): 8.

67  *"You must not think"*: Richard Avedon, "Wanderlust," Scholastic Art and Writing Awards, 1941, http://blog.artandwriting.org/wp-content/uploads/2012/08/Avedon%E2%80%94Wanderlust.pdf.

68  *"If only I could try"*: Richard Avedon, "Wanderlust," *The Magpie* 25, no. 1 (January 1941): 67.

69  *"It's funny, Margie and I"*: Adam Gopnik, "The Light Writer," in Richard Avedon, *Evidence, 1944–1994* (New York: Random House and Eastman Kodak Professional Imaging, with the Whitney Museum of American Art, 1994), 108.

69  *"You can't live in your head"*: Lee, *Eye of Summer*, 166–67.

69  *"'Poets,' Artie interrupted"*: Lee, 167.

70  *"Spring will come"*: "Student Tops 32 in Poetry Contest," *New York Times*, May 24, 1941.

71  *"After school closed"*: Pelisson and Garvey, *Castle on the Parkway*, 78.

72  *"Speaking of Dorothy Parker"*: Richard Avedon, "Speaking of Parker," *The Magpie*, Spring 1941.

72  *"Because I wasn't smart"*: Avedon conversation with Ross.

72  *Spence tells Connie*: Lee, *Eye of Summer*, 183.

73  *"[I] had to shatter our perfect hothouse"*: Nicole Wisniak interview with Richard Avedon, "A Portrait Is an Opinion," *Egoïste* 9 (1985): 49.

73  *"She was sort of"*: Author interview with Steven Lee.

73  *"If you should die"*: Richard Avedon, "To M.L.," *The Magpie* 24, no. 2 (Spring 1940): 67.

## CHAPTER 4: THE MENTORS AND THEIR PRODIGY (1942–1945)

74  *"The main thing he taught me"*: Charles Michener, "The Avedon Look," *Newsweek*, October 16, 1978, 71.

74  *"His ribs were open"*: Vicki Goldberg, "Richard Avedon," in *Light Matters* (New York: Aperture, 2011), 48.

75  *"An inconsistent student"*: Adam Begley, *The Great Nadar: The Man Behind the Camera* (New York: Tim Duggan Books, 2017), 10.

76  *"I belong to the generation"*: Roger Angell, *This Old Man: All in Pieces* (New York: Anchor Books, 2016), 43.

76  *"who are so gallantly"*: "Roosevelt Praises Maritime Service," *New York Times*, December 13, 1942, 49.

77  *"I just talked"*: Norma Stevens and Steven M. L. Aronson, *Avedon: Something Personal* (New York: Spiegel and Grau, 2017), 141.

78  *"In art, never explain"*: Michel Guerrin unpublished interview with Richard Avedon for *Le Monde*, 1993.

79  *"Don't come in here"*: *The Helm* 1, no. 1 (ca. 1943).

80  *"Days on the mainland"*: *The Helm* 1, no. 1, back cover.

80  *"I didn't have to ask"*: Stevens and Aronson, *Avedon*, 143.

81  He nurtured his love of dance: Arthur Knight, "Choreography for Camera," *Dance Magazine*, May 1957, 16–22.

81  *"Miss Gloria Vanderbilt"*: *Harper's Bazaar*, January 1942, 68.

82  *"I was so noisy"*: Calvin Tomkins unpublished interview with Richard Avedon, July 1994, Museum of Modern Art archives, New York, 10.

83  Dick then hired Bijou Barrington: Winthrop Sargeant, "A Woman Entering a Taxi in the Rain," *New Yorker*, November 8, 1958.

84  hitchhiking to Far Rockaway beach: Tomkins interview with Avedon.

84  His first sale: Richard Avedon, "My First Sale," *Famous Photographers Magazine* 4, no. 13 (1970).

84  *"I thought I'd hit the jackpot"*: James Baldwin: *The Price of the Ticket*, documentary, produced and directed by Karen Thorsen, Nobody Knows Productions and Maysles Films, 1990.

85  *"Munkacsi brought a taste"*: Richard Avedon, foreword to *Martin Munkacsi*, eds. F. C. Gundlach, Klaus Honnef, and Enno Kaufhold (New York: Thames and Hudson, 2006).

85  *"Do you know where"*: Michael Gross, *Focus: The Secret, Sexy, Sometimes Sordid World of Fashion Photographers* (New York: Atria, 2016), 51.

85  *"She was so beautiful"*: Stevens and Aronson, *Avedon*, 151.

85  *"this was the only time"*: Stevens and Aronson, 152.

85  the family of a wealthy lawyer: Margalit Fox, "Doe Avedon, Fashion Model and Actress, Dies at 86," obituary, *New York Times*, December 23, 2011, B17.

86  *"The closest I can come"*: Anatole Broyard, *Kafka Was the Rage: A Greenwich Village Memoir* (New York: C. Southern Books, 1993), 134–36.

87  *"I was all out of whack"*: Stevens and Aronson, *Avedon*, 143.

88  *"thousands of soldiers"*: Claire Potter, "Queer Hoover: Sex, Lies, and Political History," *Journal of the History of Sexuality* 15, no. 3 (September 2006): 368.

88  *"nothing pleased him more"*: Sargeant, "A Woman Entering a Taxi."

88  *"some of Avedon's friends"*: Sargeant, "A Woman Entering a Taxi."

89  *"By all accounts"*: Beth Saunders, "More Than a Honeymoon: The Influence of Japan on Adolf de Meyer's Photographs," Metropolitan Museum of Art blog, April 3, 2018, https://www.metmuseum.org/blogs/now-at-the-met/2018/adolf-de-meyer-honeymoon-japan.

89  *"You know that Dick was gay"*: Author interview with Nowell Siegel, son of Doe Avedon, April 22, 2017.

90  *"for good luck"*: Tomkins interview with Avedon.

91 *"Alexey Brodovitch was both a captive witness"*: Kerry William Purcell, *Alexey Brodovitch* (London: Phaidon, 2002), 36.

91 *"the elegance and lucidity"*: Purcell, 75.

91 *"I'd have a weekly appointment"*: Penelope Rowlands, *A Dash of Daring: Carmel Snow and Her Life in Fashion, Art, and Letters* (New York: Atria Books, 2005), 331.

92 *One day the phone rang*: Tomkins interview with Avedon.

92 *"Alexey Brodovitch only wore"*: Henry Wolf, "Hall of Fame," *Communication Arts* 14, no. 4 (1972): 28.

92 *"He dismissed all my carefully wrought"*: Jane Livingston, *The New York School: Photographs, 1936–1963* (New York: Stewart, Tabori and Chang, 1992), 337.

93 *"He just dropped in at my office"*: Steve Frankfurt bedside interview with Alexey Brodovitch, 1964, Museum of Modern Art archives, New York, 13.

93 *"The aim of the course"*: *New School Bulletin 1945–1946* 3, no. 1 (September 1944), New School for Social Research, New York, New School Archives and Special Collections Digital Archive, course catalog collection.

94 *Irving Penn told Dick a story*: Videotape, Richard Avedon in public conversation with David Ross, the Whitney Museum of American Art, New York, April 25, 1994, Whitney Museum archives.

94 *"Why not use spaghetti?"*: Penelope Rowlands unpublished interview with Richard Avedon, June 6, 2003, for *Dash of Daring*.

94 *"All the young photographers"*: Videotape, Eric Himmel interview with Lillian Bassman, 2003, courtesy of Eric Himmel.

95 *"in would walk Saul Steinberg"*: Tomkins interview with Avedon.

95 *He told Dick a story*: Frankfurt interview with Brodovitch.

95 *"He just had this tremendous dark side"*: Tomkins interview with Avedon.

97 *"And it was my first coup"*: Rowlands, 77.

97 *"When I started making photographs"*: Rowlands, 78, 80.

97 *"If you enjoyed our work"*: Rowlands, 80.

98 *"You surely don't expect"*: Rowlands, 94.

98 *"Her hair was blue"*: Tomkins interview with Avedon.

99 *"It wasn't just"*: Rowlands, 194.

99 *"I've always been attracted"*: Rowlands, 68.

99 *"A slim, dark, eager young man"*: Gross, *Focus*, 48.

100 *"That she had turned up"*: Rowlands, 197.

100 *"The whole issue must be about fuchsia"*: Rowlands, 197.

100 *"One cannot live"*: Sargeant, "A Woman Entering a Taxi."

100 *"Why Don't You"*: S. J. Perelman, "Frou-Frou, or the Future of Vertigo," *New Yorker*, April 16, 1938.

100 *"very* much *like my father"*: Helen Whitney interview with Richard Avedon, in *Richard Avedon: Darkness and Light*, directed by Helen Whitney, *American Masters* documentary, PBS, 1995.

101 *He is pictured smiling*: *Harper's Bazaar*, October 1944, contents page.

102 *spotted a teenage girl*: Author interview with Amy Greene, née Edilia Franco, June 25, 2018.

104 *"Think of it"*: Rowlands, 346.

104 *She burst into uproarious laughter*: Rowlands, 330.
105 *"Are you the new photographer"*: Tomkins interview with Avedon.

## CHAPTER 5: EAU DE PARIS (1946–1948)

108 *"The stinger was a favorite drink"*: Videotape, Eric Himmel interview with Lillian Bassman, 2003, courtesy of Eric Himmel.
108 *"Paul and I were free spirits"*: Himmel interview with Bassman.
109 *"We walked to Cherry Grove"*: Jerry Rosco, *Glenway Wescott Personally: A Biography* (Madison: University of Wisconsin Press, 2002), 174.
109 *"Just beyond these bungalows"*: Rosco, 174.
110 *"a very gay community"*: Himmel interview with Bassman.
111 *"my dad was killer sarcasm"*: Author interview with Lizzie Himmel, June 27, 2017.
111 *"were freethinkers and socialists"*: Eric Himmel, unpublished biography of Paul Himmel and Lillian Bassman, courtesy of Eric Himmel.
111 *According to Lizzie*: Author interview with Lizzie Himmel.
112 *"Finally, inevitably, it was a worldview"*: Himmel, unpublished biography.
112 *"One time," she remembered*: Himmel interview with Bassman.
115 *the fourteen-year-old Elizabeth Taylor*: *Junior Bazaar*, December 1946, 69.
116 *In a 1999 meditation*: Cathy Horyn, "A Picture That Divided the Old from the New," *New York Times*, December 28, 1999.
117 *"Avedon's real fascinations"*: Michael Gross interview with Lillian Bassman, in *Focus: The Secret, Sexy, Sometimes Sordid World of Fashion Photographers* (New York: Atria, 2016), 83.
118 *Robbins had already been anointed*: Anna Kisselgoff, "3 Sailors Aging Gracefully at City Ballet," *New York Times*, June 10, 1994.
118 *"It was only Jerome Robbins"*: John Martin, "The Dance: On Ballet Matters," *New York Times*, May 27, 1944.
118 *"these new kids on the block"*: Allen Robertson, "Fancy Free: The Birth of an American Classic," *Playbill*, February 10, 2010.
119 *"I didn't want to be"*: Terry Teachout, "Jerome Robbins in Person," *Commentary*, October 1, 2004.
119 *"Please save me"*: Teachout.
122 *added an additional flight*: Penelope Rowlands, *A Dash of Daring: Carmel Snow and Her Life in Fashion, Art, and Letters* (New York: Atria, 2005), 362.
122 *Christian Dior's debut*: Rowlands, 363.
123 *"This changes everything"*: Rowlands, 365.
123 *"Do you realize what we mean"*: Michel Guerrin unpublished interview with Richard Avedon for *Le Monde*, 1993.
123 *"The convergence of the happiness"*: Guerrin interview with Avedon.
124 *"That was the convergence"*: Guerrin interview with Avedon.
125 *"Dior, at the time"*: Guerrin interview with Avedon.
125 *"The Corolle was one line"*: Penelope Rowlands, *A Dash of Daring: Carmel Snow and Her Life in Fashion, Art, and Letters* (New York: Atria Books, 2005), 364.

125 *Another spread for the Paris feature*: "New Fashion," *Harper's Bazaar*, October 1947, 194.

126 *"[Avedon] started out with* Junior Bazaar": Himmel interview with Bassman.

127 *"All but one"*: Richard Avedon, "Postscript," in *Made in France* (San Francisco: Fraenkel Gallery, 2001).

127 *"I was really painfully shy"*: Videotape, Richard Avedon in public conversation with David Ross, Whitney Museum of American Art, New York, April 25, 1994.

127 *"Rita described going"*: Author interview with Maura Spiegel, biographer of Sidney Lumet, April 5, 2017.

128 *A full-page picture of "Doe Avedon"*: *Theatre Arts*, March 1949, New York Public Library, Library for the Performing Arts.

128 *While there, Gershe met Clemence Dane*: Deposition, July 19, 1990, *Leonard Gershe vs. Ronald Haver, Michael Sidney Luft, Alfred A. Knopf, Inc.*, Leonard Gershe papers, Film and Television Archive, special collections, Young Research Library, University of California, Los Angeles.

129 *"Cannot wait to see you"*: Radiogram, Dick and Doe Avedon to Leonard Gershe, September 12, 1947, Gershe papers.

129 *"Dick was in such distress"*: Author interview with Stephen Lipuma, April 11, 2018.

129 *"I think that Dick and Dad"*: Author interview with Lizzie Himmel.

129 *"We were all having"*: Himmel interview with Bassman.

130 *"The reason they got divorced"*: Author interview with Nowell Siegel, April 22, 2017.

130 *"I would have crawled"*: Margalit Fox, "Doe Avedon, Fashion Model and Actress, Dies at 86," obituary, *New York Times*, December 23, 2011.

130 *"Take me to Paris again"*: Rowlands, *Dash of Daring*, 379.

130 *"I don't button my seatbelt"*: Calvin Tomkins unpublished interview with Richard Avedon, July 1994, Museum of Modern Art archives, New York.

131 *Avedon described Bousquet*: Rowlands, *Dash of Daring*, 352.

131 *Bousquet was a fixture*: Rowlands, 353.

131 *"Carmel Snow taught me everything"*: Tomkins interview with Avedon.

132 *"She brought me to meet Colette"*: Tomkins interview with Avedon.

132 *"small, dark and electric"*: Excerpt, Ginette Spanier, "It Isn't All Mink: The Autobiography of a Woman of Style," *New York Post Magazine*, June 25, 1961, 10.

133 *"I never went about"*: Guerrin interview with Avedon.

133 *He described a typical meeting*: Tomkins interview with Avedon.

134 *"The very word"*: Dorian Leigh with Laura Hobe, *The Girl Who Had Everything: The Story of the "Fire and Ice Girl"* (Garden City, NY: Doubleday, 1980), 74.

135 *"To protect the designers"*: Leigh, 80.

135 *"Instead of using"*: Leigh, 75.

136 *"'My Paris' never existed"*: Norma Stevens and Steven M. L. Aronson, *Avedon: Something Personal* (New York: Spiegel and Grau, 2017), 56.

## CHAPTER 6: THE PROSCENIUM STAGE (1948–1952)

138 *"Photography in Fashion: Fashion in Photography"*: "Richard Avedon, 9 Photographs," *Portfolio* 1, no. 1 (Winter 1950).

140 *a bon voyage party*: Videotape, Eric Himmel interview with Lillian Bassman, 2003, courtesy of Eric Himmel.

141 *At the party*: Himmel interview with Bassman.

141 *She acknowledged that Dick and Milton*: Author interview with Amy Greene, June 25, 2018.

142 *a very chatty letter*: Richard Avedon to Lillian Bassman, February 1949, courtesy of Eric Himmel.

142 *"It could have been impotence"*: Author interview with Eric Himmel, December 13, 2015.

143 *"Freud himself, after all"*: Edmund White, *The Unpunished Vice: A Life of Reading* (New York: Bloomsbury, 2018), 73.

143 *Dick started seeing Bergler*: Norma Stevens and Steven M. L. Aronson, *Avedon: Something Personal* (New York: Spiegel and Grau, 2017), 382.

144 *When his debut novel*: Christopher Bram, *Eminent Outlaws: The Gay Writers Who Changed America* (New York: Twelve, 2012), 8.

144 *"The book is immature"*: "Spare the Laurels," *Time*, January 26, 1948, 102.

144 *Vidal was equally eviscerated*: C. V. Terry, review of *The City and the Pillar*, *New York Times*, January 11, 1948.

145 *Leonard Gershe would write a play*: Deposition, July 19, 1990, *Leonard Gershe vs. Ronald Haver, Michael Sidney Luft, Alfred A. Knopf, Inc.*, Leonard Gershe papers, Film and Television Archive, special collections, Young Research Library, University of California, Los Angeles.

145 *"There are times and places"*: James Baldwin, "Previous Condition: A Story," *Commentary*, October 1948.

146 *"What on earth"*: Gore Vidal, introduction to *The Luminous Years: Portraits at Mid-Century*, by Karl Bissinger (New York: Harry N. Abrams, 2005).

147 *"actual inspiration for Holly Golightly"*: Author interview with Elinor Dee Pruger (née de la Bouillerie), June 23, 2018.

147 *After late evenings*: Carol Matthau, *Among the Porcupines: A Memoir* (New York: Turtle Bay Books, 1992), 119.

147 *"It was far too easy"*: Dorian Leigh with Laura Hobe, *The Girl Who Had Everything: The Story of the "Fire and Ice Girl"* (Garden City, NY: Doubleday, 1980), 75.

148 *"another of the many Holly Golightly figures"*: Sam Kashner, "Capote's Swan Dive," *Vanity Fair*, November 15, 2012.

148 *She arrived in New York*: Robert Lacey, "How Ford Models Changed the Face of Beauty," *Vanity Fair*, May 27, 2015.

149 *"Avedon's greatest creation"*: Transcript, Irving Penn at the Alexey Brodovitch workshop in the Steven Franklin Agency, November 18, 1964, Museum of Modern Art archives, New York, 15.

150 *"Certainly he is the most controversial"*: Jonathan Tichenor, "Richard Avedon: Photographic Prodigy," *U.S. Camera* 12, no. 1 (January 1949).

150 *The portraits of Dietrich*: "Marlene Dietrich Sings in a Berlin Dive," *Harper's Bazaar*, August 1948, 114.

151 Harper's Bazaar *published the first*: "Highway Cyclorama," *Harper's Bazaar*, September 1947, 209.

151 *In the same issue*: "A New Magnetic Field," *Harper's Bazaar*, September 1947, 240.

152 *"The great pleasure for my Leica"*: Margin note in Henri Cartier-Bresson's hand, essay typescript, "Henri Cartier-Bresson: The Early Work," by Peter Galassi, 1987, Department of Photography archive, Museum of Modern Art, New York.

152 *"photography is the simultaneous recognition"*: Henri Cartier-Bresson, *The Decisive Moment* (New York: Simon & Schuster, 1952).

153 *"He is like Tolstoy"*: Charlie Rose television interview with Richard Avedon, *Charlie Rose*, PBS, July 6, 2000.

153 *His masthead title*: *Theatre Arts* 33, no. 3 (April 1949): contents page.

154 *"At once elegant and gritty"*: Jane Livingston, "The Art of Richard Avedon," in Richard Avedon, *Evidence, 1944–1994* (New York: Random House and Eastman Kodak Professional Imaging, with the Whitney Museum of American Art, 1994), 11.

154 *Bobby Clark, the vaudeville performer*: *Theatre Arts* 33, no. 8 (September 1949): cover.

155 *"It might have something to do"*: Livingston, "The Art of Richard Avedon," 11.

155 *"They gave me $25,000"*: Michel Guerrin unpublished interview with Richard Avedon for *Le Monde*, 1993.

156 *In July 1949,* Life *did publish*: "Broadway Album: Avedon Pictures Capture Season's Triumphs," *Life*, July 18, 1949, 60–65.

156 *One such example*: Carmel Snow, "Report from Paris," *Harper's Bazaar*, October 1949, 128.

158 *Dick had a new secret weapon*: Author interview with Helen Kanelous, daughter of Laura Kanelous, June 9, 2017.

159 *"Avedon was only able to"*: Author interview with Earl Steinbicker, October 19, 2018.

159 *His fashion advertising was interspersed*: Author interview with Steinbicker.

160 *"Carmel taught me everything"*: Calvin Tomkins unpublished interview with Richard Avedon, July 1994, Museum of Modern Art archives, New York, 5.

160 *"I have the most wonderful Mainbocher"*: Tomkins interview with Avedon.

160 *Dick and Evelyn were married*: Michael Gross, *Focus: The Secret, Sexy, Sometimes Sordid World of Fashion Photographers* (New York: Atria, 2016), 59.

160 *"ground-floor kitchen"*: Gross, 66.

161 *"When I first walked into the studio"*: Author interview with Steinbicker.

162 *The ASMP had been established*: Kay Reese and Mimi Leipzig interview with Barrett Gallagher, 1990, American Society of Magazine Photographers website, https://www.asmp.org/resources/about/history/interview-founders/barrett-gallagher/.

162 *"who love to flirt with fire"*: "Fire and Ice" ad copy, *Vogue*, November 1, 1952.

163 *Revson objected to the model's hand*: Leigh with Hobe, *The Girl Who Had Everything*, 88.

164 *One day, though, in mid-September 1952*: John Durniak, "Camera," *New York Times*, September 15, 1991.

165 *When the* Queen Elizabeth *arrived at Southampton*: "U.S. May Ban Chaplin: Inquiry Ordered," *Guardian*, September 19, 1952.

165 *"this was his last message"*: Durniak, "Camera."

## CHAPTER 7: LE CIRQUE D'HIVER (1953–1957)

166 *She could stretch her relationship*: Jane Kramer, "The Life of the Party," *New Yorker*, February 6, 1995.

167 *"She was my 'Auntie Mame'"*: Author interview with Helen Kanelous, June 9, 2017.

167 *"the spread was the key"*: Kramer, "Life of the Party."

167 *"serve and smile and then kiss"*: Author interview with Gina Roose, June 3, 2017.

169 *"the people there"*: Kramer, "Life of the Party."

170 *"I mean, that kind of snobbism"*: Calvin Tomkins unpublished interview with Richard Avedon, July 1994, Museum of Modern Art archives, New York.

170 *Lee Friedlander remembered a story*: Author conversation with Lee Friedlander, October 10, 2017.

170 *"I once made a portrait of Marian Anderson"*: Shannon Thomas Perich, "Avedon and Marian Anderson at Smithsonian," National Public Radio website, January 18, 2010, https://www.npr.org/sections/pictureshow/2010/01/marian_anderson.html.

171 *"It was very hushed"*: Tomkins interview with Avedon.

172 *Third Avenue and Forty-Ninth Street*: Author interview with Earl Steinbicker, October 19, 2018.

172 *the Avedons gave a dance*: Gloria Vanderbilt, *It Seemed Important at the Time: A Romance Memoir* (New York: Simon & Schuster, 2004), 82.

172 *"I was intrigued"*: Vanderbilt, 82.

173 *"one of the most glamourous audiences"*: Newscaster in telecast footage of the live event, http://themarilynmonroecollection.com/a-marilyn-monroe-east-of-eden-photograph.

173 *"I was joined by a slender handsome man"*: Aram Saroyan, *My Own Avedon: A Memoir with Photographs* (Los Angeles: An Air Book, 2010).

174 *"As he took the photographs"*: Saroyan.

176 *"We got busted anyway"*: Author interview with Jamie Bernstein, November 22, 2015.

176 *Dick would write a tribute to Bernstein*: Richard Avedon, "Leonard Bernstein," in Roddy McDowall, *Double Exposure* (New York: William Morrow, 1966), 196.

177 *There is a picture*: Snapshot, Georgia Hamilton, Steve Elliot, Dick, and Evie Avedon in Venice, Steve Elliot family collection.

178 *Avedon photographed Sunny Harnett*: "Paris Evening Lines," *Harper's Bazaar*, September 1954, 206.

179 *Marilyn Monroe stands on a subway grate*: "Almanac: Marilyn Monroe's Billowing Dress," *CBS Sunday Morning*, September 15, 2019, CBSNews.com, https://www.cbsnews.com/news/almanac-marilyn-monroe-dress-the-seven-year-itch/.

180 *Dick may have known Sam Shaw*: Author interview with the Sam Shaw family (Edie Marcus, Meta Stevens, Melissa Stevens), October 6, 2017.

180 *The day before the subway grate scene*: Author interview with Shaw family.

181 *Marilyn Monroe and Billy Wilder appeared*: "The Big Build-Up," *Harper's Bazaar*, November 1954, 122.

182 *"Want to see me do her?"*: Susan Strasberg, *Marilyn and Me: Sisters, Rivals, Friends* (New York: Warner Books, 1992).

182 The Family of Man: Fact sheet, "The Family of Man," Edward Steichen papers, folder V.B.i.21, Museum of Modern Art archives, New York.

183 *"Maybe being in two wars"*: Phyllis Battelle, "'Family of Man' on Exhibit," *New York Journal-American*, June 14, 1955.

183 *White dismisses* The Family of Man: Minor White, introduction to *Aperture* (Summer 1955).

183 *Roland Barthes declared it*: Roland Barthes, "The Great Family of Man," in *Mythologies*, trans. Annette Lavers (St. Albans, UK: Picador, 1976), 100–102.

184 *Walker Evans registered his disdain*: Walker Evans, "Robert Frank," in Tom Maloney, ed., *US Camera 1958* (New York: US Camera Publishing Corporation, 1957), 90.

185 *Sam Shaw invited him on the set*: Author interview with Shaw family.

186 *"Carmel Snow's Paris Report"*: "Dior's Sinuous Evening Line," *Harper's Bazaar*, September 1955, 214–15.

187 *commanded over $1 million at auction*: Auction catalog, "Photographs from the Avedon Foundation," November 20, 2010, sale 5621, Christie's, Paris.

187 *"a monument in the history of fashion"*: Auction catalog, "A Beautiful Life: Photographs from the Collection of Leland Hirsch," April 10, 2018, sale N09835, Sotheby's, New York, https://www.sothebys.com/en/auctions/ecatalogue/2018 /a-beautiful-life-photographs-from-the-collection-of-leland-hirsch-n09835 /lot.27.html.

187 *Marlene Dietrich appears*: "The Hats of Paris by Night," *Harper's Bazaar*, October 1955, 128.

187 *"The shock-surprise in his photos"*: "High Fashion—in a Menagerie," *U.S. Camera*, June 1956, 65.

188 *"In came this girl"*: Laura Jacobs, "Everyone Fell for Suzy," *Vanity Fair*, November 20, 2006, https://archive.vanityfair.com/article/2006/5/everyone-fell-for -suzy.

188 *Tattersall tells a very different story*: Norma Stevens and Steven M. L. Aronson, *Avedon: Something Personal* (New York: Spiegel and Grau, 2017), 86–87.

189 *"Don't be ridiculous"*: Author interview with Carmen Dell'Orefice, April 1, 2015.

189 *"It was a radical departure for fashion"*: Author interview with Judith Thurman, March 15, 2018.

190 *He claimed to have been struck*: Helen Whitney interview with Richard Avedon, in *Richard Avedon: Darkness and Light*, directed by Helen Whitney, *American Masters* documentary, PBS, 1995.

191 *Dick described the session*: Whitney interview with Avedon.

191 *"I trust performances"*: David Ansen, "Avedon," *Newsweek*, September 12, 1993.

192 *"And then there was the inevitable drop"*: Maria Morris Hambourg and Mia Fineman, "Avedon's Endgame," in *Richard Avedon Portraits* (New York: Harry N. Abrams and the Metropolitan Museum of Art, 2002).

192 *"All my portraits are self-portraits"*: Andrew Solomon, "The Vision Thing," *Harpers & Queen*, February 1995, http://andrewsolomon.com/articles/the-vision-thing/.

## CHAPTER 8: ON BORROWED WINGS (1957–1959)

194 *"Dick was so full of energy"*: Unpublished interview with Stanley Donen, artist files, Department of Photographs, Metropolitan Museum of Art, New York. (Interviewer requests to remain anonymous.)

195 *"It was all very strange"*: Michel Guerrin unpublished interview with Richard Avedon for *Le Monde*, 1993.

195 *"Why not use Avedon himself?"*: Bertrand Tavernier interview with Stanley Donen, *Cahiers du Cinéma* 143 (May 1, 1963).

196 *"Avedon played a huge part"*: Tavernier interview with Donen.

196 *"a delightfully balmy romance"*: Bosley Crowther, *"Funny Face* Brings Spring to Music Hall," *New York Times*, March 29, 1957.

196 *"biggest one-week gross"*: *Hollywood Reporter*, April 26, 1957. See also Sam Irvin, *Kay Thompson: From* Funny Face *to* Eloise (New York: Simon & Schuster, 2011), 256–57.

197 *he was able to arrange*: Phyllis Lee Levin, "Fantasy Marks the Work of Fashion Photographer," *New York Times*, April 5, 1957.

197 *"first class airplane transportation"*: Agreement, Richard Avedon, Visual Consultant, *Funny Face* Files, Margaret Herrick Library at the Academy of Motion Picture Arts and Sciences, Los Angeles.

198 *"What a glorious idea"*: Tom Vallance, "Leonard Gershe," obituary, *Independent*, March 22, 2002.

199 *Avedon and Donen first met*: Author interview with Earl Steinbicker, October 19, 2018.

199 *"floating in and out"*: Author interview with Steinbicker.

199 *"Donen was most intrigued"*: Author interview with Steinbicker.

200 *Dick advised Donen and Ray June*: Arthur Knight, "Choreography for Camera," *Dance Magazine*, May 1957, 16–22.

200 *"The key moment"*: Robert M. Rubin, "Old World, New Look," in *Avedon's France: Old World, New Look*, by Robert M. Rubin and Marianne Le Galliard (New York: Harry N. Abrams and Bibliothèque Nationale de France, Paris, 2017), 22.

201 *"the practical realization of suggestions"*: Edward Jablonski, "Funny Face," *Films in Review*, April 1957, 170–74.

201 *"I pumped him on everything"*: Unpublished interview with Donen. (Interviewer requests to remain anonymous.)

202 *His title was "production creator"*: "The Judy Garland Musical Special," *General Electric Theater*, April 8, 1956, season 4, episode 28, CBS.

203 *Avedon "proposed adding"*: Knight, "Choreography for Camera."

203 *"The nature of being a director"*: Videotape, Richard Avedon in public conversation with David Ross, Whitney Museum of American Art, New York, April 25, 1994.

204 *annual income of $250,000*: Winthrop Sargeant, "A Woman Entering a Taxi in the Rain," *New Yorker*, November 8, 1958.

204 *the average income*: "Income of Families and Persons in the United States, 1960," report number P60-no. 37, January 17, 1962, US Department of Commerce, Bureau of Census.

590 NOTES

204 *"I was dazzled"*: Aram Saroyan, *My Own Avedon: A Memoir with Photographs* (Los Angeles: An Air Book, 2010).

205 *Aram was about to enter high school*: Author interview with Aram Saroyan, April 25, 2017.

205 *layout with eight of Saroyan's pictures*: "Lens on Europe," *Seventeen*, January 1958.

205 *Dick had hired him initially*: Norma Stevens and Steven M. L. Aronson, *Avedon: Something Personal* (New York: Spiegel and Grau, 2017).

206 *"Johnny was a lonely child"*: Author interview with Steinbicker.

207 *"She probably wanted the magazine"*: Calvin Tomkins unpublished interview with Richard Avedon, July 1994, Museum of Modern Art archives, New York.

207 *cinematic freeze-frame*: "Carmel Snow's Paris Report," *Harper's Bazaar*, September 1957, 207–23.

209 *Dick entered her salon*: Carmel Snow with Mary Louise Aswell, *The World of Carmel Snow* (New York: McGraw-Hill, 1962), 212; Penelope Rowlands, *A Dash of Daring: Carmel Snow and Her Life in Fashion, Art, and Letters* (New York: Atria, 2005), 47–71.

209 *"Mrs. Snow humanized clothes"*: Levin, "Fantasy Marks the Work of Fashion Photographer."

210 *Avedon photographed Harold Brodkey*: "Young Writers," *Harper's Bazaar*, April 1958, 178–79.

210 *palpable contact between subject and photographer*: Author interview with Temi Rose, daughter of Harold Brodkey, February 3, 2018.

210 *Dick photographed Monroe*: "Fabled Enchantresses," *Life*, December 22, 1958, 137.

211 *"I'm taking you all to see Lenny Bruce"*: Author interview with Helen Kanelous, June 9, 2017.

211 *"A Woman Entering a Taxi"*: Sargeant, "A Woman Entering a Taxi."

212 *"Models do get lost"*: Sargeant.

212 *"Formality is"*: Sargeant.

213 *"Dickaboo" was a term*: Truman Capote to Richard Avedon, "Dickaboo . . . ," September 22, 1960, in Gerald Clarke, ed., *Too Brief a Treat: The Letters of Truman Capote* (New York: Random House, 2004), 295.

213 *"the greatest photographer"*: Truman Capote to Marie and Alvin Dewey, "Dear Marie and Alvin . . . ," January 22, 1960, in *Too Brief a Treat*, 278.

213 *Capote describes the scene*: Truman Capote, "Comments," in Richard Avedon and Truman Capote, *Observations* (New York: Simon & Schuster, 1959).

214 *"The Winner"*: Capote, 44.

215 *"What other photographer"*: "Book Reviews," *Aperture*, March 1959.

215 *a letter he received from Edward Steichen*: Edward Steichen to Richard Avedon, dated October 8, 1959, Edward Steichen papers, Museum of Modern Art archives, New York.

217 *another book of photographs appeared in 1959*: Robert Frank, *The Americans* (New York: Grove Press, 1959).

217 Popular Photography *magazine derided*: "An Off-Beat View of the U.S.A.," *Popular Photography* 5, vol. 46, May 1960, 104–106.

218 *"everyone was sort of alone more"*: Author interview with Robert Frank, April 10, 2007.

218 *Twenty years after*: Gene Thornton, "Catching America on the Wing," *New York Times*, February 18, 1979.

218 *"People thought I hated America"*: Author interview with Frank.

## CHAPTER 9: THE NEW DECADE (1960–1962)

220 *"How naïve I was"*: Charles McGrath, "No Longer Writing, Philip Roth Has Plenty to Say," *New York Times*, January 16, 2018.

221 *"Because their act was so intelligent"*: Mike Nichols and Elaine May: "Take Two," directed by Phillip Schopper, *American Masters*, PBS, 1996.

222 *"friends for life"*: Norma Stevens and Steven M. L. Aronson, *Avedon: Something Personal* (New York: Spiegel and Grau, 2017), 99.

222 *Dick exposed Mike*: Stevens and Aronson, 182.

223 *"Richard Avedon taught me"*: Sam Kashner and Charles Maslow-Freen, "Mike Nichols's Life and Career: The Definitive Oral History," *Vanity Fair*, October 2015.

224 *"The government is taking"*: "Nichols and May water cooler talk 1/29/60," YouTube video, posted by "Anthony DiFlorio," February 9, 2016, https://youtube .com/watch?/V-P6R-q0jJLuk.

224 *dressed as modern-day sphinxes*: "the sphinx within," *Harper's Bazaar*, April 1960, 112–19.

225 *"The girls for the most part"*: Suzy Knickerbocker, "Photo Gallery Has Sphinx Spinning," *New York Mirror*, April 1, 1960, 6.

225 *"When we come back"*: Truman Capote to Marie and Alvin Dewey, "Dear Marie and Alvin . . . ," January 22, 1960, in Gerald Clarke, ed., *Too Brief a Treat: The Letters of Truman Capote* (New York: Random House, 2004), 277–78.

226 *"I expected to find him"*: Anne Taylor Fleming, "The Private World of Truman Capote," *New York Times Magazine*, July 9, 1978.

227 *"It was one of the most brilliant"*: Gerald Clarke, *Capote: A Biography* (New York: Simon & Schuster, 1988), 329.

227 *"a bobcat she'd once seen"*: Truman Capote, *In Cold Blood* (New York: Random House, 1966).

228 *"When I approached them"*: Videotape, Richard Avedon in public conversation with David Ross, Whitney Museum of American Art, New York, April 25, 1994.

228 *"The mug shot–like portrait"*: Wall text, *Crime Stories: Photography and Foul Play*, Metropolitan Museum of Art, March 7–July 31, 2016.

228 *"I'm not impressed with the* fact *of Eisenhower"*: Transcript, Alexey Brodovitch workshop in the Steven Franklin Agency, September 23, 1964, Museum of Modern Art archives, 4.

230 *"dopey idea"*: Stevens and Aronson, *Avedon*, 181.

230 *"The thing about Evie"*: Stevens and Aronson, *Avedon*, 185.

230 *"Mrs. Avedon is very canny"*: Winthrop Sargeant, "A Woman Entering a Taxi in the Rain," *New Yorker*, November 8, 1958.

231 *"They missed the point"*: Richard Kostelanetz, *Conversing with Cage* (Ann Arbor: University of Michigan Press, Limelight Editions,1988).

232  *"There is too much* there *there"*: Kostelanetz.

232  *"Everything just went along"*: Rachel Cohen, *A Chance Meeting: Intertwined Lives of American Writers and Artists, 1854–1967* (New York: Random House, 2004), 257.

232  *Dick and this trio would find a common language*: "The Gift of Nonconforming," *Harper's Bazaar*, September 1960, 250.

234  *"Gloria didn't really give parties"*: Aram Saroyan, *Trio: Oona Chaplin, Carol Matthau, Gloria Vanderbilt: Portrait of an Intimate Friendship* (New York: Simon & Schuster/Linden Press, 1985), 178.

234  *"Opening night was a gala"*: Sam Kashner, "Who's Afraid of Nichols and May?," *Vanity Fair*, January 2013.

235  *"Avedon: Observations on the 34th First Family"*: "Avedon: Observations on the 34th First Family," *Harper's Bazaar*, February 1961, 96–101.

235  *"As Avedon was setting up"*: Shannon Thomas Perich, "The Kennedys: Portrait of a Family," *Smithsonian*, October 25, 2007.

236  *"When I took Caroline's picture"*: Shannon Perich, "Today in History: Richard Avedon Photographs the Kennedys," Smithsonian: Behind the Scenes, National Public Radio, January 3, 2011, https://www.npr.org/sections/pictureshow/2011/01/03/132616931/kennedys.

236  *it was really Diana Vreeland*: Stephen Mooallem, "The Allure of Jackie Kennedy." *Harper's Bazaar*, February 2017, 184.

236  *"She had that wonderful pizzazz"*: *Diana Vreeland: The Eye Has to Travel*, directed by Lisa Immordino Vreeland and Bent-Jorgen Perlmutt, Samuel Goldwyn Films, 2011.

237  *"Jackie had no qualms"*: *Diana Vreeland: The Eye Has to Travel.*

237  *"You might know exactly the right thing"*: *Diana Vreeland: The Eye Has to Travel.*

237  *Oleg Cassini was Vreeland's answer*: Mooallem, "The Allure of Jackie Kennedy."

239  *"Dick was very nervous"*: Author interview with Alen MacWeeney, June 2, 2016.

240  *"Basically, Avedon took over"*: Author interview with MacWeeney.

241  *"He danced like a god"*: Dominick Dunne, "The Rockefeller and the Ballet Boys," *Vanity Fair*, February 1987.

241  *"He was so open"*: Julie Kavanagh, *Nureyev: The Life* (New York: Pantheon, 2007), 153.

242  *"As I went on photographing"*: Kavanagh, 154–55.

243  *"The world at large"*: "Rudolf Nureyev," *Harper's Bazaar*, September 1961, 218.

244  *"Doorman, very conventional"*: Author interview with MacWeeney.

246  *"What will I do?"*: Author interview with MacWeeney.

246  *"a veritable Niagara roar"*: Kavanagh, *Nureyev*, 228.

246  *"Can you find out what Balanchine thought?"*: Kavanagh.

247  *"I was so amazed"*: Author interview with Joel Meyerowitz, September 14, 2017.

248  *"She wasn't model-y enough"*: Author interview with Meyerowitz.

248  *"It was about leaping"*: David Walker, "Joel Meyerowitz on What He Learned about Street Photography from Garry Winogrand," *Photo District News*, July 31, 2018.

248 *"in search of the poetry"*: Author interview with Meyerowitz.

250 *Burton invited Nichols to visit him in Rome*: *Becoming Mike Nichols*, directed by Douglas McGrath, HBO, 2016.

250 *Nichols had shared the details*: Author interview with Ruth Ansel, October 27, 2015.

250 *"I decided to do a satire"*: Michel Guerrin unpublished interview with Richard Avedon for *Le Monde*, 1993.

251 *"The whole thing was shot in Paris"*: Author interview with Ruth Ansel.

251 *"Mike Nichols and Suzy Parker Rock Europe"*: "Mike Nichols and Suzy Parker Rock Europe," *Harper's Bazaar*, September 1962, 213–21.

251 *"He had a talent to direct"*: Author interview with MacWeeney.

251 *"Marvin Israel laid it out"*: Guerrin interview with Avedon.

252 *"From what I understand"*: Author interview with Ansel.

252 *"this is where his vision"*: Author interview with Ansel.

252 *her first novel*: Marjorie Lee, *The Eye of Summer* (New York: Simon & Schuster, 1961).

## CHAPTER 10: FIRE IN THE BELLY (1963–1965)

254 *"An artist paints not"*: Janet Flanner, "Pablo Picasso's Idiosyncratic Genius," *New Yorker*, March 2, 1957.

255 *"an inevitability about psychoanalysis"*: Anatole Broyard, *Kafka Was the Rage: A Greenwich Village Memoir* (New York: C. Southern Books, 1993), 445.

255 *"I wanted to discuss my life"*: Broyard, 52.

256 *"I did my best work"*: Calvin Tomkins unpublished interview with Richard Avedon, July 1994, Museum of Modern Art archives, New York.

256 *"Dick was this wonderful combination"*: Author interview with Ruth Ansel, October 27, 2015.

257 *"We came from privilege"*: *Who Is Marvin Israel?*, directed by Doon Arbus and Neil Selkirk, 2005.

257 *"The Full Circle"*: "The Full Circle," *Harper's Bazaar*, November 1961, 133–37.

257 *The "Editor's Guest Book"*: "The Editor's Guest Book," *Harper's Bazaar*, November 1961, 107.

258 *"Each photograph for Diane was an event"*: *Who Is Marvin Israel?*

258 *"then Marvin was a brother"*: Tomkins interview with Avedon.

258 *"two brothers who were opposites"*: Jane Livingston, "The Art of Richard Avedon," in Richard Avedon, *Evidence, 1944–1994* (New York: Random House and Eastman Kodak Professional Imaging, with the Whitney Museum of American Art, 1994), 35.

260 *"I was there with Dick"*: Author interview with Earl Steinbicker, October 19, 2018.

260 *"how we're going to pay"*: Norma Stevens and Steven M. L. Aronson, *Avedon: Something Personal* (New York: Spiegel and Grau, 2017), 342.

260 *"Avedon 64: A Collage"*: Lobby installation at the McCann Erickson offices, 485 Lexington Avenue, sixteenth floor, November 16, 1964.

261 *"Avedon invented an exhibition"*: Livingston, "The Art of Richard Avedon," 35.

262 *"created one of the most compelling"*: John Lewis, "Ministers of Change," in James Baldwin and Steve Schapiro, *The Fire Next Time* (Cologne: Taschen, 2017), 22.

262 *Baldwin came to sit*: Richard Avedon, portrait of James Baldwin, *Harper's Bazaar*, April 1963, 152.

262 *"Baldwin had been a boy preacher"*: Hilton Als, "Fade to Black," *New Yorker*, February 13 & 20, 2017.

262 *"the Avedons knew something"*: Hilton Als, "The Way We Live Now," in Richard Avedon and James Baldwin, *Nothing Personal* (Cologne: Taschen, 2017).

263 *"If you and I are white"*: James Baldwin, "Letter from a Prisoner," *Harper's Bazaar*, April 1963, 152–53.

264 *"a slim girl with dark glasses"*: John Fowles, "September 1963," in *The Journals*, vol. 1, 1949–1965 (Chicago: Northwestern University Press, 2008), 565.

264 *"A political and financial magician"*: Glen Jeansonne, *Leander Perez: Boss of the Delta* (Jackson: University of Mississippi Press, 2006), xxiii.

264 *"Animals, right out of the jungle"*: *Baton Rouge State Times*, April 3, 1965.

265 *"This is where I send niggers and Jews"*: Video, Neil Selkirk interview with Marguerite Lamkin Littman, London, October 2005, https://www.neilselkirk.com/avedon.

265 *she found a place for Dick to hide*: Author interview with Marguerite Lamkin Littman, October 5, 2017.

265 *"We had breakfast with him"*: Author interview with Steinbicker.

266 *"We got some shots"*: Author interview with Steinbicker.

268 *"Jimmy was plagued with personal sadness"*: Baldwin and Schapiro, *The Fire Next Time*, 255.

269 *"Baldwin wrote whatever came"*: Stevens and Aronson, *Avedon*, 193.

270 *"'Nothing Personal' was about the breakdown"*: Als, "The Way We Live Now."

271 *"For a long, long time"*: Richard Avedon to Claude Eatherly, March 30, 1963, in Als, "The Way We Live Now."

271 *Major Eatherly is the central portrait*: Colin Westerbeck, public talk, "A Terrible Beauty Is Born: Richard Avedon, Irving Penn, and the Portraiture of the Cold War," Art Institute of Chicago, April 5, 2009.

272 *"Since World War II"*: Garry Winogrand, Guggenheim Fellowship application, 1964, published in Trudy Wilner Stack, *Winogrand 1964* (Santa Fe: Arena Editions, 2002).

272 *"'Nothing Personal' pretends to be"*: Robert Brustein, "Everybody Knows My Name," *New York Review of Books*, December 17, 1964.

272 *"Would he rather it was printed"*: Truman Capote, letter to the editor, *New York Review of Books*, December 17, 1964.

273 *"For over a decade"*: "Books: American Gothic," *Time*, November 6, 1964, 108.

274 *"The Illusive Iberians"*: "The Blaze of Spain," *Harper's Bazaar*, January 1965, 107.

275 *"Listen, we can't publish these"*: Janelle Okwodu, "'You've Got to Stay Interesting,' and More Life Advice from 87-Year-Old Supermodel China Machado," *Vogue*, October 10, 2016, https://www.vogue.com/article/china-machado-interview-exhibition-life-lessons.

275 *"There is something"*: "The Editor's Guest Book," *Harper's Bazaar*, February 1959, 101.

275 *"probably the most beautiful"*: Janelle Okwodu, "'You've Got to Stay Interesting,' and More Life Advice from 87-Year-Old Supermodel China Machado," *Vogue*, October 10, 2016, https://www.vogue.com/article/china-machado -interview-exhibition-life-lessons.

275 *"I never felt beautiful"*: Okwodu.

276 *"I often feel that people"*: Janet Malcolm, *Diana and Nikon* (New York: Aperture, 1997), 53.

277 *"I had twenty-five dollars"*: Video, "Interview: Holly Solomon on Warhol," Christie's website, https://www.christies.com/features/2001-August-holly -solomon-on-warhol-137-3.aspx.

277 *"I wanted to be Brigitte Bardot"*: Paul Tschinkel interview with Holly Solomon, in *Robert Mapplethorpe*, directed by Paul Tschinkel, 2006.

277 *"What no one really understood"*: Paul Tschinkel interview with Solomon.

278 *"Just watch the red light"*: Interview with Ethel Scull, in *Painters Painting: The New York Art Scene 1940–1970*, directed by Emile de Antonio, Virgil Films and Entertainment, 2009, originally distributed in 1973.

279 *In 2014, at a Christie's auction*: "Post-War and Contemporary Evening Sales," May 13, 2014, sale 2487, lot 23, Andy Warhol, *Race Riot*, https://www.christies .com/lotfinder/Lot/andy-warhol-1928-1987-race-riot-5792521-details.aspx.

280 *"Reviews no longer victimize me"*: David Michaelis, "The Now of Avedon," *Vanity Fair*, December 2009, 184.

280 *"I vomited for about two weeks"*: Michael Gross, "War of the Poses," *New York*, April 27, 1992, 29.

280 *"America was preparing"*: Michaelis, "The Now of Avedon."

281 *"It was a marvelous time"*: David Wills, *Switched On: Women Who Revolutionized Style in the '60s* (San Francisco: Weldon Owen, 2017), epigraph.

282 *"John [Lennon] knew what he was worth"*: Michaelis, "The Now of Avedon," 200.

283 *"They were getting drunker"*: Author interview with Steinbicker.

284 *"She was gorgeous"*: Author interview with David McCabe, January 9, 2019.

284 *"Dick immediately understood"*: Author interview with Ansel.

285 *"an Avedon style handbook"*: Vince Aletti, "Dark Passage," *Village Voice*, April 12, 1994.

## CHAPTER 11: TUNING IN (1965–1967)

286 *"There has never been"*: Walter Benjamin, "Theses on the Philosophy of History," in *Illuminations: Essays and Reflections* (Boston: Mariner Books, 2019), 200.

286 *"one of the most chic"*: Florence Pritchett Smith, "The Mood and the Food," *New York Journal-American*, November 7, 1965.

288 *"by no means lacking"*: Grace Glueck, "Warhol's Pad Is Scene of Blast Launching 'Pop Art,' New Book," *New York Times*, June 30, 1965.

288 *"Andy was all about"*: Author interview with David McCabe, January 5, 2019.

289 *"Oh, there's Barnett Newman"*: Author interview with McCabe.

289 *"Richard Avedon, photographer"*: John Durniak, "Avedon Show," *Popular Photography*, May 1965.

290 *"The imaginary beauties"*: John Szarkowski, exhibition wall text, *The Glamour Portrait*, Museum of Modern Art, New York, August 2–September 19, 1965.

291 *"Not since Thomas Wolfe"*: "Horror Spawns a Masterpiece," *Life*, January 7, 1966.

292 *legendary Black and White Ball*: Charlotte Curtis, "Capote's Black and White Ball: The Most Exquisite of Spectator Sports," *New York Times*, November 29, 1966, 53.

292 *"I am one hundred percent proof"*: Amy Fine Collins, "A Night to Remember," *Vanity Fair*, July 1996.

293 *"a magnificent triumph"*: Bosley Crowther, "Who's Afraid of Audacity?," *New York Times*, July 10, 1966.

293 *"choral masterpiece from 1965"*: Alex Ross, "The Legend of Lenny," *New Yorker*, December 15, 2008.

293 *"You stand alone"*: Richard Avedon, "Leonard Bernstein," in Roddy McDowall, *Double Exposure* (New York: William Morrow, 1966), 196.

293 *"Every morning"*: John Leland, "Norman Podhoretz Still Picks Fights and Drops Names," *New York Times*, March 17, 2017.

294 *"Whenever a friend succeeds"*: Susan Barnes, "Behind the Face of the Gifted Bitch," *Sunday Times Magazine* (London), September 16, 1973.

294 *Evie brought in Billy Baldwin*: Author interview with Earl Steinbicker, October 21, 2018.

294 *"My jaw dropped"*: Author interview with Ruth Ansel, October 27, 2015.

294 *"Dick's liberal tendencies"*: Norma Stevens and Steven M. L. Aronson, *Avedon: Something Personal* (New York: Spiegel and Grau, 2017), 339.

295 *"Evelyn and I came together"*: Paula Chin, "Richard Avedon," *People*, May 23, 1994.

295 *"Do you think he's gay?"*: Author interview with McCabe.

296 *"You are not supposed"*: *Diana Vreeland: The Eye Has to Travel*, directed by Lisa Immordino Vreeland and Bent-Jorgen Perlmutt, Samuel Goldwyn Films, 2011.

296 *"The Great Fur Caravan"*: "The Great Fur Caravan," *Vogue*, October 15, 1966, 96.

297 *"I was highly impressed"*: Unpublished interview with Veruschka, 2008. (Interviewer requests to remain anonymous.)

297 *"I don't think it was just me"*: Unpublished interview with Veruschka.

298 *"all fifteen trunks"*: Author interview with Polly Mellen, June 27, 2016.

298 *"Who needs friends"*: Author interview with Mellen.

298 *Their caravan included*: Author interview with Mellen.

299 *"It was an erotic thing"*: Unpublished interview with Veruschka.

300 *"the bustling life"*: Colette, *Chéri; and, The Last of Chéri* (New York: MacMillan, 2001), 112.

300 *"Lartigue intuitively grasped"*: Press release, Museum of Modern Art exhibition, *The Photographs of Jacques Henri Lartigue*, New York, July 1, 1963.

300 *"It is easier"*: John Szarkowski, introduction to *The Photographs of Jacques Henri Lartigue* (New York: Museum of Modern Art, 1963).

300 *"I can't begin"*: Richard Avedon to John Szarkowski, March 4, 1963, archive, Department of Photography, Museum of Modern Art, New York.

301 *"Watching you look"*: John Szarkowski to Richard Avedon, March 13, 1963, archive, Department of Photography, Museum of Modern Art, New York.

301 *"The other day Mr. Szarkowski"*: Richard Avedon to Jacques-Henri Lartigue, March 1963, Donation Jacques-Henri Lartigue, Paris.

301 *"Your book is ravishing"*: Richard Avedon to Jacques-Henri Lartigue, October 10, 1966, Donation Jacques-Henri Lartigue, Paris.

302 *"His first bicycle"*: Richard Avedon to John Avedon, January 29, 1967, in Robert M. Rubin and Marianne Le Galliard, *Avedon's France: Old World, New Look* (New York: Harry Abrams and Bibliothèque Nationale de France, 2017), 44.

303 *"I felt very early on"*: Stephen Shore, "The Photo That Made Me: Stephen Shore, Tarrytown, N.Y., 1960," *Time* LightBox, February 17, 2015, https://time .com/3683272/the-photo-that-made-me-stephen-shore-tarrytown-n-y-1960/.

303 *"I don't have a philosophy"*: Stephen Shore artist's record, Museum of Modern Art library, New York.

303 *"If you do this with everyone"*: Author interview with Stephen Shore, July 19, 2017.

304 *"create their own style"*: Author interview with Gideon Lewin, April 17, 2018.

304 *Dick had gone to the opening*: Doon Arbus interview with John Szarkowski, February 11, 1972, in *Diane Arbus: Revelations* (New York: Random House, 2003), 184.

304 *"In the past decade"*: John Szarkowski, exhibition wall text, *New Documents*, Museum of Modern Art, New York, February 28–May 7, 1967.

305 *"The observations of the photographers"*: Jacob Deschin, "Photography: People Seen as Curiosity," *New York Times*, March 5, 1967.

305 *"I think anybody"*: Author interview with John Szarkowski, January 2005.

306 *"sometimes two or three times a week"*: Bill Bachmann recorded interview with Sebastien Chieco, March 15, 1991, courtesy of Bill Bachmann.

306 *"The atmosphere was charged"*: Author interview with Lewin.

306 *"The borders called attention"*: Sandra Phillips, "The Question of Belief," in *Diane Arbus: Revelations*, 60.

306 *"I had a carousel of slides"*: Author interview with Danny Lyon, December 27, 2018.

307 *"could summon sensational effects"*: Joel Smith, "A Gorgeous Mental Discretion," in *Peter Hujar: Speed of Life* (New York: Aperture with Fundación MAPFRE, 2017), 10.

307 *"few genuinely original artists"*: Author interview with Stephen Koch, director of the Peter Hujar Archive, November 19, 2015.

308 *"Peter saw himself as a portraitist"*: Author interview with Koch.

309 *"London's mini-bosomed fashion model"*: Charlotte Curtis, "Twiggy: She's Harlow, and the Boy Next Door," *New York Times*, March 21, 1967.

309 *"One of the reasons"*: Thomas Whiteside, "A Super New Thing," *New Yorker*, October 27, 1967, 130.

310 *"One thing you have to realize"*: Whiteside, 149.

310 *"At our first sitting"*: Whiteside, 149.

311 *"an Eyeflower that blooms"*: *Vogue*, July 1, 1967, contents page.

311 *"Twiggy takes a back-dive"*: *Vogue*, July 1, 1967, 54.

311 *"The best pictures I've taken"*: Whiteside, "Super New Thing."

312 *"I adored him on sight"*: Stevens and Aronson, *Avedon*, 95.

312 *"The wistful waif"*: "'67's Twig Becomes a Tree," *Life*, April 19, 1968.

312 *"After the Twig, the Tree?"*: "After the Twig, the Tree?," *Time*, October 13, 1967, 74.

314 *"Regarding Penn's attitude toward Avedon"*: Colin Westerbeck, correspondence with author, May 15, 2017.

314 *"I must say I'm tired"*: Maria Morris Hambourg, "The Heart of the Matter," in *Irving Penn: Centennial* (New York: Metropolitan Museum of Art and Yale University Press, 2016), 24.

314 *A true story characterizes*: Philip Gefter, "Irving Penn: Platinum Prints," *Aperture* 182 (Spring 2006): 88–89.

315 *"Penn realized that Alexander Liberman"*: Westerbeck, correspondence with author.

315 *The next day Dick*: Author interview with Lewin.

315 *"People Are Talking About"*: "People Are Talking About . . . ," *Vogue*, December 1, 1967, 234–35.

316 *"Nureyev: A Photographic Study"*: "Nureyev: A Photographic Study of the Human Form in Action," *Vogue*, December 1, 1967, 210–15.

317 *Ginsberg was on a national tour*: "This Day in Lettres, 29 May (1967): Allen Ginsberg to the General Public," *The American Reader*, http://theamericanreader .com/29-may-1967-allen-ginsburg-to-the-general-public/.

318 *Robert Frank acknowledged*: Robert M. Rubin, "Landsmen/Lensmen, Richard Avedon and Allen Ginsberg," in *Avedon: Murals and Portraits* (New York: Gagosian Gallery Publications, 2012), 86.

## CHAPTER 12: A WALK ON THE WILD SIDE (1968–1970)

321 *"The Art Nouveau influence"*: Arthur Goldsmith, "How to Shoot a Psychedelic Beatle," *Famous Photographers Magazine*, 1968, archive, Yale University Art Gallery.

322 *"What I came back with"*: Goldsmith.

322 *Dick and his assistant Gideon Lewin*: Author interview with Gideon Lewin, April 17, 2018.

323 *Eventually, they combined*: Goldsmith, "How to Shoot a Psychedelic Beatle."

323 *"We were like a family"*: Author interview with Lewin.

324 *The critic Harold Rosenberg*: Eliot Fremont-Smith, "The Tedium Is the Message," *New York Times*, September 4, 1968.

325 *"I trust performances"*: David Ansen, "Avedon," *Newsweek*, September 12, 1993.

325 *"The surface is all you've got"*: Richard Avedon, "Borrowed Dogs," reprinted in *Richard Avedon Portraits* (New York: Harry N. Abrams and the Metropolitan Museum of Art, 2002).

325 *"The reason I'm painting"*: Roger Kamholz, "Andy Warhol and His Process," Sotheby's website, November 10, 2013, https://www.sothebys.com/en/articles /andy-warhol-and-his-process.

326 *"We knew that"*: Author interview with Peter Rogers, September 23, 2016.

327 *"If the coat doesn't come"*: Author interview with Rogers.

327 *Gideon figured out a way*: Author interview with Lewin.

328 *"We weren't photographing"*: Author interview with Rogers.

328 *"I had been trying to find Garland"*: Author interview with Rogers.

330 *"Be a good girl"*: Norma Stevens and Steven M. L. Aronson, *Avedon: Something Personal* (New York: Spiegel and Grau, 2017), 191.

330 *"I would meet them at Rumpelmayer's"*: Stevens and Aronson, 191.

331 *"Louise's beauty was the event"*: *Richard Avedon: Darkness and Light*, directed by Helen Whitney, *American Masters* documentary, PBS, 1995.

331 *"I'd already done enough to Louise"*: Stevens and Aronson, *Avedon*, 192.

332 *Mike Nichols claimed*: Stevens and Aronson, 187.

332 *Evie was a patient*: Stevens and Aronson, 187–88.

333 *That year Dick brought Evie and John*: Donald G. McNeil Jr., "His Father's Photos Extol Beauty but John Avedon's New Book on Tibet Doesn't Paint a Pretty Picture," *People*, November 26, 1984.

334 *Dick provided a car*: McNeil.

334 *"This was the time of post-Summerhill"*: Author interview with Harry Mattison, March 11, 2019.

336 *"Could it possibly be"*: *Darkness and Light*.

336 *because he spoke French*: Stevens and Aronson, *Avedon*, 354.

336 *"All my spare time"*: Richard Avedon to John Szarkowski, July 15, 1968, Department of Photography archive, Museum of Modern Art, New York.

337 *"We think, we talk"*: Richard Avedon to Jacques-Henri Lartigue, March 28, 1968, Donation Jacques-Henri Lartigue, Paris.

338 *"I am not a person"*: Author interview with Neil Selkirk, November 7, 2016.

339 *To this end Avedon and Hiro*: Author interview with Selkirk.

339 *Harry Mattison, initially Johnny's friend*: Author interview with Mattison.

339 *"The first time"*: Stevens and Aronson, *Avedon*, 356.

339 *"Dick sent us violets"*: Author interview with Anjelica Huston, March 6, 2016.

340 *"Dick was clearly shaken"*: Author interview with HarryMattison.

340 *"What would it be like"*: Author interview with Huston.

341 *She felt more spontaneous*: Author interview with Huston.

341 *"Dick shared with me"*: Stevens and Aronson, *Avedon*, 358.

342 *"I think it looks so divinely beautiful"*: Diana Vreeland, "RE: Irish Trip, dated Oct 3, 1969," in *Memos: The Vogue Years*, ed. Alexander Vreeland (New York: Rizzoli, 2013).

343 *"I had this block"*: Paul Roth, "Unholy Trinity: The Making of Richard Avedon's 'Andy Warhol and Members of the Factory,'" in *Avedon: Murals and Portraits* (New York: Gagosian Gallery Publications, 2012), 181.

343 *"I can't tell you how grateful"*: Roth, 181.

344 *"You know my compulsion"*: Richard Avedon to John Szarkowski, July 15, 1968, Department of Photography archive, Museum of Modern Art, New York.

344 *"Let us get together"*: John Szarkowski to Richard Avedon, October 2, 1968, Department of Photography archive, Museum of Modern Art, New York.

344 *"the disruptive and transgressive"*: Roth, "Unholy Trinity," 181.

345 *"You were clear"*: Audio interview with Richard Avedon and Doon Arbus,

"Legends Online: Avedon, the Sixties," Photo District News on-line: pdngallery .com/legends.

345 *"now wants to turn his lens"*: "Scene," *Village Voice*, September 6, 1969.

346 *"There are no standard photographic props"*: James Stevenson, "McCarthy in New York," Talk of the Town, *New Yorker*, March 2, 1968, 31–32.

346 *"They couldn't see"*: Roth, "Unholy Trinity," 183.

348 *"This is no longer"*: Jason Epstein, "A Special Supplement: The Trial of Bobby Seale," *New York Review of Books*, December 4, 1969.

348 *"Dick was looking"*: Author interview with Paul Roth, April 14, 2016.

349 *Among the many readers*: Lacey Fosburgh, "Church Starts Reading Names of Dead GIs," *New York Times*, November 17, 1969.

350 *"For many observers"*: Louis Menand, "This Is the End," in *Avedon: Murals and Portraits*, 29.

350 *"the defendants known as the Chicago Seven"*: Menand, 25.

350 *they made him feel ashamed*: Menand, 32.

350 *"Do the Panthers like"*: Tom Wolfe, "Radical Chic: That Party at Lenny's," *New York*, June 8, 1970.

351 *"Black Panther Philosophy"*: Charlotte Curtis, "Black Panther Philosophy Is Debated at the Bernsteins," *New York Times*, January 15, 1970.

351 *"the group therapy"*: Editorial, "False Note on Black Panthers," *New York Times*, January 16, 1970.

352 *"where hypocrisy is even possible"*: Randall Jarrell, *Pictures from an Institution: A Comedy* (Chicago: University of Chicago Press, 1986), 72.

353 *"I wanted to start with the Warhol group"*: Roth, "Unholy Trinity," 183.

354 *"the beautiful garbage of clothes"*: Roth, 183.

355 *"Take off your shoes"*: Bollen, "Avedon Exposed," *Interview*, May 2, 2012, https://www.interviewmagazine.com/culture/avedon-exposed.

355 *"one of the coins of that time"*: Richard Avedon in public conversation with Adam Gopnik, "The Constructed Moment," Metropolitan Museum of Art, New York, October 8, 2001.

355 *"I'll send over a limousine"*: Bollen, "Avedon Exposed."

356 *"a portrait, a beautiful portrait"*: Roth, "Unholy Trinity," 187.

356 *"figures progressing around the belly"*: Maria Morris Hambourg and Mia Fineman, "Avedon's Endgame," in *Richard Avedon Portraits* (New York: Harry N. Abrams and the Metropolitan Museum of Art, 2012).

357 *"one of the signal achievements"*: Roth, "Unholy Trinity," 183.

## CHAPTER 13: CLOSE TO HOME (1970–1971)

358 *"I used to think consciousness"*: Diane Arbus to Allan Arbus and Mariclare Costello, January 11, 1971, in Doon Arbus and Elisabeth Sussman, eds., *Diane Arbus: A Chronology* (New York: Aperture, 2011), 111.

359 *When Dick finally walked*: Diane Arbus to Amy Arbus, early July 1970, in *Diane Arbus: Revelations* (New York: Random House, 2003), 210.

359 *"We were all working"*: Audio interview with Ted Hartwell in *Who Is Marvin Israel?*, directed by Doon Arbus and Neil Selkirk, 2005.

360 *"Nothing stayed where it started"*: Audio interview with Paul Corlett in *Who Is Marvin Israel?*

360 *"I have to attribute"*: Audio interview with Hartwell.

361 *"Getting undressed, getting naked"*: Charlie Rose interview with Richard Avedon and Doon Arbus; *Charlie Rose*, PBS, November 11, 1999.

361 *"It was the most electrifying experience"*: Audio interview with Hartwell.

362 *In the Minneapolis essay*: Richard Avedon, catalog essay, *Avedon*, Minneapolis Institute of Art, July 2–August 30, 1970 (in limited edition).

363 *"Everyone who opposes"*: Richard Avedon, exhibition wall text, *Avedon*, Minneapolis Institute of Art, July 2–August 30, 1970.

363 *"I followed my enthusiasms"*: Rose interview with Avedon and Arbus.

363 *"It was my original intention"*: Avedon, catalog essay.

363 *"In present postwar America"*: John Lahr, "The Silent Theater of Richard Avedon," *Evergreen Review*, August 1970, 34.

364 *"enough to intimidate me"*: Gene Thornton, "Wicked Fun, but What Are They Really Like?," *New York Times*, July 26, 1970.

365 *"I'm about to impose"*: Richard Avedon to John Szarkowski, June 16, 1970, Department of Photography archive, Museum of Modern Art, New York.

366 *"lost for two weeks"*: John Szarkowski to Richard Avedon, July 17, 1970, Department of Photography archive, Museum of Modern Art, New York.

366 *"Dick's show is terrific"*: Diane Arbus to Amy Arbus, early July 1970, in *Diane Arbus: Revelations*, 209.

367 *"Diane and Garry and I talked"*: Lee Friedlander in public conversation with Giancarlo T. Roma, New York Public Library, June 20, 2017.

368 *Several of the portfolios*: Author interview with Gideon Lewin, April 17, 2018.

368 *"It looks good"*: Diane Arbus to Allan Arbus, ca. October 1970, in *Diane Arbus: Revelations*, 211.

369 *"Dick's public relations"*: Diane Arbus to Allan Arbus.

369 *"With Diane Arbus"*: Philip Leider, "Photography," Sotheby's catalog, October 16, 2004, 150.

369 *"Leider's admission of Arbus"*: John P. Jacob, essay, in Diane Arbus, *A Box of Ten Photographs* (New York: Aperture, 2018), 51.

370 *"without his incomparable friendship"*: Jacques-Henri Lartigue, dedication, *Diary of a Century* (New York: Viking Press, 1970).

370 *"Dick wants to see everything"*: Author interview with Kevin Moore, February 19, 2019. Moore, the author of *Jacques-Henri Lartigue: The Invention of an Artist* (Princeton, NJ: Princeton University Press, 2004), provided direct documentation of Lartigue's journal entry.

371 *"Please forgive me"*: Richard Avedon to Jacques-Henri Lartigue, October 16, 1969, Donation Jacques-Henri Lartigue, Paris.

371 *"I don't trust anyone except Florette"*: Avedon to Lartigue, October 31, 1969, Donation Jacques-Henri Lartigue, Paris.

371  *"He was a very pleasant Frenchman"*: Bachmann interview with Sebastien Chieco, courtesy of Bill Bachmann.

372  *"This will be the most beautiful"*: Avedon to Lartigue, November 26, 1969, Donation Jacques-Henri Lartigue, Paris.

372  *"I didn't spit on the package"*: Avedon letter to Lartigue, March 30, 1970, Donation Jacques-Henri Lartigue, Paris.

372  *"There was very little money"*: Bea Feitler, essay, *O Design de Bea Feitler* (Rio de Janeiro: Cosac Naify, 2012), Bea Feitler papers, Libraries and Archives, New School for Social Research, New York.

372  *"I love the Lartigue book"*: Diane Arbus postcard to Bea Feitler, December 4, 1970, Bea Feitler papers, Libraries and Archives, New School for Social Research, New York.

373  *"Photography has always reminded"*: Richard Avedon, afterword to *Diary of a Century*.

373  *"Lartigue's celebrity in America"*: Moore, *Jacques-Henri Lartigue*.

374  *"a family album illustrated"*: Anaïs Nin, review of *Diary of a Century*, *New York Times Book Review*, February 21, 1971, 4–5.

374  *"I have just finished seeing"*: Richard Avedon to John Szarkowski, December 21, 1970, Department of Photography, archive, Museum of Modern Art, New York.

374  *"I think the Lartigue book"*: John Szarkowski to Richard Avedon, December 30, 1970, Department of Photography, archive, Museum of Modern Art, New York.

375  *"My reason for coming"*: Gloria Emerson, "Avedon Photographs a Harsh Vietnam," *New York Times*, May 9, 1971.

376  *"Saigon seems to be"*: Paul Roth, "Family Tree," in *Richard Avedon: Portraits of Power* (Göttingen, Germany: Steidl and the Corcoran Gallery of Art, 2008), 253.

376  *"There you met friends"*: William Shawcross, "Avedon's Mission," in *Avedon: Murals and Portraits* (New York: Gagosian Gallery Publications, 2012), 129.

376  *His calendar includes*: Shawcross, 146–47.

376  *"a delightful man"*: Shawcross, "Avedon's Mission."

377  *"without an ounce of self-pity"*: Emerson, "Avedon Photographs a Harsh Vietnam."

377  *"I went to Vietnam"*: Michel Guerrin unpublished interview with Richard Avedon for *Le Monde*, 1993.

377  *"I was amazed"*: Shawcross, "Avedon's Mission," 133.

378  *"a card-carrying anti-war activist"*: Louis Menand, "This Is the End," in *Avedon: Murals and Portraits*, 32.

378  *"I might have had a political opinion"*: Guerrin interview with Avedon.

378  *"I photographed every day"*: Guerrin interview with Avedon.

378  *"I know these men"*: Richard Avedon in a student seminar, Tokyo, 1977, quoted in Roth, "Family Tree," 259.

378  *"A police line-up"*: "The Best and the Rightest: A Souvenir," *Time*, April 21, 1976.

379  *"unmoved by life"*: Gloria Emerson, "This Symbol of Immense American Power in Vietnam," *New York Times*, April 7, 1975, p. 31.

379  *"They sang verses"*: Emerson, 31.

380 *Lartigue, in Dick's own words*: Marianne Le Galliard, "Lartigue by Avedon: A Labor of Love," in Robert M. Rubin and Marianne Le Galliard, *Avedon's France: Old World, New Look* (New York: Harry N. Abrams and Bibliothèque Nationale de France, 2017), 45.

380 *"We couldn't even reach him"*: Norma Stevens and Steven M. L. Aronson, *Avedon: Something Personal* (New York: Spiegel and Grau, 2017), 202.

381 *"I love the quality in him"*: Richard Avedon, essay dated 14 July 1974, exhibition brochure checklist for *Richard Avedon: 1946–1980*, University Art Museum, Berkeley, California, March 5–May 4, 1980.

381 *"I do terribly admire"*: Ann Ray Martin, "Telling It as It Is," *Newsweek*, March 20, 1967, 110.

381 *"he was the greatest"*: Arthur Lubow, *Diane Arbus: Portrait of a Photographer* (New York: Ecco, 2016), 559.

381 *"she made the act of looking"*: "Performing for the Camera: A Self-Portrait with Richard Avedon," *At Random* (Random House in-house magazine) 2, no. 3 (Fall 1993): 28–33.

382 *"The worst is"*: Arbus and Sussman, *Diane Arbus: A Chronology*, 111.

382 *aunt Sally's odd behavior*: Author e-mail correspondence with Robert Lee, April 9, 2018.

383 *Diane Arbus took her life*: Lubow, *Diane Arbus: Portrait of a Photographer*, 592.

383 *"she was found dead"*: Arbus and Sussman, *Diane Arbus: A Chronology*, 111.

383 *"I'm going in"*: Lubow, *Diane Arbus: Portrait of a Photographer*, 596.

383 *"Incised wounds of wrists"*: Arbus and Sussman, *Diane Arbus: A Chronology*, 113.

383 *"Diane killed herself"*: Author interview with Doon Arbus and Neil Selkirk, April 5, 2019.

384 *Amy, who had ridden horses*: Author interview with Amy Arbus, September 28, 2017.

384 *"My family really thought"*: Author interview with Amy Arbus.

## CHAPTER 14: FATHERS AND SONS (1970–1974)

385 *"What we think is less"*: R. D. Laing, *The Politics of Experience* (New York: Pantheon, 1983), 30.

385 *"We called our theater company"*: Author interview with André Gregory, February 29, 2016.

386 *"There is probably going to be blood"*: Clive Barnes, "Savage 'Alice in Wonderland,'" *New York Times*, October 9, 1970.

386 *"Being Dick Avedon"*: Author interview with Gregory.

386 *"I think there's a great misconception"*: Doon Arbus interview with André Gregory, in Richard Avedon, *Alice in Wonderland: The Forming of a Company and the Making of a Play* (New York: Merlin House, 1973).

387 *"It was all catered"*: Author interview with Gregory.

388 *"Here the photographer"*: Jane Livingston, "The Art of Richard Avedon," in Richard Avedon, *Evidence, 1944–1994* (New York: Random House and Kodak Professional Imaging, with the Whitney Museum of American Art, 1994), 78.

388 *"The difference between them"*: Philip Pocock, "Interview with Thomas Ruff," *Journal of Contemporary Art*, June 1, 1993, 78–86.

389 *"If you use photography"*: Videotape, Thomas Ruff in public conversation with author, Aperture Foundation, New York, February 12, 2010.

389 *"every wrinkle, stubble"*: Colin Westerbeck, public talk, "A Terrible Beauty Is Born: Richard Avedon, Irving Penn, and the Portraiture of the Cold War," Art Institute of Chicago, April 5, 2009.

390 *"I was using"*: Richard Avedon, "Jacob Israel Avedon," *Camera*, November 1974.

390 *"What I love about you"*: *Richard Avedon: Darkness and Light*, directed by Helen Whitney, *American Masters* documentary, PBS, 1995.

391 *"How could you do it?"*: Norma Stevens and Steven M. L. Aronson, *Avedon: Something Personal* (New York: Spiegel and Grau, 2017), 206.

391 *"He was one of the smartest"*: Stevens and Aronson, 289.

393 *He subscribed to the notion*: Owen Edwards, "Pictures of Avedon," *Playboy*, June 1975.

393 *"For many years"*: Videotape, Richard Avedon in public conversation with David Ross, Whitney Museum of American Art, New York, April 25, 1994.

394 *"He looked me"*: Avedon conversation with Ross.

395 *"the best, most powerful"*: David Ansen, "Avedon," *Newsweek*, September 12, 1993, 44–78.

395 *"known as a wag"*: Terry Teachout, "The Man Who Wasn't Gershwin," *Commentary*, March 2019.

396 *"There was enough"*: Ansen, "Avedon."

396 *"I remember Oscar Levant"*: Iris Chekenian, "Letter to the Editor," *New York Times*, April 3, 1994.

397 *It took place*: Author interview with Lauren Hutton, April 22, 2016.

398 *"Dick was like another kid"*: Author interview with Hutton.

398 *"A contract with an exclusive"*: Author interview with Hutton.

399 *"Hutton has now signed"*: "Eyecatchers," *Time*, July 16, 1973, 53.

399 *"He was making a pass"*: Author interview with Hutton.

401 *"I had a choice"*: Avedon conversation with Ross.

402 *it would irk Dick*: Author interview with Doon Arbus and Neil Selkirk, April 5, 2019.

402 *"a lot of the early freak pictures"*: Doon Arbus interview with John Szarkowski, February 11, 1972, in *Diane Arbus: Revelations* (New York: Random House, 2011), 163–64.

403 *"John [Szarkowski] was a testosterone giant"*: Stevens and Aronson, *Avedon*, 283.

403 *"which I feel to be representative"*: Richard Avedon to John Szarkowski, January 26, 1972, Department of Photography archive, Museum of Modern Art, New York.

404 *"Even in the early years"*: John Szarkowski, *Looking at Photographs: 100 Pictures from the Collection of the Museum of Modern Art* (Greenwich, CT: New York Graphic Society, 1973).

405 *"The importance of Avedon's work"*: Szarkowski.

406 *"Freaks was a thing"*: Press release, Museum of Modern Art Exhibition, *Diane*

*Arbus*, New York, November 7, 1972–January 21, 1973; quoted in *Diane Arbus: A Monograph*, ed. Doon Arbus and Marvin Israel (New York: Aperture, 1973).

406 *"Diane Arbus's pictures"*: John Szarkowski, exhibition wall text, *Diane Arbus*, Museum of Modern Art, New York, November 7, 1972–January 21, 1973.

406 *"brings us a body of work"*: Hilton Kramer, "125 Photos by Arbus on Display," *New York Times*, November 8, 1972, 52.

407 *Dick sent a letter to Szarkowski*: Richard Avedon to John Szarkowski, August 14, 1973, Department of Photography archive, Museum of Modern Art, New York.

407 *"Of the several projects"*: Szarkowski to Avedon, August 28, 1973, Department of Photography archive, Museum of Modern Art, New York.

407 *"My father died"*: Avedon to Szarkowski, September 5, 1973, Department of Photography archive, Museum of Modern Art, New York.

407 *"Photographic portraiture"*: John Szarkowski, exhibition wall text, *Jacob Israel Avedon*, Museum of Modern Art, New York, May 1–June 16, 1974.

408 *"These pictures are taken"*: Gene Thornton, "Avedon's Father, Adams' Nature, Siskind's Homage," *New York Times*, May 12, 1974.

408 *"Panicking," writes Edwards*: Edwards, "Pictures of Avedon."

408 *"a pretty harrowing"*: Hilton Kramer, "Art: The Reinhardt Style and Theater Era Evoked," *New York Times*, June 8, 1974, 26.

409 *"I am tardy in writing"*: Szarkowski to Avedon, July 16, 1974, Department of Photography archive, Museum of Modern Art, New York.

## CHAPTER 15: THE CLOSET DOOR (1974–1976)

410 *"Investigate some fact"*: Fyodor Dostoyevsky, *A Writer's Diary*, vol. 1, 1873–1876, trans. Kenneth Lantz (Evanston, IL: Northwestern University Press, 1994), 651.

410 *Lewin, Dick's studio manager*: Author interview with Gideon Lewin, April 17, 2018.

411 *Dick bought the carriage house*: Author interview with Lewin.

411 *"I've left home"*: Author interview with Lewin.

411 *"She started putting out cigarettes"*: Author interview with André Gregory, February 29, 2016.

412 *She was never shy*: Author interview with Alicia Grant Longwell, February 3, 2016.

412 *"I'm better at photography"*: Norma Stevens and Steven M. L. Aronson, *Avedon: Something Personal* (New York: Spiegel and Grau, 2017), 188.

412 *she was actually closer*: Author interview with Renata Adler, July 12, 2016.

413 *Evie accused her*: Author interview with Adler.

413 *"I must have been crazy"*: Stevens and Aronson, *Avedon*, 188.

413 *Avedon had met Renata Adler*: Author interview with Adler.

413 *"My friend and I"*: Author interview with Ashton Hawkins, June 1, 2016.

414 *"the group did not seem"*: Author interview with Hawkins.

414 *"I think we ate potatoes"*: Author interview with Stephen Sondheim, September 28, 2015.

414 *"It is a magical island"*: Author interview with Tim Husband, May 4, 2016.

415 *Dick as "her twin"*: Author interview with Adler.

415 *"I was so in thrall of Dick"*: Author interview with Owen Edwards, January 25, 2016.

416 *"He was the dream guest"*: Author interview with Edwards.

416 *"I would go over a few times"*: Author interview with Hawkins.

417 *"I would venture to say"*: Author e-mail correspondence with Steven M. L. Aronson, February 21, 2019.

417 *"he loved fashion photographs"*: Maxime de la Falaise McKendry, unpublished manuscript, "The Fashion Photograph: A Biographic Experience of Richard Avedon," n.d., personal papers of Ashton Hawkins.

419 *living in a ménage à trois*: Author interview with Doug Gruenau, June 10, 2017.

419 *"an intimacy with no past and no future"*: Owen Edwards, "Pictures of Avedon," *Playboy*, June 1975.

420 *he ostensibly divulged his homosexuality*: Stevens and Aronson, *Avedon*, 262.

420 *"Private acceptance of homosexuality"*: Joseph Epstein, "Homo/Hetero: The Struggle for Sexual Identity," *Harper's*, September 1970.

420 *occasional homosexual encounters*: Stevens and Aronson, *Avedon*, 264.

420 *clandestine romance with Mike Nichols*: Stevens and Aronson, *Avedon*, 263.

421 *"I look at these photos"*: Mike Nichols, "We'll Always Have Paris," in Richard Avedon, *Performance* (New York: Harry N. Abrams, 2008), 131.

421 *"Dick and Mike went off"*: Stevens and Aronson, *Avedon*, 196.

421 *the* Box of Ten *portfolio*: Doon Arbus and Elizabeth Sussman, eds., *Diane Arbus: A Chronology* (New York: Aperture, 2011), 107.

421 *"I'm sure you have a friend"*: Mike Nichols, "We'll Always Have Paris," 131.

422 *"But could there have been an affair?"*: Author e-mail correspondence with Mark Harris, April 11, 2019.

422 *"I don't want it defining me"*: Stevens and Aronson, *Avedon*, 262.

422 *"He seemed to feel strongly"*: Richard Avedon to John McKendry, February 20, 1974, personal papers of Ashton Hawkins.

423 *"I was a very unlikely person"*: Author interview with Paul Katz, October 30, 2015.

423 *"It wasn't a passion"*: Author interview with Katz.

424 *The gist of the letter*: Author interview with Katz.

424 *"I was complaining"*: Ralph Gibson, "Remembering Robert Frank," *Photograph*, November/December 2019, 55.

425 *"he would enter the public consciousness"*: Author interview with Katz.

426 *"That's a beautiful woman"*: Videotape, Richard Avedon in public conversation with David Ross, Whitney Museum of American Art, New York, April 25, 1994.

427 *"Harold was interested in ideas"*: Author interview with Gruenau.

427 *"It's like a great comforting storm"*: Avedon conversation with Ross.

427 *"Women who are photographed by me"*: Avedon conversation withDavid Ross.

428 *"I found it magnificent"*: Robert Stevens interview with Irving Penn, in "Avedon" (master's thesis, Visual Studies Workshop, 1978), 53.

428 *"Laura and Dick were very good friends"*: Bachmann interview with Sebastien Chieco, courtesy of Bill Bachmann.

428 *"Dick was with me and my father"*: Author e-mail correspondence with Helen Kanelous, April 1, 2019.
429 *"I had been trying"*: Author interview with Jann Wenner, October 22, 2015.
430 *"Overall it was"*: Author interview with Wenner.
430 *"I was very depressed"*: Christopher Bollen interview with Renata Adler, *Interview*, August 14, 2014, https://www.interviewmagazine.com/culture/renata-adler.
431 *"There is nothing particularly partisan"*: Will Blythe, "About Face," *American Photographer*, October 2012.
432 *"You'd pore over a face"*: Blythe.
432 *Dick had sent an assistant*: Author interview with Longwell.
433 *"Dick, I can't explain it"*: Bollen interview with Adler.
433 *Felt confessed to*: "Introducing Deep Throat," *New York Times*, June 1, 2005.
433 *"Be kind to me"*: David Schonauer, "Faces in the Crowd," *American Photo*, March–April 2007, 48.
433 *"Power is the ultimate aphrodisiac"*: Leslie Bennett, "Kissinger Ponders What Challenges to Take On," *New York Times*, December 29, 1978, B1.
434 *"I had changed something"*: Author interview with Wenner.
434 *"He sabotaged the press run"*: Author interview with Wenner.
435 *Gideon brought up the subject*: Author interview with Lewin.

## CHAPTER 16: MUSEUM PIECE (1977–1980)

436 *"In the room"*: T. S. Eliot, "The Love Song of J. Alfred Prufrock," in *Collected Poems: 1909–1962* (New York: Harcourt Brace, 1991), 3.
437 *"Fashion work has long attracted"*: Charles Michener, "The Avedon Look," *Newsweek*, October 16, 1978.
437 *Ashton Hawkins guided the project*: Author interview with Tim Husband, May 4, 2016.
437 *"I had a party for her"*: Author interview with Ashton Hawkins, June 1, 2016.
438 *"It was so much more familial"*: Author interview with Johnnie Moore Hawkins, June 1, 2016.
438 *"All decisions regarding the content"*: Penelope Bardel (acting secretary and counsel of the Metropolitan Museum of Art, New York) to Richard Avedon, July 26, 1977, personal papers of Ashton Hawkins.
438 *"there was no prejudice"*: Author interview with Colta Ives, May 1, 2019.
439 *"Dick was courtly"*: Author interview with Ives.
439 *"For me to be finally present"*: Maxime de la Falaise McKendry, unpublished manuscript, "The Fashion Photograph: A Biographic Experience of Richard Avedon," n.d., personal papers of Ashton Hawkins.
439 *the line of people spread*: McKendry.
439 *"If Peter was going"*: Author interview with Stephen Koch, November 19, 2015.
440 *"the progression from small to big"*: Malcolm, 132.
441 *"Avedon continues the work"*: Malcom, "Photography: A Series of Proposals," *New Yorker*, October 23, 1978, 132–43.

441 *"every wrinkle, stubble"*: Colin Westerbeck, public talk, "A Terrible Beauty Is Born: Richard Avedon, Irving Penn, and the Portraiture of the Cold War," Art Institute of Chicago, April 5, 2009.

442 *"The photographs have a reality"*: Harold Rosenberg, "Portraits: A Meditation on Likeness," in Richard Avedon, *Portraits* (New York: Farrar, Straus and Giroux, 1976).

442 *"romantic of the intellectual life"*: Elizabeth Hardwick, "Knowing Sontag," *Vogue*, June 1978, 184–85.

442 *"Fashion is an acute mentalizing"*: Susan Sontag, "The Avedon Eye," *Vogue*, September 1978, 460–61.

443 *"Edward Steichen started"*: Bill Cunningham, "Forever Avedon," *SoHo Weekly News*, September 21, 1978.

445 *"Dick would have certainly discussed"*: Author e-mail correspondence with Alicia Grant Longwell, May 5, 2019.

446 *"summed up in the notion"*: Rosenberg, "Portraits."

446 *"painters depended on photographs"*: Rosenberg.

447 *"Work was not the only"*: Norma Stevens and Steven M. L. Aronson, *Avedon: Something Personal* (New York: Spiegel and Grau, 2017), 323.

447 *"the family that eats"*: Stevens and Aronson, 327.

448 *"to write my piece"*: Author interview with Owen Edwards, January 25, 2016.

449 *"Dick had a long view"*: Author interview with Alicia Grant Longwell, February 3, 2016.

450 *"Is the vanguard dead?"*: "People Are Talking About . . . ," *Vogue*, November 1976, 229.

451 *"Suspect in Rape"*: "Suspect in Rape Called Impostor of a Celebrity," *New York Times*, September 17, 1977.

451 *Aram Saroyan recounted an evening*: Aram Saroyan, *My Own Avedon: A Memoir with Photographs* (Los Angeles: An Air Book, 2010).

452 *"phallic symbols between the legs"*: Ben Lifson, "Thanks for le Temps Perdu," *Village Voice*, July 24, 1978.

452 *Avedon's car was double-parked*: Author interview with Koch.

452 *They stayed at the Grikos*: Author interview with Husband.

453 *"Felicia Bernstein memorial garden"*: Author interview with Edwards.

453 *"It's very meaningful"*: Author interview with Jamie Bernstein, November 22, 2015.

453 *"I was like one of the cows"*: Michel Guerrin unpublished interview with Richard Avedon for *Le Monde*, 1993.

454 *"I can't guarantee"*: Laura Wilson, *Avedon at Work: In the American West* (Austin: University of Texas Press, 2003), 14.

455 *"They bring thousands of rattle-snakes"*: Guerrin interview with Avedon.

455 *"He was alert, buoyant"*: Wilson, *Avedon at Work*, 14.

456 *"We started from scratch"*: Author interview with David Ross, December 15, 2015.

457 *"I came to understand"*: Stevens and Aronson, *Avedon*, 646–67.

457 *"real Bianca Jagger"*: Richard Avedon to Ashton Hawkins, June 3, 1977, personal papers of Ashton Hawkins.

457 *"I fell in love with Dick"*: Author interview with Ross.

458  *They found mold*: Author interview with Longwell.

458  *I need you here*: Author interview with Ellen Brodkey, September 7, 2017.

459  *I know I look like a Polish wedding cake*: Saroyan, *My Own Avedon*, 29.

459  *For more than two decades*: Jim Elliott, introduction to *Richard Avedon: 1946–1980*, catalog of an exhibition at University Art Museum, Berkeley, California, March 5–May 4, 1980.

459  *It is difficult to believe*: John Russell, "Photography: Avedon Show on Coast," *New York Times*, April 9, 1980, C24.

460  *These disciplines, these strategies*: Richard Avedon, foreword to *In the American West* (New York: Harry N. Abrams, 1985).

460  *the paradox of all high art*: Roland Barthes, unpublished typescript, "Thus and So," trans. Richard Howard, for a piece in *French Photo*, January 1977.

461  *All my portraits*: Andrew Solomon, "The Vision Thing," *Harpers & Queen*, February 1995, http://andrewsolomon.com/articles/the-vision-thing/.

461  *It was a senseless*: James Elliott, museum notice posted at the exhibition *Richard Avedon: 1946–1980*, University Art Museum, Berkeley, May 1, 1980.

461  *a tall, gaunt man*: "Avedon Photograph Sprayed in Berkeley," *San Jose Mercury News*, May 2, 1980.

461  *What the hell*: Richard Avedon statement in a staff memo, University Art Museum, Berkeley, California, May 1, 1980.

## CHAPTER 17: A BALANCE OF OPPOSITES (1981–1985)

463  *It isn't about the West*: Richard Avedon, "On Art: Quotes," *Harvard Crimson*, February 20, 1987.

463  *The beginning of this project*: Laura Wilson, *Avedon at Work: In the American West* (Austin: University of Texas Press, 2003), 20.

464  *I can hear*: Wilson, 20.

464  *He mirrored the person's posture*: Wilson, 22.

464  *a major retrospective*: *August Sander: Photographs of an Epoch*, Philadelphia Museum of Art exhibition, March 1–May 25, 1980.

465  *Sander is one*: Author interview with Ellen Brodkey, September 7, 2017.

465  *Not until his forties*: Author conversation with Julian Sander, great-grandson of August Sander and director of the Galerie Julian Sander, Cologne, September 13, 2019.

466  *the right combination*: Wilson, *Avedon at Work*, 27.

466  *They found Roberto Lopez*: Wilson, 32.

467  *His is "a face"*: Wilson, 102.

467  *Sometimes Dick would read aloud*: Author interview with Ruedi Hofmann, May 6, 2016.

467  *Dick was sitting*: Wilson, *Avedon at Work*, 42.

468  *There were five hundred*: *Richard Avedon: Darkness and Light*, directed by Helen Whitney, *American Masters* documentary, PBS, 1995.

468  *Dick made 121 exposures*: Wilson, *Avedon at Work*, 47.

469  *I made two pictures*: Whitney, *Darkness and Light*.

469 *"When we were out West"*: Author interview with Hofmann.

470 *"Our yardstick for beauty"*: Edith Loew Gross, "The Spirit of a New Age," *Vogue*, October 1981, 491.

471 *"Charming a snake"*: Gross, *Vogue*, 494–95.

471 *"I wasn't afraid"*: Whitney, *Darkness and Light*.

472 *"And when it got"*: Author interview with Polly Mellen, June 27, 2016.

472 *"Nastassja rose to the moment"*: Whitney, *Darkness and Light*.

472 *"he was letting them win"*: Norma Stevens and Steven M. L. Aronson, *Avedon: Something Personal* (New York: Spiegel and Grau, 2017), 652.

473 *"Jeans are sex"*: Isabel Wilkinson, "The Story Behind Brooke Shields's Famous Calvin Klein Jeans," *T: The New York Times Style Magazine*, December 2, 2015.

473 *"I first met Dick"*: Author interview with Brooke Shields, April 6, 2017.

473 *"It was the first time"*: Author interview with Calvin Klein, July 12, 2017.

474 *"I did not anticipate"*: Author interview with Klein.

475 *"Everything had already been thoroughly planned"*: Author interview with Shields.

475 *"He had a darker side"*: Author interview with Shields.

475 *"One of the most talked about"*: Philip H. Dougherty, "Phase 3 of Wild Dior Antics," *New York Times*, July 11, 1983.

475 *"There's no downside"*: *Darkness and Light*.

476 *"When they were good"*: The Diors, full-page ad, *Vogue*, October 1, 1982.

477 *"Atget represented to John"*: Author interview with Susan Kismaric, August 3, 2012.

477 *"As a way of beginning"*: John Szarkowski, introduction to *The Work of Atget: Old France*, vol. 1, by John Szarkowski and Maria Morris Hambourg (New York: Museum of Modern Art, 1981).

478 *"Among young, so-called serious"*: Author interview with Joel Meyerowitz, September 14, 2017.

478 *"Alongside MoMA's trajectory"*: Robert M. Rubin, "Old World, New Look," in *Avedon's France: Old World, New Look*, by Robert M. Rubin and Marianne Le Galliard (New York: Harry N. Abrams and Bibliothèque Nationale de France, 2017), 33.

479 *"Unlike the elaborate orchestration"*: John Szarkowski quoted in press release, Museum of Modern Art exhibition, *Irving Penn*, New York, September 12–November 27, 1984.

480 *"Those guys! Those poor guys"*: Stevens and Aronson, *Avedon*, 283.

480 *"They didn't expect"*: Author interview with Hofmann.

481 *On her last day*: Author interview with Alicia Grant Longwell, February 3, 2016.

481 *"He got the room downstairs"*: Author interview with Hofmann.

482 *"impossible, feisty, angry"*: Stevens and Aronson, *Avedon*, 227.

482 *Doon Arbus flew down*: Author interview with Doon Arbus, June 11, 2019.

483 *"Marvin died. I can't speak"*: Stevens and Aronson, *Avedon*, 226.

483 *Avedon traveled through 13 states*: Press release, Amon Carter Museum exhibition, *In the American West: Twenty Years Later*, Fort Worth, September 17, 2005–January 8, 2006.

483 *Hofmann made an entire set*: Author interview with Hofmann.

483 *"Make the person more gentle"*: Wilson, *Avedon at Work*, 114.

483 *"Despite competition with"*: Suzanne Muchnic, "Avedon Takes a Gritty Look at Wild West," *Los Angeles Times*, September 22, 1985.

484 *It attracted five thousand*: Storer Rowley, "Richard Avedon's Look at the West Raises Horizons—and Lifts," *Chicago Tribune*, October 13, 1985.

484 *"Never before had so many"*: Wilson, *Avedon at Work*, 114.

484 *"touched a chord"*: Muchnic, "Avedon Takes a Gritty Look."

484 *"I use an 8 × 10 camera"*: Richard Avedon, foreword to *In the American West* (New York: Harry N. Abrams, 1985).

485 *"style has always been understood"*: Max Kozloff, "Richard Avedon's 'In the American West,'" in *Lone Visions, Crowded Frames: Essays on Photography* (Albuquerque: University of New Mexico Press, 1994).

485 *"Avedon's West is not"*: Wilson, *Avedon at Work*, 121.

485 *"Laureate of the invisible"*: Maria Morris Hambourg and Mia Fineman, "Avedon's Endgame," in *Richard Avedon Portraits* (New York: Harry N. Abrams and the Metropolitan Museum of Art, 2002).

486 *"The guy, he's good"*: Rowley, "Richard Avedon's Look at the West."

486 *"it is a fictional West"*: Press release, *In the American West: Twenty Years Later.*

486 *"Stealing their souls?"*: Michel Guerrin unpublished interview with Richard Avedon for *Le Monde*, 1993.

487 *"It's trivializing to make someone"*: Douglas C. McGill, "Art People: The Camera as Interpreter," *New York Times*, December 27, 1985.

487 *"This is about class"*: Paula Span, "Richard Avedon's Stark Faces of the West," *Washington Post*, October 29, 1985.

487 *"taking subjects from the social and economic"*: Aram Saroyan, *My Own Avedon: A Memoir with Photographs* (Los Angeles: An Air Book, 2010).

487 *"While stopping shy of Surrealism"*: Andy Grundberg, "Photography View: Modern Masters," *New York Times*, December 29, 1985.

488 *"They stand like bent ramrods"*: Muchnic, "Avedon Takes a Gritty Look."

## CHAPTER 18: THE YEARS OF HIS DISCONTENT (1986–1992)

489 *"a man whom we esteem"*: "Bernstein and Baldwin Join Legion of Honor," *New York Times*, June 20, 1986, C27.

490 *including Betty Comden*: "French President Honors Baldwin and Bernstein," *Los Angeles Times*, June 20, 1986.

490 *to fulfill a fashion shoot for Dior*: Author e-mail correspondence with Bill Bachmann, June 2, 2019.

490 *"Avedon's constructed hagiography"*: Robert M. Rubin, "Old World, New Look," in *Avedon's France: Old World, New Look*, by Robert M. Rubin and Marianne Le Galliard (New York: Harry N. Abrams and Bibliothèque Nationale de France, 2017), 38.

491 *"The street ended"*: James Baldwin, *Giovanni's Room* (New York: Vintage International, 2013), 63.

491 *"locked eyes with a young man"*: Norma Stevens and Steven M. L. Aronson, *Avedon: Something Personal* (New York: Spiegel and Grau, 2017), 266.

492 *"I see myself in him"*: Stevens and Aronson, 267.

492 *"Dick was a very private person"*: Author e-mail correspondence with Bill Bachmann, June 3, 2019.

493 *Laura Wilson did not remember*: Author interview with Laura Wilson, June 6, 2019.

493 *"Dick feared that"*: Stevens and Aronson, *Avedon*, 271.

494 *"It was one of the last refuges"*: Donald G. McNeil Jr., "His Father's Photos Extol Beauty, but John Avedon's New Book on Tibet Doesn't Paint a Pretty Picture," *People*, November 26, 1984.

494 *John told the* New York Times: Herbert Mitgang, "The Road to Dharamsala," *New York Times*, June 24, 1984.

494 *"The author supplies"*: Jonathan Mirsky, "Tibet Since the Invasion," review of *In Exile from the Land of Snows*, *New York Times*, June 24, 1984.

495 *"I'm just so dazzled"*: Stevens and Aronson, *Avedon*, 521.

495 *"John didn't come"*: Stevens and Aronson, 360.

495 *"I said something to the effect"*: Stevens and Aronson, 629.

496 *"one of the radical revolutionaries"*: Author interview with Elizabeth Cox Avedon, March 16, 2017.

497 *they asked Dick to be his godfather*: Author interview with Elizabeth Cox Avedon.

497 *he had AIDS*: Elizabeth Cox, *Thanksgiving: An AIDS Journal* (New York: Harper & Row, 1990).

498 *"Everyone detected with AIDS"*: William F. Buckley Jr., "Crucial Steps in Combating the AIDS Epidemic; Identify All the Carriers," *New York Times*, March 18, 1986.

498 *"Dick said that Keith"*: Author interview with Elizabeth Cox Avedon.

499 *Since Mary knew*: Author interview with Mary Shanahan, April 19, 2017.

499 *"as he always showed everyone"*: Adam Gopnik, *At the Strangers' Gate: Arrivals in New York* (New York: Vintage Books, 2018), 114–15.

500 *"His motive for asking me up"*: Gopnik, 118.

501 *"Richard Avedon became our surrogate father"*: Gopnik, 108.

501 *"Dick's eye was matchless"*: Adam Gopnik, "Richard Avedon," in Kadee Robbins, ed., *The Kirk Varnedoe Collection: With Artists' Statements* (Savannah, GA: Telfair Museum of Art, 2006).

502 *"I will contrast Schiele's candor"*: Richard Avedon, "Borrowed Dogs," public talk, *Vienna 1900* symposium, 1986, Museum of Modern Art archives, New York.

503 *"My portraits are much more"*: Nicole Wisniak, interview with Richard Avedon, "A Portrait Is an Opinion," *Egoïste* 9 (1985): 49.

504 *Wisniak would have pages*: Joseph Fitchett, "The Editor of Egoiste, the Annual Monthly," *International Herald Tribune*, October 20, 1987.

504 *"I wrote to him for years"*: Jon Anderson, "Supreme Egoiste," *Chicago Tribune*, February 10, 1988.

505 *"I do the magazine"*: Anderson.

505 *predatory was the word*: Stevens and Aronson, *Avedon*, 256.

506 *"I'm positive that theirs"*: Stevens and Aronson, 259.

506 *"Egoïste is the only magazine"*: Vince Aletti, *Issues: A History of Photography in Fashion Magazines* (New York: Phaidon, 2019), 260.

506 *"You must understand and accept"*: Richard Avedon to Nicole Wisniak, June 11, 1985, in Rubin and Le Galliard, *Avedon's France*, 37.

506 *"Acutely fashion-conscious"*: Fitchett, "Editor of Egoiste."

507 *"Diana Vreeland just exploded"*: *Diana Vreeland: The Eye Has to Travel*, directed by Lisa Immordino Vreeland and Bent-Jorgen Perlmutt, Samuel Goldwyn Films, 2011.

507 *"I know what they're going to wear"*: Georgia Dullea, "400 at Metropolitan Museum Fondly Recall the Vreeland Touch," *New York Times*, November 7, 1989, D23.

507 *Anna Wintour, as "cold"*: Moira Hodgson, "Grace Under Pressure," review of *In and Out of Vogue*, *New York Times Book Review*, September 24, 1995, 13.

508 *he made four trips to Stockholm*: David Ansen, "Avedon," *Newsweek*, September 13, 1993, 48.

508 *"I could go every night"*: Dodie Kazanjian, "Avedon's Eye," *Vogue*, February 1, 1994, 246.

508 *Auditioning for Dick*: Author interview with Lambert Wilson, April 24, 2017.

509 *"Dick did get Calvin to spend"*: Author interview with Sam Shahid, February 28, 2017.

509 *"I felt surprised"*: Author interview with Wilson.

509 *"They're a caricature of everything"*: Author interview with Calvin Klein, July 12, 2017.

510 *When he proudly presented*: Author interview with Bill Bachmann, April 8, 2017.

511 *"Dick would bring a huge tin"*: Author interview with Marc Royce, April 20, 2017.

512 *"Both are chaotic"*: Aletti, *Issues*, 260.

512 *"Kids were climbing"*: Steve Appleford, "I Was Looking for Beauty and Found It," *Los Angeles Times*, March 27, 1994.

512 *"When the stroke of midnight"*: Michael Radou Moussou, "The Berlin Wall: Richard Avedon's Rendezvous with History," *Huffington Post*, November 8, 2014, https://www.huffpost.com/entry/richard-avdeon-berlin-wall_b_6126382.

512 *"For the first time, the passage"*: Rubin and Le Galliard, *Avedon's France*, 768.

513 *"Avedon saw beyond"*: Aletti, *Issues*, 260.

513 *"I wanted him to go"*: Rubin and Le Galliard, *Avedon's France*, 767.

513 *"Avedon was obsessed"*: Rubin and Le Galliard, 769.

513 *"You really felt"*: Appleford, "I Was Looking for Beauty."

514 *"It was as if lightning struck"*: Author interview with André Gregory, February 29, 2016.

514 *"I never felt anything"*: Wisniak interview with Avedon.

## CHAPTER 19: RENEWAL (1992–1996)

515 *"In photography, as everywhere"*: Adam Begley, *The Great Nadar: The Man Behind the Camera* (New York: Tim Duggan Books, 2017), 122.

516 *Ms. Brown asserted*: Deirdre Carmody, "Tina Brown to Take Over at The New Yorker," *New York Times*, July 1, 1992, A1.

516 *Richard Avedon as the first staff photographer*: Deirdre Carmody, "Richard Avedon Is Named New Yorker Photographer," *New York Times*, December 10, 1992.

516 *"I've photographed just about everyone"*: Andy Grundberg, "Richard Avedon, the Eye of Fashion, Dies at 81," *New York Times*, October 2, 2004, A1.

516 *"The plan was to use him"*: Norma Stevens and Steven M. L. Aronson, *Avedon: Something Personal* (New York: Spiegel and Grau, 2017), 636.

516 *"I thought there was one photographer"*: Author e-mail correspondence with Tina Brown, October 18, 2018.

517 *"epigrammatic compression of a whole subject"*: Adam Gopnik, "Postscript: Richard Avedon," *New Yorker*, October 3, 2004.

517 *"He would call me"*: Stevens and Aronson, *Avedon*, 245.

518 *"An Afrikaner Dante"*: Lawrence Weschler, "An Afrikaner Dante," *New Yorker*, November 8, 1993, 79.

518 *"When I say that this"*: Author e-mail correspondence with Lawrence Weschler, March 22, 2017.

519 *Fiona Shaw, the Irish actress*: John Lahr, "Showcase by Richard Avedon: Shaw Business," *New Yorker*, May 20, 1996, 90.

519 *Dick photographed Ralph Fiennes*: Anthony Lane, "The Play's the Thing," *New Yorker*, April 17, 1995, 86.

520 *"most portraiture is ennobling"*: Michel Guerrin unpublished interview with Richard Avedon for *Le Monde*, 1993.

520 *"We all perform"*: "Performing for the Camera: A Self-Portrait with Richard Avedon," *At Random* (Random House in-house magazine) 2, no. 3 (Fall 1993): 28–33.

521 *described by the publishing house*: "Performing for the Camera."

521 *"Avedon says the Kodak grant"*: Kay Larson, "His Pictures Are Bigger Than Yours," *Washington Post*, May 1, 1994.

521 *"Saint Ray," as DeMoulin was called*: Larson.

522 *"It was the first book"*: Author interview with Mary Shanahan, April 19, 2017.

522 *"This book tracks"*: Richard Avedon, introduction to *An Autobiography* (New York: Random House, 1993).

522 *"It was a deliberate"*: Author interview with Shanahan.

523 *"a mixed bag"*: Degen Pener, "Egos and Ids: To Snap and to Be Snapped," *New York Times*, October 3, 1993.

524 To Be 70: Videotape, *To Be 70*, viewed during author interview with Bill Bachmann, April 8, 2017.

524 *"On the afternoon"*: "Performing for the Camera."

524 *framed original letter*: Stevens and Aronson, *Avedon*, 575.

525 *It was in this context*: Author interview with Maura Moynihan, November 14, 2018.

525 *"Dick included Evie"*: Author interview with Moynihan.

526 *the children played together*: Author interview with Elizabeth Cox Avedon, March 16, 2017.

526 *"The statements made"*: Stevens and Aronson, *Avedon*, 574.

526 *"only a vindictive and troubled"*: Stevens and Aronson, 574.

527 *"were inured to nudity"*: Stevens and Aronson, 574.

527 *One day Maura appeared*: Author interview with Shanahan.

528 *"I have very happy memories"*: Author interview with Moynihan.

528 *"there are no findings"*: *Elizabeth Avedon vs. Richard Avedon*, decision of dismissal by Hon. David B. Saxe, Supreme Court of the State of New York, index no. 126375–93, January 5, 1993 [*sic*]; (actual date January 5, 1994).

528 *he paid Betti $500,000*: Stevens and Aronson, *Avedon*, 578.

528 *The National Gallery wanted*: Author interview with Sarah Greenough, June 25, 2019.

529 *"It was the first show"*: Author interview with David Ross, December 15, 2015.

529 *"He was an enormously"*: Author e-mail correspondence with David Ross, July 1, 2019.

530 *"I believed that Dick"*: Author interview with Ross.

530 *"I'm going to have a private viewing"*: Richard Avedon to John Szarkowski, February 15, 1994, Department of Photography archive, Museum of Modern Art, New York.

530 *The grander, star-studded events*: "Avedon in Person and Image," *New York Times*, April 10, 1994, 7.

531 *"walk out of the pages"*: Larson, "His Pictures Are Bigger Than Yours."

531 *"Richard Avedon has the instincts"*: Mark Stevens, "Court Gestures," *New York*, April 4, 1994, 70.

531 *"Given the distance"*: Arthur Danto, "Richard Avedon," *The Nation*, May 9, 1994, 640–44.

532 *"His photos from the last two decades"*: Vince Aletti, "Dark Passage," *Village Voice*, April 12, 1994.

532 *"It was hard not to notice"*: Michael Kimmelman, "Farewell Fashion; Hello Art," *New York Times*, March 25, 1994.

533 *"Avedon didn't feel obliged"*: Jane Livingston, "The Art of Richard Avedon," in *Richard Avedon, Evidence, 1944–1994* (New York: Random House and Eastman Kodak Professional Imaging, with the Whitney Museum of American Art, 1994), 42–43.

534 *"It is not so much"*: Adam Gopnik, "The Light Writer," in *Evidence, 1944–1994*, 113–16.

534 *"just look at their faces"*: Carol Lawson, "Richard Avedon—An Artist Despite His Success?," *New York Times*, September 7, 1975.

534 *"I think he expected"*: Author interview with Shanahan.

535 *"Photography is the common language"*: Holland Cotter, "Images That Preserve History, and Make It," *New York Times*, September 20, 2012, C27.

535 *"I was bored"*: Author interview with Lizzie Himmel, June 27, 2017.

536 *He remembers Dick saying*: Author interview with Chris Callis, July 3, 2019.

536 *Amy Arbus referred to a picture*: Author interview with Amy Arbus, September 28, 2017.

536 *"when my toe hit"*: Author interview with Arbus.

537 *"[She] went to a place"*: Richard Avedon, "Richard Avedon on Amy Arbus," *Aperture* 151 (Spring 1998).

537 *"It was incredibly cathartic"*: Author interview with Arbus.

537 *"I wasn't bored"*: Author interview with Himmel.

537 *the magazine had issued*: Press release, "Avedon's Master Class to Contribute to the New Yorker," *New Yorker*, February 24, 1993.

538 *"Are you available"*: Author interview with Callis.

538 *"I was just transported"*: Author interview with Eileen Travell, August 10, 2017.

539 *"If you were to make"*: Author interview with Susan Lacy, July 12, 2019.

539 *"We had one of those magical lunches"*: Author interview with Helen Whitney, November 18, 2015.

540 *"I have to be in touch"*: *Richard Avedon: Darkness and Light*, directed by Helen Whitney, *American Masters* documentary, PBS, 1995.

540 *"It's something about madness"*: *Darkness and Light*.

540 *"Why is it that"*: Christopher Knight, "'Darkness and Light' Gives a Snapshot of Avedon's Life," *Los Angeles Times*, January 24, 1996.

542 *"It's just strange"*: *Darkness and Light*.

542 *"To you it seemed like this"*: Franz Kafka, *Dearest Father: Stories and Other Writings*, trans. Ernst Kaiser and Eithne Wilkins (Berlin: Schocken Books, 1954).

543 *Whitney left the book out*: Author interview with Whitney.

## CHAPTER 20: THE ELEGANT DENOUEMENT (1998–2004)

544 *"In any case, he knew"*: Robert M. Rubin and Marianne Le Galliard, *Avedon's France: Old World, New Look* (New York: Harry N. Abrams and Bibliothèque Nacionale de France, 2017), 770.

545 *"I am always happy when important work"*: Author conversation with Shelley Dowell, May 7, 2020.

545 *Peter MacGill acknowledged*: Norma Stevens and Steven M. L. Aronson, *Avedon: Something Personal* (New York: Spiegel and Grau, 2017), 293.

545 *Dick's subtle courtship*: Author interview with Jeffrey Fraenkel, November 30, 2016.

546 *"It was hot"*: Author interview with Fraenkel.

547 *"When Dick hinted how easily"*: Author e-mail correspondence with Jeffrey Fraenkel, July 27, 2019.

547 *"Dick thought of himself"*: Author interview with Fraenkel.

548 *"Fraenkel Gallery is pleased"*: Exhibition press release, *Richard Avedon: Early Portraits*, Fraenkel Gallery, San Francisco, December 1999.

549 *Among the half dozen Avedon images acquired*: Author interview with Frish Brandt, July 23, 2019.

549 *Marjorie Lederer Lee's obituary*: "Marjorie Lederer Lee, 78, Poet and Novelist Who Wrote Songs," obituary, *New York Times*, May 9, 1999, 38.

550 *"Finally he was talking"*: Author interview with John Lee, May 24, 2017.

551 *"I'd forgotten them"*: Judith Thurman, "Hidden Women," in Richard Avedon, *Made in France* (San Francisco, Fraenkel Gallery, 2001).

552 *"As an afterthought"*: Author e-mail correspondence with Fraenkel.

553 *"He liked to spoil people"*: Author interview with Judith Thurman, March 15, 2018.

554 *"Dick Avedon really has determined"*: Author interview with Thurman.

554 *"You set up your photograph"*: Thurman, "Hidden Women."

554 *"Avedon's performance photography"*: Thurman.

555 *"The Met is emerging"*: Deborah Solomon, "But Is It Art?," *New York Times Magazine*, October 4, 1998.

556 *"He was not used to giving"*: Author interview with Fraenkel.

556 *"The photographer Richard Avedon"*: Carol Vogel, "Avedon Decides on a Payback," *New York Times*, November 17, 2000.

557 *"I loved his vivacity"*: Author interview with Maria Morris Hambourg, August 27, 2019.

557 *"Dick trusted her eye"*: Author interview with Mia Fineman, July 30, 2019.

558 *"He instinctively yielded"*: Author interview with Hambourg.

558 *"The overall structure of the show"*: Author interview with Fineman.

558 *"He was a virtual membrane"*: Stevens and Aronson, *Avedon*, 592.

559 *"Whatever debt Avedon may owe"*: Maria Morris Hambourg and Mia Fineman, "Avedon's Endgame," in *Richard Avedon Portraits* (New York: Harry N. Abrams and the Metropolitan Museum of Art, 2002).

560 *"an equal achievement"*: Philippe de Montebello, introduction to *Richard Avedon Portraits*.

560 *"The show unfolds"*: Anthony Lane, "Head On: A Richard Avedon Retrospective," *New Yorker*, September 15, 2002.

560 *"This show of portraits"*: Mark Stevens, "The View from Here," *New York*, September 25, 2002.

561 *"Otherwise, the show is gorgeous"*: Michael Kimmelman, "Images That Burn into the Mind," *New York Times*, September 27, 2002.

563 *"He told me"*: Stevens and Aronson, *Avedon*, 599.

563 *"He is one of the greatest"*: Author interview with Hambourg.

563 *"Dick always grapples"*: *Richard Avedon: Darkness and Light*, directed by Helen Whitney, *American Masters* documentary, PBS, 1995.

564 *"I knew there were allegations"*: Author interview with Luke Avedon, September 14, 2017.

564 *"I did not want"*: Author interview with Luke Avedon.

566 *"Dick paid for"*: Author interview with Luke Avedon.

566 *"It is the most honest"*: Author interview with Sam Shahid, February 18, 2017.

566 *"I did the most exquisite"*: Videotape, Richard Avedon in public conversation with David Ross, Whitney Museum of American Art, New York, April 25, 1994.

567 *"The energy and ambition"*: Laura Wilson, "Avedon's Final Take," *Sunday Times* (London), January 2, 2005, https://www.thetimes.co.uk/article/avedons-final-take-t6knsswfsnp.

567 *"Do we do"*: Richard Avedon fax to Pamela Maffei McCarthy, July 2, 2004, *New Yorker* files.

567 *"he was a worrier"*: Author interview with Pamela Maffei McCarthy, July 19, 2019.

568  *"he was thinking"*: Wilson, "Avedon's Final Take."

568  *"In the blistering hot"*: Wilson.

569  *"I urged him"*: Wilson.

570  *"I couldn't sleep"*: Wilson.

570  *"To know Dick Avedon"*: Adam Gopnik, "Richard Avedon," *New Yorker*, October 11, 2004.

570  *"with my boots on"*: Author interview with Lauren Hutton, April 22, 2016.

# SELECTED
# BIBLIOGRAPHY

Aletti, Vince. *Issues: A History of Photography in Fashion Magazines.* New York: Phaidon, 2019.

Arbus, Diane. *A Box of Ten Photographs.* New York: Aperture, 2018.

———. *Diane Arbus: Revelations.* New York: Random House, 2003.

Arbus, Doon, and Elisabeth Sussman, eds., *Diane Arbus: A Chronology.* New York: Aperture, 2011.

Avedon, Richard. *Alice in Wonderland: The Forming of a Company and the Making of a Play.* New York: Merlin House, 1973.

———. *An Autobiography.* New York: Random House, 1993.

———. *Avedon: Photographs, 1947–1974.* New York: Farrar, Straus and Giroux, 1978.

———. *Evidence, 1944–1994.* New York: Random House and Eastman Kodak Professional Imaging, with the Whitney Museum of American Art, 1994. Catalog of an exhibition at the Whitney Museum of American Art, New York, March 24–June 26, 1994.

———. *In the American West.* New York: Harry N. Abrams, 1985.

———. *Made in France.* San Francisco: Fraenkel Gallery, 2001. Catalog of an exhibition at Fraenkel Gallery, San Francisco, November–December 2001.

———. *Performance.* New York: Harry N. Abrams, 2008.

———. *Portraits.* New York: Farrar, Straus and Giroux, 1976.

———. *Richard Avedon Portraits.* New York, Harry N. Abrams and the Metropolitan Museum of Art, 2002. Catalog of an exhibition at the Metropolitan Museum of Art, New York, September 26, 2002–January 5, 2003.

———. *Richard Avedon: Portraits of Power.* Göttingen, Germany: Steidl and the Corcoran Gallery of Art, 2008. Catalog of an exhibition at the Corcoran Gallery of Art, Washington, DC.

Avedon, Richard, with James Baldwin. *Nothing Personal.* New York: Atheneum, 1964.

Avedon, Richard, with James Baldwin and Hilton Als. *Nothing Personal.* Cologne: Taschen, 2017.

Avedon, Richard, with Truman Capote. *Observations*. New York: Simon & Schuster, 1959.

Baldwin, James. *Giovanni's Room*. New York: Dial Press, 1956.

Baldwin, James, and Steve Schapiro. *The Fire Next Time*. Cologne: Taschen, 2017.

Baldwin, James, and Sol Stein. *Native Sons: A Friendship That Created One of the Greatest Works of the 20th Century:* Notes of a Native Son. New York: One World, 2004.

Begley, Adam. *The Great Nadar: The Man Behind the Camera*. New York: Tim Duggan Books, 2017.

Berger, John. *Ways of Seeing*. New York: Penguin, 1990.

Bernstein, Jamie. *Famous Father Girl: A Memoir of Growing Up Bernstein*. New York: Harper, 2018.

Bissinger, Karl. *The Luminous Years: Portraits at Mid-Century*. New York: Harry N. Abrams, 2003.

Blair, Sara. *Harlem Crossroads: Black Writers and the Photograph in the Twentieth Century*. Princeton, NJ: Princeton University Press, 2007.

Bram, Christopher. *Eminent Outlaws: The Gay Writers Who Changed America*. New York: Twelve, 2012.

Brodovitch, Alexey. Unpublished transcripts of workshops in 1964 at the Steve Franklin Agency.

Broyard, Anatole. *Kafka Was the Rage: A Greenwich Village Memoir*. New York: C. Southern Books, 1993.

Burton, Humphrey. *Leonard Bernstein*. New York: Doubleday, 1994.

Cantwell, Mary. *Manhattan, When I Was Young*. New York: Penguin, 1996.

Clarke, Gerald. *Capote: A Biography*. New York: Simon & Schuster, 1988.

———, ed. *Too Brief a Treat: The Letters of Truman Capote*. New York: Random House, 2004.

Gopnik, Adam. *At the Strangers' Gate: Arrivals in New York*. New York: Vintage Books, 2018.

Gray, Francine du Plessix. *Them: A Memoir of Parents*. New York: Penguin Press, 2005.

Gross, Michael. *Focus: The Secret, Sexy, Sometimes Sordid World of Fashion Photographers*. New York: Atria, 2016.

———. *Model: The Ugly Business of Beautiful Women*. New York: William Morrow, 1995.

Grundberg, Andy. *Brodovitch*. New York: Harry N. Abrams, 1989.

Guerrin, Michel. Unpublished transcript of interview with Richard Avedon for *Le Monde*, 1993.

Hall-Duncan, Nancy. *The History of Fashion Photography*. New York: Alpine Book Company, 1979. Catalog of an exhibition at the International Museum of Photography, George Eastman House, Rochester, New York, and other museums, June 25, 1977–September 30, 1978.

Hambourg, Maria Morris, and Jeff L. Rosenheim. *Irving Penn: Centennial.* New York: The Metropolitan Museum of Art and Yale University Press, 2017. Catalog of an exhibition at the Metropolitan Museum of Art, New York, April 20–July 30, 2017.

Harrison, Martin. *Appearances: Fashion Photography Since 1945.* London: Jonathan Cape, 1991.

Karnath, Lorie. *Sam Shaw: A Personal Point of View.* Ostfildern, Germany: Hatje Cantz, 2010.

Kozloff, Max. *New York: Capital of Photography.* New York: Yale University Press and the Jewish Museum, 2002. Catalog of an exhibition at the Jewish Museum, New York, April 28–September 2, 2002.

———. *The Theatre of the Face: Portrait Photography Since 1900.* New York: Phaidon, 2007.

Lartigue, Jacques-Henri. *Diary of a Century.* Edited by Richard Avedon. Translated by Carla van Splunteren. New York: Viking Press, 1970.

Lee, Marjorie. *The Eye of Summer.* New York: Simon & Schuster, 1961.

Leigh, Dorian, with Laura Hobe. *The Girl Who Had Everything: The Story of the "Fire and Ice Girl."* Garden City, NY: Doubleday, 1980.

Livingston, Jane. *The New York School: Photographs, 1936–1963.* New York: Stewart, Tabori and Chang, 1992.

Lubow, Arthur. *Diane Arbus: Portrait of a Photographer.* New York: Ecco, 2016.

Malcolm, Janet. *Diana and Nikon: Essays on Photography.* New York: Aperture, 1997.

Matthau, Carol. *Among the Porcupines: A Memoir.* New York: Turtle Bay Books, 1992.

McDowall, Roddy. *Double Exposure.* New York: William Morrow, 1966.

Moore, Kevin. *Jacques-Henri Lartigue: The Invention of an Artist.* Princeton, NJ: Princeton University Press, 2004.

Moser, Benjamin, *Sontag: Her Life and Work.* New York: Ecco, 2019.

Pelisson, Gerard J., and James A. Garvey III. *The Castle on the Parkway: The Story of New York City's DeWitt Clinton High School and Its Extraordinary Influence on American Life.* Scarsdale, NY: The Hutch Press, 2009.

Purcell, Kerry William. *Alexey Brodovitch.* London: Phaidon, 2002.

Rowlands, Penelope. *A Dash of Daring: Carmel Snow and Her Life in Fashion, Art, and Letters.* New York: Atria, 2005.

Rubin, Robert M., and Marianne Le Galliard. *Avedon's France: Old World, New Look.* New York: Harry N. Abrams and Bibliothèque Nationale de France, 2017. Catalog of an exhibition at the Bibliothèque Nationale de France, Paris, October 18, 2016–February 26, 2017.

Saroyan, Aram. *My Own Avedon: A Memoir with Photographs.* Los Angeles: An Air Book, 2010.

————. *Trio: Oona Chaplin, Carol Matthau, Gloria Vanderbilt: Portrait of an Intimate Friendship*. New York: Simon & Schuster/Linden Press, 1985.

Schulberg, Budd. *What Makes Sammy Run?* New York: Vintage Books, 1990 [1941].

Simeone, Nigel, ed. *The Leonard Bernstein Letters*. New Haven, CT: Yale University Press, 2013.

Sontag, Susan. *On Photography*. New York: Farrar, Straus and Giroux, 1977.

Stevens, Norma, and Steven M. L. Aronson. *Avedon: Something Personal*. New York: Spiegel and Grau, 2017.

Szarkowski, John. *Looking at Photographs: 100 Pictures from the Collection of the Museum of Modern Art*. Greenwich, CT: New York Graphic Society, 1973.

————. *The Photographer's Eye*. New York: Museum of Modern Art, 2007.

Tomkins, Calvin. Transcript of unpublished interview with Richard Avedon for a *New Yorker* profile on Carmel Snow, July 1994; archives of the Museum of Modern Art, New York.

Wilson, Laura. *Avedon at Work: In the American West*. Austin: University of Texas Press, 2003.

# ILLUSTRATION CREDITS

## PHOTOGRAPHIC INSERT 1

Page 1: All photographs courtesy of the Robert Lee family.

Page 2: *Top:* Courtesy of Stephen Elliot.
    *Middle, top left:* Courtesy of Harper's Bazaar.
    *Middle:* Bassman-Himmel Studio/courtesy Lizzie and Eric Himmel.
    *Bottom left:* Bassman-Himmel Studio/courtesy Lizzie and Eric Himmel.

Page 3: *Top:* Bassman-Himmel Studio/courtesy Lizzie and Eric Himmel.
    *Bottom:* Photographer unknown.

Page 4: *Top:* Robert Doisneau/Rapho Gamma.
    *Bottom:* Henri Cartier-Bresson/Magnum.

Page 5: *Top:* Sam Shaw, courtesy Shaw Family Archive, Ltd.
    *Bottom:* Barrett Gallagher, courtesy Cornell University Library/Special Collections.

Page 6: *Top:* Sam Shaw, courtesy Shaw Family Archive, Ltd.
    *Bottom:* Global ImageWorks.

Page 7: *Top:* Zuma Press, Inc/Alamy Stock Photo.
    *Bottom:* The Cecil Beaton Studio Archive at Sotheby's.

Page 8: *Top:* Lou Jacobs, Jr/MPTV Images.
    *Bottom:* Earl Steinbicker.

## PHOTOGRAPHIC INSERT 2

Page 1: *Top:* David McCabe.
    *Bottom left:* Photographer unknown.
    *Bottom right:* Alen MacWeeney.

Page 2: *Top:* Burt Glinn, Magnum Photos.
    *Bottom:* Gideon Lewin.

Page 3: *Top:* Gideon Lewin.
    *Middle:* Denis Cameron/Shutterstock.
    *Bottom:* Photographer unknown.

Page 4: *Top:* Florette Lartigue/Lartigue Archive, Paris.
    *Bottom:* Courtesy Minneapolis Institute of Art.

Page 5: *Top:* Jack Mitchell/Getty Images.
      *Bottom:* Adrian Panaro.
Page 6: *Top:* Alan Kleinberg.
      *Middle:* Laura Wilson.
      *Bottom:* Ruedi Hoffman, courtesy Laura Wilson.
Page 7: *Top:* Maggie Steber.
      *Bottom:* Ron Galella/Getty Images.
Page 8: *Top left:* Courtesy Elizabeth Cox Avedon.
      *Top right:* Rose Hartmann/Getty Images.
      *Bottom:* Eileen Travell.

# INDEX

# ABOUT THE AUTHOR

PHILIP GEFTER is the author of *Wagstaff: Before and After Mapple-thorpe*, which received the 2014 Marfield Prize, and a collection of essays, *Photography After Frank*. He was an editor for the *New York Times* for more than fifteen years. He lives in New York City.